O ND 1457 .C52 N483 1980
Fu
Traces of the brush.

TRACES OF THE BRUSH

肇有千秋業

Traces of the Brush

STUDIES IN CHINESE CALLIGRAPHY

by SHEN C. Y. FU in collaboration with

Marilyn W. Fu, Mary G. Neill, Mary Jane Clark

NEW HAVEN AND LONDON
YALE UNIVERSITY PRESS

This catalogue accompanied an exhibition
held at the Yale University Art Gallery, New Haven, Connecticut
between April 6 and June 27, 1977,
and at the University Art Museum, Berkeley, California
between September 20 and November 27, 1977.

The exhibition and first printing of the catalogue
were made possible by a grant from the National Endowment
for the Arts, a federal agency, with matching funds
from the Robert Lehman Foundation.

The calligraphy for the list of titles in Chinese and for the
pages preceding the essays was executed by the author.
Photography by Joseph Szaszfai of New Haven, Connecticut.
Designed by Klaus Gemming of New Haven, Connecticut.

Second printing published with assistance from
the foundation established in memory of
Philip Hamilton McMillan
of the Class of 1894, Yale College.

COVER:
Wang Hsi-chih, *Hsing-jang t'ieh*, detail,
no. 1a in this catalogue, and the double dragon red
imperial seal of the Sung emperor Hui-tsung

FRONTISPIECE:
K'ang Yu-wei, *Your Writing Will Last a Thousand*
Autumns, no. 90 in this catalogue.

Copyright © 1977 by the Yale University Art Gallery
All rights reserved
Library of Congress Catalogue Card Number: 79–24080
 ISBN 0–300–02487–8 (cloth)
 ISBN 0–300–02490–8 (paper)
Manufactured in the United States of America.

Published by Yale University Press, 1980. This book
may not be reproduced, in whole or in part, in any form
(beyond that copying permitted by Sections 107
and 108 of the U.S. Copyright Law and except by
reviewers for the public press), without written
permission from the publishers.

Published in Great Britain, Europe, Africa, and
Asia (except Japan) by Yale University Press,
Ltd., London. Distributed in Australia and
New Zealand by Book & Film Services, Artarmon,
N.S.W., Australia; and in Japan by Harper & Row,
Publishers, Tokyo Office.

TABLE OF CONTENTS

海外書蹟研究

己未華版 暑於傅申署

LENDERS TO THE EXHIBITION

The Art Museum, Princeton University, *Princeton, New Jersey*

Chien-lu Collection

Ching Yuan Chai Collection

Cincinnati Art Museum, *Cincinnati, Ohio*

The Cleveland Museum of Art, *Cleveland, Ohio*

John M. Crawford, Jr., *New York, New York*

The Detroit Institute of Arts, *Detroit, Michigan*

Douglas Dillon, *New York, New York*

Robert H. Ellsworth, *New Fairfield, Connecticut*

Jeannette Shambaugh Elliott, *Jacksonville, Illinois*

Mr. and Mrs. Hans Frankel, *Hamden, Connecticut*

Mr. and Mrs. Shen C. Y. Fu, *Arlington, Virginia*

Honolulu Academy of Arts, *Honolulu, Hawaii*

Hou Chen Shang Chai Collection

Lothar Ledderose, *Berlin*

The Metropolitan Museum of Art, *New York, New York*

Museum of Fine Arts, *Boston, Massachusetts*

Nelson Gallery–Atkins Museum, *Kansas City, Missouri*

Wang Chi-ch'ien, *New York, New York*

Mr. and Mrs. Fred Fang-yu Wang, *Short Hills, New Jersey*

Mr. and Mrs. Wan-go H. C. Weng, *New York, New York*

Yale University Art Gallery, *New Haven, Connecticut*

Three Anonymous Lenders

FOREWORD

ESTEEMED as the epitome of artistic accomplishment, calligraphy in China has traditionally been considered superior to painting and was, indeed, the mode of expression from which painting devolved. The elegance and sophistication of the fluent brushstrokes which make up the Chinese characters can be appreciated even by those unfamiliar with the Chinese aesthetic. We tend to admire forms of art in which the practitioner gives evidence of great skill and years of arduous training. The abstract expressionist movement in America in recent decades has probably made us even more sensitive to calligraphy, an art form in which the gesture—the seemingly spontaneous application of the artist's brush—is of supreme importance.

Little understood in the West is the degree to which calligraphy is integrated into Chinese culture, expressive of philosophical attitudes and embedded in cultural life. Significantly, calligraphy establishes the criteria for the judgment of Chinese painting, which came to be appreciated because of its affiliation with and dependence upon the brushstrokes of calligraphy.

The scholarly study of calligraphy is complicated by the existence of the many copies of much admired prototypes; since some of these copies are contemporaneous and others were done in later centuries, the question of authenticity is a complex one. The copies are often beautiful and accurate reproductions of lost originals, and have an aesthetic value of their own, in addition to their documentary value. The purpose of this exhibition and catalogue is to provide for the Western audience a means for understanding and gaining access to this fascinating subject. The author, Shen C. Y. Fu, an eminent scholar of Chinese art, addresses himself not only to questions of connoisseurship—establishing and defining the various categories of copies—but also to a preliminary outline for a comprehensive history of Chinese scripts. We offer the text of this catalogue as a contribution to the understanding and appreciation of the highly cultivated art of calligraphy.

Professor Fu has enjoyed the collaboration of his wife, Marilyn Fu, a doctoral candidate in Chinese art at Princeton University, as well as that of Mary Gardner Neill, Associate Curator of Oriental Art at Yale, and of Mary Jane Clark, a Yale doctoral candidate in Chinese art. Mrs. Neill, in addition to her scholarly role in this project, has assumed much of the organizational responsibility for the exhibition. In addition, June Guicharnaud provided indispensable editorial services for the catalogue section and, along with Peter Neill, for three of the six essays.

The exhibition would obviously not have been possible had the lenders not been willing to part with their treasures for an extended period of time so the show could be seen on both coasts of the United States. Nor could the exhibition have been mounted and the catalogue published without generous grants from the National Endowment for the Arts, a federal agency, and from the Robert Lehman Foundation.

Alan Shestack, *Director*
Yale University Art Gallery

James H. Elliott, *Director*
University Art Museum, Berkeley

PREFACE AND ACKNOWLEDGMENTS

CHINESE CALLIGRAPHY has a history of more than three thousand years. During that time, calligraphers have perfected the same strokes and essential configurations of the characters, the nature of each defined by an inimitable structure and subsequently molded into a characteristic style or "image" by its master practitioners. As a result of this long history, specific methods and principles, as well as standards of judgment on all aspects of the art have accumulated to form a rich visual and written legacy.

Each calligrapher must absorb and command this tradition, then transcend it, before he can achieve a "personal" style. Indeed, "to create one's own style," while at the same time having derived it from the art of the ancient masters, has been the criterion of greatness through the centuries. For the student and twentieth-century viewer, it is also essential to have a knowledge of the background and history of the art for his appreciation to be more than superficial.

In this regard, a comment should be made about the general belief that "Chinese calligraphy is an abstract art." While Chinese calligraphy does exhibit abstract *qualities*, it is not "abstract" to a calligrapher or to one who knows the conventions. Because the written language is still fundamentally ideographic—with a "given" sequence of forms—the freedom of the calligrapher lies essentially in his mastery of the brush, in the beauty and energy of the strokes he produces, and in the compositional sensitivity he develops. Within the limitations of the conventions, the aesthetic potentials are infinite.

Traces of the Brush, as exhibition and catalogue, owes its existence to the idea of a symposium on Chinese calligraphy. This had been in my mind ever since 1970, when the first International Symposium on Chinese Painting was held at the National Palace Museum, Taipei. Then, in 1971, the Philadelphia Museum of Art held the first exhibition devoted solely to Chinese calligraphy in America, organized by Dr. Tseng Yu-ho Ecke, who also wrote the catalogue, and by Curator Jean Gordon Lee. The receptivity of students and scholars, as well as the general public, to the exhibition and catalogue showed a high degree of interest and a readiness for more serious discussion of problems in the field.

In the fall of 1975, Professor Kwang-chih Chang, Chairman of the Council on East Asian Studies, Yale University, informed me of the possibility of the Council's sponsorship of such a symposium in 1977 through its Ford Foundation Grant for Research Seminars, a proposal approved by the members of the Council. The idea for an

accompanying exhibition and catalogue received the enthusiastic support of Alan Shestack, Director of the Yale University Art Gallery, and Mary Gardner Neill, Associate Curator of Oriental Art. Subsequently, a grant from the National Endowment for the Arts, and matching funds from the Lehman Foundation were obtained. Our colleagues Professors James Cahill and Yoshiaki Shimizu, of the University of California at Berkeley, showed interest in the exhibition and arrangements were made for the show to travel to Berkeley.

Working under the pressure of deadlines, the objects were selected, the loans negotiated, and the research and writing of the catalogue were completed in a matter of a few months. This book is therefore the result of the efforts of many, but in particular, three others: Mary Neill, who not only oversaw production and designed the installation, but who with Mary Jane Clark, assisted me in producing the catalogue entries. Ms. Clark, a Ph.D. candidate in Chinese art, Yale University, devoted herself completely to this meticulous task. Marilyn W. Fu, a Ph.D. candidate in Chinese art and archaeology, Princeton University, and former Assistant Curator of Chinese Art, the Metropolitan Museum of Art, New York, worked with me on the essays and on many of the ideas found here. I am grateful for their dedication. However, I alone am responsible for any shortcomings.

Needless to say, this project would have been impossible were it not for the kindness of the lenders, many of whom also placed their objects on preliminary loan so that the scrolls could be studied firsthand. In particular, I thank Mr. John M. Crawford, Jr., Mrs. Jeannette Shambaugh Elliott, Mr. Robert H. Ellsworth, Mr. C. C. Wang, the anonymous lenders, and the Chien-lu Collection. I thank also Mr. and Mrs. Fred Fang-yu Wang, Mr. and Mrs. Wan-go H. C. Weng, and Mr. Stephen Hwa, who provided information related to objects in their collections, and Professor and Mrs. Hans Frankel, who also improved the English renderings of some of the poems. Most of all I am grateful to the collectors for their willingness to lend certain objects which, as a result of study, I consider "problem pieces." Such generosity and open-mindedness has encouraged open discussion of difficult problems and has enabled the field of Chinese art history to advance.

In addition, I would like to thank Professor Wen Fong, Princeton University, who encouraged this undertaking from the start, and Professor Richard Barnhart, also of Princeton, who initially suggested that "all the Chu Yun-

ming's be shown together." The late Professor Arthur F. Wright, Yale University, lent his wide-ranging interest and warm personal support to the project, and to our profound sadness, was not able to see it completed.

Our editors Peter Neill and June Guicharnaud applied their considerable expertise to the manuscript. Klaus Gemming responded with sensitivity to produce this handsome book design, and the high quality of photographs is the work of Joseph Szaszfai and his staff. Judith-Ann Corrente, Ph.D. candidate at Harvard and Assistant in the Oriental department helped in editing and production, and Martha Achilles, Dorothy Hooker, and Nona Jenkins typed the manuscript. To Robert Soule, Superintendent, Yale University Art Gallery, and his excellent staff must be credited the beautiful installation.

Research was facilitated by the East Asian Research Collection of Sterling Memorial Library, for which I thank Mr. Hideo Kaneko, Curator, and Mr. Anthony Marr, head of the Chinese division, and their helpful staff. Mr. and Mrs. James Lo, of Princeton, New Jersey, provided several photographs. Thanks are also extended to the museums and collectors who have allowed reproduction of their objects as comparative figures in the essays.

My final selection of the objects was governed by both intrinsic quality and art historical importance. Since the study of Chinese calligraphy in the West has barely begun,

and this exhibition coincides with the first symposium on the subject, the representation could not be too specialized. The decision to borrow only works from American collections (except for one object from Germany) also made some duplication with the Philadelphia exhibition inevitable. However, in a new context, many of the same objects may be seen in a different light.

As for the content of the catalogue, the essays were not meant as a complete history of calligraphy, but to provide a context for the objects in the exhibition. Essay I introduces the techniques and tradition of copying as a form of "reproduction" to de-emphasize and differentiate it from the "forgery" in studies of Chinese calligraphy. Essays II, III, and IV introduce the masterworks from the standpoint of the development of the major script types, and Essay V discusses the importance of format as an aesthetic determinant and the colophon as a major calligraphic source. Essay VI takes the work of a single master, Chu Yun-ming, as a "case-study" in later Chinese calligraphy, and offers an approach by which a master's range and quality may be better defined.

Shen C. Y. Fu
Associate Professor
History of Art, Yale University

October, 1976

Note to the Second Printing

In the midst of assuming my new duties as curator of Chinese art at the Freer Gallery, Smithsonian Institution, I am delighted to hear of the reprinting by Yale University Press of *Traces of the Brush*. The catalogue was out of print less than six months after the exhibition had closed. Since that time, we have had numerous requests from the general public, students, and teachers asking for a reissue. I must stress that the essays were not meant as a text, but they do introduce the relevant problems in the field and place the ninety works in a historical context. Ultimately, I hope the book stimulates the reader to view and appreciate intimately the individual examples of brushwriting for their beauty and energy and as revelations of the artistic personalities of the calligraphers.

This second printing contains a few minor corrections but no major revisions. The reprint is largely due to the efforts of my wife and chief collaborator on the exhibition and catalogue, Marilyn Wong Fu. She worked closely with Judy Metro, art editor at the Yale Press, to whom we express our thanks. We are also grateful for the enthusiastic support of Professor Jonathan Spence, our former colleague at Yale and present chairman of the Council on East Asian Studies.

S. C. Y. F.

September, 1979
Washington, D.C.

I

Reproduction and Forgery
in Chinese Calligraphy

The number of each object in the exhibition *(no.)* corresponds to its place in the
Catalogue which is arranged chronologically. Plate numbers follow this same system.

IN CHINA calligraphy was appreciated as an art as early as the second century A.D. With appreciation there arose a demand for calligraphy among connoisseurs and collectors. By the fourth and fifth centuries, expert methods had been developed by which calligraphy could be copied and reproduced. Therefore, long before the inventions of modern technology, the Chinese made reproductions by hand which were intended to be honest and exact duplications of the original. A distinction should be made, however, between "reproductions" and "forgeries"—that is, exact copies made with the intent to deceive and meant to be taken for originals.

Because reproductions made in the traditional manner were not initially meant to be counterfeits, there was no reason to conceal certain aspects of the working process. Familiarity with this process will help the student to distinguish between a reproduction and its original, or a reproduction and a forgery.[1] This essay deals with the techniques of copying and their relationship to reproduction and forgery, as well as questions of style and quality which will be discussed through historical examples, and analyzed from the point of view of technique.

General Discussion of Methods and Terms

The earliest writings by Chinese critics on the history of copying date from the fourth century A.D. What follows is a general discussion of the methods and terms distilled from these sources.[2]

1. Lin ("to copy in a freehand manner")

Lin is the most common form of copying technique in calligraphy and painting. The artist confronts the original and transfers its forms by free-hand imitation. The method trains both eye and hand, and the copyist learns to discriminate between the essential qualities—good and bad—of the model. Learning a foreign language provides an analogy: one first learns vocabulary and syntax, then acquires the ability to express oneself more individually. In calligraphy, one achieves proficiency with the brush, then is able to make originals, reproductions, and, potentially, forgeries. At this level of fluency, only the artist's intention differentiates the "true" from the "false."

2. Mo ("to copy by tracing")

Using this technique, the artist places a sheet of paper over the model, and copies by tracing. The method has two subcategories: the first, a free method in which the forms are traced relatively quickly by a succession of single, continuous brush strokes, as if actually writing the forms; the second, a slower, more mechanical process, in which every detail is traced meticulously. Several traditional terms are associated with these subcategories:

a. *Ying-huang* ("hard and yellow"): In early China a paper called *ying-huang* was frequently used for tracing copies.[3] A thirteenth-century writer described how this paper was prepared: "Place the paper over a hot iron and apply yellow wax evenly over the surface. The paper will appear as transparent as clear horn, and one will be able to see all details placed beneath it as fine as a hair."[4] This was probably an early form of "tracing" paper: the wax would soak through the porous fibers, giving the paper a semitransparency which made it ideal for making copies, whether free-hand or meticulous tracings.[5]

b. *Hsiang-t'a* ("tracing by illumination"): According to the writer quoted above, this particular method entailed placing the paper "against the model, and holding it up to a bright window, facing the light."[6] Any paper of fine, thin texture and good quality could be used.

c. *Shuang-kou k'uo-t'ien* ("outline tracing and filling in"): This special technique pertains only to calligraphy.[7] With a fine brush, the shape of each original stroke is painstakingly outlined, then filled in. Even dry-brush or split-hair strokes are imitated. As the copyist must see through the paper to the original, either *ying-huang* paper or the *hsiang-t'a* method is generally used. When employed expertly, this method produces the most accurate duplication of all the ancient means of reproduction. Two famous T'ang copies of Wang Hsi-chih's calligraphy are *Sang-luan t'ieh* in the Imperial Household Collection, Japan *(fig. 2)*—a *shuang-kou k'uo-t'ien* copy made by the *hsiang-t'a* method—and *Feng-chü t'ieh* in the Palace Museum, Taipei—a tracing on *ying-huang* paper. The earliest work in the present exhibition, *Hsing-jang t'ieh (no. 1a, fig. 1)*, was also produced by these techniques.

Thus, not only can the original calligraphy be reproduced, but its condition—breaks, losses, or wormhole damage—may be recorded. Of course, if the original was undamaged and the copy was made early enough to acquire a patina of "age," one may easily confuse the two. And if that led to a mistaken, or dishonest attribution, then what was originally a reproduction might, in fact, be considered a forgery.

3. Fang ("to imitate")

After training by copying the works of a particular master, a calligrapher may choose to demonstrate the master's style in a free-hand manner. This method of free-hand imitation is called *fang*. The technique began quite early in China; however, the more self-conscious use of a style as subject, *fang-ku* ("imitating the

ancients"), is a relatively late phenomenon in the history of calligraphy.[8] The *fang* copyist usually signs his own name; yet if he does not and transcribes only the name of the original writer, or if the copyist's signature is effaced at a later date, then this "reproduction" may be considered a forgery.

4. *Tsao* ("to invent")

Tsao is essentially a subcategory of *fang:* the copyist adopts the style of a master, with the intention not to reproduce but rather to create a "new" work, an invention. Whether it is based on a well-known title or description, or whether it is a complete fabrication of a work by a master whose true writing is no longer extant, the result usually reflects the period-style image of the inventor and may give the expert some clue to its actual date.

5. *K'o-t'ieh* ("carved reproductions" or "lithographs")

K'o-t'ieh refer to the "rubbings" or "ink squeezes" taken from carved surfaces of either stone or wood.[9] The method was intentionally devised to reproduce calligraphy and might involve a single work or a collection of separate works. Essentially, it is an early form of mass reproduction of the calligraphic image.[10]

K'o-t'ieh became widespread after the tenth century.[11] The most important difference between it and the preceding methods of reproduction is that, while the others result in black-inked characters against a white ground, *k'o-t'ieh* reproductions result in white characters against a black-inked background, and thus cannot be confused with the original. *K'o-t'ieh* methods reflect a long tradition of engraved stone inscriptions which existed from the pre-Ch'in period through the T'ang dynasty, and includes the famous Ten Stone Drums, and the Han and T'ang commemorative steles. These are monuments into which characters were incised, and therefore rubbings taken from them would result in white characters on an inked background.[12] The earliest *k'o-t'ieh* probably date from the Five Dynasties. The tradition was sustained into the late Ch'ing period, even after the invention of modern alternatives for image reproduction, which was evidence of the demand for such copies and their important place in the history of calligraphy.

The process is begun by tracing the outline of the original brushstrokes; the outlines are then transferred onto a stone or wood surface by retracing. Then, following this pattern, the copyist carves out the stroke forms—ideally, consulting the original in order to capture as much of the feeling of the brush as possible. Finally, an ink rubbing is made from the finished carving.

A Ming dynasty connoisseur, Sun K'uang (1543–

1613), described the steps involved as the "Five Barriers": first, the outlining; second, the filling in with red pigment; third, transferring or "printing" the red pigment onto the wood or stone; fourth, making the carving; and fifth, making the rubbing. The "barriers" were the five steps between the copy and the original. If, subsequently, a *re-carving* were made from a *k'o-t'ieh* reproduction, then the resultant image would be ten steps removed from the original.[13] That is why rubbings require such a great deal of study, and why some re-carvings are so disdained by connoisseurs.

Each step involves an interpretation on the part of the copyist and the rubbing-maker and a potential deviation from the original. Compared to the more exact "outline tracing and fill-in" methods of reproduction, then, *k'o-t'ieh* involves not only several extra steps but also the intervening barrier of the carver's knife, which is more difficult to control than a brush. This is especially true of small-sized calligraphy, where it is far more difficult to be accurate and each deviation from the original contributes to the total distortion of the image reproduced. There is no doubt, however, that *k'o-t'ieh* copies have helped to preserve a considerable body of works. Reproductions by this method have provided models for many early calligraphers and preserved material that would otherwise have been lost.

Although *k'o-t'ieh* reproductions cannot be mistaken for originals, the problem of authenticity remains. First, the original work chosen for reproduction may have been an attribution or a forgery. Secondly, if, with time, a version of a *k'o-t'ieh* series became rare and a valuable collectors' item, reproductions or "re-carvings" from it could only result in confusion between the reproductive "generations." For this reason, the study of rubbings is a special field within the history of calligraphy which demands its own expertise. In the West, collections of *k'o-t'ieh* are rare, compounding the difficulties in studying them.

Brief Historical Summary

Lin, or "copying by sight," has from ancient times been the basic and most common method of copying. *Mo*, or "tracing," seems also to have started quite early, though not as early as *lin*, and the specialized method of *shuang-kou k'uo-t'ien*, "traced outline and fill-in method," probably began no later than the fourth to fifth centuries during the Six Dynasties; in fact, there is evidence that the terminology for such methods was generally accepted by the sixth century.[14] It would appear that these methods reached their peak during the seventh century, when trained craftsmen were employed by the T'ang court to

make tracing copies. In the Chen-kuan era (627–649), for example, specialists, *t'a-shu-jen*, were ordered to trace the famous "Preface to the Orchid Pavilion Gathering" (*Lan-t'ing chi-hsu*) of Wang Hsi-chih.[15] The T'ang historian and connoisseur Chang Yen-yuan, in his *Li-tai ming-hua-chi* (Preface dated 847), also mentioned that "official tracing copies," called *kuan-t'a*, were being made.[16] In other words, reproductions had become so common that official versions had to be differentiated from those being made by the ordinary populace.

The high T'ang period, following the An Lu-shan rebellion in 756, seems to have been a watershed, since far fewer records of tracings were made from that time on. The reason for the decline in tracing copies was the parallel rise of the *k'o-t'ieh* method, which eventually supplanted tracing as a primary means of copying.

Although no examples survive, evidence suggests that *k'o-t'ieh* began in the Five Dynasties period (907–960). In 992, by order of the Northern Sung Emperor T'ai-tsung, the famous anthology *Ch'un-hua-ko t'ieh* was compiled, and, subsequently, compilations of masterworks and model calligraphy in *k'o-t'ieh* form increased in popularity. During the Yuan dynasty (1279–1368) few *k'o-t'ieh* series seem to have been made, possibly due to the brief reign of the Mongols and to the fact that more original calligraphy, dispersed from the collections of high officials and the Imperial Court during the change of dynasty, was in circulation among scholars. That the art of making tracing copies did not die out during the Yuan can be seen in an important Yuan dynasty *shuang-kou k'uo-t'ien* copy of the *Lan-t'ing* Preface. Lu Chi-shan (active ca. 1320–45?) is known as the copyist, and colophons by leading scholar-officials and calligraphers of the Yuan endorse the work.[17] Later, in the Ch'ing dynasty, this tracing copy was reproduced in a *k'o-t'ieh* series by the Ch'ien-lung Emperor, indicating its importance to later generations.[18]

The interest in *k'o-t'ieh* was revived after the middle Ming, from about the sixteenth century to the end of the Ch'ing period. Then, with the development of photography, the *k'o-t'ieh* tradition declined. At the beginning of the twentieth century, a technique combining the traditional *k'o-t'ieh* methods with photography was devised to make new carvings. The modern collector P'ei Po-ch'ien (1854–1926), for example, had *Chuang-t'ao-ko fa-t'ieh* carved, employing photography in place of the first two steps of the *k'o-t'ieh* process. In the late Kuang-hsu period (1875–1908) an enlarged carved version of the *Lan-t'ing* Preface was reproduced by photographic means. Photography was also utilized to reduce monumental writing to smaller sizes for collection in book form—a modification of scale, precise and distortion-free. Since the rationale for each method of reproduction

was increased accuracy, it was inevitable that, despite the resistance of traditional taste, the early twentieth century would mark the effective end of the *k'o-t'ieh* method.

Case Studies

Wang Hsi-chih (303?–361?)
Hsing-jang t'ieh, an early T'ang tracing copy
of a letter (*no. 1a*)

Because of Wang Hsi-chih's great fame as the "calligraphy sage" in China, any attribution to him now extant is both valuable and problematical. Scholars generally believe that no authentic works by his hand remain. Therefore, to speak of the corpus of Wang Hsi-chih's works is to speak of a large and varied number of reproductions and forgeries. The value of any of these attributions depends on the individual quality and date of the copy, whether reproduction or forgery.

For example, any copy dating from the T'ang dynasty (A.D. 618–907) is of value to knowledgeable collectors. T'ang reproductions have been considered of such high quality that Chinese connoisseurs regard them as "just one step from the genuine work." The *Hsing-jang t'ieh* (*no. 1a*) is one such copy. It was a prized specimen in the collection of the Northern Sung Emperor Hui-tsung (r. 1101–25), an eminent calligrapher, connoisseur, and painter, and was listed in his calligraphy catalogue, the *Hsuan-ho shu-p'u*. Few extant reproductions of Wang's work have such impeccable credentials; indeed, this is the *only one* in a Western collection. By the addition of this major work, the stature of Western collections of Chinese calligraphy is greatly enhanced. As Tung Ch'i-ch'ang's colophon on the work states, "These two lines are worth more than thirty-thousand other scrolls."

The scroll has been extensively studied by previous scholars and collectors. For example, the paper on which it is written has been identified as *ying-huang* by the two collector-connoisseurs Chang Ch'ou (1577–1643) and An Ch'i (1683–1744).[19] Wang K'o-yü (active 1628–43) claimed that the paper was made of "yellow hemp fibre," which led the modern historian Nishikawa Nei to call it *ying-huang ma-chih* ("hemp-fibre paper treated by the *ying-huang* method").[20]

UPON CAREFUL EXAMINATION, the *Hsing-jang t'ieh* may be seen as a masterful execution, using combined "single-stroke" and "outline and fill-in" methods. If the original brush-stroke had a sharp edge, the copyist attempted to reproduce that effect; if, however, a difference in pressure, speed, or slant of the brush, or in depth of ink, caused the original stroke to be lighter or heavier, or the ink paler or denser, the copyist attempted

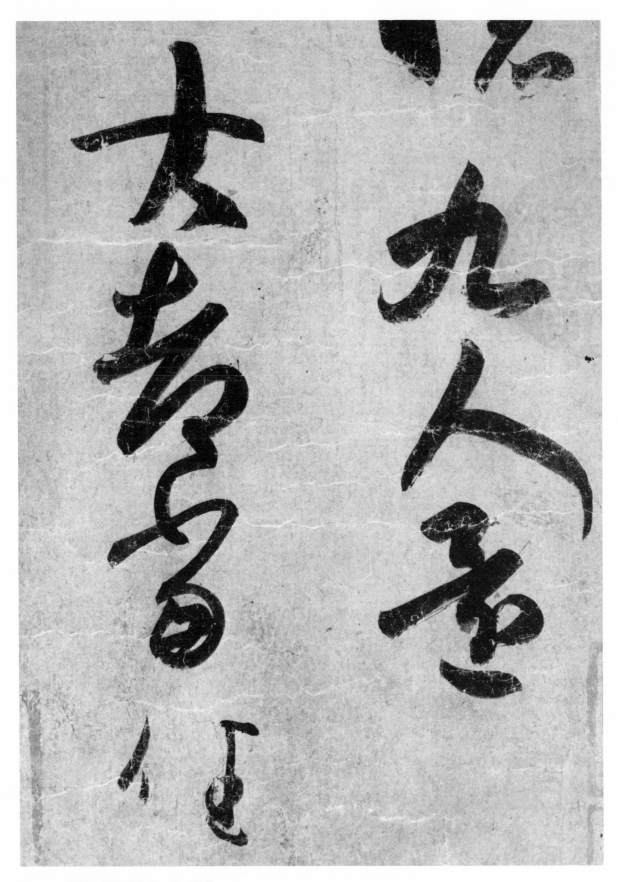

FIG. 1. Wang Hsi-chih (303 ?–361 ?).
Hsing-jang t'ieh. Enlarged detail, *(no. 1a).*

I · REPRODUCTION AND FORGERY

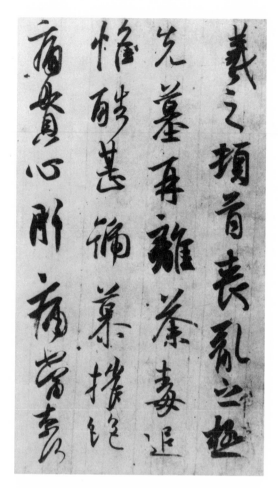

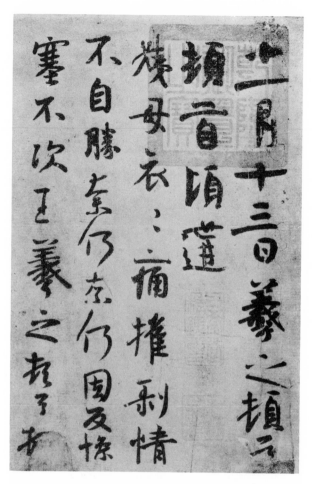

FIG. 2. Wang Hsi-chih (303 ?–361 ?). *Sang-luan t'ieh.* T'ang tracing copy. Detail of handscroll. Imperial Household Collection, Japan.

FIG. 3. Wang Hsi-chih (303 ?–361 ?). *I-mu t'ieh.* T'ang tracing copy. Detail. Palace Museum, Peking.

to express the subtle differences in tonality by adjusting his ink tone accordingly *(fig. 1).* The slightest irregularities are reproduced from the original. In the three characters in the right column of the enlarged detail, for example, note the underside of several strokes where the traces of an unruly hair or two protruding from the original brush did not escape the copyist's eye. The copyist's accuracy is further evident in that he also recorded idiosyncrasies in the original paper. For example, the last character of the left line *(fig. 1, bottom left)* contains a faint ink outline between the right and left parts, indicating the presence of a break or repair in the original.

Among the early tracing copies of Wang Hsi-chih, the *Sang-luan t'ieh (fig. 2),* in Japan, is considered best by scholars.[21] According to Nishikawa's study, the original of the *Sang-luan t'ieh* was probably written by Wang Hsi-chih at about age fifty, the beginning of his late

period. By contrast Nishikawa believes the *Hsing-jang t'ieh* to date from Wang's early period, comparable to the *I-mu t'ieh (fig. 3),* another of the best known early-style reproductions of Wang Hsi-chih.[22] Yet the quality of the *Hsing-jang t'ieh* is also apparent when the work is compared to other Wang Hsi-chih tracings, such as the famous set of "Works by the Wang Family," now in Liaoning.[23] Compared to this set, *Hsing-jang t'ieh* is the superior reproduction; the shading and dimensionality imbue it with a living quality that is absent from the others.

Extant records make no mention of the *Hsing-jang t'ieh* between the Southern Sung and late Ming, at which time the work entered the private collection of the wealthy and astute collector Wu T'ing (active ca. 1575–1625). Among Wu's friends were the pre-eminent connoisseurs of the day, Tung Ch'i-ch'ang (1555–1636) and Ch'en Chi-ju (1558–1639). Wu T'ing had a copy carved

in either 1596 or 1614 *(no. 2a)* as part of his anthology of calligraphy in *k'o-t'ieh* form, *Yü-ch'ing-chai t'ieh*. This rubbing, aside from the minor relocation of several seals, generally preserves the shape and relationship of the characters of the original.[24]

In 1747, *Hsing-jang t'ieh* was also included in another important compilation of *k'o-t'ieh*, the Ch'ing Imperial anthology of the Ch'ien-lung Emperor, *San-hsi-t'ang fa-t'ieh (fig. 4)*.[25] This carver also took liberties with the

FIG. 4. Wang Hsi-chih (303 ?–361 ?). *Hsing-jang t'ieh.* Detail of rubbing from *San-hsi-t'ang fa-t'ieh* (1747).

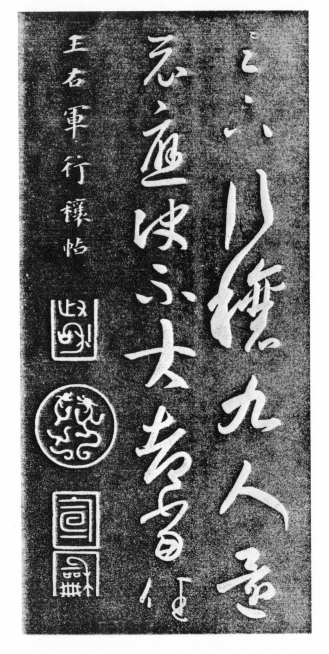

seals, choosing to reproduce only selected Hui-tsung seals and changing their position. In addition, he tampered with the arrangement of the characters themselves, enlarging the space between them to make two columns of the same length and closer together. The result is uniform, loose, and devoid of the spontaneous spacing of the original.

One other tracing copy of the *Hsing-jang t'ieh* is known to exist in the Palace Museum, Taipei, which may be judged a forgery of Ming date and of inferior quality.[26]

TUNG CH'I-CH'ANG (1555–1636) wrote several colophons on the *Hsing-jang t'ieh*. Stylistically, the most important and impressive is eleven lines of running script, dated 1609 *(no. 1b)*, which exemplifies the artistic peak of this major calligrapher, theorist, and painter. The writing is fresh and energetic, and the brush is wielded with discipline and ease. The ink tone progresses from dark to light and from wet to dry, enhancing the vigor of the brush. This aesthetic aspect of the writing becomes more significant when compared to the *Yü-ch'ing-chai* rubbing *(no. 2b)*. Although accurately carved, the most noticeable shortcoming of the rubbing is its failure to duplicate the subtle changes of ink tonality, especially the dry-brush effects which interested Ming calligraphers. This can be seen especially in the character *erh*, with its long tail: in the original the ink dries naturally during the downward course of the brush, producing a streaked effect which the rubbing can only crudely reproduce.

The *Hsing-jang t'ieh*, then, has been reproduced in several forms: in the T'ang period a tracing copy was made from the original; then, in the Ming and the Ch'ing, separate reproductions were made of the T'ang copy by carving; then a lithographic reproduction *(no. 2)* was made of the Ming rubbing after the T'ang copy. Further, in the late Ming a forgery of the T'ang tracing copy was made.

The importance of reproductions in the history of calligraphy is thus exemplified by this single work. Because of the lack of original material from the early periods, reproductions in their various forms become valuable substitutes for "lost works" and important sources for study.

After Ch'u Sui-liang (596–658)
A Ming dynasty tracing copy of
"Elegy to T'ang Wen-huang" *(no. 3)*

"Elegy" was a celebrated work, composed by Ch'u Sui-liang in 649 on the death of the T'ang Emperor T'ai-tsung (r. 627–649), known posthumously as Wen-huang.[27] The supposed original was first recorded in the collection of the Southern Sung Emperor Kao-tsung

FIG. 5. After Ch'u Sui-liang (596–658).
Elegy to T'ang Wen-huang. Tracing copy by Yen Ch'eng
(ca. 1540–ca. 1600). Detail, *(no. 3)*.

FIG. 6. Mi Fu (1051–1107). *Ta-hsing Huang-t'ai-hou
wan-tz'u*. Dated 1101. Detail of rubbing.
Collection unknown.

(r. 1127–62).[28] During the Ming, the work passed
through various notable collections when colophons were
added and several copies and carvings were made.[29]

This version *(fig. 5)*, according to the colophon by
Weng T'ung-ho (1830–1904) *(see also no. 85)*, is a tracing
copy done by Yen Ch'eng (ca. 1540–1600).[30] Although
no signature identifies the work, the earliest seals are
Yen's.

Yen's father was a close associate of Wang Shih-chen
(1526–90); thus an excellent opportunity existed for Yen
to have seen "Elegy" in Wang's collection. While little
is known of Yen Ch'eng himself, the quality of this re-
production testifies to the fact that he was no ordinary
calligrapher and had developed considerable expertise as
a copyist, which was somewhat surprising given the
general belief that there were few expert practitioners of

the art so removed from the T'ang dynasty.

Close scrutiny of "Elegy" reveals that it is a tracing
copy made by the "outline and fill-in" method. The ink
tone is unnaturally uniform throughout; the strokes are
crisp and fluent, although somewhat flat; and missing
parts of the characters and wormholes are outlined by
fine brushlines—all signs that the work is some form of
reproduction. The paper is porous, white, and untreated,
suggesting that the tracing was done by the *hsiang-t'a*
method.

As discussed earlier, the *k'o-t'ieh* process of reproduc-
tion may introduce inaccuracies, a fact verifiable when
rubbings are compared with each other or with a tracing
copy. In this case the original work from which the trac-
ing copy was taken is no longer extant, but four carved
versions taken from the original do exist. One of the

better of these is illustrated here *(fig. 17, facing no. 3)*. The tracing copy, then, being only one step removed from the original, becomes quite important in any evaluation of the artist's style and the quality of the rubbings.

If one compares "Elegy" with *Hsing-jang t'ieh*, the differences of technique are evident, even though both are tracing copies. Where "Elegy" is on untreated paper, *Hsing-jang t'ieh* is on yellow "wax-paper." Where the characters in "Elegy" are uniformly black and the stroke lines smooth, indicative of the "outline and fill-in" techniques, the characters in *Hsing-jang t'ieh* have a more rounded dimension—some shaded and some strikingly black, some edges crisp and some soft—which is indicative of the more adaptable combined method.

It is interesting to note that although Yen Ch'eng's intent was to reproduce "Elegy," some confusion followed in the ensuing years. In the nineteenth century, after the work had entered the Weng family collection, the descendants of the previous owner, Yen Yü-t'ang, became convinced that what they had lost was an original Ch'u Sui-liang and not a tracing copy. In other words, an honest reproduction was still mistaken for an original —or a forgery—by the misinformed.

A STYLISTIC ANALYSIS of the Ch'u Sui-liang's calligraphy presents another interesting set of problems. Among the works attributed to Ch'u, aside from attributed versions of the "Preface to the Orchid Pavilion Gathering," only one ink original is extant.[31] Among these, only one other attribution resembles "Elegy"; but the two works differ from his best-known work, *Sheng-chiao-hsu*, dated 653.

The brushwork and structure of "Elegy" have a quiet, refined, antique flavor, and, to the well-practiced eye, are suggestive of the manner and method of Mi Fu (1051–1107).[32] A comparison with Mi Fu's *Ta-hsing Huang-t'ai-hou wan-tz'u*, dated 1101 *(fig. 6)*, reveals the intriguing stylistic resemblance between Mi's work and "Elegy."[33] Mi admired and studied Ch'u's calligraphy.[34] It would not be unrealistic, then, to conjecture that his writing bears some resemblance to that in "Elegy."

Is it possible that this resemblance may consist in something more than influence, that indeed Mi Fu made the "original" transcription on which this tracing copy was based? The supposition may be supported in part by the interesting fact that, in the first line of "Elegy," the first character of the reign date, *Chen-kuan*, contains a missing stroke as a form of taboo. *Chen* is a homophone for the personal name of the Northern Sung Emperor Jen-tsung (r. 1022–63). It was the custom in China to avoid writing the personal names of emperors reigning and deceased within one's dynasty; there is no reason, then, for a T'ang master to leave that character incomplete, but every reason for a Sung master who

lived after Jen-tsung to do so. That Sung master may have been Mi Fu.

After Huang T'ing-chien (1045–1105)
Anonymous free-hand copy of
"Three Poems by Han-shan and P'ang Yun" *(no. 5)*

This scroll, known as *Han-shan-tzu P'ang chü-shih shih*, is a transcription of three poems by the T'ang poets Han-shan and P'ang Yun. Two versions exist: one in the Palace Museum, Taipei *(fig. 7)* and the other in the Crawford collection, New York *(no. 5, fig. 8)*.[35] The two are quite close—the number of characters per line, and the number of lines are the same—but one is not an exact duplicate of the other. A comparison of the style of the two scrolls leads to the conclusion that they are neither written by the same hand, nor come from the same period.

As creations of one of the four great Sung masters of calligraphy, the works of Huang T'ing-chien (1045–1105) have been treasured by connoisseurs from that time to the present. Kao-tsung, the Southern Sung Emperor (r. 1127–62), one of his greatest admirers, was known to have imitated his style and collected several of his works. The *Han-shan P'ang Yun* scroll in the Palace Museum was in Sung Kao-tsung's collection and bears his seal, *Nei-fu shu-yin*, impressed on the joins between the paper.[36]

Early documentation indicates that, from the twelfth century onward, the scroll was considered to be a genuine work by Huang T'ing-chien. Later, when it entered the Ch'ing Imperial Collection and was recorded in the third edition of the Ch'ien-lung Emperor's catalogue of calligraphy and painting, *Shih-ch'ü pao-chi san-pien* (1743–1817), questions were raised by the Emperor's "second thought" authentication. He wrote on the scroll: "This is an 'outline and fill-in' forgery. The poems also contain mistakes. I formerly graded this object as *shang-teng* [the highest category]. Actually it is a mistake."[37] This opinion has, of course, influenced modern connoisseurs.

WHEN EXAMINED under strong light and magnified, there is absolutely no indication that the Taipei scroll is a tracing copy.[38] Where one would expect to find such indications—such as the ends of the strokes and the "flying white" places—all are smooth, vigorous, and natural. The rounded brushstrokes contain tense, tremulous energy. The organization of the component elements is purposefully asymmetrical. The shifting balance of characters in a column combines with outstretched horizontals and elongated diagonals to convey a dense, tangled expression. In sum, the brush method, structure, and spirit of the writing are all consistent with what we

know of as Huang T'ing-chien's work before the onset of his fully developed "old-age" style *(compare no. 6).*

The scroll is undated and signed "Fu-weng," a signature Huang T'ing-chien is known to have used after 1095. The inscription states that he executed the work at the Accepting One's Fate Studio *(Jen-yun-t'ang),* a name he later changed. This evidence suggests that the work is datable to the fourth through ninth lunar months of 1099.[39] Huang also writes that he was testing a new brush by the maker Chang T'ung, and the work reveals sharp tips at the stroke ends and fine ligatures, characteristics of a new brush. Given the documentation, brush methods, internal consistency of technique, and content of the inscription, there is no doubt that the Palace Museum *Han-shan P'ang Yun* scroll is a genuine work by Huang T'ing-chien.

THE CRAWFORD COLLECTION version is more problematic. From the documentary point of view, the earliest seal on the Crawford scroll is *Ch'ün-yü chung-mi,* one of a set of seven famous seals belonging to the Chin Emperor Chang-tsung (r. 1190–1209).[40] It was customary for Chin Chang-tsung to impress multiple seals on a work; but this scroll contains only one seal impression. More importantly, when compared with the same seal on other well-known scrolls from the Chin collection, such as the Ku K'ai-chih "Admonitions of the Instructress to the Court Ladies" (British Museum), the Chao Kan "Early Spring on the River," and the Huai-su "Self-Statement" (both Palace Museum, Taipei), it is clear that the seal on the Crawford *Han-shan* scroll is not correct. Therefore, the scroll's documentation cannot be traced back to the Chin period.

In addition, even though the first three colophons were supposed to have been written in different periods, the brushwork and ink tone are similar and may have been written by a single hand. More obviously, the third colophon by Ku Ying-hsiang (1483–1565) is dated one year after his death. On the basis of these observations, none of the three colophons are authentic.

But the real crux of the problem lies not in a forged seal or colophons but in the calligraphy itself. Stylistically, the scroll exhibits a certain quality and a general resemblance to Huang T'ing-chien's work. The strokes, however, while rounded and generally written with a centered tip, lack the central tension and energy found in the Palace Museum version and other genuine works. Moreover, the stroke ends do not show crisp, pointed tips typical of a new brush, just as Huang's asymmetrical character arrangement, purposeful spacing, and elongation of strokes are missing.

The upper two characters of the Palace Museum version *(shui* and *jen) (fig. 7),* contain two different right descending diagonals *(na).* They are written with a "struggling" brush. This is not weakness, but the effect of Huang T'ing-chien's principles of brush manipulation (see essay IV). Similar strokes in the Crawford version *(fig. 8),* however, are quite smooth and straight.

Furthermore, Huang T'ing-chien organized his characters in an intimate vertical relationship. Note the second character from the top in the right line, *liu (fig. 7)*: the dot of the right-hand element is placed in the space of the upper character, and in the left column, while the first three characters are placed in a vertical line, the last two have been shifted slightly to the right. The interaction of dots and lines with neighboring characters was a purposeful artistic choice representing Huang's unique approach to the organization of form. In the Crawford version, not only are the characters evenly spaced and placed along a central axis, but the spatial relationship between characters is very loose.

It may also be noted that the paper on which the Crawford scroll was executed is redder and darker than papers from authentic Sung works, and the texture appears closer to that of a variety of dyed papers made during the Ming. Moreover, the relaxed postures of the characters contain elements of the post-Chao Meng-fu (1254–1322) influence as well that of Tung Ch'i-ch'ang (1555–1636).

In sum, the cumulative evidence supports the conclusion that the Crawford *Han-shan* is a free-hand copy after the Palace Museum version, done, at the latest, before the genuine version entered the Ch'ing Imperial Collection, and most probably after the revival of Huang T'ing-chien's influence in the second half of the middle Ming.[41]

After Huang T'ing-chien (1045–1105)
"Poems," Anonymous imitation of the
late Ming period *(no. 7)*

Forgers, while competent in other respects, do not have an art historian's perspective of a particular artist's development; thus they frequently produce a work inconsistent with a demonstrable stylistic progression. For a forger to master the standard image of an artist's style is an accomplishment; for him to understand further the developmental differences between early and late works is indeed asking a great deal. Even the most accomplished forger cannot meet all the demands of both knowledge and technique.

As discussed above, the copyist who made the Crawford scroll was not a practiced virtuoso in the style of Huang T'ing-chien. He was schooled in his own trends and was attempting to copy directly from his model. He worked without a stylized image of Huang's style in his mind; and his brushwork is more a reflection of the

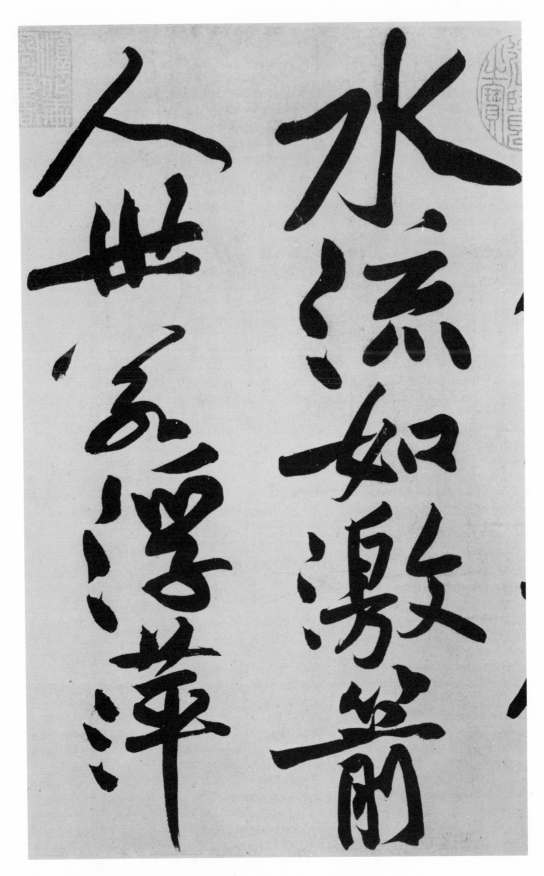

FIG. 7. Huang T'ing-chien (1045–1105).
Three Poems by Han-shan and P'ang Yun. Datable 1099.
Detail of handscroll. Palace Museum, Taipei.

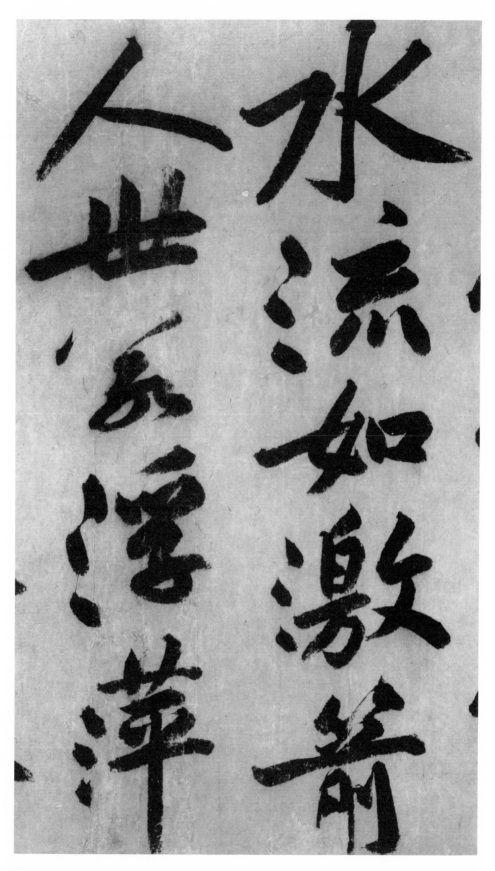

FIG. 8. After Huang T'ing-chien (1045–1105).
Three Poems by Han-shan and P'ang Yun.
Detail of handscroll, *(no. 5)*.

prevalent training (i.e. the Ming-Ch'ing revival of Chao Meng-fu's calligraphy) than of his personal style.

"Poems" from the collection of Wango Weng, is not a genuine work by Huang T'ing-chien, and yet it contains characteristics reflective of the popular image of Huang's style during his renewed influence in the middle Ming (see essay IV). The forger, accustomed to imitating Huang's style, exaggerated the most salient "Huang-like" characteristics. This scroll, too, is a free-hand execution but reveals a more complicated mixture of Huang T'ing-chien's traits and the forger's period and personal styles.[42]

The first section of the two-part scroll is dated 1087. A close study of Huang T'ing-chien's stylistic development would indicate that by this date he had not yet developed the special characteristics associated with his mature style. This scroll, however, contains stylizations which only appear in later works (ca. 1095 onward). Such a limited conception of a master's style is generally true in the case of forgeries.

Other inconsistencies are also apparent. The paper on which the work is written appears to have been aged artificially by dyeing. Further, in the dedication on the dated section, the name Chun-ta refers to Shen Liao (1032–85), who, according to all records, passed away two years before Huang's dedication, suggesting that the inscription is an invention which was not based on any lost original—a piece of internal evidence that confirms the stylistic argument.

Chao Meng-fu (1254–1322)
"Twin Pines Against a Flat Vista" (no. 13)
and Its Copy (no. 14)

In Shanghai during the late 1940's, a prominent collector named T'an Ching invited a group of talented artists to set up a workshop with the purpose of reproducing some two dozen paintings of the Yuan, Ming, and Ch'ing periods from T'an Ching's personal collection. Each member of the workshop had a specialty, whether imitating antique calligraphy and painting, or simulating fine old mountings. T'ang Lin-shih, T'an's teacher, is said to have headed the group and was responsible for reproducing the seals.[43]

The copies resulting from this project were of high quality—virtual replicas. It is rare, not just in the twentieth century but in the whole history of forgeries, to have the date of manufacture within living memory and to have copies and originals available for examination and comparison.[44] Written records of such past endeavors have been preserved, but seldom have the objects survived to be identified with their makers.

One of the products of T'an Ching's workshop is Chao Meng-fu's "Twin Pines Against a Flat Vista," from the Cincinnati Art Museum (no. 14), an exact replica of a scroll by the same title from the Metropolitan Museum of Art, New York (no. 13). Students of Chinese painting who have followed this case with interest over the years will at last welcome this opportunity to study them both at close hand, rather than depend only on photographs and their visual memory.[45]

As noted before, modern methods of reproducing images made many of the traditional means of reproducing calligraphy and painting obsolete. Early calligraphers were also interested in any mechanical devices which could aid the copying process. In a letter to a friend, Huang T'ing-chien notes: "... T'ang Lin-fu made a special table for copying calligraphy. The center had a drawer in which a lamp could be placed. While making tracing copies in this way, he would not lose any fine detail."[46] In principle, the Sung design is similar to one used by modern copyists and probably by the T'an Ching group: a table with a glass surface is provided with a lamp to illumine the original work from below and over which the intended copy could be placed. The basic principle behind both is, of course, the hsiang-t'a tracing method, whereby the tracer faced the natural light and worked in a vertical position. With modern technology and proper training, contemporary artists might be expected to make better forgeries than the ancients. The T'an Ching workshop did not disappoint us, and yet all aspects of their copies are reputed to have been reproduced by traditional means. Judging from the copies, the calligraphy inscribed on the painting was of the most impressive quality.

At first glance, the mechanical similarity between the two scrolls is alarming: both calligraphy and painting are duplicated to the finest detail. The T'an Ching specialists employed the single-stroke tracing method, retouching occasionally to reinforce weak or flawed elements. The resultant brushwork has a relatively natural appearance; indeed, unless one focuses on the smallest details, it is difficult to tell the copy from the original.

There are differences, however. As perfect as the calligraphy in the Cincinnati version seems to be, careful examination and enlarged details (fig. 10) betray the process of slow copying, which are most evident in the fine linking strokes and the attempted simulation of the inadvertent, but natural, lapses in the original. For example, the character yü in the Metropolitan scroll (fig. 9, lower right) shows a large but discontinuous loop in its right-hand element as the brush swings upward and is lifted off the paper. In trying to imitate this loop, the copyist slowly traced the form, but stopped his brush, making a slight "head" as he put it down again. The linkage shows none of the smooth "flow" of the original. In

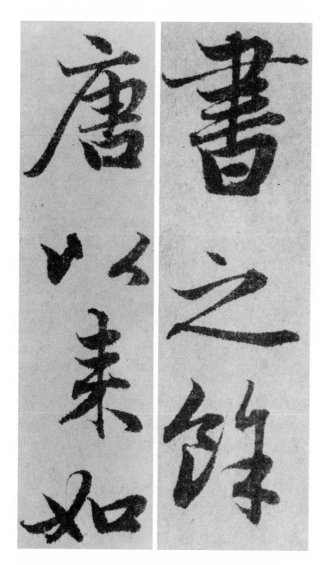

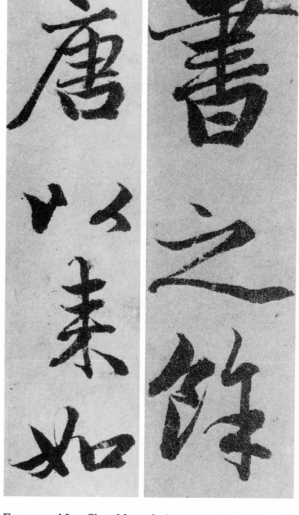

FIG. 9. Chao Meng-fu (1254–1322). *Twin Pines against a Flat Vista*. Enlarged detail of inscription, *(no. 13)*.

FIG. 10. After Chao Meng-fu (1254–1322). *Twin Pines against a Flat Vista*. Enlarged detail of inscription, *(no. 14)*.

addition, the left-hand element of the same character betrays a jagged rhythm and several "touched-up" areas. The characters *lai* and *ju* in the next column (*lower left*) also betray similarly unnatural linking strokes when compared with the original.

Ink tonality in both the calligraphy and painting appears listless and pallid in the Cincinnati version when compared to the Metropolitan version. This is particularly noticeable in the execution of the small branches and pine needles of the pine tree: the Metropolitan version shows a vitality in the brushwork which carries through each deft stroke. Through variations in ink tone, dry, dark needles mix with pale, suggesting an ambient space. Emphatic contours added to the tree trunk and branches

enhance this feeling of growth. The Cincinnati version, by contrast, lacks equivalent vigor. This, and an unnatural appearance of the paper, leave the over-all impression that the Metropolitan "Twin Pines" is the stronger work and provided the model on which the Cincinnati version was based. However, the intriguing question remains whether this conclusion could be reached without comparison with the original.[47]

Hsien-yü Shu (1257 ?–1302)
"Admonitions to the Imperial Censors" *(no. 16)*
and Its Copy *(no. 17)*

Hsien-yü Shu was a contemporary of Chao Meng-fu

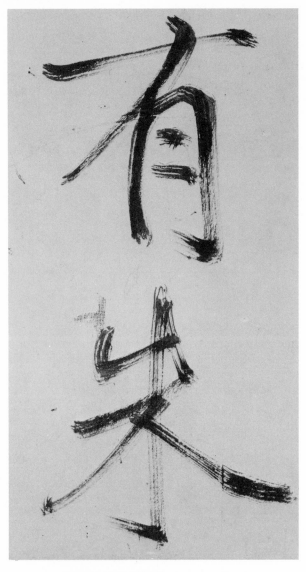

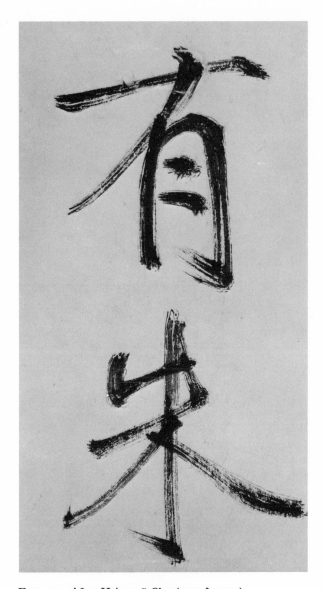

FIG. 11. Hsien-yü Shu (1257?–1302). *Admonitions to the Imperial Censors*. Dated 1299. Detail of handscroll, *(no. 16)*.

FIG. 12. After Hsien-yü Shu (1257?–1302). *Admonitions to the Imperial Censors*. Late Ming tracing copy. Detail of handscroll, *(no. 17)*.

(1254–1322) and one of the few calligraphers whom Chao respected. Their friendship was of mutual artistic benefit, and their interests were fundamental in helping to establish the early Yuan cultural revival and return to ancient models.[48]

Two versions of "Admonitions to the Imperial Censors" exist *(no. 16, fig. 11, and no. 17, fig. 12)*. The two scrolls are extremely similar; in fact, solely from photographic reproductions, it is difficult to see the difference in actual quality without enlarged details. In a work such as this, where bold, blunt brushwork prevails and a monumental force carries with it a calligraphic impact rather than refinement and elegance of detail, the copy

succeeds surprisingly well in both technique and over-all spirit.

A closer look at the second version, however, reveals its unsatisfactory elements. The difference in ink tonality is most striking. In the original the ink tone varies from dark to light—a natural phenomenon, since the ink is used up in the brush. In some strokes, a streaked or "flying white" effect (*fei-pai*) is seen where the paper shows through the exhausted ink. In the copy, however, the ink tone is almost uniformly black; when examined closely, what appears to be a single stroke in the original is, in the copy, actually built up in layers by a repetition of fine strokes. This is a classic example of the "outline

and fill-in" method of tracing. Large writing is much more difficult to duplicate successfully by this method because there is more space to a single stroke and there are a larger number of fine details which must be attended to than in smaller writing. Thus the "filling-in" process by myriad finer strokes in large copies can be extremely laborious and finally assumes the "piled-up" surface quality seen in this copy.

In other respects, the copy accurately reproduces the subtleties of the actual writing process. In the original, Hsien-yü Shu used a stiff, slightly worn brush. When he turned corners to make "folding" strokes, unkempt bristles produced a "ragged" effect, which can also be seen in some of the hooks where Hsien-yü Shu did not pause to make a polished stroke-end. In the copy, each of these ragged edges has been faithfully and accurately duplicated. It is these accidental brush qualities of the original which are the most difficult to reproduce.

One unsatisfactory element of the copy is the presence of a white powder spotting the surface of the ink, which was an attempt at deception, since the Chinese have long held that only truly ancient works exude what is known as "ink frost" (mo-shuang). It may have also been added to conceal some of the uneven surfaces caused by the heavy-ink application. Also some ink spots on the original were probably incurred during the tracing process.

That the copy was intended as a forgery is clear. The copyist did not sign his name, leave a colophon, or apply his seal; indeed, Hsien-yü Shu's seals are reproduced in toto. While twenty-six lines are missing from the opening of the original scroll, the tracing copy is complete in its fifty-four lines of 204 characters. When the original entered the Ch'ing Imperial Collection, it was recorded in the first edition of the catalogue, Shih-ch'ü pao-chi (1744–45), and, at that time, the scroll was intact.[49] Later, in 1945, during the civil war, the scroll left the palace, and sometime before entering Chang Ta-ch'ien's collection that same year, the first twenty-six lines were lost. The copy must predate this incident, for it is unlikely to have been executed under revolutionary conditions or in such a short time following its removal from the palace. According to the seals on the original, Liang Ch'ing-piao (1620–91) was the last previous collector before the Ch'ing Emperor. At the latest, then, the copy was made in the early Ch'ing.

Yang Wei-chen (1296–1370)
Colophon to "Gazing at a Waterfall,"
painting by Hsieh Po-ch'eng (no. 23)

This scroll is a fine representation of Yuan dynasty style, and a rare example of the painter Hsieh Po-ch'eng's

style. Works by minor artists like Hsieh provided the background for the achievement of painters like Wang Meng (1308–85), Ch'en Ju-yen (active ca. 1340–70), and Hsu Pen (active ca. 1370–80). In some respects, however, the scroll is problematical. Close examination and comparison with known examples of Yang Wei-chen's calligraphy suggest that both the painting and the calligraphy are extremely close copies of what must have been an original work.

The calligraphy (no. 23) shows the distinctive traits of Yang Wei-chen in his smaller free-hand style, such as his "Drinking with my Wife" (no. 22). But a closer scrutiny of the characters in an enlarged detail (fig. 13) (shih or wan, for example), reveals the lack of directness and strength in the effort to reproduce only the shapes. In addition, the ink does not flow in a natural sequence as it would if the writer were working spontaneously. On the contrary, in several areas the writer has recharged his brush in midstroke or in the course of a linkage.

The work represents a relatively high quality copy, however, and was most probably done before the middle Ming. Thus it can be taken as a rare reproduction of a lost painting. The fact that it is a copy or a reproduction does not diminish its importance in the study of late Yuan art.

FIG. 13. Yang Wei-chen (1296–1370). Colophon to "Gazing at a Waterfall," painting by Hsieh Po-ch'eng. Detail of hanging scroll, (no. 23).

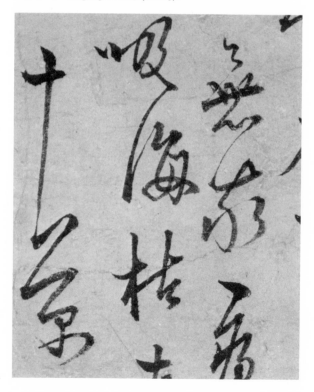

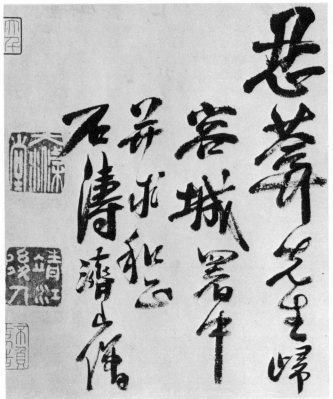
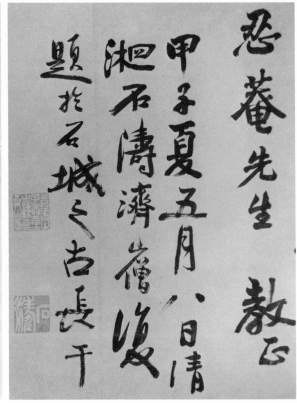

FIG. 14. Tao-chi (1641–ca. 1710). (Left) *Farewell Poem to Jen-an*. Detail of handscroll, *(no.72)*. (Right) *Portrait of Jen-an*. Dated 1684. Detail of handscroll. Identical seals were once affixed to *Farewell Poem*. Ta-feng-t'ang Collection. (Not to scale.)

Tao-chi (1641–ca. 1710)
"Farewell Poem to Jen-an," attached to
"Rocky Bank of a River" by Tao-chi *(no.72)*

This important, but neglected, example of Tao-chi's large writing *(no.72)* contains an inconsistency of seals and signature which has caused scholars to dismiss both the poem and the painting. A proper look at the scroll, however, will show how this inconsistency may be clarified.

The two large seals after his signature read: *Ta-ti-t'ang* and *Ching-chiang hou-jen*, names Tao-chi is known to have used after 1696–97, when he renounced Buddhism, turned to Taoism, and embraced his Ming imperial heritage. These seals conflict with his Buddhist signature, "mountain-monk" *(shan-seng)*. The contradiction is doubly troublesome because the style and high quality of the calligraphy argue for its authenticity.

The contradiction may be resolved only by careful examination of the seals. Two larger seals, for some unknown reason, have been removed and new ones stamped in their place. Oily traces of the removed seals are still visible on the paper, and the legends also are partially legible. The first seal reads: *Shan-kuo chih-tzu, T'ien-t'ung chih-sun, Yuan-chi chih-chang*. The second reads: *Shih-t'ao*. These seals also appear on a colophon in large-sized writing attached to another Tao-chi scroll dated 1684, "Portrait of Jen-an" *(fig.14)*.[50] The seals are Buddhist, date prior to his conversion, and are therefore compatible with the signature. A third vertical seal, found at the far right of the present poem, reads: *Tsan-chih shih-shih-sun, A-chang*. But it, too, is a replacement; the larger original, a trace of which now shows as a half-seal, reads: *Ch'ien-feng wan-ho chih-t'ang*, and also appears on the 1684 scroll.

In other words, the present seals on the colophon are later replacements and cannot be used as arguments against the calligraphy. This conclusion is supported by the fact that the same seals appear on other genuine works by Tao-chi, notably the scroll dedicated to the same person and bearing Tao-chi's rare early colophon in large-sized writing. Finally, the style of "Farewell Poem" is consistent with other examples of Tao-chi's genuine calligraphy, and this, plus its high quality, confirms its authenticity.[51]

Kao Feng-han (1683–1748)
"The Tang-ch'ü Stele," dated 1740, transcription of Han dynasty stele by General Chang Fei (no.75)

There are two versions of this hanging scroll: the number of lines, the seals, the script, and the style of the calligraphy appear identical.

This situation suggests two possibilities: that one version is an extremely close copy of the other; or that both are copies, possibly by the same hand, made after a third original. Close examination of the version in the Chien-lu Collection indicates that it could not have been copied after the version published in 1908 (fig.18, facing no.75).[52] The strokes are written in a straightforward manner, neither retouched nor filled-in. Despite the eccentric script style, the writing has a natural quality. The physical condition is good; and the texture and color of the paper, as well as the seal cutting and seal paste, are acceptable.

The inscription in cursive script compares well with Kao's frontispiece to his album of "Flowers and Callig-raphy" (no.74), dated 1738, two years earlier. Works dated after 1737, when Kao's right arm became paralyzed and he began to write with his left hand, present additional difficulties because the awkwardness of the style invited forgery. A seemingly clumsy work may still be genuine, however; even though the writing is awkward, it still reflects the qualities of the master's hand. In this case, the Chien-lu version appears authentic and suggests that the scroll published in 1908 is an extremely close copy by a different calligrapher.

Weng T'ung-ho (1830–1904)
"Couplet on Confucian and Taoist Virtues" (nos.85 and 86)

Unlike the several previous examples of sets in which one work was the original and the other a copy, the two sets of couplets bearing the signature of Weng T'ung-ho are both genuine (figs.15 and 16). And yet it is known that Weng wrote only one set.

FIG. 15. Weng T'ung-ho (1830–1904). *Couplet on Confucian and Taoist Virtues*. Detail of left panel, (no.85).

FIG. 16. Weng T'ung-ho (1830–1904). *Couplet on Confucian and Taoist Virtues*. Detail of left panel, the "second layer," (no.86).

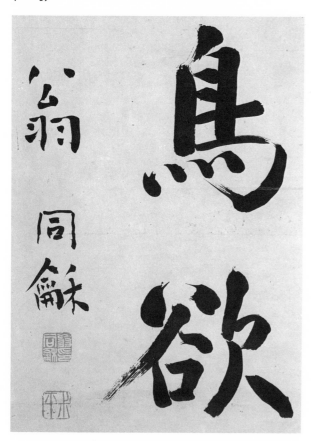

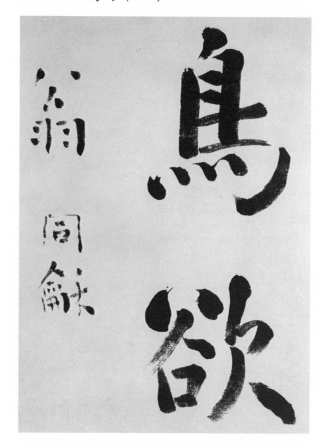

When connoisseurs confront a difficult work, they may often resort to explaining that the questionable work is a retouched version of the "peeled" second layer. A "peeled" second layer is possible when the original work was written (or painted) on paper which consisted of two layers laminated together as a single sheet. When used for calligraphy, the ink naturally soaks through from the first to the second layer. There are two reasons for the second layer to be removed. If the original paper is too thick, the mounter may remove the bottom layer to make it easier to mount and to preserve. Or, if an older work is being remounted, the soaking process often loosens the glue which originally laminated the two layers together, whereupon the second layer must be peeled off.[53] In either instance, a dishonest mounter may purposefully remove the second layer.

When this work was first seen at the mounter's shop, the style appeared different from other familiar late works by Weng T'ung-ho which were often casually written with a slightly nervous quality to the strokes. But the brushwork and structure of this couplet were calm and stable, and written in a more serious manner. Still, the strokes looked flat and the ink thin. When these observations were discussed with the mounter, he explained that he had removed a second layer from the work during the remounting process, thus accounting for the unusual "look" of the scroll. Thus there were actually two genuine sets of the same couplet available for purchase.

THE INK TONE of the second layer is related to the size of the characters written on the upper layer, to the thickness of the paper, and to the amount of ink the calligrapher customarily loads his brush with when writing. If the characters are large in size, the calligrapher must use more ink than usual, so that the ink soaks through more completely to the second layer. However, certain strokes require a "fast ending," such as a diagonal *na*, *p'ieh*, or a hook stroke; they do not receive as much ink, and consequently are paler and shorter in length on the second layer.

With smaller-sized writing, less ink is necessary in the brush, resulting in even paler ink on the second layer. This can be seen in the colophon written on this work by Weng T'ung-ho's grandnephew, Weng Pin-sun. By the time of the grandnephew's generation, the paper had become older and its absorbency decreased. The colophon of the second layer registers only spots of ink and is practically illegible. As for the seals, because the material was mineral cinnabar, none of the red pigment soaked through, leaving only the ghostlike oily trace of the seal impression where the binding medium permeated the paper.

If a dishonest mounter wished to sell the second layer as an original, he would have to fill in the pale-ink sections with darker ink and stamp the work with a pair of comparable seals. The piece would then be half-genuine and half-forged. There are two small areas of retouched strokes on the second layer of the Weng couplet: the ink is noticeably different in value. The experienced connoisseur would be able to detect similar but less obvious deviations, just as he would detect signs of tracing copies and other reproductions.

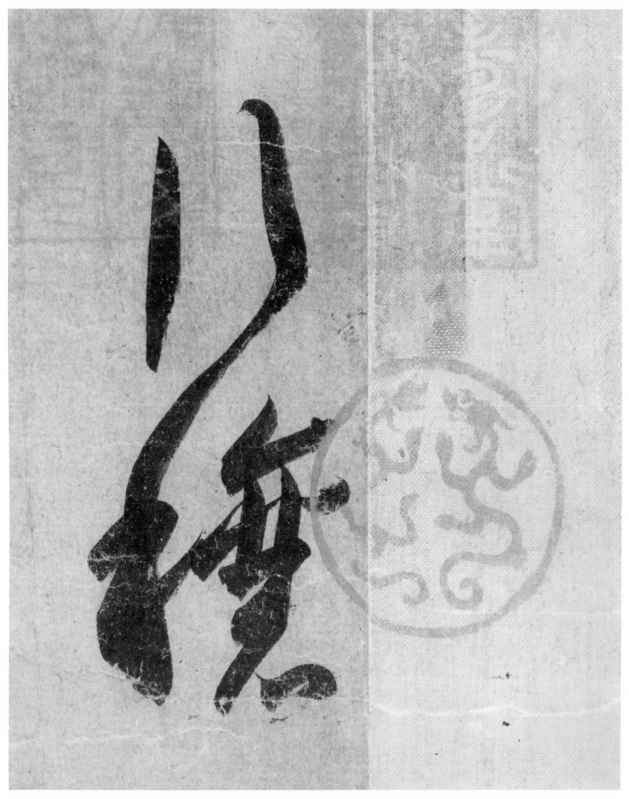

1a Wang Hsi-chih (303 ?–361 ?), Detail of *Hsing-jang-t'ieh*.
Early T'ang tracing copy.
Anonymous loan, The Art Museum, Princeton University.

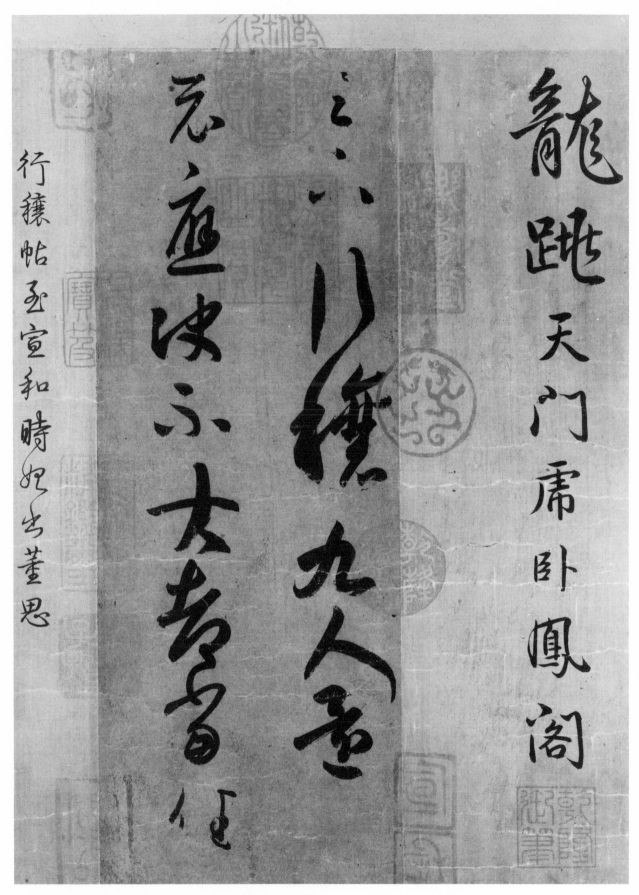

1a Wang Hsi-chih (303 ?–361 ?), *Hsing-jang t'ieh*.
Early T'ang tracing copy.
Anonymous loan, The Art Museum, Princeton University.

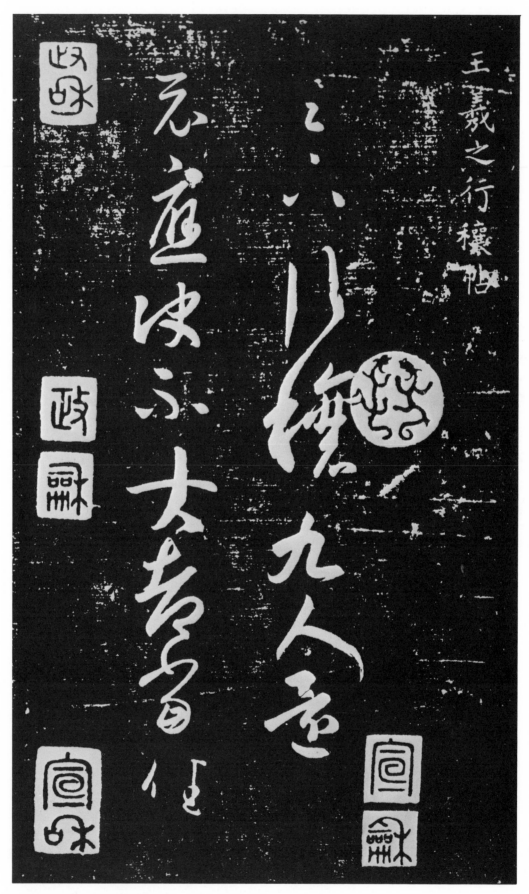

2a Wang Hsi-chih (303 ?–361 ?), *Hsing-jang t'ieh*.
Facsimile of rubbing.
Anonymous loan, The Art Museum, Princeton University.

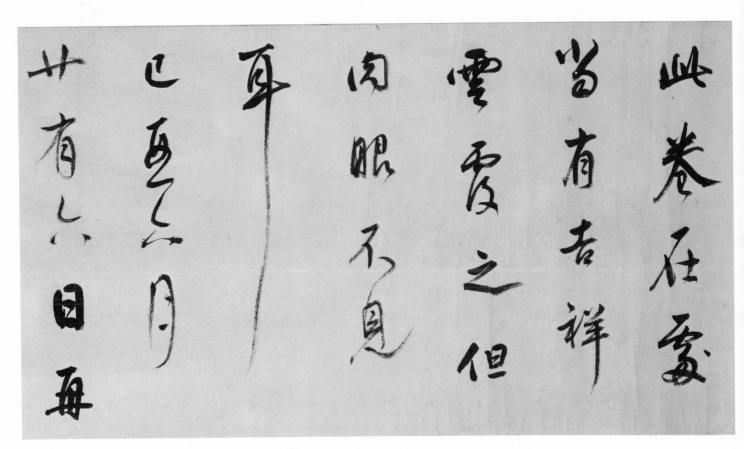

1b Tung Ch'i-ch'ang (1555–1636), *Colophon to Hsing-jang t'ieh*.
Dated 1609. Section of handscroll.
Anonymous loan, The Art Museum, Princeton University.

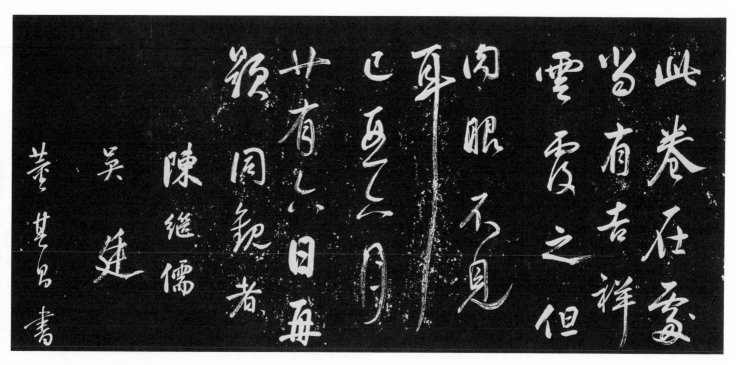

2b Tung Ch'i-ch'ang (1555–1636), *Colophon to Hsing-jang t'ieh*.
Facsimile of rubbing.
Anonymous loan, The Art Museum, Princeton University.

維貞觀廿三年

玥廿六日已巳

大行皇帝

旋殯于大極之西階粤八月庚子

于翠微宮之含風殿

將遷坐于

昭陵禮也鳳紀嶷秋龍帷將曙

化同軒區縞素哀子嗣

皇帝覽風樹而增感攀銅池

3 After Ch'u Sui-liang (596–658), *Elegy to T'ang Wen-huang*.
Tracing copy by Yen Ch'eng (ca. 1540–ca. 1600). Album leaf.
Collection of Mr. and Mrs. Wan-go H. C. Weng.

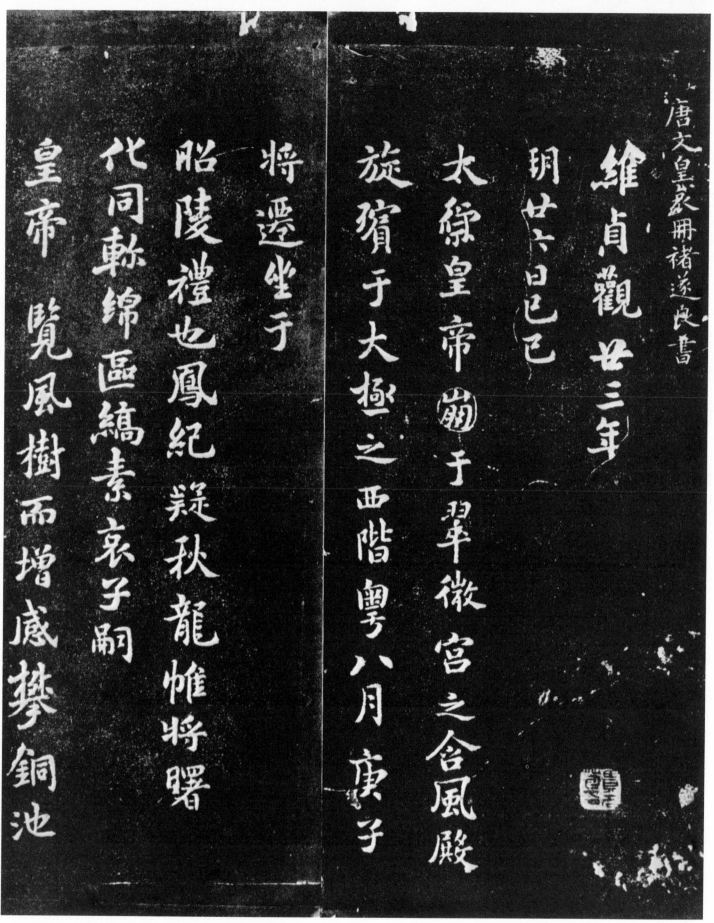

維貞觀廿三年

玄其日巳巳

太綠皇帝崩于翠微宮之含風殿

旋殯于大極之西階粤八月庚子

唐文皇哀冊褚遂良書

將遷坐于

昭陵禮也鳳紀疑秋龍帷將曙

化同軒緜區縞素哀子嗣

皇帝覽風樹而增感攀銅池

FIG. 17. Ch'u Sui-liang (596–658). *Elegy to T'ang
Wen-huang*. Detail of rubbing from *Hsiu-ts'an-hsuan t'ieh*
(ca. 1619).

I · REPRODUCTION AND FORGERY 27

5 After Huang T'ing-chien (1045–1105),
Three Poems by Han-shan and P'ang Yun.
Anonymous free-hand copy. Section of handscroll.
Collection of John M. Crawford, Jr.

7a OPPOSITE, TOP
After Huang T'ing-chien (1045–1105), *Poems*.
Dated 1087. Section of handscroll.
Collection of Mr. and Mrs. Wan-go H. C. Weng.

7b OPPOSITE, BOTTOM
After Huang T'ing-chien (1045–1105), *Poems*.
Section of handscroll.
Collection of Mr. and Mrs. Wan-go H. C. Weng.

人意人生天地未歸
客計較貴賤羞犬羹
當須醉倒戴月歸不
信鄉夢留不止
元祐六年五月
十又七日為
嶺達友舊書于
百尺樓中
黃庭堅

六載紅蓮客盡池又
半年無人知白
雪有意補青天肝
論興廢詩書謁
聖賢尊甲午日月
躬達付陶甄
庭堅

13 Chao Meng-fu (1254-1322), *Twin Pines against a Flat Vista.*
Inscription on handscroll.
The Metropolitan Museum of Art, Gift of the Dillon Fund, 1973.

14 After Chao Meng-fu (1254–1322), *Twin Pines against a Flat Vista.*
Tracing copy. Inscription on handscroll.
Cincinnati Art Museum.

斯冠有失

斯衣德不

稱脈中心

惡而神草

搢侫神羊

觸邪顧忌

斯冠有失

斯衣德不

稱脈中心

惡而神草

搢侫神羊

觸邪顧忌

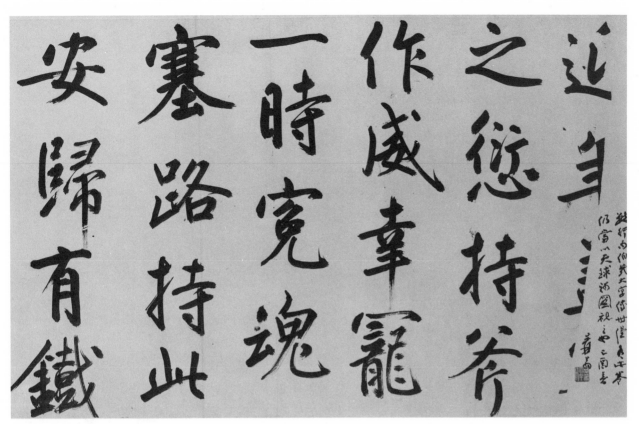

16 Hsien-yü Shu (1257 ?–1302), *Admonitions to the Imperial Censors*.
Dated 1299. Sections of handscroll.
Anonymous loan, The Art Museum, Princeton University.

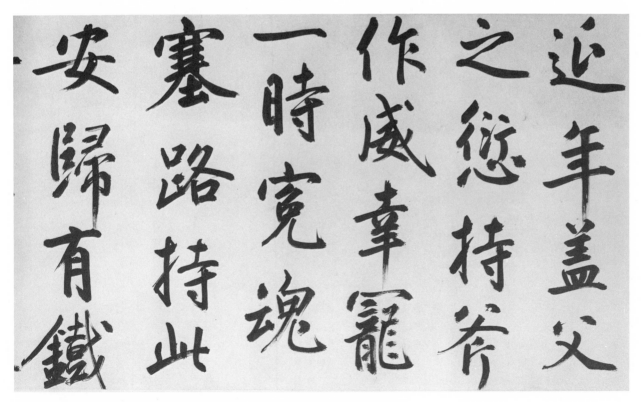

17 After Hsien-yü Shu (1257 ?–1302), *Admonitions to the Imperial Censors*.
Tracing copy. Sections of handscroll.
Anonymous loan, The Art Museum, Princeton University.

22 Yang Wei-chen (1296–1370),
Drinking with My Wife under the First Full Moon.
Detail of album leaf.
Anonymous loan.

23 Yang Wei-chen (1296–1370), *Colophon to*
"Gazing at a Waterfall," painting by Hsieh Po-ch'eng.
Detail of hanging scroll.
Collection of John M. Crawford, Jr.

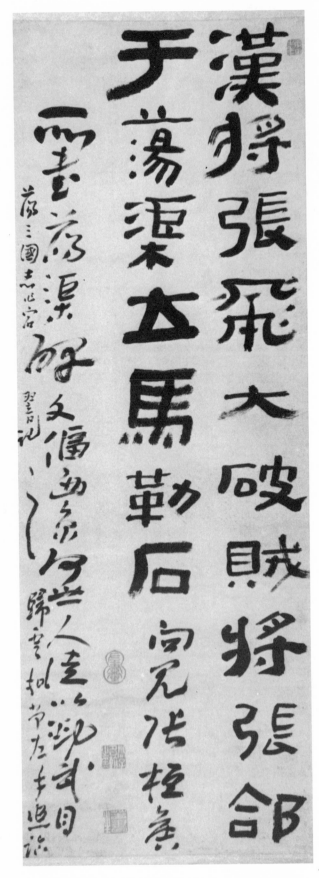

漢將張飛大破賊將張郃

于蕩渠立馬勒石

75 Kao Feng-han (1683–1748),
The Tang-ch'ü Stele.
Transcription of Han dynasty stele.
Dated 1740. Hanging scroll.
Chien-lu Collection.

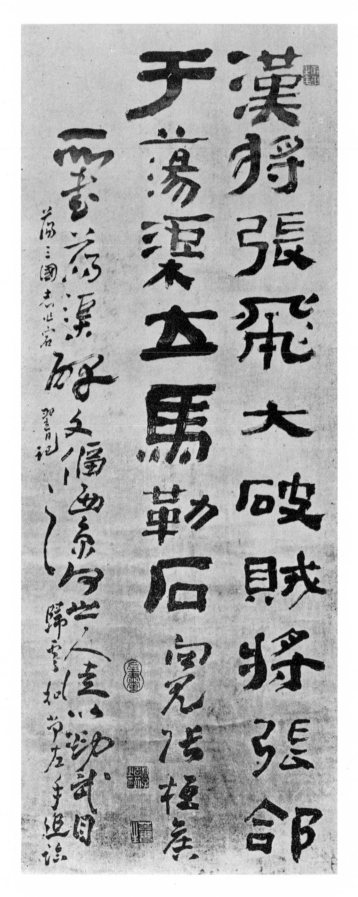

FIG. 18. After Kao Feng-han (1683–1748).
Transcription of Stele by General Chang Fei.
Hanging scroll. Collection unknown.

85 Weng T'ung-ho (1830–1904), *Couplet on Confucian and Taoist Virtues.*
Pair of hanging scrolls.
Mr. and Mrs. Shen C. Y. Fu.

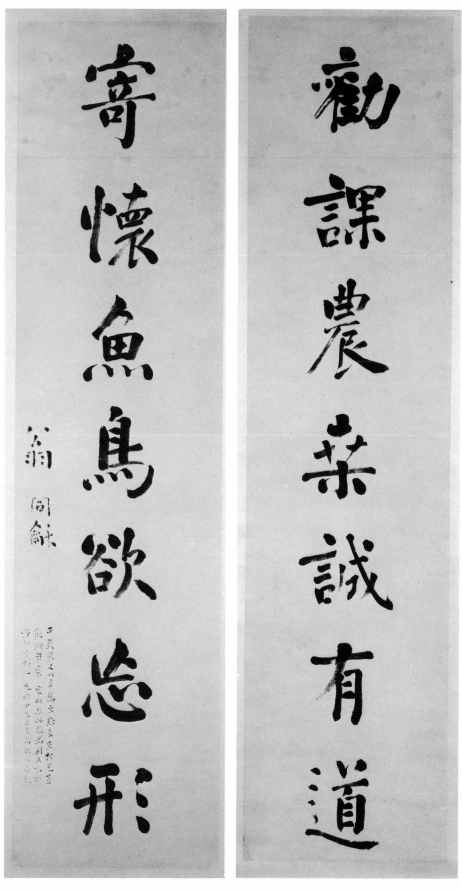

86 Weng T'ung-ho (1830–1904), *Couplet on Confucian and Taoist Virtues.*
Pair of hanging scrolls.
Mr. and Mrs. Shen C. Y. Fu.

篆書与隸書

II

The Seal and Clerical
Script Traditions

DURING the second half of the Ch'ing dynasty, due to the influence of archaeological studies and epigraphy—the study of bronze and stone inscriptions (*chin-shih-hsueh*)—many more calligraphers devoted themselves to the serious practice of writing seal and clerical scripts. The importance of this revival for seal and clerical scripts, and the stele inscriptions of the Six Dynasties period has been recognized by modern historians of calligraphy. However, the development of these scripts during the Sung, Yuan, Ming, and early Ch'ing has been neglected. After the Ch'in and Han periods, when seal and clerical script gave way to the early forms of cursive, running, and standard scripts for daily writing, the archaic forms continued to be practiced by scholars and calligraphers. There are a number of good works extant today in seal and clerical scripts to illustrate this fact. The achievement of these earlier masters and the development of these scripts prior to the mid-Ch'ing should be investigated in order to place the Ch'ing achievement in a proper perspective. The purpose of this essay is to call attention to the development of the two script types and to contribute material for further study. The discussion will deal first with the development of seal script, and then turn to clerical script for the same time span.

Seal Script (*chuan-shu*)

Brief Introductory Background

The seal script referred to here will, for the most part, be "lesser seal" script (*hsiao-chuan*), which first appeared in the Ch'in period (221–207 B.C.). Its development marked a final stage in the evolution of Chinese archaic scripts, from the early "shell and bone" type (*chia-ku wen*) through "greater seal" script (*ta-chuan*), to the standardization of the earlier forms, or "lesser seal" script. Characters were no longer written large or small according to their complexity, but were spaced to fit an imaginary square. The strokes were of relatively even thickness, and the characters, uniform in size, were arranged in more orderly columns.

Until the *chin-shih-hsueh* movement of the mid-Ch'ing, when calligraphers who practiced seal script spoke of *chuan-shu*, they meant the so-called "lesser seal" (*hsiao-chuan*). Pre-Ch'ing calligraphers derived their forms for seal script from such intermediary sources as the *Shuo-wen chieh-tzu* (ca. A.D. 100), the first comprehensive dictionary of etymology, compiled by Hsu Shen, and the stone stele inscriptions of Li Yang-ping (active 759–780?) of the T'ang dynasty.[1] The main difference between pre-Ch'ing and mid-Ch'ing calligraphers, then, was that the latter went directly back to the Ch'in

dynasty inscriptions, and, in addition, expanded their range of sources to include Han and Six Dynasties stele inscriptions and title-heads (*pei-e*). It was the breadth, variety, and historicity of these "newer" sources that enabled the mid-Ch'ing calligraphers to break out of the older conventions of the seal script practiced by earlier masters.

The Seal Script of the Ch'in Dynasty

Li Ssu (d. 208 B.C.), chief minister to Ch'in Shih-huang, the first Emperor of China, is credited with unifying seal script. The *I-shan-pei*, dated 219 B.C., is his most famous attributed work, but its importance is diminished by the fact that the original stele was destroyed before the eighth century, the extant one being a

FIG. 19. Li Ssu (d. 208 B.C.). *Lang-yeh-t'ai*. Dated 219 B.C. Detail of rubbing.

re-carving based on a tenth-century copy.[2] The *Lang-yeh-t'ai*, dated 219 B.C. (*fig.19*), is believed to be the only genuine work by Li Ssu. It is preserved in its original form as a stele; therefore, the calligraphy of this inscription should be the standard for seal script of the Ch'in dynasty.[3]

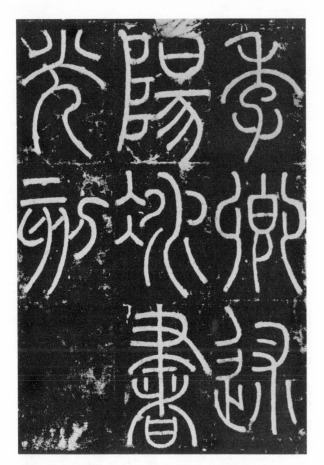

FIG. 20. Li Yang-ping (active 759–780?).
Li-shih San-fen-chi. Dated 767. Detail of rubbing.

FIG. 21. Hsu Hsuan (917–992). Copy of Li Ssu,
I-shan-pei. Detail of rubbing.

Li Yang-ping and Other T'ang Masters of Seal Script

The T'ang master Li Yang-ping (active 759–780?) proclaimed that he was the only master of seal script after Li Ssu. *Li-shih San-fen-chi*, dated 767 *(fig. 20)*, is among the famous rubbings associated with his name.[4] Li's style is neat, the characters moderately attenuated. Curved stroke-forms predominate over angles and straight lines. His strokes are slim and rounded, the tips perfectly formed. The style is attractive, not overly tense or imposing. However, by stressing balance, clarity, and perfection of technique, Li Yang-ping lost the resonance and vitality of the Ch'in models, such as Li Ssu's *Lang-yeh-t'ai*.

Li Yang-ping exerted a strong influence on later seal script calligraphers. But his importance in the history of calligraphy has been overemphasized, for there were a number of lesser known calligraphers who wrote in a comparable style.[5]

Seal script in the T'ang dynasty was molded and limited by the aesthetic of the prevailing mature standard script (*k'ai-shu*): it was precise, symmetrical, and neat. On the other hand, compared to the seal script of the Han dynasty, for example, it lacked richness and variety.[6] Epitomized by Li Yang-ping's style, it had a dominant influence on calligraphers from the T'ang to early Ch'ing, a strong but unfortunately limiting force.

Masters of Seal Script during the Five Dynasties and Sung Periods

The study of seal-script etymology flourished between the Five Dynasties (907–960) and the Northern Sung (960–1126) periods. The scholar Hsu Hsuan (917–992), who was among the leading practitioners at the time, wrote a commentary to the *Shuo-wen chieh-tzu*, and made a copy of Li Ssu's *I-shan-pei (fig. 21)*.[7] His style, like other examples extant, shows that he was strongly influenced by the strict, fine, and perfectly balanced structure of T'ang seal script. As a calligrapher, he was praised by the editors of the Northern Sung Emperor Hui-tsung's imperial catalogue, *Hsuan-ho shu-p'u*, as the successor to Li Yang-ping from the T'ang.[8]

Sung calligraphers preserved the T'ang seal script style, tended to specialize, and generally did not write in other scripts.[9] Conversely, such masters as Su Shih (1036–1101) and Huang T'ing-chien (1045–1105), who excelled in standard and running scripts, showed little interest in the seal or clerical scripts. Mi Fu (1051–1107) was an exception.[10] His *ta-chuan* style is directly derived from bronze inscriptions, and unlike Li Yang-ping's, it emphasized brushwork over structure. Unfortunately,

Mi did not develop that style as a specialty, and so appears not to have had much further influence.

Sung and pre-Sung calligraphy is preserved primarily in the form of rubbings.[11] But starting with the Yuan period (1279–1368), more ink originals have survived.

Chao Meng-fu and Other Yuan Masters of Seal Script

In the Yuan, the *fu-ku* movement included seal script as part of its "revival of the past." The concept of a "synthesis" of past styles, advocated by Chao Meng-fu, helped to reestablish the orthodoxy of the two Wangs and Chung Yu (151–230). Moreover, the practice of small-standard (*hsiao-k'ai*) and running (*hsing-shu*) scripts reached a new excellence. Chao Meng-fu, who also followed the T'ang and Sung seal-script traditions and even designed and carved his own seals, became one of the earliest artists to master the combined arts of seal writing and carving, calligraphy and painting (*chin-shih shu-hua-chia*).[12]

Chao also left the earliest extant large-sized seal script writing in ink original form. At least five titles of his commemorative inscriptions in ink on paper are known, and others are extant in the form of rubbings.[13] In his practice of seal script, Chao was influenced more by the T'ang and Sung calligraphers than by actual Ch'in dynasty models. He did not innovate; indeed, his seal script was the least distinguished of his artistic accomplishments. But he did succeed in his personal desire to master all the major scripts.

The six-character frontispiece to his "Record of the Miao-yen Temple in Huchou" (*Hu-chou Miao-yen-ssu chi*), datable to 1309–10 (*no.15a*) in The Art Museum, Princeton University, is one of the finest examples of Chao's seal script.[14] It is comparable in quality to his "Record of the Huai-yun Temple," a work dated to 1310 (*fig.22*).[15]

While Chao Meng-fu could not abandon the precision of the Li Yang-ping and Hsu Hsuan schools, he did imbue his brushwork with a greater sense of movement, combined with thickened and rounded "entering" and "finishing" strokes. (This sense of fine detail can best be seen in his standard script.) He also showed an early interest in the dry-brush effects of elongated strokes.

Worthy of mention are several of Chao Meng-fu's followers. Among them is his son, Chao Yung (1289–ca. 1363), whose *Chu-hsi*, a frontispiece to a handscroll in the Liaoning Museum, and *Chu-chü*, a frontispiece to a painting by Wu Chen (*fig.23*), show Chao's influence, but also some striking changes.[16] For example, Chao Yung introduced a slightly flattened stroke, which

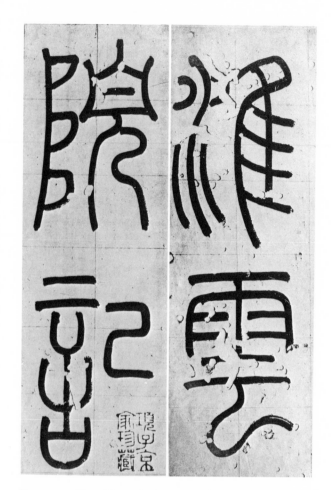

FIG. 22. Chao Meng-fu (1254–1322). *Frontispiece to "Record of the Huai-yun Temple."* Dated 1310. Detail of handscroll. Collection unknown.

registers even more movement and sweep than his father's. Written with larger gestures, more freely and more exuberantly, his characters foreshadow Ming dynasty styles.

Yü Ho (active ca. 1330–60?) was another close follower of Chao Meng-fu who practiced seal script. Yü was a superb technician. His "Thousand Character Classic," a small album in clerical and seal scripts, dated 1354 (Palace Museum, Taipei), reveals that he persistently practiced, concentrated on, and studied that art, which raised him to the level of recognition he now receives in traditional criticism.[17] Although no small seal script writing by Chao Meng-fu survives, much of what his style must have been can be seen in Yü's work.

Another work in the Chao family style is the *Mu wei-i-jen mu-chih*, dated 1363 (Palace Museum, Taipei).[18] The epitaph was written and transcribed by Chao Su, Chao Meng-fu's grandnephew, for his deceased mother. Chao Su's seal script title-piece and his standard-script seem

FIG. 23. Chao Yung (1289–ca. 1363). *Frontispiece to Wu Chen, "Chu-chü."* Detail of handscroll. Collection unknown.

FIG. 24. Wu-ch'iu Yen (1272–1311). *Colophon to Tu Mu, "Chang Hao-hao shih."* Dated 1305. Detail of handscroll. Palace Museum, Peking.

to be almost identical to Chao Meng-fu's style; close examination, however, reveals that the seal script, in particular, is stiffer, constrained, and harder. It is nonetheless an interesting and important example of "generational likeness."

Wu-ch'iu Yen (1272–1311), a contemporary of Chao Meng-fu, was one of the most famous Yuan dynasty specialists, praised by the prominent scholar-official Yü Chi (1272–1348) as being the best seal-script calligrapher of his day.[19] Although examples of his calligraphy are extremely rare, a seven-character inscription of his, dated 1305 *(fig.24)*, was appended as a colophon to a T'ang work.[20] Not only is the brushwork strong and disciplined, but it shows the same precise attention to spacing and balance associated with the Li tradition. The strokes also reveal some personal traits: they begin with square-shaped heads and end with a slight bulge, which are signs of increased brush movement. That Wu-ch'iu Yen was famous for his seal script undoubtedly meant that he, too, influenced such younger masters as Chao Yung and possibly Yü Ho. It is unfortunate that so little of his work is extant.

Two other late Yuan seal script calligraphers should be noted: Chou Po-ch'i (1298–1369) and Wu Jui (1298–1355). Chou Po-ch'i served in the Hsuan-wen Library under the Mongol Emperor Jen-tsung, and was praised by the famous calligrapher K'ang-li Nao-nao

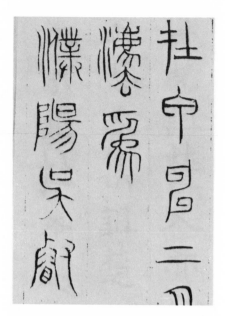

FIG. 25. Wu Jui (1298–1355). *Thousand Character Classic*. Dated 1344. Detail. Shanghai Museum.

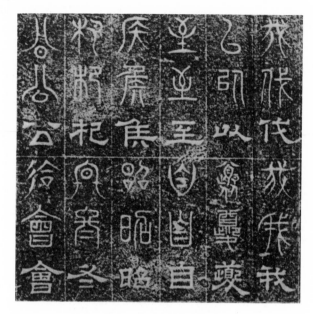

FIG. 26. *Stone Classic in Three Scripts*. Dated 240–248. Detail of rubbing.

(1295–1345, *see no. 21*).[21] His *Hsiang-ho-ching*, in small seal script, dated 1358 (Palace Museum, Taipei), would indicate that he was talented in executing the conventional style. Wu Jui's "Thousand Character Classic" in seal script, dated 1344 (*fig. 25*; Shanghai Museum), reveals his preference for a taller structure, with square brushwork starting with blunt heads and ending with long pointed tails.[22] In his inscription Wu writes that his source for this style was the famous *Tsu-ch'u-wen*; but stylistically, it seems closer to the "Stone Classic in Three Scripts," of the Wei period dated 240–248 (*fig. 26*).[23] Wu is a Yuan calligrapher who should be remembered for having moved beyond the dominant Li Yang-ping trend to somewhat broader sources.

Seal Script of the Early Ming Dynasty

As the modern historian of calligraphy Ma Tsung-ho has noted, the main achievement of the Ming dynasty was its running and cursive scripts.[24] While this point of view is generally accepted, it does not mean that no one was practicing seal script during the Ming.[25] True, individual works in seal script are rare; but numerous examples of large-size seal writing are extant in the form of frontispieces (*yin-shou*) to handscrolls and albums, or as title-pieces to stele inscriptions (*pei-e*).

Before discussing the achievements of Li Tung-yang

(1447–1516), the predominant figure of Ming seal script, some of his precursors should be briefly considered.

Chin Yu-tzu (original *ming* Shan, 1368–1431) was a Hanlin scholar and one of a group, including Yang Shih-ch'i, Ch'ien I, and Hsieh Chin, all of whom served as high counselors under the Yung-lo, Hung-hsi, and Hsuan-te Emperors. Chin's extant works are rare, but among them is a title-piece in a conventional seal-style to an epitaph written by Shen Tu (1357–1434).[26]

Ch'eng Nan-yun (active ca. 1403–36) was summoned to the court of the Yung-lo Emperor because of his skill as a calligrapher.[27] One of his several extant works in seal script is the frontispiece to Fang Ts'ung-i's "Cloudy Mountains" (*fig. 27*),[28] in which Ch'eng emphasized the design potential of the script, arranging curving lines and empty spaces symmetrically. The thickness of the strokes is even, and their smooth rounded ends required masterful control. On the whole, Ch'eng's style is memorable for its elegant and decorative, if slightly static, quality.[29]

Chin Shih (active ca. 1436–80) entered government service in the Central Drafting Office thanks to his calligraphy,[30] which, in both clerical and seal script, is well represented in present-day collections (e.g. *no. 27*, in clerical script). At age seventy-four Chin wrote a frontispiece to Chao Meng-fu's "Classic of Filial Piety" (*fig. 28*; Palace Museum, Taipei),[31] which has a striking simplicity, and stresses vigor over balanced spacing. The

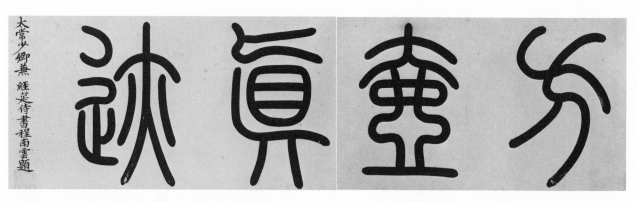

FIG. 27. Ch'eng Nan-yun (active ca. 1403–1436). *Frontispiece to Fang Ts'ung-i, "Cloudy Mountains."*

Detail of handscroll. The Metropolitan Museum of Art, New York. Gift of J. Pierpoint Morgan, by exchange.

writing shows the influence of Chin Shih's clerical style, in that the brushwork tends to be asymmetrical, and he allows the brush-tip to be slightly exposed at the beginning and ends of the strokes during the course of writing. Other works by Chin Shih are more conservative, more related to Hsu Hsuan, with thin, spindly strokes and a more symmetrical spacing.

Sun Kung (active ca. 1450?) is known chiefly for his frontispiece to Wu Yuan-chih's "Red Cliff" (ca. 1195; Palace Museum, Taipei). His writing of the title to this rare Chin dynasty painting shows the influence of Ch'eng Nan-yun, given its strong decorative quality and the balanced arrangement of the strokes. Sun continued his attempt at perfect symmetry and control of the brush-stroke from "head" to "tail," thereby clearly revealing his period and his affiliation with regard to style.

Li Tung-yang (1447–1516)
Frontispiece to "Poetic Feeling
in a Thatched Pavilion" *(no. 24b)*

According to Li Tung-yang's official biography in the Ming History, he excelled in clerical and seal scripts, and his fame had spread even to the surrounding "barbarian countries." The critic Wang Shih-chen (1526–90) praised Li's versatility and noted that his seal script was better than his clerical, and his clerical better than his standard, running, and cursive scripts. Indeed, not only was Li the most famous seal script calligrapher of the Ming, but a large number of his works have survived.[32]

The strength of Li Tung-yang's seal style lies in its bold solidity. He surpassed his predecessors Li Yang-ping and Hsu Hsuan in directness and vigor. He emphasized the individual brushstroke and textural rich-

FIG. 28. Chin Shih (active ca. 1436–1480). *Frontispiece to Chao Meng-fu, "Classic of Filial Piety."* Detail of handscroll. Palace Museum, Taipei.

FIG. 29. Hsu Lin (1462–1538). *Frontispiece to Wen Cheng-ming, "Autumn Mountains."* Detail of handscroll. The Art Institute of Chicago.

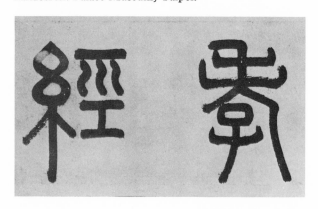

ness of ink. And he cultivated a dry-brush technique which gave his writing a sense of movement and thrust. Li's work might be faulted for its lack of subtlety; yet it is a clear departure from previous trends, and its innovations were developed by later masters. Such changes were due to the forcefulness of Li's personality and his personal achievement rather than to any major changes having taken place during the Ming period.

In Li's frontispiece to "Poetic Feeling in a Thatched Pavilion" (no. 24b), one can see the speed and directional movement of the brush which he was later to develop more fully (especially the first character, ts'ao). Although the frontispiece is unsigned and without seals, the writing can be confidently attributed to Li Tung-yang because of its style as well as the colophon by Shen Chou, his Suchou contemporary. It is important that Li Tung-yang's contribution to this scroll be identified, since the frontispiece was overlooked in a number of late Ming and early Ch'ing painting catalogues.

HSU LIN (1462–1538), a younger contemporary, was indebted to Li Tung-yang; yet a comparison of his title to Wen Cheng-ming's "Autumn Mountains" (fig. 29) with Li Tung-yang's frontispiece reveals a startling contrast.[33] Where Li is bold and emphatic, Hsu is strong and subtle. For example, Hsu's seal type is angular and his spatial relationships stress nuance, so that in one instance—the overlapping triangles of the character "mountain"—a subtle dimensionality is created which is equal to Li's forcefulness.[34]

During Hsu's lifetime, Li Tung-yang and his contemporary Ch'iao Yü (1457–1524) were known as the "sages of seal script" (chuan-sheng). However, when they saw Hsu Lin's work, they expressed their respect for him.[35] It is of more than passing interest that Hsu was to gain the recognition of two such high officials as Li Tung-yang and Ch'iao Yü, whose praise testified to the recognition of talent as an absolute level of achievement.[36] It was also a sign that, by the middle Ming period, the prestige of official status was not a requisite for appreciation by scholar-officials who were themselves talented artists. This was also true in the case of the brilliant Suchou circle of officials and artists during the middle Ming.

Suchou and Sungchiang Masters of Seal Script

Li Ying-chen, Wu I, and Lu Shen were members of a larger coterie of talented literati from Suchou and Sungchiang, the best known of whom were the Suchou masters Chu Yun-ming and Wen Cheng-ming (see also essay III for an account of Suchou and Sungchiang rivalry).

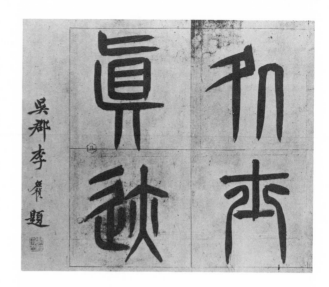

FIG. 30. Li Ying-chen (1431–1493). *Frontispiece to Lin Pu, "Two Letters."* Detail of album. Palace Museum, Taipei.

FIG. 33. *T'ien-fa shen-ch'an.* Stele. Dated 276. Detail of rubbing.

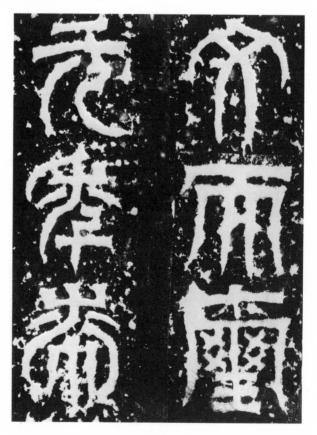

During the Ch'eng-hua era (1465–87), Li Ying-chen (1431–93), because of his superior calligraphy, was summoned to the capital to serve in the Central Drafting Office. Eventually, he became Chu Yun-ming's father-in-law and Wen Cheng-ming's teacher, and exerted an obvious influence on those important Ming calligraphers. Indeed, his work was praised by Wen Cheng-ming as being "the best in this dynasty."[37] Li's extant works are not numerous, and his seal script is especially rare. One excellent example is a frontispiece to two letters by the Northern Sung poet-calligrapher Lin Pu (967–1028) which had been in Shen Chou's collection (fig. 30).[38] In it Li Ying-chen's brushwork emphasizes angular turns and his strokes taper to a point—features that relate to the T'ien-fa shen-ch'an stele from the Wei period (fig. 33).[39]

Wu I (1472–1519)
Two Frontispieces to "Enjoying the Pines" (no. 49)
and "Summer Retreat in the Eastern Grove" (no. 50a)

The most recognizable quality of Wu's writing is a slight elongation of each character element and a striving for elegance and refinement. Of these two works, "Enjoying the Pines" is less attenuated, with fuller brushwork.[40] Yet equal attention is paid to curving forms and close spacing, which results in a "pinched effect"

FIG. 31. Wen Cheng-ming (1470–1559). *Inscription accompanying the "Cho-cheng-yuan." Leaf from an album. Dated 1533. Collection unknown.*

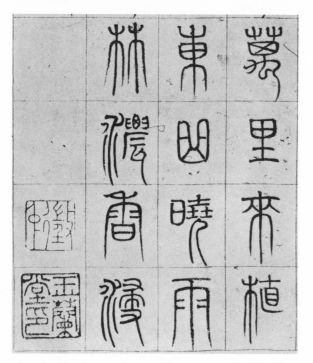

and a swaying movement of the verticals. Otherwise, his structures and firm touch link Wu stylistically to the T'ang master Li Yang-ping, and also to his Ming predecessor, Li Tung-yang. While the latter's energy as a man of letters and an official—indeed, his formidable self-confidence—is reflected in the memorable vitality of his art, the same cannot be said of Wu I, a man of fine sensibility but lesser force.

Lu Shen (1477–1544)
Frontispiece to "Rocks and Streams" (no. 53a)

As Chancellor of the National University and Grand Supervisor of Imperial Instruction, Lu Shen was an educator, a noted historian, an antiquarian, and a prolific man of letters who made his native Sungchiang proud.[41] He was best known for his running script in the style of Chao Meng-fu and Li Yung (678–747), and was admired by Tung Ch'i-ch'ang and Mo Shih-lung (see also essay III). But little mention has been made of his seal script in the traditional sources. In this frontispiece to Lu Chih's "Rocks and Streams," Lu Shen shows equal competence in the archaic script type. The style suggests Li Tung-yang in its brusqueness and thick brushwork. And although it shows no signs of innovation or any unusual expression of personality, the work is nonetheless representative of the period style.

Wen Cheng-ming (1470–1559)

As one of the two great Ming masters who lent distinction to Suchou's achievement in calligraphy, Wen Cheng-ming's range extended beyond the modern scripts—standard, running, and cursive—to include the archaic scripts. It is said that Wen sought to match Chao Meng-fu in total mastery. There is no written evidence to support this, but given the fact that both made an intensive study of the art of antiquity, their interest in the several archaic scripts may be read as a similar pattern of intention.[42]

Wen Cheng-ming's command of the ancient and modern scripts may be seen in his "Thousand Character Classic in Four Scripts" (Ssu-t'i ch'ien-tzu-wen), a virtuoso performance in seal, clerical, cursive, and standard scripts—four thousand characters set neatly into a grid.[43] This was little more than a technical exercise for Wen however, and of no great artistic merit. Written too loosely for the size of the script and in too casual a manner, the strokes are thin and flaccid.

Unfortunately, few other examples of Wen's seal script are extant. Some of the best accompany his album of paintings, "Garden of the Unsuccessful Politician"

(*Cho-cheng-yüan*), dated 1533 *(fig. 31)*. Here the writing shows more regard for structure and brushwork and—given the sharpness and tapered straightness of the strokes—the influence of his teacher Li Ying-chen *(fig. 30)*.[44] In this album Wen's competence in seal script is amply demonstrated.[45]

Wen P'eng (1498–1573)

Wen P'eng, Wen Cheng-ming's son, followed his father's styles in the modern scripts, but had a special feeling for seal-style writing. In addition, he holds a prominent position in the history of seal design and carving. His brush-written seal script is rare; however a frontispiece *Hsi-shan yü-i*, precedes a landscape handscroll by Huang Kung-wang *(fig. 32*, Liaoning Museum).[46] These four characters show Wen P'eng's striking departure from the dominant Li Tung-yang tradition *and* from his father's style: Wen uses the standard script brush method, with its flat, squarish folding strokes of varying thickness, to write seal characters. He intentionally introduces eccentric irregularities in an almost playful way: the three verticals of the "mountain" character deviate subtly from the perpendicular, and the raindrops in the character "rain" are drawn with great wit, as are the three verticals, each of which differs in breadth, direction, and finish.

Ch'en Shun (1483–1544)
Frontispiece to "The Western Promontory" *(no. 56)*

Ch'en Shun's running and cursive scripts are well known, but his ability in seal script remains obscure.[47] The frontispiece to his painting "The Western Promontory" in the Ching Yuan Chai collection gives us a rare opportunity to view his accomplishment in this genre. As with his running and cursive writing, Ch'en Shun's approach was casual. He refused to be limited by the more severe confines of the seal-script conventions. As a contemporary of Wen P'eng, he shared with him the desire to shape the brushwork and structure of seal script writing into a less inhibited, more personal idiom. The actual direction was not fully articulated in their art, but the results of their efforts were to be developed by the next generation of calligraphers.

The Late Ming Trend

By the late Ming, practicing calligraphers were generally divided into three main groups: Wen Cheng-ming and his followers, centered around Suchou; Tung Ch'i-ch'ang and his coterie at Sungchiang; and those late-Ming individualists not associated with any particular

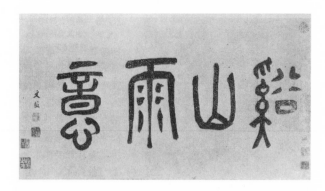

FIG. 32. Wen P'eng (1498–1573). *Frontispiece to Huang Kung-wang, "Hsi-shan yü-i."* Detail of handscroll. Liaoning Museum.

region. These masters practiced mainly the modern scripts and seem to have lost interest in the ancient scripts; for the most part, they modeled their writings on traditional copybooks (*t'ieh*) as opposed to early carved stele inscriptions (*pei*).[48]

By the late sixteenth and early seventeenth centuries, interest in seal script was limited to only a few calligraphers, the most notable of whom was Chao Huan-kuang.

Chao Huan-kuang (1559–1625)
and "Cursive-seal" Script *(no. 11b)*

Chao Huan-kuang was a native of Suchou, although three generations removed from the "golden age" of Wen Cheng-ming, and the chief practitioner of a new type of script, "cursive-seal" (*ts'ao-chuan*). It is said that he based his innovations on the early stele *T'ien-fa shen-ch'an pei*, dated 276 *(fig. 33)*, adding his own variations.[49] Not only did Chao have a learned interest in early scripts, but he was the author of several studies on calligraphy and on bronze and stone inscriptions.[50] While Chao has been considered the inventor of this strange but admirable script, in his writings he noted that a certain Chang Tung-pai had practiced the style before him.[51] Unfortunately, no works by Chang have survived.

A rare example of Chao's "cursive-seal" script is his transcription of the collector Pi Hsi-chih's comments appended to the Southern Sung master Chang Chi-chih's "Diamond Sutra" *(no. 11b, detail fig. 34)*. The characters are well-balanced, separated by spacious columns, and the brush movements are direct and simple, with some linked strokes—hence the "cursive" aspect of the writing, which is an anomaly in seal script. Chao contradicted the regularity of seal script—that is, the accepted conventions of even speed and stroke thickness. His stiff brush drew straight lines and angular turns, with some strokes thick,

FIG. 34. Chao Huan-kuang (1559–1625). *Colophon to Chang Chi-chih, "Diamond Sutra."* Dated 1620. Detail of signature, *(no. 11).*

some fine, some drawn quickly, some slowly, some with saturated ink, and some with almost no ink at all.

In the history of seal script, "cursive-seal" represented a liberation, the culmination of a trend which began with the greater brush movement in the late works of Li Tung-yang and followed by the "proto-cursive-seal" of Wen P'eng, Ch'en Shun, and their generation. Thus it was Chao Huan-kuang who accelerated the slow escape from tradition toward freer shapes and ink textures.

Fu Shan (1607–1684)

One late Ming–early Ch'ing calligrapher must also be discussed in this context. A generation after Chao Huan-kuang, Fu Shan is known to have applied "cursive-seal" brushwork to older seal-script types, producing strange, almost grotesque, writing.[52] The freedom and experi-

mentation represented by Fu Shan's work and the potential of the script itself could not be developed further by later Ch'ing calligraphers, however. For that reason, in the ensuing years, "cursive-seal" was abandoned. And yet, after its extremes, anything was possible.

The Mid-Ch'ing *Chin-shih-hsueh* and *Pei-hsueh* Movements

During the Yung-cheng era (1723–35), as a result of the revived interest in archeological, paleographical, and philological studies called *Han-hsueh*, which sought authentic sources for textual emendation, Ch'ing dynasty scholars began to study the inscriptions on bronze and stone monuments (*chin-shih, pei-hsueh*), to search out the artifacts of the Han, Wei, Tsin, and T'ang dynasties, and to collect rubbings of those inscriptions as sources for their epigraphical studies. This "rediscovery" of ancient sources and models was the basis for the revolutionary development in seal script during the Ch'ing. The "legitimacy" claimed by the intervening dynasties —which in fact was a form of conservative "survival"— was suddenly seen as an "illegitimate succession." Only a return to historic origins could provide the right stimulus for change that was the *chin-shih-hsueh* movement, which reached its peak in the Ch'ien-lung (1736–95) and Chia-ch'ing (1796–1820) eras.[53]

This turning point is epitomized by Wang Shu (1668–1739), who returned directly to the actual rubbings of Li Yang-ping and other T'ang masters to develop a style based on the thin, wiry perfection of such works as Li's *San-fen-chi (fig. 20).* More importantly, Wang Shu made transcriptions of the Chou dynasty "Stone Drums," datable to 768 B.C., using the same brushwork developed from Li Yang-ping's style.[54] Hua Sung (active 1730–40), a contemporary of Wang Shu's, wrote in a similar style. His thin, strong, and perfectly even stroke forms were called "iron-wire" seal script (*t'ieh-hsien chuan*) and were a typical product of that generation.[55]

Teng Shih-ju (1743–1805)

After Wang Shu's death, there were two basic approaches to seal script calligraphy: Ch'ien Tien (1741–1806), Hung Liang-chi (1746–1809), Sun Hsing-yen (1753–1818), and others maintained the conservative, conventional style, in contrast to a second group led by Teng Shih-ju.[56] Teng grew up at a time when the seal-script tradition was still dominated by Wang Shu's transitional style.[57] Like the writings of his conservative contemporary Ch'ien Tien, Teng's early works relate to the wiry elegance of Li Yang-ping. However, Teng later abandoned Li as his model and turned to even earlier

works of the Ch'in, Han, and the Three Kingdoms periods; and by seeking out the authentic sources of seal script, he literally made the older conventional style obsolete.[58]

Stylistically, Teng broke through the mechanical precision of Li Yang-ping's style by structurally introducing a degree of irregularity into his geometric symmetry. An example of his late work, dated 1804, is an illustration of this *(fig. 35)*. Teng's study of other scripts, especially clerical, enabled him to draw upon a wider range of stroke movements in his seal writing. Thus his characters have a dignified swaying movement and a moist inflection. Teng was not interested in streaked dry-ink effects, nor in exhibiting any overt energy—both of which had been qualities of the middle Ming calligraphers Li Tung-yang and Hsu Lin. Rather, Teng wrote at a leisurely pace and sought a rhythmic tension in which his energy was contained and directed.

Teng's calligraphy is one of the major products of the *chin-shih-hsueh* movement. He had the courage and scope to seek out new sources of inspiration in the old, and by his example, his followers each developed distinctive styles which gave to the ensuing period an unprecedented richness and variety.[59]

Ta-shou (1791–1858)
"Title of a Han Dynasty Portrait" *(no. 80)*

The Ch'an monk Ta-shou, also an early member of the *chin-shih-hsueh* movement, was a calligrapher whose dedication to learning earned him the title of *Chin-shih seng*, "the Monk of Bronze and Stone Studies," given him by the antiquarian, high official, critic, and historian Juan Yuan (1764–1849).[60] Ta-shou earned a reputation for his erudition and was often asked by Juan Yuan and other Ch'ing collectors to write colophons to works in their collections. Moreover, he made superior rubbings of inscriptions. He was particularly interested in Han seal script, and adapted the calligraphic forms of ancient bronze seals and impressed bricks to his personal style. He eliminated diagonal and curving strokes in favor of horizontals and angles, a structural vestige necessary to accommodate characters to the square seals and the rectangular bricks of the Han. This style had a strong decorative appeal, especially suitable for writing vertical frontispieces, commemorative labels, or title-pieces such as "Title of a Han Dynasty Portrait."

This hanging scroll, a transcription of a Han dynasty stone carving, shows the distinctive qualities of Ta-shou's seal script. The size of each character varies depending on its complexity as well as the spacing, which is approximately equal to the thickness of adjacent strokes. Yet the exaggerated size of certain characters creates a subtle and

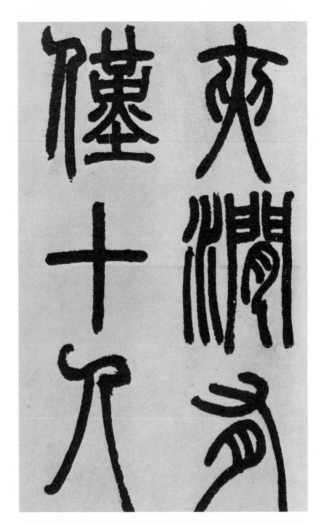

FIG. 35. Teng Shih-ju (1743–1805). *Record of the Thatched Hall of Mr. Po.* Dated 1804. Detail of hanging scroll. Private collection, Japan.

pleasing sense of irregularity. The strokes were written at a slow, controlled pace with a centered brush-tip. As for the work as a whole, it is appealing in its blunt naïveté and evokes the forceful simplicity of the Han. Although Ta-shou's style did not become a major trend in the Ch'ing revival, its influence has carried all the way through to the twentieth century.

Yang I-sun (1813–1881)
"Eulogy for Famous Officials" *(no. 83)*

Yang I-sun is said to have learned his seal script through having studied the "Stone Drum" inscriptions.[61] However, his sources are not so simple. "Eulogy for Famous Officials," a set of eight hanging scrolls *(fig. 36, detail)*, is one of his most monumental works. It contains

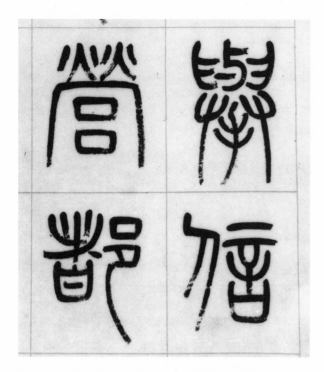

FIG. 36. Yang I-sun (1813–1881). *Eulogy for Famous Officials.* Dated 1873. Detail of hanging scroll, *(no.83).*

elements as diverse as early Chou bronze inscriptions, the "Stone Drums," and other works of the pre-Han and Han, all of which have been absorbed and reworked into a style distinctively Yang's own.

The ink tone is an even charcoal-black, and dry-brush effects appear naturally toward the ends of the strokes. The characters have thick heads tapering to partially blunted tails; simple curves and subtly flexed horizontals and verticals are stressed. Yang's debt to his great predecessor Teng Shih-ju is apparent, and he earned a reputation comparable to Teng's in the realm of seal script alone.

Wu Ta-ch'eng (1835–1902)
"Images of Evening in a Garden" *(no.88)*

Wu was one generation younger than Yang I-sun and nine years older than Wu Ch'ang-shih (1844–1927).[62] A pupil of Yü Yueh *(no.84),* Wu was a scholar in the Hanlin Academy, a one-time governor of Kwangtung and Hunan, the author of a treatise on artillery practice, and director of the border defense of several regions. He devoted his free time to the collecting and study of antiquities, to a catalogue of his vast collection of vessels and implements, and to treatises on ancient seals, weights and measures, jades, and early scripts, in particular the

Shuo-wen ku-chou-pu, an analysis of 5700 pre-Ch'in characters.

Wu Ta-ch'eng, who was considered one of the great seal-script masters, is known to have made a copy of a work by Yang I-sun at the request of a friend. In 1877 Wu went to visit the famous master at his home in Hai-yü (Ch'ang-shu, Kiangsu), where Yang executed a long work in smaller-sized seal script for the younger calligrapher.[63] Since this direct contact verifies a stylistic relationship between the two, it is worth comparing their works *(nos.83 and 88).* Yang's structure is elegant and spacious; his strokes, thin and well-inked, with dry-brush effects indicative of movement. Wu, on the other hand, preferred a tighter structure, emphasizing stability. His brush moves in a solemn, steady manner—simple strength emanating inner power. This severity, which was intentional, has a trace of awkwardness to it and is in fact a cultivated taste. Still, Wu's reputation was wider-ranging than Yang's and was grounded in his formidable energy and breadth of scholarship.

Wu Ch'ang-shih (1844–1927)
"Ink Play" *(no.78b)*

Wu Ch'ang-shih's roots were in the Ch'ing, but his influence extended well into the twentieth century. His background was fostered by the *chin-shih-hsueh* movement, his early prototypes being mostly bronze inscriptions. Later, he specialized in the script style of the "Stone Drums," developing a personal manner of distinctive monumentality with moist, rich brushwork.[64]

"Ink Play," a frontispiece to Cheng Hsieh's "Orchids and Bamboo" *(no.78a),* is an example of his earlier, more restrained style. Wu's mature work was notable for its successful departure from the geometrical precision of his contemporaries; these tendencies are present here as well. The right side of a two-element character, for example, might be shifted sharply upward. Rounded stroke-heads were sometimes marked by a suffused ink blot where the brushtip was tucked and reversed. Brushwork and structure were free and revealed a raw energy. In sum, Wu's learning, combined with the enormous charm of his painting, assured his fame as one of the finest seal-script calligraphers (and seal carvers) of the late Ch'ing.

The Accomplishments of the
Chin-shih-hsueh Calligraphers

The accomplishments of the *chin-shih-hsueh* calligraphers involved prerequisites of a technical, artistic, and scholarly nature. Seal script writing presumes the

master's ability to handle the brush in the manner required to form strokes of controlled thickness. (In large-sized seal script, the brush is usually held upright, with control emanating from the shoulder through the arm and hand, and less from the fingers, as would be found, for example, in standard script.) But seal script also requires a highly developed sense of balance and design, a precise feeling for lines and spaces. Technical mastery and artistic sense are closely linked, for it is the strength of the brushstrokes that animates the surrounding spaces. Without this sense of life in the strokes, the structure, no matter how spatially pleasing, remains static and lifeless.

Beyond the technical and artistic requirements, however, the *chin-shih-hsueh* calligraphers possessed a third essential—a thorough knowledge of the archaic conventions and possible configurations of their models, based primarily on a study of etymology (*wen-tzu-hsueh*) and of philology in its broader sense. In this respect, the calligraphers of the mid-Ch'ing and after differed from their predecessors in the specificity and the degree of those pursuits.

The variety of models available to them from the Ch'in, Han, and Six Dynasties periods was large, due to the independence, both regional and individual, which characterized the evolution of the scripts before reaching a stable "norm," or plateau, of development. In that initial phase, because seal script was the prevailing type, was being actively practiced, and in the process of growth and stabilization, the early styles embody a natural truth, an honesty of expression which could not be matched by later reinterpretations or re-carvings. The Ch'ing calligraphers were very much aware of this. And while they worked primarily from rubbings of inscriptions, they sought to recapture this honesty in brush-written forms, not merely by imitation, visual allusion, or personal embellishment, but by an absorption so complete that their subsequent interpretations were valid transformations of the original. The composition, the spacing, the mode and energy of the brushwork became *interpretations* in the mind of the calligrapher in search of the ideal balance and proportion within the limitations of the chosen script and model. Each character therefore represented a defined range of aesthetic choices; yet the calligrapher was composing a fresh work, using the harmonies, rhythms, and cadences of the earlier mode. This was essentially the method and approach which emerged as the matrix of later Chinese calligraphy and painting.

Clerical Script (*li-shu*)

Brief Introductory Background

The development of clerical script before the mid-Ch'ing *pei-hsueh* movement generally parallels that of seal script. Derived from "lesser-seal" script, it reached its height in the Eastern Han period (A.D. 25–220); subsequently, the Chinese writing system underwent further formal changes, evolving toward the early *k'ai-shu*, or standard script form. As the new script became more convenient to use, it supplanted clerical script for daily usage. Thus, after the Han, clerical script suffered a gradual decline, becoming an archaic form practiced by a relatively small number of calligraphers. Like seal script, the pattern of the development of clerical after it had reached its peak was one of "survival" interrupted by brief periods of modified "revival."

Clerical script represented a major turning point in the evolution of the Chinese script which led directly into the modern forms. From seal to clerical script, the main changes took place in brushwork and structure: an even-pressured, contained stroke yielded to modulated, flaring brush movements, and curves were supplanted by straight lines and angles. This marked the beginning of a realization of the brush's potential for expressive movement and articulated forms.

Clerical Script in the T'ang and Sung Periods: *T'ang-li*

The first major revival of the script took place during the T'ang period (A.D. 618–905), and the style which developed during that time came to be known as T'ang-style clerical (*T'ang-li*), differentiating it from the older Han style (*Han-li*). *T'ang-li* dominated the tradition through the Ming period, again paralleling the development of seal script. The T'ang period developments were therefore vital not only in the history of these two scripts but in the final evolutionary stages of standard script.

The chief explanation for the T'ang revival appears to be the patronage of the Emperor Hsuan-tsung (r. 713–755), who commissioned the treatise *Tzu-t'ung*, a clarification of the methods of clerical script.[65] As a result of this decree, its practitioners increased. Most clerical writing extant from the T'ang, then, dates from Hsuan-tsung's reign.[66] Of all the practitioners, Hsu Hao (703–782) stands out as a calligrapher of stature in both clerical and standard scripts. Han Tse-mo (active 750–762), although not well-known today—none of whose work in clerical survives—was also considered a leading master of it in the tradition of Ts'ai Yung (132–192) of the Han.[67]

Early Sung clerical script followed *T'ang-li* and the

Five Dynasties' clerical styles. The prevailing interest, however, was in running-cursive script (*hsing-ts'ao*) and in writing modeled after the *t'ieh* tradition—for example, the carving of *Ch'un-hua ko-t'ieh* by imperial order in 992, the important early anthology of Tsin-T'ang calligraphy.[68] According to biographical sources, however, a considerable number of calligraphers practiced clerical at the time but little remains of their work, especially in its original brush-written form.[69]

Among the Four Great Masters of the Northern Sung, only Mi Fu (1051–1107) wrote in clerical script,[70] using his customary running-script brush method. The overall structure tended to be vertically oriented, with the component parts loosely arranged, and the brushwork more natural than stylized. Compared to his achievements in other scripts, however, Mi's clerical and seal writing may be seen as a minor personal experiment.

FIG. 37. Huang Po-ssu (1079–1118). *Colophon to Liu Kung-ch'üan, "Poems on the Orchid Pavilion Gathering."* Dated 1111. Detail of handscroll. Palace Museum, Peking.

A rare Sung example is a colophon, dated 1111, by the historian and antiquarian Huang Po-ssu (1079–1118) *(fig. 37)*, to "Poems on the Orchid Pavilion Gathering" by Liu Kung-ch'uan (778–865).[71] The colophon consists of twelve lines of small, neat clerical script. Huang was one of several prominent Sung scholars, after Ou-yang Hsiu (1007–72), who were interested in archaeology and epigraphy under the Emperor Hui-tsung.

Clerical Script in the Yuan

In the late Sung and early Yuan the famous loyalist painter Kung K'ai (1222–1307) preferred to use a form of clerical script for inscribing his works.[72] His "Chung K'uei Traveling" (Freer Gallery of Art, Washington, D.C.) and his "Bony Horse" (Abe Collection, Osaka) both contain his colophons. His style is striking, with brushwork that is uniform in thickness, and only an occasional flared stroke. The later critic Feng Fang (active 1525–76) correctly observed that Kung was using the seal method to write clerical script. Kung K'ai was staunchly individualistic, even in his writing style, which he imbued with a simple naïveté. But it was an unorthodox style and unique to the Yuan.

Chao Meng-fu (1254–1322) was a master of all script types. His friend Hsien-yü Shu (1257?–1302), the critic, connoisseur, and collector, observed that "Tzu-ang's seal, clerical, standard, running, and 'mad cursive' are the best in our dynasty"—an opinion confirmed in Chao's official biography.[73] Few examples of his clerical script are extant, but his style is somewhat reflected in the work of his follower Yü Ho (active ca. 1320–60?), who wrote a "Thousand Character Classic" in clerical and seal scripts (*Chuan-li ch'ien-wen*), dated 1354 (Palace Museum, Taipei).[74] The style is elegant, but tighter and stricter than Chao Meng-fu's is presumed to be.[75]

The well-known scholar Yü Chi (1272–1348) was also a master of clerical script. His colophon on a painting by K'o Chiu-ssu, "Bamboo and Chrysanthemum" (Palace Museum, Taipei), shows why Yü was praised as the best clerical writer of the time.[76] Yü was a versatile master in the mid-Yuan, when there were few practitioners of clerical. By the late Yuan, however, a growing number of masters had adopted the style.[77]

"A Breath of Spring" by Tsou Fu-lei (Freer Gallery of Art) contains two important late Yuan examples of clerical: the frontispiece by the historian and poet Yang Yü (1285–1361) *(fig. 38)* and the inscription dated 1350 by Ku Yen.[78] Yang's three-character title is probably one of the largest examples of clerical script extant from both the Yuan and Ming periods. Large, but not overly forceful, the writing reflects something of the free Sung-style clerical. Ku's inscription is more typical of late Yuan

FIG. 38. Yang Yü (1285–1361). *Frontispiece to Tsou Fu-lei, "A Breath of Spring."* Detail of handscroll.

Courtesy Smithsonian Institution, Freer Gallery of Art, Washington, D.C.

clerical style and demonstrates the strict undeviating brushwork and structure favored by the later masters of that period.

There is little question that clerical script flourished in the Yuan, a fact that may be measured by the large number of extant works and writings on etymology and calligraphy which appeared during the brief century of dynastic reign.[79]

Clerical Script in the Ming

By the Ming period (1368–1644), seal script had gained in popularity, while interest in clerical had declined. Practitioners of clerical are still mentioned in biographical sources, but the comparative number of extant works are fewer. Ming clerical tends to be larger in size. For example, Shen Tu's (1357–1434) frontispiece in eight large characters to Lu Chien-chih's transcription of the *Wen-fu (fig. 39)*, reveals the heavy, broad, confident strokes foreshadowing the mature Ming style.[80] The precisely shaped heads and sharp diagonals and the same sense of genteel perfection can be seen in Shen Tu's other writing in small standard and cursive scripts.

Chin Shih (active ca. 1436–80)
"Splendors of the Brush" (no. 27)

By contrast, the four large characters "Splendors of the Brush," by Chin Shih, reveal a different temperament and aesthetic. The brushwork and structure are similar to Shen Tu's, but Chin's personal touch is livelier, combining light and heavy strokes whose rough edges stress brush movement. The over-all effect, however, lacks substance, especially given the knoblike stroke-

ends. Although Chin Shih is little known today, he was praised by Li Tung-yang for his seal writing and was considered by contemporaries to have captured the flavor of Han and Tsin writing.[81]

Wen Cheng-ming (1470–1559)
"Essay on Streams and Rocks" (no. 53b)

Wen Cheng-ming was as prolific in clerical as he was in other scripts and painting. Several of his dated frontispieces are extant.[82] In his early works (before 1510) the balance and structure of his characters were tentative and awkward, but by the 1530's he had formed his own style. His frontispiece, dated 1530, to Wen Po-jen's "Miniature Portrait of Yang Chi-ching" *(fig. 40)* shows how forceful and decisive his brushwork had become. Like his large-sized writings in the style of Huang T'ing-chien or Mi Fu *(nos. 50b, 51)*, the straight, angular strokes imply roughness and movement, a coarseness derived from his use of a hard stiff brush; in this, he was possibly influenced by an important precursor, Yao Shou (1422–95, *no. 28*).[83]

Wen Cheng-ming's small clerical is exemplified in his two versions of the "Thousand Character Classic in Four Scripts," dated 1536 and 1545. Such virtuoso pieces, with their tiny characters set into a rigid grid, leave an impression of mechanical neatness. Wen's "Essay on Streams and Rocks," accompanying a painting by Lu Chih, in the Nelson Gallery *(no. 53b)*, is rare for its length, consistency and script-size in a format of the same type. It is an impressive demonstration of Wen's discipline and absolute brush control. Indeed, Wen Cheng-ming's best clerical appears in his frontispieces, where the script is magnified and the given space was large

FIG. 39. Shen Tu (1357–1434). *Frontispiece to Lu Chien-chih, "Transcription of Lu Chi's 'Wen-fu.'"* Detail of handscroll. Palace Museum, Taipei.

FIG. 40. Wen Cheng-ming (1470–1559). *Frontispiece to Wen Po-jen, "Miniature Portrait of Yang Chi-ching."* Dated 1530. Detail of handscroll. Palace Museum, Taipei.

enough for the great master to maneuver his brush.

Wen Cheng-ming's execution of clerical earned him recognition as a noted master of the script during the Ming. The large number of his works that have survived made him all the more influential—not only through his son, Wen P'eng (1498–1573), but also, eventually, through Wang Shih-min (1592–1680) in the early Ch'ing.[84]

Wang Shih-min (1592–1680)
"In Pursuit of Antiquity" (no.66)

Known in the West mainly as a painter, Wang Shih-min was equally well known in his time as a calligrapher of clerical script.[85] His extant works include hanging scrolls, couplets, and frontispieces to paintings. While his writing was generally unexceptional, "In Pursuit of Antiquity," the two-character title to an album by his gifted student of painting Wang Hui, is extraordinary and one of the finest examples of his clerical. In it Wang Shih-min achieved a pleasing balance between the complex upper character "pursue" (ch'ü) and the simpler lower character "antiquity" (ku) through the controlled thickness of his brush strokes, the "concealed" brush-tip at the stroke heads, the turning and twisting in mid-course, and the "returned" tail at the finish. Further, the strokes are not entirely smooth and therefore more pleasing, avoiding any mechanical brush quality.

Tao-chi (1641–ca. 1710)
"House by a Creek" (no.73)

Tao-chi was another well-known early Ch'ing painter-calligrapher whose clerical writing is preserved mainly in small inscriptions on his paintings—"House by a Creek," for example, a leaf inscribed in clerical script from "An Album of Twelve Landscape Paintings" (*fig.41, detail*) in the Museum of Fine Arts, Boston. Tao-chi's characters are drawn with squat, plump proportions and highly supple brushstrokes, his writing characterized by many small movements, and close attention to fine detail in the "entering" and "finishing" strokes. His diagonals are wave-like and strongly arched. Small-sized clerical was indeed one of Tao-chi's finest scripts.[86]

The Late Ming–Early Ch'ing Transition

Between Wen Cheng-ming in the Ming period and Teng Shih-ju in the Ch'ing, an important transitional figure was Cheng Fu (1622–93), a native of Nanking. Cheng moved beyond the confines of the conservative *T'ang-li* tradition in his study of the rubbings of Han steles. Moreover, his collection of books and antiquities was substantial. Thus his work was inspired by early models—in particular, the *Tsao-ch'uan-pei*, dated A.D. 185.[87] Cheng's clerical script (*fig.42*) is characterized by a moist touch and strongly modulated, flaring diagonals, which give a sensitive liveliness to his writing. The brush-work is supple and varied, with tapered and blunt, rounded and flattened strokes.

Also a master of clerical script was Cheng's contemporary Chu I-tsun (1629–1708), the scholar-poet and

FIG. 41. Tao-chi (1641–ca. 1710). *House by a Creek.*
Detail of album leaf, *(no. 73).*

bibliophile,[88] whose work, together with Cheng's and that of their many followers, formed a first stage in the transition from the conservative *T'ang-li* tradition to the *chin-shih-hsueh* movement.

Among Cheng Fu's major followers were Wan Ching (1659–1741)[89] and Kao Feng-han (1683–1748) *(no. 75).* Before Kao's arm became paralyzed in 1737, his clerical script was completely influenced by Cheng Fu. The scroll by Kao in this exhibition *(no. 75)* is not in his usual style; it is, rather, a direct imitation of a Han stele by Chang Fei. In the inscription found on the scroll, however, Kao mentioned that he was using his left hand, which makes the work valuable as an example of his later style. Cheng Fu would appear to have also influenced another of the Eight Yangchou Eccentrics, Cheng Hsieh (1693–1765), as well as his student Chu Wen-chen (1718–ca. 1777/78), whose colophon to his teacher's handscroll *(no. 78b)* follows Cheng Fu's style and is proof that the latter's influence lasted well into the eighteenth century.

A third contemporary Yangchou master of clerical script was Chin Nung (1687–1764) *(no. 77).* Like the other masters, Chin went back to investigating earlier sources and rejected the older *T'ang-li* tradition. The unusual character of his models, combined with his creative powers, resulted in clerical script of particular distinction. He had no following to speak of, and his achievement was so personal that it cannot be compared with that of Teng Shih-ju, the great master of the *chih-shih-hsueh* movement. Like his work in seal script, Teng's study of authentic Han models for inspiration marked a major change, after Cheng Fu, in the practice of clerical script.

I Ping-shou (1754–1815)
"The Fragrance of Antiquity" *(no. 79)*

One of Teng's younger contemporaries was I Ping-shou (1754–1815), whose work "Fragrance of Antiquity" is written in a mixture of seal and clerical scripts. The writing exhibits his fine sensibility in the balance of lines and space and of a subtle placement of characters within the horizontal format. This sense of design might

FIG. 42. Cheng Fu (1622–1693). *Transcription of "Tung-hsuan ching."* Dated 1689. Detail of hanging scroll. Collection unknown.

well have led to merely shallow decoration, but I Ping-shou retained a certain simplicity in his style which saved him from superficiality. In his brushwork he used mainly the seal-script technique—even in thickness, strong and rounded. By restraining his brush and thus avoiding flamboyance, I Ping-shou was able to capture the subtle flavor of antiquity. This work was to have been hung in a scholar's study to keep one in constant touch with the past—an intention that is mentioned in I Ping-shou's inscription.

Yü Yueh (1821–1902)
"Excerpts from 'The Literary Mind'" (no.84)

Yü Yueh was a prominent late Ch'ing scholar. As a youth, he practiced seal and clerical scripts; his preference for clerical was in fact so strong that he employed it for his correspondence and daily writing.[90] Yü Yueh's interest in clerical was actually a function of his broader commitment to *chin-shih-hsueh* in general, and to philology and etymology in particular.

Yü Yueh studied rubbings from early inscriptions, and that exposure to them, plus his own practice of the scripts, led to his developing a distinctive personal style based on a comprehensive absorption of those older forms. He cultivated simple direct brushwork, and in "Excerpts from 'The Literary Mind and the Carving of Dragons'," he demonstrates the "struggling" effects of dry brushwork against paper. His style is free, with parallel horizontal formations that bear some resemblance to the Han seal script of Ta-shou *(no.80)*. Linked strokes and curving forms vary the structures. Yü manipulates the brush with steady pressure, which lent the writing a spirit of restraint similar to that of seal script. His own innovations are the rounded stroke-heads, the squared-off tails, and the diagonal *na* stroke, which does not thicken. Moreover, his frequent use of clerical not only added an unmannered fluency to his writing, but is a reflection of his temperament as a scholar and a teacher.

This couplet is not dated, but Yü Yueh used the studio name "Ch'ü-yuan" after 1873, when he built his residence in Suchou upon retirement.[91] Stylistically, the work appears similar to his late writings of ca. 1900.

Conclusion

Generally speaking, the T'ang dynasty was a significant turning point for both seal and clerical scripts. Before the T'ang, both scripts had been undergoing a process of evolutionary change, which naturally resulted in creativity and a diversity of styles, and in the large number of works by unknown calligraphers and in regional styles which developed independently of and unrestricted by any dominant master or school.

After the T'ang period, however, practitioners of seal and clerical began to follow specific masters' styles, a trend that eventually led to a certain uniformity and to stagnation. The subsequent periods of ancient-script revival were closely linked with the contemporary work that was being done in etymology and philology. Despite a brief revival of seal script which took place in the period spanning the Five Dynasties and the early Northern Sung, the latter part of the Sung dynasty witnessed a decline in the practice of both seal and clerical scripts, as running script became dominant.

Another revival of seal and clerical script came about during the Yuan period. A few isolated calligraphers moved beyond the dominating *T'ang-li* to practice *Han-li*, but their styles were shortlived. Although the Yuan period was one of the shortest dynasties and also the first in which all of China was under alien rule, it did foster a studious interest in calligraphy and the publication of many books on the subject. Moreover, at least half of the practicing calligraphers excelled in seal and clerical scripts. From the extant examples—of small-sized writing, for the most part—the Yuan achievement in clerical was high, surpassing both the Sung and the Ming.

From the Ming dynasty, many more examples, especially of large-sized clerical, are extant. In seal script the even higher level of achievement is seen in the wide variety of personal styles which developed. But even the accomplishments of the Yuan and Ming calligraphers were to be overshadowed by the late Ch'ing *chin-shih-hsueh* movement, when seal and clerical scripts were returned to their origins and not bound to intermediary traditions, thereby restoring vitality to those ancient scripts.

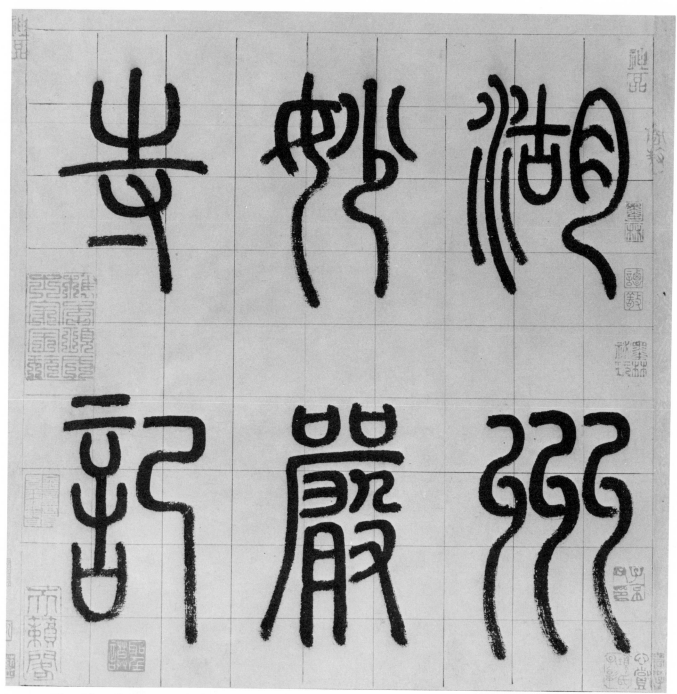

15a Chao Meng-fu (1254–1322), *Record of the Miao-yen Temple in Huchou.*
Frontispiece to transcription by the artist.
Anonymous loan, The Art Museum, Princeton University.

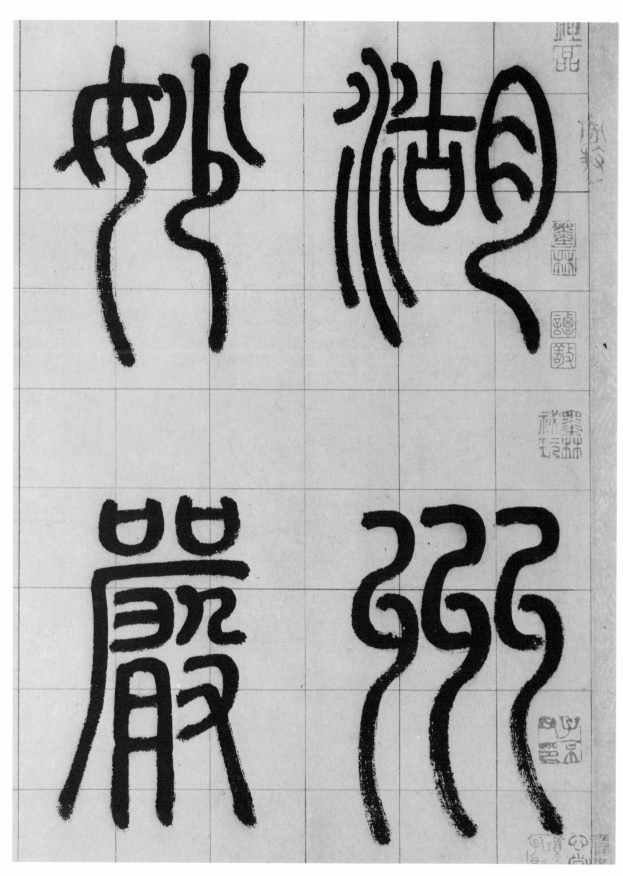

15a Chao Meng-fu (1254–1322), *Record of the Miao-yen Temple in Huchou*.
Detail of frontispiece.
Anonymous loan, The Art Museum, Princeton University.

24b Li Tung-yang (1447–1516), *Poetic Feeling in a Thatched Pavilion.*
Frontispiece to painting to Wu Chen. (Detail below.)
The Cleveland Museum of Art, Purchase, Leonard C. Hanna, Jr. Bequest.

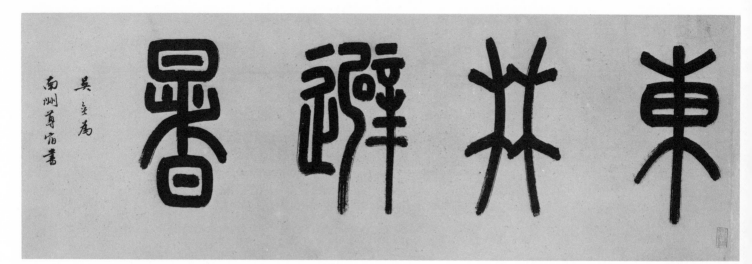

50a Wu I (1472–1519), *Summer Retreat in the Eastern Grove.*
Frontispiece to painting by Wen Cheng-ming. (Detail below.)
Collection of John M. Crawford, Jr.

49 Wu I (1472–1519), *Enjoying the Pines*.
Frontispiece to painting by Shen Chou.
Collection of John M. Crawford, Jr.

53a Lu Shen (1477–1544), *Streams and Rocks*.
Frontispiece to painting by Lu Chih.
Nelson Gallery–Atkins Museum.

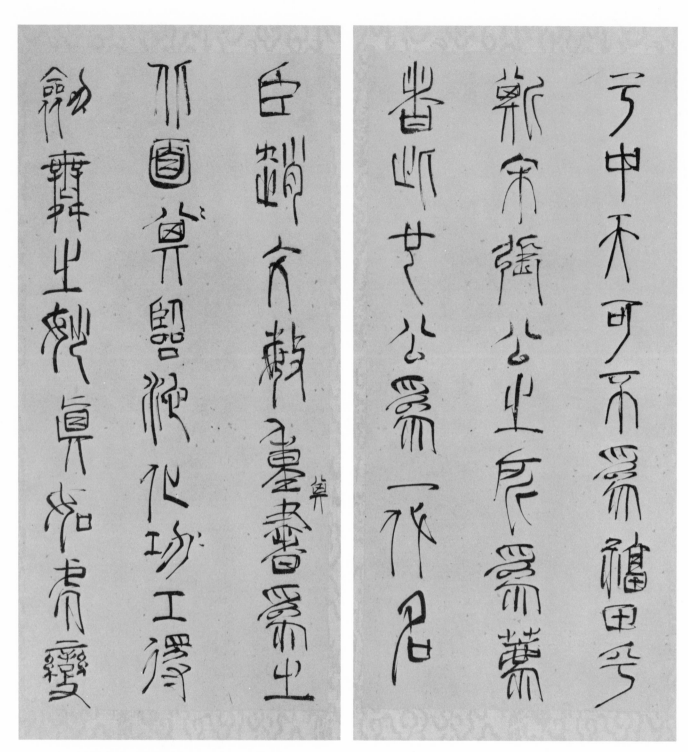

11b Chao Huan-kuang (1559–1625), *Colophon to "Diamond Sutra,"*
transcribed by Chang Chi-chih.
Dated 1620. Album leaf.
Anonymous loan, The Art Museum, Princeton University.

11c Yü Yueh (1821–1906), *Colophon to "Diamond Sutra,"*
transcribed by Chang Chi-chih.
Dated 1885. Album leaf.
Anonymous loan, The Art Museum, Princeton University.

56 Ch'en Shun (1483–1544), *The Western Promontory.*
Frontispiece to his painting.
Ching Yuan Chai.

漢費縣重
丰車畫
元重像

漢費縣重丰元

80 Ta-shou (1791–1858),
Title of a Han Dynasty Portrait.
Transcription of a stone carving.
Dated 1847. Hanging scroll.
Anonymous loan.

篆書 （楊沂孫）

掎輿元勳潛謀嘉績塡實
關中足食軍儲嘗都立官
宓彩修文乎陽宓彩繼而

義是邢或蓻或諜觀國业
常與吉形說尒免貴祀
炎

班孟堅灊初名臣叙贊
同治十二季中冬之月在皖城寓室書奉
熙宇大兄大人雅鑒
海虞濠叟楊沂孫篆

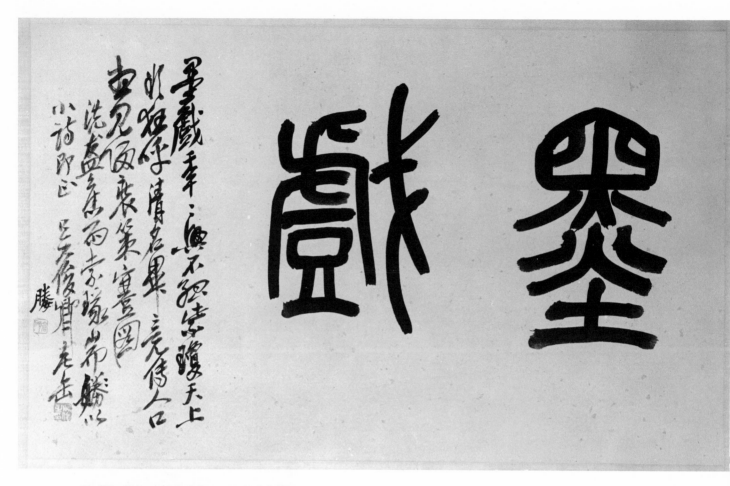

78b Wu Ch'ang-shih (1844–1927), *Ink Play*.
Frontispiece to Cheng Hsieh, *Orchids and Bamboo*.
Anonymous loan, The Art Museum, Princeton University.

27 OPPOSITE
Chin Shih (active 1440–1470), *Splendors of Brush and Ink*.
Frontispiece to collection of calligraphy.
Anonymous loan.

53b Wen Cheng-ming (1470–1559), *Essay on Streams and Rocks*,
following painting by Lu Chih.
Nelson Gallery–Atkins Museum.

66 OPPOSITE
Wang Shih-min (1592–1680), *In Pursuit of Antiquity*,
title to Wang Hui's *Landscapes after Sung and Yuan Masters*.
Album leaf.
The Art Museum, Princeton University.

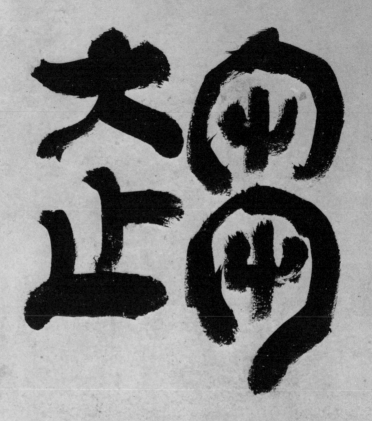

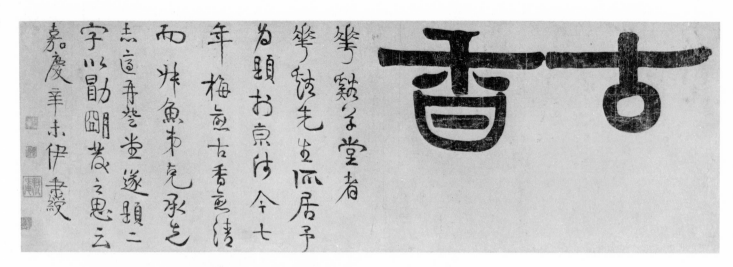

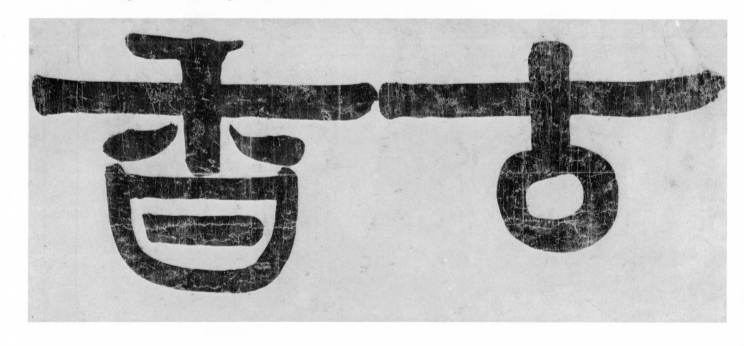

79 I Ping-shou (1754–1815), *The Fragrance of Antiquity.*
Dated 1811. Horizontal hanging scroll. (Detail below.)
The Jeannette Shambaugh Elliott Collection at Princeton.

84 OPPOSITE
Yü Yueh (1821–1906), *Excerpts from
The Literary Mind and the Carving of Dragons.*
Pair of hanging scrolls.
Anonymous loan.

紛哉萬象神理共契

偉矣前修情采自凝

曲園俞樾

III

The Cursive Script Tradition

THE EVOLUTION of Chinese script has been toward ever simpler and more expedient forms of writing. This process best characterizes the rise and early development of cursive script (ts'ao-shu). In the later phases of its development interest in the aesthetic potential of cursive as a medium for freer artistic expression became quite apparent. From the fourth century onward, cursive writing was a chief means by which master calligraphers expressed their individuality. Each new generation was able to capture the spirit and energy of its age through the cursive medium, regardless of the rise and fall of the other scripts, a tribute to its efficacy and longevity as a script type.

Origin and Definitions

Several traditional theories about the origin of cursive script exist; those supported by archaeological evidence date it to the late Ch'in (221–207 B.C.) and early Han (206 B.C.–A.D. 220) periods.[1] It is important to remember that cursive script arose *with* clerical during this time, and that both scripts underwent concurrent evolutionary changes.

There are three stages to the evolution of ts'ao-shu:

(a) chang-ts'ao, "draft-cursive," the earliest form of cursive;

(b) chin-ts'ao, "modern" cursive, or simply "cursive," which developed by the second century A.D.;

(c) k'uang-ts'ao, "mad" or "wild" cursive, a later type introduced in the eighth century A.D.

Draft-cursive (chang-ts'ao)

Draft-cursive was widely practiced by the Eastern Han period (A.D. 25–220) and answered the need for a quicker, simplified form of the then-current clerical (li-shu) script.[2] Although the basic brushwork was derived from clerical, draft-cursive stressed the action of the brush-tip, abbreviating or linking several strokes into one or two movements. Some strokes emphasized a "flared" or "wave-like" flick of the brush characteristic of clerical methods. Developed out of practical needs, the simplified forms and new symbols of draft-cursive were introduced as substitutes for the older, more complex forms in use, and constituted, in fact, an informal shorthand.

"Modern" Cursive (chin-ts'ao)

By the late Han and Wei periods, when formal writing had developed from clerical to early variants of standard and running script, draft-cursive underwent further change. The flared, wave-like strokes, brief repetitive rhythms, occasional stroke linkages, and emphasis of dots over lines gradually evolved into more sustained and carefully articulated brush movements. Connections between two or more characters in a vertical column also developed. These changes led to the second cursive form chin-ts'ao, or "modern cursive," most probably derived from a combination of draft-cursive, the contemporary running, and early standard strokes, abbreviated and linked together.

Traditionally, Chang Chih (ca. A.D. 150) is credited with the invention of "modern cursive." By the Tsin period evidence that these scripts were being practiced for more than utilitarian writing needs may be seen in the work of the leading artists of the time: Wang Hsi-chih (303 ?–361 ?) (no. 1a; figs. 2, 3), his son Hsien-chih (344–388), and others.[3] In this respect, the development of cursive script as a generic type was revolutionary in the history of calligraphy because it offered a new horizon of aesthetic potential for the brush.

"Wild" Cursive (k'uang-ts'ao)

The artistic possibilities of cursive writing would be more fully demonstrated several centuries later in the T'ang period (618–907) with the introduction of the third form, k'uang-ts'ao, "wild" or "mad" cursive. During the reign of the Emperor Hsuan-tsung (r. 712–756), literature and art flourished and a new type of cursive writing began to evolve in the hands of scholars and calligraphers. The writing of Wang Hsien-chih was considered the prototype and inspiration for this script style. Its highest achievement was reached by Chang Hsu (ca. 700–750) and his follower, the monk Huai-su (ca. 735–800 ?).[4] Huai-su's nickname, "wild monk" (k'uang-seng), later became attached to this highly expressive style (fig. 44). Compared to prior cursive styles, "wild" cursive had more connections between strokes and between characters in a column. The resultant shapes were often extreme and exaggerated and appear to have been written rapidly and in a state of exhilaration. Freest and most eccentric of all writing styles, "wild" cursive was developed for purely artistic reasons and represented the extreme of calligraphic self-expression.

Pre-Sung Masters of Cursive Script

A discussion of early masters of cursive begins with P'ing-fu t'ieh, a letter by the famous poet-critic Lu Chi (261–303), now in the Palace Museum, Peking (fig. 43).[5] The writing consists mainly of draft-cursive script spontaneously mixed with elements of several other script types. Unlike Wang Hsi-chih's writing, which

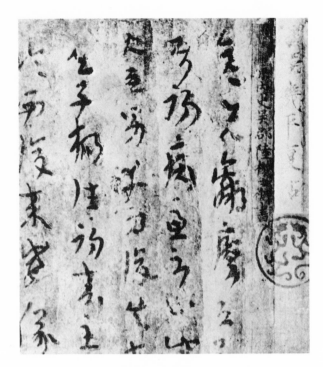

FIG. 43. Lu Chi (261–303). *P'ing-fu t'ieh*. Detail of handscroll. Palace Museum, Peking.

survives only as tracing copies or rubbings, *P'ing-fu t'ieh* appears to be an original manuscript, and as such, is one of the earliest known examples of cursive. The poet's natural writing style is demonstrated—humble, unaffected, even unartistic—with a relative lack of studied brushwork. The style is comparable in period characteristics to the archaeological fragments of writing on paper and wooden slips discovered in the first decades of this century at Lou-lan, Edsin Gol, and other Central Asian sites.[6] For that reason, *P'ing-fu t'ieh* is generally accepted as authentic.

Lu Chi's letter is an interesting example of a major poet whose brush-written style is entirely compatible with the period features of the script, but who, as an individual, could not be considered a master calligrapher. He was writing for the sake of communication, and his artistic talents lay in other spheres. This plain, unassuming style therefore differs in intent from that of Wang Hsi-chih and his son, who were more keenly aware of the process of aesthetic cultivation in calligraphy, both as an artistic endeavor and as a reflection of their aristocratic personalities. Their styles therefore embrace and transcend basic period features. In this respect, their work remained a constant challenge to later calligraphers and infinitely more satisfying as calligraphy.

Wang Hsi-chih (303?–361?)
Hsing-jang t'ieh (no. 1a)

Wang Hsi-chih wrote in draft and modern cursive types, as well as a mixture of other forms.[7] The *Hsing-jang t'ieh (no. 1a)* contains both running and cursive elements, some draft-cursive brushwork, and only two linked connections between characters. The first linkage appears between *hsing* and *jang*, the two most important characters in the first line, for which the letter is named.

The sensitive and faithful quality of this tracing copy enables us to imagine the original work. The brushstrokes have a rounded, fleshy, monumental feeling. Even the thinner strokes and connections have a substantial ductile strength, achieved by manipulating the brush so as to "conceal" the sharp tip as it "enters" and "completes" certain movements. The internal composition os the characters and their external spacing (*hang-ch'i*) are presented with spontaneity and vitality: each character varies in size and differs in the balance of its axis; each has its own poised individuality and existence, yet each responds to the next, in rhythmic, dancing succession. Fluent, yet unrushed, the pace befits a great master preoccupied with the refinements of brush detail.

The two Emperors Sung Hui-tsung (r. 1101–25) and Ch'ing Kao-tsung (Ch'ien-lung, r. 1736–95) were among the many prominent collectors of this work. The Ch'ien-lung Emperor counted the scroll among his favorites and inscribed on the mounting, in a metaphorical attempt to capture the powerful energy of the writing, a famous quotation from the Liang Emperor Wu (r. 502–549): "Dragons leaping at the Gate of Heaven, Tigers crouching before the Phoenix Hall."

The most famous writer of cursive script after Wang Hsi-chih was his son, Wang Hsien-chih.[8] The father's writing was considered more monumental, with fewer connecting strokes, while the son's appears to have had more linkages between characters and more overt energy—important precedents for wild cursive.

THE STYLE of Wang Hsi-chih, patriarch of cursive and running scripts, was faithfully perpetuated in the Sui period by the monk Chih-yung (6th century), Wang's seventh generation descendant, and, in the T'ang, by Sun Kuo-t'ing (648?–703?).[9] Chih-yung's "Thousand Character Classic," in cursive and standard scripts, and Sun's manuscript on the art of calligraphy, *Shu-p'u hsu*, dated 687, also assumed orthodox authority, and, along with Wang Hsi-chih's masterworks, formed a mode of classicism which proved to be a continual source of renewal for later generations. Concurrently, Wang Hsien-chih's more exuberant style, the predecessor of wild cursive which culminated in the T'ang in the work of

Chang Hsu, Huai-su, and Kao-hsien (active 845–860), was carried on in the Five Dynasties by Yang Ning-shih (873–957) (fig. 71), and then, in the Northern Sung, by Chou Yueh (active 1023–48) and Su Shun-ch'in (1008–48).[10]

Modern cursive, and eventually wild cursive, became part of a living tradition from the Sui and T'ang periods through the Sung and Yuan. This led to a gradual decline of draft-cursive, which tended to be practiced only as an archaic script until its later revival in the Yuan period. Wang Hsi-chih and Wang Hsien-chih represent the two mainstreams which dominated the cursive tradition before the emergence, in the Northern Sung, of Huang T'ing-chien and Mi Fu.

Cursive Script Masters of the Sung and Yuan Periods

Huang T'ing-chien (1045–1105) "Biographies of Lien P'o and Lin Hsiang-ju" (no. 4)

The influence of Huang T'ing-chien was based not only on his achievement in the art of calligraphy but also on his fame as a poet, art theorist, and critic of calligraphy. Fortunately, a sizable number of his calligraphic works survive to give a complete picture of his achievement as an artist.[11] "Biographies of Lien P'o and Lin Hsiang-ju," from the Crawford collection, New York, is one of two major works surviving in cursive script.[12]

The brushwork in the Crawford scroll is refined and somewhat tender. The strokes are rounded, written almost entirely with an upright brush, and curves predominate over angles. Compared to Huang's other extant works, the Crawford scroll is relatively early and probably dates from between 1094 and 1097, the period of his first exile.[13]

Huang T'ing-chien said that in 1094, while wandering in the Huang-lung mountains of Kiangsi, he became enlightened regarding the secrets of cursive writing. Therefore, he felt that his former writing showed too many sharp angles, and that, at a clean desk near a bright window, with good ink and a responsive brush, he could write several thousand characters without tiring.[14] The Crawford scroll contains some 1700 characters, and is, in fact, Huang's longest extant work. The brushwork contains few angled turns, and the moist ink tones, ranging from a rich black to silvery grey testify to sustained interest and exhilaration.

Composed by the great Han historian Ssu-ma Ch'ien (145 B.C.–before 86 B.C.), the "Biographies" tell the story of two noble ministers, rivals who "placed the immediate needs of the nation first, and put aside their

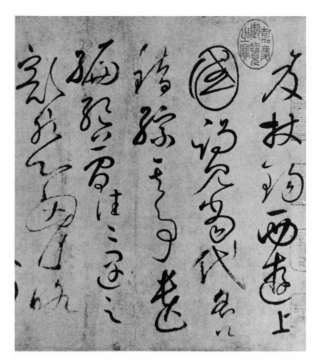

FIG. 44. Huai-su (ca. 735–800 ?). *Self-statement.* Dated 777. Detail of handscroll. Palace Museum, Taipei.

private grievances." Huang T'ing-chien's exile was due to his inadvertent involvement in certain factional struggles at court; thus his choice to transcribe this moving account of Lien P'o and Lin Hsiang-ju may reflect his feeling that his exile was due to personal malice rather than principles of good government. These implications may also help to support the date of the scroll to his first exile.[15]

The stylistic sources of Huang T'ing-chien's cursive writing are complex, but Huai-su's (fig. 44) can be considered one of the chief influences. The consistently rounded and supple brushwork, with its circular momentum, reflects the T'ang master. The Crawford scroll is relatively "early"; still, it represents Huang's mature style and is an exceptional treasure from the Sung period.

Mi Fu (1051–1107) "Sailing on the Wu River" (no. 8)

Mi Fu's training in brushwork and composition was based on the structural discipline of the T'ang master Yen Chen-ch'ing (709–785) and tempered by the refined orthodoxy of the two Wangs. "Sailing on the Wu River," from the Crawford collection, reveals Mi's thorough absorption of these earlier methods transformed to an un-

precedented level of brush mastery. The large-sized calligraphy contains a mixture of running and cursive scripts with occasional standard elements. The first thirteen lines are mainly in running script, with three to four characters in each column; then a single character ("pulleys") appears suddenly in pale dry ink filling the vertical space. According to the poem, boatmen and rope-pullers on the river banks are attempting to dislodge his boat from a mudbank. In sympathy with their energy and excitement, Mi's calligraphy increases in cursiveness, the ink tones shifting from rich blackness to smoky paleness. With a great shout, the boatmen heave the craft forward "like the wind" *(fig.45)*, and the momentum of the writing culminates in the enormous character "battle" (*chan*), which, as the visual and auditory climax of the poem, expresses their triumph over frustration. The writing then subsides into an easy naturalness.

Visually, "Sailing on the Wu River" is one of Mi's most exciting works and probably dates from his maturity.[16] It is not surprising that the later cursive master Wang To (1592–1652) *(cf. nos. 64,65),* in his colophon on the mounting, wanted to burn incense and prostrate himself in homage before the scroll.

TRADITIONALLY, Mi Fu and Huang T'ing-chien represent different modes of expression in cursive writing: Huang T'ing-chien belongs to the tradition of "wild" cursive, and Mi to the more orthodox "modern" cursive. To be sure, Mi's forms are not as extreme as Huang T'ing-chien's and cannot be called "wild" cursive, still, Mi was possessed by the spirit of the script. By contrast, even though Huang T'ing-chien's forms belong to the wild cursive tradition, his brushwork shows an even-tempered fluency and restraint which is closer to modern cursive style. Mi Fu's movements, pacing, and intensity vary over a wide spectrum from heavy to light, dark to pale, fast to slow, exuberant to subdued, his rounded tensile strokes made with the "centered point" of the brush (*chung-feng*) giving way to modulated slanting strokes made with an obliquely held brush (*ts'e-feng*). Always full and substantial, constantly moving and changing, the infinite variety of shape of Mi's strokes contrast strongly with the remarkable consistency of Huang's brush. Where Huang favors variety in columnar spacing and the intimate integration of character with character, Mi prefers broad, generous spacing and the characters as self-contained units, except where linked by an occasional continuous stroke.

Although Mi drew on many sources for his calligraphy, his image of perfection was the art of the two Tsin masters, Wang Hsi-chih and Wang Hsien-chih. He summed up his basic attitude toward the study of cursive in the following: "In cursive, if one does not thoroughly grasp the Tsin methods, then one's writing will certainly become an inferior product."[17] He follows this opinion with severe criticism of the T'ang masters of wild cursive—Kao-hsien, Chang Hsu, and Huai-su—again emphasizing his contrast with Huang T'ing-chien, who admired the latter two masters.

Mi Fu (1051–1107)
"Hasty Reply before Guests" *(no. 9c)*

This letter is written in a style close to cursive and bears comparison with the preceding handscroll. The letter is named for a phrase found in the last line: "Facing guests, I brushed a hasty reply." Because of the informal format and pressing circumstances of the execution, Mi's hand shows a degree of naturalness and spontaneity not usually found in his larger works, such as "Sailing on the Wu River," which were written with artistic purposes more in mind. The charm and elegance derived from the Tsin masters are here subdued, but his stylish and essentially cultivated air is nonetheless present.

The Transformation of Cursive Script in the Yuan and Ming Periods

In the early Yuan, Chao Meng-fu (1254–1322) and Hsien-yü Shu (1257?–1302) mark the end of the influence of the Great Northern Sung Masters—Su, Huang, and Mi—which had extended into the Chin and Southern Sung periods. The orthodox Wei/Tsin styles had not been seriously studied and practiced since the Northern Sung period, and draft-cursive script, in particular, was almost forgotten. None of the Four Great Masters excelled in the script, and even though the Southern Sung Emperor Kao-tsung is known to have transcribed the Classics in draft-cursive, he did not start a trend. Chao Meng-fu, a member of the Sung imperial family, was one of the earliest Yuan calligraphers to take up the interest, possibly as a result of Kao-tsung's influence. At least three examples of Chao's work in draft-cursive are still extant.[18] By the mid-Yuan to early Ming period, then, draft-cursive overtook modern cursive to become the dominant form through a full-fledged revival.

The draft-cursive of the Yuan-Ming period was a transformed script. As practiced by its leading exponents, Chao Meng-fu, Yü Ho, K'ang-li Nao-nao, Yang Wei-chen, and Wu Chen, it was actually a mixture of script characteristics, a tendency begun in the T'ang when a few draft-cursive elements were interspersed among predominantly modern cursive forms. Sun Kuo-t'ing's (648?–703?) *Shu-p'u hsu* and Ho Chih-chang's (659–744)

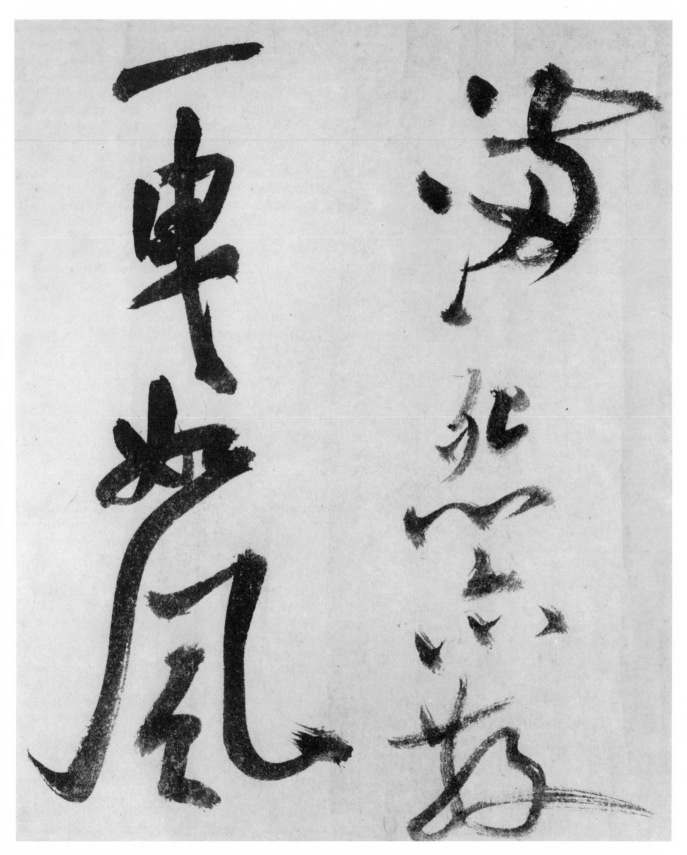

FIG. 45. Mi Fu (1051–1107). *Sailing on the Wu River.*
Detail of handscroll, *(no.8).*

"Classic of Filial Piety" are two famous examples of this tendency, which became widespread and accepted by the Yuan.[19] The abundance of linkages between characters was the "modern" component, while the presence of sharp flicked strokes and more brush-tip action was the "draft" component. Calligraphers were therefore using draft-cursive methods to write modern cursive, or vice versa.

In the late Yuan and early Ming an even further ramification of the growing tendency toward synthesis occurred through a combining of all *three* types of cursive—*chang-ts'ao, chin-ts'ao* and *k'uang-ts'ao*. The mixture was so complete that in some cases it is difficult to state exactly what form of cursive is present. Because of this synthesis, from the Yuan period onward, pure draft-cursive was seldom practiced.[20]

Hsien-yü Shu (1257 ?–1302)
"Song of the Stone Drums" *(no. 18)*

Chao Meng-fu and Hsien-yü Shu studied cursive script together, but Chao deferred to Hsien-yü, who, as a northerner, possessed the heroic spirit and inner drive which Chao Meng-fu, as a southerner, lacked.[21] Hsien-yü Shu's artistic personality suited the potentials of cursive, and "Song of the Stone Drums," dated 1301 and one of his most famous works, expresses these traits with strong brushwork, tense and bursting with energy. Even in areas of faster movement, the lines reflect a firm, well-controlled wrist, transferring the energy to the very brush tip, forming crisp, well-jointed turns and hooks.[22] This directed strength is consistent in his cursive, running, and standard script writings (cf. *no. 16*, and essay IV).

Hsien-yü Shu's achievement in cursive resided ultimately in his intensive study of the works of the ancient masters, many of which he had in his collection.[23] As a major connoisseur of the early Yuan (see below, essay V), his taste was definitive. One of his most exemplary works in cursive style, an album leaf, "Comments on Ancient Masters of Cursive" *(fig. 46)*, is an art historical comment on the major masters of cursive who preceded him:

Chang Hsu, Huai-su, and Kao-hsien were all famous masters who excelled in cursive script. Chang Hsu's [style] was wild and untrammeled, often exceeding methods. Huai-su safeguarded method and was especially rich in antique feeling. But Kao-hsien's brushwork was too rough and only grasped sixty or seventy percent [of antique methods]. Then with Huang T'ing-chien, there was a great decline, and [both method and antique feeling] could not be recovered.[24]

The two ideas stressed here are the importance of "methods and principles" (*fa-tu*) and "antique feeling" (*ku-i*), which complement Chao Meng-fu's ideas and were to be key tenets in the calligraphy and painting of later Yuan scholars. Most striking is the attack on Huang T'ing-chien, a trenchant comment not only on his cursive style but also on the spirit of independence which was Huang's legacy to the Southern Sung. Hsien-yü Shu saw this influence as destructive, causing him to reevaluate the achievements of T'ang and Sung according to Tsin standards. Success in restoring a sober discipline to the practice of cursive script was not achieved by his effort alone, but nonetheless he set an early direction of recovery which bore results through the whole of the Yuan period.

Hsien-yü Shu's calligraphy reveals the degree to which his theory was realized in his art. "Song of the Stone Drums" exhibits his "personal" style to advantage, yet, for all its virtues, it can be faulted for being somewhat coarse and deficient in subtlety and elegance (*yun*). In the album leaf, on the other hand, his study of the Tsin masters resulted in an unusual abundance of *yun*, testifying to the degree which the style of the ancients as an image of perfection in a calligrapher's mind could raise his art to a higher level.

K'ang-li Nao-nao (1295–1345)
"Biography of a Carpenter" *(no. 21)*

K'ang-li Nao-nao, a high official of the Mongol government, was the first calligrapher to specialize in and gain fame from cursive. There is the anecdote told by contemporaries that upon hearing that Chao Meng-fu could write 10,000 characters per day, K'ang-li replied that he habitually wrote 30,000 per day before putting down his brush.[25] Perhaps an exaggeration, but it is a testament to K'ang-li's diligence and speed, two of his outstanding traits.

Compared to Hsien-yü Shu, K'ang-li's brushwork is lighter, his turning strokes rounder and smoother. His brush pressure is relatively even, the characters more uniform in size, and the energy level lower, all of which contribute to a greater speed in execution. Strictly speaking, these traits might be cited as faults in any other master. K'ang-li's writing, however, possesses a fresh, airy feeling, a pure and uncommon spirit. Fluent but not sweet, even-tempered yet not monotonous, these qualities rank him as a great master.

The writing of "Biography" is an excellent example of the accommodating mixture of different cursive types. It is mainly written in modern cursive, but the brush action is draft-cursive. When compared to Hsien-yü Shu's "Song of the Stone Drums" *(no. 18)*, the generic changes in cursive writing are apparent. K'ang-li's style

FIG. 46. Hsien-yü Shu (1257 ?–1302). *Comments on the Ancient Masters of Cursive*. Album leaf. Palace Museum, Taipei.

is not the same revived orthodoxy of the two Wangs as seen in the more refined works of Hsien-yü Shu, but has a new "face" with an even greater admixture of draft-cursive elements.

Wu Chen (1280–1354)
"Poetic Feeling in a Thatched Pavilion" (no. 24a)

Among the four Yuan Masters of painting, Wu Chen was the only one who practiced cursive script. A contemporary of Wu's said he derived his cursive from the works of the T'ang dynasty monk Ch'ung-kuang, who wrote in the style of Chang Hsu.[26] A late Ming critic felt that Wu's brushwork was modeled on Huai-su's and was "abundant in antique elegance."[27] Indeed, Wu Chen's style bears a distinct resemblance to one of Huai-su's attributed works, "Thousand Character Classic" in modern cursive.[28] As in the Huai-su attribution, the characters of Wu Chen's inscription, dated 1347, on his charming painting "Poetic Feeling in a Thatched Pavilion," are moderate in size, restrained and self-contained in feeling, with rounded brushwork and a modest presentation. Wu Chen's hand was the perfect complement to his paintings, adding a literary personal touch but not competing with his pictorial scenes. All of his works, whether landscape or bamboo, share this harmony.[29]

Despite the personal achievement, Wu Chen's writing still belongs to the category of "painter's calligraphy," and not of "calligrapher's calligraphy"—it is good but not outstanding. Compared to K'ang-li's which has a professional's expertise, Wu Chen's calligraphy has an amateur's flavor. Moreover, Wu Chen's style is somewhat constricted and lacking in openness. These traits, however, are not felt in his painting in which his strokes are decisive, and his compositions expansive and monumental.[30] Wu Chen shows himself to be more of a natural painter than a calligrapher, his training and practice grounded in the pictorial rather than in the calligraphic tradition.

Among Wu Chen's contemporaries, the Taoist painter Fang Ts'ung-i (1301 ?–after 1378) reached a higher achievement in cursive, and moreover wrote in a purer form of draft-cursive, an achievement based on his mastery of clerical script. Like his painting, Fang's calligraphy can be described as both elegant and untrammeled.[31]

Yang Wei-chen (1296–1370)
"Drinking with My Wife under the First Full Moon" (no. 22)

Although his poetry was better known, Yang Wei-chen's writing was actually the most distinctive and individually expressive of the Yuan period.[32] Compared to Feng Tzu-chen, for example (no. 19) (see below, essay

FIG. 47. Yang Wei-chen (1296–1370). *Poem and colophon to Tsou Fu-lei, "A Breath of Spring."* Detail of handscroll. Courtesy Smithsonian Institution, Freer Gallery of Art, Washington, D.C.

FIG. 48. Yang Wei-chen (1296–1370). *Drinking with My Wife under the First Full Moon.* Detail of album leaf, *(no.22).*

IV) his brushwork is more substantial, disciplined, and exemplary of past traditions; without doubt, Yang Wei-chen's calligraphic achievement exceeds that of Feng Tzu-chen.

One of the most striking and important examples of Yang's writing is his poem and colophon following "A Breath of Spring," a handscroll depicting plum blossoms, by Tsou Fu-lei (*fig.47*; Freer Gallery of Art).[33] The brushwork spans an enormous range, with heavy, rich ink succeeded by dry pale ink, and characters large and small leaping out at the viewer with great force. The script is a mixture of running and cursive, but the exuberant spirit is the essence of wild cursive.

The album leaf, "Drinking with my Wife under the First Full Moon" (*fig.48*) is an example on a smaller scale, but it contains all of Yang's distinctive features. The characters appear stretched downward and compressed sideways, so that the writing seems massed together without the usual clear columnar spaces. Angles and straight lines predominate; characters of charcoal-black density contrast with spidery diagonals and linking strokes. The brush moves in a swift, decisive rhythm. Yang attacks the stroke with a crisp, clean entrance, making triangular-shaped "heads," and then proceeds with direct and simple movements, often using the flattened "belly" of the brush to produce broad horizontals and verticals. Yang's individualism may be seen in the unusual spacing, which by its close arrangement shows a strong sense of spatial design, and in the stroke details, the hooks and diagonals, which often deviate from the norm. Compared to the smooth, swift, and almost uniform brushwork of K'ang-li, for example, Yang Wei-chen's is more self-conscious, eccentric, and varied, qualities consistent with his literary expression.

The Late Yuan-Early Ming Transition

Unlike the transition from Sung to Yuan, with an accompanying "revolution" and negation of Southern Sung styles and values in calligraphy and painting, the change from Yuan to Ming witnessed no rupture in calligraphy styles: early Ming calligraphy was a continuation of late Yuan trends. In particular, calligraphers like K'ang-li Nao-nao (1295–1345), Yang Wei-chen (1296–1370), and Jao Chieh (ca. 1300–67) were important to early Ming writers.[34] Jao Chieh (*fig.49*) represents a "cross" between Yang and K'ang-li: like the latter, he demonstrated the new mixture of cursive and draft-cursive elements.[35] Together, Jao and K'ang-li exerted the strongest influence on the early Ming development. Yang Wei-chen's personality was too individual and his style too eccentric to attract many

followers; however, in his later years his activity as a poet and littérateur in Sungchiang exerted an important indirect influence, not necessarily related to formal style, but to the force of his personality.

The "Three Sung":
Sung Sui, Sung K'o, Sung Kuang

Sung Sui, Sung K'o, and Sung Kuang figured prominently in early Ming calligraphy, and their work was mainly derived from K'ang-li Nao-nao and Jao Chieh.[36] Sung Sui (1344–80) was the second son of the well-known scholar-official Sung Lien (1310–81).[37] Sung Lien was better known for his small standard (see below, essay IV), but father and son were both influenced by K'ang-li in their cursive styles. Sung Sui's works are rare and exist only in rubbing form.

The styles of Sung K'o (1327–87) and Sung Kuang (active ca. 1350) are derived from Jao Chieh. While Sung Kuang's works are also rare, Sung K'o's works are readily available. Of the three Sung, K'o achieved the greatest influence and reputation as major master of the

FIG. 49. Jao Chieh (ca. 1300–1367). *Poem for Portrait of Monk Chung-feng.* Dated 1365. Detail. Palace Museum, Taipei.

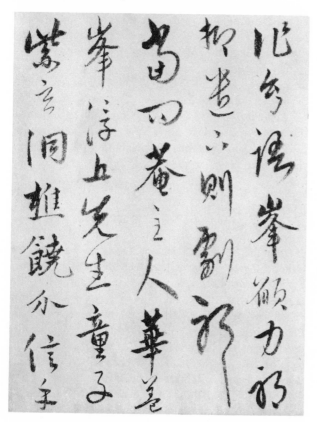

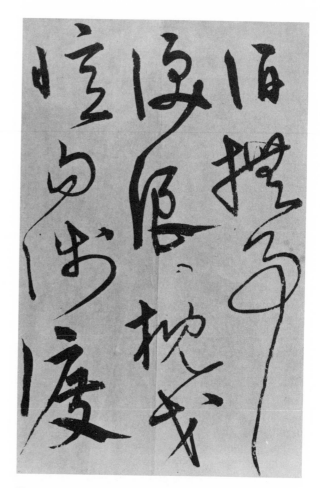

FIG. 50. Sung K'o (1327–1387). *Poem by Tu Fu.* Detail of handscroll. Collection unknown.

early Ming.[38] A serious student of draft-cursive, he attempted in some works to write a purer form of the script.[39] One of his finest works, however, is in the more prevalent "mixed" style, a transcription of a poem by Tu Fu in large cursive *(fig. 50)*. Here he writes in a bold, free manner after the spirit of Huai-su *(fig. 44)*. It is tempting to read Sung K'o's study of military strategy in his calligraphy: rounded and strong, fast and sharp, his brushwork opens with a crisp, firm attack and ends with the characteristic splayed or tapered strokes of draft-cursive. The open spacing and combination of widely curving and angular rhythms give Sung K'o's writing a more pronounced personal character than that found in the work of either K'ang-li or Jao Chieh.

The Suchou and Sungchiang "Schools"

Their Rise and Fall in the Ming Period

During the early Yuan period, the major scholars and calligraphers came from both north and south China. Because reunification by the Mongols made possible a gathering of the best from all regions, there was no strong regional "school." By the mid-Yuan, however, the cultural centers in Chiangnan (southeast China in the Yangtze delta) had risen to a degree whereby their cultural achievements led the empire, thus favoring the prominence of two key regions by the late Yuan and early Ming: the Wu area in Kiangsu province (otherwise known in the Ming as Suchou), and Sungchiang (known also as Hua-t'ing or Yun-chien), its neighboring prefecture.[40]

Historians of Chinese painting are familiar with the accomplishments and nomenclature of the Wu, Che (for Chekiang), and Sungchiang "schools." The Sungchiang "school" of painting as a regional grouping arose only in the late Ming with the appearance of Tung Ch'i-ch'ang (1555-1636), but Sungchiang's prominent calligraphers emerged much earlier, in the late fourteenth century. Sungchiang's traditions in calligraphy were in fact much stronger than they were in painting and so far have been neglected.

Sung K'o's vigorous calligraphy dominated the cursive writing of the early Ming period. A native of the Ch'ang-chou district of Suchou prefecture, Sung can be considered the ancestor of the Suchou "school" of calligraphy. Yet his major influence was exerted not on Suchou calligraphers but rather on those from Sungchiang. Ch'en Pi (active 1380) of Hua-t'ing was an early example. Highly regarded by later contemporaries, Ch'en's style contains fewer draft-cursive elements and more curvilinear rhythms than that of Sung K'o.[41]

Sungchiang's Early Dominance

After Ch'en Pi, the two most important calligraphers were the brothers Shen Tu (1357-1434) and Shen Ts'an (1379-1453). They were close followers of Sung K'o and made a conscious effort to imitate his writing style. Residents of Sungchiang were proud of the Shens' achievement. Lu Shen (1477-1544) said:

Since the beginning of this dynasty, the calligraphers from Sungchiang have been the best under heaven. Generally they all derived their sources from Sung K'o and Ch'en Pi. With the two Shen [brothers], their high achievement in calligraphy was recognized and praised by the emperor, and they became officials in the Palace. Later they were promoted Academicians in the Hanlin Academy. So in our district, they are called the Senior and Junior Academician.[42]

The Yung-lo Emperor was so enamored of his style that he praised Shen Tu with the ultimate compliment, "the Wang Hsi-chih of our dynasty."[43]

Several generations later, Chu Yun-ming of Suchou would recognize their achievement and influence, while revealing his envy: "Recently the renowned calligraphers Huang Han, the two Chien, and Chang Pi all come from Sungchiang. That is because the reputation of the two Shen brothers in Sungchiang encouraged the residents to pay particular attention to calligraphy even up to the present. But rare jade from Ching can only appear once!"[44]

Shen Tu (1357-1434) and Shen Ts'an (1379-1453) "Preface and Poems by Chu Hsi" and "Poems" (nos. 26a and b)

In this joint work, the younger Shen Ts'an's eight poems in draft-cursive precede the elder Shen Tu's transcriptions, which alternate standard and draft-cursive scripts of various sizes. The cursive writing of the brothers is quite similar, as in the two illustrated sections, but the younger's touch is lighter and livelier, while the elder's is weightier with a greater internal tension, especially in his smaller-sized cursive. The writing by Shen Tu is rare; a later contemporary, Lu Shen (1477-1544), mentioned that Shen Tu did not often write in running or cursive scripts to avoid competing with his younger brother.[45] This scroll is therefore important in its demonstration of Shen Tu's range and high quality.

The influence on Shen Tu of Sung K'o may be seen if this scroll is compared to Sung's "Transcription," dated 1370, of Chao Meng-fu's "Thirteen Colophons to the *Lan-t'ing*" (*fig. 64*), which was known to have been in the Shens' collection.[46] Shen Ts'an is also considered a follower of Sung Sui, thus establishing a further link with the "Three Sung" of the early Ming.[47]

Chang Pi (1425-1487) and the New Trend

After the Shens, Sungchiang produced a number of minor calligraphers mentioned by Chu Yun-ming above, but it was not until the next generation and Chang Pi (1425-87) that cursive writing underwent significant, visible changes.[48] In contrast to the prevailing trends in his native Sungchiang, Chang Pi practiced mainly wild cursive and tended to eliminate draft-cursive elements from his brushwork. His work departs radically from the disciplined and orthodox perfection of Sung K'o's, Ch'en Pi's, Shen Tu's, and Shen Ts'an's, which represented the last of the late Yuan/early Ming phase.

Chang Pi's calligraphy was the beginning of a new trend which would culminate in the work of Chu Yun-ming.

The Rise of the Suchou Masters

Hsu Yu-chen (1407–72) was Chang Pi's counterpart in Suchou.[49] From the few examples of his work extant, Hsu's style appears to combine Huai-su's cursive structures with Ou-yang Hsun's brushwork (fig.88). Hsu's interest in the freer types of cursive was to be continued in the work of his grandson Chu Yun-ming and the generations immediately following.

Generally recognized as the two greatest calligraphers in the Ming, Chu Yun-ming and Wen Cheng-ming benefited from the Suchou tradition of great masters, which actually traced back to the T'ang period (both Chang Hsu and Sun Kuo-t'ing were residents of Wu). Here, too, strong local pride prevailed. By the fifteenth century, there was a common saying that, "In Suchou every family practiced calligraphy and every person painted," and that "For calligraphy, Suchou cannot be surpassed."[50] Thus the rivalry between Suchou and Sung-chiang had become quite intense by the generation of Chu and Wen.

Other high-ranking officials and calligrapher-connoisseurs in the Suchou circle were Wu K'uan (1436–1504) and Wang Ao (1450–1524). In his "Ode to Pomegranate and Melon Vine" (no. 31), Wang Ao's cursive inscription is paired with a painting by Shen Chou (1427–1509), Wang's good friend and the patriarch of the Ming Suchou painters (cf. no. 29).[51] Wang Ao's calligraphy style reveals direct, angular brushwork and sharp, firm movements with much "bone" and little "flesh." This represents an extreme facet of the period style, seen also in Hsu Yu-chen's writing, which was to appear in different degrees in the younger masters Chu and Wen.

Chu Yun-ming (1461–1527) and Wen Cheng-ming (1470–1559)

Chu Yun-ming and Wen Cheng-ming ushered in the "golden age" of Ming calligraphy. One important aspect of their styles was the revival of certain early traditions—Wei/Tsin in small standard script and T'ang/Sung in running and cursive scripts. This revival, also discussed in essay IV, reinforced the "revival of the past" (fu-ku) theories of the Yuan period. Chu Yun-ming was guided in his emulation of models by his father, who restricted him to the ancients, and then, after his father's death, by his grandfather Hsu Yu-chen.

After Chang Pi of Sungchiang, Chu Yun-ming's calligraphy represents the full maturation of the "Ming" style. The combination of his strong and exuberant personality, his emphasis on calligraphy as a form of emotional release, his development of the abstract pictorial potential of calligraphic form, and his casual brushwork meant that calligraphy after Chu would never quite be the same. The artists of following generations seem limited by comparison; they developed only single aspects of his multifaceted talent and were unable to encompass the range and high spirits of his best works, such as his "Red Cliff" handscroll in the Shanghai Museum (fig. 81).

After Chu's death, Wen Cheng-ming continued as the leading master of the era. Wen's family of followers garnered unprecedented fame in the history of calligraphy. Indeed, the whole circle of relationships of this charmed circle of Suchou literati formed a close web, both familial and artistic, intertwining the work of each member with the others, regardless of generation. An understanding of these relationships is essential to their art.

Stylistically, the accomplishments of Chu and Wen form an interesting contrast. Wen Cheng-ming was both a calligrapher and painter, while Chu gained fame for his calligraphy alone. Wen was interested in all script styles, both ancient and modern, yet his artistic personality was stable and controlled. Chu wrote only in the modern scripts, but his artistic personality was ever-changing. Despite his "specialization" in calligraphy, the complexity of Chu's artistic style and the presence of a large number of forgeries create problems of connoisseurship and art history which demand independent treatment (see below, essay VI).

Wen Cheng-ming (1470–1559)
"First Frost" (no. 52) and Poem to "Summer Retreat" (no. 50b)

Wen Cheng-ming wrote in two types of cursive, the first based on the Wang Hsi-chih tradition, especially as seen in the Chi Wang Sheng-chiao-hsu (fig. 53).[52] The brushwork and structure of this classic, a collation of characters from works by Wang Hsi-chih compiled in 672, became the matrix for Wen's "personal" style. He used it for small-sized and, occasionally, large-sized writings, such as the hanging scroll "First Frost." The brushwork is lean and firm, bearing some of the period-style "spikiness" seen most typically in Wang Ao's hand. As derived from Wang Hsi-chih, Wen's personal elements show more angularity, with diagonal ligatures, detailed hooks, and sharply tapered finishing strokes.

Wen's second cursive was freer, a combination of Huai-su's and Huang T'ing-chien's styles. His poem accompanying his painting "Summer Retreat in the Eastern Grove" from the Crawford collection, is a rare

and early example of his large-sized cursive writing. Compared to Huang T'ing-chien's cursive *(no. 4)*, Wen's style captures the spirit of "wild" cursive primarily through the tangled and elongated strokes associated with the Northern Sung master. However, Wen's brushwork is flatter, more aggressive and angular. His brush moves in a zigzag manner, reflecting the Ming preference for overt expression of brush strength. Huang T'ing-chien, on the other hand, wrote from a deep inner reserve of energy, his brush refinements epitomized in his rounded "concealed tip" brush manipulation. In spite of the compositional freedom, Huang did not display all his efforts, but maintained a core of restraint. These are some of the aesthetic differences between the Sung and Ming periods. Still, Wen Cheng-ming's mastery of cursive reveals him to have been the equal of Chu Yun-ming in this script (see also below, essay IV).

Wang Ch'ung (1494–1533)
"Poems on the Lotus Marshes" *(no. 57)*

Wang Ch'ung, a close friend of Wen Cheng-ming, was one generation younger but died earlier.[53] The outstanding Suchou master of a group of calligraphers whose fame could almost rival Wen Cheng-ming's, Wang Ch'ung is said to have derived his style from the work of Wang Hsien-chih and Yü Shih-nan, but the influence of the style of his immediate predecessors Chu Yun-ming and Ts'ai Yü (ca. 1475 ?–1541) was even greater. In 1525 Chu Yun-ming transcribed a version of the "Nineteen Old Poems" for Wen Chia *(fig. 77)*; Wang Ch'ung borrowed the scroll from Wen Chia and copied it several times, appending an explanation of the circumstances and indicating his admiration for Chu and the latter's influence on him.[54]

Ts'ai Yü, a close friend of Wen Cheng-ming, also provided a link to the older generation of calligraphers and scholars.[55] In 1511, at age seventeen, Wang became Ts'ai's pupil in poetry and classics, staying at his residence for three years. Wang had met Wen Cheng-ming's family two years before, and later, in 1520, he and Wen's eldest son, P'eng (1498–1573), continued their studies together under Ts'ai.[56]

In Wang Ch'ung's smaller-sized writing, the rounded brushstrokes and abbreviated rhythms show his debt to Ts'ai.[57] In Wang's larger cursive, such as "Poems on the Lotus Marshes" from the Wango H. C. Weng collection, his style reveals the strong influence of Sung K'o, his Suchou predecessor (cf. *fig. 50* with *no. 57*). In Wang's work, characters vary freely in size, with brilliant unexpected changes of form and a feeling of exuberant expansiveness pervading the whole compositional arrangement. The rounded brushwork and blunted stroke

"heads," the minimized angular connections, and the occasional sharply pointed "tails" distinguish Wang's personal style.

Wang Ch'ung was not a fluent calligrapher, especially when compared to Chang Pi or Chu Yun-ming. Indeed, he cultivated a certain awkwardness in his style which saved it from being overly facile. The scroll in the Weng collection is outstanding in its monumentality and feeling of freshness, as if written in a state of pure exhilaration. Wang Ch'ung died prematurely; yet he had already achieved recognition for his personal calligraphy style and was praised in the same breath as Chu and Wen.

Ch'en Shun (1483–1544)
"Lotus under the Autumn Moon," *(no. 54)*
and "Thoughts on an Ancient Site," *(no. 55)*

Ch'en Shun was eleven years older than Wang Ch'ung and the eldest of Wen Cheng-ming's followers and family members. In his cursive script he shows himself to be one of the chief heirs to Chu Yun-ming's innovations. His artistic personality was such that he could not write in the neat, disciplined hand of the Wen family style, choosing rather a more expressive manner.[58] Of these two works by Ch'en, "Lotus under the Autumn Moon," the hanging scroll from the Jeannette Shambaugh Elliott Collection at Princeton, owes a greater debt to Wen Cheng-ming in columnar spacing and brush control than does the handscroll "Thoughts on an Ancient Site" *(fig. 51)*. This latter work is striking, however, for its pictorial character and the largeness of the writing. Unlike the hanging scroll, there is no clear demarcation of columns, especially in the opening lines, and the component parts shift and merge in full acknowledgment of Chu Yun-ming's cursive principles. But weaknesses in the brushwork are also apparent. The strokes are flat and unarticulated, coarse and rough, moving in a broad arching pattern across the paper.

Praised by late Ming critics for its abundant natural energy, Ch'en's style shows an ever-present casualness. In his large-sized writing, the brush sprawled across the paper without the concentration usually found in Wang Ch'ung's or Wen Cheng-ming's writings. Yet these qualities were aesthetic choices cultivated by Ch'en and the post-Chu Yun-ming generation of cursive writers. Unlike his immediate predecessors, Ch'en Shun had no deep roots in the past, preventing him from being judged a master of major stature. Still, he was one of the most independent of the Wu school members.

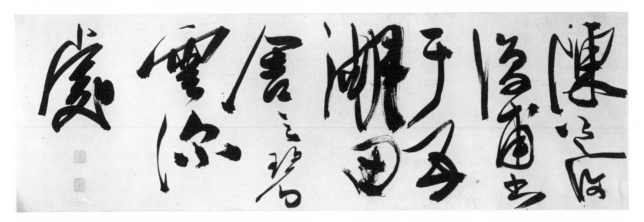

FIG. 51. Ch'en Shun (1483–1544). *Thoughts on an Ancient Site.* Detail of handscroll, *(no. 55).*

Wang Wen (1497–1576)
"Mountain Hermitage in Summer" *(no. 58)*
and "Dragon Boat Song" *(no. 59)*

A younger contemporary of Ch'en Shun, Wang Wen was of the same generation as Wang Ch'ung and Wen Cheng-ming's eldest son, P'eng (1498–1573). Wang Wen retired early from office to nearby Wu-hsi and became known locally for his painting and calligraphy.[59] Although no direct teacher-pupil links are known between him and the Suchou masters, Wang's calligraphy reveals the Wu school influence and, like Ch'en Shun's, epitomizes several of the conspicuous tendencies in cursive script developed after Chu and Wen.

"Mountain and Hermitage in Summer" and "Dragon Boat Song" are both in large running-cursive script. Wang's debt to Wen Cheng-ming can be seen in the tall, narrow structure of the characters, while his personal traits are found in the thick, sturdy brushwork and minimal brush-tip articulation. Propelled by large swinging arm movements derived from Chu Yun-ming, the effects are robust and energetic. Particularly noteworthy is "Dragon Boat Song," written at the venerable age of seventy-five. Wang maintained a characteristic rhythm in the horizontal composition, with each column containing a number of characters of the same size, only to be interrupted by a single emphatic and elongated form occupying an entire column.

The difference between Wang and his elders, Chu and Wen, lies mainly in the manipulation of the brush. Chu, and especially Wen, produced works of monumental proportions, deriving character and expression from brush-tip detail. By contrast, Wang's coarse, flat brushwork and hefty movements diffused the energy rather than concentrating it in the brush-tip. His contemporary Wang Ch'ung, for example, used primarily the rounded brush-tip, creating a loftier, more elegant style. Still, Wang Wen carried on the monumental aspects of Wen Cheng-ming's calligraphy more successfully than Wen's other followers and thus deserves to be remembered.

Sungchiang's Gradual Recovery

Calligraphy flourished in the Suchou area after Chu and Wen, and the Sungchiang calligraphers and critics remained sensitive to the competition. Contemporaries praised the work of Lu Shen (1477–1544) *(no. 53a),* attempting to promote his fame in opposition to Suchou:

At the beginning of the dynasty, there were many calligraphers from our district of Sungchiang who excelled in calligraphy and attained fame, but for a long time few have gained an equal reputation. Now His Excellency, Lu Shen stands out. . . . Those who understood say that after Chao Meng-fu, there is only Lu Shen. This is not hollow flattery.[60]

The critic and calligrapher Mo Shih-lung (ca. 1540–87) ranked Lu above Chao Meng-fu, and Tung Ch'i-ch'ang went so far as to place Lu above Wen Cheng-ming:

In our dynasty, we [calligraphers] ought to recognize our origins in Shen Tu from our district. Then Lu Shen, who in his standard script followed Yen Chen-ch'ing, and in his running script followed Li Yung, had nothing to regret in his work. He can rank as our patriarch, a position unattainable by Wen Cheng-ming.[61]

This statement reflects Tung Ch'i-ch'ang's well-known disdain for Wen Cheng-ming as much as his admiration for Lu Shen. It also sets forth the early Ming Sungchiang authorities and identifies some of Lu's models. Lu Shen's works are rare, however. His frontispiece in seal script to the painting "Streams and Rocks" *(no. 53a)* is an example which shows that he wrote in the archaic as well as modern scripts. Lu Shen's fame may, in part,

be attributed to his stature as an official and an historian, and to his local humanitarian efforts, all of which reflect the traditional "reading" of character into a man's writing style.[62]

Lu Shen was followed in prominence by Mo Ju-chung (1509–89), the father of Mo Shih-lung (ca. 1540–87).[63] Mo Ju-chung's calligraphy, rare today, was preferred by Tung Ch'i-ch'ang to his son's. Mo Shih-lung's disappointment over his official career and his premature death cut short his potential as a calligrapher, for which he was highly admired by his contemporaries.[64] The handscroll *Shan-chü tsa-fu* (Tokyo National Museum) is testimony to his talent. The brush is wielded with great flair and discipline, and shows Mo to be deeply immersed in Mi Fu's art, which explains why he was so regarded in his day.

Mo Shih-lung's counterparts in Suchou were the numerous Wu school followers who appear to have lost the original creative energy of its patriarchs, Chu and Wen. During this period Sungchiang again achieved prominence which culminated in the achievement of Tung Ch'i-ch'ang, artistic giant in painting, calligraphy, and art theory. Tung Ch'i-ch'ang wrote:

The calligraphy tradition from our Sungchiang district started with Lu Chi (261–303) and his brother Lu Yün (262–303), who preceded Wang Hsi-chih. After them there was no one to continue their art, until the two Shen brothers [Tu and Ts'an], Chang Pi, Lu Shen and Mo Ju-chung emerged. They were not too widely recognized, however, because their [achievement] was overshadowed by the two masters Chu Yün-ming and Wen Cheng-ming of the Wu district. Wen and Chu became a landmark in their time, but they could not surpass the Two Shens, because [their training and achievement] was shallow and without any solid basis. As for my calligraphy, I want to rid my work of their [influence] and satisfy myself. I do not intend to argue [with other critics] but will wait for those who really understand calligraphy to make their own judgment [of my art].[65]

Tung's confidence in his own achievement is evident. He speaks of his intention to alter the tradition of his predecessors, and indeed he succeeded in doing so. In the history of later calligraphy, he represents another great demarcation after Chao Meng-fu, Chu Yün-ming, and Wen Cheng-ming. Tung's sources are of particular interest in that they do not differ substantially from those of Chao Meng-fu, Chu Yün-ming, or Wen Cheng-ming; he also returned for inspiration to the Tsin/T'ang masters. However, Tung succeeded not only in making a clean break with the Ming calligraphers and the Suchou tradition, but also in establishing the foundation for early Ch'ing developments.

Tung Ch'i-ch'ang (1555–1636)
Colophons to the *Hsing-jang t'ieh (no. 1b)*

Like Chu Yün-ming and Wen Cheng-ming, Tung Ch'i-ch'ang is considered a great master because his influence extended beyond his region throughout the Chinese empire. Even after his death, Tung's authority was respected in the Chiangnan area and the imperial precincts. The K'ang-hsi Emperor (r. 1662–1722) personally endorsed Tung's calligraphy and instituted it as a model for examination candidates. The style retained favor in court circles during the Ch'ien-lung era (1736–95), and continued to be practiced by individuals outside the court throughout the remainder of the Ch'ing period.[66]

A master of the major scripts, Tung based his cursive style on Huai-su's. In his colophon dated 1609 to the *Hsing-jang t'ieh* (see above, essay I, *no. 1b*), Tung's brushwork is rounded and moist, the flavor of the strokes elegant and pure. When writing, he often had an image of Huai-su in mind as an ideal and sought a plain simplicity in his strokes.[67]

Some Ming and Ch'ing "Individualists"

During this period, a number of artists and calligraphers in places other than Sungchiang and Suchou developed independent styles. These "individualists" were also known for their talents in government, literature, intellectual thought, or painting; their calligraphy was generally an extension of these talents and a personal rather than a regional achievement.

Ch'en Hsien-chang (1428–1500)
"Writing about Plum Blossoms while Ill"
(no. 30)

A prominent thinker and educator, Ch'en Hsien-chang was a contemporary of Shen Chou (1427–1509) and Yao Shou (1423–95). After Ch'en's death, his memorial tablet was placed in the Confucian temple in Shantung, an honor rarely extended to a native of Canton. His calligraphy was an expression of the enlightenment he sought in solitude for twenty years.

While living in retreat in the mountains, Ch'en could not obtain ordinary brushes. He made his own, using a local reed, *mao-lung*, which contributed to the broad, coarse strokes of his distinctive style.[68] "Writing about Plum Blossoms," dated 1492, is a mature piece which exemplifies Ch'en's independence from orthodox methods. His brushwork and structure are innocent of ancient allusions. Technically, Ch'en does use "concealed-tip" entering strokes, often blunting the "tails,"

but the brush moves in an unhesitating manner, with the sooty black strokes and streaked textures conveying a rustic unaffected vigor.[69]

The individualism of Ch'en's calligraphy suggests the simple spirit of Sung dynasty Ch'an monk-calligraphers. The function of calligraphy in his life is expressed in the following passage:

Whenever I write calligraphy, I try to seek serenity in action, to release but not to release, to restrain but not to restrain. This achieves the best of movement. . . . I have method but am not constricted by it. I am uninhibited but not loose, awkward but beyond mere skill, strong but still soft. After establishing my forms, the force is racing. After fully expressing my ideas, they overflow with the extraordinary. Calligraphy composes my mind, harmonizes my emotions, and tunes my nature. That is why I practice it.[70]

Hsu Wei (1521–93)
"Watching the Tides" (no.60)

Hsu Wei, a resident of Chekiang, a renowned painter, dramatist, precursor of Tao-chi and the Yangchou Eccentrics, was also a calligrapher whose art reflected his troubled life.[71] Unlike Ch'en Hsien-chang's, his writing and painting were emotional outpourings, not a search for clarity of mind or serenity of spirit. When speaking of his accomplishments, he judged his calligraphy above his literary and painting skills.[72]

In his large calligraphic works such as the hanging scroll "Watching the Tides," the characters function as design elements: random changes of size, loose individual structures, and tight columnar spacing create an impression of compositional disarray. In his brushwork Hsu established a heaving rhythm with abrupt changes of speed and pressure (tun-ts'o). Impulsively, he elongated the last stroke of one character so that it assumes an independent existence, registering an erratic control and the resistance of brush against paper. As in his painting, Hsu began with a fully loaded brush which produced thick, blotched heads; here, also, he contrasted wet and dry ink textures conspicuously (cf.no. 61). The characters appear awkward and even ugly, but as the iconoclastic thinker and critic Yuan Hung-tao (1568–1610) noted appreciatively, Hsu Wei's art lay not in the principles and methods of calligraphy, but in a divine, even demonic, fervor.[73]

WANG TO (1592–1652) from Honan, Fu Shan (1607–84) from Shansi, Ni Yuan-lu (1594–1644) from Chekiang, and Huang Tao-chou (1585–1646), Hsu Yu (active 1630–63), and Chang Jui-t'u (1570–1641?) from Fukien, major calligraphers of the late Ming–early Ch'ing period, tended to derive their early styles from orthodox models and then to develop their "individualist" forms of expression. They have been discussed more fully by modern historians and calligraphers, and therefore will be dealt here only in brief.

Chang Jui-t'u (1570–1641?)
"Out Wandering" (no.62)

Chang Jui-t'u, the only native of Fukien in the Ming period to become Grand Secretary, was also a painter and one of the Four Masters of late Ming calligraphy, together with Hsing T'ung, Mi Wan-chung, and Tung Ch'i-ch'ang. In his running and cursive scripts, by holding the brush obliquely, Chang developed the use of the "side-tip" (ts'e-feng). "Out Wandering," from the Robert H. Ellsworth collection, is typical of his style. His characters are tightly knit and placed in widely separated, narrow columns. The brushwork is straightforward, with folded corners and few curves; it contrasts markedly, for example, with that of his contemporary Tung Ch'i-ch'ang (1555–1636) (cf. no.1b), whose smooth, tubular brushwork reveals greater variations of pressure and ink tonality. Nevertheless, the angular articulation and abbreviation of brush movements which both employed are indicative of the period style.[74]

Chang Ch'ien-fu (chin-shih degree 1640)
"Visiting, Deep in the Mountains" (no.63)

Chang Ch'ien-fu is virtually unknown; he has been identified as the son of Chang Jui-t'u and may have lived from about 1600–60. This hanging scroll from the Chien-lu Collection is the only known example of his writing. A contemporary of Wang To, Chang wrote in a style which combines Wang's rounder forms with the narrow structure and generous spacing of his father's writing. Chang Ch'ien-fu's brushwork exhibits fewer mannerisms and more variations in the size and components of the characters, in addition to a rhythmic brush pressure, and more fluent connecting strokes. Even though his "personal" style is not as distinctive as his father's, Ch'ien-fu's self-discipline and learning are evident.

Wang To (1592–1652)
"Poems Written while Drunk" (no.65)

Even after he became an accomplished calligrapher and high government official, Wang To kept to a rigorous schedule, one day imitating ancient models (lin-t'ieh), the next writing freely and answering requests for calligraphy. He seldom deviated from this regimen till his death.[75] "Poems Written while Drunk" is in his freehand cursive style. The brush moves in an excited throbbing rhythm; the ink tones range from the rich

black of a newly loaded brush to pale streaks as the ink ran out, producing appealing textures on the satin surface. The wine went to his head; the calligraphy is true "mad-cursive."

In his running (cf. no.66) and cursive scripts, Wang To preferred a thin, stiff-haired brush which allowed him to stress the bony quality of the strokes; the "heads" are "tucked in" with slight emphasis, sometimes blotting, while the "tails" evince a sudden decrease in pressure. In his running script, the brushwork is straighter and more direct, the structure taller and closer to Tsin style, while in his cursive, the brushwork depends on a more complex fluctuating movement of the arm, showing the influence of Huang T'ing-chien (1045–1105) and the mid-Ming cursive writers, Chang Pi or Chu Yun-ming. Still, Wang To's deep roots in orthodox methods did not permit the liberating influence of these Ming writers to develop into either eccentricity or vulgarity.

Fu Shan (1607–84)
"Clearing at Dusk" (no.67)

Equally prominent during this period was Fu Shan, who left this account of his study of calligraphy:

When I was 8 or 9 years old, I had started to copy Chung Yu but could not achieve a likeness. When I was older there was little I did not try to copy, such as the *Huang-t'ing-ching, Ts'ao E pei, Yueh I lun, Tung-fang tsan, Shih-san hang, Lo-shen-fu,* and *P'o-hsieh-lun*—but I still could not achieve a likeness. Following that, I practiced Yen Chen-ch'ing's *Yen-shih-chia miao-pei,* and finally grasped some of his unusual features. Then I proceeded to copy his *Cheng-tso-wei t'ieh* and succeeded in achieving a resemblance. As a further step, I copied the *Lan-t'ing.* Even though I could not grasp its spiritual expression, I gradually came to understand the major principles of this art [of calligraphy].[76]

Yen Chen-ch'ing, the great T'ang master, provided the basis for Fu Shan's standard script, as well as his running and cursive scripts. In "Clearing at Dusk" from the Jeannette Shambaugh Elliott Collection at Princeton, Fu Shan's brush moved forcefully across the paper, linking strokes and characters and exposing the sinews and tendons. His characters are compact, yet convey an expansive feeling, the essence of Yen Chen-ch'ing's art.

Fu Shan wrote: "I would rather [my calligraphy] be clumsy and not dainty, awkward and not charming. I would prefer deformities to slipperiness, the spontaneous to the premeditated."[77] Yet he did not advocate eccentricity for its own sake; rather, he believed that "if one stroke did not resemble the ancients, it was not calligraphy."[78] He sought to reconcile seemingly contradic-tory aesthetic ideals—the "orthodox" (cheng) and the "clumsy" (cho).

THE PROMINENCE of the northerners Wang To and Fu Shan was unusual in this period of domination by southern calligraphers. Wang To exerted an influence on his younger contemporary Fu Shan who commented that Wang's calligraphy was too mannered before he reached his fortieth year, but attained true greatness thereafter, because he "refused to beat time" along with the others (wu-i ho-p'ai).[79] Wang and Fu are often compared. Their cursive writing, for example, has been characterized as a form of "continuous, unbroken cursive" (lien-mien ts'ao) and often confused by some.[80] However, Wang's cursive is more strongly articulated, mixing angular hooks with rounded strokes. Fu's writing contains more ligatures, has a looser structure, and flatter strokes. They also practiced archaic scripts—Wang To, a balanced and orthodox clerical; Fu Shan, a highly experimental cursive-seal—a contrast which underlines the differences in their artistic personalities.[81]

The other famous contemporaries, Ni Yuan-lu, Huang Tao-chou, and Hsu Yu (active 1630–63), also developed distinctive styles. In the West, Hsu Yu is least known. He was a student of Ni Yuan-lu, but his style resembles Wang To's. Hsu Yu further developed Hsu Wei's unconventional arrangement of characters. While Westerners admire these "pictorial compositions," Chinese calligraphers considered them contrived, and the style was short-lived.

Chu Ta (1626–1705)
"Thoughts on Wang Wei" (no.69)

Like Tao-chi (1641–ca. 1710), Chu Ta was a member of the Ming royal family, one of the "left-over subjects" (i-min) who remained loyal to the dynasty after its fall to the Manchus. Known primarily as painters, their accomplishments in calligraphy were equally important. Chu Ta's highest achievement in cursive writing dates from his late years; most of his extant calligraphy is also from this late period.

"Thoughts on Wang Wei" from the collection of Mr. and Mrs. Fred Fang-yu Wang, is a fine example of his larger-sized cursive style: a clean spacious composition with characters individually balanced, an abundance of mildly curving lines, and limited linkages between characters. The brushwork is blunt, rounded, and of even thickness, as in his paintings. A sense of volume in the strokes is achieved by the consistent use of "concealed tip" brush movements and an "upright" brush method which concentrated energy in the center of the brush-tip. Essentially, Chu Ta was employing seal script methods to write cursive forms.

Chu Ta's cursive script differs fundamentally in concept from the other late-Ming calligraphers discussed above. His forms are reduced to their minimum. Ink tones vary little. Yet the simplicity contains a flavor which is deep and rich. Each character was composed with satisfying asymmetry, and the pace of the writing is leisurely and rhythmic.

Chu Ta was a great master. His calligraphy style has an unmistakable identity, reflected in his signature, which presents a totally unified but legible graphic design.[82]

Weng T'ung-ho (1830–1904)
"Tiger" (no.87)

Weng T'ung-ho served the Ch'ing government in the highest positions: Chancellor of the National University, President of the Censorate, and of three of the Ministries, and Grand Councillor. He was one of the leaders of the Reform Movement which sought to influence and educate the young Emperors T'ung-chih and Kuang-hsu in the fateful power struggle with the Empress Dowager Tz'u-hsi. Weng's influence and progeny survive into the modern period as links to this eminent man of letters. His prominence as a scholar, official, and imperial tutor was presaged at the moment of his birth by the coincidence of hour, day, month, and year all bearing the same cyclical character (yin) corresponding to the "sign of the tiger." This hanging scroll, consisting of a single character, was written in Weng's sixtieth year, also the "year of the tiger," a full cycle after his birth.

"TIGER!" was virtually written in one continuous stroke. The enormous brush, dripping with ink, commenced with the topmost strokes, left and right, then swooped downward to the left, back upward and around, gaining speed as the brush reached the vortex of the circle. Recharged with ink and momentum, the final vertical "tail" was added. As a cipher, its potency—both as an expression of the writer's stature and of the heavenly endowed power of the tiger—would have been sufficient to exorcise any evil threatening a household in which the scroll was hung.

Post-Ch'ing Developments in Cursive Script

The Ch'ing period was not known for cursive writing, but rather for the revival of archaic scripts in the chin-shih-hsueh and pei-hsueh movements.[83] The early twentieth century, however, witnessed a revival of draft-cursive script, closely related to the discoveries in Central Asia of brush writing on paper and wooden slips dating from the Han through the Tsin dynasties.

This draft-cursive revival encouraged a more widespread practice of the script and reflected the impact of Western culture and scientific learning on China. The period saw the invention of systems of romanization and phonetic symbols for the Chinese language and even a proposal to abolish characters altogether. Some scholars advocated the practice of draft-cursive as an alternative system because of its simplification.[84]

This movement attracted the interest of Yü Yu-jen (1878–1964), who, before his death, was the most important cursive calligrapher of this century. Yü first studied draft-cursive, but realized that it was neither as standardized nor as well-practiced as modern cursive. By selecting forms from the master calligraphers throughout history as models for each Chinese graph, he devised a standardization which he set forth in his book, Standard Cursive Script (Piao-chun ts'ao-shu), published in 1936 in Shanghai.[85] Yü Yu-jen succeeded in influencing the practice of cursive, and today his Standard Cursive Script is still consulted by modern calligraphers.

Although the revival of cursive was an important aspect of the modern revolution of the Chinese written language, it lost most of its impetus when government support was not forthcoming. As a result, cursive script continues to be an esoteric language even to educated Chinese, very few of whom can read the cursive symbols. Today, its practice is limited to a small circle of specialists.

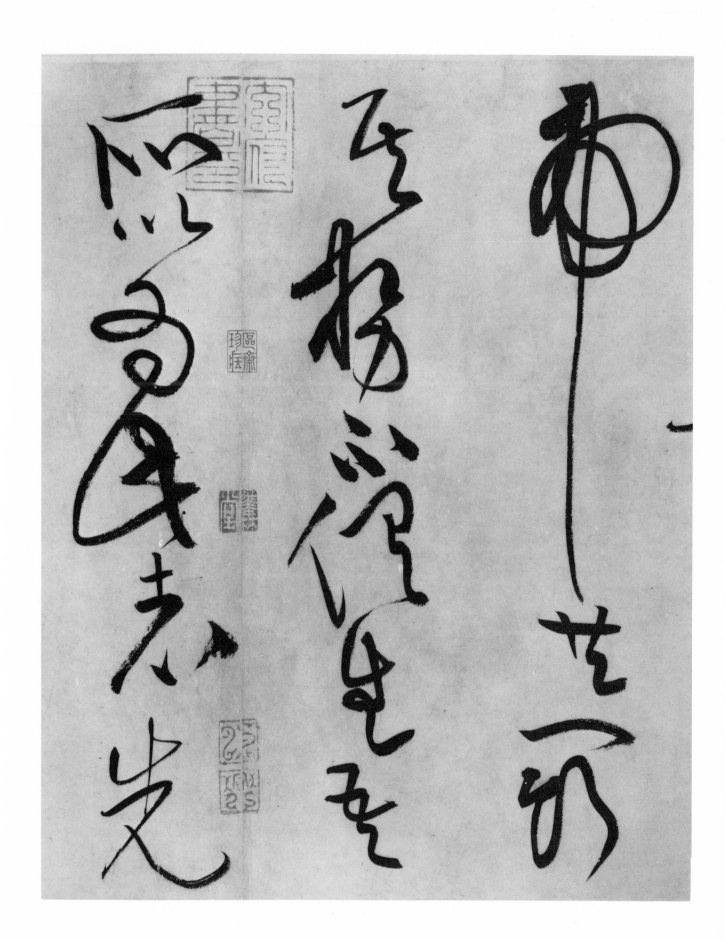

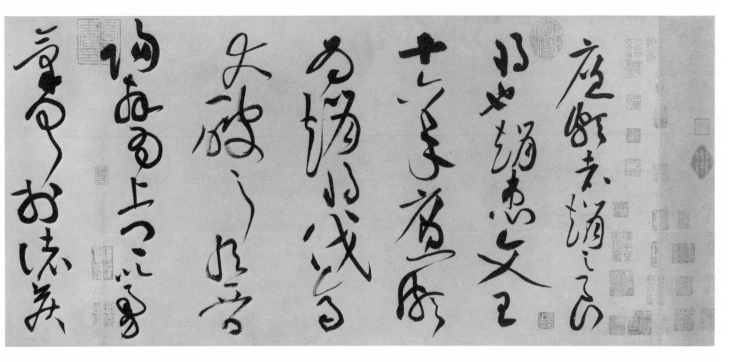

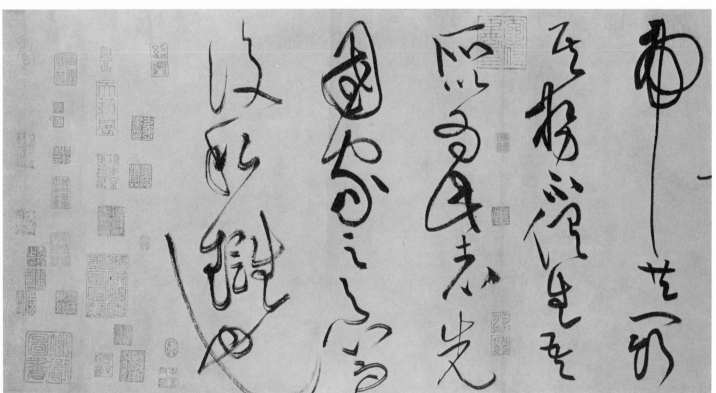

4 Huang T'ing-chien (1045–1105),
Biographies of Lien P'o and Lin Hsiang-ju.
Sections of handscroll. (Detail opposite.)
Collection of John M. Crawford, Jr.

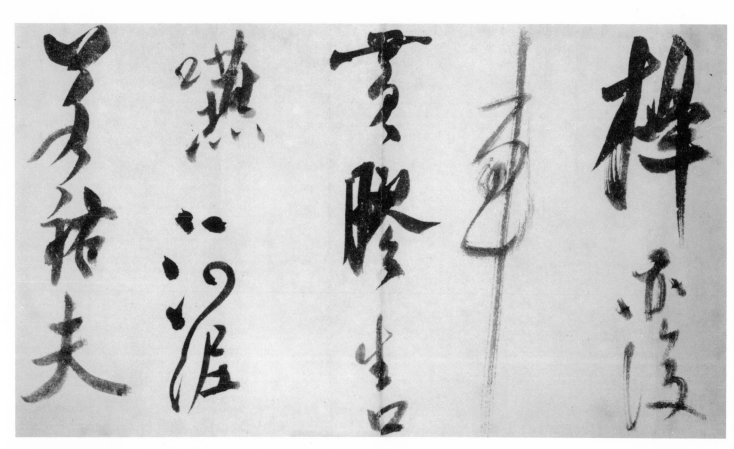

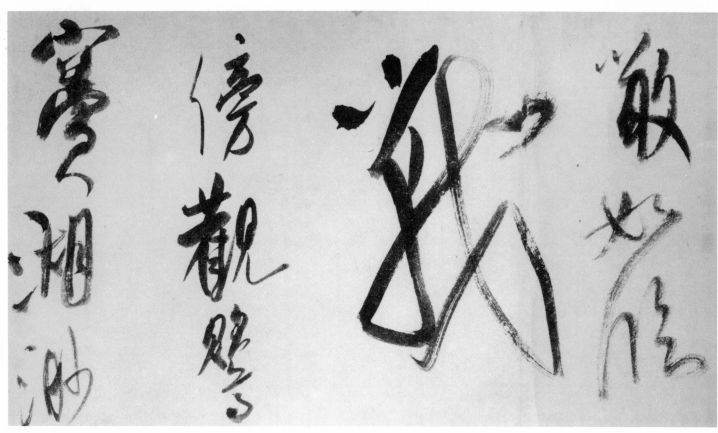

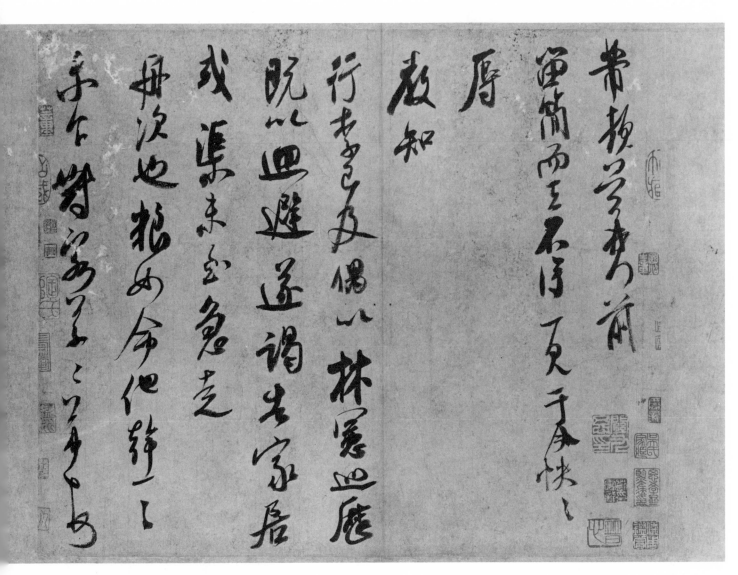

9c Mi Fu (1051–1107), *Hasty Reply before Guests.*
Letter mounted as album leaf.
Anonymous loan, The Art Museum, Princeton University.

8 OPPOSITE
Mi Fu (1051–1107), *Sailing on the Wu River.*
Sections of handscroll.
Collection of John M. Crawford, Jr.

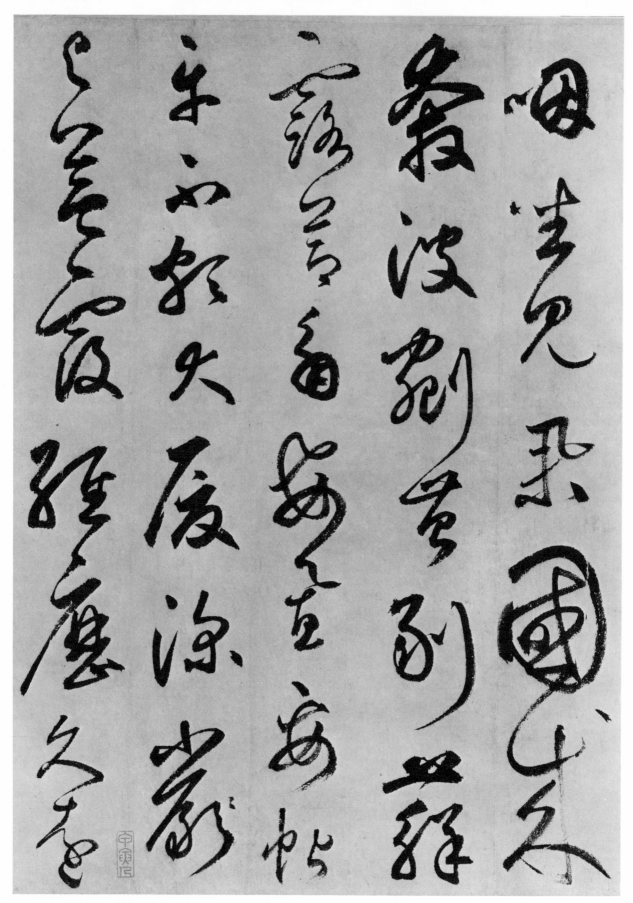

18 Hsien-yü Shu (1257?–1302), *Song of the Stone Drums.*
Dated 1301. Section of handscroll.
Collection of John M. Crawford, Jr.

梓人傳　柳子厚

亮善者之第在亮
往其為梓人絕志亮
以偹作字而更為
以殘品引統結獨墨
家不在遊断之盡曰
其劃四至度材祝
棟字之未高涼圖方
經志之室至指大而
厚五叙為推高家
故能一字故念指古

而結事也梓楷在墳曰
曰惟高冠也竹手來可
我指教年偹梓人之道
之指教故書而蕩之
梓人為夫之室由畫
匹勢志以陽之材料
遇云而画去揚氏潜
之名
康王懐為
作卿修時書時
至順二年冬十月
之世皆也　　[seal]

21　K'ang-li Nao-nao (1295-1345), *Biography of a Carpenter*.
Dated 1331. Sections of handscroll.
Anonymous loan, The Art Museum, Princeton University.

依村傍草亭 瀟洒意匠宏 林深
篝鳥禾塵迄畫竹 松清泉石伴
延賞更書 悅性情 月當於 元
近任逍遥半生

至正七年丁亥秋七月為

元澤書此草亭詩意 梅道人書

24a Wu Chen (1280–1354), *Poetic Feeling in a Thatched Pavilion.*
Dated 1347. Inscription on painting.
The Cleveland Museum of Art, Purchase, Leonard C. Hanna, Jr. Bequest.

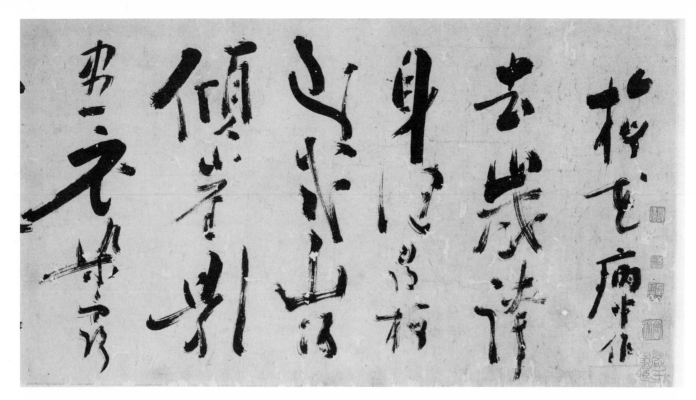

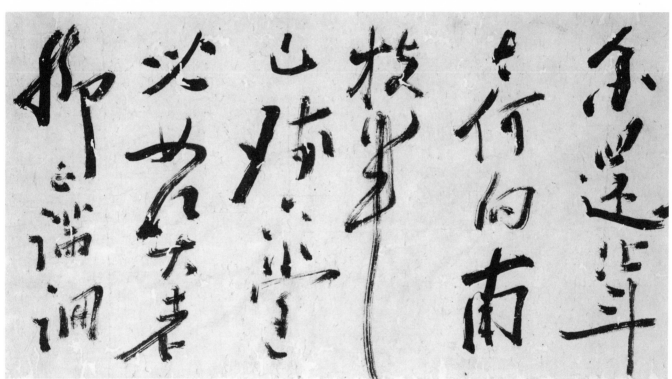

30 Ch'en Hsien-chang (1428–1500), *Writing about Plum Blossoms while Ill*.
Dated 1492. Sections of handscroll.
Anonymous loan, The Art Museum, Princeton University.

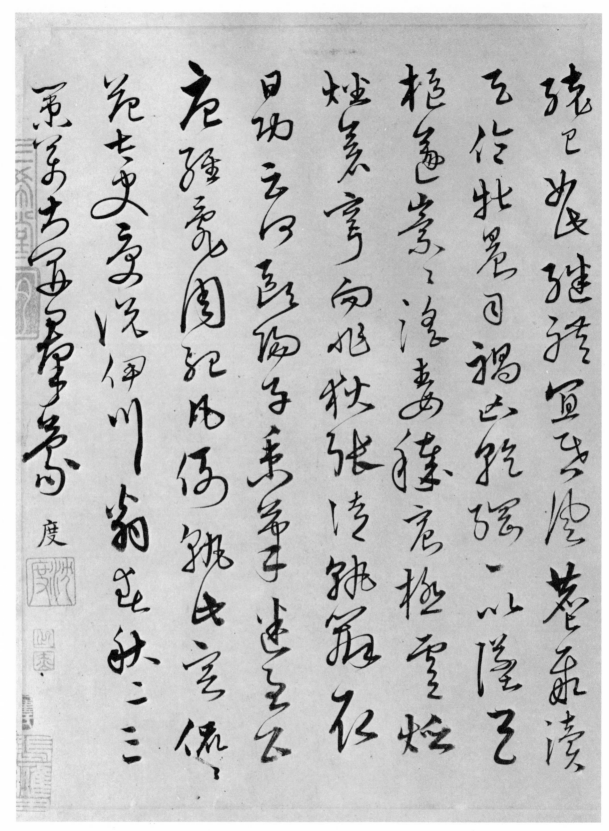

26a Shen Tu (1357–1434), *Transcription of Preface and Eight Poems.*
Section of handscroll.
Anonymous loan, The Art Museum, Princeton University.

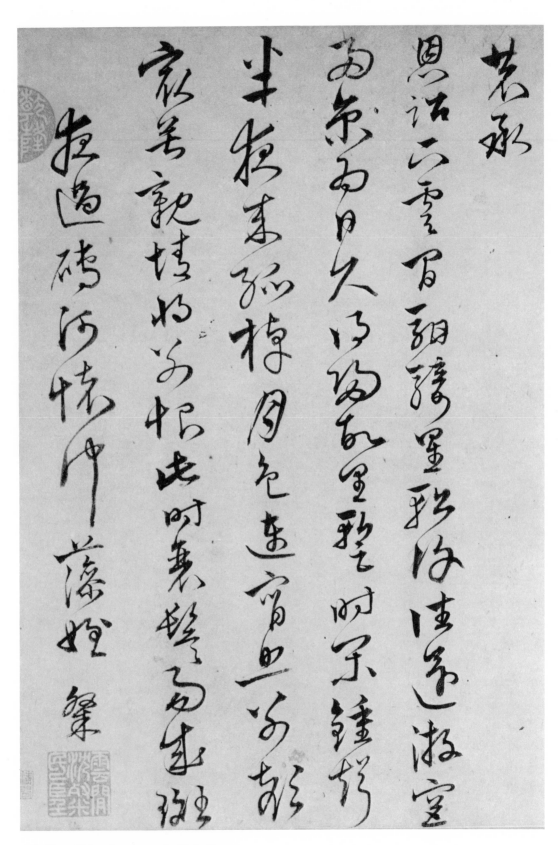

26b Shen Ts'an (1379–1453), *Eight Poems.*
Section of handscroll.
Anonymous loan, The Art Museum, Princeton University.

50b Wen Cheng-ming (1470–1559), *Poems and Colophons to
"Summer Retreat in the Eastern Grove."*
Second poem, section of handscroll.
Collection of John M. Crawford, Jr.

52 Wen Cheng-ming (1470–1559), *First Frost*.
Hanging scroll.
Anonymous loan.

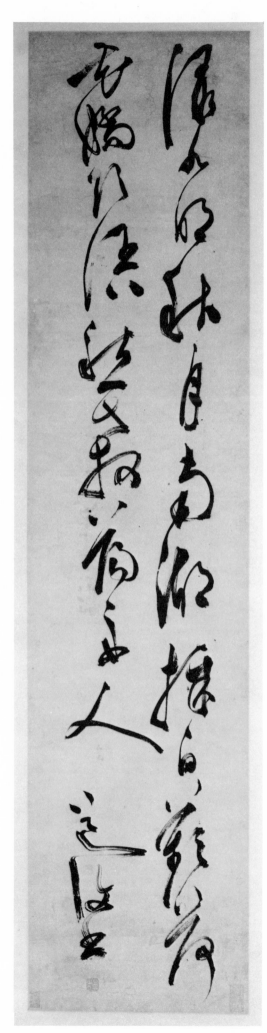

54 Ch'en Shun (1483–1544),
Lotus under the Autumn Moon.
Hanging scroll.
The Jeannette Shambaugh Elliott
Collection at Princeton.

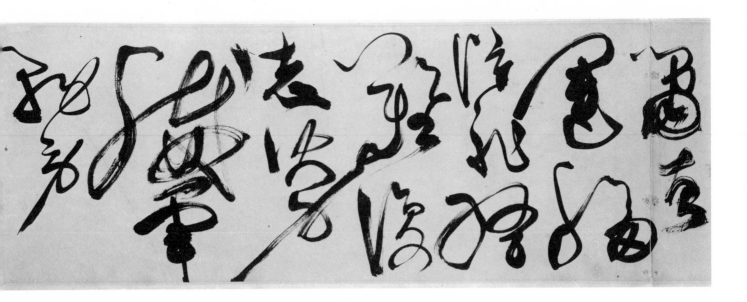

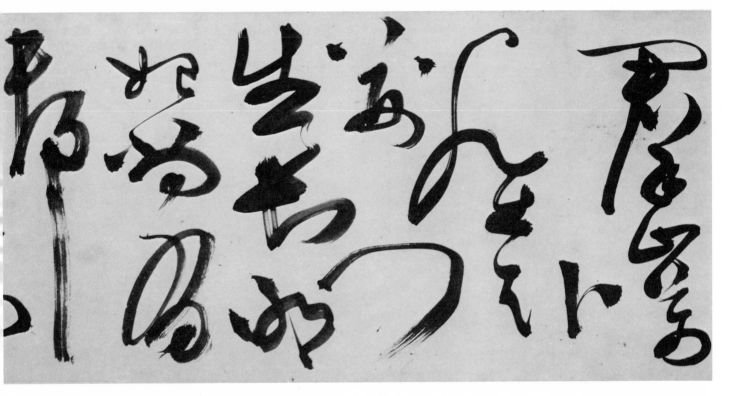

55 Ch'en Shun (1483–1544), *Thoughts on an Ancient Site.*
Section of handscroll.
Anonymous loan.

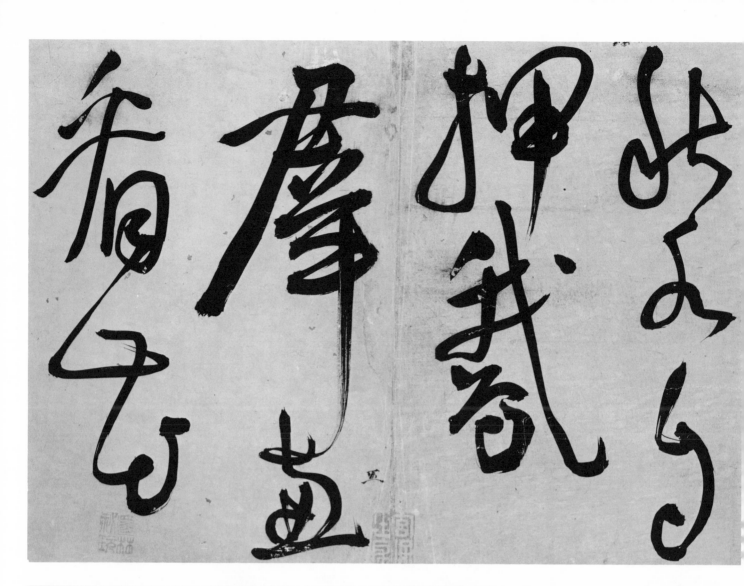

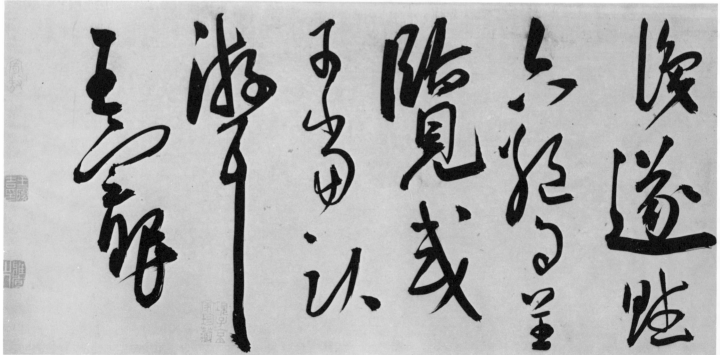

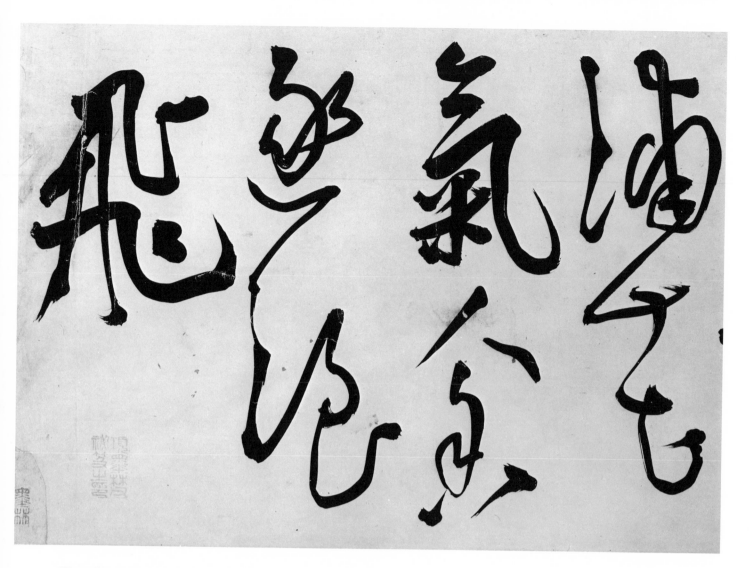

57 Wang Ch'ung (1494–1533), *Six Poems on the Lotus Marshes.*
Sections of handscroll.
Collection of Mr. and Mrs. Wan-go H. C. Weng.

58 Wang Wen (1497–1576),
Mountain Hermitage in Summer.
Hanging scroll.
Anonymous loan.

59 Wang Wen (1497–1576), *Dragon Boat Song*.
Dated 1571. Sections of handscroll.
The Jeannette Shambaugh Elliott Collection
at Princeton.

60 Hsu Wei (1521–1593), *Watching the Tides.*
Hanging scroll. (Detail opposite.)
Anonymous loan.

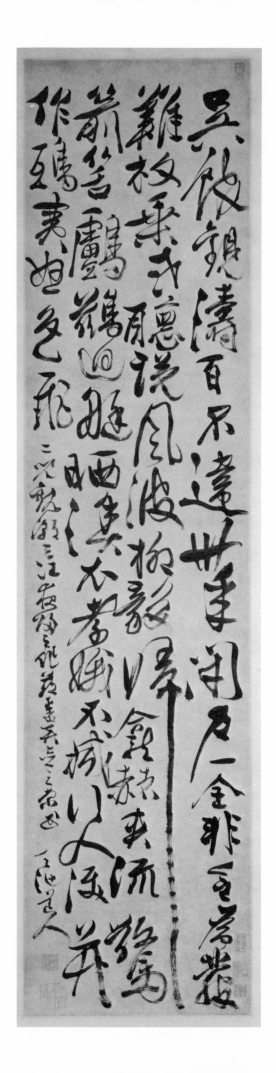

用刀一金非　　　　
君　　　　君　　
　　劍　　　
藏　　　　流　
不滅　　　　

　　　　與

龍蛇走　　　　
一瓢道人

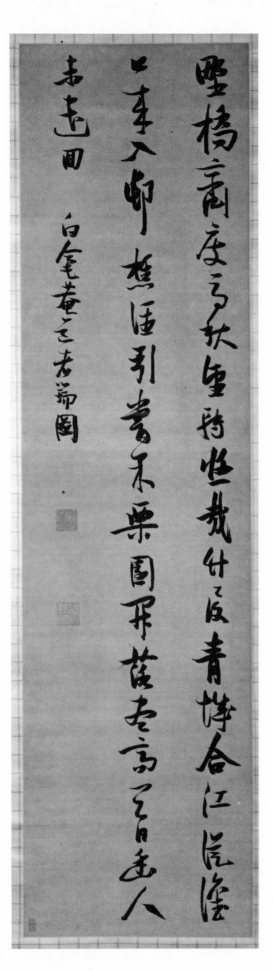

62 Chang Jui-t'u (1570–1641 ?),
Out Wandering.
Hanging scroll.
Collection of Robert H. Ellsworth.

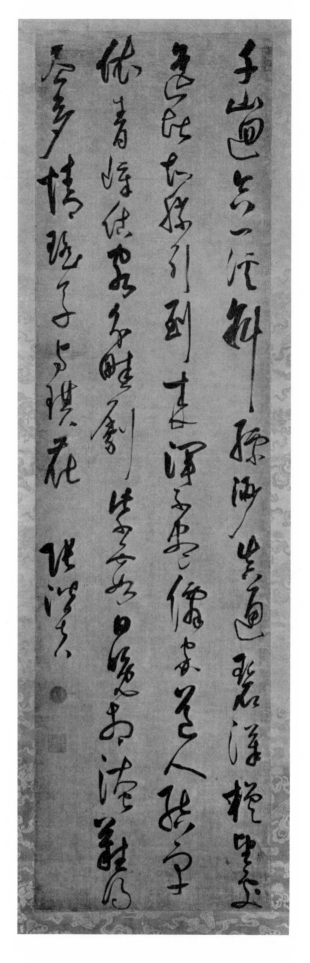

63 Chang Ch'ien-fu (*chin-shih* degree, 1640),
Visiting, Deep in the Mountains.
Hanging scroll.
Chien-lu Collection.

65 Wang To (1592–1652), *Poems Written while Drunk.*
Section of handscroll.
Anonymous loan.

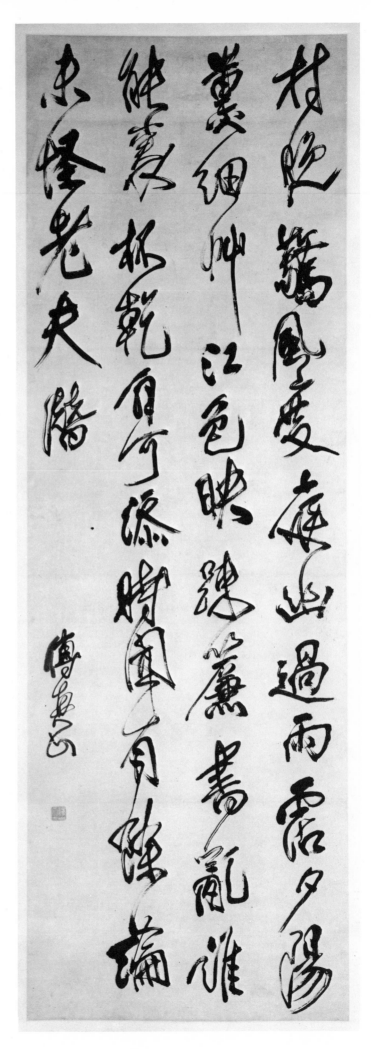

67 Fu Shan (1607–1684), *Clearing at Dusk*.
Hanging scroll.
The Jeannette Shambaugh Elliott
Collection at Princeton.

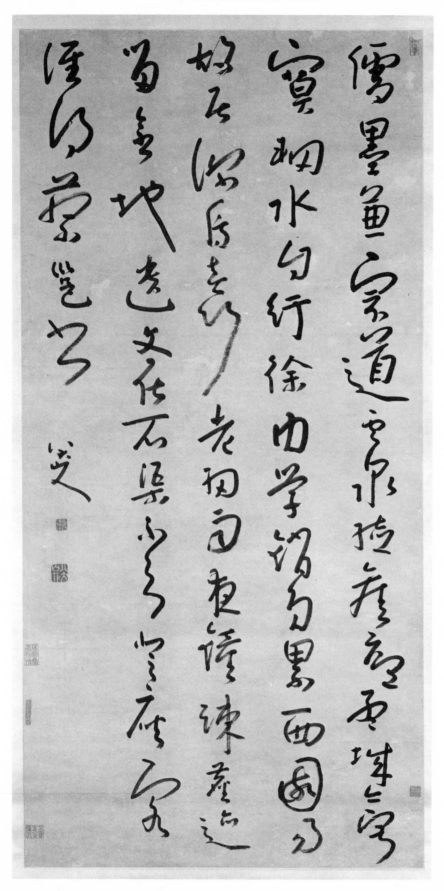

69 Chu Ta (1626–1705), *Thoughts on Wang Wei.*
Hanging scroll.
Collection of Mr. and Mrs. Fred Fang-yu Wang.

87 Weng T'ung-ho (1830–1904), *Tiger*.
Dated 1890. Hanging scroll.
Collection of Mr. and Mrs. Wan-go H. C. Weng.

行書與楷書

IV

The Running and Standard
Script Traditions

STYLISTICALLY running script combines the legibility of standard script with the artistic freedom of cursive. The components of each character tend to be linked together and partly simplified; however, strokes are not eliminated, nor is a new symbol substituted, as in cursive writing.

Running script is believed to be a simplification of the early standard forms; but it is also accurate to recognize the origin of both running and standard in clerical script.[1] Only after the Han dynasty did running and standard develop into stabilized and independent script types. Liu Te-shen of the Eastern Han period (A.D. 25–220) is traditionally credited with the invention of running script, but its most famous early proponents were Chung Yu (151–230) of the Wei, and Wang Hsi-chih (303?–361?) and Wang Hsien-chih (344–388) of the Tsin period.[2] The running, running-standard, and standard styles of these early masters formed the core of the important Yuan and Ming "revivals of antiquity" which so revitalized later calligraphy. Because running script developed earlier than mature standard script, it will be discussed first.

Running Script (hsing-shu)

The Sung Masters of Running Script

As with cursive, the development of running script, freer and more informal than the early seal and clerical types, greatly expanded the scope of artistic possibilities for calligraphers. After the Tsin, the T'ang period witnessed the rise of two calligraphic extremes: the strict mature standard and the free "wild" cursive. During the Sung, the major development took place in running script, even though cursive and mixtures of running and cursive were also common.

The Four Great Masters of the Northern Sung, Ts'ai Hsiang (1012–67), Su Shih (1036–1101), Huang T'ing-chien (1045–1105), and Mi Fu (1051–1107) all wrote in cursive and standard scripts, but their special achievement was in running script: even their standard writing contained elements of running script. This new form was called Sung-k'ai, a form of hsing-k'ai, ("informal regular" or "running-standard" script).

The Sung masters' uniquely individual styles were of far-ranging importance in the history of calligraphy. Their running styles were truly "personal"—expressive of their complex personalities as poets, statesmen, connoisseurs and critics. Indeed, their achievements were emblematic of the high state of Sung dynasty culture in general.

The concept of handwriting as a mirror of human

personality was understood in the Han period and honored as part of an aesthetic ideal in the Tsin period. But with the Sung masters, the degree of individuality was commensurate with their stature as men of letters and signified a departure in both style and substance from the aristocratic styles of the Two Wangs, which depended on privileged family tradition and the pure artistic cultivation of calligraphy. The Sung masters initiated a trend toward more personal—even idiosyncratic—styles, which, in reflecting one's character rather than one's class, established a new standard within reach of all scholars. Calligraphy became a more democratic art. The notion of calligraphy as the "heart-print" (hsin-yin) was a basis for the literati art theory which was to dominate the practice of calligraphy and painting in subsequent dynasties.

Works by the Four Masters are rare. There are no examples by Ts'ai Hsiang or Su Shih in Western collections, but Huang T'ing-chien and Mi Fu are well-represented in this exhibition.

Huang T'ing-chien (1045–1105)
"Scroll for Chang Ta-t'ung" (no.6)

Huang T'ing-chien wrote this work, dated 1100, for his nephew who had traveled to Jungchou, Szechuan, with his mother to visit Huang in exile. It is one of five famous scrolls which Huang executed in large-sized running script and represents the summit of his career as a calligrapher. While Huang's dated works span a period of twenty years, his monumental writings were written under the hardship of political exile, some seven years before his death.[3]

Huang was a decade younger than the famous poet–statesman–calligrapher Su Shih, and came to Su's notice through his poetry. They became close friends, the proud Huang T'ing-chien acknowledging Su as the greatest calligrapher of the time. Su also understood Huang's art. He once playfully commented on Huang's calligraphy, saying that it was sometimes too thin, resembling "snakes dangling from treetops." The metaphor captured the tense natural poise and stroke energy of Huang's distinctive hand.

The sources of Huang's calligraphy were diverse, but he was most deeply influenced by Yen Chen-ch'ing (709–785), Su Shih, and the I-ho-ming ("Memorial to a Dead Crane"), a cliff inscription dated 514 (fig. 52), which Huang believed carried the authority of Wang Hsi-chih.[4] As in his poetic achievement, Huang T'ing-chien was indebted to his predecessors; but in studying them, his purpose was to grasp the essential principles of their art through an intuitive understanding of their inner spirit (shen-hui), rather than through the externals of

FIG. 52. *I-ho-ming*. Dated 514. Detail of rubbing.

formal style. Hence their influence was modified by his own theory and practice of calligraphy.

Two key brush methods characterize his personal style: using a "suspended wrist and arm" (*hsuan-wan*) while writing, and "employing full strength during the execution of each stroke" (*pi–chung yung-li*). They account for such personal stylistic features as elongated strokes extending from a central structure and an asymmetrical balance of individual characters, often with the internal lines organized in opposition or parallel arrangement. This asymmetry also governed his columnar spacing, where characters were shifted from side to side or upward into neighboring spaces. This spacing was derived from his experiments in cursive and from the influence of Huai-su's style. The rounded, substantial brushlines of his cursive writing also appear in his running script, reflecting the influence of the *I-ho-ming* cliff inscription. This work's large-sized writing, with its full, rounded brushwork accentuated by the weathered stone surface, and its free arrangement of strokes was an ideal which Huang sought in his writing. He said, "The *I-ho-ming* is the great ancestor of monumental writing."[5]

Compared to the fluency and charm of the "Poems by Han-shan," dated 1099 *(fig.7)*, the "Scroll for Chang Ta-t'ung" suggests the transition from maturity to old-age. The struggling intensity glimpsed in this scroll is

carried through to his handscroll, *Sung-feng-ko*, dated 1102 (Palace Museum, Taipei), where the "flesh" of the strokes has been reduced to the gaunt bony frame of old age.

Huang T'ing-chien's running style was among the most personally expressive in the history of calligraphy. Without being strange or eccentric, he extended the boundary of orthodox literati taste. His legacy to succeeding generations was a spirit of independence which became the mainstay of the Southern Sung calligraphers, especially of the Ch'an (or Zen) monk-calligraphers with whom both he and Su Shih were closely associated.

Mi Fu (1051–1107)
"Three Letters" *(nos.9 a,b,c)*

Since the Tsin period, when the aesthetic appreciation of calligraphy reached an early height, the personal letter was a chief vehicle for calligraphic expression. When composing a letter the calligrapher, aware of its aesthetic as well as communicative functions, took pride in both its artistic and literary presentation. Although by the T'ang and Sung periods other formats, such as the handscroll, gained in popularity, the letter retained its traditional importance and continued to be regarded as a work of art; indeed, most of the treasured works attributed to the Tsin and the Sung masters are in letter format.

Running script was the type most commonly used in letters. Essentially the freehand or daily script of every calligrapher, it revealed his training in the styles of the old masters. This is readily apparent in a group of three undated letters by Huang T'ing-chien's younger contemporary, Mi Fu.

The three letters by Mi Fu are not dated and key phrases in the texts provide their titles. "Abundant Harvest" (*Sui-feng t'ieh*) (*no.9a*) is the most serious in tone. Mi Fu, in office during a successful harvest, addresses a colleague who has just assumed an official post and advises him on how to govern his new district. The second letter, "Escaping Summer Heat" (*T'ao-shu t'ieh*) (*no.9b*), speaks of retreating to the mountains during the oppressive heat. "Hasty Reply before Guests" (*Tui-k'o ts'ao-ts'ao*) (*no.9c*) is a reply to a friend's letter sent to Mi by a messenger who arrived while Mi was entertaining some guests. He brushed a quick response, and not surprisingly, this is the least "finished" of the three, freest and most cursive.

"Abundant Harvest" and "Escaping Summer Heat" are similar in style and in the form of Mi's signature. He signs his name "Fu" in its simplified form, an indication that the two letters were written after age forty, when he began using the simpler graph. More specifically, the content of "Abundant Harvest" dates it to one of two

periods of Mi's official positions—either 1092–94 or 1097–98.[6]

In view of the wide range of styles found in Mi's oeuvre, the style of the three letters is strikingly consistent, especially when compared to larger and more exuberant works, such as his "Sailing on the Wu River" *(no. 8)*. The letters are written in a modest hand, with the characters balanced in slight asymmetry. The brush is wielded with relatively even pressure, using predominantly brushtip action and fine motions. The tall characters are compactly constructed; the verticals characteristically arch inward at the apex. All three letters evidence Mi's study of the Tsin and T'ang masters and his specific attention to brushwork, while "Abundant Harvest" and "Escaping Summer Heat" are among the most restrained of his works in running script, comparable to his important "Poems on Szechuan Silk," dated 1088 (Palace Museum, Taipei).

Brushwork mirrors the artistic personality, and Mi Fu and Huang T'ing-chien offer a striking contrast. While Huang T'ing-chien's brush pace is slow and steady, Mi's brush moves alternately fast and slow, changing quickly in rhythmic bursts. Although Huang's brushwork is self-contained and introspective, his compositions stretch and tangle. Inversely, Mi's compositions are contained, but his brushwork has an extroverted and expansive enthusiasm expressed through a series of movements which are supple yet firm, crisp yet soft. His sensitive brush touch differs fundamentally from the inner weight and power of Huang T'ing-chien's. The characteristics of each artist remain consistent through variations in script and character size.

CALLIGRAPHERS of the Southern Sung and Chin periods continued for the most part the styles of the Northern Sung masters. It was not a period known for innovation in either the ancient or modern scripts.[7] There were a number of poets and officials, however, who developed personal styles in running script which reflect the spirit of independence begun in the early Sung. Among the better-known literati whose calligraphy is worthy of note are the poets Lu Yu (1125–1220) and Fan Ch'eng-ta of the Southern Sung, and Wang T'ing-yun (1151–1202) *(cf. fig. 72)* and Chao Ping-wen (1159–1232) of the Chin.

Fan Ch'eng-ta (1126–93)
Colophon to "Fishing Village at Mt. Hsi-sai"
(no. 10)

Fan Ch'eng-ta's colophon to "Fishing Village at Mt. Hsi-sai" in the Crawford collection, New York, complements this bucolic painting. Fan had gained a reputation for his pastoral and "garden and field" poetry, but his calligraphic works are rare, and this colophon is the most important and largest of his ink originals. Stylistically, his writing reflects the primary influence of Mi Fu, with some elements, such as elongated strokes, taken from Huang T'ing-chien. Fan's brushwork exhibits the variations of pace and pressure characteristic of Mi Fu. However, Fan's brush splays flatly outward in the diagonals, hooks, and verticals; he shows little concern for the individual balance of characters or the perfection of stroke forms, preferring clear columns and spacious margins. In contrast, Mi's brushwork is rounder and more complex in its refinements, revealing a broader repertory of brush movement. Fan has grasped his predecessor's forms, but has chosen to develop his art in a more personal way.

Essentially, this was the spirit of both the Southern Sung and Chin calligraphers—the second and third generation inheritors of the Northern Sung legacy. Chiang K'uei (ca. 1155–1231), the Southern Sung poet and critic, noted that Huang T'ing-chien represented a major change in the history of cursive writing, but that "this trend continued into the present, making little worth looking at."[8] This harsh comment on his generation reflects the fact that most calligraphers were practicing styles which lacked the authority of ancient methods. In not returning to the major antique sources which formed the basis for the achievement of the Northern Sung masters, their styles were far more limited. It is not surprising, therefore, that during the Southern Sung no calligraphers of the first rank in running or cursive scripts could challenge the greatness of the Northern Sung masters.

Some Yuan Masters of Running Script

Chao Meng-fu (1254–1322)
Inscription on "Twin Pines against a Flat Vista"
(no. 13)

The significant role of Chao Meng-fu and Hsien-yü Shu in early Yuan art extended in particular to calligraphy—in cursive, running, and standard scripts. Their revival of Wei, Tsin, and T'ang styles revitalized the art in the Yuan with a new understanding of ancient models which had been lacking in the Southern Sung.

In his inscription, "Twin Pines against a Flat Vista" from the Metropolitan Museum of Art, Chao writes, "As for my own work, while I dare not compare it with the ancients, when I look at what painters have done in recent times, I daresay mine is a bit different." In his calligraphy and painting, Chao avoided the influence of his contemporaries such as his friend Ch'ien Hsuan (ca. 1235–1300), seeking instead the ancient masters through

intensive study.[9] Chao's inscription in running style does not represent his highest achievement, but every character and brushstroke in these six lines has its source in the ancients.[10] If, for example, Chao's writing is compared with the *Chi Wang Sheng-chiao hsu (fig. 53)*, the important T'ang dynasty compilation of Wang Hsi-chih's calligraphy, one can see how close Chao came to a total absorption of the proportions of the characters, the rhythmic balance of thin and thick strokes, the fine ligatures, and the perfection of brushstroke detail associated with the style of Wang Hsi-chih.[11]

Chao's link with the spirit of the Tsin masters was a certain nobility of expression, strongly based on a calligraphic tradition and a thorough study of classic forms. Calligraphy based on this attitude differed from that of the Sung masters whose styles were primarily expressions of their scholarly personalities. In reviving the Wei, Tsin, and T'ang styles, Chao Meng-fu also revived the importance of specialized training and studiousness in calligraphy as an art with a historical tradition.

The Ch'ing critic and calligrapher Wang Shu (1668–

FIG. 53. Wang Hsi-chih (303 ?–361 ?). "*Chi Wang Sheng-chiao-hsu,*" compiled by Huai-jen. Dated 672. Detail of rubbing.

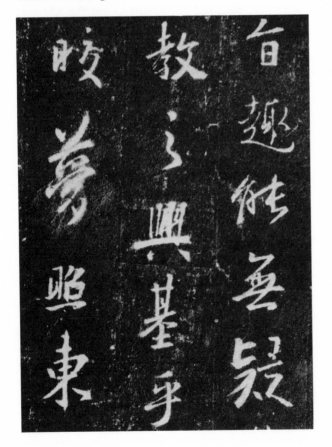

1743) noted his influence in calligraphy: "Since Cháo Meng-fu emerged, there is no calligrapher in this world who has not been touched by his method . . . But not only was the Yuan caught up in his influence, even until the middle Ming, calligraphers could still not shed it."[12] Yet, as handsome as Chao's running style is, it may be faulted for being too balanced and sophisticated. Indeed, it lacks a certain energy and spiritual drive; any follower of Wang Hsi-chih's style was vulnerable to such weaknesses. Therefore, despite his enormous influence and achievement as a calligrapher, Chao Meng-fu's style has been open to criticism.

Feng Tzu-chen (1257–after 1327)
Colophon to Kuo Hsi, "Lowlands with Trees"
(no. 19)

As Academician-in-Waiting in the Chi-hsien Academy, Feng Tzu-chen was one of the learned scholars asked by the Mongol Princess of the State of Lu (Princess Sengge, d. 1331) to inscribe the scrolls in her collection.[13] Feng was also active in Ch'an Buddhist circles and was a friend of the Master, Chung-feng Ming-pen (1264–1325); thus a number of Feng's calligraphic works for Chinese and Japanese adepts were taken to Japan by monks returning from study in China.[14] His colophon to Kuo Hsi's "Lowlands with Trees" is one of his finest remaining works.

In a period in which calligraphy was largely dominated by the influence of Chao Meng-fu and the revival of orthodox methods, Feng's writing exemplifies the individualist trend current among the monk–calligraphers such as Chung-feng Ming-pen, who developed an unmistakably eccentric style, representative of his spiritual independence. While Feng's style does contain certain elements of Mi Fu's, such as concave verticals and narrow proportions, his writing was more a result of natural ability than of profound study of ancient masters. His sense of balance and structure and his crisp brushwork deserve notice, but his style cannot be considered innovative or of major rank. Rather, Feng's work illustrates the survival of Southern Sung individualism in the Yuan, an undercurrent to the *fu-ku* trends which gradually gained authority.

The Revival of Sung Styles in the Middle Ming Period

During the early Ming the styles of Sung K'o (1327–87) *(fig. 64)* and the brothers Shen Tu (1357–1434) and Shen Ts'an (1379–1435) *(no. 26)* gained imperial and popular recognition. Their influence could be measured

FIG. 54. Yao Shou (1423–1495). *Frontispiece to "Trees, Birds, Flowers."* Detail of handscroll. The Art Institute of Chicago.

by the widespread practice of a neat, attractive, but limited range of standard and running-standard scripts. By the next generation, the reaction to this decline resulted in a revival of older styles.

The Ming *fu-ku* functioned much as the early Yuan revival, combating the narrow, imitative styles of previous generations through a greater range of antique sources. As during other dynasties, the return to the models of the past proved to be a source of renewal.

In cursive script, Chang Pi (1425–82) (see essay III) had imitated the "wild" cursive as interpreted by Huang T'ing-chien, and, together with Hsu Yu-chen (1407–72) *(fig. 88)*, paved the way for Chu Yun-ming. Chu and Chang redirected later Ming cursive away from draft-cursive script. In standard script, Chu Yun-ming and Wen Cheng-ming chose models from the Wei and Tsin periods, such as Chung Yu (151–230), to counteract the prevailing "sweetness" of the court style with an "awkward," more antique flavor. In running script, one aspect of the revival centered on three Sung masters, Huang T'ing-chien (1045–1105), Su Shih (1036–1101), and Mi Fu (1051–1107).

The Influence of Huang T'ing-chien

Yao Shou (1423–95)
"Writing about Banana Plants" *(no. 28)*

Yao Shou, a contemporary of Chang Pi from nearby Chia-hsing, Chekiang, was one of the earliest Ming calligraphers to pattern his style after Huang T'ing-chien. A painter as well as calligrapher, Yao wrote his prose-poem on the subject of banana plants at the age of 67. A mature work, it should be compared to his frontispiece, "Contribution of Mountains and Streams," attached to the handscroll he completed in his last year,

when he was 73 *(figs. 54, 69)* (see essay V). In both scrolls, Yao's debt to Huang T'ing-chien's style is evidenced in the tall structure of the characters, the elongated strokes, the slant to the upper right, and the full brushwork, all characteristic of, for example, Huang's "Scroll for Chang Ta-t'ung" *(no. 6)*. The differences in Yao Shou's style are accounted for by the intermediary achievement of the late Yuan masters Chang Yü (1277–1348) and Yang Wei-chen (1296–1370); Yao was influenced by their interest in the strong contrasts of sooty, dry-textured ink. While both Huang T'ing-chien and Mi Fu also liked variations of ink tone, Yao Shou, like Yang Wei-chen, chose charcoal-black ink which produced noticeably parched textures at regular intervals. In this handscroll in particular, Yao was using a small brush which carried little ink, and as a result, the proportion of dry-brush to wet-inked characters is almost equal; this did not occur to the same degree in earlier scrolls which tended to have a lower proportion of dry-brush characters.

Shen Chou (1427–1509)
Frontispiece to "Autumn Colors among Streams and Mountains" *(no. 29)*

Shen Chou's exclusive choice of Huang T'ing-chien as a model for his calligraphy was directly related to four major examples of the Sung master's work in Shen's personal collection, the most important of which was *Fu-po shen-tz'u-shih*, dated 1101 (Hosokawa collection).[15] Thus, unlike Yao Shou for whom no specific references exist, Shen Chou learned Huang's style through the study of his actual works.

In this frontispiece, the characters reveal the dense internal arrangement, tall structure, and slightly elongated diagonals and verticals which are the hallmarks of Huang

T'ing-chien's style. Moreover, the brushwork is weightier and fuller than is usual in Shen's smaller-sized writing.[16] But Shen tended to stress the skeletal elements of Huang's brushwork; like Yao Shou, he preferred the dry hard qualities—a conscious aesthetic choice which reflects the period style. Otherwise, Shen's approach is a typical Ming master's interpretation of Sung style: the brushwork is smoother and more simplified, and, for the most part, lacking the small movements and stroke details which make the earlier masters' writing so rich.

Chu Yun-ming (1461–1527)

Chu Yun-ming also had several opportunities to study the work of Huang T'ing-chien. He saw Huang's famous transcription in cursive script of a poem by Li Po when it was in the possession of the Suchou collector Hua Ch'eng, and both Shen Chou and Chu wrote colophons to it.[17] Then, from 1515 to 1518, when Chu served as a magistrate in Kwangtung, the only example of ancient calligraphy he brought with him was Huang's *Chia-hsiu-t'ang t'ieh*: "Looking at it day and night, I became quite familiar with it, but I never really took up my brush with the intention of imitating it."[18] Nonetheless, by the time Chu returned to Suchou, he had become so familiar with the Sung master's methods that they accounted for some significant changes in his cursive style (see below, essay VI).

Wen Cheng-ming (1470–1559)
Poems and Colophon to "Summer Retreat in the Eastern Grove" (no. 50b)

Wen Cheng-ming, Shen Chou's pupil, acquired a reputation equal to his teacher's in painting, but surpassed it in calligraphy. Through Shen Chou, Wen was introduced to Huang T'ing-chien's calligraphy, which he eventually adopted almost exclusively for his large-sized running script. Wen Cheng-ming first saw Huang's great masterpiece *Fu-po shen-tz'u-shih* in Shen Chou's collection, and then again after the latter's death when he wrote a colophon on it.[19] It is also likely that he saw other scrolls by Huang in Shen's collection. In addition, two examples of Huang's smaller-sized running script were included in volume 5 of Wen Cheng-ming's compilation of calligraphy, *T'ing-yun-kuan t'ieh*.

In the poems datable to 1512 attached to "Summer Retreat in the Eastern Grove" from the Crawford collection, Wen Cheng-ming offers a sampling of his early mastery of three major styles: large running after Huang T'ing-chien; "wild" cursive after Huai-su, as interpreted through Huang's cursive; and large running after Su Shih.[20] In the first passage, Wen successfully captured the "image" of Huang's style, especially the "tangled" and "snakelike" qualities of his brushwork which are also seen in the cursive sections. Wen used a stiff, unkempt brush, whereby he accentuated a gangling sharpness, a quality characteristic of Wen Cheng-ming's "personal" hand and reflecting the early influence of his teacher Li Ying-chen (1431–93), who was also Chu Yun-ming's father-in-law *(cf. fig. 84)*. The rough aggressive brushwork is typical of several of Wen's later large-sized works in which the scale of the characters demanded maximum force and the sacrifice of fine detail.[21] Such treatment contrasts with the neatness of his smaller-sized scripts, yet it was the driving energy exhibited in these larger works that contributed to Wen's reputation.

The Influence of Su Shih

"Summer Retreat in the Eastern Grove" is dated by Wen's colophon in smaller script written in 1515, three years after the execution of the large writing. The subtle shift in style from Huang T'ing-chien to Su Shih, to his "personal" hand provides a fascinating display of the calligrapher as interpreter. Although Wen Cheng-ming made an intensive study of Su Shih's calligraphy, he does not seem to have favored his style, as few examples of it remain. The depth of Wen's mastery can be seen, however, in his most famous "Su-style" work, the "Red Cliff Prose-poem," (Palace Museum, Taipei) in which he completed the missing 36 characters of the opening lines of Su's original transcription *(fig. 55)*.[22] The detail illustrates Su Shih's compressed proportions, full-bodied brushwork, and rich ink tonalities, characteristics which prompted Huang T'ing-chien to state that Su's writing was the finest in the empire, albeit "sometimes a little too squat, like a frog being pressed under a rock."[23]

In the Crawford scroll, Wen Cheng-ming captured a striking likeness. He chose a monumental running-standard size, and compared to the "Huang-style" passage, the structure is broader, the strokes fuller, and the slant to the upper right accentuated. Tense, trembling lines have been replaced by more expansive forms, especially the strongly inflected right-diagonal *(na)* stroke. Still, when the same characters are compared with Su's original (such as *fei*, "to fly," at the far left), it can be seen that Wen seized Su's style through the exaggeration of key features; the brushwork remains straightforward and flattened, with a tapering sharpness and aggressiveness typical of Wen Cheng-ming and of the Ming period in general. Su's strokes, on the other hand, contain the complex small movements, restrained energy, and rhythmic subtlety of the great Sung masters.

FIG. 55. Su Shih (1036–1101). *The Red Cliff*. Detail of handscroll. Palace Museum, Taipei.

Wu K'uan (1436–1504)
"Four Poems" *(no. 31)*

Wen Cheng-ming's older contemporary Wu K'uan preceded him in his interest in Su Shih's style.[24] He became the most famous "Su" practitioner in the Ming, just as Shen Chou had become known for his style after Huang T'ing-chien. A high-ranking official, Wu had the opportunity to view a large number of ancient scrolls to which he appended colophons, including the "Scroll for Chang Ta-t'ung" *(no. 6)*. Examples of individual works of calligraphy by him are rare.[25] The scroll of "Four Poems" from the C. C. Wang collection is one of Wu K'uan's most important works.

Like Wen Cheng-ming, Wu K'uan employs the low rectangular proportions, strong slant to the upper right, and thick brushwork as the visual references to Su Shih's style. The differences, however, are also apparent and again reflect as much the period features of Ming–style writing as Wu K'uan's hand. Wu's approach is even more direct and simplified than Wen's, and his preference for thick dry ink and a blunt brush, as well as his inattention to finishing details give his writing a bold brusque quality.

In contrast to Wen Cheng-ming's greater use of the sharp brushtip, Wu K'uan's flattened brush action resulted in dissipated energy and coarse effects. In this respect Wu K'uan's approach to calligraphy would be echoed by Wang Wen (1497–1576) *(no. 58)* two generations later. Early in their careers both settled on a "fixed" calligraphic manner which gained distinction by virtue of their forceful personalities, rather than their intense cultivation of the art of calligraphy or study of past masters. Still, Wu K'uan's sympathy for Su Shih's style played an important role in the revival of Sung styles in the Ming, influencing the younger Wen Cheng-ming and later generations.[26]

The Influence of Mi Fu

Mi's influence in the mid-Ming was not as great as that of Huang or Su; there appears to be no one who specialized in his style. A versatile calligrapher like Chu Yun-ming was, however, attracted to Mi's style. In his colophon to Mi's famous scroll written on Szechuan silk, Chu notes his interest in practicing Mi's style, but in a colophon to another work by Mi, he confesses that "his talent and abilities were both inadequate."[27] No ink originals reflect this phase of Chu's study, but a transcription of his poems preserved in rubbing form and dated 1507 shows that Chu could produce an inspired likeness of Mi Fu's style when the mood struck him.[28]

Wen Cheng-ming (1470–1559)
"Sunset on the Chin and Chiao Mountains,"
(no. 51)

Wen Cheng-ming's thorough command of the Sung masters' styles is seen in a rare and unusual example of his writing in Mi Fu style from the Frankel collection, probably the only extant scroll of such length devoted entirely to Mi's manner.[29] Dated 1521, it is relatively "early" in the artist's career, and, like the Crawford scroll, shows his ability to sustain this style with surprising consistency, as well as to capture the spirit of the model. On first examination, it hardly resembles Wen Cheng-ming's style; yet, on closer scrutiny characteristics of his larger-sized writing may be seen. References to Mi Fu are contained in the elongated structures, the concave vertical strokes, the slash–like, unarticulated stroke endings of the hooks and diagonals, the dry-brush strokes, and the reckless execution (cf. essay III, *no. 8* and *fig. 45*), traits not found to the same degree in his writing in Su or Huang styles.

In the last section of the scroll, Wen added comments in his typical freehand script, and his signature, which is identical to those found on other of his genuine works

from the same period, leaves no doubt about the scroll's author.

The Sung Revival in Other Fields

It is interesting to note that the revival of Sung styles in calligraphy was paralleled in the other arts. In literature a movement called *ni-ku* ("imitating the ancients") was initiated to counteract the increasingly detrimental influences of the *t'ai-ko-t'i* ("examination hall") style of composition. The Han, Wei, and Tsin classics were advocated as models for prose essays, and "high" T'ang poetry for verse.[30] Still another literary movement called *Sung-wen* promoted the prose writing of Sung masters as models, in opposition to the *ni-ku* movement and its deference to the more ancient classics. While the *ni-ku* and *Sung-wen* approaches competed in the literary sphere, in calligraphy eclecticism was tolerated.[31] For example, Yao Shou, Shen Chou, and Wu K'uan revived Sung models, while Chu Yun-ming and Wen Cheng-ming revived Tsin and T'ang models, as well as those of the Sung.

This eclectic tendency was particularly true in the case of Wen Cheng-ming's calligraphic sources. His personal style in running-cursive and running-standard was derived from Tsin/T'ang models, and his large-sized cursive and running, from the Sung. Of the Ming masters, then, Wen Cheng-ming had the deepest roots in ancient styles. His temperament led to a different selection of past models than Chu Yun-ming, but their mastery was comparable.

Late Ming and Early Ch'ing Masters of Running Script

As in cursive script, lesser Suchou calligraphers were influenced by Chu Yun-ming and Wen Cheng-ming, but as a rule they did not return to the Tsin/T'ang or Sung sources. Thus, as in the case of Chao Meng-fu in the Yuan, the range of followers' styles became increasingly narrow and was accompanied by a marked loss of originality. In Sungchiang, however, the decline of the Suchou "school" witnessed the "recovery" of Sungchiang calligraphers, among them Mo Shih-lung and Tung Ch'i-ch'ang. Both masters benefitted from the revival of the antique, with Mi Fu as their chief Sung source.

Tung Ch'i-ch'ang (1555–1636)
Colophons to the *Hsing-jang t'ieh (no.1b)*

Tung Ch'i-ch'ang's three colophons to the important T'ang tracing copy of Wang Hsi-chih's letter have been mentioned in other contexts. The colophons appear in small standard, running-cursive, and medium-sized running script. His style is of interest here because it was his conscientious and broad study of ancient sources in calligraphy, as well as in painting, which enabled him to establish his orthodoxy on such a firm basis. His calligraphy reveals his complex absorption of ancient sources, combining the mildness and ease of the tradition of the Two Wangs with the firmer brush articulation of the T'ang masters, Yen Chen-ch'ing and Liu Kung-ch'uan. In his smaller writing, certain aspects of Huai-su's and Mi Fu's approaches can also be seen.

His larger-sized colophon *(no.1b)* is one of his finest writings. Dated 1609 and written at the age of fifty-five, it is, nevertheless, an "early" example, before his calligraphy became stylized with old age. He charges the individual strokes with high energy: a decisive crispness balances the softer, rounder tendencies of his brushwork. Tung was greatly excited by the scroll and honored it with his finest writing and repeated praises: "Wherever this scroll is, there should be an auspicious cloud hovering above to protect it."

Wang To (1592–1652)
"Transcription of Letters by Wang Min" *(no.64)*

The transcription of letters composed by the Tsin master Wang Min (351–388), a nephew of Wang Hsi-chih, was one of two types of writing which he practiced—one day imitating the ancients, the next writing freely and answering requests for calligraphy. His two works in the exhibition *(cf. no.65)* represent both aspects of his routine.

The scroll, dated 1641, shows that Wang was still practicing Tsin-style calligraphy in his middle years, yet without slavish imitation. Rather, Wang used the text and style of ancient writing as a catalyst—a form of artistic inspiration and spiritual emulation essential to a calligrapher's understanding of the past and to the improvement of his brushwork. It was also an effective antidote to the tendency to over-stylization inherent in writing too often in one's personal style.

The effectiveness of Wang To's strict regimen is reflected in his accomplishments, which rivaled Tung Ch'i-ch'ang's. Even in daily writing, the complexity of Wang's sources, the breadth of his training, and the habitual attention to detail, are clearly evident. The slightly elongated and elegant structures are derived from Tsin and Mi Fu styles, while the brushwork reflects his training in the styles of Yen Chen-ch'ing and Liu Kung-ch'uan in its well-articulated joints and sinews.[32] The presence of bony "knuckles" and a restrained energy also characterize his style. Although written with a casual air, the strokes are imbued with an

historical background, and yet they also carry the individual densities, moist textures, and rhythmic tensions of Wang's own personal style. It is writing of this calibre, whether in running, cursive or standard scripts, which has continued to give definition to calligraphy's long history.

Chu Ta (1626–1705)
"Preface to 'Gathering along the River'" (no.70)

This small album leaf, "Preface to 'Gathering along the River'" (Lin-ho chi-hsu), is a transcription of another version of "The Preface to the Orchid Pavilion Gathering" (Lan-t'ing chi-hsu).[33] Using a new brush, Chu Ta sought a refined and delicate quality on the opposite scale of values from his large-sized writing (cf. no.69). Nonetheless, the strokes betray his typical rounded and firm brush touch. Each character is poised like a living creature; its structure is slightly asymmetrical, yet stable and antique, without any formal eccentricities. The brush moves at a comfortable pace, producing subtle movements and a feeling of serenity. Despite its modest size, the abundance of fine detail and the balance and individuality of the structures give the work an unusual sense of monumentality.[34] It exemplifies the simplicity and plainness of Chu Ta's late style and was probably written around 1700.[35]

Tao-chi (1641–ca. 1710)
"Farewell Poem to Jen-an" (no.72)

Like Chu Ta, Tao-chi's calligraphy was as distinctive as his painting, but while Chu's artistic style was stable and consistent, Tao-chi's encompassed a wide range of forms. The calligraphy on his "Farewell Poem to Jen-an" and on his "Album of Twelve Landscape Paintings" dated 1703 (no.73), both from the Museum of Fine Arts, Boston, demonstrates his early and late styles.[36]
"Farewell Poem" is attached to a landscape handscroll, "Rocky Bank of a River," which is dated 1691, and was dedicated to "T'ung-chün." However, "Farewell Poem" was written for a different person, Jen-an, who has been identified as Huang Yü-chien (chin-shih 1659). Thus the "Poem" did not originally follow the present painting, but was remounted with it at a later date (see above, essay I). Tao-chi's early friendship with Huang is documented by a scroll which Tao-chi painted for him in the summer of 1684 at the Ch'ang-kan temple in Nanking. Upon completing a portrait of Huang in a landscape, Tao-chi brushed an inscription in large characters (fig.14). "Farewell Poem" reflects a similar circumstance; it is not dated, but Tao-chi indicates that Huang was about to return to his official post at Jung-

FIG. 56. Tao-chi (1641–ca. 1710). *Farewell Poem to Jen-an*. Detail of handscroll, (no.72).

ch'eng, presumably after the portrait scroll had been finished.

The "Farewell Poem," Tao-chi's largest extant work, is written in characters of impressive size—the largest is nearly 10 inches (28 cm) high.[37] Executed with an upright brush and "concealed tip" manipulations, its outstanding brush qualities are roundness and substantiality. While Tao-chi and Chu Ta share a basic approach, Tao-chi seeks variety rather than plainness, emphasizing extremes of stroke thickness, character size, and shape. In making humorous references to certain older styles, such as Chung Yu's blunt brushwork and awkward structures and Huang T'ing-chien's exaggerated horizontals (fig. 56), Tao-chi's writing exhibits a characteristic exuberance.[38]

VERSATILE PAINTER-CALLIGRAPHERS became more common following Chu Ta and Tao-chi, especially with the appearance of the Yangchou Eccentrics, four of whom are represented in the exhibition: Kao Feng-han (nos.74, 75), Li Shan (no.76), Chin Nung (no.77), and Cheng Hsieh (no.78a). Their painting styles evolved from a tradition begun in the mid-Ming by such masters as Ch'en Shun and Hsu Wei, and were derived most immediately from Tao-chi. With the exception of Chin Nung, they all wrote in an easy running script. Their painting and calligraphy styles were both distinctive and eclectic; not only did they mix script methods—Cheng

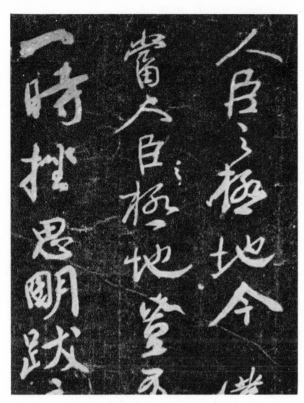

FIG. 57. Yen Chen-ch'ing (709–785). *Cheng tso-wei t'ieh.* Dated 764. Detail of rubbing.

Hsieh, for example, used clerical methods in his running script—but they also regarded calligraphy as a form of painting and freely introduced design elements and painterly brush forms into their daily writing.

Some Late Ch'ing Masters of Running Script

As a result of the *pei-hsueh* movement, calligraphers took an interest in the engraved inscriptions of the Six Dynasties' period and the monumental stele writing of the T'ang master Yen Chen-ch'ing (709–785). These sources enriched the personal running styles of several late Ch'ing masters.

Ho Shao-chi (1799–1873) Couplet collated from the "Preface to the Orchid Pavilion Gathering" (no.81)

Ho Shao-chi's study of calligraphy began with the ancient seal and clerical scripts, and northern stele inscriptions, before progressing to the modern standard and running scripts.[39] Thus when he turned to later models, such as the monumental style of Yen Chen-

ch'ing, his training in commemorative writing enabled him to grasp Yen's essential methods and spirit. Yen's running-style manuscript, the *Cheng-tso-wei t'ieh (fig. 57),* appears to have influenced him significantly, and despite Ho's claim that he did not pay attention to informal writings, he did study the *Chi Wang Sheng-chiao-hsu (fig.53).*[40] Ho's style combined northern monumentality (Yen) and southern elegance (Wang); both traditions are evident in this couplet.

The brushwork is derived from Yen Chen-ch'ing (the character *tso,* for example, bears a striking resemblance to Yen's manuscript), especially in the fully articulated "entering" and "closing" strokes, the well-finished diagonals and hooks, and the broadness of the strokes. He alludes to the Tsin master's style in the columnar arrangement of the titled, swaying characters. Ho's personal elements are reflected in the supple brush movements, the contrast of thick and thin strokes, and the ductile energy carried between strokes (such as the last character in the right panel). Despite some of the thin formations, the couplet does not exhibit the tense, struggling strokes of his latest works; therefore it may well date to about 1855.[41]

Ho Shao-chi cultivated calligraphy as an *art;* he copied a particular stele inscription many times, striving to capture a different aspect of style with each attempt—whether composition, brushwork or rhythms.[42] Ho came from a prominent Hunan family; his father was not only a high official, known for his calligraphy and painting, but his three brothers also excelled in calligraphy.[43] The family accomplishment was a reflection of the high state of culture in their home province. Several famous scholar-generals from Hunan were also known for their calligraphy, the two most famous being Tseng Kuo-fan (1811–72) and Tso Tsung-t'ang (1812–85), both of whom admired Ho Shao-chi.

Tso Tsung-t'ang (1812–85) "Early Summer Dwelling" (no.82)

Tso Tsung-t'ang dominated both the political and military arenas. In his calligraphy, he appears to have had more talent than discipline, but he developed a distinctive style following his study of old masters. The sense of movement is outstanding in this couplet, revealing Tso's dynamic personality. Tso was praised for his seal script, but his artistic temperament seems to have preferred speed and lightness, so that a flying quality permeates his strokes even though they are not frequently linked. The heavy opening "heads" of the strokes are decisive, offsetting the sense of movement with stability (cf. *fig.66).*

Like his friend Ho Shao-chi, Tso Tsung-t'ang was

strongly influenced by the style of the T'ang master Yen Chen-ch'ing *(fig. 57)*. Tso emphasized the "bone" of Yen's style by using more brushtip, while Ho employed the "belly" and the "tip" of the brush to give his strokes more "flesh." Tso's brush moved in an angular zigzag pattern, whereas Ho's fluctuated with a vertical pressure. Despite these differences, Ho Shao-chi's influence on the younger Tso may be detected in their mutual practice of Yen's style, and in details, such as the tense flexed diagonal stroke, with its slightly drooping tip.

Yang Shou-ching (1839–1915)
"Setting Sun over the Forest" *(no. 89)*

Yang Shou-ching holds a more distinguished position in the history of calligraphy in Japan than in China. After failing the local examinations because of his poor calligraphy, Yang studied more seriously, and at twenty-five he traveled to Peking to study under P'an Ch'un (d. 1892), who introduced him to scholarly activities. By his forties Yang had built a reputation as a bibliographer, rare book collector, scholar of bronze and stone studies, and geographer.[44]

In 1880, the Chinese ambassador Ho Ju-chang invited Yang to Japan where he discovered a wealth of old Chinese books no longer available in China. He purchased them, raising funds through the sale of rubbings of stele inscriptions, seals, and old coins which he had brought with him. Yang became friends with prominent Japanese sinologists for whom these antiquities were new and rare items, and also introduced calligraphy methods which he had learned from P'an Ch'un. In turn, Japanese scholars journeyed to China to study with P'an and other masters. During the Meiji era (1866–1912), the prominent Japanese calligrapher Meikaku Kusakabe (1838–1922) studied with Yang, and, through his subsequent work, thousands of steles in Japan exhibit Yang's influence.[45] The introduction of new calligraphic methods and sources, especially those of the Six Dynasties, constituted a turning point in the history of modern Japanese calligraphy. By 1883, Yang had returned to China, and by 1906 and 1909, when the high official, antiquarian, and scholar Tuan-fang (1861–1911) invited Yang to catalogue and inscribe colophons on works in his collection, Yang was widely recognized as a calligrapher.[46]

"Setting Sun over the Forest," a couplet in running script, dated 1909, was a product of this period. The couplet embodies typical "old-age" characteristics—a tough bony quality and little attention to fine detail. His stylistic sources are not obvious; his writing has an independent spirit.

K'ang Yu-wei (1858–1927)
"Your Writing Will Last a Thousand Autumns" *(no. 90)*

K'ang Yu-wei's approach to calligraphy was essentially theoretical. His study of the art was based primarily on early rubbings, and, in 1890, at the age of thirty-two, he published *Kuang-i-chou shuang-chi*, a major treatise on the *pei-hsueh* movement.[47]

"Your Writing Will Last a Thousand Autumns" exhibits the wide sweeping shapes which characterize K'ang's style, especially the uplifted hooks and diagonals which exaggerate the direction of the "returning brushtip" (*hui-feng*). K'ang was not interested in small details, so if judged by orthodox standards, the brushwork would

FIG. 58. K'ang Yu-wei (1858–1927). *Transcription of a Couplet by Ch'en T'uan (d. 989). Datable 1921.* Pair of hanging scrolls. Collection unknown.

be considered coarse. K'ang's style, in fact, derives from two well-known sources, the *Shih-men-ming*, dated 509, and a famous couplet by the Sung master Ch'en T'uan (d. 989), which K'ang borrowed around 1918 from the calligrapher Li Jui-ch'ing (1867–1920) and copied hundreds of times.

The majority of K'ang's works bear no date, but may be datable to after 1913 on the basis of a seal which appears on them. This seal, which says that he "traveled around the world three times within a period of fourteen years after 1898," appears on "Your Writing Will Last a Thousand Autumns." The couplet also compares well in terms of its style, signature, and seals, with a copy of the Ch'en T'uan couplet which K'ang Yu-wei wrote for a Japanese patron in 1921 *(fig. 58).*[48]

Standard Script (*k'ai-shu*)

Standard script (*k'ai-shu*) was the last of the formal script types in the evolutionary sequence.[49] It developed from clerical script around the end of the Han dynasty, but it was not until the Sui (581–618) and early T'ang periods (618–906) that the various generically related types stabilized into the configuration known as "standard" script.[50]

Technically, standard script combined the most advanced brush techniques of the different script types which had developed in the intervening years. Formal changes could be seen in specific strokes, such as the right and left descending diagonal strokes (*na, p'ieh*), and the right and left hook strokes (*kou*). Standard script entailed extra movements, pauses, and changes of brush direction, as well as variations in pressure and speed. Some technical innovations were derived from running and cursive scripts which link, or tend to link, succeeding strokes; a tall rectangular structure was the outcome of the downward movement of the characters in the column. Utilizing the newest methods, standard script was also the most legible and convenient form of writing. Therefore, after the T'ang, it did not undergo radical changes.

In the T'ang, the major practitioners of the script were Ou-yang Hsun (557–641), Yü Shih-nan (558–638). Ch'u Sui-liang (596–658, cf. *no. 3*), and Yen Chen-ch'ing (709–785, cf. *fig. 57*). Their styles became almost synonymous with standard script and the criteria by which the script was judged in later generations. Material from the T'ang survives primarily in the form of stele inscriptions; only large numbers of sutra writings exist in brushwritten form. Few ink originals by the great masters have survived to show this script at its height.[51]

Standard Script in the Sung

In the Sung, standard script was secondary to running script. None of the Four Great Masters wrote in the strict, formal T'ang standard style. Since their standard script often contained the ligatures and movements of running, it is often called *Sung-k'ai*, which is a form of running-standard script. Of the Four Masters, Ts'ai Hsiang (1012–67) wrote in the most formal hand. His colophon to Yen Chen-ch'ing's *Tzu-shu kao-shen* is an important example of the script in ink original form and testifies to the importance of Yen Chen-ch'ing in the Sung.[52] All Four Masters studied his style. Yen's expansive yet finely articulated strokes and his substantial characters provided a solid basis for the Four Masters' personal styles.

Two other important practitioners were the Northern Sung emperor Hui-tsung (r. 1101–25) and his son, the Southern Sung emperor Kao-tsung (r. 1127–62). Hui-tsung is known for a distinctive imperial style, "slender gold script" (*shou-chin t'i*), which is a form of running-standard. Technically, its embellishments are an exaggeration of certain brush movements intrinsic to the standard type.[53] The refinement of Hui-tsung's style embodied the cultural standards of Sung art. Kao-tsung imitated a number of models, including Wang Hsi-chih and Huang T'ing-chien, introducing a pliant charm into the imperial style which the royal family carried on for several generations.[54]

Chang Chi-chih (1186–1266) "Diamond Sutra" *(no. 11a)*

Chang Chi-chih was one of the few Sung calligraphers who specialized in standard script.[55] His writing epitomizes the definition of *Sung-k'ai*—a fluency created by numerous ductile ligatures. His personal style was further characterized by strong contrasts between fine, thin strokes and broad, arching strokes, with the "head" and "tail" strokes revealing the directional movements of the brush.

Chang wrote in both medium- and large-sized scripts, using the former primarily in transcribing sutra texts. "Diamond Sutra" is an album impressive for its length and the neatness and precision of the writing. It is one of several transcriptions in which he records both the year and his age—in this case, 1246, when he had reached the age of sixty-one—thus confirming 1186 as the year of his birth.[56] Chang's large-sized script, and in particular his title-heads, is strong and forceful, achieving a stately monumentality unusual in brush-written characters on that scale.[57] It is on the basis of this accomplishment that Chang should be recognized as a major calligrapher of the late Sung period.

Chao Meng-chien (1199–1267)

During the late Southern Sung and early Yuan, the works of Chao Meng-chien and Chou Mi exemplified both the dynastic transition and some of the stylistic changes that were to occur in the work of Chao Meng-fu, Chao Meng-chien's cousin. A member of the imperial family, Chao Meng-chien possessed an artistic temperament which found expression in painting and calligraphy.[58] His scroll "Narcissi" (no. 12) is a superb performance in monochrome ink. When he earned his *chin-shih* degree in 1226, Chao Meng-chien had already begun an intensive study of calligraphy. Yet, in an inscription dated 1254 to his scroll of poems (fig. 59), Chao lamented that, "After thirty years of practicing calligraphy, my efforts look like this. I believe all the more now that the practice of calligraphy is not easy."[59]

Chao also showed an early interest in pre-T'ang calligraphy: "To learn from the T'ang masters is not as good as to learn from the Tsin masters. Everyone can say this, but who understands how difficult it is to learn from Tsin [models]. If one studies T'ang [calligraphy], one would not fail to learn basic methods and principles. But if one attempted to study Tsin [calligraphy] without having first mastered T'ang [methods], that would show how little one knew of one's capacity."[60]

Chao Meng-chien's calligraphic style reflects the spirit of Sung individualism which prevailed in his time: the brushwork is crisp, with fluent, well-flexed strokes and a resonant charm and movement. But upon closer analysis the structures are not well-balanced and the shapes not ideally proportioned; his interest in the art of the past was a general rather than a specific study, and the discipline itself was left for the next generation.

Standard Script in the Early Yuan

Chou Mi (1232–98)
"The Most Fragrant Flower," colophon to
Chao Meng-chien's "Narcissi" (no. 12)

Chou Mi is an important figure in the history of Chinese arts and letters, a major lyric poet, connoisseur and historian, active in the Hangchou area during the early Yuan. Twenty-two years older than Chao Meng-fu, Chou exerted a formative influence on Chao, and their friendship took the form of an important handscroll, "Autumn Colors on the Ch'iao and Hua Mountains," dated 1296, which Chao painted for Chou.[61]

Examples of Chou's calligraphy are rare.[62] His colophon which follows Chao Meng-chien's "Narcissi," provides an interesting comparison with Chao's writing (cf. fig. 59). The period style is evident in certain structural elements, especially the simple, flattened and sometimes

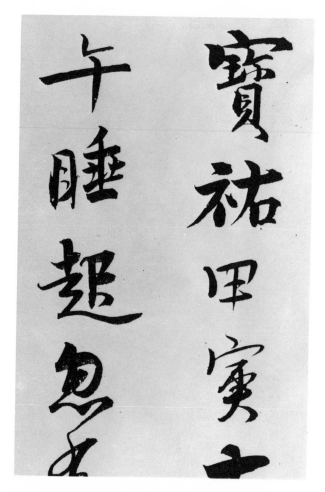

FIG. 59. Chao Meng-chien (1199-1267). *Poems.* Dated 1254. Detail of handscroll. Shanghai Museum.

elongated strokes. However, while Chao mixed straight and flexed strokes, Chou Mi stressed the simple firm movements, evoking a feeling of purity and reserve. Although his basic brush methods derive from Ou-yang Hsun, his poised compositions reflect his personal style and sensitivity.[63]

Chao Meng-fu (1254–1322)
"Record of the Miao-yen Temple in Huchou" (no. 15b)

Chao Meng-fu was aware of the decline in the art of calligraphy in the late Southern Sung. Even though he mastered all the major script types, it was in standard script that he made his important contribution to the Yuan "recovery" of standards in calligraphy. Critics have noted that in his early works Chao followed the "family" style of Emperor Sung Kao-tsung.[64] Chao was also influenced by Kao-tsung and Chao Meng-chien's

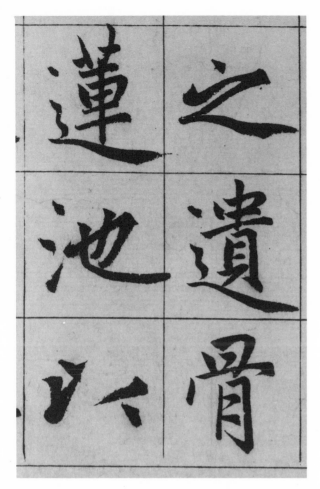

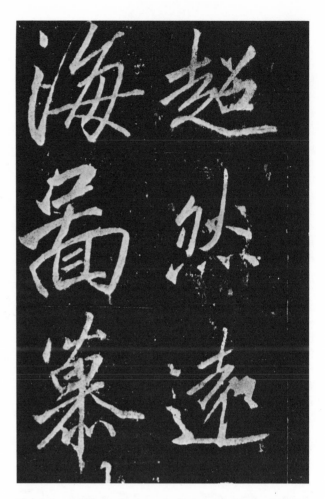

FIG. 60. Chao Meng-fu (1254–1322). *Record of the Miao-yen Temple*. Detail of handscroll, *(no. 15b)*.

FIG. 61. Li Yung (678–747). *Stele of the General Li Ssu-hsun*. Datable to after 739. Detail of rubbing.

interest in the Tsin and T'ang masters. The works of Wang Hsi-chih (e.g. *fig. 53*) were the main sources for Tsin calligraphy, and the stele inscriptions of Li Yung (678–747) *(fig. 61)* for T'ang calligraphy.[65] The influence of Li Yung, as well as the standard script styles of Wei dynasty steles, is particularly evident in the important transcriptions of commemorative texts to be carved in stele form which Chao executed.[66]

"Record of the Miao-yen Temple," datable to about 1309–10, by the official positions in Chao's signature, is one of these transcriptions.[67] It reveals the extent of his study of the past which, in its seriousness and discipline, differed so much from that of his immediate predecessors. In his transcriptions, Chao sought a formality of presentation which recalled T'ang models. Each character is ideally composed, and the strokes are perfectly formed *(fig. 60)*. Chao demonstrates a mastery of all the technical points of brushmanship which make standard such a demanding script form: he uses his brush like a knife, fully preparing it as it cuts into the "heads" of the strokes; his energy is completely channeled as the brush forms diagonals and hooks, imbuing the strokes with intensity. This restraint saved his brushwork from being facile. His debt to Li Yung's style is clear in the diagonal ligatures and elongated shapes. In "Record of the Miao-yen Temple," Chao imbues the script with an elegance and refinement which surpasses his other works. His achievement in this type of stele writing was not just a personal accomplishment; it lent distinction and impetus to standard-script writing throughout the Yuan, and well into the Ming dynasty.

Hsien-yü Shu (1257 ?–1302)
"Admonitions to the Imperial Censors" *(no. 16)*

As a northerner, Hsien-yü Shu's bold calligraphy style helped to restore monumentality to Yuan calligraphy. His transcription of the "Admonitions" essay by the

Chin poet-scholar Chao Ping-wen (1159–1232) is one of two extant works in large-sized standard script.[68] When compared to Chao Meng-fu's "Record" *(no. 15b and fig. 60)*, the differences in their methods are apparent: Chao's characters are smaller and more compact, his brushwork is crisp and tapered, with the use of an "exposed" brushtip to form flattened stroke-heads; while Hsien-yü's brushwork is blunt and rounded, using a "concealed tip" to form "tucked-in" stroke-heads. Since his interest was not in the perfection of individual strokes, but rather in the impact of the entire work he allowed his brush to run dry toward the end of a column to maintain a forceful continuity.

As in cursive script, Hsien-yü was a conscientious student of Tsin/T'ang methods; the individual structures of the characters have their sources in these precedents. In fact, in the colophons to this scroll, Hsien-yü Shu's contemporaries remarked on the resemblance of his writing to the *Lan-t'ing*, the *Li-tui-chi*, a work by Yen Chen-ch'ing, and the *I-ho-ming* (cf. *fig. 52*).[69] Its similarity to the latter work does not lie in the subtle compositional arrangement of the characters, which influenced Huang T'ing-chien, but rather in the "centered-tip" brush method.

Chao Meng-fu's dignified classicism in standard script complemented Hsien-yü Shu's vigor. Hsien-yü praised Chao's mastery of all script types, but considered his small-standard the best.[70] This was a reflection of Hsien-yü Shu's pride in his large-sized writing and a recognition of the different personality traits expressed in either script size.

Small-Standard Script in the Middle and Late Yuan

Liu Kuan (1270–1342),
Yü Chi (1272–1348),
and K'o Chiu-ssu (1290–1343)
Colophons to Kuo Hsi's "Lowlands with Trees"
(no. 19)

After Chao Meng-fu and Hsien-yü Shu, the rise in standards of calligraphy was reflected in the increased practice of small-standard script *(hsiao-k'ai)*. Scholars showed their preference for the script in their many colophons to early paintings.[71] During the reign of the Emperor Wen-tsung (r. 1328–31), the Imperial K'uei-chang-ko ("Pavilion") was established as an official center for the connoisseurship of calligraphy and painting, and became a gathering place for talented scholars and artists.[72] Poetic colophons by several prominent Yuan officials active in the K'uei-chang-ko are attached

FIG. 62. Chao Meng-fu (1254–1322), Yü Chi (1272–1348), K'o Chiu-ssu (1290–1343), and Liu Kuan (1270–1342). *Colophons to Kuo Hsi, "Lowlands with Trees."* Detail of handscroll, *(no. 19)*.

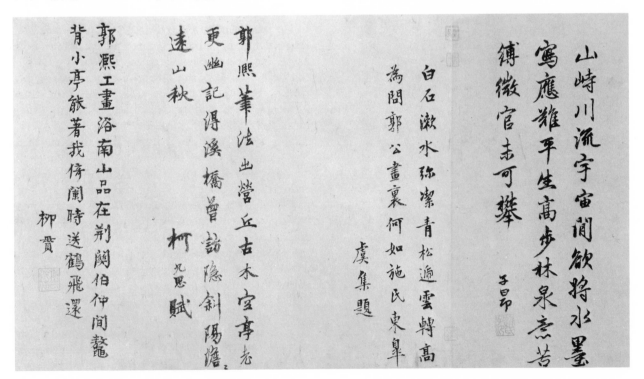

to the painting by Kuo Hsi, "Lowlands with Trees," from the Crawford collection *(fig. 62).*

Liu Kuan, a friend of Hsien-yü Shu and Chao Meng-fu, was an important thinker from Chin-hua, Chekiang, a member of the Bureau of History, and Academician-in-Waiting in the Hanlin Academy.[73] His quatrain in two lines shows his choice of Yen Chen-ch'ing and Liu Kung-ch'üan as models; the writing is neat, with the characters in square perpendicular shapes.

FIG. 63. Ni Tsan (1301–1374). *Poem and Letter to Ch'en Chih.* Detail of handscroll, *(no. 25b).*

Yü Chi was an eminent scholar in the K'uei-chang-ko whose prolific literary output and critical perceptions earned him a revered position in Yuan cultural history.[74] Yü Chi wrote in large-standard (also showing the influence of Yen Chen-ch'ing) and small-standard scripts; his colophons appear on a number of important early paintings in addition to the Kuo Hsi.[75] His writing in the latter is plain, with pure, simple strokes.

K'o Chiu-ssu (1290–1343)
"Palace Poems" *(no. 20)*

As "Master Connoisseur of Calligraphy" in the K'uei-chang-ko, K'o Chiu-ssu was highly esteemed by the emperor and could influence imperial taste and patronage. His calligraphic style was consistent and seems to have been derived from the T'ang masters Ou-yang Hsun (557–641) and his son, Ou-yang T'ung (d. 691).[76] Although the tall structure and narrow arrangement of inner strokes are similar to theirs, K'o Chiu-ssu's personal flair is apparent in the subtle curvatures of the horizontal and vertical strokes, and in the thin ligatures, embellishments which reveal his fine brush-tip action.[77] The brushwork of his poetic colophon to Kuo Hsi's painting *(fig. 62)* is slightly heavier. K'o Chiu-ssu's style embodies the excellence of the mid-Yuan achievement in small-standard script which continued into the early Ming.[78]

Ni Tsan (1301–74)
"Poems and Letters" *(nos. 25a,b)*

The late Yuan master Ni Tsan developed a distinctive personal style in both his painting and calligraphy. Ni's broad and open structures reveal the styles of Ch'u Sui-liang (596–658) and Chung Yu (151–230) as his models. However, Ni Tsan's strokes begin with sharp "exposed" heads and end with a firm emphasis, giving his lines a tensile, stylized quality.

The scroll "Poems and Letters" from the Hou Chen Shang Chai is composed of writings addressed to different persons mounted together by a later collector. Their style and quality are inconsistent, but two authentic sections have been selected. The first section *(no. 25a)* was written for Keng-yü, Ni's friend Hsu Ta-tso (1333–95). Dated mid-autumn 1373, one year before Ni's death, it displays the broader structure and thin flexed strokes with "knoblike" accents which appeared in his works from about 1370.

The second section *(no. 25b and fig. 63),* written for the painter-poet Ch'en Chih (1293–1362), is not dated. In it Ni expresses his anxiety: he says that even though he is poor, he will "let things be" *(tzu-jo),* and apologizes that ordinarily he would not admit his situation to any-

one. Thus the letter must have been written after ca. 1355, when Ni Tsan, who had given up his possessions, was no longer the wealthy landlord. Stylistically the brushwork of this section is gentler, the strokes given less emphasis, and the structures slightly taller than in his later style. If compared to other of Ni's genuine dated works, this letter may be dated to between 1360 and 1362, the year of Ch'en's death.[79]

Standard Script in the Ming

The small-standard script of the early Ming master Sung K'o (1327–87) represented a significant stylistic shift after Chao Meng-fu. The eldest of a group of scholars active in Suchou and nearby areas who wrote in small-standard script, Sung K'o gave the script a new "look." One of his finest works is a transcription in various scripts of the famous "Thirteen Colophons to the *Tu-ku Lan-t'ing* by Chao Meng-fu" *(fig. 64).*[80] Sung K'o made his copy in 1370, sixty years, or one complete cycle, after Chao brushed the original, testifying to his admiration for Chao.

Shen Tu (1357–1434)
"Preface and Poems by Chu Hsi" *(no. 26a)*

Shen Tu was one of Sung K'o's most important followers. His "Preface and Poems" contains several passages in small-standard script of different sizes. Even in his extremely small writing, the methods are complete: close attention is given the "entering" and "finishing" strokes, and tension is sustained throughout the movements, a feat requiring great precision and concentration. In both brushwork and structure, Shen Tu equals the high standard set by Sung K'o.

Shen Tu and Sung K'o gained their reputations from their calligraphy, whereas an earlier scholar like Sung Lien (1310–81), who exerted an important influence on Sung K'o and his generation, was an eminent historian and man of letters.[81] Sung Lien's writing was therefore imbued with a genuine scholarly flavor, whereas the calligraphy of the followers of Sung K'o and Shen Tu (who were not necessarily important scholars) tended to become over-precise and monotonous. This decline in tradition was given the pejorative description "examination-hall style" (*kuan-ko t'i*). The reaction against writing of this type led to the important revival in the middle Ming of the Sung and Wei/Tsin masters' styles, culminating in the achievements of Chu Yun-ming and Wen Cheng-ming.

FIG. 64. Sung K'o (1327–1387). *Transcription of Chao Meng-fu,* "*Thirteen Colophons to the 'Tu-ku Lan-t'ing.'*" Dated 1370. Detail of handscroll. Li Ch'i-yen Collection, Hong Kong.

Chu Yun-ming (1461–1527) and Wen Cheng-ming (1470–1559)

The importance of Chu Yun-ming and Wen Cheng-ming in the revival of ancient styles in the Ming has been discussed above. Both were also masters of standard script, especially small-sized standard. Chu Yun-ming's transcription of Chu-ko Liang's *Ch'u-shih-piao,* dated 1514 *(fig. 83),* embodies his newly sought "primitivism," meant to counteract the "examination-hall style." He also imitated Wang Hsi-chih's *Huang-t'ing-ching.*[82] Chu studied the Wei/Tsin masters through carved models of *fa-t'ieh.* Rubbings from these anthologies frequently lost the fine links and details, leaving only a basic form. Chu Yun-ming and his younger contemporary Wang Ch'ung tried to capture this simplicity in their brush-writing. Their formal writings were so faithful that they could look like carvings; this flavor was also assimilated into their "personal" styles.

Wen Cheng-ming's special prowess in small-standard

writing was demonstrated in his eighties, when he produced masterful renderings in the miniature style, without relinquishing his neatness or precision.[83] In this script type as well, the differences in artistic personalities are apparent: Wen Cheng-ming was interested in clarity and brushtip action which served him well in small-writing, whereas Chu Yun-ming favored naïve clumsiness. Even though they emulated the same models, such as the *Huang-t'ing-ching*, they brought out entirely different aspects of its style.

Followers of Wen's style were numerous, but in imitating his forms, they produced lifeless replicas. This trend was countered by the energies of Tung Ch'i-ch'ang (1555–1636). However what was begun by Tung as a reaction against orthodoxy eventually became orthodoxy itself.

Standard Script in the Ch'ing

During the early Ch'ing, imperial patronage of Tung Ch'i-ch'ang's and Chao Meng-fu's calligraphy encour-

FIG. 65. *Epitaph of Wang Tan-hu*. Dated 359. Stele excavated near Nanking. Detail of rubbing.

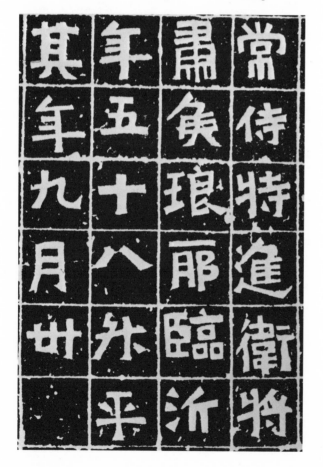

aged the development of monotonous styles which echoed the early Ming court phase and prevented the full development of the more monumental writing practiced by such masters as Wang To (1592–1652) and Fu Shan (1607–84).[84] Only during the mid-Ch'ing did the rise of the *pei-hsueh* movement and the increased impact of Yen Chen-ch'ing's style lead to new developments in standard script.

Chin Nung (1687–1764)
"Plum Blossoms and Calligraphy" *(no.77)*

Chin Nung's personal style is reminiscent of the flat squared forms of ancient steles. He adapted the brushwork from clerical script, for which he was famous, to write standard forms, developing an "archaic standard" script. In his boldly-placed inscription on "Plum Blossoms and Calligraphy," Chin Nung stressed the methods of stone carving: the brush commences with a slanted "cut" into the paper, is drawn flatly across with a straight tense movement, and ends with a slight upward hook. All strokes are formed with taut energy.

The sources of Chin Nung's style extended beyond the T'ang to the Tsin and were stimulated by the contemporary *pei-hsueh* movement. Several examples from the Tsin period have recently been excavated; their resemblance to his style is meaningful, suggesting that Chin Nung may have seen similar ones *(fig.65).*[85] In these examples the direct attack of the carver's knife dominates the forms, and Chin Nung's "translation" of these back into brushwriting was his singular achievement. It was an "anti-brush" method, and shows how much standard script had changed from the classicism of Chang Chi-chih or Chao Meng-fu.

Chin Nung's art had a wide audience. Common folk appreciated his innovations, and despite his eccentricity, scholars recognized his erudition and the antique basis of his art.

Weng T'ung-ho (1830–1904)
"Couplet on Confucian and Taoist Virtues"
(no.85 and *fig.67)*

Weng T'ung-ho was one of several late Ch'ing masters whose calligraphy benefited from the revival of Yen Chen-ch'ing's strong style.[86] In his early years, Weng practiced the styles of Ou-yang Hsun and Ch'u Sui-liang; in his middle years, he turned to Yen; and in his fifties, he practiced the inscriptions from Han steles.[87]

"Couplet on Confucian and Taoist Virtues" appears to have been rendered after an example by an earlier contemporary Tso Tsung-t'ang (1812–85) *(fig.66).* Tso's style was also influenced by Yen's forms through Ho

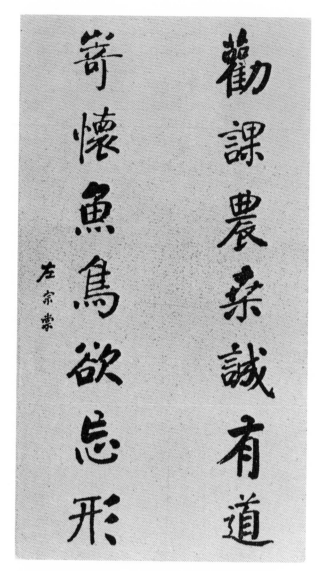

FIG. 66. Tso Tsung-t'ang (1812–1885). *Couplet on Confucian and Taoist Virtues.* Pair of hanging scrolls. Collection unknown.

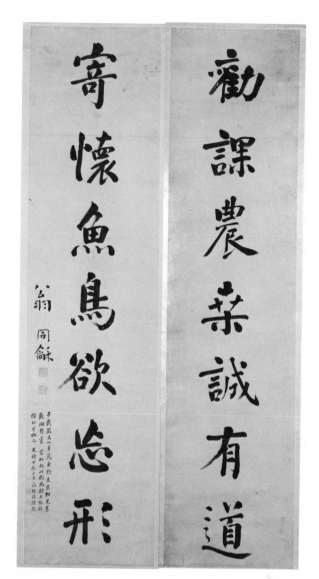

FIG. 67. Weng T'ung-ho (1830–1904). *Couplet on Confucian and Taoist Virtues, (no.85).*

Shao-chi, but Tso tended to stress movement and the contrast of thick and thin strokes. Weng's writing is calm and stable; the strokes are weighty and broad, with generous spacing. (Compare, for example, the topmost characters in the two works.) The brushwork here does not have the trembling movement of Weng's late style,

so the couplet may well have been executed in his fifties, ca. 1880. The relatively early style, the valuable colophon by Weng's grandnephew, the relationship to the couplet by Tso Tsung-t'ang, and the "second" layer make this a work of unusual interest.

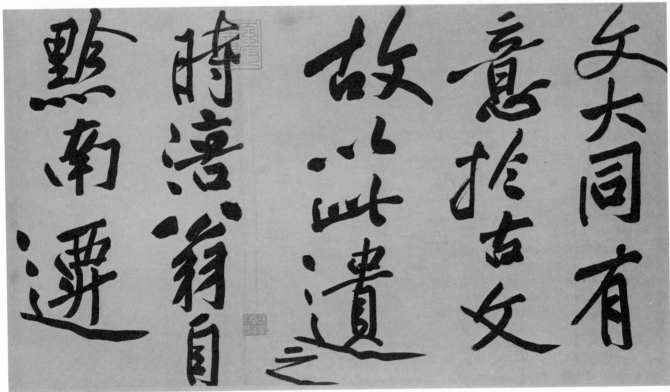

6 Huang T'ing-chien (1045–1105), *Scroll for Chang Ta-t'ung*,
inscription to an essay transcribed for his nephew.
Dated 1100. Sections of handscroll. (Detail opposite.)
Anonymous loan, The Art Museum, Princeton University.

六

病

饿

拜

心

不

心

芾頓首屏啟契邑辛歲豐

無事足以養拙苟祿無足為

者然

明公初當軸當措生民於仁

壽縣令承流宣化惟日拭目

傾聽徐与含靈共陶

重化而已　芾頓首屏啟

9a Mi Fu (1051–1107), *Abundant Harvest.*
Letter mounted as album leaf.
Anonymous loan, The Art Museum, Princeton University.

9b Mi Fu (1051–1107), *Escaping Summer Heat.*
Letter mounted as album leaf.
Anonymous loan, The Art Museum, Princeton University.

10 Fan Ch'eng-ta (1126–1193), *Colophon to "Fishing Village at Mt. Hsi-sai."*
Dated 1185. Sections of handscroll.
Collection of John M. Crawford, Jr.

尚有滄江幅水竹

郭郎平遠今

無魯畫師班重

屋爾何 海嶽

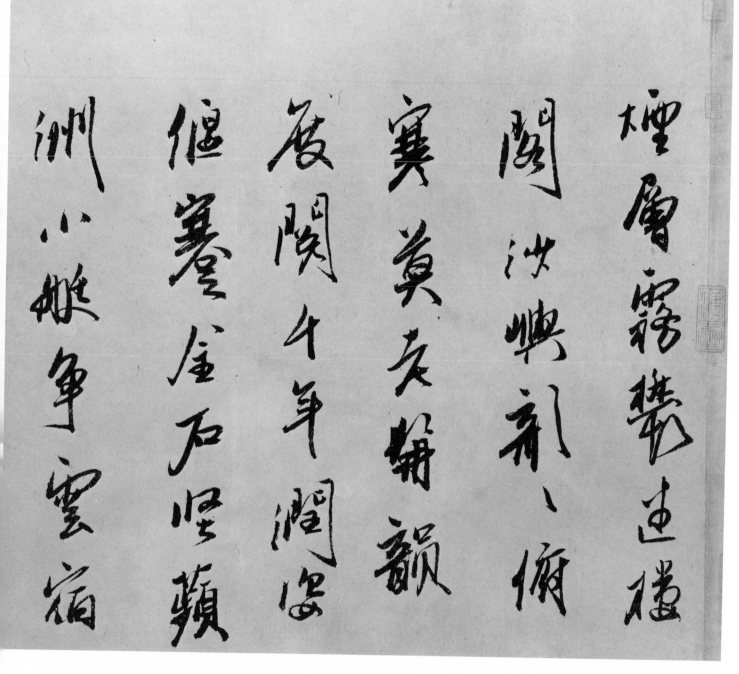

19 Feng Tzu-chen (1257–after 1327), *Colophon to "Lowlands with Trees."*
Sections of handscroll.
Collection of John M. Crawford, Jr.

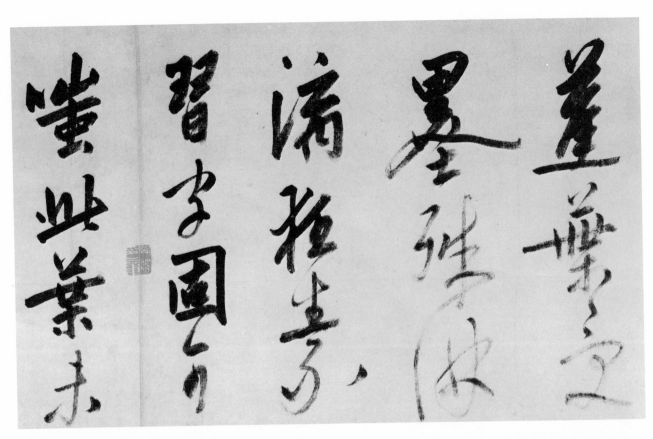

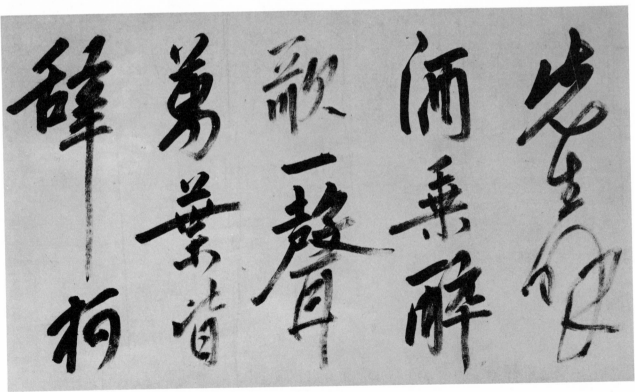

28 Yao Shou (1422–1495), *Writing about Banana Plants*.
Dated 1489. Sections of handscroll.
Anonymous loan, The Art Museum, Princeton University.

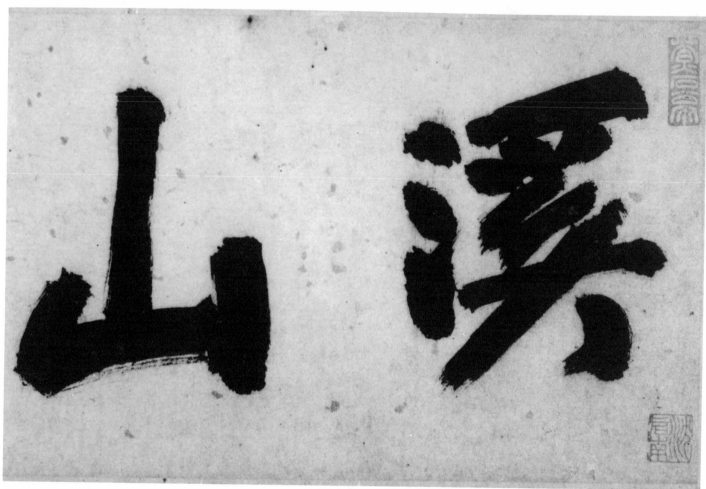

29 Shen Chou (1427–1509), *Autumn Colors among Streams and Mountains.*
Frontispiece to his painting. (Detail below.)
Lent by Douglas Dillon. Courtesy Metropolitan Museum of Art.

和王濟之
齋居苦雨

病臥三月

餘幽憂滿

懷積素

居當杪

秋更為雨

聲迫漂

此意多已

識其素

還還兒

寧宏破

無年

31 Wu K'uan (1436–1504), *Four Poems.*
Sections of handscroll.
Collection of Wang Chi-ch'ien.

50b Wen Cheng-ming (1470–1559), *Poems and Colophons to*
"Summer Retreat in the Eastern Grove."
(Above) third poem. (Below) first poem. Sections of handscroll.
Collection of John M. Crawford, Jr.

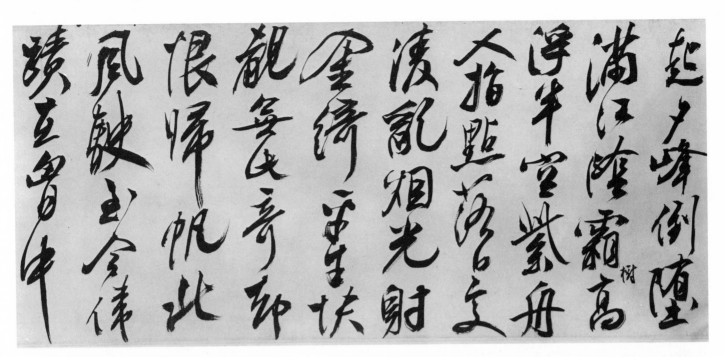

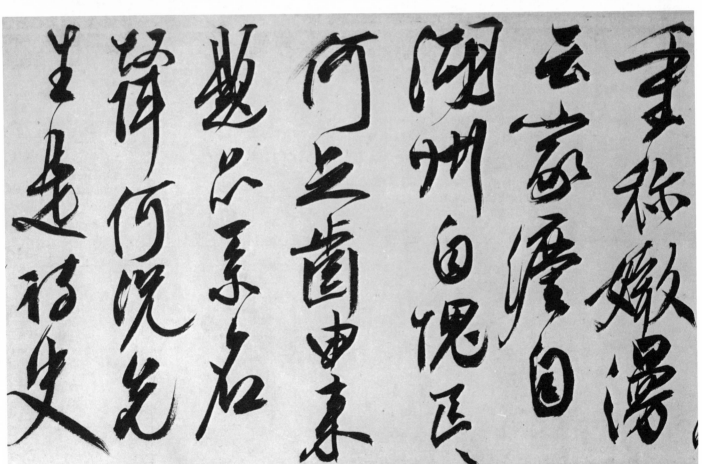

51 Wen Cheng-ming (1470–1559), *Sunset on the Chin and Chiao Mountains.*
Dated 1521. Sections of handscroll.
Collection of Mr. and Mrs. Hans Frankel.

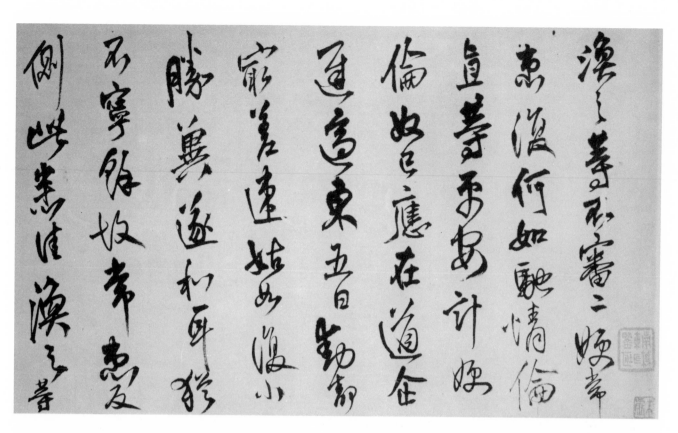

64 Wang To (1592–1652), *Transcription of Letters by Wang Min.*
Dated 1641. Sections of handscroll.
Anonymous loan.

永和九年暮春會于會稽山陰之蘭亭脩
禊事也羣賢畢至少長咸集此地迺峻領崇
山茂林脩竹又有清流激湍暎帶左右引以為
流觴曲水列坐其次是日也天朗氣清惠風和
暢娛目騁懷洵可樂也雖無絲竹管絃之盛
一觴一詠亦足以暢叙幽情己故列序時人錄其
所述

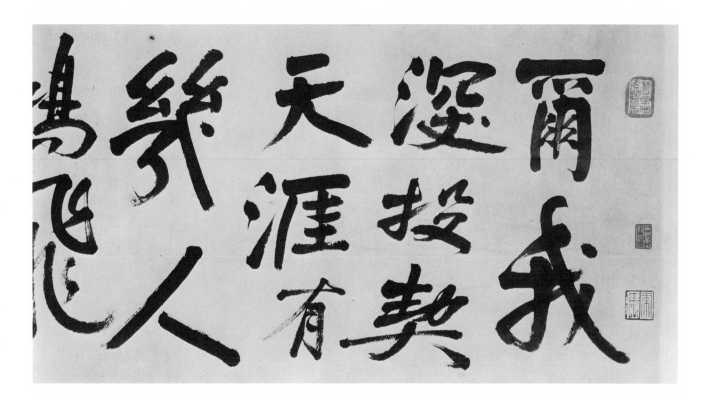

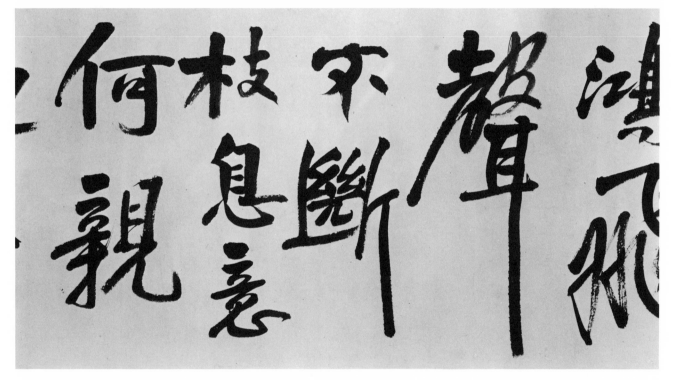

72 Tao-chi (1641–ca. 1710), *Farewell Poem to Jen-an*.
Sections of handscroll.
Keith McLeod Fund, 55.387. Courtesy Museum of Fine Arts, Boston.

70 OPPOSITE
Chu Ta (1626–1705), *Preface to "Gathering along the River."*
Album leaf.
Collection of Mr. and Mrs. Fred Fang-yu Wang.

81 Ho Shao-chi (1799–1873), *Couplet collated from
"Preface to the Orchid Pavilion Gathering."*
Pair of hanging scrolls.
Anonymous loan.

少林七兄屬

畫長梁燕從容語

風定瓶花自在香

左宗棠

82 Tso Tsung-t'ang (1812–1885), *Early Summer Dwelling.*
Pair of hanging scrolls.
Anonymous loan.

89 Yang Shou-ching (1839–1915), *Setting Sun over the Forest.*
Dated 1909. Pair of hanging scrolls.
Anonymous loan.

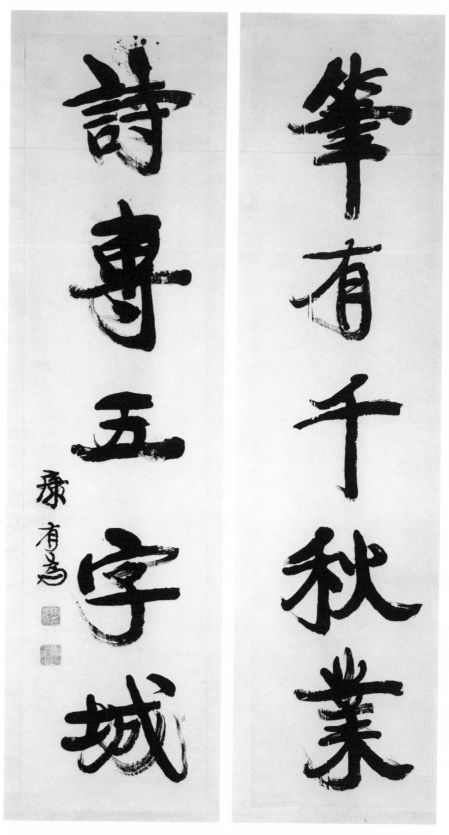

90 K'ang Yu-wei (1858–1927), *Your Writing Will Last a Thousand Autumns.*
Pair of hanging scrolls.
Yale University Art Gallery.

孝男張即之伏遇六
月初一日
顯考太師資政殿大
學士張六三相公遠

隱諱誓山縂兩俾臣
馬溥祐六年歲在丙
午即之手六十一歲
謹題

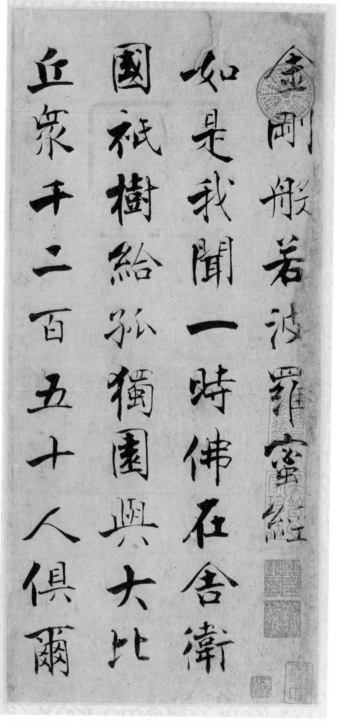

11a Chang Chi-chih (1186–1266), *Diamond Sutra.*
Dated 1246. Album leaves.
Anonymous loan, The Art Museum, Princeton University.

玉潤金明 記曲屏小几剪葉秧根經
羊汜人重見瘦影娉婷雨帶風標
零亂步雲冷鶩瓷吹春相逢舊
京洛素醫塵緇仙掌霜凝
國香流落恨正冰銷翠薄誰念
遺簪小窗天遠應想揀弟梅兄
渺、魚波望極五十絃愁滿湘
雲凄凉耿芸語夢入東風雪盡
江清 夷則商國香慢
弁陽老人周密

12 Chou Mi (1232–1298), *The Most Fragrant Flower*,
colophon to "*Narcissi*," painting by Chao Meng-chien.
Section of handscroll.
The Metropolitan Museum of Art, Gift of the Dillon Fund, 1973.

15b OPPOSITE
Chao Meng-fu (1254–1322),
Record of the Miao-yen Temple in Huchou.
Section of handscroll.
Anonymous loan, The Art Museum, Princeton University.

趙孟頫書并篆額

妙嚴寺本名東際距吳興郡城七十里而近曰徐林東接為咸南對涵山西傍洪澤北臨洪城暎帶清流而離絕蹟塵誠一方勝境也先是宗

白茅初薦饌月色當壚蕭太

清親祀甘泉除祕祝受釐宣室問

蒼生星乘仙仗神光日遠

天顏瑞彩明多少送官齋呼嶽

豐年有象樂昇平

宮詞二首

至尊明日慶生辰準備龍衣慰貼新

奉御進呈先取昔窟珠錯落間麒麟

三碗調冰瀲雪花金絲纏扇繡紅紗

影賤御製題端午勑送皇姑公

主家

柯九思錄呈

無言大禪師

上京宮詞

瀍京三伏暑無多　仙樂飄颻落
禁坡翡翠樓高　起曉日水精殿冷
看天河千官錫宴齋宮錦萬馬
爭標盡寶珂獨有小臣如鵠立
九重閶闔問秋禾
應制賦郊祀大禮慶成二首
輦路千門喜氣浮太平
天子祀圜丘奉常奏備離溫室
尚服陳羅進大裘雲載朱斿飄
綵鳳天臨玉輅駕翠虬腐儒繆樛羾
金閶籍目醉縈光出御樓蒼

20 K'o Chiu-ssu (1290–1343), *Palace Poems*.
Sections of handscroll.
Anonymous loan, The Art Museum, Princeton University.

八月七日偕　耕雲嫂訪　耕漁隱者風雨庵寮中

為留三日二有圖書筆硯之樂九日耕隱賦詩見

贈輙次韻奉荅　瓚再拜

耕雲同一笑也

雲臥雨聲集　庭樹颯以秋身同孤飛鶴心若不繫

舟揮柂松菌濡豪臨硯流蘭芳日泂悴吾

生行歸休不作螻蟻夢游神鳳麟洲青山滄相對

白暖忽滿頭仙亏雲冉冉風鳴竹脩　譚引伐木詩焉

嚶尚相求居吳二十載未及茲山遊君才如貌謝搞辭

亦云優懌然敬愛容寧不為此留幸土鳳雨徹戶

脩何綢繆地無塵器雜況此巖宂幽晴歸引

歲癸丑中秋日瓚

題　耕漁軒

漢水東西合人家高下居琴書忘產業眹陟隱耕漁

積雨窠留宿新晴人趂廬歡喧素洗耳清洲逺前除

僕末軒中自古日至此凡四日矣風雨乍晴神情開朗

而又与　耕雲　耕漁英言娛樂如行至山中文鋷自呈照暎

人也喜而復賦此詩十日瓚

25a Ni Tsan (1301–1374), *In Response to Keng-yin*
and *The Keng-yü Studio*.
Dated 1373. Section of handscroll.
Hou Chen Shang Chai.

先生与言也回知　偶不胸中天平謬筆乃此不煩　攅昨目迫暮疾書草三奉荅得非多美昨書中　漂摇不動心嗟不自戕成濯三牛山何日見喬林　鑛淨禪那曾往嶺雲深猿猱騰攫何頑怖風雨　米綜流水寫徽音古意寥三我獨尋道業巳銷金　昨草三寫呈次韻亢用詩益重欵以呈　窻眠　埃壠鳶飛安可挽青雲氣翻三猶羲羲皇人清風北　先俯仰欷歔魚浮沉各天淵慎勿傷本性不雕而上　共酔對酌歡劇更恛然豪窮則巳言達誰當　舣到家日雨砌潤滑三琖酒仍滿眼素琴久無絃呼我　伹方俱秋忽然巳改年樓前櫻桃花開落春風顛　真獨有道先生執事　檢閲故不洇漬乃承示教良感旋錄繆詩呈教埃飛鐸　門埃字蓋和卷玉都司見貽詩韻有此字無韻書可

25b Ni Tsan (1301–1374), *Poems and Letters to Ch'en Chih.*
Section of handscroll.
Hou Chen Shang Chai.

昆崙大無外旁薄下深廣陰陽無停機

寒暑互來往羲皇古聖神妙契一俯仰

不待窺馬圖人文已宣朗渾然一理貫昭

晰非罔象珠重無極翁為我重指掌

得　篇雖不能探索微妙追迹前言然皆切於目

用之實故言示近而易知既以自警且以貽諸同志云

26a Shen Tu (1357–1434), *Transcription of Preface and Eight Poems*.
Section of handscroll.
Anonymous loan, The Art Museum, Princeton University.

乾隆元年應舉至
都門與徐亮直翰林過張司寇
屯司寇出觀趙王孫墨梅小立軸
冷春清艷展視撫人大伭予緗
塵況素衣也今二老僊去予亦衰顏
追寫塞葩不覺黯然自失恨不全二
老見我橫枝滿幅含豪作簡齋
詩句一題其上也
七十五叟農畫記

77 Chin Nung (1687–1764), *Plum Blossoms and Calligraphy.*
Dated 1761. Detail of inscription.
Yale University Art Gallery; Leonard C. Hanna, Jr., B.A. 1913, Fund.

題跋与法書

V

Format and the Integration
of Painting and Calligraphy

FORMAT, whether handscroll or hanging scroll, album leaf or fan, has had a formative influence on the principles of painting and calligraphy. The integration of word and image has been a function, historically and aesthetically, of format selection. The purpose of this essay is to discuss this function briefly, to provide material for further research, and to reaffirm the interrelationship of writing and painting in the study of Chinese art history.[1]

The Handscroll

One of the earliest extant scrolls which combined painting and calligraphy is "Admonitions of the Court Instructress to her Ladies," a handscroll attributed to Ku K'ai-chih (341–402), in the British Museum (fig. 68).[2] The scroll illustrates an early didactic text composed by the late Han scholar Chang Hua (232–300), and represents the prototype for a number of important early handscrolls from the Sung (960–1278) and Yuan periods (1279–1368).[3] The treatment of it is episodic, with an alternation of words and illustrations, which was an agreeable solution to the handscroll format; for, seated at a desk, one could view it in succeeding sections. This alternating treatment became one of the standard features of the Chinese painted scroll.

Normally, the text preceded the painting, so that it was not a question of writing "on" the painting, but rather of adding pictures to illustrate the words. The inscriptions could be written by the painter or by contemporaries. Because the calligraphy usually occupied a minor part of the total presentation, illustrated scrolls have commonly been considered paintings and, for the most part, have been studied as such. Nonetheless, they are important as a resource in the study of the history of calligraphy.

As the illustrated handscroll developed, poetry began to replace an existing text. When the painter himself composed the poetry and wrote the calligraphy, this triple mastery was called the "three perfections" (san-chueh), a phrase coined as early as the eighth century, and which subsequently became a significant concept in Chinese aesthetics.[4] Scrolls which combine the three arts by a single master are rare, but a number of them exist that date from the Yuan dynasty or later. They reflect a shift in subject matter—from the historical or narrative figures and landscapes of the earlier period, to bamboo, flowers, old trees, and rocks, subjects associated with the amateur paintings by scholars of the Northern Sung. These now served as vehicles for a purer, more personal form of self-expression, one more closely allied to the essential function of poetry as an expression of distilled

FIG. 68. Ku K'ai-chih (341–402). *Admonitions of the Court Instructress.* Calligrapher unknown. Detail of handscroll. Courtesy of the British Museum.

moods or emotions. Of course, the text's relationship to the subject differed from that in the earlier scrolls, but the *visual* alternation of writing and image remained the same. As expressions of a single mind and hand, the scroll that consisted of poetry, painting, and calligraphy offered the potential for an exceptional unity of concept and presentation, as well as for an intimate verbal and pictorial relationship within the simple additive framework.

In the late Yuan and early Ming, the work of Chao Chung (active ca. 1350–75) and Yao Shou (1423–95) not only demonstrates the high degree of stylistic consistency that could be achieved by a single master in his calligraphy and painting, but exemplifies two distinct temperaments and artistic styles. Chao's "Ink Flowers," dated 1361 (Cleveland Museum of Art),[5] looks back to the archaic and introspective restraint of Southern Sung conservative painting and calligraphy, while Yao Shou's handscroll, "Trees, Birds, and Flowers" (fig.69; Art Institute, Chicago) looks forward to the bold calligraphic brushwork of later Ming styles. In the sixteenth century the same combination of poetry, calligraphy, and painting was embodied in the work of such artists as Ch'en Shun (1483–1544) and Hsu Wei (1521–93).

Hsu Wei (1521–93)
"Twelve Plants and Twelve Calligraphies"
(no.61)

Hsu Wei's handscroll is a superb example of the aesthetic diversity and formal unity that was possible to

F I G . 69. Yao Shou (1423–1495). *Trees, Birds, Flowers.*
Detail of handscroll. The Art Institute of Chicago.

achieve within the handscroll format. The alternation of various flowers, plants, and rocks, and the moist ink suffusions, together with the supple linework of the calligraphy and painted image, echo each other in nervous rhythms. Strong calligraphic momentum is generated, and Hsu magnified it in his treatment of grapevines, for example. Moreover, his preference for a "loaded" brush led to characteristic suffused ink blots in both his writing and painting.

Cheng Hsieh (1693–1765)
"Orchids and Bamboo" *(no. 78a)*

"Orchids and Bamboo" differs radically from "Twelve Plants" because of its departure from the alternating word and image pattern. The painting was conceived as a continuous unity with no ground line: the orchids and bamboo are scattered randomly across the paper just as they might be in nature. Cheng Hsieh's inscription appears at the end of the scroll; and the calligraphy, in various script types by four contemporaries, was added more than a decade after the painting had been completed. Cheng Hsieh's judicious spacing not only allowed for these additions but implies that he may have anticipated them. While the inscriptions are subtly placed, the calligraphy, other than that of his pupil Chu Wen-chen, is undistinguished and contrasts with Cheng Hsieh's, which is most notable. His diagonal and elongated strokes repeat the lithe forms of the orchid petals, which free float in the air toward his inscription. Indeed, Cheng's bamboo and orchid leaves reflect the essence of calligraphic brushwork; and his calligraphy, the extension of painterly forms.

Among the later masters, Cheng was outstanding in

that he totally integrated the calligraphic inscription into the painting, and developed its potential for organic unity far beyond his predecessors, such as Tao-chi (1641–ca. 1710), to whom he is indebted as a painter. A prolific artist, Cheng is well represented in Western collections.

The Colophon

The colophon—an inscription in prose or poetry appended to a work of calligraphy or painting—was not originally meant to be part of the composition. As a category of writing, it is valued both for its historical content and for any literary or artistic qualities it may have. The colophon therefore is one of the major contributions to the history of Chinese calligraphy and deserves far greater attention than it has received thus far.

The earliest colophons appear as brief comments following transcriptions of Buddhist sutras. While the majority date from the fifth and sixth centuries, the earliest is dated 296 *(fig. 70)* and consists of five lines appended to a sutra fragment from the Western Tsin period which records the exact day, month, and year of the writing as well as the number of characters.[6] It is a postscript by the transcriber, who wished to record data for the future. That notion of historical record was the motivation for many colophons.

While a colophon may be no more than a signature, it is especially valuable to scholars if it includes a date, a place name, some comment on the circumstances of the writing, and a dedication, all of which became conventional elements of the colophon.[7] There is no written evidence concerning the practice until the T'ang period

(618–906), when literature and painting flourished as the chief means of expression of the literati class. Extant material is as follows:[8]

(a) "Poems on paintings" (*t'i-hua-shih*). Poems inspired by paintings are a distinct category. The great poet Tu Fu (712–770) is credited with having initiated the custom, and indeed, a number of famous poems by him about paintings and painters are frequently quoted.[9] However, these are not known to have been inscribed onto the paintings. It is only from the Sung period onward that paintings with inscribed poems are extant.

(b) "Self-inscriptions" (*tzu-t'i*). The painter may also add his comments to the work after it has been completed. Several great artists of the T'ang, such as the poet-painter Wang Wei (701–761), Wu Tao-tzu (active 742–755), and Chang Tsao (active 766–778) are known to have inscribed their paintings.[10] These early inscriptions indicate that the painter was a man of letters, not an artisan. Such inscriptions later became the custom among literati painters.

(c) Inscriptions by others (*pa-wei*). The Chinese term for colophon was used as early as the eighth century, and a record of two dated colophons by the T'ang Emperor Hsi-tsung (r. 874–888) are recorded in a twelfth century text.[11] Records of this kind are rare, and little original material has survived. One of the earliest extant colophons in this category dates to the Five Dynasties period and may be found on a scroll (*fig. 71*) now in the Palace Museum, Taipei. Dated 947, it bears the signature of Yang Ning-shih (873–957), a calligrapher who strongly influenced the Northern Sung masters.[12]

The colophon reached its height as a form of literary expression in the Sung period. As a genre of informal writing, it offered an opportunity to express private thoughts, philosophy, and criticism in poetry or prose. Colophons were often written at pleasant gatherings where fine poetry was composed and works of art were viewed and criticized. Thus, in many cases, they represent the considered opinions of the writer following his close examination of an art object. As literature, the colophon may reveal the mind of the writer, and as calligraphy, it may be the finest brush-writing of a master.

Although there are very few extant works by such great early Sung calligraphers as Su Shih, Huang T'ing-chien, and Mi Fu, each of them has left a large body of recorded colophons. Their fame often led to the removal of these colophons by later collectors and to their remounting as separate works of art.[13]

However, major colophons do remain by Huang T'ing-chien (1045–1105), the great Northern Sung master; his colophon to Su Shih's "Poems on the Cold Food Festival" and his five colophons to Li Kung-lin's

FIG. 70. *Colophon to a Buddhist Sutra.* Dated 296. Collection unknown.

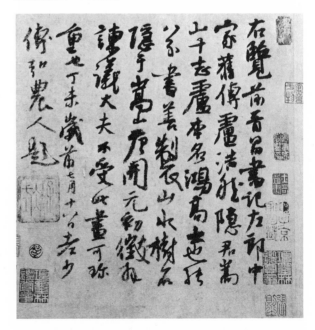

FIG. 71. Yang Ning-shih (873–957). *Colophon to Lu Hung, "Ten Views from a Thatched Cottage."* Dated 947. Detail of handscroll. Palace Museum, Taipei.

"Five Tribute Horses," are rare instances of comments that have remained attached to the original work.[14] Huang's colophons to the "Five Horses" identify the painter and describe the presentation of the horses to the Emperor. Each comment accompanies a superb depiction of a horse and its groom in an alternating arrangement similar to that of the early "Admonitions" scroll. A prime specimen of the collaboration between two of the most eminent litterateurs of Sung culture, the distinguished colophons, by confirming the authorship of the painting, infinitely enhance the value of the scroll.

Huang T'ing-chien (1045–1105)
"Scroll for Chang Ta-t'ung" (no.6)

The calligraphy of Huang T'ing-chien's "Scroll for Chang Ta-t'ung," originally attached to a transcription for his nephew of a text by Han Yü (now lost), is so large and impressive that the scroll is more than a mere colophon. Indeed, it is on a par with the few examples of the master's individual, large-sized writing dating from his later years.[15] Huang executed this work with such concentration and energy that, at the end of the scroll, he could say in all honesty that he did not know if he could ever write such characters again.

Other colophons from the Northern Sung period have been found on earlier scrolls, such as T'ang copies or early rubbings of the *Lan-t'ing*, but they are usually brief and have none of the calligraphic impact of a major master's writing, such as that of Huang T'ing-chien.

Fan Ch'eng-ta (1126–93)
Colophon to "Fishing Village at Mt. Hsi-sai" (no.10)

A larger number of works with their original colophons have survived from the Southern Sung and Chin periods.[16] "Fishing Village at Mt. Hsi-sai," a lengthy poetic commentary dated 1185, by Fan Ch'eng-ta, is followed by six colophons dated within a decade by such prominent scholar-officials as Hung Mai (1123–1202), Chou Pi-ta (1126–1204), Wang Lin (1128–92), and Chao Hsiung (1129–93). Of them all, it is Fan's colophon which is outstanding. His feeling for the simplicity of rural life is conveyed by the immediacy of his descriptive detail: the content reveals the scholar's desire for a pastoral retreat, an important theme in Chinese poetry since the time of T'ao Ch'ien (365–427). Toward the end of the colophon, Fan grew more excited as he imagined retirement in Hsi-sai, so that his brushwork became freer and more cursive. Thus what is in fact merely a charming painting was elevated to major stature by Fan's touch, conveying his personal experience and the timeless longing of a scholar.

Chou Mi (1232–98)
"The Most Fragrant Flower," Colophon to
"Narcissi" (no.12)

A colophon very different in tone and sentiment from the above—a lyric poem by Chou Mi—was appended to another scroll of the late Southern Sung period: "Narcissi" by Chao Meng-chien (1199–1267). When the Mongol army moved south in 1276 to conquer the Southern Sung, they destroyed Chou's vast family library and collection of antiquities. He therefore retired to Hangchou, where he became the center of an important literary and artistic circle which included the leading poets, scholars, and officials of the day. Among them were Hsien-yü Shu and Chao Meng-fu, who viewed and inscribed "Narcissi."[17] Today, the earliest colophons that are still on the scroll are by Chou Mi and Ch'iu Yuan (1247–after 1327), another loyalist poet born during the Southern Sung. When Chou viewed the scroll by Chao Meng-chien, a member of the Sung royal family, he doubtless recalled his life under the former dynasty, so that the "fragrant flower" of his lyric might well conceal loyalist sentiments. As Wen Fong commented: "After the shattering Mongol conquest, poetry and painting became part of an underground culture in the south, lamenting a lost time and turning into a sort of resistance art, and flower paintings tended to be looked upon increasingly for their allegorical significance."[18] Thus the colophons heighten the painting's purely aesthetic aspect—a sensitive and breathtaking rendering of fields of wild narcissi—lending specific depth to its content.

Two scrolls from the Chin period (1115–1234), when north China was occupied by the Jurched, are proof of the continuation of Northern Sung traditions by the literati under pre-Mongol rule. A long colophon dated 1228 by the poet-scholar Chao Ping-wen (1159–1232), complements "Red Cliff," a painting by Wu Yuan-chih illustrating Su Shih's famous prose-poems. The calligraphy is in an exuberant mixture of Mi Fu's and Su Shih's styles, and its responsive rhyme intensifies the literary dimension.[19] Moreover, the calligraphy is the only extant example of this major Chin dynasty poet's work.

Another scroll from the Chin period is "Secluded Bamboo and Withered Tree," by Wang T'ing-yun (1151–1202), an esteemed man of letters. The monochromatic depiction is followed by Wang's poetic colophon *(fig.72)* in a style which is strongly indebted to Mi Fu's. More than a dozen other colophons by Yuan scholar-officials are also appended to it. In the first, dated 1300, by Hsien-yü Shu (1257?–1302), a northerner and, with Chao Meng-fu, a key figure in the early Yuan cultural renaissance, Hsien-yü noted that even though

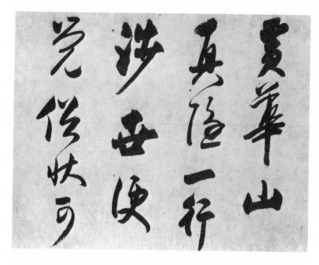

FIG. 72. Wang T'ing-yun (1151–1202). *Colophon to his "Secluded Bamboo and Withered Tree."* Detail of handscroll. Fujii-Yurinkan, Kyoto.

many calligraphers since Wang Hsi-chih have excelled in painting, and vice versa, the superior achievement usually overshadowed the other. He also mentioned that Wang's calligraphy and painting were equal to Mi Fu's, and concluded by affirming the alliance of the two arts: "In the painting there is calligraphy, and in the calligraphy there is painting."[20]

Hsien-yü Shu (1257?–1302)
"Admonitions to the Imperial Censors" *(no.16)*

Hsien-yü Shu's stature as a calligrapher was heightened by his perception as a connoisseur; indeed, his taste and his observations can be taken as representative of the vanguard of literary opinion in the early Yuan.[21] To his transcription of Chao Ping-wen's essay "Admonitions to the Imperial Censors" are appended fourteen colophons by Yuan contemporaries, all of whom were active either in high government positions or in the literary circle in Hangchou, where Hsien-yü Shu resided. As in the case of Wang T'ing-yun's scroll, these colophons are by northerners, southerners, and foreigners in Yuan China and testify to the esteem with which both masters were regarded.

Western collectors have been fortunate in acquiring several important Yuan dynasty handscrolls with superior calligraphy still attached. "Ink Bamboo" by the northerner Li K'an (1245–1320) in the Nelson Gallery, Kansas City, bears colophons by Chao Meng-fu (1254–1322) dated 1308 *(fig.73)* and Yuan Ming-shan (1269–1322) dated 1309, both of which are distinguished for the impressive size of the writing.[22] Another important

colophon to a Yuan dynasty painting is Yang Wei-chen's free, monumental writing *(fig.47)* on Tsou Fu-lei's "A Breath of Spring" (Freer Gallery of Art, Washington, D.C.).[23]

Feng-Tzu-chen (1257–after 1327)
and other Yuan colophons on Kuo Hsi's
"Lowlands with Trees" *(no.19)*

As in Huang T'ing-chien's colophon to the "Five Tribute Horses," the artist of "Lowlands with Trees" is identified by the Yuan scholar Feng Tzu-chen in his important colophon. Its value lies in its being a supporting document as well as an exemplary specimen of Feng's handwriting. Following Feng's colophon are six others by leading Yuan dynasty scholars and calligraphers, including Chao Meng-fu, Yü Chi, K'o Chiu-ssu, and Liu Kuan, names that are as important as those attached to Hsien-yü Shu's "Admonitions" scroll *(no.16)*.

Chao Meng-fu (1254–1322)
"Twin Pines against a Flat Vista" *(no.13)*

One final example from the Yuan dynasty is Chao Meng-fu's handscroll "Twin Pines Against a Flat Vista," which is significant by virtue of its format as well

FIG. 73. Chao Meng-fu (1254–1322). *Colophon to Li K'an, "Ink Bamboo."* Dated 1308. Detail of handscroll. Nelson Gallery–Atkins Museum, Kansas City.

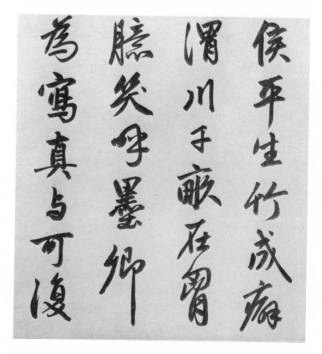

as Chao's inscription at the end. The brushwork demonstrates a more advanced application of calligraphic principles to pictorial form than had been seen before, yet the composition is based on the asymmetrical principles of earlier Southern Sung methods. The dominant pictorial theme is placed to the right, and the composition, despite its linear simplicity, fills the entire picture area. The artist's six-line inscription at the left was clearly added as an afterthought: it overlaps the distant shoreline, and the lines are narrowly compressed. Yet the inscription not only is indispensable to the total balance of the work, but it provides the painter's critical comments on his style.[24]

Chao's paintings are among the earliest surviving handscrolls that include lengthy inscriptions by the artist. In his other works, such as "Autumn Colors on the Ch'iao and Hua Mountains," dated 1296 (Palace Museum, Taipei), or "Sheep and Goat" (Freer Gallery of Art), Chao is equally sensitive to the placement of the inscription as a harmonious addition to the composition.[25] His colophons therefore differ fundamentally from those written on separate sheets of paper, whether by the artist or others, and subsequently appended to the work. Chao's were true "self-colophons": the painting came first; then the writing was added, not purely as a demonstration of calligraphy *per se*, but equally, as an explication.[26]

Wen Cheng-ming (1470–1559)
Two Colophons in Several Styles
(no. 53 and 50b)

Colophons that date from the Ming and Ch'ing periods differ slightly from those executed in earlier periods. Since large numbers of works from those dynasties exist, as do independent works of major Ming and Ch'ing calligraphy, later colophons are relatively less important in the study of calligraphy. Still, several of importance from this period should be noted, in particular, two by Wen Cheng-ming: his long essay in clerical script on Lu Chih's "Streams and Rocks" *(no. 53)*, and his poems and colophon to his painting, "Summer Retreat in the Eastern Grove" *(no. 50b)*. In the latter scroll his writing is in the styles of the Sung masters, Su Shih and Huang T'ing-chien, as well as in the rare large-cursive styles of Huai-su and Huang T'ing-chien. In both scrolls, the calligraphy contributes substantially to the paintings' aesthetic and art historical value.

Two other examples from the late Ming in this exhibition are Tung Ch'i-ch'ang's colophon, dated 1609, which accompanies the *Hsing-jang t'ieh (no. 1b)*, and Tao-chi's "Farewell Poem to Jen-an" *(no. 72)*. Both pieces of calligraphy are rare within the artists' oeuvre and contribute to the aesthetic value of the scrolls.

COLOPHON WRITING was an important form of literary activity in the life of the Chinese scholar, just as calligraphy and its study reflected his cultural background, intellectual refinement, and personal character. The colophon could be as intimate as a letter or as formal as a "work of art". It was revealing of the writer's character because of its expressive brush-forms and content. And as handed down to later generations, it represented the communion of connoisseur and object, constituting a transmission of esteemed values that were of importance to subsequent artists and students of Chinese art history.

The Frontispiece

The frontispiece, or title (*yin-shou*), is another aspect of the handscroll format within which important examples of calligraphy are preserved. Often overlooked in records of paintings and studies of calligraphy, it is a rich source of monumental writing in various scripts: it was the chief vehicle for large-sized writing during the Yuan and Ming periods.

The frontispiece can be traced to the Han period, when commemorative stone steles (*pei*) were surmounted by title-heads (*pei-e*), usually in large-sized seal script. The transition from that format to the handscroll frontispiece is not clear; however, even though the handscroll was well-developed by the Six Dynasties period, it does not seem to have appeared as a medium for large writing until the Yuan.

The earliest examples of a form of handscroll frontispiece which survive accompany Buddhist sutras. By the tenth century it had become the custom to embellish the opening section of the sutra with pious illustrations of the Buddha, and that emphasis on the opening portion of a handscroll may have served as a precedent for the formal frontispiece. An additional reason for that emphasis may have been the actual process of mounting calligraphy and painting. When a handscroll is mounted, a protective sheet of paper precedes the actual work, and although it was not designed for calligraphy, the sheet was frequently decorated with writing later on.

Manuscript transcriptions of texts for steles may also have provided a prototype for the frontispiece. Examples of calligraphy which were intended to be carved into steles survive in their original brushwritten format; indeed, Chao Meng-fu is known to have written several in a handscroll format *(no. 15a)*, and the writing was subsequently adjusted to fit the stele shape before it was carved. The title-piece that eventually surmounted the stele, written as a preface to the text, was probably the

antecedent of the frontispiece in large-sized writing. Chao was not necessarily the initiator of the custom, but he was asked to transcribe a sizable number of these inscriptions because of the excellence of his calligraphy. Thus the format was undoubtedly quite familiar by the Yuan period. In fact, three examples of frontispieces by calligraphers of the latter half of the fourteenth century have been cited: Chao Yung (1289–ca. 1363), Chou Po-ch'i (1298–1369), and Yang Yü (1285–1361).

Chao Meng-fu's son, Chao Yung, is known to have written large seal-script in prefatory titles to painted handscrolls *(fig. 23)*. These are probably the earliest examples of the full-fledged calligraphic frontispiece. The choice of script type for the frontispiece probably also derives from stele writing, for both clerical and seal scripts had been used in the past for title-heads. Thus, when Yang Yü wrote his frontispiece to "A Breath of Spring" *(fig. 38)*, he was following a precedent.

Calligraphic frontispieces were most popular during the Ming, when they functioned as an additional format for the display of large-sized writing, so that more examples of seal and clerical script from the Yuan and Ming periods are preserved. Several specimens from the Ming dynasty bear out this point *(nos. 24a, 27, 49, 50a, 53a, 56, and 66)*.

During the Ming, standard and running scripts were also used for frontispieces. Those by Yao Shou *(fig. 54)*, Shen Chou *(no. 29)*, and Chu Yun-ming *(no. 35a)* are representative. Toward the end of the Ming period, Ch'en Shun *(cf. no. 56)* used cursive, an informal script, for his titles, a fact which reflects the calligrapher's increasing freedom within the fixed format.

During the Ch'ing period the repertoire of formats for large-sized writing was expanded to include short horizontal scrolls containing studio names *(no. 79)* or double panels displaying rhymed or antithetical couplets *(nos. 81, 82, 84, 85, 88, 89, 90)*, both commonly hung on walls as decoration. Because of this change in taste, the more intimate format of the handscroll frontispiece declined in popularity.

The Hanging Scroll and Album Leaf

Early Chinese painters before the Sung seldom signed their works. If they did, it was usually done in a discreet manner, with the signature placed in small characters on a tree trunk or concealed among foliage. This was to prevent their signature from intruding upon the finished composition. Self-inscriptions by three eighth-century masters—Chang Tsao, Wu Tao-tzu, and Wang Wei—are recorded as having been found on wall paintings

(pi-hua).[27] These inscribed murals were the antecedents of the inscribed hanging scroll format.

As seen in the discussions on the handscroll, the prominent Northern Sung scholar-calligraphers played an important role in the elevation of the colophon to an art, a fact which indicates an important shift of emphasis in the Sung from painting as the domain of unlettered craftsmen to painting as the realm of the scholar-amateurs who inscribed their own works or invited the eulogies of friends.

The distinction between handscroll and hanging scroll is straightforward; in the case of the hanging scroll, the painting surface proper and the mounting are the only two areas for writing. Any calligraphy added to the painting would be considered an intrusion, and poor writing or improper placement could ruin the work. Thus scholar-painters became quite selective about whom they invited to inscribe their hanging scrolls— that is, if they had any control over the matter. For example, Su Shih tells an anecdote about his cousin and best friend, the poet-painter of bamboo, Wen T'ung (1018–79). When Wen had finished a painting for a friend, he would warn others to keep away until Su Shih had a chance to inscribe it, for he had left prime space on it for him alone. Wen T'ung felt that only Su Shih understood his art, and also that writing of his caliber would be the true complement to his initial effort.[28] Unfortunately, there are no examples of the collaboration between the two.

However, the Northern Sung Emperor Hui-tsung's (r. 1101–25) calligraphy is extant in both hand and hanging scroll formats.[29] He often wrote inscriptions in his famous "slender gold" script *(shou-chin t'i)* to precede his paintings, as well as titles and poems on other famous works in his collection. The Emperor inscribed "A Literary Gathering" by one of his court painters, with poetry written in large-sized cursive script *(fig. 74)*.[30] Then Hui-tsung's chief minister, Ts'ai Ching (1046–1126), responded to the Emperor's poem with another in the same rhyme pattern on the upper left side of the painting. This is one of the earliest and most complete examples of the responsive integration of poetic forms with painting and calligraphy apart from the Emperor's own works in the handscroll format.

In the Southern Sung another format came into fashion: the round fan. This small format was ideal for the intimate genre scenes and idyllic settings of Southern Sung court life, and were often enhanced by lines of calligraphy that expressed suitable poetic themes. It is important to remember that such fans were actually used. When mounted on a circular frame, the painting would be on one side, and the poetic inscription on the other. This custom was the prototype for the painted

FIG. 74. Emperor Sung Hui-tsung (r. 1101–1125) (upper right) and Ts'ai Ching (1046–1126) (upper left). *Colophons to "A Literary Gathering."* Hanging scroll. Palace Museum, Taipei.

of writing directly on the painting, whether his own or his courtiers', he was asserting his individuality as well as exercising imperial prerogative, and his calligraphy naturally dominated the inscribed object.

In the Yuan period, Chao Meng-fu was appropriately among the first to inscribe hanging scrolls, since he was a distant member of the Sung imperial family. One of his early poetic inscriptions appears on his painting "East Tung-t'ing Mountain" (Shanghai Museum).[32] Like his imperial predecessors, Chao's calligraphy is conspicuous, whereas his inscriptions on handscrolls are on a proportionately smaller scale *(no. 13)*. Chao Meng-fu may be said to have introduced this custom to the Yuan literati, for others in his circle also began to inscribe hanging scrolls. Thus by the mid-fourteenth century it had become a widespread practice.[33]

Yuan poets and calligraphers were sensitive to the total harmony of a work and sought to achieve the integration of calligraphy with painting by the proper selection of script type. Unlike the imperial inscriptions of the preceding dynasty, the writing of this period was usually placed so as not to dominate the composition. Such Yuan painters as Huang Kung-wang (1269–1354), Wu Chen (1280–1354), Ni Tsan (1301–74), and Wang Meng (1308–85) inscribed their paintings in a manner which blended appropriately. The script was usually small and placed in neat rows to one side or in a block at the center. As such, the integration of words and image was still additive, even though space was allotted in advance for the inscription; yet it did not compete with the painted forms.[34] This simplicity and restraint served as a standard for subsequent generations.

Yang Wei-chen (1296–1370)
Colophon to "Gazing at a Waterfall"
(no. 23)

A number of masters tried to break away from what they considered a conservative tendency. One of them, the scholar and calligrapher Yang Wei-chen, was outstanding in his individuality and his strong desire for self-expression. His colophon to "A Breath of Spring" *(fig. 47)* demonstrates his free, unconventional approach. Although his colophons on hanging scrolls were usually more restrained due to the obvious limitations of space, they still make a strong visual impact often equal to the painting.[35]

In his colophon to Hsieh Po-ch'eng's hanging scroll, Yang's writing fills the entire upper fourth of the painting, even though the size of the characters is relatively small. The landscape is full, and the space above the mountaintop hardly seems sufficient. He anticipated his need for space in the two opening lines at the upper right,

and inscribed radial folding fan, which was introduced from Korea into China and became popular in the fifteenth century.

When the small square format was mounted onto screens as part of furniture decoration, it also carried complementary painting and calligraphy. As with the fan, the accompanying poetry was generally a rhymed couplet in five- or seven-character meter.

Couplets or longer poems were also deemed suitable as inscriptions on hanging scrolls. The Southern Sung Emperors Kao-tsung, Hsiao-tsung, Ning-tsung, and Li-tsung, as well as the Empress Yang Mei-tzu, all at one time or another wrote poetic inscriptions on fans or hanging scrolls.[31] It is significant that in the Sung, the inscribers of hanging scrolls and fans were limited to members of the imperial family (and occasionally high ranking ministers), whereas handscrolls were inscribed by scholars. When Sung Hui-tsung initiated the custom

which extend down into the picture area and intrude upon a distant mountain, and he balanced this unusual arrangement by extending the last line at the far left. Yang's spacing in his colophons on paintings was not equalled by later masters.

By the late Yuan, the writing of colophons by literati had reached its height of popularity. Unlike the hand-scroll, on which a large number of inscriptions could be easily accommodated merely by adding more sheets of paper, the space within a hanging scroll was limited, so that it took foresight and consideration of the total design to accommodate even a small number of colophons. The charming depiction of settlements along the Ching River by Ch'en Ju-yen (active 1340–70) in the Palace Museum, Taipei, is a conspicuous example.[36] The scroll is fairly bursting with ten enthusiastic poems and comments of such compatriots as Ni Tsan. Another such example is Chang Chung's (active 1330–60) "Bird and Peach Blossoms," in which quadruple rows of twenty colophons surround the simple depiction of a bird on a branch. Yang Wei-chen's colophon dominates the center of the scroll (fig. 75).[37]

The inscribing of poetic eulogies onto paintings at literary gatherings became almost an institution by the end of the Yuan dynasty, and continued on into the Ming. Thus prime calligraphy by numerous scholars has been preserved. Through study of such literary paintings, whether extant or recorded, much knowledge about artistic circles, especially those of the thirteenth and fourteenth centuries, may be derived. They also document the contact of artist with artist and the possible sources of mutual influence. Indeed, colophons on paintings are a record of the communal activity of intellectuals of like minds but of different generations and are a major factor in the transmission and continuity of artistic traditions in any period.[38]

Wang Ao (1450–1524)
"Ode to Pomegranate and Melon Vine"
(no. 32)

An excellent collaborative effort from the Ming dynasty is Wang Ao's "Ode" on Shen Chou's "Pomegranate and Melon Vine." Shen Chou intentionally painted his subject in the lower part of the composition, leaving more than two-thirds of the upper surface blank for Wang's eulogy.[39] In this case, the thin spikiness of Wang's brushwork prevents the upper half from becom-

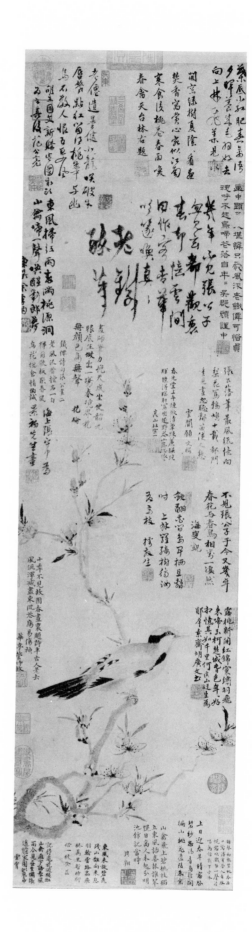

FIG. 75. Chang Chung (active 1330–1360). *Bird and Peach Blossoms*. Hanging scroll. Palace Museum, Taipei.

ing top-heavy with writing; moreover, the sharp lines are echoed in Shen Chou's small twigs, which offer a charming contrast to the delicately toned leaves and flat washes of the melon vine.

Kung Hsien (ca. 1620–89)
"Solitary Willow Dwelling"
(no.68)

"Solitary Willow Dwelling," by the late Ming master Kung Hsien is another hanging scroll with a long inscription. The branches of a single willow reach up to a sky filled with calligraphy, which Kung Hsien wrote in response to two poems sent him by a friend, evoking the mood of the solitary tree. Since the calligraphy plays more than a minor role in this work and is not, in fact, a colophon, it would be appropriate to consider the painting an illustration of the poems and an accompaniment to Kung's calligraphy. As for the work as a whole, it exemplifies, in hanging scroll format, one artist's mastery of poetry, painting, and calligraphy. Such scrolls are rare, since there were probably few artists who could master all three arts. But even so, those who did still failed to produce many works of this type. Whether it was a declining taste of the time, or a lack of interest on the part of the painter-poet must remain a matter of speculation.

Chu Ta (1626–1705)
"Falling Flower"
(no.71)

Chu Ta was a master calligrapher and painter, yet he seldom inscribed his paintings with long poems or colophons, choosing instead to write and paint in separate formats. His compositions were exceptional, and in painting landscape, birds, or flowers, he succeeded in breaking through the bounds of convention. His small album leaf "Falling Flower" consists of a single flower with four petals (*luo-hua*). Is it falling in mid-air or is it floating on the surface of a clear pond? The depiction is achieved with subtle, touching restraint.

The scroll is accompanied by a large two-character inscription: "to be involved in social affairs (*she-shih*)." Chu Ta often used the term to sign other paintings, but the writing was seldom that large, and the painted image that small.[40] Having inscribed the words with a satisfying intensity, he then placed his signature and seal, *Pa-ta shan-jen*, in the exact center of the composition. Indeed, both seal and signature reveal a sure sense of spatial symmetry. The juxtaposition of the three elements is extraordinary and quite unprecedented in Chinese painting and calligraphy.

Tao-chi (1641–ca. 1710)
Colophons to "Album of Twelve Landscape Paintings"
(no.73)

In his "Album of Twelve Landscape Paintings" from the Museum of Fine Arts, Boston, Tao-chi varied the script type to harmonize or contrast with the landscape depiction of each leaf. The content of the inscriptions ranges from his own poems to critical comments on the theory of painting. Dated 1703, this album is a late work which reveals Tao-chi's versatility and consistent quality.[41] The inscription on the leaf illustrated is a declaration of his independence from the strictures of the prevailing orthodoxy and conventions of the ancients: "Each person, whether a painter or a calligrapher, has a responsibility by birth to represent his generation."[42] This statement contains the kernel of his individuality, and his painting and calligraphy exemplify its principles.

Kao Feng-han (1683–1748)
"Flowers and Calligraphy" *(no.74)*

Kao Feng-han, like Tao-chi, used his art to express a highly individual personality. His album "Flowers and Calligraphy," dated 1738, from the Jeannette Shambaugh Elliott Collection at Princeton, is an excellent example of his integration of painting and calligraphic principles. The two cursive characters, "Ink Villa" (*mo-chuang*), are boldly centered; then, in smaller characters, Kao filled the side and upper borders, as if he were inscribing a painting. This treatment of a calligraphic frontispiece is strikingly innovative and a memorable feature of the album.

Chin Nung (1687–1764)
"Plum Blossoms and Calligraphy" *(no.77)*

Of all the Yangchou Eccentrics, Chin Nung was the outstanding calligrapher, but his writing style differs noticeably from the others' in its intentional awkwardness, reserve, and conscious archaism. His inscriptions also differ from those of his Yangchou contemporaries, since he often filled most of the available space in a painted composition, especially in his album leaves.[43] Given the small size of the format, his writing is unusually neat, but the characters form tight lines which conform closely to the irregular spaces left by the painted images.

In his hanging scrolls, Chin Nung played more freely with the available pictorial space but showed the same ingenuity regarding the relationship of word and image. In his "Plum Blossoms and Calligraphy" he wrote an inscription at the very center of the painting. After the

forked branches were completed, Chin judiciously planned the columns to rise according to the natural shape of the trunk, completely filling the heart of the tree. Spontaneous as the design may seem, it was not at all accidental.[44]

BY THE EIGHTEENTH CENTURY, the freedom of the painter-calligrapher was such that calligraphy and painting had achieved total integration. While earlier calligrapher-painters, such as Su Shih and Chao Meng-fu, applied principles of calligraphy to painting, masters like Tao-chi, Cheng Hsieh, Kao Feng-han, and Chin Nung applied principles of painting to their calligraphy. Their writing styles were not limited by tradition and convention, for they regarded calligraphy as a form of painting. The characters became graphic elements, responsive to the artists' sense of spatial design. They painted characters, so that their writing took on the individual qualities of their brush-style. Of course, from a traditional calligrapher's point of view, such styles were highly unorthodox, but it was in this respect that they stepped far beyond tradition.

僕自幼學書之餘時〻戲弄小筆柏
於山水獨不能工盖自唐以來如王右丞大李
將軍鄭虔文法〻奇絶〻此不能一二見至五
代荊關董范筆出〻与妙世兂言遊絶
僕而作者雖未敢与古人此較視〻世畫手則
自謂少異耳曰野雲䆫壶故士其末盖頋

13 Chao Meng-fu (1254–1322), *Twin Pines against a Flat Vista.*
Sections of handscroll.
The Metropolitan Museum of Art, Gift of the Dillon Fund, 1973.

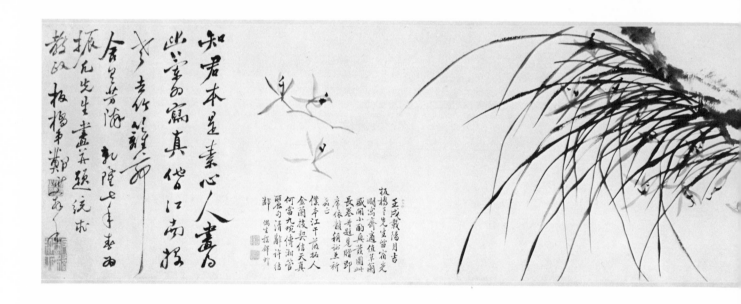

61 Hsu Wei (1521–1593), *Twelve Plants and Twelve Calligraphies.*
Sections of handscroll.
Honolulu Academy of Arts.

78 Cheng Hsieh (1693–1765), *Orchids and Bamboo.*
Dated 1742. Sections of handscroll.
Anonymous loan, The Art Museum, Princeton University.

32 OPPOSITE
Wang Ao (1450–1524),
Ode to the Pomegranate and Melon Vine,
colophon to painting by Shen Chou.
Hanging scroll.
The Detroit Institute of Arts,
Gift of Mr. and Mrs. Edgar B. Whitcomb.

23 Yang Wei-chen (1296–1370),
Colophon to "Gazing at a Waterfall,"
painting by Hsieh Po-ch'eng.
Section of hanging scroll.
Collection of John M. Crawford, Jr.

石榴芋器然瓜于藍豆任赤庭陵牡羚

村榴于瓜芋沙河三豆芷

蒂豈芋生朱色悟雉首一朵

孤興詢之父芋不夷人任云和羹錘之

芋朱為保微圓家回頴禾河中連理

禾子花起飯人澤光任赤彈庭白名

男魚三芋少榴家子亭

扬佐榴圓為任和臨放壽祈男丙坦此

村圓少傳魚老子大傳名郭峯畫菓翠

朱宋色

但韻沒之一後生

于瓜朱市色

士王鑒

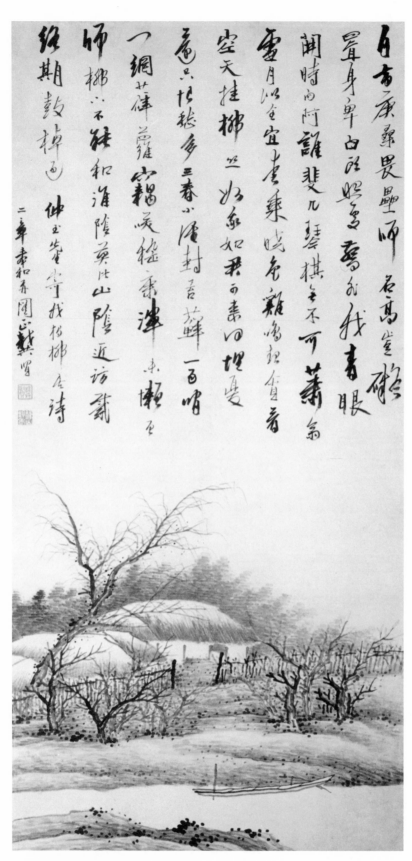

68 Kung Hsien (ca. 1620–1689),
The Solitary Willow Dwelling, poem on his painting.
Hanging scroll.
Ching Yuan Chai.

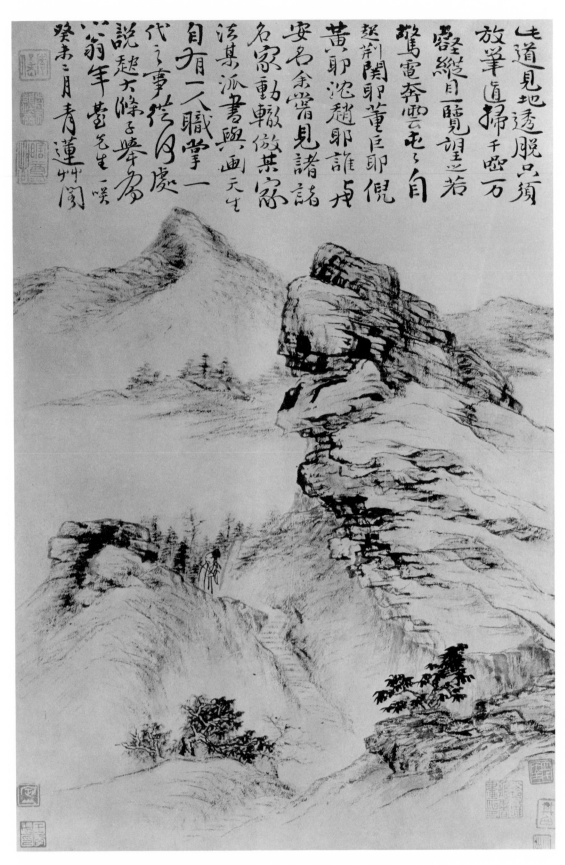

毛道見地透脫只須
放筆直掃千巖万
壑縱目一覽遍若
驚電奔雲屯~自
趙荊關郭董巨郭倪
黃郭沈趙郭誰祗
安名余嘗見諸諸
名家動輒傚其家
法某派書與画天生
自有一人職掌一
代之事從月處
說趙大滌子蘗為
翁年畫先生一嘆
癸未二月青蓮艸閣

73 Tao-chi (1641–ca. 1710), *Mountain Path*,
twelfth leaf of *Album of Twelve Landscape Paintings*.
Dated 1703.
William Francis Warden Fund, 48.11d,
Courtesy Museum of Fine Arts, Boston.

71 Chu Ta (1626–1705), *Inscription to his painting, "Falling Flower."*
Album dated 1692. Album leaf.
Collection of Mr. and Mrs. Fred Fang-yu Wang.

乾隆元年應舉里
都門與徐亮直翰林過張司
屯司寇出觀趙王孫墨梅小立軸
冷春青艷展視撩人大侶予緗
塵涴素衣也今一老僊去予亦衰顏
追寫塞葩不覺黯然自失恨不本二
老見我橫枝滿幅舍豪作簡齋
詩句一題其上也
七十五叟農畫記

77 Chin Nung (1687–1764),
Plum Blossoms and Calligraphy.
Dated 1761. Hanging scroll.
Yale University Art Gallery;
Leonard C. Hanna, Jr., B.A. 1913, Fund.

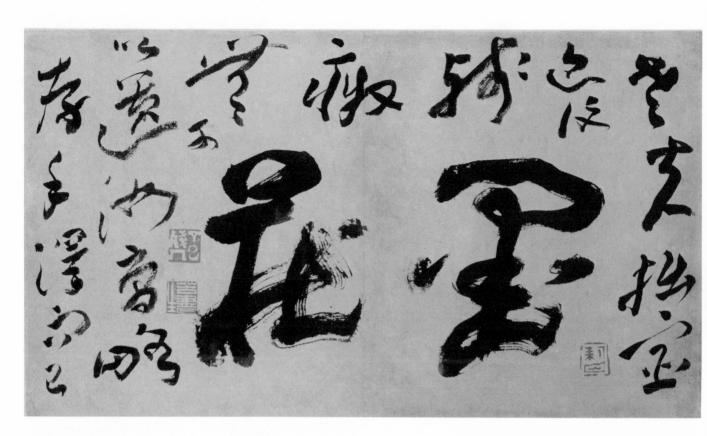

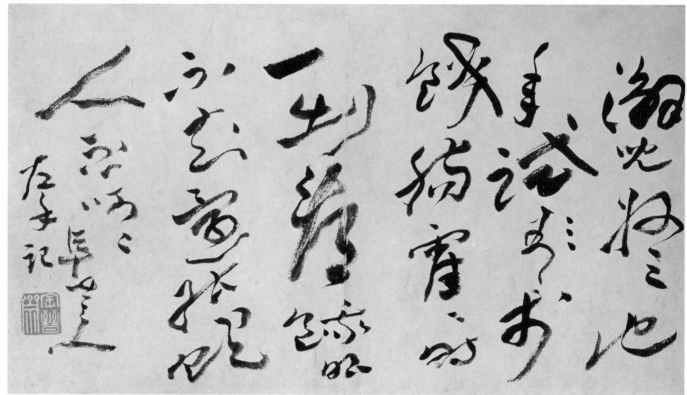

74 Kao Feng-han (1683–1748), *Flowers and Calligraphy.*
Dated 1738. Album leaves.
The Jeannette Shambaugh Elliott Collection at Princeton.

76 Li Shan (1686–ca. 1762), *Orchids and Bamboo*.
Album leaves.
The Jeannette Shambaugh Elliott Collection at Princeton.

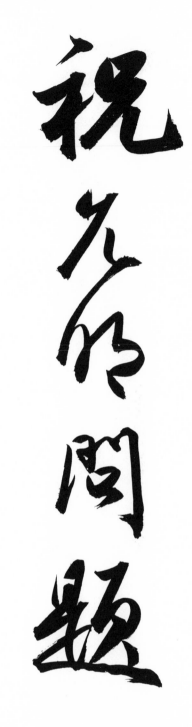

VI

Chu Yun-ming: Defining
a Master's Range and Quality

TRADITIONALLY, the works of Chu Yun-ming (1461–1527), the greatest calligrapher of the Ming period, have been considered a turning point in the history of calligraphy.[1] In American collections today, they are well represented. They vary greatly, however, in quality and in representative "styles." So it is not surprising that scholars and collectors hold considerably different opinions of Chu's works. The following discussion is based on a preliminary study of Chu Yun-ming material and is meant as a departure for further enquiry.

Problems and Methods

There are several reasons for the difficulties that surround the study of Chu's calligraphy. For one, Chu was an extremely versatile master: he wrote in several script types—standard, running, and cursive. For another, he wrote in the styles of many different masters. His personality thrived on variety and change. He liked to exhibit his technique. He liked to follow his interest of the moment. As Wen P'eng (1498–1573), the eldest son of his friend Wen Cheng-ming (1470–1559), wrote:

In our dynasty, there are so many who excel in calligraphy that I cannot count them. But they all usually write in only one style, and that style has only one idea behind it. Chu Yun-ming alone was able to absorb the merits of all the different scripts. The reason is that when he was young, there was no calligraphy he did not study; but having once studied it, there was nothing in which he was not able to achieve complete mastery.[2]

The Ch'ing calligrapher and critic Wang Shu (1668–1743) noted the same diversity: "I have seen more than two hundred works by Chu Yun-ming, but there is not one which is like another."[3] Wang went on to say that the brushwork of many works was very casual, perceiving a qualitative discrepancy in Chu's stylistic diversity. A similar comment was made by the late Ming calligrapher and critic Mo Shih-lung (ca. 1539–87):

The works in running and cursive script that he [Chu] wrote to answer social obligations were undisciplined and free, loose, and careless (tsung-heng san-luan). If one examines these carefully, there are many places which have lost [the principles of] brushwork (shih-pi). But when he is in a good mood and feels satisfied with his work, then the writing is strong, crisp, and extraordinary.[4]

It is understandable that students of the history of calligraphy have found it difficult to comprehend his range and his special brush characteristics, or to link his varied works together. The chief problem, then, is how to measure Chu's qualitative and stylistic range.

Forgeries of Chu Yun-ming were a problem soon after the master died. A late Ming critic, An Shih-feng, claimed that "Chu Yun-ming's calligraphy is everywhere under heaven; his forgeries are also everywhere under heaven."[5] By the late sixteenth and early seventeenth centuries, the Ming had produced another great calligrapher, Tung Ch'i-ch'ang (1555–1636), whose forceful artistic image altered the fashion in calligraphy and supplanted Chu Yun-ming and Wen Cheng-ming in collectors' minds. In deference to this late Ming shift in popular fashion, forgers produced works signed "Tung Ch'i-ch'ang" instead of "Chu Yun-ming." Therefore, most forgeries of Chu can be dated before the end of the Ming. The existence of so many early forgeries, of course, further complicates the case.

Several different approaches may be used to study a master's surviving works. The most immediate would be to assemble all the attributions, gradually isolating authentic examples on the basis of stylistic analysis, and verifying data by such means as documentation, colophons, and seals.

One can also study both the master's writings and calligraphy with a view to understanding his theories and sources, whether they be ancient masters, immediate predecessors, teachers, or contemporaries. The criticism of such contemporaries, immediate followers, and later critics would also be valuable in determining the complete range of his abilities. Further, a thorough familiarity with the major trends and masters of calligraphy during, before, and after his lifetime would provide another essential stylistic context. Studying a master in these various ways would thus eventually lead to a deeper understanding of his artistic personality.

Basic Works

Application of the above methods of study has resulted in a large number of Chu Yun-ming's works having been singled out as genuine, but the following discussion is limited to a group of only fifteen. These have been chosen because their authenticity can be verified by objective evidence and accompanying documentation, thus avoiding subjective judgments of quality. They appear in descending order of documentary completeness.

Authentication by Contemporaries

Amenable to the first approach are three works with a convincing record of transmission, consisting of a form of authentication by one or more of Chu Yun-ming's contemporaries.

"Works by Four T'ang and Sung Masters" (*Shu T'ang-Sung ssu-chia-wen*), transcription in small running-standard script. Handscroll, dated 1487. Palace Museum, Peking.

This calligraphy (*fig.76*) is one of Chu Yun-ming's earliest dated works, executed at age twenty-seven.[6] The writing is rather small, but it is in his own personal hand and shows his early training in the standard script style of Chung Yu (151–230). There is a colophon dated 1557 by Wen Cheng-ming which is genuine, although written on a separate sheet of paper. Genuine Wen Cheng-ming seals are found at the opening and closing sections of Chu Yun-ming's writing and also accompanying the colophon. These help to verify the fact that Wen Cheng-ming saw this scroll, and that it was the one he authenticated by adding his colophon.

Wen Cheng-ming's friendship with Chu Yun-ming, which began when Wen was sixteen and Chu twenty-five, lasted throughout their lifetimes, as each became a leading master of calligraphy. Any calligraphy of Chu Yun-ming's that Wen Cheng-ming considered authentic should be acceptable to us. In addition, other colophons by contemporary calligraphers are on this work, which was in the important collection of Hsiang Yuan-pien (1525–90), also a contemporary. This scroll may therefore be accepted as genuine on the basis of documentary evidence alone.

FIG. 76. Chu Yun-ming (1461–1527). *Works by Four T'ang and Sung Masters.* Dated 1487. Detail of handscroll. Palace Museum, Peking.

"Nineteen Old Poems" (*Ku-shih shih-chiu shou*), transcription in running-cursive script, with concluding lines in standard and draft-cursive scripts. Dated 1525, ninth lunar month (age sixty-six). *T'ing-yun-kuan t'ieh*, vol. 11.

According to his colophon of 1525, Chu paid a call on Wen Chia (1501–83), Wen Cheng-ming's son. On the desk, ink was prepared, and there was a brush of good quality, as well as fine Korean paper made from silk cocoons. Chu couldn't resist taking up the brush and writing these Han poems. This account of his is confirmed by a favorite anecdote of the Suchou élite which recounts how Wen Chia, knowing Chu was short of money, prepared writing materials in his study to tempt him to transcribe the poems, through which he might obtain the funds he needed.[7] This scroll (*fig.77*) was thus known to have existed then, and Wen Chia would naturally have treasured it, since his father respected Chu Yun-ming. By the next year, the scroll had attracted three colophons by contemporaries: Ku Lin (1476–1545), Ch'en Shun (1483–1544), and Wang Ch'ung (1494–1533). It remained in the Wen family, and in 1547 was reproduced as one of two dated works by Chu included in volume 11 of *T'ing-yun-kuan t'ieh*, Wen Cheng-ming's compilation of calligraphy.[8] For these documentary reasons, the work should be considered indisputably authentic.

Chu Yun-ming's writing is of fine quality, crisp and more alert than is usually found in this script type. Written in a mixture of Chung Yu and Chao Meng-fu styles, the poems and the accompanying standard and draft-cursive passages are of particular importance in verifying other attributions to Chu Yun-ming.

"A Statement about Calligraphy" (*Shu-shu*), in small draft-cursive. Dated 1526, tenth month. *T'ing-yun-kuan t'ieh*, vol. 11.

This scroll is dated two months before Chu Yun-ming's death. There is no dedication, but given the fact that it was the second dated writing by Chu included in volume 11 of *T'ing-yun-kuan t'ieh*, it is also authentic. Since few other works in draft-cursive script attributed to Chu Yun-ming exist, however, this one is not as helpful in authenticating other of his works.

Authentication by Accompanying Colophons

Aside from the works that have a convincing record of transmission, there are certain examples of Chu Yun-ming's writing which exist as colophons to other works—a different situation from that of the previous group,

FIG. 77. Chu Yun-ming (1461–1527). *Nineteen Old Poems.* Dated 1525. Detail of rubbing from *T'ing-yun-kuan t'ieh*, vol. 11 (1547).

since the colophons accompanying Chu Yun-ming's may simply be comments on the major works, yet were not intended to comment on Chu's writing. Still, if the colophons which precede or follow Chu Yun-ming's are by his contemporaries and can be verified by other means, then the colophon by Chu Yun-ming is also likely to be authentic. There are varying degrees of acceptability, however. The most important is that the colophons be written on the same sheet of paper.

Colophon to "Letters by Chao Meng-fu and Family" (*Pa Chao-shih i-men fa-shu ts'e*), in running script. Album, undated. Palace Museum, Taipei.

Following Chu Yun-ming's colophon *(fig.78)* on the same paper are comments, dated 1503, by Yang Hsun-chi (1458–1546), a poet, historian, bibliophile, and contemporary who was active in the Suchou circle of literati.[9] Yang Hsun-chi's colophon compares favorably with his other works in terms of style and quality and is therefore of primary significance in helping to authenticate Chu's colophon, which may also date to 1503 or

earlier. Not only did Chu Yun-ming write his colophon appropriately in Chao Meng-fu style, but it is gentler and more elegant than usual. Moreover, its high quality guarantees it is genuine.[10]

Poem to Tai Chao in running script, accompanying painting "Farewell at the Bridge of the Hanging Rainbow" (*Ch'ui-hung pieh-i*). Handscroll, datable to 1508. Collection of John M. Crawford, Jr. *(no. 35b)*.

Chu Yun-ming has two examples of calligraphy on this scroll: a frontispiece in large running script *(no. 35a)* and the poem cited here *(no. 35b)*. The poem, mounted following a painting by T'ang Yin, was originally one of thirty-six farewell poems written for Tai Chao, in 1508, by numerous important Suchou scholars. Only nineteen exist in this mounting.[11]

The present colophons are not all written on the same

FIG. 78. Chu Yun-ming (1461–1527). *Colophon to "Letters by Chao Meng-fu and Family."* Detail of album. Palace Museum, Taipei.

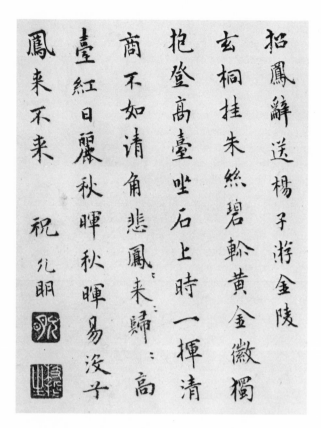

FIG. 79. Chu Yun-ming (1461–1527). *Summoning the Phoenix, colophon to T'ang Yin, "Journey to Nanking."* Datable 1505. Detail of handscroll. Courtesy Smithsonian Institution, Freer Gallery of Art, Washington, D.C.

Recorded in Chu's collected works, the poem is written in a firm hand in his Ou-yang Hsun style.[14] Because of its unusual reserve, it is important as a standard for this type.

"Eulogy," in running-cursive script, attached to Wen Po-jen, "Miniature Portrait of Yang Chi-ching." Handscroll, datable ca. 1521. Palace Museum, Taipei.

Chu Yun-ming's colophon *(fig.80)* follows Wen Po-jen's portrait on a separate sheet of paper, and is followed by Tu Mu's (1459–1525) eulogy as transcribed by Wen P'eng on the same sheet.[15] Moreover, the calligraphy is verifiable through comparison with other Wen P'eng works.[16]

Chu's colophon is important because it exhibits free cursive elements mixed with running and is therefore valuable in relation to other works. It is distinctive in that the structure of some of the characters tends to "split apart" laterally and that the released strokes extend beyond the mass of the character. In addition, the space between columns is relatively close.

Poem in running script, on Shen Chou, "Orchid and Magnolia" (*Chih-lan yü-shu*). Hanging scroll, undated. Palace Museum, Taipei.

The painting by Shen Chou (1427–1509) is undated, but bears two inscriptions, one by Chu Yun-ming and a

sheet of paper; however, judging from the circumstances of their writing and the quality of the calligraphy, all appear to be genuine. Chu Yun-ming's calligraphy on this scroll should be accepted as one of his major authentic works.

"Summoning the Phoenix" (*Chao-feng tz'u*), poetic colophon in standard script, attached to T'ang Yin, "Journey to Nanking" (*Nan-yu-t'u*). Handscroll, datable to 1505. Freer Gallery of Art.

According to the preface by P'eng Fang (active ca. 1500–20?), all the colophons found on this scroll are by contemporaries and are dated the same year.[12] They celebrate the departure from Suchou of a friend, Yang Chi-ching (ca. 1477–1530). After Chu Yun-ming's colophon *(fig.79)*, there are poems by Ch'ien T'ung-ai (1475–1549) and Hsing Shen (ca. 1500–50?) on the same sheet of paper. These are genuine.[13] On the basis of their proximity, Chu Yun-ming's poem should also be accepted.

FIG. 80. Chu Yun-ming (1461–1527). *Eulogy attached to Wen Po-jen, "Miniature Portrait of Yang Chi-ching."* Datable 1521. Detail of handscroll. Palace Museum, Taipei.

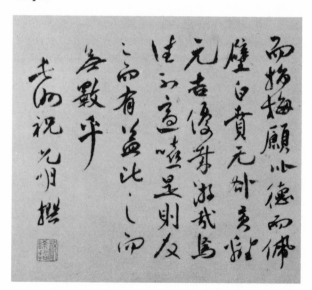

second by Wu K'uan (1436–1504).[17] The fine quality of the painting, Shen Chou's own inscription, plus Wu K'uan's, are all valid verifications of Chu Yun-ming's writing.

Poem in running-standard script, on Ch'en Shun, "Flowers Growing on a T'ai-hu Rock." Fan painting mounted as album leaf, dated 1514. Palace Museum, Taipei.

Several important colophons appear on this small work: T'ang Yin's follows Ch'en Shun's inscription, then follows Chu Yun-ming's, then Wen Cheng-ming's and those of two other contemporaries.[18] In this, as well as in the previous works, examples of Chu Yun-ming's calligraphy are accompanied by other inscriptions or poems by contemporaries which can be further verified. These examples should be accepted as genuine and should form part of the standard corpus of Chu Yun-ming's calligraphy.

In the preceding works, the possibility remains that any group of genuine colophons may contain one or two forgeries: a genuine colophon may have been removed and a forged one squeezed into the blank area; or a forged colophon may have been inserted on a separate sheet between two genuine ones. In none of these examples, however, has this been judged to be the case.

Authentication by Attached Colophons

Examples of Chu Yun-ming's calligraphy which have verifiable writing or other data attached separately—that is, not on the same sheet—represent a third category. In most cases, the calligraphy is by contemporaries. Such examples are weaker from a documentary point of view. The colophon in question may be a replacement or it may be genuine. Still, the presence of the attached colophons is important evidence which cannot be ignored. The following works have undergone examination and are adjudged not to be replacements, even though they were written on separate sheets of paper.

Poems in running-cursive script, accompanying Shen Chou, "Watching the Mid-Autumn Moon." Handscroll, undated. Museum of Fine Arts, Boston (no. 38).

Shen Chou's landscape is followed by three separately mounted colophons, two by Shen Chou and one by Chu Yun-ming. None are dated. However, the content of Shen Chou's poem is datable to around 1487, and Chu Yun-ming's poems were probably written sometime afterward. Despite the fact that the colophons are mounted

separately, the paper, ink, dimensions, and general condition are comparable. Since both Shen Chou's painting and colophons are genuine, Chu's colophon may also be accepted.

Colophon in medium-sized running script to Mi Fu, "Poems Written on Szechuan Silk" (Shu Shu-su t'ieh). Handscroll, undated. Palace Museum, Taipei.

This is one of Mi Fu's most famous works; it is dated 1088 and has a complete record of transmission.[19] Chu Yun-ming's undated colophon is preceded by a Shen Chou colophon dated 1506; it is followed, on separate sheets, by colophons by Wen Cheng-ming, dated 1557, and two other contemporaries, then by an authentication by Tung Ch'i-ch'ang, dated 1634. The seals of Hsiang Yuan-pien are found on all the joins between the Shen Chou, Chu Yun-ming, and Wen Cheng-ming colophons. This one should therefore be accepted as genuine.

"Autumn Meditations" (Ch'iu-hsing), transcription in cursive script of poems by Tu Fu (712-70). Handscroll, undated. Collection of Robert H. Ellsworth (no. 37).

Originally, this transcription contained all eight poems from Tu Fu's set, but the present scroll contains only the last two, followed by Chu Yun-ming's signature. Wen Cheng-ming saw the scroll in 1534 and completed the missing six poems on a separate sheet of paper which is mounted following Chu Yun-ming's writing, thus authenticating the original. The high quality of both sections also speaks for their genuineness.

"Poems and Letters for Shen Pien-chih" (Shih-han chuan), in running script. Handscroll. Palace Museum, Taipei.

This scroll consists of variously dated and undated poems and letters written by Chu to his friend Shen Pien-chih, mounted together as a single scroll by the recipient.[20] A number of important colophons are appended by such members of the Suchou circle as Wen Cheng-ming, Wen Chia, Wen P'eng, Ch'en Shun, and others. Several of these are dated, making possible the establishment of a chronological framework of content and style when carefully studied. The scroll was also owned at one time by the late Ming collector Wu T'ing (ca. 1575–1625), and Wen Cheng-ming's informal label in one line dated 1519 on a separate sheet preceding the title, is further evidence for authentication.

"The Red Cliff" (*Ch'ien-hou Ch'ih-pi-fu*), transcription in "wild" cursive script of prose poems by Su Shih (1036–1101). Handscroll, undated. Shanghai Museum.

Chu Yun-ming's transcription in large cursive script (*fig.81*) is followed by a colophon, dated 1532, by Huang Hsing-tseng (1490–1540), two colophons by Wen Cheng-ming, the second dated 1533, and one by Wen Chia, dated 1533.[21] Wen Chia states that the scroll is a product of Chu Yun-ming's late years, and Wen Cheng-ming liked it so much that he wrote the text of his colophon twice, first in small standard script and again in running-cursive script. There are no seals of contemporaries on the calligraphy by Chu Yun-ming itself; nonetheless, the scroll may be accepted as having been authenticated by Wen Cheng-ming and his contemporaries.

This scroll, a key work by Chu Yun-ming, must be

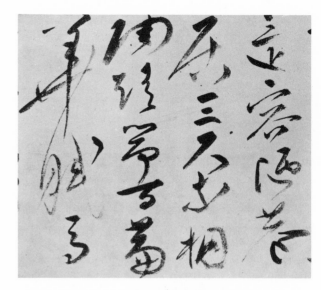

FIG. 82. Chu Yun-ming (1461–1527). *Colophon to Shen Chou, "Landscape after Wang Meng."* Dated 1496. Detail of handscroll. Collection unknown.

FIG. 81. Chu Yun-ming (1461–1527). *The Red Cliff, I and II.* Detail of handscroll. Shanghai Museum.

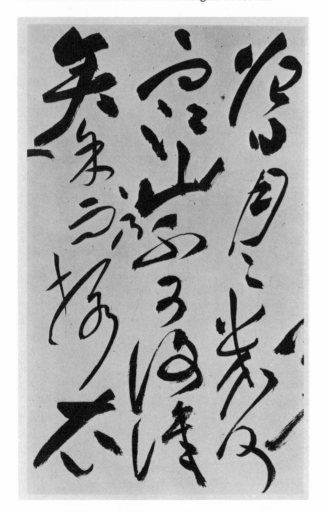

taken into account in all discussions of his cursive script, for writing of such caliber represents the height of his art and forms the basis for his high reputation as a cursive calligrapher.

Colophon in "wild" cursive script to Shen Chou, "Landscape after Wang Meng." Handscroll, undated. Collection unknown.

This colophon (*fig.82*) is attached to a genuine work by Shen Chou dated 1496.[22] It was written in a highly excited state with greater speed and less pictorial purpose than "Red Cliff." The scroll reveals the high quality and variety of Chu's brushwork, as well as the degree of disintegration in character structure, which was possible without exaggeration or repetitious mannerism.

Chu Yun-ming's Range and Style

Studying the works authenticated above is a means by which to define Chu's calligraphic range and then to judge the acceptability of other attributed works through stylistic analysis. His stylistic repertoire may be summarized as follows:

(1) *Small standard script.* Chu wrote in two types: one after Wang Hsi-chih (mainly the *Huang-t'ing-ching*), with T'ang dynasty elements, and the second after Chung Yu (151–230). When working in the latter style (e.g. his *Ch'u-shih-piao, fig.83*), the strokes are plump,

short, and flexed, with a broad structure. The brushwork Chu developed in this script became the basis for some of his brushwork in draft-cursive and in cursive.

(2) *Standard script in Ou-yang Hsun style.* This writing *(fig.79)* is characterized by thin, firm strokes, an elongated structure, and a tight internal arrangement. The columnar spacing is clear and roomy. The style may derive from either Ou-yang Hsun (557–641) or Yü Shih-nan (558–638); in any case, it differs from his other styles in its severity.

(3) *Running-standard script in Chao Meng-fu style.* This was one of Chu's most distinguished scripts. The strokes are full and well-flexed, with a feeling of expansion. The columnar spacing is ample, as in the preceding type *(fig. 78).* And while the style is not always pure Chao, it did, when mixed with other types, become the chief basis for Chu's running script.

(4) *Running script.* This was Chu's most relaxed style, which includes many personal elements; nonetheless, it often contains a combination of elements from Chung Yu or Chao Meng-fu, according to his mood *(fig.77).*

(5) *Running-cursive.* This personal style, slightly freer than the preceding, shows the tendencies developed in his cursive to a fuller extent *(fig.80).*

(6) *Freehand cursive.* Again Chu's own style, this type shows broad variation and range in both quality and form *(fig.82).*

(7) *"Wild" cursive.* Chu's most experimental ideas as a calligrapher were developed in this script, but as in the preceding style, breadth and innovation have made it the most difficult to authenticate *(fig.81).*

This summary is far too simple. Chu Yun-ming's range was so wide that even when he adopted a particular model or script type, no two works were in precisely the same style. His own views on his writing, along with those of his contemporaries and other critics, shed additional light on the problem.

The Written Evidence

Chu Yun-ming left several important comments on his own calligraphy in his collected writings. On a colophon to one work no longer extant, he wrote:

I have studied some calligraphy, but I did not really work hard at it in a cumulative way. Fortunately, what I did receive in the way of instruction was from my late father. Since my childhood, he never allowed me to learn the writing of any recent or modern calligrapher. Everything I happened to see consisted of models of calligraphy from the Tsin and T'ang periods. But I was playful and lazy and never put in ten continuous days' effort on one model. Now I am imitating [*hsiao*] the styles of different masters: I am writing according to my idea of their styles. Those who understand have been known to give their casual

approval of my ability. In the face of such praise I feel ashamed and regret [that I did not study harder].

This scroll was written in Nanking for Ku Ssu-hsun, who forced me to write it. The styles include the *Huang-t'ing-ching, Lan-t'ing, Chi-chiu-chang,* the Two Wangs, Ou-yang Hsun, Yen Chen-ch'ing, Su Shih, Huang T'ing-chien, Mi Fu, and Chao Meng-fu. As I was quite pressed for time, there are many mistakes, and the likenesses are quite distant from the image. I was just about to return home at the time, and didn't really have the leisure or interest. I also lacked a good brush. The only thing I captured was a certain childish manner.[23]

This is an exceedingly important passage for any understanding of Chu Yun-ming's background and approach. It is usually claimed that his father-in-law, Li Ying-chen (1431–93) *(fig.84),* and his grandfather, Hsu Yu-chen (1407–72) *(fig.88),* had a dominant influence on his early training.[24] While this is certainly true, Chu is clear about the amount of guidance he received from his father, Chu Hsien (ca. 1435–83), who, despite his death when his son was twenty-two, had the foresight to stress the emulation of ancient masters over contemporary or recent ones.[25] Given an impulsive and fun-loving personality, it is not surprising that Chu professes not to have spent

FIG. 83. Chu Yun-ming (1461–1527). *Transcription of Chu-ko Liang, "Ch'u-shih-piao."* Dated 1514. Detail of handscroll. Tokyo National Museum.

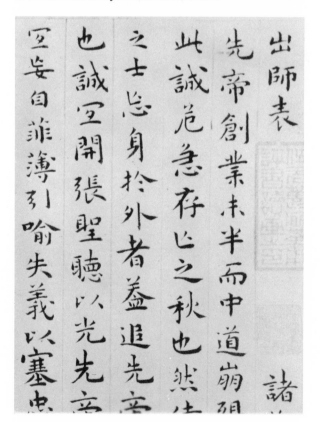

much time imitating the older masters; still, he had followed his family's teachings well enough to be known for his ability to reproduce, on request and from memory, the styles of the greatest calligraphers of the past.

Later criticism of Chu Yun-ming is consistent with his own comments, even to the enumeration of the masters he could imitate. The critic and historian Wang Shih-chen (1526–90) noted that "Chu Yun-ming's standard script followed Chung Yu, the Two Wangs, Chih-yung, Yü Shih-nan, Ou-yang Hsun, Ch'u Sui-liang, and Chao Meng-fu; his running and cursive scripts followed Wang Hsien-chih, Chih-yung, Ch'u Sui-liang, Huai-su, Chang Hsu, Li Yung, Su Shih, Huang T'ing-chien, and Mi Fu. He could imitate them all with extreme accuracy."[26]

Whether the Chu family had a good collection is not clear from the available sources. It was likely that models of T'ang and pre-T'ang calligraphy came from the extant compilations of rubbings, *fa-t'ieh*. As for Sung and Yuan masters, Chu Yun-ming had a better chance to see their original works in local collections, such as the calligraphy on Szechuan silk by Mi Fu to which he wrote a colophon.

Chu Yun-ming's creativity was grounded in his complete absorption of a wide variety of ancient models. He objected to the theory then current that writing which followed the past was "slaves' calligraphy" (*nu-shu*). Indeed, he voiced his opposition in an essay devoted to the subject: "Follow the Tsin and travel through the T'ang, preserve and uphold [their principles], but do not lose your way!"[27]

"Personal" Style

With such a multiplicity of styles at his command, how can one recognize Chu's "personal" style? To isolate and describe its predominant characteristics is at the core of the problem of authenticity. The following analysis is based on an understanding derived from authenticated works and comprises a certain consistency of brush movement, a general structural tendency, and an over-all similarity of formal energy.

Chu Yun-ming's brush rhythms derive from two basic methods. The first stressed an articulated stroke with shaped "head" and "tail," the brushwork was tense and poised, and the energy sustained through the course of the stroke and the entire character. This method was not his personal preference, but represented acquired discipline and classical training; it is best represented by his Ou-yang Hsun and Chao Meng-fu styles.

The second method produced a simpler, generally unarticulated stroke. The brush was placed down, drawn, and lifted with a brief flexed motion. The resultant strokes had leech-like shapes with a tapered head and tail. The method appears to have been derived from Chung Yu. The simpler, less attentive rhythms, demanding less energy, seem to have suited Chu's temperament best; thus his "personal" style favors this type of stroke.

In his cursive writing, Chu employed both those methods to advantage. He combined and contrasted looped, rounded, and flexed strokes with flat, straight, tense, and unmodulated movements that resulted from the more direct brush attack. The over-all rhythms were discontinuous, punctuated by limited linkages and the occasional emphatic extension of verticals, diagonals, and horizontals. The structure of individual characters tended to be broad, with generous internal spacing, while the columnar spacing could be quite close, accommodating the broader characters.

These forms are a synthesis of his study of ancient

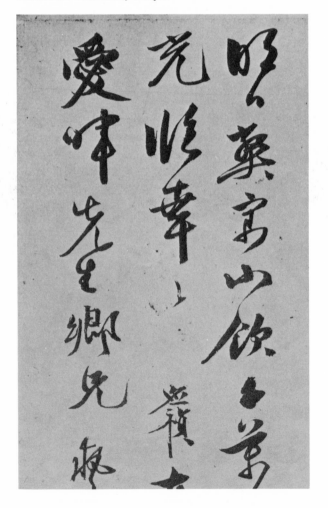

FIG. 84. Li Ying-chen (1431–1493). *Letter*. Detail. Nakamura Collection, Tokyo.

styles, molded by his own character and temperament. In works in which his "personal" style predominates, he was not making any intentional specific visual references to the ancient masters' brushwork or structure in a sustained fashion, nor was he using the transmitted spirit of a master to elevate his own execution of the forms. He followed his own natural preferences and wrote without any particular image of perfection in mind, making no special effort to reach out beyond his abilities toward an ideal. The forms reflect this attitude; at their best, they look quite plain; at their worst, they are too casual and fluent, to the point of carelessness. This is one reason Chu's style has been criticized by traditional connoisseurs, especially those who seek purity and loftiness in a great master's style.[28]

Works in the Exhibition

The works included in this exhibition range from standard script to "mad" cursive, from small-sized to large-sized scripts, from a "mini"-album to enormous fifty-foot handscrolls. The quality and styles represented by these works also vary accordingly: there are works which can be confidently confirmed as genuine, and there are those which are of questionable authenticity. The criteria for authentication have been distilled from the previous discussion and the conclusions based on close comparative study. The discussion will proceed in order of script type, from small standard to large "wild" cursive.

"Poems and Essays by Sung Yü." Miniature album in small standard script, dated 1507 (no. 34).

This album suggests Chu's "free-hand" standard style, somewhat influenced by Chung Yu. In certain ways it is related to his "Works by Four T'ang and Sung Masters," dated 1487 (fig. 76), but the brushwork in this work is softer, with slightly less "bone" to the strokes. The problem with the album is less stylistic than documentary: the attached colophons are all later copies. From the available evidence, it appears that they are copies of those colophons written by Ku Lin, Ch'en Shun, and Wang Ch'ung on "Nineteen Old Poems" (fig. 77). The date of Ku Lin's colophon has been changed, and a colophon by Wen Po-jen has been added. The original colophons confirmed Chu's statement that "Nineteen Old Poems" was for Wen Chia; the colophons in this album also mention Wen Chia and therefore do not relate to the Chu Yun-ming writing which precedes them. It is clear that the colophons have been adapted to fit the smaller album format and are patched together in false support of the Chu Yun-ming calligraphy.

FIG. 88. Hsu Yu-chen (1407–1472). *Preface and Poem.* Detail of rubbing from *T'ing-yun-kuan t'ieh,* vol. 10 (1556).

"Dreaming of Spring Grasses." Handscroll in running-standard script, dated 1510 (no. 33a).

This writing is controlled and neat, and the brushwork firm. The structure is slightly elongated and close to an Ou-yang Hsun model. Without prior knowledge of Chu Yun-ming's broad study of the ancient masters and, in particular, of Ou-yang's style, one would probably not recognize this as Chu Yun-ming's style.[29] Chu's colophon to T'ang Yin's "Journey to Nanking," a basic work mentioned above (fig. 79), is also in Ou-yang's style: the columnar spacing is ample, and the narrow

configuration of the characters and severe bony brush-work are all quite similar.

The severity and restraint of this handscroll, and of Chu's Ou-yang Hsun type of writing in general, reveal a "classic" side to Chu's nature. Indeed, he was capable of producing precise and exacting brushwork and lofty, elegant characters. Such ability and discipline cause one to reconsider those works which show extreme careless-ness of brushwork and common structure.

Frontispiece to "Bridge of the Hanging Rainbow." Handscroll in large running-standard script *(no. 35a)*.

From the external and documentary evidence con-cerning this work, the frontispiece should be accepted as genuine. The four-character title, *Ch'ui-hung pieh-i*, relates directly to the poetry and painting and is men-tioned specifically in Tai Kuan's preface, which tells the whole story of the scroll. As there is no evidence to suggest that the frontispiece was replaced, there is no reason to doubt its authenticity.

This is one of the largest examples known of Chu's informal standard script. The general structure of the characters and the brushwork are derived from his study of Chao Meng-fu. His Chao-style writing *(fig. 78)* was one of his best. Chu Yun-ming praised Chao Meng-fu's calligraphy in several of his colophons.[30] Once, when requested to write a work in Chao's style, Chu replied that he did not specialize in this type of writing and that he had "never spent even three days' work on [Chao]."[31] Such modesty belies Chu's actual accomplishment in this style. The late Ming critic Wang Shih-chen (1526–90) mentioned an essay by Chu in Chao-style, and noted that while Chao's style was strong and attractive, Chu's style was strong and *antique*, and therefore superior.[32]

The writing of the frontispiece is mild and stable, with more ink and "flesh" to the strokes than usually appears in other Chao-style works. It has a plain quality which makes it not very striking at first glance, but its unpretentiousness is part of its excellence. This, plus its rarity as large writing, makes it deserving of our respect.

"Pear Valley" (*Li-ku chi*), in running script. Second section of a handscroll, dated 1510, 6th lunar month *(no. 33b)*.

This work is representative of Chu Yun-ming's "per-sonal" style, although there are traces of Chung Yu brushwork, along with some Ou-yang, some Chao, and even some Mi elements. However, Chu was not purpose-

fully imitating any of the above-named masters. The energy level is mild, and the brush was handled with ease. Some of the characters can be faulted for being too diffuse in structure and too casual in brush articulation. But despite such weaknesses, its larger size, and later date, the work bears a certain over-all resemblance to his earlier "Four Works by T'ang and Sung Masters," dated 1487 *(fig. 76)*, in that they both show a broad con-struction and a flattening and thickening of the horizon-tal and vertical strokes.

A comparison of "Pear Valley" with its companion, "Essay on Spring Grasses" *(no. 33a)*, is of interest because the differences in the script type, degree of cursiveness, and the Ou-yang Hsun mode of the latter account for what may seem a stylistic contrast. When, however, the stricter characters of "Pear Valley" are identified and compared with the more cursive ones in "Spring Grasses," the essential elements of both appear very similar in shape, structure, and basic brush tech-nique. Yet despite the disparity of stylistic "references," Chu's personal structure and brush habits naturally prevail.

Cursive and "Mad" Cursive Script: Comments by Contemporaries

Chu Yun-ming was best known during his lifetime for his cursive script. Wen Cheng-ming's colophon in the "Red Cliff" handscroll in Shanghai *(fig. 81)* reports: "Today when people look at Chu Yun-ming's calli-graphy, they always appreciate the marvels of his cursive script." Some critics have thought that his "mad" cursive surpassed even the patriarchs of the script, Chang Hsu and Huai-su.[33] His friend Wang Ch'ung (1494–1533) linked Chu's affinity for the style with his personality: "His nature and personality are bold and direct, and he has no patience for strictness and reserve. Therefore in his calligraphy he produced more mad cur-sive and large scrolls."[34] This perceptive analysis sup-ports the earlier observation that his running-cursive and cursive styles were most often in his own "personal" style, and those scripts obviously were the most suitable vehicle for free self-expression; indeed, Chu Yun-ming appeared to thrive on the sense of release they offered.

Thus, despite all the praise, it is not surprising that his "mad" cursive also received the most criticism. For example, Mo Shih-lung commented that "his cursive writing for social obligations was undisciplined and free, loose and careless . . . there were many places which lost the principles of brushwork." The calligrapher Hsing T'ung (1551–1612), a contemporary of Mo Shih-lung and Tung Ch'i-ch'ang, sharply criticized Chu's cursive as being too self-indulgent and bordering on the hereti-

cal.[35] Another critic, Hsiang Mu (ca. 1565–1630?), son of the famous collector Hsiang Yüan-pien (1525–90), observed that "in the beginning he modeled himself after Tsin and T'ang masters. In his late period he became eccentric and vulgar (*kuai-su*)."[36] And Hsiang Mu wrote an essay on the theory and practice of calligraphy, so he, like Hsing T'ung, can doubtless be considered a representative of orthodox taste.

The popularity of Chu's cursive writing explains why there are so many forgeries of his work in that style. An Shih-feng noted that there were so many of them, they became "a trap for clumsy eyes."[37] The Ch'ing calligrapher Yü Chi (1738–1823) went so far as to remark that all Chu's "mad" cursive in circulation were forgeries.[38] Given this situation during the late Ming and Ch'ing, it is doubly difficult to clarify Chu's cursive and "mad" cursive writings today.

The challenge lies in determining what is "undisciplined and free," "loose and careless," "eccentric and vulgar," and yet genuine Chu Yun-ming, and in distinguishing them from what is bold, attractive, and flamboyant, but nonetheless a forgery.

"Retreat on an Autumn Day" (*Hsien-chü ch'iu-jih*), in cursive script. Handscroll, dated 1510, 5th lunar month (*no. 36*).

In this scroll Chu transcribed a favorite poem in his "personal" style. Some of the characters are well-formed—the four characters of the title, for example—and some are less satisfactory. There is a preponderance of casual, undefined strokes (such as the *wei*, top, third line) which fail to reflect the classical training Chu is known to have assimilated.

As noted above, however, a casual manner was a recurrent trait of Chu's personal style. Among the fifteen authentic works discussed here, the colophon to Wen Po-jen's "Miniature Portrait of Yang Chi-ching" (*fig. 80*) and that of his "Nineteen Old Poems" (*fig. 77*) show the same tendency. The latter scroll reveals greater attention to brushwork, however, and the structure of the characters is tighter. In the "Retreat on an Autumn Day" the acceptable characteristics are present, but not written with as much conviction.

Two other transcriptions of this poem by Chu are extant: one in the Palace Museum, Taipei, dated autumn 1525 (*fig. 85*), and the other a rubbing.[39] The 1525 work was written with great excitement after drinking; yet although the forms appear wild, the brushwork is more precise than his first version dated 1510. The Taipei scroll was written with forceful, centered-tip movements, and the interval of fifteen years may account for the superior quality of this later work. At any rate, the three

FIG. 85. Chu Yun-ming (1461–1527). *Retreat in Autumn*. Dated 1525. Detail of handscroll. Palace Museum, Taipei.

versions of the same text in a range of styles represent a valuable sequence for the study of Chu's writing.

"Autumn Meditations" (*Ch'iu-hsing*), transcription of Tu Fu's poems. Handscroll in cursive script, undated (*no. 37*).

The T'ang poems are transcribed on paper which is fine, smooth, and dense in texture; and the strokes of the springy brush have a firm, rounded quality (*fig. 86*). The brushwork is well-articulated and suggestive of "iron-wire" cursive. As Wen Cheng-ming noted in his enthusiastic colophon: "The spirit of the writing has an irrepressible vigor and alertness." The superior quality of "Autumn Meditations" is immediately recognizable when the scroll is compared with the two previous works, "Pear Valley" and "Retreat on an Autumn Day," revealing the variable quality of Chu's work.

Colophon, in running-cursive script, to Shen Chou, "Watching the Mid-Autumn Moon"; and poem, in cursive script, to "Farewell at the Bridge of the Hanging Rainbow" (*nos. 38 and 35b*).

These scrolls, which have been previously discussed, are accompanied by genuine writings by Chu's contemporaries. Stylistically, the brushwork in both is rather thin, and the forms relatively contained and refined.

The last few lines of the colophon to Shen Chou's work (*no. 38*) are similar to "Retreat in Autumn" (*no. 36*). The first half is more energetic and has a touch of formal re-

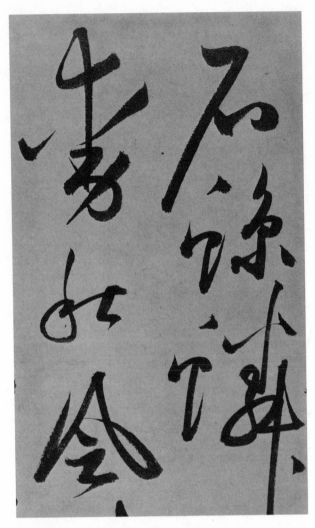

FIG. 86. Chu Yun-ming (1461–1527). *Autumn Meditations*. Detail of handscroll, *(no. 37)*.

"Farewell Poem." Hanging scroll in large cursive script, undated *(no. 39)*.

The vertical format of this scroll gave Chu Yun-ming the liberty of accentuating the vertical and diagonal sweeps of his writing, and of introducing more continuous links between strokes than was usual. These arching loops and sweeps make the work visually exciting, even though the brushwork itself is relatively plain. Details were overlooked in the momentum of execution. Some of the turning strokes are flat where the corner had been turned, since the hairs of the brush had not been neatly prepared. The ink is relatively pale, but the paper has a warm, natural tone, and the over-all flavor of the writing is still refined and elegant. Its authenticity is supported by the seal of Chang Hsiao-ssu, a famous late Ming collector.

"Winter Journey in the North." Folding fan mounted as album leaf, in cursive script *(no. 40)*.

Calligraphy written on folding fans customarily preserves clear columnar spacing, often with alternately long and short lines to accommodate the radial shape. Chu Yun-ming's calligraphy on radial fans follows this customary arrangement, but his most extraordinary works are those in which he packed the characters densely over the surface without clearly distinguishing the columns, thereby introducing a pictorial dimension into the format.[41]

"Winter Journey" has been introduced with excellent commentary by Marc Wilson and K. S. Wong in their *Friends of Wen Cheng-ming*. The fan has neither an identifying seal nor a signature—only collectors' seals; but this striking concept of pictorial writing cannot be identified with any other calligrapher of the period. As the critic An Shih-feng (ca. 1625) described Chu's technique: "He spontaneously accommodates the shape to the available space in a most ingenious way *(sui-ti fu-hsing)*."[42] This accommodation is quite remarkable in line eleven: when Chu reached the last stroke of the bottom character, *yeh* ("night"), he realized that the character to the right was too large, leaving insufficient space. He suddenly stopped his dashing speed and finished the stroke by tracing it inside the circular loop of the neighboring character, thus observing the traditional proscription against the strokes of two characters touching. This technique also produced an unexpected "three-dimensional" effect and is proof of Chu's responsiveness to compositional design.

Although earlier calligraphers like Huai-su and Huang T'ing-chien had developed pictorial spacing to a high degree in their handscrolls, Chu was the first to adapt

semblance to Huang T'ing-chien's style, possibly as a reference to Shen Chou, whose calligraphy was modeled after Huang T'ing-chien's. In the colophon to "Farewell" *(no.35b)* the structure of the characters is somewhat elongated, the columnar spacing wider, and the brushwork slower. Common to both works is a quality of refinement which is unusual in Chu Yun-ming's cursive writing, and found more often in his Ou-yang- and Chao-style writings.

Since these two works reflect less of Chu's personality, they seem less "typical." But oddly enough, their style is purer and more elevated than usual. And not only does their documentation give them importance, but their style adds to our knowledge of Chu's range, although few other works are directly related to them.[40]

their principles in an innovative manner to the folding fan. Unable to confine himself to the narrow radial folds of the slats of the frame, he treated the uneven surface as if it were entirely flat. Chu Yun-ming described writing on a folding fan as "like asking a dancing girl to demonstrate her technique on a pile of broken bricks and tiles!"[43]

Two other published fans may also be compared in this regard. A folding fan in the Art Institute in Chicago shows a sense of spacing slightly different from "Winter Journey."[44] Its composition is also strong, but the brushwork in the Chicago fan has a weightier, surer touch. In that sense, it is one of Chu's best cursive pieces. The composition of another fan (*fig.87*), presumably an earlier work, falls between "Winter Journey" and the Chicago fan.[45] The brushwork is sharper, with an exciting mixture of broad, weighty strokes and thin, linear ones.

"Prose Poem on Fishing." Handscroll in cursive script (*no.41*).

The style of this handscroll is not the usual cursive associated with Chu Yun-ming. In his final inscription he noted: "Under lamplight, I picked up a worn-out brush to commemorate the happiness of this occasion."[46] As a result, the calligraphy shows little of the customary brush-tip strength or thin ligatures, and little detailing in the dots and hooks.[47] This brush probably also accounts for a slight stiffness at the turns. However, the strength of this work is due also to its bluntness: the strokes are rounded and thick, with a desirable weightiness and a natural subtlety. The plainness suits Chinese taste, and this scroll has been preferred by several Chinese connoisseurs to other Chu attributions in American collections. The coarseness of the paper contributes to a dry-brush ink quality which is different in feeling from that of his usual works. The strokes have a sooty density which is lacking in those works written on smoother, tighter papers—the preceding fans, for example.

"Bringing the Wine" (*Chiang-chin chiu*).
Handscroll, second section, in cursive script (*no.42*).

"Bringing the Wine" (*Chiang-chin chiu*).
Handscroll, in cursive script (*no.43*).

Stylistically, these two scrolls share certain characteristics. The rounded strokes seem to have been written with a centered tip. The brushwork is fast; there are exaggerated contrasts between the light and heavy and the thin and thick strokes; and the variations are quite

FIG. 87. Chu Yun-ming (1461–1527). *Poem.* Folding fan. Saito Collection.

regular. Both works are dominated by diagonal and horizontal strokes which flail out into the surrounding columns, combined with knoblike blobs of ink at the beginning and ends of the strokes. The outer parts of the character, therefore, contrast strongly with the tight inner parts. There is no doubt that both works give the impression of brush vigor. The individual strokes, however, lack focus, internal energy, and conviction. They make for erratic movement without substance.

Chu Yun-ming's cursive characters do tend to "split" apart, an over-all indication of the broadness of his structures, and he composes his characters spaciously, and in extreme cases, too casually. But this regular contrast between tight and loose forms and stylized rhythm are not found in his other works.

The standards of Chu Yun-ming's writing frequently reflected the variety of his moods. Still, any irregular quality and pronounced change in his structures and brushstrokes may also be interpreted as a function of his diverse sources and a reflection of his broad background. In the two versions of "Bringing the Wine," the regularity and exaggeration of the strokes reveal the writer's narrow stylistic range: the diagonals slant at much the same angle; the heavier strokes are similar in thickness. In effect, this is a cursive script based on the repetition of one or two recognized aspects of Chu Yun-ming's style.

"Flowers of the Seasons," dated 1519; "Poems on Plum Blossoms," undated; "Orchid Flower Song," dated 1507; and "Orchid Flower Song," undated. Four handscrolls (*nos.44–47*).

The similarity of these four scrolls stems, first of all, from their large format and script size. The strokes are broad and confident, with striking contrasts of thick and thin, dense wetness and dry streakiness. There are also sharp contrasts of scale, with some columns consisting of

only one large, elongated character, and others of two to four smaller characters.

Drawn with flamboyant gestures, these scrolls reflect the image of Chu Yun-ming as an emotional and uninhibited master of "wild" cursive. They have an extraordinary initial attraction, and their dramatic appeal is undeniable.

Of the four, "Flowers of the Seasons" (no.44) is the most overtly energetic due to the use of a harder and stiffer brush which carries the writer's tremendous drive into the strokes. Even though the forms themselves are not necessarily cohesive, the energy appears to be centralized within the structure of each character. The wide, throbbing brush gestures are especially insistent in this work and give it a specific identity.

"Poems on Plum Blossoms" (no.45) combines these formal similarities with more linked strokes and virtuoso brushwork. The brush here was softer, however, so that the force was diffused throughout the hairs rather than concentrated within the tip. The color of the paper is unnaturally dark.

"Orchid Flower Song," dated 1507 (no.46), is similar to "Poems on Plum Blossoms." The paper is almost the same tan color. Both show a consistent mannerism in the "mountain" character of the signature (fig.89). In the illustrated section, the second character of Chu Yun-ming's signature and the top character of the third line demonstrate this: the brush started from the upper left, veered sharply upward to the right as if making a hook, shot upward again, pausing with some pressure to form the top of the graph, and then swooped down to the right to make a hook-shaped comma form. This configuration should be carefully compared with reliable *Chih-shan* signatures.

The format of "Orchid Flower Song," undated (no. 47), is smaller and the strokes sharper and thinner than no.46. While most strokes were written with the brush tip, the characteristic movements are zigzags across the surface, creating thin spiky angles in contrast with thick heavy stresses. There are fewer flared gestures than in the preceding three scrolls.

Close examination of all four scrolls reveals a number of stylistic similarities:

In terms of brushwork, the strokes convey a heavy, almost melodramatic force. The flattened "belly" of the brush was used consistently in sustained movements; then the brush pressure changes abruptly, producing alternately thin and thick strokes.

The structure of the characters is generally quite tight, especially those with thicker brushwork, so that the inner spaces seem black. The impression is more one of mass than of space.

There is a strong downward pull in the characters, as if the vertical axis were weighted; the columnar forces are quite distinct, even with only one or two characters in a line; and the spacing between columns is clear and open.

Although the characters are in "mad" cursive, with an abundance of wide flaring links, the characters are relatively legible. This is because they were conceived as individual entities, occupying their own prescribed space, even when there are links between them.

To VERIFY the authorship of these four scrolls, they should be analyzed stylistically in relation to what is known of Chu Yun-ming's authentic cursive writing.

Chu's brushwork is usually stronger and more exact. He was able to handle the brush in such a way that the energy was usually concentrated to the very tip, penetrating the paper in a decisive way. Although he could be quite careless, his brushwork generally reflected his two basic approaches, including well-articulated entering strokes or softer flexed strokes with exposed heads.

Chu put greater emphasis on the individual dot and stroke as a formal component of his characters. This harks back to his training in draft-cursive, in which there are fewer linked strokes, and in which the dots are usually written separately.

The dot-stroke mentality influenced the structure of the columns and caused the writing to be much less legible. Chu integrated components between characters and conceived of them as elements in a total spatial design. Thus strokes may be related spatially in a column, without actually being linked. Without some foreknowledge of the text, one may be uncertain as to where one character ends and another begins.

As he wrote, Chu also consciously sought dissimilarity between similar forms. He did not seek that variety for its own sake; rather, it was the result of a wider scope of possibilities operating in his mind and from which he could choose spontaneously.

In Chu's genuine cursive works there is a mixture of both "tip" and "belly" brush movements which recede and reappear in a spontaneous rhythmic way, so that one is not made aware that one type of stroke is used too often or that another is used too seldom. By contrast, in the two scrolls entitled "Bringing the Wine," the brush tip is too often used without sufficient energy, so that the strokes have a limp, tube-like feeling to them; conversely, in the last group of four, the "belly" of the brush is used too much, flattening out the stroke in unmodulated sweeps.

Chu Yun-ming's special sense of design was recognized by critics who described his compositions as "a spontaneous accommodation of shape to the available space." That particular spatial sense is also missing from the six preceding works; moreover the links

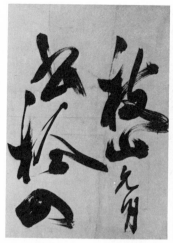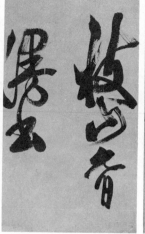

FIG. 89. Chu Yun-ming (1461–1527). *Signatures from four scrolls. (Left to right, nos. 44,45,46,47.)*

between strokes are stressed to such a degree that they dominate the basic stroke forms.

TO RESOLVE such discrepancies in style, the relationship between these scrolls and the work of certain younger contemporaries of Chu Yun-ming, such as Ch'en Shun (1483–1544) and Wang Wen (1497–1576), must be scrutinized. The brushwork in Ch'en's "Thoughts on an Ancient Site" *(no. 55)*, for example, reveals his tendency to use the flat of the brush under constant pressure to bring out ribbon-like and streaked ink effects to a degree not seen in Chu Yun-ming's genuine cursive writings. Wang Wen's handscroll "Dragon Boat Song" *(no. 59)*, dated 1571, for example, reveals a similar use of thick, heavy strokes of even weight to create a dense inner effect. Equally striking is Wang Wen's sense of scale: his writing is excessively large for a handscroll. Both artists showed an interest in extreme variations of character size, as well as in the isolation of a single elongated character in a line of vertical space, a device repeated in rhythmic fashion. As the brushwork and structural characteristics of these four scrolls are so distinctly different from our understanding of Chu Yun-ming's style, it seems likely that they are the products of the generation of Ch'en Shun, Wang Wen, or later followers of Chu Yun-ming.

"Evening Reflections" (*Fan-chao*). Hanging scroll in cursive script *(no. 48)*.

Stylistically, this hanging scroll somewhat resembles the four large handscrolls discussed above, except that wavy billowing strokes are here replaced by a strongly

fluctuating (*tun-ts'o*) dry-brush effect and abrupt changes of brush pressure in the vertical and diagonal strokes, resulting in a hyperactive alternation of heavily inked and streaky textures. These extreme fluctuations of pressure and speed are found in almost every character, with some strokes ending in sharp clawlike hooks.

Some of the characters were simply miswritten and are barely recognizable. The most blatant transgression is "mountain" (second character from top, left line), which has an extra stroke and was written in an indecipherable stroke order. In addition, "shining" (*chao*, second character from top right) has its lower component of the "fire" radical missing, while "village" (*ts'un*, third from top left) has a dot missing. These omissions are disturbing because they reveal a level of education and literary background beneath those of Chu Yun-ming. In other words, the forms have no history, no learning behind them.

All this is not just a question of legibility. In the "Red Cliff" handscroll, written in Chu's freest "wild" cursive, the characters may be indecipherable, but they were not miswritten. Chu was experimenting with brushwork in its purest form: the exaggerations are contained within a larger concept, defined by the master's knowledge and technique. Among its several hundred characters, "Red Cliff" does contain strokes with abrupt fluctuations, but they are infrequent and the result of irrepressible excitement. In this scroll of fourteen characters, they appear everywhere. Certain of Chu's stylistic traits, as seen in a scroll like "Red Cliff," were appropriated by a second writer without full understanding.

Conclusion

The study of so versatile a calligrapher as Chu Yun-ming has just begun, and, as in the case of the painter Tao-chi, will inevitably be controversial. But even if many current attributions were eventually judged to be forgeries, all would not necessarily be lost. The early forgeries—those made shortly after the lifetime of the master whose name they bear—should play an important role in all studies of his works. If their place were fully understood, such knowledge would contribute to a more complete history of calligraphy and would add to our total comprehension of the taste and styles of the period. The only true harm a forgery can do is to be mistaken for an original, thus distorting our image of a master's genuine gifts and learning, and confusing the course of history.

夢草記

語兄弟者則以謝氏西堂之夢

為美談且池塘春草之句得扵

靈運時惠連猶未知昌為其助

乎大略文人妙思有觸乃發惠

連才藻超頴靈運每對之輒

33a Chu Yun-ming (1461–1527), *Dreaming of Spring Grasses.*
Dated spring 1510. Section of handscroll.
Hou Chen Shang Chai.

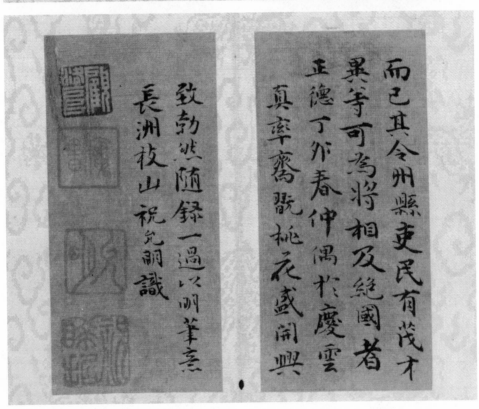

34 Chu Yun-ming (1461–1527), *Poems and Essays.*
Dated 1507. Album leaves.
Collection of John M. Crawford, Jr.

222　VI · CHU YUN-MING

正德庚午仲春之望

京闈鄉貢進士祝 允明

記

正德五年歲在庚午夏六月

沈望

京闈鄉貢進士太原祝允

33a & b Chu Yun-ming (1461–1527), *Signatures*:
(Left) *Dreaming of Spring Grasses*. (Right) *Pear Valley*.
Dated 1510. Sections of handscroll.
Hou Chen Shang Chai.

梨谷記

有物以人傳者如塑氏以槐有
人以物傳志如田氏之荊皆倩
托一者也而人物交暎而互傳
志則猿谷之梁是已潘安仁
之賦謂北之大谷之梁海內惟

33b Chu Yun-ming (1461–1527), *Pear Valley*.
Dated 1510. Section of handscroll.
Hou Chen Shang Chai.

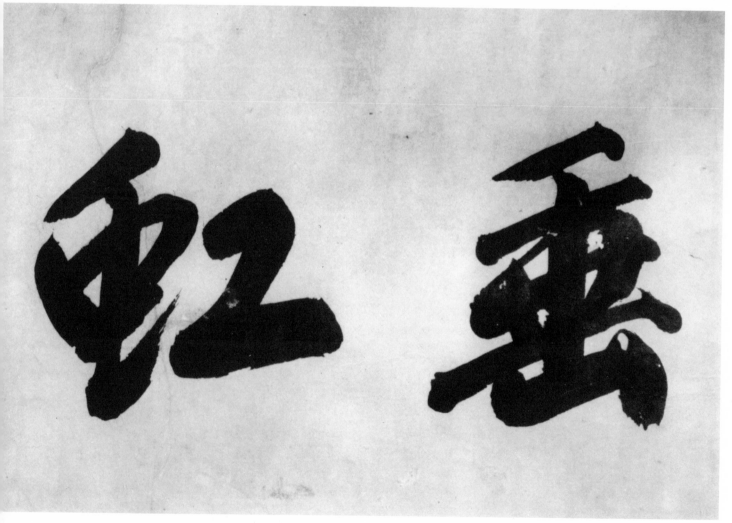

35a Chu Yun-ming (1461–1527), *Farewell at the Bridge of the Hanging Rainbow.*
Frontispiece to painting by T'ang Yin. (Detail below.)
Collection of John M. Crawford, Jr.

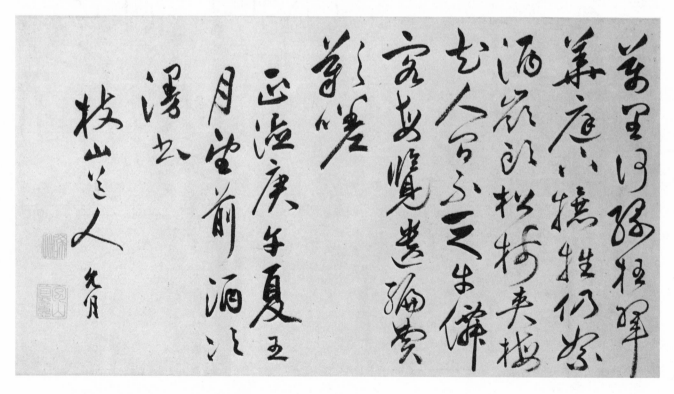

36 Chu Yun-ming (1461–1527), *Retreat on an Autumn Day.*
Dated 1510. Sections of handscroll.
The Jeannette Shambaugh Elliott Collection at Princeton.

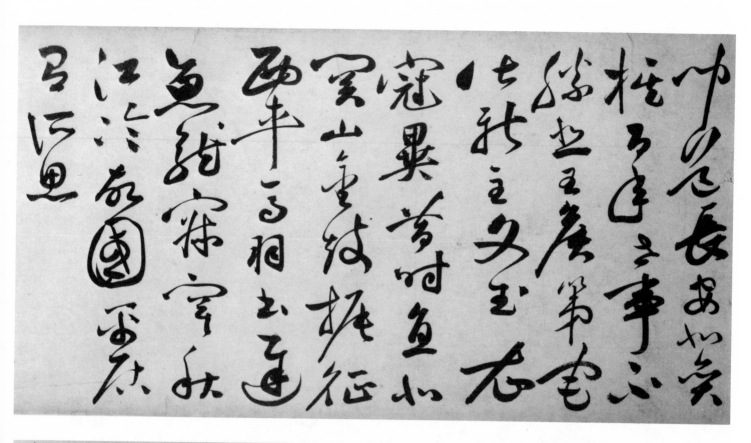

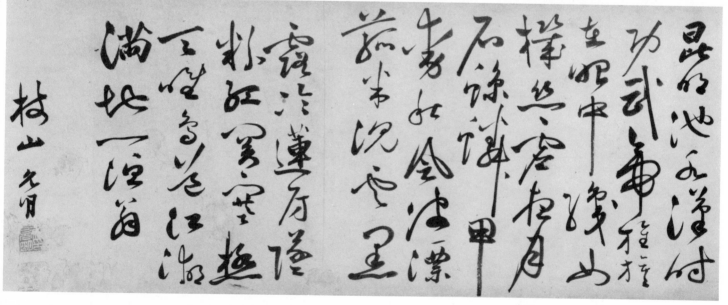

37 Chu Yun-ming (1461–1527), *Autumn Meditations*.
Sections of handscroll.
Collection of Robert H. Ellsworth.

把手江南夢

爲拈訣辭分會中坡

古長虹立吐作

天家補笺文祝

允明

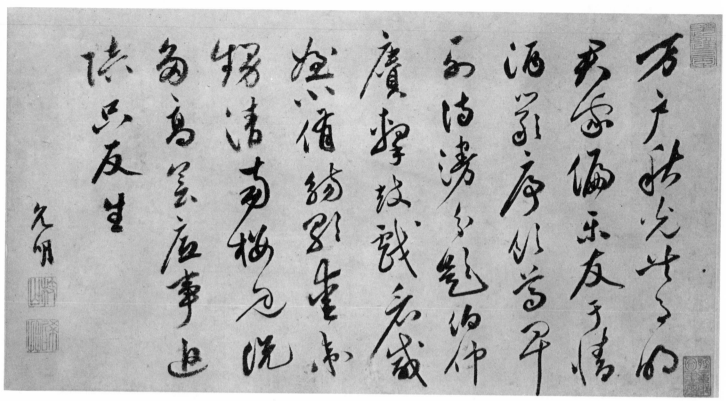

38 Chu Yun-ming (1461–1527), *Colophon to*
"*Watching the Mid-Autumn Moon*," painting by Shen Chou.
Section of handscroll.
Chinese and Japanese Special Fund, 15.898,
Courtesy Museum of Fine Arts, Boston.

35b OPPOSITE
Chu Yun-ming (1461–1527),
Farewell at the Bridge of the Hanging Rainbow,
poem to painting by T'ang Yin.
Section of handscroll.
Collection of John M. Crawford, Jr.

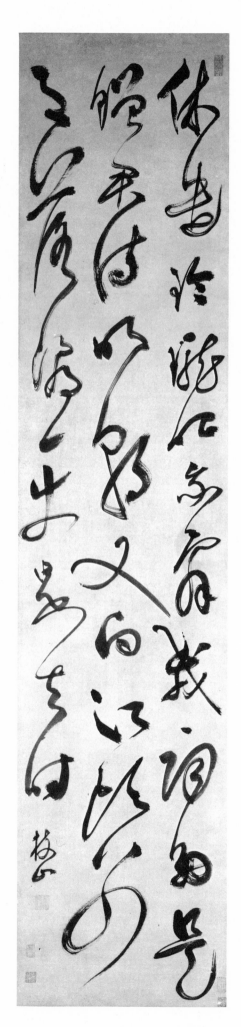

39 Chu Yun-ming (1461–1527), *Farewell Poem*.
Hanging scroll.
Anonymous loan.

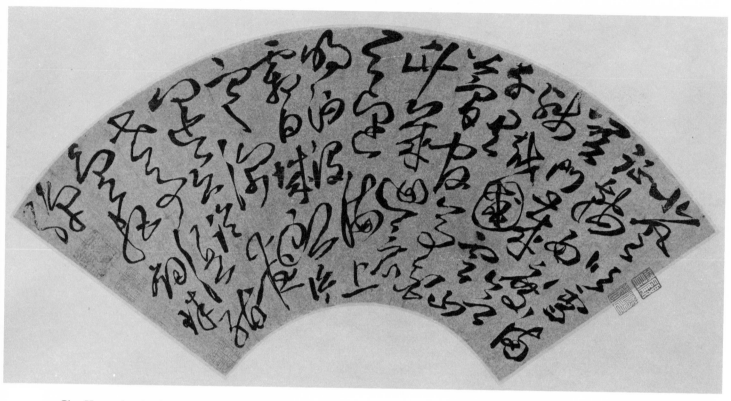

40 Chu Yun-ming (1461–1527), *Winter Journey in the North.*
Fan mounted as album leaf.
Collection of John M. Crawford, Jr.

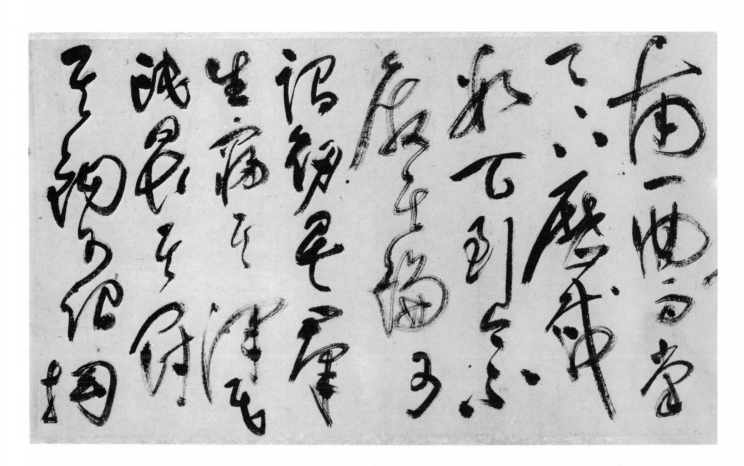

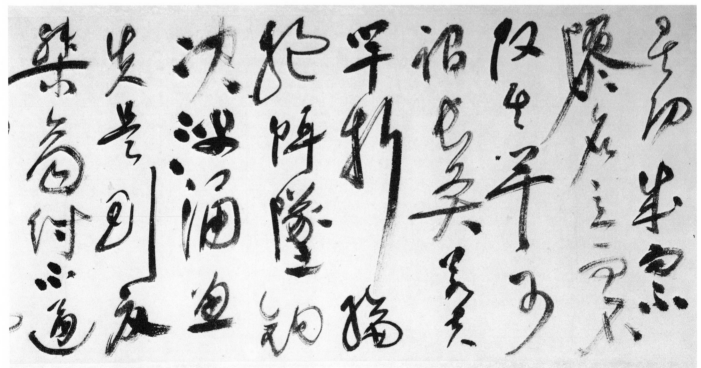

41 Chu Yun-ming (1461–1527), *Prose-poem on Fishing*.
Dated 1507. Sections of handscroll.
Collection of John M. Crawford, Jr.

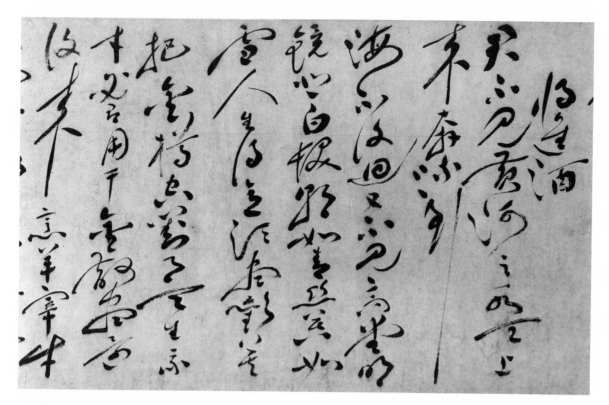

42 Chu Yun-ming (1461–1527), *Bringing the Wine.*
Section of handscroll.
Collection of Robert H. Ellsworth.

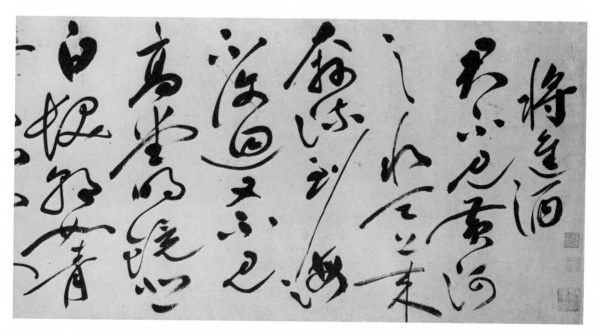

43 Chu Yun-ming (1461–1527), *Bringing the Wine.*
Section of handscroll.
The Jeannette Shambaugh Elliott Collection at Princeton.

44 Chu Yun-ming (1461–1527), *Flowers of the Seasons.*
Dated 1519. Section of handscroll.
Anonymous loan, The Art Museum, Princeton University.

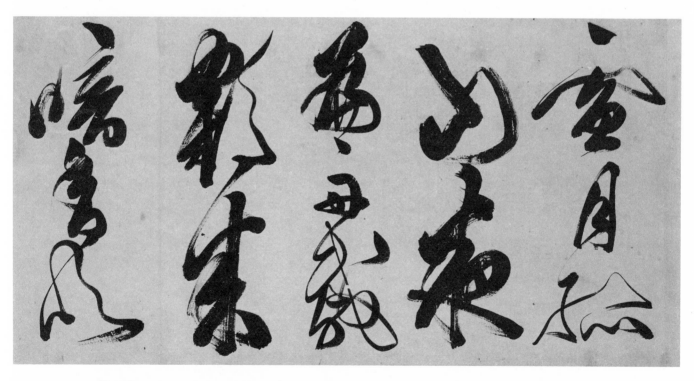

45 Chu Yun-ming (1461–1527), *Poem on Plum Blossoms.*
Section of handscroll.
Collection of Robert H. Ellsworth.

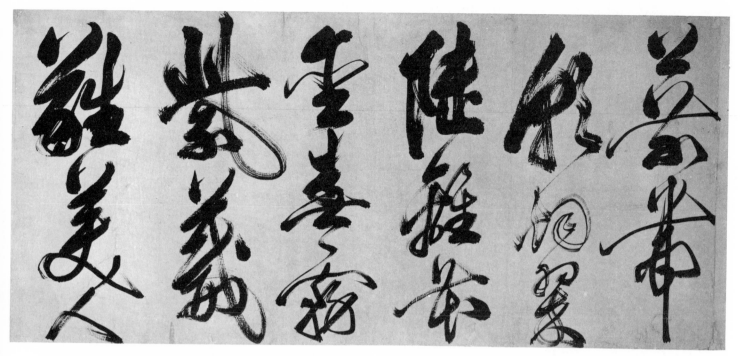

46 Chu Yun-ming (1461–1527), *Orchid Flower Song*.
Dated 1507. Section of handscroll.
Collection of John M. Crawford, Jr.

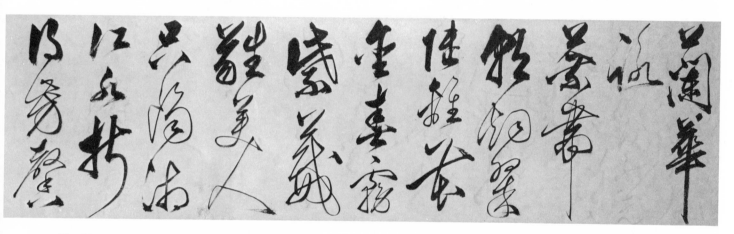

47 Chu Yun-ming (1461–1527), *Orchid Flower Song*.
Section of handscroll.
Collection of Robert H. Ellsworth.

48 Chu Yun-ming (1461–1527),
Evening Reflections.
Hanging scroll.
Collection of John M. Crawford, Jr.

CATALOGUE

LIST OF TITLES
IN CHINESE

展出法書目

1a	王羲之行穰帖（唐人硬黃鈎摹本）
1b	董其昌跋行穰帖
2	餘清齋刻本行穰帖並跋
3	褚遂良哀冊（明嚴澂白麻紙鈎摹本）
4	黃庭堅草書廉頗藺相如傳卷
5	黃庭堅寒山龐蘊詩卷（臨本）
6	黃庭堅書古文贈張大同卷大行楷跋
7	黃庭堅書詩卷（明人偽造）
8	米芾書吳江舟中詩大行草卷
9	米芾書歲豐逃暑對客草〻三札冊
10	范成大跋宋人西塞漁社圖卷
11a	張即之中楷書金剛經冊
11b	趙宧光草篆書畢熙志跋金剛經冊
11c	俞樾效趙宧光草篆跋金剛經冊
12	周密跋趙孟堅水仙圖卷
13	趙孟頫自題雙松平遠圖卷
14	趙孟頫題雙松平遠圖（近人臨本）
15a	趙孟頫篆書「湖州妙嚴寺記」引首
15b	趙孟頫楷書湖州妙嚴寺記卷
16	鮮于樞大行楷書御史箴卷
17	鮮于樞御史箴卷（鈎摹本）
18	鮮于樞草書石鼓歌卷
19	馮子振跋郭熙樹色平遠卷
20	柯九思小楷宮詞卷
21	康里巎草書柳宗元梓人傳卷
22	楊維楨自書鬻婦飲詩頁
23	楊維楨跋謝伯誠山水軸（臨本）
24a	吳鎮自題草亭詩意卷
24b	李東陽篆書「草亭詩意」引首
25	倪瓚詩札卷
26a	沈度書朱熹感寓詩卷
26b	沈粲草書詩卷
27	金湜隸書「翰墨菁華」冊頁
28	姚綬行草芭蕉詩卷
29	沈周自書「溪山秋色」引首
30	陳獻章自書梅花詩卷
31	吳寬大行書詩卷
32	王鏊題沈周瓜擂圖軸
33	祝允明書夢草秋谷二記合卷
34	祝允明書宋玉詩賦冊
35a	祝允明書「垂虹別意」引首
35b	祝允明書垂虹別意詩

CATALOGUE

1a. Wang Hsi-chih (303 ?–361 ?)

Hsing-jang t'ieh, early T'ang tracing copy of a letter written by Wang Hsi-chih.
Cursive script (*ts'ao-shu*), 2 lines.
Undated.
Letter mounted as handscroll, ink on *ying-huang* paper. 9⅝″ × 3½″ (24.4 cm. × 8.9 cm.).
Anonymous loan, The Art Museum, Princeton University.

COMMENTS

This portion of Wang Hsi-chih's letter is composed of 15 characters written in 2 lines. One possible transcription, given by Tung Ch'i-ch'ang (1555–1636), follows the letter. The second half of the letter is reportedly preserved in the form of rubbings.[1]

No signature or seals of artist.

BIOGRAPHY OF ARTIST

Wang Hsi-chih (*tzu* I-shao; official title, Yu-chün chiang-chün) is acclaimed as the sage of Chinese calligraphy.[2] From a prominent Shantung family of calligraphers, he surpassed all his contemporaries, and his running and cursive script styles had a profound influence on succeeding generations. Wang served in various official capacities, including posts in Hupei and Chekiang, then retired in 355 and lived in the Shan-yin district of Chekiang. His best-known compositions, "The Preface to the Orchid Pavilion Gathering" (*Lan-t'ing-chi hsü*), dated 353, and the Huang-t'ing Taoist scripture (*Huang-t'ing ching*) are classic models.

LABELS

(mounted preceding Wang Hsi-chih's letter
and listed in chronological order)

Sung Emperor Hui-tsung (r. 1101–25), 1 line in faint gold ink on narrow strip of silk, 6 characters in "slender gold" script. [Inscribed] "Wang Hsi-chih, *Hsing-jang t'ieh*." No seals.

Tung Ch'i-ch'ang (1555–1636), 1 line in standard script, ink on paper, 6 characters. [Inscribed] "Wang Yu-chün, *Hsing-jang t'ieh*." No seals.

Ch'ien-lung Emperor (r. 1736–95), 1 line in running script, ink on paper, 14 characters. [Inscribed] "Wang Hsi-chih, *Hsing-jang t'ieh* chen-chi shen-p'in, Nei-fu mi pao." One imperial seal.

COLOPHONS

Tung Ch'i-ch'ang, first of 4 colophons: transcription of letter, 1 line in small standard script. [Signed] "Transcribed by Ch'i-ch'ang." No seals.

Tung Ch'i-ch'ang, second of 4 colophons: transcription of poem by Su Tung-p'o (1036–1101), 3 lines in running script. Tung records this poem, written in praise of another short but highly valued piece of calligraphy, because it could well describe this letter by Wang Hsi-chih. It includes the words: "These two lines are worth more than thirty-thousand other scrolls." No seals.

Tung Ch'i-ch'ang, third of 4 colophons, 24 lines in running script, dated 1604. Tung notes that the *Hsing-jang t'ieh* was not included in the *Ch'un-hua-ko t'ieh* records of the Sung imperial collection. No seals.

Tung Ch'i-ch'ang, fourth of 4 colophons: see no. 1b.

Sun Ch'eng-tse (1592–1676), 4 lines in running script, undated. Sun notes that this is the best of several of Wang Hsi-chih writings he had seen in recent years. [Signed] "Sun Ch'eng-tse." [Seal] *Yen-shan-chai* (rectangle, relief).

Ch'ien-lung Emperor (r. 1736–95), first of 3 colophons: 1 line in running script preceding the letter, undated. "Dragons leaping at the Gate of Heaven, tigers crouching before the Phoenix Hall."[3] One imperial seal.

Ch'ien-lung Emperor, second of 3 colophons, 6 lines in running script, dated 1748. Two imperial seals.

Ch'ien-lung Emperor, third of 3 colophons: 6 lines in running-standard script, dated 1748. Two imperial seals.

Chang Ta-ch'ien (contemporary), 2 colophons, 6 lines in running script. Chang notes that he acquired this scroll in 1957 from a Mr. Li in Hong Kong. First colophon: [Signed] "Yuan." [Seals] *Shu-chün Chang Yuan* (square, intaglio), *Ta-ch'ien chü-shih* (square, relief). Second colophon: [Signed] "Chang Ta-ch'ien, Yuan." [Seal] *Chang Yuan ch'ang-shou* (square, relief).

COLLECTORS

Sung Emperor Hui-tsung (r. 1101–25), 6 seals.
Yuan Meng-li(?) (Ming), 2 seals.
Wu T'ing (active ca. 1575–1625), 2 seals.
An Ch'i (1683–1744), 11 seals.
Ch'ien-lung Emperor (r. 1736–95), 19 seals.
Chia-ch'ing Emperor (r. 1796–1820), 1 seal.
Ching Heng-i(?) (20th century), 1 seal.
Li Ching-mai (20th century), 8 seals.
Ch'eng Ch'i (contemporary), 2 seals.
Mr. and Mrs. Chang Ta-ch'ien (contemporary), 34 seals.
Unidentified, 1 seal.

PUBLISHED

Chang Yen-yüan, *Fa-shu yao-lu*, the *Yu-chün shu chi*

section, 10/169 (where the complete text of the letter is recorded in 30 characters). *HHSP* 15/347. Wang K'o-yü, *SHW* 1/7; also in *SKT* 1/304 (he records that he saw the letter aboard Chou Min-chung's boat on the Wu River in 1618). Chang Ch'ou, *Ch'ing-ho shu-hua-fang, ch'ou*, 26a. Wang Shu, *Hsu-chou t'i-pa* 4/17b–18a. *SCPC* II/2599–2600. An Ch'i, *Mo-yuan hui-kuan* 1/5–6. Yang Shou-ching, *P'ing-t'ieh chi*. *SZ* 4/37. *SMS* 37/16. Nishikawa Nei, *Shohin* 142. Chu Hsing-chai, *I-yuan t'an wang* (1964), pp. 263–65. Wang Chuang-wei, *Shu-fa ts'ung-t'an* p. 22. Ch'en Chih-mai, *Chinese Calligraphers*, no. 68a. Leon L. Y. Chang, *La Calligraphie chinoise* (1971), pp. 122–23. Chuang Yen, "*Hsing-jang t'ieh*," in the series of articles entitled *Shan-t'ang ch'ing hua 27*, in *Tzu-yu t'an* (1972) 23/7, pp. 27–32; "*Tsai t'an Hsing-jang t'ieh*," ibid., 23/9. Nishikawa Nei, *Showa rantei kinenten zuroku* (Tokyo, 1973), pl. 157. Iijima Syunkei, *Shodō jiten*, p. 2.

COMPARATIVE MATERIAL

Rubbings from stone carvings: Wu T'ing, *Yü-ch'ing-chai t'ieh* (1596 and 1614; see nos. 2a and b); *San-hsi-t'ang fa-t'ieh*, I. Copy: *KKSHL* 8/1.
Facsimile: pub. by Benridō, Kyoto (1959).
SZ 4/73. *SBT* 1/4, 12. *Shohin* 13, 80, 142, 199. *KKFS* 1. *SMS* 18, 21, 22, 37, 44, 48, 73. *Wakan bokuhō senshū* 3. *SG* 1.

NOTES

1. See Nakata Yūjirō, *Ō Gishi o chūshin to suru hōjō no kenkyū*, pp. 39–40 and fig. 29; Fontein and Wu, *Unearthing China's Past*, no. 114, pp. 210–12. The original meaning of this early letter has become obscure over the centuries.

2. Wang Hsi-chih's dates are problematical, and 5 different sets of possible dates have been suggested. See Nakata Yūjirō, *Chūgoku shojin den*, pp. 289–90; Toyama Gunji, *Chūgoku no sho to hito*, p. 9.

3. This well-known expression was originally used by Liang Emperor Wu (r. 502–549) to describe the excellence of Wang Hsi-chih's calligraphy.

1b. Tung Ch'i-ch'ang (1555–1636)

Colophon to *Hsing-jang t'ieh*, a letter written by Wang Hsi-chih (303 ?–361 ?).
Running script (*hsing-shu*), 11 lines.
Dated 1609.
Handscroll, ink on paper.
Colophon only: $11\frac{5}{16}''$ × 33″ (30.3 cm. × 83.8 cm.).
Anonymous loan, The Art Museum, Princeton University.

TRANSLATION

Wherever this scroll is, there should be an auspicious cloud hovering above to protect it. But the human eye cannot see that cloud.

INSCRIPTION AND SIGNATURE OF ARTIST

"Inscribed again on the 26th day of the 6th month in the year *i-yu* [1609], looking [at the scroll] together with Ch'en Chi-ju and Wu T'ing. [Signed] Written by Tung Ch'i-ch'ang."

Tung Ch'i-ch'ang (*tzu* Hsuan-tsai, *hao* Ssu-pai, Ssu-weng, Hsiang-kuang) was a resident of Hua-t'ing, Sung-chiang. In 1589 he became a *chin-shih* and a member of the Hanlin Academy, and late in life he was appointed Minister of Rites. In contrast to a frustrating official career, Tung's interest in painting and calligraphy flourished. As the central figure in the artistic circle of Sungchiang, a noted connoisseur and collector, he articulated a new approach to art history. His calligraphy and painting reveal an intensive study of past styles and a firsthand knowledge of treasured works, whereas his own particular styles had considerable influence on succeeding generations.

The calligraphy shown here is one of the best examples of Tung's colophon writing, which is comparable in quality to his inscription on Tung Yuan's painting *Hsiao-hsiang t'u*.

COMPARATIVE MATERIAL

SNT 1/11, 12, 32, 34, 36–38, 53, 119, 126, 128–43. *SBT* 1/17, 23; 2/184; 3/204, 208–09, 212, 250–51; 4/341–44; 5/38–59, 60–61; 6/83–96; 7/155; 8/18–25; 10/28–34; 12/232–52. *Shohin* 207. *Ming Ch'ing SHHC* 181–83. *Pai-chueh-chai* 2. *SZ* 21/6–25. *SMS* 77, 78. *SG* 8.

2a. Wang Hsi-chih (303 ?–361 ?)

Facsimile of rubbing[1] of the *Hsing-jang t'ieh*, a letter written by Wang Hsi-chih.
Cursive script (*ts'ao-shu*), 2 lines.
Rubbing datable to 1614;[2] facsimile made late 19th century.
Handscroll.
Letter portion only: $11\frac{3}{16}''$ × 6″ (28.4 cm. × 15.2 cm.).
Anonymous loan, The Art Museum, Princeton University.

LABEL

Anonymous, "Wang Hsi-chih, *Hsing-jang t'ieh*," a single line in standard script, replacing the original 3 labels.

COLOPHONS

The same as on no. 1, but the space between lines has been compressed. Naturally, the collectors' seals postdating Wu T'ing's life do not appear on Wu's rubbing. One early seal, which was double and belonged to the Sung Emperor Hui-tsung, was moved closer to the letter in the rubbing.

COLLECTOR

Wu T'ing (active ca. 1575–1625), 2 seals (not found on nos. 1a or b).

PUBLISHED

SMS 37/17.

NOTES

1. When Wu T'ing owned the *Hsing-jang t'ieh*, he super-

vised the carving of a series of calligraphic works, including this letter. The collection of rubbings from those carvings is called the *Yü-ch'ing-chai fa-t'ieh*. When Yang Shou-ching (see no. 89) went to Japan in 1880, he took a set of the rubbings with him, and this facsimile was produced at that time.

2. Wu T'ing's carving project was undertaken at two different times: parts were done in 1596; the remainder, in 1614. The carving of the *Hsing-jang t'ieh* can therefore be dated 1614.

2b. Tung Ch'i-ch'ang (1555–1636)

Facsimile of rubbing of the colophon to *Hsing-jang t'ieh*.
Running script (*hsing-shu*), 11 lines.
Dated 1609.
Handscroll, ink on paper.
$11\frac{3}{16}''$ × $24\frac{1}{2}''$ (28.4 cm. × 62.2 cm.).
Anonymous loan, The Art Museum, Princeton University.

NOTE

The colophon is identical in every way to no. 1b, except for the spacing between lines, which was reduced in the carving.

3. After Ch'u Sui-liang (596–658)

Tracing copy of "Elegy to T'ang Wen-huang" (*T'ang Wen-huang* [T'ai-tsung] *Ai-ts'e*), made by Yen Ch'eng (ca. 1540–ca. 1600).
Standard script (*k'ai-shu*).
Original text dated 649.
Album of 6 double leaves, ink on paper.
Single leaf: approx. 9" × $8\frac{11}{16}''$ (22.8 cm. × 22.1 cm.).
Collection of Mr. and Mrs. Wan-go H. C. Weng.

No signature or seals of artist.[1]

BIOGRAPHY OF CH'U SUI-LIANG

Ch'u Sui-liang (*tzu* Teng-shan), a native of Honan, was a well-known calligrapher and scholar-official who served the T'ang Emperor T'ai-tsung (posthumous title Wen-huang, r. 627–649). Known as a connoisseur of Wang Hsi-chih's calligraphy, he was highly respected by the Emperor, and when T'ai-tsung died in 649, Ch'u Sui-liang was responsible for composing this "Elegy," which he read at the interment.[2]

No inscription or signature of the copyist, Yen Ch'eng.

SEALS OF COPYIST YEN CH'ENG

T'ien-ch'ih (round, relief), *Ch'eng* (half-seal, intaglio), *Yen shih Tao-ch'e* (square, intaglio), *Ch'ung-lang-ko yin* (square, intaglio), *Ch'eng-chung* (square, relief).

BIOGRAPHY OF COPYIST

Yen Ch'eng (*tzu* Tao-ch'e), a minor official of the Ming period, was from Ch'ang-shu, Kiangsu. His father Yen Na lived from 1511 to 1584, so that Yen Ch'eng, his second son, was probably born around 1540.

COLOPHON (on leaves 7 and 8)

Weng T'ung-ho (1830–1904), 16 lines in standard script, dated 1885. Weng states that compared to other carvings of the same work, this piece by Yen Ch'eng is spirited and lively. Moreover, according to him, all the seals in the album belong to Yen and to his son Yen Mao. This work was originally in the collection of Yen Yü-t'ang (Yen Teng-chün, 19th century), who gave it to Weng's father, Weng Hsin-ts'un, in 1823. Weng had it remounted in 1850, but since the mounter was careless, the piece was damaged. When Weng T'ung-ho received it from his father, he had it remounted from a handscroll into the present album format. Descendants of Yen Teng-chün's family mistakenly assumed that the work given to Weng's father was the original Ch'u Sui-liang.

COLLECTORS

Yen Mao (Yen Ch'eng's son), 3 seals.
Weng T'ung-ho (1830–1904), 3 seals.
Unidentified, 1 seal and 4 half-seals.

COMPARATIVE MATERIAL

SMS 141. *SG* 3/95–152. *SZ* 8/1–25, pp. 10–18.

NOTES

1. The 2 signatures at the end of the Elegy are those of Yü Huai (ca. 800–840) and Hsueh Shao-p'eng (ca. 1050–1100), who signed their names to indicate that they saw and authenticated Ch'u Sui-liang's calligraphy. Yen Ch'eng also traced these 2 signatures in his album.
2. "Elegy," composed by Ch'u Sui-liang, is recorded in Yao Hsuan (968–1020), ed., *T'ang wen ts'ui* (Shang-wu edn.) 32/254–55.

4. Huang T'ing-chien (1045–1105)

"Biographies of Lien P'o and Lin Hsiang-ju" (*Lien P'o Lin Hsiang-ju chuan*), by Ssu-ma Ch'ien (145 B.C.–before 86 B.C.).[1]
Cursive script (*ts'ao-shu*), 203 lines.
Undated.
Handscroll, ink on paper.
$12\frac{13}{16}''$ × 59' 9" (32.5 cm. × 1822.4 cm.).
Collection of John M. Crawford, Jr.

No signature or seals of artist.

BIOGRAPHY OF ARTIST

Huang T'ing-chien (*tzu* Lu-chih, *hao* Fu-weng, Shan-ku), a native of Fen-ning, Kiangsi, was a prominent calligrapher, poet, and art critic. He is known as the founder of the Kiangsi school of poetry and as one of the Four Great Masters of Sung calligraphy. Indeed, his distinguished personal style of calligraphy greatly influenced later masters.

As the result of his role in compiling the Veritable Records of the Emperor Shen-tsung's reign, Huang was accused of criticizing governmental policies and was exiled to Szechuan for 6 years; his scroll for Chang Ta-t'ung (no. 6) was done at that time.[2] In 1105 Huang died in Kwangsi, the place of his second exile.

Hsiang Yuan-pien (1525–90), 1 line in running-standard script, undated. Hsiang notes that Huang T'ing-chien's calligraphy was written in large cursive script (*ta ts'ao*), a term which refers less to the actual size of the characters than to their degree of cursiveness. [Signed] "A treasure of Hsiang Yuan-pien of the Ming [dynasty]." [Seals] *Tzu-ching* (gourd shape, relief), *Mo-lin shan-jen* (square, intaglio).

Chang Ta-ch'ien (contemporary), 2 lines in running script, dated 1956. Chang reminisces about another scroll by Huang T'ing-chien, *Fu-po-shen tz'u*, which was originally in his collection, and wonders whether those 2 scrolls would ever be reunited. [Seals] *Chang Yuan chih yin-hsin* (square, intaglio), *San-ch'ien Ta-ch'ien* (square, relief).

COLLECTORS

Sung Emperor Kao-tsung (r. 1127–62). [Seals] *Nei-fu shu-yin* (square, relief), 30 seals; *Shao-hsing* (double square, relief), 30 seals; *Shao-hsing* (double square, relief), 1 seal; *Shao-hsing* (oval, relief), 1 seal.
Chia Ssu-tao (1213–75), 1 seal.
Ou-yang Hsuan (1283–1357), 1 seal.
Fang Ts'ung-i (ca. 1301–ca. 1380), 2 seals.
Ts'ao Tzu-wen (unid.), 1 seal.
Hsiang Yuan-pien (1525–90), 72 seals.
Ku Lu (active late 14th century), 1 seal.
An Ch'i (1683–1744), 4 seals.
Ch'ien-lung Emperor (r. 1736–95), 2 seals.
Prince Yung-hsing (Ch'eng-ch'in Wang) (1752–1823), 11th son of Ch'ien-lung Emperor, 2 seals.
T'an Ching (20th century), 40 seals.
Chang Ta-ch'ien (contemporary), 7 seals.
Liu Ting-chih (contemporary mounter), 1 seal.
J. M. Crawford (contemporary), 1 seal.
Unidentified, 5 seals.

PUBLISHED

Wang Yun, *Shu-hua mu-lu*, p. 31; also *Ch'iu-chien hsien-sheng ta-ch'uan wen-chi* (*SPTK* I ed., vol. 291), 95/901.
Chang Ch'ou, *Chen-chi jih-lu*, 2/17b. Ku Fu, *P'ing-sheng chuang-kuan*, 2/59. Wu Sheng, *Ta-kuan lu*, 1/4a. An Ch'i, *Mo-yuan hui-kuan*, 1/26b. Sickman, ed., *Chinese Calligraphy and Painting*, no. 12, pp. 69–70. Ecke, *Chinese Calligraphy*, no. 21.

COMPARATIVE MATERIAL

SBT 2/183–84; 3/186–89, 195–96; 6/12, 13; 7/61–65. *KKFS* 10–1, –2. *Shohin* 150. *SMS* 23, 32, 45, 162. *Shanghai FSHC* 6. *SG* 6. *SZ* 15/58–85, pp. 18–25.

NOTES

1. This text is an abridged and slightly altered transcription of the first part of *Shih-chi*, chapter 81, in which Ssu-ma Ch'ien recounts stories concerning a general and a minister under King Hui-wen of Chao (r. 298–266 B.C.). For further details, see Sickman, ed., *Chinese Calligraphy and Painting*, no. 12, p. 69.
2. For detailed information, see Shen C. Y. Fu, "Huang T'ing-chien's Calligraphy and His Scroll for Chang Ta-t'ung: A Masterpiece Written in Exile," (Ph.D. dissertation, Princeton University, 1976).

5. After Huang T'ing-chien (1045–1105)

Anonymous free-hand copy of "Three Poems by Han-shan and P'ang Yun" in five-character meter.
Running script (*hsing-shu*), 26 lines.
Undated.
Handscroll, ink on tan paper.
12¼" × 89⅛" (31.2 cm. × 226.4 cm.).
Collection of John M. Crawford, Jr.

INSCRIPTION, SIGNATURE, AND SEAL OF ARTIST

"... These 2 scrolls of poems by Han-shan [ca. 740] and P'ang chü-shih [P'ang Yun, prob. 8th century] were written on behalf of the Reverend Monk Fa-sung at the Jen-yun Hall with a brush made by Chang T'ung. [Signed] Fu-weng."1 (Trans. A. Fang, in Sickman, ed., *Chinese Calligraphy and Painting*, no. 11, p. 68.) [Seal] *Shan-ku tao-jen* (square, relief).

COLOPHONS

Shih Yen (late 13th century), 4 lines in clerical script, undated. [Seal] *Shih Min-chan* (square, intaglio).

Fan Chih-ta (unid.), 6 lines in standard script, undated. [Seal] *Fan shih Te-yuan* (square, relief).

Ku Ying-hsiang (1483–1565), 6 lines in running script, dated 1566 (after Ku's recorded death). [Seals] *Ku shih Wei-hsien* (square, intaglio), *Ta-ssu-k'ou yin* (square, relief).

Wang Chih-teng (1535–1612), 9 lines in running script, dated 1576/7. [Seals] *Ch'ing-yang chün* (rectangle, intaglio), *Wang Chih-teng yin* (square, intaglio).

Chang Hung (contemporary), 33 lines in running-standard script, dated 1957.

COLLECTORS

Chin Emperor Chang-tsung (r. 1190–1208), 1 seal.
Li Ch'i (unid.),2 1 seal.
Pi Lung (active 1770's), 2 seals.
Lu Ch'iao (unid.), 1 seal.
J. M. Crawford (contemporary), 3 seals.
Unidentified, 3 seals.

PUBLISHED

Sickman, ed., *Chinese Calligraphy and Painting*, no. 11, pp. 67–69.

COMPARATIVE MATERIAL

The original version by Huang T'ing-chien is in the collection of the National Palace Museum, Taipei (*KKSHL* 1/54–55 and *KKFS* 10–2/18–25).

NOTES

1. "The Old Man of River Fu" is a *hao* which Huang T'ing-chien used after his first exile in Fuchou, Szechuan.
2. In Sickman, ed., *Chinese Calligraphy and Painting*, Li Ch'i is listed as the grandson of Li Jih-hua (1533–1636); his full name, however, was not Li Ch'i but Li Ch'i-chih (active mid-17th century).

6. Huang T'ing-chien (1045–1105)

"Scroll for Chang Ta-t'ung," inscription to an essay transcribed for his nephew.[1]
Running-standard script (*hsing-k'ai*), 46 lines.
Dated 1100.
Handscroll, ink on paper.
$13\frac{7}{16}'' \times 217\frac{15}{16}''$ (34.1 cm. × 553.5 cm.).
Anonymous loan, The Art Museum, Princeton University.

TRANSLATION OF OPENING SECTION

(On the last day of the 1st month, in the 3rd year of the Yuan-fu reign period [1100], my nephew Chang Ta-t'ung from Ya-chou [Szechuan], was preparing his belongings to) return home soon. He came to me and asked for some calligraphy. I have been having stomach and chest pains, and today I had some leisure time, so I tried my brush to write this essay. Chang Ta-t'ung has been interested in learning ancient-style prose [*ku-wen*], so I am giving this to him.

TRANSLATION OF DETAIL

(Now I, Fu-weng, am 56.) I have foot trouble and cannot bend over.

SIGNATURE OF ARTIST

[Signed] "Fu-weng" (in text). No seals.

COLOPHONS (listed in chronological order)

Wu K'uan (1435–1504), 7 lines in running script, undated. Wu, who wrote this colophon for Wu Yen (1457–1519) around 1494, notes that Huang T'ing-chien transcribed the essay for his nephew while at Po-tao (Jung-chou). [Signed] "Wu K'uan." [Seal] *Wu Yuan-po yin* (square, relief).

Li Tung-yang (1447–1516), 7 lines in running-cursive script, undated. [Signed] "Inscribed by Li Tung-yang." [Seal] *Hsi-ya* (rectangle, relief).

Wang To (1592–1652), 3 lines in small standard script, dated 1646. Wang records that he saw this calligraphy at the Ch'iu-yüeh Studio [which belonged to Ts'ao Jung (1613–85)]. [Signed] "Inscribed by Wang To of Hsi-lo." No seals.

Mo Shao-te (early 19th century), 6 lines in small standard script, dated 1812. [Signed] "Mo Shao-te of Ting-an." [Seal] *Shao, Te* (double seal, square, relief and intaglio).

Chang Ta-ch'ien (contemporary), 32 lines in running-cursive script, dated 1948. [Signed] "Chang Ta-ch'ien, Yuan." [Seals] *Chang Yuan chih yin-hsin* (square, intaglio), *Ta-ch'ien chü-shih* (square, relief), *Pai-sui ch'ien-ch'iu* (square, relief).

COLLECTORS

Sung Emperor Kao-tsung (r. 1127–62), 8 seals.
Yang I-ch'ing (1454–1530), 1 seal.
Chou Hsiang-yun (20th century), 6 seals.
Chang Ta-ch'ien (contemporary), 12 seals.
Unidentified, 5 seals.

PUBLISHED

Shan-ku pieh-chi (dated 1182) 6/5. *Shan-ku nien-p'u* (Preface, 1199), 12/2b–3a. Wang Yun, *Shu-hua mu-lu*, pp. 21–22. Facsimile by Benrido (Kyoto, ca. 1963). *Shohin* 150. *Masterpieces of Asian Art in American Collections II*, no. 38, pp. 96–97. Shen C. Y. Fu, "Huang T'ing-chien's Calligraphy and His Scroll for Chang Ta-t'ung: A Masterpiece Written in Exile" (Ph.D. dissertation, Princeton University, 1976).

NOTE

1. This inscription follows the text of the essay *Sung Meng Chiao hsu*, composed by Han Yü (768–824), which Huang transcribed at the request of his nephew Chang Ta-t'ung (*ming* Hsieh). The transcription of the essay—the major portion of the scroll—was separated from its inscription at a relatively early date and is no longer extant.

7a. After Huang T'ing-chien (1045–1105)

"Poems," anonymous imitation; probably late Ming period (16th–17th centuries).
Running script (*hsing-shu*), 55 lines.
Dated 1087.
Handscroll, ink on paper, mounted together with no. 7b.
$7\frac{9}{16}'' \times 88\frac{5}{8}''$ (19.2 cm. × 225 cm.).
Collection of Mr. and Mrs. Wan-go H. C. Weng.

INSCRIPTION, SIGNATURE, AND SEAL OF ARTIST

One poem in 5-character meter; one poem in 7-character meter. [Inscribed] "Written for my friend Jui-ta[1] at the Hundred-foot-high Tower [*Pai-ch'ih-lou*] on the 17th day of the fifth lunar month, in the second year of the Yuan-yu reign [1087]. [Signed] Huang T'ing-chien." [Seal] *Shan-ku lao-jen* (square, relief).

COLOPHONS AND COLLECTORS' SEALS

See no. 7b.

NOTE

1. Jui-ta is the *tzu* of the Sung official, writer, and poet Sung Liao (1032–85). The section dedicated to him, however, is dated 1087, two years after his death.

7b. After Huang T'ing-chien (1045–1105)

"Poems," anonymous imitation; probably late Ming period (16th–17th centuries).
Running script (*hsing-shu*), 20 lines.
Undated.
Handscroll, ink on paper, mounted together with no. 7a.
$7\frac{13}{16}'' \times 25\frac{9}{16}''$ (19.9 cm. × 64.9 cm.).
Collection of Mr. and Mrs. Wan-go H. C. Weng.

INSCRIPTION AND SIGNATURE OF ARTIST

One poem in 7-character meter; one poem in 5-character meter. [Signed] "T'ing-chien." No seals.

COLOPHONS

Chung Ch'i-ying (unid.), 8 lines in running-standard script, dated 1313. [Seal] *Yü-t'ang chin-ma* (square, intaglio).

Ch'en Shen (early Yuan), 15 lines in running script, dated the year *ting-ch'ou* (1337?). [Seal] *Ch'en Shen* (square, relief).

COLLECTORS

Yao Kuang-hsiao (1335–1419), 3 seals.
Feng Shih-k'o (*chin-shih* degree, ca. 1567–72), 2 seals.
Ch'ien Fu (either late Ming or mid-18th century), 2 seals.
Wang Ju-k'un (unid.), 3 seals.
Weng Tzu-hsuan (unid.), 2 seals.
Chung Ch'i-ying (unid.), 1 seal.
Unidentified, 13 seals, 3 illegible half-seals.

8. Mi Fu (1051–1107)

"Sailing on the Wu River" (*Wu-chiang chou-chung shih*), poem in five-character meter.
Running-cursive script (*hsing-ts'ao*), 44 lines.
Undated.
Handscroll, ink on paper.
$12\frac{5}{16}'' \times 18' 4\frac{1}{4}''$ (31.3 cm. × 559.8 cm.).
Collection of John M. Crawford, Jr.

SUMMARY OF POEM

As Mi Fu sails up the Wu River, the wind changes direction and more men must be hired to pull the boat. The boatmen dispute their salaries, claiming that they are not paid enough for such taxing labor. The muddy river bottom would seem to sympathize with them, since the boat refuses to budge. Finally, once the money issue is settled, the boatmen stop their complaining and unite to give a great heave. The boat moves like the wind while the men, as if in battle, shout in unison.

SIGNATURE OF ARTIST

"Written in a boat on the Wu River, on the paper sent to me by Chu Pang-yen [unid.] from Hsiu [-chou]. [Signed] Mi Yuan-chang." No seals.

BIOGRAPHY OF ARTIST

Mi Fu (*tzu* Yuan-chang, *hao* Hai-yüeh, Nan-kung, Hsiang-yang man-shih) was an art critic, collector and connoisseur, painter, and calligrapher. An eccentric and outspoken personality, he held numerous official posts and spent most of his life in southern China. His artistic talents received only brief official recognition when he was made a member of Emperor Hui-tsung's Imperial Institute of Painting and Calligraphy. But his high esteem of the southern painters Tung Yuan and Chü-jan helped to reinstate the Chiangnan school of painting, whereas his own landscapes gave rise to a new school of painting, the Mi school.[1]

Together with Ts'ai Hsiang, Su Shih, and Huang T'ing-chien, Mi is known as one of the Four Masters of Calligraphy of the Sung period. After having studied the calligraphy of the Tsin and T'ang dynasties—mainly the tradition of the two Wangs and Yen Chen-ch'ing—he developed a distinguished personal style, characterized by its spontaneity and rhythmic quality, and which had considerable influence on later generations.

COLOPHONS

Sun K'uang (1542–1613), 13 lines in running script, dated 1591. [Seal] *Wen-yung* (square, relief), *Sun K'uang chih yin* (square, relief), *Yu-hsin t'ai hsuan* (square, relief).

Wang To (1592–1652), on mounting silk preceding Mi Fu's calligraphy; 6 lines in running script, dated 1643. Wang notes the names of several people who also viewed the scroll at the same time. No seals.

COLLECTORS

Chu Kang, Prince of Chin (1358–98), third son of Ming T'ai-tsu, 6 seals.
Ch'ien-lung Emperor (r. 1736–95), 6 seals.
Chia-ch'ing Emperor (r. 1796–1820), 1 seal.
Hsuan-t'ung Emperor (r. 1908–11), 1 seal.
Chang Wen-k'uei (contemporary), 3 seals.
J. M. Crawford (contemporary), 3 seals.

PUBLISHED

SCPC III/1448. Ch'en, *Ku-kung i-i shu-hua mu chiao-chu*, 52. *Mi Nan-kung shu Wu-chiang chou-chung shih chen-chi* (facsimile: Taipei, 1972). Sickman, ed., *Chinese Calligraphy and Painting*, no. 10. Ecke, *Chinese Calligraphy*, no. 22.

COMPARATIVE MATERIAL

KKFS 11–2/27b (another work by Mi Fu signed Yuan-chang). Wang Chuang-wei, *SFTT* 9 (rubbings made by calligrapher and connoisseur K'ung Chi-su [1727–91]). *SBT* 1/40, 41; 2/148; 3/197–208; 6/14–17; 10/165, 166. *Shohin* 8, 111, 153. *KKFS* 11–1, –2, –3. *Ku-kung FSHC* 8. *SMS* 43, 74, 125. *SZ* 15/86–110, pp. 26–36. *SG* 6. Kao Hui-yang, "Mi Fu ch'i jen chi ch'i shu-fa" (Master's thesis, College of Chinese Culture, Taipei, ca. 1972). Cheng Chin-fa, "Shu-fa-chia te Mi Fu," *Shih-yuan* 6 (1975): 63–96; "Pei-Sung shu-t'an yü Mi Fu shu-fa te yuan-yuan," *Yu-shih Monthly* 278 (1976): 51–59.

NOTE

1. For biographical information see Wai-kam Ho, "Mi Fei," *Encyclopedia of World Art* 10 (London, 1965): 85–90; Sun Tsu-pai, *Mi Fei, Mi Yu-jen* (Shanghai, 1962).

9a. Mi Fu (1051–1107)

"Abundant Harvest" (*Sui-feng*), first of three letters by the artist.
Running script (*hsing-shu*).
Undated.
Letter mounted as album leaf, ink on paper.
$12\frac{1}{2}'' \times 13''$ (31.7 cm. × 33 cm.).
Anonymous loan, The Art Museum, Princeton University.

SIGNATURE AND SEAL OF ARTIST

[Signed] "Fu." [Seal] *Yü-hsiung hou-jen* (rectangle, relief).

INSCRIPTION TO ALBUM ON OUTER WRAPPER

Yeh Kung-ch'o (1880–ca. 1968), 3 lines in running script, dated 1928: "Three letters by Mi Yuan-chang. There were originally 5 letters by Mi Fu in the collection of [the Ch'ing Prince] Kung-ti which I had an opportunity to see. These letters now belong to the Chih-chai collection; it can be said the letters are now in their rightful home. However, the [original] 5 letters are [reduced] to 3; it seems as if they are lost from their group. I imagine that sometime in the future these objects will be reunited. Respectfully written for future documentation. [Signed] Kung-ch'o." No seals.

OUTER LABEL

One line in standard script. "Five letters by Mi Hai-yueh of the Sung. [Signed] Authenticated and collected by Lu-ts'un [An Ch'i]." No signature or seals.

No colophons.

COLLECTORS

Kuan Ssu (active 1600–30), 1 seal.
An Ch'i (1683–1744), 1 seal.
Fei Chao-k'un (unid.), 2 seals.
Tung Wen-chi (*chin-shih* degree, 1649), 1 seal.
Mr. Fei (unid.), 2 seals.
Liu Yun-lung (unid.), 3 seals.
Wu P'u-hsin (contemporary), 6 seals.
Unidentified, 7 half-seals.

9b. Mi Fu (1051–1107)

"Escaping Summer Heat" (*T'ao-shu*), second of three letters by the artist.
Running script (*hsing-shu*).
Undated.
Letter mounted as album leaf, ink on paper.
$12\frac{3}{16}'' \times 16''$ (30.9 cm. × 40.6 cm.).
Anonymous loan, The Art Museum, Princeton University.

SIGNATURE OF ARTIST

[Signed] "Fu." No seals.

No colophons.

COLLECTORS

Ming Government Bureau of Regulations and Investigations, 1 half-seal.
Wang Ssu-jen (1576–1646), 1 seal.
Kuan Ssu (active 1600–30), 1 seal.
Ch'en Hung-shou (1599–1652), 2 seals.
Liu Yun-lung (unid.), 3 seals.
Lü Shan-ch'ao (unid.), 1 seal.
Lü Yin-feng (unid.), 2 seals.
Liu Hsun-hou (unid.), 1 seal.

An Ch'i (1683–1744), 2 seals.
Fei Chao-k'un (unid.), 2 seals.
Wu P'u-hsin (contemporary), 4 seals.
Unidentified, 7 seals.

9c. Mi Fu (1051–1107)

"Hasty Reply before Guests" (*Tui k'o ts'ao-ts'ao t'ieh*), third of three letters by the artist.
Running-cursive script (*hsing-ts'ao*).
Undated.
Letter mounted as album leaf, ink on paper.
$12\frac{1}{2}'' \times 15\frac{9}{16}''$ (31.7 cm. × 39.7 cm.).
Anonymous loan, The Art Museum, Princeton University.

SIGNATURE OF ARTIST

[Signed] "Fu." No seals.

No colophons.

COLLECTORS

Kuan Ssu (active 1600–30), 1 seal.
Fei Chao-k'un (unid.), 2 seals.
Liu Yun-lung (unid.), 2 seals.
An Ch'i (1683–1744), 1 seal.
Mr. Tung (unid.), 1 seal.
Mr. T'ao (unid.), 1 seal.
Mr. Ch'ien (unid.), 1 seal.
Wu P'u-hsin (contemporary), 1 seal.
Unidentified, 8 seals.

PUBLISHED

An Ch'i, *Mo-yuan hui-kuan*, hsu, 2/45a.

COMPARATIVE MATERIAL

KKFS 11-1, –2, –3. *SG* 6.

10. Fan Ch'eng-ta (1126–1193)

Colophon to "Fishing Village at Mt. Hsi-sai" (*Hsi-sai Yü-she t'u*), anonymous Sung painting.
Running script (*hsing-shu*), 32 lines.
Dated 1185.
Handscroll, ink on silk.
Colophon only: $15\frac{7}{8}'' \times 108\frac{15}{16}''$ (40.3 cm. × 276.7 cm.).
Collection of John M. Crawford, Jr.

PARAPHRASE

When Fan was an official in She-hsien [S. Anhui], he had already considered retiring; at the time, Li Chieh held a position in Hsiu-ning. Ten years later, Fan retired from the position of *shang-shu lang*, returned home, and built a house by Stone Lake. Chieh, who was then prefect of K'un-shan [Kiangsu], was also thinking of preparing a retreat for himself in Yun-chien [Sungchiang]. Twenty years later, Li brought this "Fishing Village" scroll to show Fan. Although Fan had retired much

earlier than Li, he envied Li's good health and his large family. As he concluded: "I am ten thousand times more envious of him than he once was of me. I hope my illness can be cured quickly. When the peach blossoms bloom and the streams fill with spring water, perhaps I can sail to his Hsi-sai [retreat] and ask the host to buy fish and wine. Singing, we shall lean against the boat and compose poems. Then I'll request young fisherboys and wood-gatherers to come and sing with us ... When drunk, how pleasant [it would be] to nap under a window shaded by a thatched awning and [listen] to the sound of the rain. The most marvelous thing in life would be to satisfy one's expectations. So I wrote this at the end of this handscroll, anticipating the real journey. [Signed] Written by Shih-hu chü-shih in the first month of the year i-ssu in the Ch'un-hsi reign [1185]." [Seals] Shun-yang Fan shih (square, intaglio), Shih-hu chü-shih (square, intaglio), Shou-chi-t'ang shu (square, intaglio), Wu chün hou yin (square, intaglio), ——— tu chih hou Fan shih shih wei hsing chia (?) (square, relief).

BIOGRAPHY OF THE ARTIST

Fan Ch'eng-ta (tzu Chih-neng, hao Shih-hu chü-shih) was born in Suchou. He became a chin-shih in 1154 and served in various official capacities, including the position of Sung ambassador to the Chin court in 1170. He retired in 1182 and died in 1193. Fan is one of the Three Poets of the Southern Sung period (his poems are collected in the Shih-hu chü-shih chi). And after having studied the calligraphy of Huang T'ing-chien and Mi Fu, he became one of the most distinguished calligraphers of the period.

COLOPHONS

Eleven colophons follow Fan Ch'eng-ta's (see Sickman, ed., Chinese Calligraphy and Painting, no. 8).

COLLECTORS

Liang Ch'ing-piao (1620–91), 5 seals.
Yeh Kung-ch'o (1880–ca. 1968), 2 seals.
Mr. Ho (unid.), 1 seal.
Chang Ta-ch'ien (contemporary), 1 seal.

PUBLISHED

SZ, 16/49–56. Sickman, ed., Chinese Calligraphy and Painting, no. 8, pp. 61–65.

COMPARATIVE MATERIAL

Fan Ch'eng-ta's colophon to "The Scholars of Northern Ch'i Collating the Texts" (handscroll, Museum of Fine Arts, Boston). SBT 7/91, 92. SMS 188. SZ 16/45–48.

11a. Chang Chi-chih (1186–1266)

"Diamond Sutra" (Chin-kang ching), Buddhist treatise originally written in Sanskrit about A.D. 350.[1]
Standard script (k'ai-shu).
Dated 1246.
Two albums of text, ink on ruled paper; total of 128 leaves: each leaf: $11\frac{1}{2}'' \times 5\frac{5}{16}''$ (29.1 cm. × 13.4 cm.).
One album of colophons, ink on paper; total of 54

leaves: each leaf: approx. $10\frac{1}{2}'' \times 5''$ (26.6 cm. × 12.7 cm.)
Anonymous loan, The Art Museum, Princeton University.

SIGNATURE OF ARTIST (on last two leaves of second album)

[Signed] "Chang Chi-chih."

BIOGRAPHY OF ARTIST

Chang Chi-chih (tzu Wen-fu, hao Shu-liao), from Ho-chou in Anhui, was the last important calligrapher of the Sung period. He is said to have studied the traditional styles of both the T'ang master Ch'u Sui-liang (596–648) and the Sung master Mi Fu (1051–1107). Chang was famous for writing sutra texts such as this, the script of which is in his best-known style. Chang's large writing is preserved only in Japan, primarily in Japanese temples.

LABELS (at front of each album)

Chang T'ing-chi (1768–1848), in clerical script, undated.
Chao Shu-ju (contemporary), in seal script, dated 1934.
Wang T'i (contemporary), in seal script, dated 1934.

COLOPHONS (in third album)

Ch'en Ch'ien (active ca. 1463), 9 lines in running script, dated 1463. Ch'en notes that Chao Meng-fu learned from Chang Chi-chih's calligraphic style. No seals.

Tung Ch'i-ch'ang (1555–1636), 26 lines in running script, dated 1620, written while on a boat near Suchou. Tung records that the scroll was first in the collection of a Mr. Sung, an official who lived in Tung's district; it later belonged to Mr. Pi Mao-k'ang (see the following 2 colophons). Tung concludes that in terms of the brush-work and structure of the characters, Chang Chi-chih did not follow any traditional model, but developed his own style. No seals.

Pi Mao-k'ang (chin-shih degree, 1598), 32 lines in running script, dated 1624. Pi invited Tung Ch'i-ch'ang to inscribe the above encomium. His son Pi Hsi-chih (see following colophon) had Chang Chi-chih's calligraphy incised in stone. [Seals] Pi Mao-k'ang yin (square, relief), Chü-tz'u shan-jen (rectangle, intaglio), Ta-hao shan-shui (rectangle, intaglio).

Chao Huan-kuang (1559–1625): see no. 11b.

Pi Ting-ch'en (Pi Mao-k'ang's grandson, active 1640–64), 8 lines in running script, dated 1664. Pi records that Wu T'ing (active ca. 1575–1625), his maternal grandfather, first owned the scroll, and that it then passed to his paternal grandfather, Pi Mao-k'ang. It had initially been carved in stone, but since at the time, even rubbings were scarce, Pi Ting-ch'en planned to have it recarved. [Seals] Pi-liang-t'ang t'u-shu yin (rectangle, intaglio), Pi Ting-ch'en yin (square, half-relief, half-intaglio), Hsiang-hsin-shih (square, relief).

Chang T'ing-chi (1768–1848), 6 lines in running script, dated 1837. [Seals] Chang T'ing-chi yin (square, intaglio), Chang Shu-wei (square, intaglio).

Lin Tse-hsu (1785–1850), 5 lines in running script,

dated 1841. Lin notes that he saw the scroll at Hangchou. [Seal] *Shao-mu shou-t'i* (square, relief).

Chang Ying-ch'ang (1790–1870), 28 lines in small running script, dated 1860, when he was 71 *sui*. [Seals] *Ying-ch'ang* (square, intaglio), *Chung-fu* (square, relief), *Heng-ch'ü Miao-i chung-ching yun-jeng* (square, intaglio), *Feng-huang-ch'ih shang* (square, intaglio).

Hsu Chih-shih (active 19th century), 37 lines in small standard script. The text was composed by Hsu Yueh-shen (1830–after 1885) in 1884; the following year he asked Hsu Chih-shih to transcribe it. [Seals] *Hsu Chih-shih* (square, half-relief, half-intaglio), *Hao Yang-p'o* (square, half-relief, half-intaglio).

Yü Yueh (1821–1906): see no. 11c.

COLLECTORS

Pi Hsi-chih (active ca. 1620), 3 seals.
Pi Ting-ch'en (active 1640–64), 5 seals.
Wang Wen-tsai, (unid.), 1 seal.
Wu T'ing (active ca. 1575–1625), 1 seal.
Wu P'u-hsin (contemporary), 9 seals.
Chou Hsiang-yun (contemporary), 3 seals.
Unidentified, 5 seals.

COMPARATIVE MATERIAL

Shen C. Y. Fu, "Chang Chi-chih's Middle-size Standard Script" ("Chang Chi-chih te chung-k'ai"), *NPMQ* (forthcoming). *SBT* 7/101–02. *SMS* 76, 86. *Shohin* 182. *Shanghai FSHC* 9. *Ku-kung FSHC* 11. *SZ* 16/71–88. *SG* 7.

NOTE

1. For an English translation from the Sanskrit see Edward Conze, trans., *Buddhist Wisdom Books Containing The Diamond Sutra and The Heart Sutra* (London, 1968), pp. 21–74.

11b. Chao Huan-kuang (1559–1625)

Colophon to "Diamond Sutra" (*Chin-kang ching*), Buddhist treatise transcribed by Chang Chi-chih (1186–1266).
Cursive-seal script (*ts'ao-chuan*), 39 lines.
Undated; probably 1620.
Album leaves, ink on paper.
Anonymous loan, The Art Museum, Princeton University.

According to the text of Chao Huan-kuang's colophon, it was composed by Pi Hsi-chih, the son of Pi Mao-k'ang (*chin-shih* degree, 1598), in 1620. Chao transcribed the colophon at Pi Hsi-chih's request.[1]

SIGNATURE AND SEALS OF ARTIST

[Signed] "Colophon by Pi Hsi-chih of Hsin-tu, [Anhui], [transcribed] in seal [script] by Han-shan, Chao Huan-kuang." [Seals] *Chao Huan-kuang yin* (square, intaglio), *Fan-fu* (square, intaglio), *Hsiao-wan-t'ang* (rectangle, relief).

BIOGRAPHY OF ARTIST

Chao Huan-kuang (*tzu* Fan-fu), a native of T'ai-ch'ang,

Kiangsu, was a learned scholar of calligraphy and etymology who wrote several books on calligraphy. According to the *Shu-shih hui-yao*, Chao was the founder of the so-called *ts'ao-chuan*, or cursive-seal, script style.

COLLECTOR

Wu P'u-hsin (contemporary), 1 seal (below Chao Huan-kuang's signature).

NOTE

1. Careful reading of the colophon shows that several leaves were accidentally mounted in the wrong order.

11c. Yü Yueh (1821–1906)

Colophon to "Diamond Sutra," (*Chin-kang ching*), Buddhist treatise transcribed by Chang Chi-chih (1186–1266).
Cursive-seal script (*ts'ao-chuan*), 11 lines.
Dated 1885.
Album leaves, ink on paper.
Anonymous loan, The Art Museum, Princeton University.

PARAPHRASE OF COLOPHON

Yü Yueh notes that this sutra as transcribed by Ch'ang Chi-chih was carved during the Ming period. By the early Ch'ing, however, the rubbings were already incomplete, so the text was recarved; but this time, the 248 characters missing from the original text were traced from matching characters within the sutra in order to restore the missing sections.

SIGNATURE AND SEALS OF ARTIST

[Signed] "Ch'ü-yuan chü-shih, Yü Yueh writes [this] following Chao Fan-fu's [Chao Huan-kuang's] cursive-seal style." [Seals] *Ch'ü-yuan sou* (square, intaglio), *Yü Yueh* (square, intaglio).

For biography of artist, see no. 84.

12. Chou Mi (1232–1298)

"The Most Fragrant Flower" (*Kuo-hsiang man*), colophon to "Narcissi" (*Ling-po t'u*), painting by Chao Meng-chien (1199–1267).[1]
Running-standard script (*hsing-k'ai*), 10 lines.
Undated.
Handscroll, ink on paper.
Colophon only: $13\frac{1}{16}'' \times 19\frac{7}{8}''$ (33.1 cm. × 50.5 cm.).
The Metropolitan Museum of Art; gift of the Dillon Fund. Acc. no. 1973.120.4.

INSCRIPTION AND SIGNATURE OF ARTIST

"The Most Fragrant Flower" is a song written in the mode sol of A-flat.[2] [Signed] "Pien-yang lao-jen, Chou Mi." [Seals] *Ch'i Chou Mi yin-chang* (square, intaglio), *Chia-t'un chen chi* (square, relief), *Chou Kung-chin fu* (square, relief), *Chou kung tzu-sun* (rectangle, intaglio).

BIOGRAPHY OF ARTIST

Chou Mi (*tzu* Kung-chin, *hao* Ts'ao-ch'uang, Pien-yang lao-jen), originally from Ch'i (Shantung), lived in Wu-hsing and later in Hangchou. His family moved south when the Chin occupied northern China in the early 12th century. A writer, poet, collector, and connoisseur, Chou served briefly as a supervisor of granaries in 1274 and as magistrate of a district in Chekiang. When the Mongols conquered China, destroying his large personal library in Wu-hsing, he retired to Hangchou and remained loyal to the Southern Sung. There Chou became host to an important literary and antiquarian circle, which included such northerners as Hsien-yü Shu and southerners like Chao Meng-fu. A perceptive observer of the times, Chou was a prolific writer and left behind several valuable historical and anecdotal accounts. (Li, *Autumn Colors*, pp. 21–23.)

COLLECTORS (seals on illustrated portion only)

Hsiang Yüan-pien (1525–90), 3 seals.
Yüan Shu (Ming), 1 seal.
Wu P'u-hsin (contemporary), 4 seals.
Wang Chi-ch'ien (contemporary), 1 seal.

PUBLISHED

For complete documentation, see Fong and Fu, *Sung and Yuan Paintings*, no. 12, pp. 143–44.

NOTES

1. Chou Mi's colophon is the first of 7 colophons following Chao Meng-chien's painting. It is written on a separate sheet of paper.
2. We are indebted to Mrs. H. Frankel for this information.

13. Chao Meng-fu (1254–1322)

"Twin Pines against a Flat Vista" (*Shuang-sung p'ing-yuan*), two inscriptions on a painting by the artist.
Running script (*hsing-shu*), 1 line and 6 lines.
Undated; probably 1300 or 1301.[1]
Handscroll, ink on paper.
10½″ × 42¼″ (26.7 cm. × 107.3 cm.).
The Metropolitan Museum of Art; gift of the Dillon Fund. Acc. no. 1973, 120.5.

ARTIST'S TITLE
(upper right, one line in running script)

"Tzu-ang Has Playfully Made 'Twin Pines against a Flat Vista.'"

INSCRIPTION, SIGNATURE, AND SEALS OF ARTIST
(to the left of painting, six lines in running script)

"Ever since my youth, after practicing calligraphy I have toyed with some small paintings, but landscape is one subject that I have not been able to master. This is because one cannot see even one or two masterpieces by Wang Yu-ch'eng [Wei], the great and small generals Li [Ssu-hsun and Chao-tao], and Chang Kuang-wen [Ch'ien] of the T'ang period [anymore]. As for the works

of the Five Dynasties masters, such as Ching [Hao], Kuan [T'ung], Tung [Yuan], and Fan [K'uan], who succeeded one another [as leading masters], the "brush idea" [*pi-i*] of all of them is absolutely different from the style of recent paintings.

"As for my own work, while I dare not compare it with the ancients, when I look at what painters have done in recent times, I daresay mine is a bit different.

"Since [Tung] Yeh-yun [unid.] has asked me for a painting, I will write this at the end of it. [Signed] Meng-fu." [Seals] *Chao Tzu-ang shih* (square, relief), *Chao Meng-fu* (half-seal, relief).

BIOGRAPHY OF ARTIST

Chao Meng-fu (*tzu* Tzu-ang, *hao* Sung-hsueh tao-jen, posth. Wen-min), a descendant of the Sung Imperial family, was born in Wu-hsing, Chekiang. Known as one of the "Eight Talents of Wu-hsing," he became a highly influential writer, painter, and calligrapher. Between 1286 and 1295 Chao served the new Mongol rulers in the Hanlin Academy, and during his stay in the north was exposed to the great traditions of early calligraphy and T'ang and Northern Sung painting. On his return south, he brought back the many works he had amassed. Chao's calligraphy, smooth-flowing and elegant, was primarily inspired by the Tsin master Wang Hsi-chih.

COLOPHONS

Yang Tsai (1271–1323), poem in 7-character meter, 9 lines in running-standard script, undated. Following his poem, Yang records that Chao Meng-fu painted this small landscape for an official, Mr. Tung Yeh-yun (unid.). [Signed] "Composed by Yang Tsai of Pu-ch'eng." [Seals] *Tsai* (square, relief), *Chung-hung-fu yin* (square, relief), *Pu-ch'eng Yang shih* (square, relief).

T'ung Hsüan (1425–98), 14 lines in running script, undated. From T'ung's remarks, it is evident that he inscribed the scroll at the request of Ch'ien Su-hsuan (Ch'ien Ning, d. ca. 1522), who owned it at the time. [Signed] "Inscribed by T'ung Hsuan of P'o-yang, Assistant Commissioner, Provincial Surveillance Officer of Yun-nan." [Seals] *Ch'ing-feng-t'ing* (round, relief), *Shih-ang* (square, relief), *Chin-men ku-li* (square, relief).

Ch'ien-lung Emperor(?) (r. 1736–95), 16 lines in his ordinary (running) style: removed. This colophon was situated above the distant mountains, to the left of the composition.

COLLECTORS

Descendants of Mu Ying (1345–92), adopted son of the Emperor Ming T'ai-tzu, 1 seal.
Ch'ien Ning (d. ca. 1522), 1 round seal (removed).
Yang Tsun (active 2nd half of 14th century), 2 seals.
Liang Ch'ing-piao (1620–91), 3 seals.
Liang Yung (unid., Liang Ch'ing-piao's family?), 1 seal.
An Ch'i (1683–1744), 6 seals.
Ch'ien-lung Emperor (r. 1736–95), 5 seals.
Ting Hui-k'ang (1869–1909), 1 seal.
K'uai Kuang-tien (1857–1910), 2 seals.
Tsai Chih (20th century), 5 seals.

T'an Ching (20th century), 9 seals.
Wang Chi-ch'ien (contemporary), 7 seals.
Unidentified, 9 seals.

PUBLISHED

Wu Ch'i-chen, *Shu-hua chi*, 4/404. Ku Fu, *P'ing-sheng chuang-kuan*, 9/18. Wu Sheng, *Ta-kuan lu*, 16/11a–12a. An Ch'i, *Mo-yuan hui-kuan, ming hua*, 1/21 a and b. Li Pao-hsun, *Wu-i-yu-i-chai lun hua shih* (1909), II/4. *Chung-kuo ming-hua* 14 (Shanghai, 1925), no. 2. Lee, *Chinese Landscape Painting* (1954 ed.) no. 26; (rev. ed. 1962), no. 28. Ch'en, *Ku-kung i-i shu-hua mu chiao chu*, 46a. Sirén, *Chinese Painting: Leading Masters and Principles*, vol. 4, p. 23; vol. 6, pl. 23; vol. 7 (lists), p. 103. *1000 Jahre Chinesische Malerei*, no. 29. *Chinese Art*, Smith College Museum exhib. cat. (1962), no. 10. Fong, "The Problem of Forgeries in Chinese Painting," *Artibus Asiae* 25 (1962): 110, n. 63. Goepper, *The Essence of Chinese Painting*, pls. 45–47. Wang Shih-chieh et. al., eds., *A Garland of Chinese Paintings* (Hong Kong, 1967), no. 10. Suzuki Kei, *Mindai kaigashi no Kenkyū: Seki-ha* pp. 48–49, pls. 10–1, –2, –3, nn. 75–77. Suzuki Kei, "A Few Observations concerning the Li-Kuo School of Landscape Art in the Yuan Dynasty," *Acta Asiatica* 15 (1968), fig. 5. Barnhart, *Wintry Forests, Old Trees*, no. 6. Fong and Fu, *Sung and Yuan Paintings*, no. 14.

COMPARATIVE MATERIAL

See no. 16.
SBT 1/5, 60; 3/236–40, 246–49; 6/35; 7/34, 104–19; 11/83–92, 96–118, 132–35. *SZ* 17/1–25. *SG* 7. *SMS* 56, 82, 83. *Shohin* 73, 199. *Ku-kung FSHC* 12. *Pai-chueh-chai MJFS* 1. Chu-tsing Li, *The Autumn Colors on the Ch'iao and Hua Mountains* (Ascona 1965). Chu-tsing Li, "The Freer Sheep and Goat and Chao Meng-fu's Horse Paintings," *Artibus Asiae* 30 (1968): 279–326.

NOTE

1. This date has been suggested after a comparison of Chao's inscriptions here with other dated examples of his calligraphy. See Mary Jane Clark, "Twin Pines and Level Distance: A Landscape Painting by Chao Meng-fu" (Master's thesis, Yale University, 1976), 35–41.

14. After Chao Meng-fu (1254–1322)

Tracing copy of "Twin Pines against a Flat Vista" (*Shuang-sung p'ing-yuan*), two inscriptions on a painting by the artist.
Running script (*hsing-shu*), 1 line and 6 lines.
Undated.
Handscroll, ink on paper.
$9\frac{1}{2}'' \times 42\frac{1}{2}''$ (24 cm. × 108 cm.).[1]
Cincinnati Art Museum, Museum purchase, Acc. no. 1950. 78.

For inscription and seals of the artist, accompanying colophons and collectors' seals, see no. 16.[2] The outer label to the scroll records that it belonged to the modern collector T'an Ching.

PUBLISHED

Hugo Munsterberg, "The Collection of Chinese Paintings in the Cincinnati Art Museum," *Art Quarterly* 15 (1952): 307–21, fig. 4. Fong, "The Problem of Forgeries in Chinese Painting," *Artibus Asiae* 25 (1962): 110, n. 63.

NOTES

1. These measurements, which would indicate that the scroll is slightly narrower than no. 13, are recorded in Munsterberg, *Art Quarterly* 15: 312–13.
2. The collectors' seals on the Cincinnati version are only slightly different: there are 7 rather than 9 seals belonging to T'an Ching, and there are no seals of the modern collector Wang Chi-ch'ien, who never owned this version.

15a. Chao Meng-fu (1254–1322)

"Record of the Miao-yen Temple in Huchou" (*Hu-chou Miao-yen-ssu chi*), six character frontispiece to transcription by the artist.
Seal script (*chuan-shu*).
Undated.
Handscroll, ink on paper.
Frontispiece only: $13\frac{7}{8}'' \times 13\frac{3}{8}''$ (35.3 cm. × 33.9 cm.).
Anonymous loan, The Art Museum, Princeton University.
For supplementary information, see no. 15b.

15b. Chao Meng-fu (1254–1322)

"Record of the Miao-yen Temple in Huchou" (*Hu-chou Miao-yen-ssu chi*), transcription of essay composed by Mo Yen (1227–1311).[1]
Medium standard script (*chung-k'ai*), 89 lines.
Undated; probably 1309–10.[2]
Handscroll, ink on paper with ruled black grid.
$13\frac{7}{8}'' \times 129\frac{1}{2}''$ (35.3 cm. × 328.9 cm.).
Anonymous loan, The Art Museum, Princeton University.

TRANSLATION OF PREFACE

The Record of the Miao-yen Temple in Huchou (*Hu-chou Miao-yen-ssu chi*), compiled by Mo Yen, the former *Ch'ao-feng ta-fu* and Junior Lord of the High Court of Justice (*Ta-li shao-ch'ing*), transcribed and title [written] in seal script by Chao Meng-fu, *Chung-shun ta-fu*, Metropolitan Prefect of T'ai-chou in Yang-chou district, and concurrently *Ch'üan nung shih*.

[Based on trans. by Robert Thorp, in Chiang, "Record," p. 1.]

TRANSLATION OF OPENING SECTION (illus.)

The original name of the Miao-yen Temple was Tung-chi.[3] It is located 70 *li* outside the city of Wu-hsing. It is near Hsu-lin. To the east of it lies Wu-hsu; to the south, Mount Han; to the west, Hung-tse [Lake]; and to the

north, [the city of] Hung-ch'eng. A clear reflecting stream meanders close by. [The temple] is cut off from the noise and dust [of the everyday world]. It is truly a marvelous spot in this area.

SIGNATURE AND SEALS OF ARTIST

[Signed] "Written and the title [transcribed] in seal script by Chao Meng-fu" (see Preface). [Seals] *Sung-hsueh-chai* (rectangle, relief), repeated 4 times, across each paper join.

COLOPHONS

Yao Shou (1422–95), first of 4 colophons, 10 lines in running script, dated 1468. Yao inscribed this and the following 3 colophons for the monk Yü-an, Abbot of the Ling-chih Temple. [Signed] "A guest at Yung-ning." [Seals] *Wan-chüan-lou* (rectangle, relief), *Hsuan-chung-tzu* (square, relief), *Kung-shou* (square, relief), *Tzu-yu tan-ch'iu* (square, intaglio), *Chia-sheng chin-shih* (square, relief).

Chang Chen (active mid-15th century), 13 lines in running script, undated. [Signed] "Inscribed by Chang Chen." No seals.

Yao Shou, second of 4 colophons, 9 lines in running script, dated 1471. [Signed] "Shou writes [this] in a secluded place of the Chih Garden [*Chih-yuan*]." No seals.

Yao Shou, third of 4 colophons, 7 lines in running script, dated 1474. [Signed] "Kung-shou." No seals.

Yao Shou, fourth of 4 colophons, 10 lines in running script, dated 1482. [Signed] "Recorded by I-shih, Yao Shou." No seals.

Chang Ch'ien (1853–1926), 3 lines in standard script, dated 1909. Chang records that he saw the scroll at Tuan Fang's home. [Signed] "Chang Ch'ien." No seals.

Wang T'ung-yü (1855–1939?), 13 lines in running script, dated 1932, at the age of 78 *sui*. Wang mentions that this scroll belonged to the following 20th-century collectors: P'ang Yuan-chi (ca. 1865–1949), Tuan-fang (1861–1911), Chang Shih-ming, Pao Hsi (early 20th century), and Chiang Hsueh-ts'ao. Although the scroll is undated, Wang dates it to 1309 or 1310, based on the official titles which Chao Meng-fu used in his Preface to the essay. [Signed] "Wang T'ung-yü." [Seals] *Wang T'ung-yü yin* (square, intaglio), *Sheng chih i tzu Hsu-yuan* (square, relief).

COLLECTORS

Hsiang Yuan-pien (1525–90), 46 seals.
Hsiang Sheng-mo (1597–1658), 22 seals.
Shen K'an (17th century), 1 seal.
Wan-yen Ching-hsien (late 19th-early 20th centuries, Manchu), 2 seals.
Chin Ch'uan-sheng (Ch'ing), 2 seals.
Pao Hsi (early 20th century, Manchu), 4 seals.
Chin Ch'eng (1878–1926), 2 seals.
T'an Ching (20th century), 10 seals.
Chang Heng (1915–63), 2 seals.
Liu Ting-chih (contemporary mounter), 1 seal.

Kung-tu (unid.), 1 seal.
Hsiao-ju-an (unid.), 1 seal.

PUBLISHED

Yü Feng-ch'ing, *Shu hua t'i-pa chi* 7/345–48. Pien Yung-yü, *SKT shu*, 16/87–88. Wu Sheng, *Ta-kuan lu* 7/15–16. Chu Hsing-chai, *Hsing-chai tu hua chi*, pp. 56–58. Chuang Yen, "Chao Tzu-ang shu *Miao-yen-ssu chi* ch'i-t'a," in series "Shan-t'ang ch'ing hua," no. 28, *Tzu-yu t'an* 23/9 (1972), pp. 7–9. Chiang I-han, "Record of the Miao-yen Temple: A Calligraphic Handscroll by Chao Meng-fu (1254–1322)," *NPMB* 10/3 (1975): 1–10.

NOTES

1. A contemporary of Chao's, Mo Yen (1227–1311), composed the record after a brief visit to the Miao-yen Temple. For more detailed information, see Chiang, "Record of the Miao-yen Temple," from which we drew some of our information; we also corrected a number of details.

2. As Wang T'ung-yü notes in his colophon to the scroll, the scroll is datable by certain official titles that Chao used in his preface to the essay.

3. See Chiang, "Record," p. 3, for a discussion of the name and location of the Miao-yen Temple.

16. Hsien-yü Shu (1257?–1302)

"Admonitions to the Imperial Censors" (*Yü-shih-chen*), transcription of an essay composed by Chao Ping-wen (1159–1232).[1]
Running-standard script (*hsing-k'ai*), 27½ lines.[2]
Dated 1299.
Handscroll, ink on paper.
$19\frac{9}{16}'' \times 161\frac{3}{16}''$ (49.7 cm. × 409.6 cm.).
Anonymous loan, The Art Museum, Princeton University.

INSCRIPTION AND SEALS OF ARTIST

"'Admonitions to the Imperial Censors.' Written on the 17th day of the 7th month, in the 3rd year of the Ta-te reign [1299]." No signature. [Seals] *Hsien-yü* (round, relief), *Po-chi yin-chang* (rectangle, intaglio), *Shen-fa*, (square, relief).

FRONTISPIECE

Chang Ta-ch'ien (contemporary), 9 lines in running script, dated 1969. [Signed] "The old man Yuan." [Seals] *Chang Yuan ssu-yin* (square, intaglio), *Ta-ch'ien* (square, relief).

BIOGRAPHY OF ARTIST

Hsien-yü Shu (*tzu* Po-chi, *hao* K'un-hsueh-min, Hu-lin yin-li, Chi-tzu chih i, Chung-shan hou-jen), a native of Yü-yang, Hopei, was a contemporary of Chao Meng-fu, and a poet, calligrapher, collector, and connoisseur. After having served the Mongols in several clerical posts, he was promoted to Registrar of the Board of Rites shortly before his death. Hsien-yü was a prominent literary figure and collector whose taste helped to formulate the

aesthetics of the Yuan literati, and his "Studio of Learning Acquired after a Painful Feeling of Ignorance" (*K'un-hsueh-chai*), in Hangchou, was a center for artistic gatherings.[3]

COLOPHONS

Chao Meng-fu (1254–1322), 1 line in running script, undated. [Signed] "Inscribed by Meng-fu." [Seal] *Chao shih Tzu-ang* (square, relief).

Teng Wen-yuan (1259–1329), 4 lines in running script, undated. Teng compares this writing stylistically to the *I-ho-ming* ("Memorial to a Dead Crane") rubbing. [Signed] "Wen-yuan." [Seals] *Teng Wen-yuan yin* (square, intaglio), *Pa-hsi Teng shih shen-chih* (square, intaglio).

Chang Ying (1260–1325), 4 lines in running script, undated. [Signed] "Chang Ying of Hsi Ch'in." [Seal] *Hsi Ch'in Chang Ying* (square, intaglio).

Chou Ch'ih (active ca. 1300–05?), 5 lines in running-cursive script, dated 1304. [Signed] "Inscribed by Chou Ch'ih." [Seals] *Chou Ch'ih ssu-yin* (square, intaglio), *Chou shih Ching-yuan* (square, relief).

T'ang Ping-lung (1241–after 1319), 4 lines in running script, undated. [Signed] "Inscribed by T'ang Ping-lung of Shan-yang." [Seal]——*T'ang Ping-lung tzu——fu* (square, intaglio).

Ch'iu Yuan (1247–after 1327), Ku Wen-shen (active 1300?), Po T'ing (1248–1328), Han Yu-chih (active 1300?), and Han Yu-wen (active 1300?), all of whom saw the scroll together. Exactly which of them wrote the colophon is not specified; 4 lines in running script, unsigned, undated. [Seal] *Te-hsing-t'ang* (square, relief).

Lo Yuan-chang (active ca. 1300–05?), 7 lines in running script, dated 1304. [Signed] "Lo Yuan-chang of Tung-p'ing." No seals.

Kuo Ta-chung (active ca. 1320?), 4 lines in clerical script, undated. [Signed] "Kuo Ta-chung of An-yang." No seals.

T'ai Pu-hua (1304–52), 6 lines in standard script, undated. [Signed] "Inscribed by T'ai Pu-hua of Pai-yeh." [Seal] *Chien-shan* (square, relief).

Mo Ch'ang (active 1310–after 1352), 11 lines in clerical script, dated 1352. [Signed] "Written by Mo Ch'ang of Wu-hsing at the Sudden Snow Study in Nan-p'ing." [Seals] *Kuang Mo tzu* (rectangle, relief), *Meng-ou-t'ing* (square, intaglio), *Mo shih Ching-hsing* (square, relief).

Chang Ta-ch'ien (contemporary), 6 lines in running script, inscribed in lower right corner of scroll; dated 1969. Chang records that when the last Ch'ing Emperor P'u-i was seized by the Russians in 1945, many objects from the Imperial collection were dispersed. At that time the scroll was torn in half. Some lines are now missing from its original opening section. [Signed] "The old man Yuan." [Seal] *Chang Yuan, Ta-ch'ien fu* (square, intaglio).

COLLECTORS

Han Shih-neng (1528–98), 3 seals.
Han Feng-hsi (ca. 1600?; Han Shih-neng's son), 1 seal.
Liang Ch'ing-piao (1620–91), 10 seals.

Chia-ch'ing Emperor (r. 1796–1820), 1 seal.
Hsuan-t'ung Emperor (r. 1908–11), 1 seal.
Chang Ta-ch'ien (contemporary), 7 seals.
Unidentified, 1 seal.

PUBLISHED

For the Chinese text, see *Hsien-hsien lao-jen fu-shui wen-chi* (*SPTK* ed., 283) 17/182. *SCPC* I/934–35. Ecke, *Chinese Calligraphy*, no. 34.

COMPARATIVE MATERIAL

SBT 1/83, 84; 3/246–49, 253–58, 260–66; 6/36; 10/168–69; 11/127–30. *Shohin* 30, 181. *Shanghai FSHC* 11. *KKFS* 17. *Ku-kung FSHC* 14. *SZ* 17/26–37.

NOTES

1. This essay, composed by the Chin poet and official Chao Ping-wen, advises the Imperial Censors on moral precepts.

2. Judging from the present format of the tracing copy (see no. 17), there were originally 54 lines of calligraphy.

3. See Marilyn W. Fu, "The Impact of Re-Unification: Northern Elements in the Life and Art of Hsien-yü Shu (1257?–1302) and Their Relation to Early Yuan Literati Culture," paper (unpublished) presented at the ACLS Conference on the Yuan Dynasty, July 1976.

17. After Hsien-yü Shu (1257?–1302)

Tracing copy of "Admonitions to the Imperial Censors" (*Yü-shih-chen*), transcription of an essay composed by Chao Ping-wen (1159–1232).
Running-standard script (*hsing-k'ai*), 54 lines.
Dated 1299.
Handscroll, ink on paper.
19½″ × 299 11/16″ (49.5 cm. × 761.3 cm.).
Anonymous loan, The Art Museum, Princeton University.

SIGNATURE AND SEALS OF ARTIST

See no. 16.

No colophons.

COLLECTORS

Chang Chün-hsi (unid.), 2 seals.
Liu Tao-ch'ing (unid.), 2 seals.
Unidentified, 8 seals.

18. Hsien-yü Shu (1257?–1302)

"Song of the Stone Drums" (*Shih-ku ko*), transcription of a poem by Han Yü (768–824).[1]
Cursive script (*ts'ao-shu*), 68 lines.
Dated 1301.
Handscroll, ink on paper.
17⅝″ × 11′ 11½″ (44.8 cm. × 364.7 cm.).
Collection of John M. Crawford, Jr.

TRANSLATION OF ILLUSTRATED SECTION

*(If the monarch would present the ten stone drums to the
 university . . .)*
. . . multitudes, attracted to the capital of culture
From all corners of the empire, would be quick to gather.
*We could scour the moss, pick out the dirt, restore the
 original surface,*
And lodge them in a fitting and secure place forever,
Covered by a massive building with wide eaves,
*Where nothing more might happen to them as it had
 before.*

> [Trans. Witter Bynner, in Birch, ed.,
> *Anthology of Chinese Literature*,
> pp. 262–64.]

INSCRIPTION, SIGNATURE, AND SEALS OF ARTIST

"The preceding 'Song of the Stone Drums' by His
Excellency [Han Yü] of Ch'ang-li, T'ang dynasty, was
written on the twentieth day of the sixth lunar month,
in the summer of the year *hsin-ch'ou* of the Ta-te reign
[1301] by Hsien-yü Shu of Yü-yang, [*tzu*] Po-chi, [*hao*]
K'un-hsueh-min." (Trans. Achilles Fang, in Sickman,
ed., *Chinese Calligraphy and Painting*, no. 40.) [Seals]
Hsien-yü (round, relief), *K'un-hsueh-chai* (square,
relief).

COLOPHONS (in chronological order)

Hsiang Yüan-pien (1525–90), 1 line in running script,
undated; label in standard script, mounted before text.
Hsiang has numbered this scroll with the character *tso*.[2]
When Hsiang noticed that Hsien-yü Shu had written one
character incorrectly (see 2 dots next to last character of
Hsien-yü's 45th line), he added the correct character *yen*
in small running script at the end of the transcribed text
(see 63rd line).

No seals.

Kao Shih-ch'i (1635–1704), 11 lines in running script,
dated 1699. For complete translation of colophon, see Lee
and Ho, *Chinese Art under the Mongols*, no. 274. [Seals]
Chiang-ts'un Shih-chi chih chang (square, intaglio), *Pu-i
san-kung i tzu-jih* (square, relief), *Hao chuang hsin chien yü
nien* (rectangle, intaglio).

Hsiang Yüan (19th century), 1 line in running script,
dated 1831. [Seals] *Hsiao T'ien-lai-ko* (oval, intaglio),
Hsiang Yüan, tzu Han-ch'üan, i-tzu Chih-fang (square,
intaglio).

Shen Yin-mo (1882–1971), 10 lines in running script,
dated 1938. For complete translation of colophon, see Lee
and Ho, *Chinese Art under the Mongols*, no. 274. [Seal]
Chu-hsi shen-shih (square, relief).

COLLECTORS

Chang Chün-heng (early 20th century, Chang Heng's
father?), 6 seals.
Chang Heng (1915–63), 3 seals.
T'an Ching (20th century), 9 seals.
Liu Ting-chih (contemporary mounter), 1 seal.

PUBLISHED

Kao Shih-ch'i, *Chiang-ts'un shu-hua mu*, fol. 9b. Lee

and Ho, *Chinese Art under the Mongols*, no. 274. Sickman,
ed., *Chinese Calligraphy and Painting*, no. 40. Ecke,
Chinese Calligraphy, no. 33.

COMPARATIVE MATERIAL

SKT, shu 17. *SBT* 3. *Yueh-hsueh-lou shu-hua lu* 3/23–25.
Shanghai *FSHC* 11.

NOTES

1. For the Chinese text, see *Ch'ang-li hsien-sheng chi*
(*SPTK* ed., no. 152), 5/52.
2. Hsiang Yüan-pien devised an inventory system for his
art collection using the characters from the "Thousand Char-
acter Essay," and marked the lower right corner of each object
with one character from it. The character *tso* in Hsiang's
colophon refers to method of numbering.

19. Feng Tzu-chen (1257–after 1327)

Colophon to "Lowlands with Trees" (*Shu-se p'ing-
yuan*), painting by Kuo Hsi (ca. 1005–ca. 1087);[1] poem in
seven-character meter.
 Running script (*hsing-shu*), 11 lines.
 Undated.
 Handscroll, ink on silk.
 Colophon only: 14″ × 29½″ (36.8 cm. × 74.9 cm.).
 Collection of John M. Crawford, Jr.

TRANSLATION OF FENG TZU-CHEN'S POEM

Layered mists and dense fog obscure storied pavilions,
Many sandy islets overlook the desolate expanse.
The old tree's spirit will last a thousand years;
*The moist washes and the manner [of the trees] are
 enduring as metal and rock.*
*Amid the duckweed of misty islands, skiffs moor for the
 night,*
And still along the cold river water bamboo grows.
*Of the honorable Kuo's [paintings of] level vistas, few
 remain.*
How treasured the master-painter's work should be!

SIGNATURE AND SEALS OF ARTIST

[Signed] "Hai-su." [Seals] 1 illegible seal, *Kuai-kuai
tao-jen* (oval, relief), *Hai-su* (square, intaglio).

BIOGRAPHY OF ARTIST

Feng Tzu-chen (*tzu* Hai-su, *hao* Ying-chou-k'o,
Kuai-kuai tao-jen), a native of Hunan province, official
and poet, was closely associated with such scholars as
Chao Meng-fu (1254–1322) and Zen masters such as
Chung-feng Ming-pen (1263–1323). The Mongol Princess
of the State of Lu (*Lu-kuo ta-chang kung-chu*), mother of
the Empress, was an avid collector of painting and
calligraphy who frequently invited scholars to inscribe
objects in her collection. Feng Tzu-chen's colophons
appear on numerous scrolls known to have once belonged
to her—for example, Huang T'ing-chien's *Sung-feng-ko*.
Feng, whose work is admired and preserved in Japan,
had befriended Japanese monks who came to China.

COLOPHONS

Feng Tzu-chen's is the first of 9 colophons to the painting. The following are the second, third, fourth, and fifth.

Chao Meng-fu (1254–1322), poem in 7-character meter, 3 lines in running script, undated. [Signed] "Tzu-ang." [Seal] *Chao shih Tzu-ang* (square, relief).

Yü Chi (1272–1348), poem in 6-character meter, 2 lines in small standard script. [Signed] "Inscribed by Yü Chi." No seals.

K'o Chiu-ssu (1290–1343), poem in 7-character meter, 3 lines in running-standard script. [Signed] "Composed by K'o Chiu-ssu." No seals.

Liu Kuan (1270–1342), poem in 7-character meter, 2 lines in small standard script. [Signed] "Liu Kuan." [Seal] *Liu shih Tao-ch'uan* (square, relief).

COLLECTORS

(seals accompanying Feng Tzu-chen's colophon)

Liang Ch'ing-piao (1620–91), 2 seals.
Yu-ku-hsuan (unid.), 2 seals.
Chang Ta-ch'ien (contemporary), 2 seals.

PUBLISHED

Sun Ch'eng-tse, *Keng-tzu hsiao-hsia-chi*, 3/1. *SCPC*, I/619. *Ta-feng-t'ang* IV/8. *Gems of Chinese Paintings* (Shanghai, 1955), no. 9. *1000 Jahre Chinesische Malerei*, no. 9. Goepper, *The Essence of Chinese Painting*, pl. 40. Sirén, *Chinese Painting* 2 (lists), p. 57. Sickman, ed., *Chinese Calligraphy and Painting*, no. 7, pls. 7–10. Lee, *Chinese Landscape Painting*, no. 15. Lois Katz, *Selections of Chinese Art* (China Institute, New York, 1966), no. 52. Barnhart, *Wintry Forests, Old Trees*, no. 3, p. 33.

COMPARATIVE MATERIAL

SBT 3/191–92. *SMS* 178 (entry by Kakui Hiroshi). *Pai-chueh-chai MJFS* 1. *SZ* 17/38.

NOTES

1. Various possibilities for Kuo Hsi's dates have been suggested by modern scholars (e.g. active ca. 1068–78, or lived ca. 1010–90), in addition to the dates given here.

20. K'o Chiu-ssu (1290–1343)

"Palace Poems" (*Kung-tz'u*), five poems in seven-character meter.[1]
Small standard script (*hsiao-k'ai*), 24 lines.
Undated; probably 1331–38.[2]
Handscroll,[3] ink on paper.
12⅛" × 20⅞" (30.8 cm. × 53 cm.).
Anonymous loan, The Art Museum, Princeton University.

TRANSLATION (fourth and fifth poems)

As His Majesty will celebrate his birthday tomorrow,
Having made ready the dragon robes, ironing [them]
smooth anew,

The Imperial valet, in presenting [one], first ascertains
[His Majesty's] choice:
[The one with] the Sui pearls here and there among the
rare gems.

Ice mixed in jade bowls, overflowing with flakes of snow,
Fans bound with golden threads, embroidered on red
gauze,
Imperial poetry on variegated paper, on the subject of the
tuan-wu:
[These] shall be sent by Imperial order to the household
of the Princess, Imperial Aunt.

[Trans. Cleaves, in "Palace Poems,"
pp. 421, 423]

SIGNATURE AND SEALS OF ARTIST

[Signed] "K'o Chiu-ssu wrote this to present to Wu-yen ta-ch'an-shih."[4] [Seals] *K'uei-chang-ko chien-shu po-shih* (square, intaglio), *Tan-ch'iu*, *K'o Chiu-ssu chang* (square, relief), *Hsun-chung chih chia* (square, relief), *Yun-chen-chai* (rectangle, relief).

BIOGRAPHY OF ARTIST

K'o Chiu-ssu (*tzu* Ching-chung, *hao* Tan-ch'iu sheng), poet, painter, calligrapher, and connoisseur, was a native of T'ien-t'ai, Chekiang. Under the Emperor Wen-tsung (r. 1328–32), K'o held the rank of *Tien-jui-yuan tu-shih*; then, when the Imperial K'uei-chang Pavilion was established, he was appointed its "Master Connoisseur of Calligraphy" (*K'uei-chang-ko chien-shu po-shih*), responsible for the examination and authentication of calligraphy in the Imperial collection. He eventually retired to Chiangnan.

The T'ang poet Wang Chien (*chin-shih* degree, 755) introduced a type of *chueh-chü* poetry which appears to be the prototype for the *kung-tz'u* form used here to describe the pleasures of court life. K'o modeled his poems after Wang Chien's style. (See Cleaves, "Palace Poems," pp. 392–418.)[5]

COLOPHONS

Liu Yung (1719–1804), 11 lines in running script, dated 1787. Liu notes that K'o's calligraphy is similar to that of Chung Shao-ching (early 8th century) and that K'o has achieved certain characteristics particular to Chao Meng-fu's (1254–1322) writing. [Signed] "Recorded by Shih-an, Liu Yung." [Seals] *Tan-hsia* (rectangle, relief), *Liu Yung chih yin* (square, intaglio).

Weng Fang-kang (1733–1818), 6 lines in running-standard script, undated. Weng states that K'o's calligraphy derives stylistically from Ou-yang Hsun (557–641). [Signed] "Weng Fang-kang of Peiping." [Seals] *Wen-yuan-ko chih ko shih* (rectangle, relief), *T'an-hsi* (square, relief).

T'ieh-pao (1752–1824), 4 lines in running-standard script, dated 1789. He remarks on the fact that K'o wrote this kind of poetry for a monk. [Signed] "T'ieh-pao." [Seals] *Lao T'ieh* (square, relief), *Shao-tsung-po chang* (square, relief).

Ch'en Ch'ung-pen (*chin-shih* degree, 1775), 1 line in small standard script, dated 1790. Ch'en notes that the calligraphy was originally written on a single sheet of

paper, which was later separated into 4 sections and mounted as an album. [Signed] "Ch'ung-pen." No seals.

Ch'en Mao-pen (*chü-jen* degree, 1792; Ch'en Ch'ung-pen's younger brother), 2 lines in running-standard script, dated 1794. Ch'en records that he remounted the calligraphy from an album to a handscroll. [Signed] "Recorded by Mao-pen." [Seals] *Ch'en Mao-pen* (square, half-relief, half-intaglio), *Chi-hsun* (square, relief).

Wang Wen-chih (1730–1802), 10 lines in running script, dated 1800. [Signed] "Wang Wen-chih." [Seals] *Wang Wen-chih* (square, relief), *Wang shih Yü-ch'ing* (square, relief).

COLLECTORS

Hsiang Yuan-pien (1525–90), 10 seals.
Nien Keng-yao (*chin-shih* degree, 1700), 1 seal.
Ch'en Mao-pen (*chü-jen* degree, 1792), 1 seal.
Ch'en I-pen (brother of Ch'en Mao-pen and Ch'ung-pen ?), 2 seals.
Wu Chao-nan (unid.), 1 seal.
Ying Ch'un (unid.), 1 seal.
Wu Tso-yü (unid.), 1 seal.
Chin Ch'uan-sheng (late Ch'ing), 3 seals.
T'an Ching (20th century), 10 seals.
Chang Heng (1915–63), 2 seals.
Liu Ting-chih (contemporary mounter), 1 seal.
Unidentified, 7 seals.

COMPARATIVE MATERIAL

Rubbing: Pao Sou-fang, *An-su-hsuan fa-t'ieh* (printed 1824), *chuan* 8. Another version of same text: Ch'eng Ch'i, *Hsuan-hui-t'ang shu-hua lu* (Hong Kong, 1971). For colophon by K'o Chiu-ssu to Ch'ien Hsuan's "Early Autumn," see Edwards, "Ch'ien Hsuan and 'Early Autumn'," *Archives* 7 (1953): 71–83. For K'o's colophon to Kuo Hsi's "Lowlands with Trees," see no. 19. For K'o's colophon to Chao Meng-fu's "Bamboos, Rocks and Lonely Orchids," see Lee and Ho, *Chinese Art under the Mongols*, no. 235. *SZ* 17/50–51. *KKFS* 18/58, 61.

NOTES

1. These poems, which discuss different aspects of the pleasures of Mongol court life, are recorded in K'o Chiu-ssu's collected works, *Tan-ch'iu chi* (Taipei reprint, 1971), pp. 3, 5, 39–40, 122–23; also in Tsung Tien, *K'o Chiu-ssu shih-liao* (Shanghai, 1963), pp. 52–53.
The last 2 poems belong to a set of 15 translated and discussed in F. W. Cleaves, "The 'Fifteen *Palace Poems*' by K'o Chiu-ssu," *HJAS* 20 (1957): 391–479.
2. In light of their content, K'o Chiu-ssu must have composed these poems in 1329 and 1330, so his calligraphy necessarily postdates those years. Stylistically, the calligraphy dates to ca. 1331–38.
3. The poems were initially written on a single sheet of paper. Some time before 1790 (date of Ch'en Ch'ung-pen's colophon), however, the scroll was cut into sections and mounted as an album. Ch'en Mao-pen later (before 1794) remounted it back into a handscroll (see his colophon, above).
4. Wu-yen ch'an-shih has been identified as the monk Kuang Hsuan (another *ming*: Chih-na), a literary figure from Kiangsu. Chao Meng-fu, Feng Tzu-chen, and K'o Chiu-ssu all presented poems to him. For his biography, see *Yuan-shih hsuan (kuei-chi)*, *jen* I/36b. We are indebted to Mr. Chiang I-han for this information.

5. For further biographical information, see Tsung Tien, *K'o Chiu-ssu nien-p'u* (*Wen Wu*, 1962), and *K'o Chiu-ssu shih-liao*; also, Chuang Shen, *Chung-kuo hua-shih yen-chiu hsu-chi* (Taipei, 1972).

21. K'ang-li Nao-nao (1295–1345)

"Biography of a Carpenter" (*Tzu-jen chuan*), transcription of an essay by Liu Tsung-yuan (773–819).[1]
Cursive script (*ts'ao-shu*), 73 lines.
Dated 1331.
Handscroll, ink on paper.
$10\frac{15}{16}$″ × $110\frac{5}{8}$″ (27.8 cm. × 281 cm.).
Anonymous loan, The Art Museum, Princeton University.

SIGNATURE AND SEALS OF ARTIST

"K'ang-li Nao-nao wrote [this] for the Vice Minister Hsin-ch'ing [unid.] on the 28th day of the 10th lunar month, in the second year of the Chih-shun reign [1331]." [Seals] *Chi-mei-t'ang* (rectangle, relief), *Ch'un-yü-lou* (rectangle, relief), *Tzu-shan* (square, relief), *Cheng-chai* (square, relief), *Fang-suo*(?) (double seal, relief).

BIOGRAPHY OF ARTIST

K'ang-li Nao-nao (*tzu* Tzu-shan, *hao* Cheng-chai, Shu-sou) was a member of the Central Asian K'ang-li tribe from the northern shore of the Aral Sea in southern Russia. Learned in history and the Chinese classics, K'ang-li became a traditional Confucianist, and like many Mongols during the Yuan period, was deeply influenced by Chinese culture. During the T'ien-li reign period (1328–29) he supervised the imperial collection of painting and calligraphy. When he was tutor to the prince, K'ang-li Nao-nao thought so highly of this essay that he specifically used it to teach good government. According to T'ao Tsung-i, in his *Shu-shih hui-yao*, K'ang-li Nao-nao is considered second only to Chao Meng-fu as a Yuan calligrapher.[2]

COLOPHONS

Wu Jung-kuang (1773–1843), 8 lines in running script, dated 1836. [Seal] *Po-jung* (square, intaglio).

P'an Shih-ch'eng (*chü-jen* degree, 1832), 10 lines in running script, dated 1850. P'an notes that when K'ang-li wrote the piece he was only 37, yet he had already attained a high degree of excellence; P'an also expresses his regret that K'ang-li didn't live longer, for had he, he would have been as famous as Chao Meng-fu. [Seals] Both impressed in blue seal ink: *Shih-ch'eng* (square, relief), *Te-yü* (square, relief).

Yang Chen-lin (active ca. 1834), 9 lines in running-standard script, dated 1834. Chronologically, this colophon was executed before the two that precede it. Yang notes that the work is stylistically similar to calligraphy by K'ang-li Nao-nao entitled *Che-lung shuo*, another essay composed by Liu Tsung-yuan (773–819), which is in the Palace Museum, Peking. [Seal] *Yang Chen-lin yin* (square, relief).

Ch'en Ch'i-k'un (*chin-shih* degree, 1826), 5 lines in standard script, undated. [Seal] *Pai-san-shih-yu-san Lan-t'ing-shih* (square, relief).

Chang Heng (1915–63), 3 lines in running script, dated Chinese New Year's Eve (January 1947). Chang notes that he saw this scroll at T'an Ching's studio. No seals.

COLLECTORS

Pien Yung-yü (1645–1702), 7 seals.
An Ch'i (1683–1744), 5 seals.
Wu Yüan-hui (active ca. 1850), 8 seals.
Wu Jung-kuang (1773–1843), 1 seal.
Ho K'un-yü (early 19th century), 1 seal.
P'an Shih-ch'eng (active ca. 1820–50), 1 seal.
Chang Hsiang-chien (*chü-jen* degree, 1839), 2 seals.
K'ung Kuang-t'ao (active ca. 1860), 1 seal.
Ch'en Ch'i-k'un (*chin-shih* degree, 1826), 1 seal.
Mr. Chang (*hao* K'o-yüan, unid.), 5 seals.

COMPARATIVE MATERIAL

SBT 6/50–51, 7/120. *Shohin* 46. *KKFS* 18/34–35. *SMS* 122. *Ku-kung FSHC* 15. *SZ* 17/44–47.

NOTES

1. Liu Tsung-yüan employed the metaphor of a head carpenter who excelled at supervising other carpenters to expound on the principles of good government. Text published in *Liu Ho-tung ch'üan-chi* (1933 ed.), 17/4b–7b.
2. For further information on K'ang-li Nao-nao, see F. W. Cleaves, "K'uei-k'uei or Nao-nao?" *HJAS* 10 (1947): 1–12; and Ch'en Yüan, *Western and Central Asians in China under the Mongols*, trans. L. C. Goodrich and Ch'ien Hsing-hai, *Monumenta Serica Monograph* 15 (1966).

22. Yang Wei-chen (1296–1370)

"Drinking with My Wife under the First Full Moon" (*Yüan-hsi yü fu yin*), poem in five-character meter, and two inscriptions by the artist.[1]
Running-cursive script (*hsing-ts'ao*).
Undated.
Album leaf, ink on paper.
$11\frac{5}{16}'' \times 22\frac{3}{8}''$ (28.7 cm. × 56.8 cm.).
Anonymous loan.

TRANSLATION OF POEM

I ask how is the night.
We enjoy this evening filled with lantern lights.
The moon rises over the east side of the house and illumines
* a lute and some books.*
My aged wife reminds me that this is the lantern festival,
By twilight we prepare food and wine.
 · · ·
My wife rises. She encourages me to drink and wishes me
* long life.*
"Looking up and winking at the face in the moon,
Let's vow to pass a drunken evening.
I invite you to share this drink,
And summon the moon to be our guest."

My wife's words are worth hearing,
And so I empty my large cup.

SIGNATURE AND SEALS OF ARTIST

[Signed] "Lao-t'ieh, Chen." [Seals] *Tung-wei-tzu* (rectangle, relief), *Ch'ing-pai ch'uan-chia* (square, relief), *Lien-fu* (square, intaglio), *T'ieh-ti tao-jen* (square, relief).

BIOGRAPHY OF ARTIST

Yang Wei-chen (*tzu* Lien-fu, *hao* T'ieh-yai, T'ieh-ti-tzu), poet, writer, painter, and calligrapher, was from K'uai-chi, Chekiang. In 1327 he received the *chin-shih* degree, having specialized in the Spring and Autumn Annals, which he taught for many years thereafter. The official posts he held in Chekiang and Hangchou were only minor ones. As an influential poet and essayist of Sung-chiang, Yang befriended other literary figures such as Chang Yü and Ni Tsan. He was also one of the foremost calligraphers of the late Yüan period. (*DMB*, Edmund H. Worthy.)

No colophons.

COLLECTORS

Chou Hsiang-yün (contemporary), 1 seal.
Wu P'u-hsin (contemporary), 1 seal.
Wang Chi-ch'ien (contemporary), 1 seal.
Unidentified, 4 seals.

COMPARATIVE MATERIAL

SZ 17/167, 187, pl. 48, 49. For colophon by Yang Wei-chen to Tsou Fu-lei's "A Breath of Spring," see Wenley, "'A Breath of Spring' by Tsou Fu-lei," *Ars Orientalis* 2 (1957): 459. Lee and Ho, *Chinese Art under the Mongols*, no. 260. Fu, "Landscape Painting by Yang Wei-chen," *NPMB* 8/4 (1973): 1–13. *SBT* 10/172. *Shohin* 90, 189. *SMS* 167. *KKFS* 18/41–42. *Ku-kung FSHC* 16. *Pai-chueh-chai MJFS* 1.

NOTE

1. In his comments following the poem, Yang noted that he copied this poem for his friend Wei Jen-chin (*tzu* Tzu-kang) from Sungchiang (active ca. 1340–68).

23. Yang Wei-chen (1296–1370)

Colophon to "Gazing at a Waterfall," painting by Hsieh Po-ch'eng (active mid-14th century).
Running-cursive script (*hsing-ts'ao*).
Undated.
Hanging scroll, ink and light color on paper.
$75\frac{3}{8} \times 14\frac{7}{16}''$ (191.4 cm. × 36.7 cm.).
Collection of John M. Crawford, Jr.

INSCRIPTION, SIGNATURE, AND SEALS OF YANG WEI-CHEN

"Hsieh Po-ch'eng of Jen-yang paints in an extraordinary manner. He has mastered the style of Tung Yüan. Now I gaze at this *Waterfall* picture — it is light and graceful, as if it would rise to the clouds. I inscribe this poem above it. . . . [A poem follows; then signed] T'ieh-ti, in the Sudden Snow Tower [*K'uai-hsueh-lou*], trying a

piece of ink made of *Yeh-mao-shih*, and having just been presented with a *Hsi-ch'un-ko* inkstone, takes a small trip over the waves." (Based. on trans. by J. Cahill, in Sickman, ed., *Chinese Calligraphy and Painting*, no. 50, p. 114.) [Seals] *Li Fu pang ti-erh-chia chin-shih* (square, relief),[1] *Ch'ing-pai ch'uan-chia* (square, relief), *Yang Wei-chen yin* (square, intaglio), *T'ieh-ti tao-jen* (square, relief).

No other colophons.

COLLECTORS

Wang Chou(?) (Ming), 1 seal.
Chiang Fan (1761–1831), 1 seal.
Yeh Meng-lung (1775–1832), 2 seals.
Mr. Ken (unid.), 1 seal.
Mr. Hsu (unid.), 1 seal.
J. M. Crawford (contemporary), 3 seals.
Unidentified, 1 seal.

PUBLISHED

Ta-feng-t'ang IV/24. Sickman, ed., *Chinese Calligraphy and Painting*, no. 50, pp. 114–15.

NOTE

1. The seal *Li Fu pang ti-erh-chia chin-shih* records the fact that Yang Wei-chen earned the *chin-shih* degree in the same year as Li Fu (active mid-14th century).

24a. Wu Chen (1280–1354)

"Poetic Feeling in a Thatched Pavilion" (*Ts'ao-t'ing shih-i*), inscription on a painting by the artist.
Running-cursive script (*hsing-ts'ao*), 6 lines.
Dated 1347.
Handscroll, ink on paper.
9⅜″ × 5½″ (23.8 cm. × 14 cm.).
The Cleveland Museum of Art; purchase: Leonard C. Hanna, Jr., Bequest. Acc. no. 63.259.

INSCRIPTION, SIGNATURE, AND SEALS OF ARTIST

"By the side of the hamlet I built a thatched pavilion. Balanced and squared, it is lofty in conception. The woods being deep, birds are happy; the dust being distant, bamboos and pines are clean. Streams and rocks invite lingering enjoyment, lutes and books please my temperament. How should I bid farewell to the world of the ordinary and the familiar, and let my heart go its own way for the gratification of my life? In the tenth month of winter, in *ting-hai*, the seventh year of Chih-chen [1347], I did this 'Poetic Feeling in a Thatched Pavilion' playfully for Yuan-tse. Written by Mei sha-mi [Plum Blossom Monk]." (Trans. Lee and Ho, *Chinese Art under the Mongols*, no. 252.) [Seals] *Mei-hua-an* (square, relief), *Chia-hsing Wu Chen, Chung-kuei shu-hua-chi* (rectangle, intaglio).

BIOGRAPHY OF ARTIST

Wu Chen (*tzu* Chung-kuei, *hao* Mei-hua tao-jen) was a native of Chia-hsing, Chekiang. A talented poet, painter,

and calligrapher, he refused to serve the Mongols and instead earned his livelihood as a diviner. He retired to his birthplace, Wei-t'ang, where he built his famed "Plum Blossom Retreat" and lived there as a recluse for the rest of his life. Wu, whose landscape paintings established him as one of the Four Masters of the Yuan period, refused to allow anyone other than himself to write inscriptions on his paintings. He specialized in cursive script.

COLOPHONS

Shen Chou (1427–1509), poem in 5-character meter. [Signed] "Shen Chou, a later follower." 1 seal.

Ch'en Jen-t'ao (1906–68), 2 colophons.

COLLECTORS

Liang Ch'ing-piao (1620–91), 7 seals.
Li Chao-heng (active early 17th century), 1 seal.
Wang I-jung (1848–1900), 1 seal.
Ch'en Jen-t'ao (1906–68), 8 seals.
Li Yen-shan (20th century), 1 seal.
Chiang Erh-shih (20th century).

PUBLISHED

For early records see Lee and Ho, *Chinese Art under the Mongols*, no. 252. *Seize peintures de maîtres chinois XII^e–XVIII^e siècles, collection Chiang Erh-shih* (Paris, 1959), no. 2. *Catalogue of Chinese Paintings in the Chiang Erh-shih Collection* (Paris, 1961). Chu Hsing-chai, ed., *Chung-kuo shu-hua* 1 (Hong Kong, 1961): 21, fig. 5. *Cleveland Museum of Art Year in Review* 50 (1953), no. 63, pp. 282–83. "Oriental Art Recently Acquired by American Museums, 1963," *Archives* 18 (1964). Sherman Lee, "Literati and Professionals: Four Ming Painters," *Cleveland Museum of Art Bulletin* 53 (1966): 3–25. Lee, *Colors of Ink*, no. 12; pp. 44, 111.

COMPARATIVE MATERIAL

James Cahill, "Wu Chen, A Chinese Landscapist and Bamboo Painter of the Fourteenth Century," (Ph.D. dissertation, University of Michigan, 1958).

24b. Li Tung-yang (1447–1516)

"Poetic Feeling in a Thatched Pavilion" (*Ts'ao-t'ing shih-i*), four-character frontispiece to painting by Wu Chen (1280–1354).
Seal script (*chuan-shu*).
Undated.
Handscroll, ink on paper.
Frontispiece only: 9⅜″ × 29½″ (23.8 cm. × 74.9 cm.).
The Cleveland Museum of Art; purchase: Leonard C. Hanna, Jr., Bequest. Acc. no. 63.259.

No signature or seals of artist.[1]

BIOGRAPHY OF ARTIST

Li Tung-yang (*tzu* Pin-chih, *hao* Hsi-yai), from Hunan, was born in Peking in 1447. A precocious child, he became a *chin-shih* at age 16. After a long and distinguished

official career, he attained the esteemed rank of Grand Secretary. Li, whose poems foreshadowed the renaissance movement of the following generation, was also highly esteemed in the literary world. The entire body of his collected works are published under the title *Huai-lu-t'ang kao*. (*DMB*, Chaoying Fang.)

No colophons.

COLLECTOR (seals on frontispiece only)

Ch'en Jen-t'ao (1906–68), 3 seals.

COMPARATIVE MATERIAL

SBT 1/31–33, 52; 2/88, 89, 109, 136, 137; 3/197, 198, 201–03; 7/130–32. *SZ* 17/62, 63. *Ming Ch'ing SHHC* 165–67.

NOTE

1. For discussion of attribution to Li Tung-yang, see Essay II.

25a. Ni Tsan (1301–1374)

"In Response to Keng-yin" and "The Keng-yü Studio," two poems in five-character meter for Hsu Ta-tso (1333–1395).[1]
Standard script (*k'ai-shu*), 18 lines.
Dated mid-autumn 1373.
Album leaf mounted as handscroll,[2] ink on paper.
$11\frac{5}{16}$" × $15\frac{1}{2}$" (28.7 cm. × 39.4 cm.).
Hou Chen Shang Chai.

TRANSLATION OF PREFACE TO FIRST POEM (four lines)

On the 7th day of the 8th month, together with Keng-yun [unid.], I visited the hermit Keng-yü [Hsu Ta-tso, 1333–95] . . . On the 9th day, Keng-yin [i.e. Hsu Ta-tso] composed a poem and presented it to me, and so I respectfully [compose], following the same rhyme . . . [Signed] Tsan again bows [respectfully].[3]

SIGNATURES OF ARTIST

First poem: [Signed] "Written in mid-autumn of the year *kuei-ch'ou* [1373]."
Second poem: [Signed] "Tsan".
No seals.

BIOGRAPHY OF ARTIST

Ni Tsan (*tzu* Yuan-chen, *hao* Yun-lin-tzu), a native of Wu-hsi, northwest of Suchou, was the epitome of the scholar-gentleman. Devoting his time to poetry, painting, and calligraphy, he lived a life of leisure on his famed estate. One of the buildings, the Ch'ing-pi-ko, housed a voluminous collection of books, paintings, and calligraphy. In the 1350's, to avoid onerous taxes and rising political unrest, Ni gave away his possessions and subsequently lived on a houseboat in the Lake T'ai region. As a landscape painter, he is admired as one of the Four Masters of the Yuan period. Wen Cheng-ming once remarked that Ni's personality was very lofty, his superb brushwork revealing the influence of Tsin and Sung calligraphy. (*DMB*, Chu-tsing Li.)

COLOPHONS

See no. 25b.

COLLECTORS (seals on this leaf only)

Nien Keng-yao (*chin-shih* degree, 1700), 1 seal.
Ni I (unid.), 1 seal.

NOTES

1. The Keng-yü Studio belonged to Hsu Ta-tso (*hao* Keng-yin). As Ni Tsan explained in his 4-line preface to the 2 poems, he visited his friend's studio together with Keng-yun. Apparently a good friend of both him and Hsu Ta-tso, Ni Tsan once presented a handscroll entitled "Mountain Dwelling" (*Shan-chü t'u*) to Keng-yun (*SKT* 20/261), and a handscroll depicting "The Keng-yü Studio" (*Keng-yü hsuan*) to Hsu Ta-tso (*SKT* 20/264).

2. There are altogether 8 leaves by Ni Tsan in this handscroll. Originally from different collections, they were probably brought together by Shen T'ing-fang (1702–72) and mounted as a set. Most of the colophons that appear at the end of the scroll (see no. 25b) were written at his request.

3. Ni Tsan made several corrections in the text of these 2 poems, which would indicate that this one was possibly an initial draft. In Chang Ch'ou, *Ch'ing-ho shu-hua fang* (*hsu*), p. 46a, there is a record of a handscroll of poems for Keng-yü that is identical to the present version, and which incorporates those corrections. That one was possibly a final, perfected version, based on this extant draft.

25b. Ni Tsan (1301–1374)

"Poems and Letter to Ch'en Chih,"[1] two poems in five- and seven-character meter.
Standard script (*k'ai-shu*), 22 lines.
Undated.
Album leaf mounted as handscroll, ink on paper.
$11\frac{13}{16}$" × $17\frac{7}{8}$" (30 cm. × 45.4 cm.).
Hou Chen Shang Chai

SIGNATURE OF ARTIST

[Signed] "Tsan." No seals.

COLOPHONS

Yuan Hua (active ca. 1372), mounted between the third and fourth leaves of Ni Tsan's calligraphy. Fu Tseng (1688–after 1749 ?). Wu Ying-fen (*chin-shih* degree, 1715; d. 1738). Hui Shih-chi (*chin-shih* degree, 1709). Chang P'eng-ch'ung (1688–1745). Ni Kuo-lien (*chin-shih* degree, 1730; d. 1743). Shen Te-ch'ien (1673–1769). Cheng Chiang (1682–1745). Chin Chih-chang. Yen Sui-ch'eng (b. 1694). Feng Keng-sheng. Cheng Lo-ying (*chü-jen* degree, 1770). Ch'ien T'ien-shu (active 1825).

COLLECTORS (seals on this leaf only)

Hsiang Yuan-pien (1525–90), 11 seals.
Nien Keng-yao (*chin-shih* degree, 1700), 1 seal.
Chang Liu (Ch'ing), 1 seal.
Chou Hsi-kuei (Ming ?), 1 seal.
Unidentified, 1 half-seal.

COMPARATIVE MATERIAL

SNT 1/6. *SBT* 3/245; 10/174. *Shohin* 99. *KKFS* 16/52–56.

NOTE

1. Ch'en Chih (*tzu* Shen-tu, 1293–1362) was a minor painter and poet during the late Yuan period. His *tzu* Shen-tu appears at the top of the third line.

26a. Shen Tu (1357–1434)

Transcription of Preface and eight poems composed by Chu Hsi (1130–1200).[1]
Preface in small standard script (*k'ai-shu*); 3 poems in small standard script (*k'ai-shu*), 5 poems in draft-cursive script (*chang-ts'ao*).
Undated.
Handscroll, ink on paper.
10⅛″ × 33⅞″ (25.8 cm. × 86 cm.).
Anonymous loan, The Art Museum, Princeton University.

SUMMARY OF PREFACE BY CHU HSI (not illustrated)

Chu Hsi was moved by the vigor of Ch'en Tzu-ang's poems, "Impressions of Things Encountered," and imitated his style in over 10 poems.

SIGNATURE AND SEAL OF ARTIST

[Signed] "Tu." [Seal] *Shen Tu* (square, relief).

BIOGRAPHY OF ARTIST

Shen Tu (*tzu* Min-tse, *hao* Tzu-lo), from Hua-t'ing, Sungchiang, was a prominent official, writer, and calligrapher. His younger brother, Shen Ts'an (*tzu* Min-wang, *hao* Chien-an), was also known for his calligraphy, poetry, and prose. After the Yung-lo Emperor was enthroned in 1402, Shen Tu was recommended as a calligrapher to the Hanlin Academy, where he penned many official documents and was joined by his brother. Both were held in high Imperial esteem as calligraphers, and occasionally even accompanied the Emperor on his journeys. Some of Tu's descendants, who were also calligraphers, enjoyed Imperial favor. (*DMB*, Liu Lin-sheng.)

COLOPHONS

Chang Chao (1691–1745), first of 2 colophons, 11 lines in running script, undated. Chang praises the 2 Shen brothers for their excellence in calligraphy, claiming that they even surpassed Wen Cheng-ming and his sons. He notes not only that the scroll was originally in the collections of Chu Chih-ch'ih (Ming dynasty) and Kao Shih-ch'i (1645–1701), but also that Shen Tu's calligraphy is not complete, that in the Preface the number of passages (*p'ien*) was eradicated and replaced with the number "eight," which was subsequently removed. He considers the signature "Tu" weak in comparison to the writing which precedes it and concludes that a dealer must have removed the other poems, forged the signature, then altered the numbering to match the group of poems that remained. [Signed] "Recorded by Chao." No seals.

Chang Chao, second of 2 colophons, 4 lines in running script, dated 1738. Chang notes that this scroll has been in his family for 3 reign periods. [Signed] "Again inscribed by Chao." No seals.

Anonymous label (mounted preceding calligraphy): "Ink original by the 2 Shen scholars of Yun-chien." No signature or seals.

COLLECTORS

Chu Chih-ch'ih (Ming), 2 double seals.
Chang Ying-t'ien (Ch'ing), 1 seal.
Ch'ien-lung Emperor (r. 1736–95), 8 seals.
Chia-ch'ing Emperor (r. 1796–1820), 1 seal.
Hsuan-t'ung Emperor (r. 1908–11), 1 seal.

PUBLISHED

SCPC II/2051–54.

COMPARATIVE MATERIAL

SBT 1/53; 8/5. Shen Tu, "Letter," album leaf (collection of John M. Crawford, Jr.). *Pai-chueh-chai MJFS* 1. *SZ* 17/54. *KKFS* 21–1/15.

NOTES

1. Chu Hsi composed these 8 poems (in 5-character meter) after a set of poems by Ch'en Tzu-ang (661–702) entitled "Impressions of Things Encountered" (*Kan-yü*).
2. The sections of calligraphy by Shen Tu and Shen Ts'an are catalogued here in chronological order rather than in actual order of appearance. Because Shen Tu is the older of the 2 brothers, his calligraphy is discussed first.
Shen Tu actually transcribed the texts of only 7 poems by Chu Hsi: one has been transcribed twice, once in small standard script and once in draft-cursive script.

26b. Shen Ts'an (1379–1453)

Eight poems in seven-character meter composed by the artist, preceding calligraphy by Shen Tu.
Draft-cursive script (*chang-ts'ao*), 48 lines.
Undated.
Handscroll, ink on paper.
11⅜″ × 59⅞″ (28.8 cm. × 152 cm.).
Anonymous loan, The Art Museum, Princeton University.

SIGNATURE AND SEAL OF ARTIST

[Signed] "Ts'an." [Seal] *Yun-chien Shen Ts'an, Min-wang* (square, intaglio).

COMPARATIVE MATERIAL

SBT 8/5, 6. *SZ* 17/55. For further information, see no. 26a.

27. Chin Shih (active 1440–1470)

"Splendors of Brush and Ink" (*Han-mo ching-hua*), four-character frontispiece to a collection of calligraphy.

Clerical script (*li-shu*).
Undated.
Two album leaves, ink on paper.
First leaf: $11\frac{9}{16}''$ × $21\frac{5}{16}''$ (29.3 cm. × 54.1 cm.); second leaf: $11\frac{9}{16}''$ × $21\frac{3}{4}''$ (29.3 cm. × 55.2 cm.).
Anonymous loan.

SIGNATURE AND SEAL OF ARTIST

[Signed] "Chung-shu she-jen, Ssu-ming, Chin Shih."
[Seal] *Pen-ch'ing* (rectangle, relief).

BIOGRAPHY OF ARTIST

Chin Shih (*tzu* Pen-ch'ing, *hao* T'ai-shou-sheng, Hsiumu chü-shih), a native of Chekiang, was active during the period 1440–70. He received the official title of *Chung-shu she-jen* because of his skill in calligraphy. When Emperor Hsien-tsung assumed the throne in 1465, he was appointed ambassador to Korea. Chin Shih excelled at painting rocks and bamboo, and at writing seal, clerical, running, and cursive scripts.

No colophons.

COLLECTORS

Chou Hsiang-yun (contemporary), 1 seal.
Wu P'u-hsin (contemporary), 2 seals.
Wang Chi-ch'ien (contemporary), 1 seal.
Unidentified, 3 seals.

COMPARATIVE MATERIAL

Chin Shih's colophon to Yen-sou's handscroll "Plum Blossoms" (Freer Gallery of Art, Washington, D.C.). Hincheung Lovell, "Yen-sou's *Plum Blossoms*: Speculations on Style, Date, and Artist's Identity," *Archives of Asian Art* 29 (1975–76): 59–79.

28. Yao Shou (1422–1495)

"Writing about Banana Plants," a prose-poem.
Running-cursive script (*hsing-ts'ao*), 81 lines.
Dated 1489.
Handscroll, ink on paper.
12" × 25' $7\frac{5}{8}''$ (30.5 cm. × 781.8 cm.).
Anonymous loan, The Art Museum, Princeton University.

TRANSLATION OF ILLUSTRATED SECTIONS

First section: "The banana leaf receives the ink, dripping wet. The crazy Huai-su [ca. 735–800?] practiced calligraphy on this kind of banana leaf. How amusing!"
Second section: "The master [Huai-su] ordered some wine and sang songs while drunk. While he was loudly singing a song, ten thousand leaves dropped off old branches."
Third section: "Completely eradicate the ten thousand vulgarities of the common world."

SIGNATURE AND SEALS OF ARTIST

[Signed] "On the third day of the 9th lunar month, in the 2nd year of the Hung-chih reign [1489], Tzu-hsia pi-

yueh shan-jen, Yao Kung-shou." [Seals] *Ts'ang-chiang hung-yueh* (rectangle, intaglio), *Kuei-yu [1453] ching-k'uei* (square, intaglio), *Ku-chu-hsia-shih* (square, intaglio), *Chia-shen chin-shih* (square, relief), *Yao shih Kung-shou* (square, intaglio), *Hsien-ch'ih Yao-tzu* (square, relief), *Yao-t'ai hsueh-ho* (square, relief), *Kung-shou yin-chang* (square, intaglio), *Chia-ho* (square, relief).

BIOGRAPHY OF ARTIST

Yao Shou (*tzu* Kung-shou, *hao* Tan-ch'iu, Ku-an, Yun-tung i-shih), a native of Chia-hsing, passed the examination for the *chü-jen* degree in 1453 and earned the *chin-shih* degree in 1464. After holding various positions in the Ministry of Works and the Censorate, he was demoted in 1467, resigned his official duties, and retired to Chia-hsing. His literary works are preserved in his *Ku-an chi*. (*DMB*, Hwa-chou Lee.) Also noted as a collector, connoisseur, calligrapher, and painter, Yao was an important early Ming precursor of the Wu School. His calligraphy was derived primarily from the Chao Meng-fu–Chang Yü tradition, but he practiced the Huang T'ingchien style as well. Yao may have been partly responsible for Shen Chou's choice of Huang as his only model.

ACCOMPANYING CALLIGRAPHY

Anonymous (probably late Ch'ing), "Preface to the Lan-t'ing Gathering" (*Lan-t'ing-chi hsu*), 18 lines in running-standard script. No seals.

COLOPHONS

Yeh Kung-ch'o (1880–ca. 1968), 3 lines in running script, undated. Yeh records that he acquired this scroll from Yen Shih-ch'ing (*hao* Yun-po). He praises the strong round, curving strokes, and claims that the calligraphy resembles that of the Taoist Chang Yü (1277–1348), possibly because, after middle age, Yao Shou too became interested in Taoist texts. [Signed] "Hsia-weng, Ch'o." [Seal] *Kung-ch'o ta-li* (square, intaglio).

Yen Shih-ch'ing (ca. 1870–after 1922), 10 lines in running script, dated 1920. Yen records that he purchased this scroll from Lo Chen-yü together with a painting by Ch'en Hung-shou and an album by Hua Yen, and notes that the untrammeled spirit of Yao Shou's calligraphy was shared only by the other middle Ming calligraphers, Lu Shen (1477–1544) and Li Tung-yang (1447–1516). [Signed] "P'iao-sou." [No seal].

No collectors' seals.

PUBLISHED

Ecke, *Chinese Calligraphy*, no. 38.

COMPARATIVE MATERIAL

Yao Shou, "Contributions of Mountains and Streams: Poems and Painting," handscroll (The Art Institute of Chicago). Colophons by Yao Shou to Chao Meng-fu's *Miao-yen-ssu chi*, handscroll (see no. 15b). Colophons to Ch'ien Hsuan's "Dwelling in the Mountains," handscroll (Palace Museum, Peking). Frontispiece to Chao Meng-fu's "The Jar-rim Window," handscroll (Palace Museum, Taipei).

29. Shen Chou (1427–1509)

"Autumn Colors among Streams and Mountains" (*Hsi-shan ch'iu-se*), four-character frontispiece to his painting.

Large running-standard script (*hsing-k'ai*).
Undated.
Handscroll, ink on paper.
Frontispiece only: $7\frac{1}{2}'' \times 29\frac{3}{4}''$ (19 cm. × 75.5 cm.).
Lent by Douglas Dillon, Courtesy of the Metropolitan Museum of Art.

SIGNATURE AND SEALS OF ARTIST

[Signed] "Inscribed by Shen Chou." [Seals] *Shih-t'ien* (square, intaglio), *Chu-shih-t'ing* (rectangle, intaglio), *Shen Ch'i-nan* (square, relief).

BIOGRAPHY OF ARTIST

Shen Chou (*tzu* Ch'i-nan, *hao* Shih-t'ien, Po-shih-weng) was a native of Ch'ang-chou, in the Suchou area of Kiangsu. A talented poet, painter, and calligrapher, he was a major figure of the Wu School. Although his landscapes indicate that he had studied the Four Masters of late Yuan, they nevertheless represent a new direction in Chiangnan painting. Shen was one of the few calligraphers of the period who specialized in Huang T'ing-chien's style.

COLLECTOR (seals on frontispiece only)

Yamamoto Teijirō (1870–1937), 3 seals.

PUBLISHED

Yonezawa Yoshiho, *Kokka* 894 (1966): 37–45. Whitfield, *In Pursuit of Antiquity*, no. 1, p. 50. Edwards, *Wen Cheng-ming*, no. 6, pp. 45–48.

COMPARATIVE MATERIAL

Ninety Years of Wu School Painting, pp. 29, 236–37, 243. *SNT* 1/48–49, 71–72, 77–78, 91. *SBT* 2/134–35; 3/210; 6/65. *SZ* 17/58, 59. *KKFS* 21-1/21–29. *CKMHCTS* 875–918.

30. Ch'en Hsien-chang (1428–1500)

"Writing about Plum Blossoms while Ill" (*Mei-hua ping-chung tso*), nine poems in five-character meter by the artist.[1]

Running-cursive script (*hsing-ts'ao*), 103 lines.
Dated 1492.
Handscroll, ink on paper.
$11\frac{3}{4}'' \times 352\frac{5}{8}''$ (29.8 cm. × 895.8 cm.).
Anonymous loan, The Art Museum, Princeton University.

TRANSLATION OF ILLUSTRATED SECTION (first poem)

Last year I boasted about my health,
Searching for plum blossoms I climbed in the mountains.
Carrying wine, I drank in the shadow of the cliffs;
I returned, my clothes dyed with fragrant dew.
To which direction does the Big Dipper now turn?

Half the southerly branches are already barren.
As I walk down the hall, my children laugh
At the way my old feet hobble.

SIGNATURE AND SEAL OF ARTIST

[Signed] "Shih-weng writes at the Elegant Study Hsiao-lu-kang." [Seal] *Shih-chai* (square, intaglio).

BIOGRAPHY OF ARTIST

Ch'en Hsien-chang (*tzu* Kung-fu, *hao* Shih-chai, Pai-sha, posth. Wen-kung), a native of Hsin-hui, Kwangtung, was an educator, scholar, and calligrapher. He spent his life in the study of the classics and philosophy. Over a period of 20 years he failed the metropolitan examinations 3 times. After his death, Ch'en was granted the title of Corrector of the Hanlin Academy; then, in 1584, his tablet was placed in a Confucian temple. (*DMB*, Huang P'ei and Julia Ching.)

COLOPHONS (in chronological order)

Anonymous, Ming(?), signature illegible, 3 lines in running-cursive script. No seals.

Pao Chen (19th century?), 11 lines in small standard script, dated 1869(?). Pao mentions that he acquired the scroll in *ting-mao* (1867?). [Signed] "Respectfully inscribed by Pao Chen-fang." [Seal] *Pao Chen yin* (square, intaglio).

Su T'ing-k'uei (ca. 1800–71), 17 lines in running script, dated 1871. Poem and colophon were both written for his friend Po-yü (*tzu* of Ch'ien Pao-shen?) when this scroll was in Po-yü's collection. [Signed] "Su T'ing-k'uei." [Seals] *Su T'ing-k'uei yin* (square, intaglio), *Ch'i-shih hou tso* (square, relief), *Tuan-fang* (oval, intaglio).

COLLECTORS

Weng Fang-kang (1733–1818), 1 seal.
Wu Hsi-tsai (1799–1870), 1 seal.
Ho Kuan-wu (20th century), 5 seals.
T'an P'ei (early 20th century?), 3 seals.
T'ao Yun-chiang(?) (unid.), 1 seal.
Sun Yü-t'ing(?) (d. 1834), 1 seal.
Hu Chen(?) (1822–67), 1 seal.
Unidentified, 7 seals.

PUBLISHED

Ch'en Hsien-chang, *Pai-sha-tzu ch'üan-chi* (Preface, 1505; 1771 ed.), 7/41b.

COMPARATIVE MATERIAL

Kuang-tung ming-chia shu-hua hsuan-chi. *SZ* 17/60, 61. *Pai-sha hsien-sheng i-chi* (1959 ed.), pp. 14 and 15 (poem handscroll, dated 1493); p. 21 (handscroll, undated). *Shohin* 240. *Shanghai FSHC* 15. *Ku-kung FSHC* 16.

NOTE

1. These poems are recorded in Ch'en's collected works under a slightly different title, "Singing of Plum Blossoms while Ill" (*Ping-chung yung mei*).

31. Wu K'uan (1436–1504)

"Four Poems," in five-character meter.[1]
Running script (hsing-shu), 126 lines.
Undated.
Handscroll, ink on paper.
$11\frac{3}{16}''$ × $492\frac{1}{16}''$ (30 cm. × 1248 cm.).
Collection of Wang Chi-ch'ien.

TRANSLATION OF ILLUSTRATED SECTION (third poem)[2]

Bedridden for more than three months
Anxiety fills my breast
Living alone at the close of autumn
I feel more burdened by the sound of incessant rain.
(Wang Ao showed me his poem on the tiresome rain . . .)

. . .

I already understand this feeling
The yellow leaves are wet, yet still flying about
[Blowing] through the window, breaking the melancholy
silence.

INSCRIPTION, SIGNATURE, AND SEALS OF ARTIST

"I have written several miscellaneous poems [to present to] Ying-ning [Yang I-ch'ing, 1454–1530, who received his *chin-shih* degree] in the same year [i.e. 1472], after [you] finished your official business.[3] You certainly will have something to teach me. Respectfully presented by K'uan." [Seals] *Yuan-po* (square, relief), *P'ao-weng* (square, relief), *Chih-ch'iu ku-chü* (square, relief).

BIOGRAPHY OF ARTIST

Wu K'uan (*tzu* Yuan-po, *hao* P'ao-an, Yü-yen-t'ing chu, posth. Wen-ting), a native of Ch'ang-chou, Nan-Chihli, was a poet and calligrapher active in the Suchou circle which had formed around the leading figures, Shen Chou and Wen Cheng-ming. Wu received the *chü-jen* degree in 1468, then placed first in the examination for the *chin-shih* degree in 1472 and was appointed as a compiler at the Hanlin Academy. He spent 30-odd years serving the bureaucracy, assisting in the compilation of various historical records. In 1503 he was appointed Minister of the Board of Rites, then died the following year. Wu's indebtedness to the plump and blunt calligraphic style of Su Shih (1036–1101) is clear from this example. (*DMB*, Lee Hwa-chou; Wilson and Wong, *Friends*, no. 3, pp. 44–46.)

FRONTISPIECE TO THE POEMS

Cha Shih-piao (1615–ca. 1698), "Poems and Calligraphy by P'ao-weng" (*P'ao-weng tz'u han*), 4 characters in large running script, ink on paper. [Signed] "Inscribed by Cha Shih-piao." [Seals] *Mei-ho* (rectangle, relief), *Cha Shih-piao yin* (square, intaglio), *Erh-chan shih* (square, relief).

No colophons.

COLLECTORS

Ma Ssu-tsan (Ch'ing, unid.), 15 seals.
Li K'o-fan (Ch'ing, unid.), 1 seal.
Wang Chi-ch'ien (contemporary), 1 seal.
Unidentified, 1 seal.

COMPARATIVE MATERIAL

SNT 1/83. *SBT* 2/108, 134–36; 6/66; 7/11; 8/8; 10/1. Shanghai *FSHC* 16. *Ming Ch'ing SHHC* 163. *SZ* 17/64, 65.

NOTES

1. Wu K'uan's 4 poems are as follows: "Sentiments" (*Yu-kan*), 16 lines; "Lament on Autumn Snow, written after the second big snowfall in the 9th month" (*Chiu-yueh ta-hsueh tsai-tso ch'iu-hsueh-t'an*), 44 lines; "Following Wang Ao's 'Tiring of the Rain, Confined to My Study'"(*Ho Wang Chi-chih Chai-chu k'u-yü*), 28 lines; "Listening to the Roosters' Crow" (*Wen chi*), 30 lines.
2. This poem has the same title and the same rhyme scheme as a poem that Wang Ao presented to Wu K'uan.
3. Wu K'uan wrote a colophon to the calligraphy handscroll by Huang T'ing-chien intended for Chang Ta-t'ung (see no. 6). That scroll was once in Yang I-ch'ing's collection.

32. Wang Ao (1450–1524)

"Ode to the Pomegranate and Melon Vine," poem in irregular meter; colophon to painting by Shen Chou (1427–1509).
Running-cursive script (hsing-ts'ao), 10 lines.
Undated.
Hanging scroll, ink on paper.
$58\frac{5}{8}''$ × $29\frac{3}{4}''$ (151.4 cm. × 75.5 cm.).
The Detroit Institute of Arts; gift of Mr. and Mrs. Edgar B. Whitcomb. Acc. no. 40.161.

INSCRIPTION, SIGNATURE, AND SEAL OF ARTIST

After the poem, Wang Ao explains that his younger brother Ching-chih asked him to inscribe this painting with a poem so that he could present it as a birthday present to Wu Chun-hung [Hsiu], in hopes that Wu, like the pomegranate, might father many sons, and that they might grow tall, like the melon. [Signed] "Junior Tutor to the Emperor, also Grand Tutor to the Heir-apparent, Minister of Revenue and Grand Secretary of the Wu-ying Tien, Wang Ao." [Seal] *Chi-chih* (rectangle, relief).

BIOGRAPHY OF ARTIST

Wang Ao (*tzu* Chi-chih, *hao* Shou-hsi, Cho-sou, posth. Wen-ko) was a scholar and writer from Suchou. Related by marriage to the imperial family, he enjoyed a long and successful official career. After passing the examinations for the *chü-jen* degree in 1474 and the *chin-shih* degree in 1475, Wang entered the Hanlin Academy as a compiler. During the next 30 years he held various positions in the capital. Involved in compiling historical records, he eventually became Junior Tutor to the Emperor. From 1506 to 1509 he served as Grand Secretary. (*DMB*, Hok-lam Chan.)

LABEL (mounted at upper right corner of poem)

Liang Ch'ing-piao (1620–91), 1 line in standard script. "'The Melon and Pomegranate' (*Kua liu t'u*) by Shen Ch'i-nan. [Signed] Authenticated by Chiao-lin."

No other colophons.

COLLECTORS

Liang Ch'ing-piao (1620–91), 2 seals.
Wang Lan-sheng(?) (1679–1737), 2 seals.
Li Tsung-wan (1705–59), 2 seals.

PUBLISHED

Bulletin of the Detroit Institute of Art 20 (1941): 45, no. 5. *Art News* 51 (1952): 34, no. 3. Jean-Pierre Dubosc, *Great Chinese Painters of the Ming and Ch'ing Dynasties* (New York, 1949), no. 9. *Mostra Internazionale d'Arte Cinese* (Venice, 1954), no. 797. Richard Edwards, *The Field of Stones* (Washington, D.C., 1962) p. 75, pl. 46A.

COMPARATIVE MATERIAL

Ecke, *Chinese Calligraphy*, no. 44. *Wen-wu ching-hua* 1/43. Wang Ao, "Poems," hanging scroll (collection of Wang Chi-ch'ien, New York).

33a. Chu Yun-ming (1461–1527)

"Dreaming of Spring Grasses" (*Meng-ts'ao chi*), first of two essays by the artist.[1]
Running-standard script (*hsing-k'ai*), 24 lines.
Dated spring 1510.
Handscroll, ink on paper.
First essay only: $11\frac{3}{8}'' \times 39\frac{1}{4}''$ (28.9 cm. × 99.6 cm.).
Hou Chen Shang Chai.

SIGNATURE AND SEALS OF ARTIST

[Signed] "Recorded by Ching-wei *hsiang-kung chin-shih*,[2] Chu Yun-ming." [Seals] *Chu Yun-ming yin* (square, relief), *Hsi-che* (square, relief), *Chih-shan* (rectangle, intaglio).

BIOGRAPHY OF ARTIST

Chu Yun-ming (*tzu* Hsi-che, *hao* Chih-shan, Chih-chih sheng), from Ch'ang-chou, Kiangsu, was one of the most prominent and colorful literary figures of the Ming period. Chu received classical training from his grandfathers, Chu Hao (1405–83) and Hsu Yu-chen (1407–72), and married the daughter of the calligrapher Li Ying-chen (1431–93). He attained the *chü-jen* degree in 1492 and served briefly as a magistrate in Kwangtung from 1515 to ca. 1520. He passed most of his life in the Suchou area, writing and composing, drinking and enjoying the company of friends such as Wen Cheng-ming and T'ang Yin (1470–1523). An uninhibited, highly creative calligrapher, Chu was inspired by the styles of the early calligraphers Chung Yu (151–230), Chang Hsu (ca. 700–750), and Huai-su (ca. 735–800?), and his broad stylistic range contrasts sharply with the consistency of Wen Cheng-ming's calligraphy. During his lifetime his small standard and "wild" cursive scripts were widely admired.

COLOPHONS: See no. 33b.

COLLECTORS

Kao Shih-ch'i (1645–1704), 2 seals.
Unidentified, 1 seal.

NOTES

1. Chu composed this essay for Lu Hsun-chieh (unid.), on the subject of Lu's *hao*, Meng-ts'ao. In the opening lines, Chu explains that Lu admired certain phrases from 2 early poems and so combined characters from each line to form this *hao*. He then discusses some interpretations of its meaning.
2. See no. 41, n. 2.

33b. Chu Yun-ming (1461–1527)

"Pear Valley" (*Li-ku chi*), second of two essays by the artist.[1]
Running-cursive script (*hsing-ts'ao*), 39 lines.
Dated summer 1510.
Handscroll, ink on paper.
Second essay only: $10\frac{3}{4}'' \times 48\frac{9}{16}''$ (27.4 cm. × 123.3 cm.).
Hou Chen Shang Chai.

SIGNATURE AND SEALS OF ARTIST

[Signed] "Written by Ching-wei *hsiang-kung chin-shih*,[2] Chu Yun-ming of T'ai-yuan." [Seals] *Hsi-che* (square, intaglio), *Chih-shan* (square, relief).

COLOPHONS

Anonymous, 3 lines in running-standard script, undated, mounted between essays. The writer notes that Kao Shih-ch'i had seen these essays; he also records that there are 3 pieces of fine old brocade mounted in the scroll. No seals.

Ku Wen-pin (1811–89), 7 lines in small standard script, dated 1863. [Signed] "Recorded by Ku Wen-pin of Yuan-ho." [Seal] *Ku Tzu-shan* (square, intaglio).

P'ei Ching-fu (1854–1926), 9 lines in running-standard script, undated. He transcribes the entry on these essays recorded in Kao Shih-ch'i, *Chiang-ts'un hsiao-hsia lu*. [Signed] "Recorded by Chieh-an [*hao*]." No seals.

P'ei Ching-fu, 5 lines in running-standard script, undated. He mentions Kao Shih-ch'i's record of the 2 essays and also notes the presence of fine Sung brocade. Unsigned. No seals.

PUBLISHED

Kao Shih-ch'i, *Chiang-ts'un hsiao-hsia lu* (Preface dated 1693), 2/65; postscript to an entry on Chu's transcription of poems by T'ao Yuan-ming. [Kao mistakenly states that the essay "Dreaming of Spring Grasses" was written for Lu Jen-chieh (unid.); it was, according to the text, actually intended for Jen-chieh's younger brother, Lu Hsun-chieh (see no. 33a, n. 1). Kao notes that the second essay, "Pear Valley," was written for Chang Yao-ch'en. An interesting detail is that Kao speaks of these essays as being in 2 separate handscrolls; apparently they were mounted together sometime after he saw them.] P'ei Ching-fu, *Chuang-t'ao-ko shu-hua lu* (Preface dated 1924), 9/47b–50a.

NOTES

1. Chang Yao-ch'en (unid.), the person for whom Chu

Yun-ming wrote this particular essay, used the *tzu* Li-ku. Chu discusses the possible meaning of this *tzu*.

2. See no. 41, n. 2.

34. Chu Yun-ming (1461–1527)

"Poems and Essays," transcription of two poems and two essays by Sung Yü (ca. 290–ca. 233 B.C.).[1]
Small standard script (*hsiao-k'ai*), 36 leaves.
Dated 1507.
Album, ink on silk.
Each leaf: $4\frac{7}{16}'' \times 2\frac{1}{8}''$ (11.3 cm. × 5.5 cm.).
Collection of John M. Crawford, Jr.

INSCRIPTION, SIGNATURE, AND SEALS OF ARTIST

"During the spring of the year *ting-mao* in the Cheng-te reign [1507] occasionally I have been in my Chen-shuai study at the Ch'ing-yun Temple enjoying the peach blossoms in full bloom. My enthusiasm is aroused, so I transcribe this once in order to show the idea of my brushwork. [Signed] Recorded by Chih-shan, Chu Yun-ming of Ch'ang-chou." [Seals] *Chih-shan tao-jen* (square, intaglio), *Yun-ming* (square, relief), *Chu Hsi-che* (square, relief).

COLOPHONS

Ku Lin (1476–1545), leaves 25–27, 11 lines in small standard script, dated 1517. [Seal] *Ts'ai-chih sheng* (square, relief).

Ch'en Shun (1483–1544), leaves 28–31, 12 lines in running-cursive script, dated 1526. [Seals] *Tao-fu* (square, intaglio), *Pai-yang shan-jen* (square, intaglio).

Wang Ch'ung (1494–1533), leaves 32–33, 7 lines in small standard script, dated 1526. [Seal] *Wang Ch'ung ssu-yin* (square, intaglio).

Wen Po-jen (1502–75), leaves 34–36, 10 lines in running-standard script, dated 1529. [Seal] *I tsai ch'ing-yuan* (square, intaglio).[2]

NOTES

1. Chu Yun-ming has transcribed the following: "Prose poem on the Wind" (*Feng-fu*), leaves 1–10; "Prose poem on the Moon" (*Yueh-fu*), leaves 10–16; Preface to the prose poem on "Teng-t'u-tzu Enjoying Feminine Beauty" (*Teng-t'u-tzu Hao-ssu fu hsu*), leaves 16–21; "Han Wu-ti's [r. 140–86 B.C.] Summons for Talented Men" (*Han Wu-ti mao-ts'ai chao*), leaves 21–23.

2. In *T'ing-yun-kuan t'ieh*, Wen Cheng-ming's collection of rubbings, 3 similar colophons by Ku Lin, Ch'en Shun, and Wang Ch'ung follow a set of 19 poems transcribed by Chu Yun-ming (volume of rubbings of Chu Yun-ming's calligraphy dated 1547). The script type of each colophon matches the corresponding one in this album; the colophons by Ch'en Shun and Wang Ch'ung are identical; and there are only minor variations in Ku Lin's. No colophon by Wen Po-jen.

35a. Chu Yun-ming (1461–1527)

"Farewell at the Bridge of the Hanging Rainbow" (*Ch'ui-hung pieh-i*), four-character frontispiece to a painting by T'ang Yin (1470–1523).
Large running-standard script (*hsing-k'ai*).
Datable 1508, according to Preface by Tai Kuan (1442–1512).[1]
Handscroll, ink on paper.
$11\frac{9}{16}'' \times 28\frac{13}{16}''$ (29.4 cm. × 73.1 cm.).
Collection of John M. Crawford, Jr.

SIGNATURE AND SEALS OF ARTIST

[Signed] "Chu Yun-ming." [Seals] *Chu Yun-ming yin* (square, intaglio), *Hsi-che* (square, relief).

NOTE

1. Originally, 34 inscriptions by artists and literati of Suchou were written as a farewell gift for Tai Chao (*tzu* Ming-fu) on the occasion of his departure for his home in Anhui. Only 19 of the inscriptions are still extant, following T'ang Yin's painting. From Tai Kuan's dated preface as well as the occasion, we can assume that Chu Yun-ming's poem and frontispiece must also date to 1508. (Wilson and Wong, *Friends*, no. 9, pp. 61–71.)

35b. Chu Yun-ming (1461–1527)

"Farewell at the Bridge of the Hanging Rainbow" (*Ch'ui-hung pieh-i*), poem in seven-character meter to a painting by T'ang Yin (1470–1523).
Small running-cursive script (*hsing-ts'ao*), 4 lines.
Datable 1508, according to Preface by Tai Kuan (1442–1512).[1]
Handscroll, ink on paper.
$11\frac{5}{8}'' \times 7''$ (29.5 cm. × 17.8 cm.).
Collection of John M. Crawford, Jr.

TRANSLATION

Through Chiangnan's striking scenery, hand in hand we go,
Tapping stone railings, our sleeves linger in goodbye.
Within your breast has always lived a long rainbow,
Which, once released, will pattern imperial robes and badges.

[Trans. Wilson and Wong, in *Friends*, p. 67.]

SIGNATURE AND SEAL OF ARTIST

[Signed] "Chu Yun-ming." [Seal] *Pao-shan chen-i* (square, relief).

NOTE

1. For complete documented history of scroll, see Wilson and Wong, *Friends*, pp. 61–71, no. 9.

36. Chu Yun-ming (1461–1527)

"Retreat on an Autumn Day" (*Hsien-chü ch'iu-jih*), poem in seven-character meter, and ten other poems.[1]
Cursive script (*ts'ao-shu*), 119 lines.
Dated 1510.
Handscroll, ink on paper.
11 11/16″ × 236 1/8″ (29.7 cm. × 599.8 cm.).
The Jeannette Shambaugh Elliott Collection at Princeton.

TRANSLATION

Escaping the heat I should temporarily shut the gate;
No need to bother seeking the ancient sages.
Let's toss away the wine cup and truly be idle,
Even a little composing I fear would interrupt our
 leisure.
The wind blows the leaves from the temple next door
 all over my courtyard;
The clouds part, revealing the mountains beyond the
 city.
In life it is often said that to be a hermit is easy
[But] to be a true recluse is more difficult than the
 pursuit of fame.

SIGNATURE AND SEALS OF ARTIST

[Signed] "Before the 15th of the 5th month of summer, in the year *keng-wu* of the Cheng-te reign [1510], Chih-shan tao-jen, Yun-ming casually wrote this after some wine." [Seals] *Hsi-che-fu* (square, relief), *Pao-shan chen-i* (square, relief), *Chih-shan* (rectangle, intaglio).

COLOPHON

Shen Chen (early 20th century), 10 lines in small running-standard script, dated 1904. Shen comments that he has seen many works by Chu Yun-ming and that, in comparison, this piece is well-controlled. [Signed] "Shen Chen." [Seals] *Shen* (round, relief), *Wen-tzu yin yuan* (square, relief).

COLLECTORS

Ch'ien Kang (unid.), 1 seal.
Mr. Wang (unid.), 1 seal.
Unidentified, 3 seals.

NOTE

1. Five of these 11 poems are recorded in Chu Yun-ming's collected works, *Chu shih shih-wen-chi*, which is composed of the *Chu shih wen-chi* (*CSWC*) and the *Chu shih chi-lueh* (*CSCL*). The 11 poems are listed below in order of appearance in the scroll. "Retreat on an Autumn Day" (*Hsien-chü ch'iu-jih*), *CSCL* 6/688; "Losing a Silver Pheasant" (*Shih pai-hsien*), *CSWC* 5/156; "Inscription to a Painting by Mi Fu" (*T'i Mi Nan-kung hua*); "Inscription to the 'Beautiful Woman of Fei-p'eng'" (*T'i Fei-p'eng shih-nü*); "Lake T'ai" (*T'ai-hu*), *CSWC* 5/153-4; "Mount Pao" (*Pao-shan*), *CSWC* 5/150; "Tiger Hill" (*Hu-ch'iu*), *CSWC* 5/154; "Poems Presented to a Fellow Townsman" (*Tseng hsiang-yu*); "Composing in the Rhymes of P'i [Jih-hsiu, late 9th century] and Lu [Kuei-meng, late 9th century] on a Leisurely Summer Day" (*Hsia yueh ch'ung-t'an ho P'i, Lu yun*); "Visiting Chang Wen-chieh's Shrine in Ch'ü-chiang" (*Ch'ü-chiang yeh Chang Wen-chieh kung ts'u*).

37. Chu Yun-ming (1461–1527)

"Autumn Meditations" (*Ch'iu-hsing*), a set of eight poems in seven-character meter by Tu Fu (712–770); two poems transcribed by the artist.[1]
Cursive script (*ts'ao-shu*), 22 lines.
Undated.
Handscroll, ink on paper.
Section by Chu Yun-ming: 8 9/16″ × 38 5/16″ (21.7 cm. × 97.4 cm.).
Collection of Robert H. Ellsworth.

TRANSLATION

First poem:
Well said Ch'ang-an looks like a chess-board:
A hundred years of the saddest news.
The mansions of princes and nobles all have new lords:
Another breed is capped and robed for office.
Due north on the mountain passes the gongs and drums
 shake,
To the chariots and horses campaigning in the west the
 winged dispatches hasten.
While the fish and the dragons fall asleep and the
 autumn river turns cold
My native country, untroubled times, are always in my
 thoughts.

Second poem:
K'un-ming Pool was the Han time's monument,
The banners of the Emperor Wu are here before my eyes.
Weaving Maid's loom-threads empty in the moonlit night,
And the great stone fish's scale-armor veers in the
 autumn wind.
The waves toss darnel seeds, drowned clouds black
Dew chills lotus calyxes, dropped powder pink.
 Over the pass, all the way to the sky, a road for none
 but the birds
On river and lakes, to the ends of the earth, one old
 fisherman.

[Trans. Tsu-lin Mei and Yu-kung Kao, in "Tu Fu's 'Autumn Meditations': An Exercise in Linguistic Criticism," *HJAS* 28 (1968): 44–80.]

SIGNATURE AND SEALS OF ARTIST

[Signed] "Chih-shan, Yun-ming." [Seals] *Chu Yun-ming yin* (square, intaglio), one seal illegible.

COLOPHON

Wen Cheng-ming (1470–1559), 12 lines in running script, following his transcription of 6 Tu Fu poems; dated 1534: "Occasionally I went to Hsing Li-wen's [Hsing Shen] studio and saw this scroll by Chu Yun-ming. But this scroll was missing the first six poems and only the last two remained. The brushwork is fluent and lively. I looked at it with great pleasure and couldn't put it down, so I took my brush and completed the missing poems. This does not mean that I wish to compare myself with Chu, but I'm just afraid that because the scroll is not complete, people won't regard it seriously. I hope those who look at my portion won't criticize me for trying to complete something which is already so good. [Signed] Cheng-ming." [Seals] *Wen Cheng-ming yin* (square,

intaglio), *Heng-shan* (square, relief), *T'ing-yun* (round, relief), *Wei keng-yin wu i-chiang* (rectangle, relief).

COLLECTOR

R. H. Ellsworth (contemporary), 1 seal.

PUBLISHED

Ellsworth, *Chinese Furniture*, pl. 20.

NOTE

1. Chu Yun-ming originally transcribed all 8 poems of the set in this handscroll. The opening 6 were subsequently removed; only the final 2, followed by Chu's signature and seals, remained. Wen Cheng-ming completed the scroll by adding the missing 6 poems and wrote a colophon.

38. Chu Yun-ming (1461–1527)

Colophon to "Watching the Mid-Autumn Moon," a painting by Shen Chou (1427–1509); poem in seven-character meter.
 Cursive script (*ts'ao-shu*), 10 lines.
 Undated.
 Handscroll, ink on paper.
 Colophon only: $10\frac{1}{8}$″ × $19\frac{3}{8}$″ (25.7 cm. × 49.2 cm.).
 Chinese and Japanese Special Fund, Museum of Fine Arts, Boston. Acc. no. 15.898.

TRANSLATION OF CHU YUN-MING'S POEM

Thousands of homes in the autumn light
Sharing the bright moon;
Your house is turned to joy
And friendship's warmth.
Wine is drunk in a strict order that
Marks off great from small;
Poems are made on given topics in order of seniority,
Then drums are beat, we watch the play
Acted by small Nephew Hsien;[1]
We pass the cup and enjoy the songs
Sung by Niece Wei[2]
I'm told that in Southern Tower
Meetings are frequent;
Why do I of all people receive the honor to join?
 [Based on trans. by Tseng and Edwards,
 in *Archives* 8: 32–33.]

SIGNATURE AND SEALS OF ARTIST

[Signed] "Yun-ming." [Seals] *Chih-shan* (square, relief), *Hsi-che-fu* (square, relief), *Hsiao-yao-t'ing-tzu* (rectangle, relief).

Chu Yun-ming's poem is accompanied by 2 poems inscribed by Shen Chou: one precedes and the other follows Chu's colophon on separate sheets of paper.

No other colophons.

COLLECTORS

Chu Yun-ming's poem:
Lo Hsiao-ch'uan(?) (Ming), 1 seal.

Other sections of handscroll:
Sun Ai(?) (15th century), 1 seal.
Kuan Ch'ieh (early 16th century), 1 seal.
Lo Hsiao-ch'uan (Ming), 3 seals.
Wu Chen (early 17th century), 1 seal.
Ch'eng Cheng-k'uei (*chin-shih* degree, 1631), 4 seals.
Ku Ho-ch'ing(?) (1766–1826), 1 seal.
Wu O (17th century?), 1 seal.

PUBLISHED

Osvald Sirén, *Chinese Paintings in American Collections* (Paris, 1928), Pt. V, pl. 164, p. 86. Sir Leigh Ashton and Basil Grey, *Chinese Art* (London, 1947), pl. 99, p. 260. Hugo Munsterberg, *A Short History of Chinese Art* (New York, 1949), pl. 47. Tseng Hsien-ch'i and Richard Edwards, "Shen Chou at the Boston Museum," *Archives of the Chinese Art Society of America* 8 (1954): 31–45. Tomita and Tseng, *Portfolio*, pls. 34, 35. Edwards, *The Field of Stones*, no. XXIII, pl. 14A (painting only).

NOTES

1. Yuan Hsien (3rd century B.C.), noted for his playing of the guitar and his knowledge of music. (Tseng and Edwards, *Archives* 8: 45, n. 7.)
2. Wei Tzu-fu (2nd century B.C.), a singing girl in the establishment of the Princess of P'ing-yang, the Emperor's sister (ibid., n. 8).

39. Chu Yun-ming (1461–1527)

"Farewell poem" (*Sung-pieh shih*) in seven-character meter.
 Large cursive script (*ts'ao-shu*).
 Undated.
 Hanging scroll, ink on paper.
 $60\frac{7}{8}$″ × $13\frac{9}{16}$″ (154.6 cm. × 34.4 cm.).
 Anonymous loan.

TRANSLATION

Don't send for Ling-lung to sing my lyrics,
They are to present to you.
Tomorrow morning we will again part at the river dock;
When the moon descends and the tides are calm,
That is the moment of departure.

SIGNATURE AND SEAL OF ARTIST

[Signed] "Chih-shan." [Seal] *Chu Hsi-che* (square, relief).

No colophons.

COLLECTORS

Chang Hsiao-ssu (late Ming), 2 seals.
Wang Po-i (Ch'ing?), 1 seal.
Chang Hsueh-ch'uang (Ch'ing?), 1 seal.
Wang Chi-ch'ien (contemporary), 1 seal.

40. Chu Yun-ming (1461–1527)

"Winter Journey in the North" (*Pei-cheng*), poem in seven-character meter.
Cursive script (*ts'ao-shu*).
Undated.
Fan mounted as album leaf, ink on gold paper.
7½″ × 19½″ (19 cm. × 49.5 cm.).
Collection of John M. Crawford, Jr.

TRANSLATION

> *Far from home, my saddle fills with snow blown by the*
> * north wind;*
> *My second crossing of the frontier gate, the year draws*
> * near its end.*
> *A dream some thousand leagues away are the misty*
> * mountains of my Wu;*
> *How often have I seen the ink-bamboo in this official*
> * stop.*
> *The turning of the sky sinks the milky way into the sea,*
> *And it's cold all over, frost white to the top of the wall.*
> *I came upon you in the deep of night, and talked of*
> * current things;*
> *Buoyed by wine, we rattled our swords in vain for the*
> * call that never came.*
>
> <div align="right">[Trans. Wilson and Wong,
in Friends, p. 53.]</div>

No signature or seals of artist.
No colophons.

COLLECTORS

P'an Cheng-wei (1791–1850), 2 seals.
J. M. Crawford (contemporary), 2 seals.
Unidentified, 1 seal.

PUBLISHED

Wilson and Wong, *Friends*, no. 6, pp. 52–53.

41. Chu Yun-ming (1461–1527)

"Prose Poem on Fishing" (*Tiao-fu*), by Sung Yü (3rd century B.C.).[1]
Running cursive script (*hsing-ts'ao*), 125 lines.
Dated 1507.
Handscroll, ink on gold-flecked paper.
12⅞″ × 26′ 9¼″ (31.5 cm. × 816.5 cm.).
Collection of John M. Crawford, Jr.

INSCRIPTION, SIGNATURE, AND SEALS OF ARTIST

"On a summer day in the year 1507, I was in [Wu]-hsi [near Suchou]; I visited Mr. Hua Shang-ku [Hua Ch'eng, 1438–1514] at the mansion of the former Lo Chuang[?]. We relaxed in the 'Pleasure Garden,' enjoying the flowers and fishing, and before we knew it, the day had passed and it was already evening. By lamplight, I took a worn brush and wrote the 'Prose Poem on Fishing' to commemorate the happiness of this occasion. [Signed] Recorded by Chu Yun-ming, *Hsiang-kung chin-shih*[2]

of Ch'ang-chou." (Based on trans. by Jonathan Chaves, in Ecke, *Chinese Calligraphy*, no. 45.) [Seals] *Yun-ming* (rectangle, relief), *Hsi-che* (rectangle, intaglio), *Chih-shan* (rectangle, relief).

No colophons.

COLLECTOR

J. M. Crawford (contemporary), 3 seals.

PUBLISHED

Ecke, *Chinese Calligraphy*, no. 45. Barnhart, "Chinese Calligraphy," fig. 15.

NOTES

1. In this poem Sung Yü uses the metaphor of fishing to express his views on the correct methods of governing a country. The poem is recorded in Yen K'o-chün (1762–1843), ed., *Ch'üan shang-ku San-tai, Ch'in, Han, San-kuo, Liu-ch'ao wen* (1894 ed., Taipei reprint 1961), 10/75. We are indebted to Mrs. H. Frankel for this reference.
2. *Hsiang-kung chin-shih* refers to a means used during the T'ang dynasty for selecting individuals of exceptional talent from the *chou* and the *hsien* to send to the capital. By the Ming period it was used merely as a polite form of address among friends to exalt those who had received the *chü-jen* degree.

42. Chu Yun-ming (1461–1527)

"Path on Mt. T'ai-hang" (*T'ai-hang lu*), poem in seven-character meter by Po Chü-i (772–864); and "Bringing the Wine" (*Chiang-chin chiu*), poem in seven-character meter by Li Po (701–762).
Cursive script (*ts'ao-shu*). First poem: 22 lines; second poem: 31 lines.
Undated.
Handscroll, ink on paper.
12 11/16″ × 116 5/16″ (32.3 cm. × 295.6 cm.).
Collection of Robert H. Ellsworth.

TRANSLATION OF ILLUSTRATED SECTION
(Opening of "Bringing the Wine")

> *Have you not seen*
> *How the Yellow River, which flows from heaven and*
> * hurries toward the sea, never turns back?*
> *Have you not seen*
> *How at the bright mirrors of high halls men mourn*
> * their white hairs,*
> *At dawn black silk, by evening changed to snow?*
> *While there is pleasure in life, enjoy it,*
> *And never let your gold cup face the moon empty!*
> *Heaven gave me my talents, they shall be used;*
> *A thousand in gold scattered and gone will all come*
> * back again.*
> *Boil the sheep, butcher the ox, [make merry while there*
> * is time;*
> *We have never drunk at all till we drink three*
> * hundred cups.]*
>
> <div align="right">[Trans. A. C. Graham, in Birch, ed.,
Anthology of Chinese Literature, p. 232.]</div>

[Signed] "Chih-shan, Chu Yun-ming." [Seals] *Chih-shan* (rectangle, intaglio), *Chu Yun-ming yin* (square, intaglio).

No colophons.

COLLECTORS

Hu Kung-shou(?) (Ch'ing), 1 seal.
R. H. Ellsworth (contemporary), 1 seal.

43. Chu Yun-ming (1461–1527)

"Bringing the Wine" (*Chiang-chin chiu*), poem in seven-character meter by Li Po (701–762).
Cursive script (*ts'ao-shu*), 51 lines.
Undated.
Handscroll, ink on paper.
13¼" × 206 1/16" (33.8 cm. × 523.3 cm.).
The Jeannette Shambaugh Elliott Collection at Princeton.

TRANSLATION OF ILLUSTRATED SECTION (opening lines)

Have you not seen
How the Yellow River, which flows from heaven and
* hurries toward the sea, never turns back?*
Have you not seen
How at the bright mirrors of high halls men mourn
* their white hairs,*
At dawn black silk, [by evening changed to snow?]
 [Trans. A. C. Graham, in Birch, ed.,
 Anthology of Chinese Literature, p. 232.]

SIGNATURE AND SEALS OF ARTIST

[Signed] "Chih-shan." [Seals] *Chu Yun-ming yin* (square, relief), *Hsi-che* (square, relief).

COLOPHON

Wang Shih-chen (1526–90), 7 lines in cursive script, undated. [Signed] "Recorded by Lan-ya, Wang Shih-chen." [Seals] *Wang shih Yuan-mei* (square, relief), *T'ien-t'ao tao-jen* (square, relief).

COLLECTORS

Feng Meng-chen(?) (active ca. 1600), 2 seals.
Jung-hsi-chai (unid.), 1 seal.
Liao-an (unid.), 1 seal and outer label dated *chi-wei* (1919?).
Unidentified, 4 seals.

44. Chu Yun-ming (1461–1527)

"Flowers of the Seasons," poem in five-character meter.
Large cursive script (*ts'ao-shu*), 81 lines.
Dated 1519.
Handscroll, ink on paper.

18" × 52' ⅜" (45.7 cm. × 1587 cm.).
Anonymous loan, The Art Museum, Princeton University.

TRANSLATION OF ILLUSTRATED SECTION

On days when apricot blossoms unfold
Purple swallows drift about.[1]
 [Based on trans. by Adele Rickett,
 in Ecke, *Chinese Calligraphy*, no. 46.]

SIGNATURE AND SEALS OF ARTIST

[Signed] "Chih-shan, Yun-ming wrote [this] in the Ssu-wang Studio. It is the spring of 1519." [Seals] *Yun-ming* (square, relief), *Hsi-che* (square, relief).

No colophons.
No collectors' seals.

PUBLISHED

Ecke, *Chinese Calligraphy*, no. 46.

NOTES

1. After writing an extra character *tzu*, Chu Yun-ming marked it with two dots to indicate that the character was an error and should be deleted.

45. Chu Yun-ming (1461–1527)

"Poem on Plum Blossoms," a lyric poem (*tz'u*).
Large cursive script (*ts'ao-shu*), 48 lines.
Undated.
Handscroll, ink on tan paper.
18 9/16" × 351⅞" (47.2 cm. × 893.8 cm.).
Collection of Robert H. Ellsworth.

TRANSLATION OF ILLUSTRATED SECTIONS

First section:
On a moonlit evening near snowy Mt. Ku.[1]
[I] came in a small skiff accompanied by a crane.
A subtle fragrance diffuses;
[The whole tree blooms with jade-like flowers.]
Second section:
I love the shadow [of the plums] on the window.
Where is the one who shares my feelings?
I just awoke in the cold moonlight.

SIGNATURE AND SEALS OF ARTIST

[Signed] "Casually written by Chih-shan, Yun-ming." [Seals] *Yun-ming* (square, relief), *Chih-shan* (square, intaglio).

FRONTISPIECE

Chang Hung (Ch'ing), "The brush moves like dragons and snakes" (*Pi-tsou lung-she*), 4 characters in running script on cream-colored, gold-flecked paper. [Signed] "Inscribed by Chang Tsung(?)-shan." [Seals] *Chang Hung chih yin* (square, intaglio), *Chung-han-shih* (square, relief).

No colophons.

COLLECTOR

R. H. Ellsworth (contemporary), 1 seal.

PUBLISHED

Ellsworth, *Chinese Furniture*, pl. 21.

NOTE

1. Mt. Ku, near Hangchou, is where the hermit Lin Pu (967–1028) lived. It is traditionally said that the hermit Lin considered the plum blossoms as his wife, and the crane as his son.

46. Chu Yun-ming (1461–1527)

"Orchid Flower Song" (*Lan-hua yung*), a set of poems in seven-character meter.
Large cursive script (*ts'ao-shu*), 64 lines.
Dated 1507.
Handscroll, ink on tan paper.
18¼″ × 418″ (46.3 cm. × 1062 cm.).
Collection of John M. Crawford, Jr.

TRANSLATION OF ILLUSTRATED SECTION (second poem)

On the leaves lies a morning mist, shades of green
tangled in confusion;
Purple creepers are wrapped in this spring fog.
A beautiful woman is just across the waters of the
Hsiang River.
I pick a fragrant flower; to whom am I going to send it?

SIGNATURE AND SEALS OF ARTIST

[Signed] "Written by Chih-shan, Yun-ming at his mountain study by Stone Lake [*Shih-hu shan-chai*], on the 15th day of the third lunar month, in the year *ting-mao* of the Cheng-te reign [1507]." [Seals] *Chih-shan Chu shih* (square, intaglio), *Hsi-che fu* (square, relief).

No colophons.

COLLECTOR

J. M. Crawford (contemporary), 3 seals.

47. Chu Yun-ming (1461–1527)

"Orchid Flower Song" (*Lan-hua yung*), a set of poems in seven-character meter.
Cursive script (*ts'ao-shu*), 55 lines.
Undated.
Handscroll, ink on paper.[1]
11¼″ × 209⁵⁄₁₆″ (28.5 cm. × 501.6 cm.).
Collection of Robert H. Ellsworth.

TRANSLATION OF ILLUSTRATED SECTION

See no. 46.[2]

SIGNATURE AND SEALS OF ARTIST

[Signed] "Chih-shan, Chu Yun-ming wrote [this] at

the Shih-en Hall." No seals.

COLOPHON

Chao Yun-fan (unid.), 7 lines in running-cursive script, undated. [Signed] "Inscribed by Chao Yun-fan of Wu-ning." [Seals] *Yun-fan yin* (square, intaglio), *Yen-fu pieh-hao Mei-nu* (square, relief), *Ou-jan yü-shu* (oval, relief).

COLLECTOR

R. H. Ellsworth (contemporary), 1 seal.

NOTES

1. During the mounting process, the 4 sheets of paper comprising the scroll had apparently been stacked one above the other and the ink had soaked through.
2. The artist transcribed several poems entitled "Orchid Flower Song" for this scroll and the preceding one, no. 46. The poem illustrated here appears on both.

48. Chu Yun-ming (1461–1527)

"Evening Reflections" (*Fan-chao*), third and fourth lines of a poem in seven-character meter by Tu Fu (712–770).
Cursive script (*ts'ao-shu*).
Undated.
Hanging scroll, ink on paper.
59³⁄₁₆″ × 12⅛″ (132.6 cm. × 30.8 cm.).
Collection of John M. Crawford, Jr.

TRANSLATION

The sun's last glow, glancing off the river, shimmers
on the rock cliff;
Trees nestled now by floating clouds, the mountain
village itself no longer seen.

[Trans. Wilson and Wong,
in *Friends*, p. 49.]

SIGNATURE AND SEALS OF ARTIST

[Signed] "Wu-hsia, Chih-shan." [Seals] *Yun-ming* (square, relief), *Chih-shan* (square, intaglio).

No colophons.

COLLECTORS

Li Shen (unid.), 1 seal.
Hua Wen-po (unid.), 1 seal.
Chou Yu (contemporary), 2 seals.
J. M. Crawford, Jr. (contemporary), 3 seals.
Unidentified, 5 seals.

PUBLISHED

Wilson and Wong, in *Friends*, no. 5, pp. 49–51.

49. Wu I (1472–1519)

"Enjoying the Pines" (*I-sung*), two-character frontispiece to painting by Shen Chou (1427–1509).
Seal script (*chuan-shu*).
Undated.
Handscroll, ink on gold-flecked paper.
12⅝″ × 35¼″ (32 cm. × 89.4 cm.).
Collection of John M. Crawford, Jr.

SIGNATURE AND SEAL OF ARTIST

[Signed] "Wu I." [Seal] *Ssu-yeh fu yin* (rectangle, relief).

BIOGRAPHY OF ARTIST

Wu I (*tzu* I-fu), a native of Shanghai, was the nephew of Wu K'uan (1435–1504; see no. 31) and lived at his uncle's Eastern Village Estate, which later became his own on Wu K'uan's death in 1504. He is best known for his seal-script writing on frontispieces to the many paintings executed by his artistic Suchou friends. While it has been noted that Wu I's seal-script style was influenced by the calligraphy of Li Yang-ping (active ca. 759–780), the well-known calligrapher Li Tung-yang (1447–1516) is traditionally recorded as having been his teacher. (Wilson and Wong, *Friends*, pp. 95–97.)

COLOPHONS

For complete documentation on scroll, see Wilson and Wong, *Friends*, no. 17, pp. 95–97.

COLLECTORS (seals on frontispiece only)

Mr. Ho (unid.), 1 seal.
Unidentified, 1 seal.

50a. Wu I (1472–1919)

"Summer Retreat in the Eastern Grove" (*Tung-lin pi-shu*), four-character frontispiece to a painting by Wen Cheng-ming (1470–1559).
Seal script (*chuan-shu*).
Undated.
Handscroll, ink on gold-flecked paper.
Frontispiece only: 12 9/16″ × 36⅜″ (32 cm. × 93.4 cm.).
Collection of John M. Crawford, Jr.

SIGNATURE OF ARTIST

[Signed] "Written by Wu I for the Venerable Abbot Nan-chou."[1] No seals.

COLOPHONS

See *no. 50b*.

COLLECTOR

P'an Po-ying (20th century), 1 seal.

NOTE

1. Nan-chou was the abbot of the Temple of the Kings of Heaven (*T'ien-wang-ssu*) on the western Mt. Tung-t'ing, near Suchou.

50b. Wen Cheng-ming (1470–1559)

Poems and Colophons to "Summer Retreat in the Eastern Grove" (*Tung-lin pi-shu*), painting by the artist; three poems in seven-character meter, followed by two additional colophons by the artist.
Poem 1: 16 lines in running script (*hsing-shu*), in the style of Huang T'ing-chien (1045–1105).
Poem 2: 17 lines in cursive script (*ts'ao-shu*), in the style of Huai-su (ca. 735–800?), as transmitted through Huang T'ing-chien.
Poem 3: 16 lines in running script (*hsing-shu*), in the style of Su Shih (1036–1101).
Datable by inscription to ca. 1512.
Handscroll, ink on paper.
Artist's poems and colophons only: 19 9/16″ × 232⅞″ (31.9 cm. × 591.6 cm.).
Collection of John M. Crawford, Jr.

TRANSLATION OF ILLUSTRATED SECTIONS

First poem: "Done in a Boat on Stone Lake during the Cold Food Festival,"[1] lines 4–6.

The setting sun shines in mid-river on rising white gulls.
Village shops are lonely and still—it's the "Cold Food Festival";
The traveler is far away upon a magnolia boat.

Second poem: "Remembrance while Walking Alone in the Morning by a Stream," lines 3–5.

I do not see my old friend by the crab-apple oar,
Swallows fly evenly over the islands of tu-jo *flowers.*
As the sun falls the evening wind blows my night wine.

Third poem: "Drinking during a Late Rain in Mr. T'ang's Garden Pavilion," lines 1–3.

In a lofty studio while the sun was setting, we casually did what others have done;
With wine-cups we lingered, with laughter.
Fragrant grasses filled the yard and swallows were on the wing.

[Trans. James Robinson, in Edwards, *Wen Cheng-ming*, p. 71.]

INSCRIPTIONS, SIGNATURES, AND SEALS OF ARTIST

First colophon (following third poem), 5 lines in cursive script. [Signed] "Wen Pi, Cheng-ming, has just written this at a place deep within the verdant green bamboo area of Mr. Ch'ien's [Ch'ien Kung-chou, 1475–1549] Western Garden."

Second colophon, 8 lines in small running-cursive script: "Previously I wrote this at [Ch'ien] Kung-chou's place, and did not know that this was [since] acquired by Nan-chou [abbot of the Temple of the Kings of Heaven]. On the twenty-fourth day of the ninth month of 1515 I happened to pass by the T'ien-wang Temple. Examining it, there welled up feelings of sadness. It has been three years since I wrote it. Each day my powers fail. I doubt

that I could do this again. [Signed] Cheng-ming again inscribed." [Trans. James Robinson, in Edwards, *Wen Cheng-ming*, pp. 71–72.] [Seals] *Wen Cheng-ming yin* (square, intaglio), *Heng-shan* (square, relief).

BIOGRAPHY OF ARTIST

Wen Cheng-ming (original *ming* Pi, *tzu* Cheng-ming, Cheng-chung, *hao* Heng-shan), from a prominent Suchou family of scholars and collectors, was a leading painter, calligrapher, and scholar of the mid-Ming period. Wen, who studied the classics with Wu K'uan and painting with Shen Chou, was—together with his literary friends Chu Yun-ming, T'ang Yin, and Hsu Chen-ch'ing—known as one of the Four Talents of Wu (Suchou). During his long life, Wen had a profound influence on several generations of artistic and literary figures, including Ch'en Shun and Wang Ch'ung. His calligraphy reflects a deep awareness of the past and his disciplined study of the traditions of early masters, especially the Tsin master-calligrapher Wang Hsi-chih and the leading Sung masters.

COLOPHON

P'an Po-ying (20th century), 5 lines in running script, undated. P'an records that he had also seen a handscroll of large calligraphy by Wen Cheng-ming in pure Mi Fu style (see, e.g., *no. 51*). [Seals] *Mo-che* (?) (square, relief), *P'an Po-ying* (square, intaglio).

COLLECTOR

P'an Po-ying (20th century), 2 seals.

PUBLISHED

Fu-t'ien chi I/153, 155. *Wen-shih wu-chia chi*, 6/14a. Sickman, ed., *Chinese Calligraphy and Painting*, pp. 134–35, no. 60. *SCPC* III/1908–09. Wilson and Wong, *Friends*, pp. 79–81, no. 12. Edwards, *Wen Cheng-ming*, pp. 69–72, no. 12.

COMPARATIVE MATERIAL

On Huang T'ing-chien style: *Ninety Years of Wu School Painting*, pp. 147, 148, 188, 190–91, 224–25.

SBT 3/211; 4/324–29; 6/70; 7/135; 8/9–10; 10/5–10, 178; 11/63–64, 93, 179–96; 197–217. *Shohin* 227, 246. *Pai-chueh-chai MJFS* 2. *Shanghai FSHC* 18. *SZ* 17/76–92.

NOTE

1. During this festival, from the 105th to the 107th day after the winter solstice, food is supposed to be eaten cold in memory of Chieh Tzu-t'ui of the Spring and Autumn Annals period.

51. Wen Cheng-ming (1470–1559)

"Sunset on the Chin and Chiao Mountains," poem in seven-character meter.[1]
Large running script (*hsing-shu*), in the style of Mi Fu. Dated 1521.
Handscroll, ink on paper.

$14\frac{1}{8}''$ × $173\frac{3}{4}''$ (35.9 cm. × 441.4 cm.).
Collection of Mr. and Mrs. Hans Frankel.

TRANSLATION OF ILLUSTRATED SECTION

(from fourth character, first line)

. . . [You] generally say that my family tradition
derives from Hu-chou [i.e. Wen T'ung].
How can I who am so insignificant be worthy of your
mention?
Usually [other people's] comments directly determine
one's reputation.
It is even more true because you are a master poet.

INSCRIPTION, SIGNATURE, AND SEALS OF ARTIST

"Previously I painted 'Sunset over the Chin and Chiao Mountains.' Mr. Wu of the Ministry of Personnel (*Li-pu*) composed long poems [expressing his gratitude for the painting] and sent them to me;[2] that was in *i-mao*, the ninth year of the Hung-chih reign [1495].[3] Now it is the year *hsin-ssu* of the Cheng-te reign [1521], already twenty-six years have passed. Li-pu [Mr. Wu] died several years ago, so as I look at my earlier work, I sign over the time separating me from my elders. My hearing and sight deteriorate daily; I feel desolate. In the evening, on the day before the winter solstice, I write this by lamplight. [Signed] Cheng-ming." [Seals] *Wen Cheng-ming yin* (square, intaglio), *Yü-lan-t'ang* (square, intaglio).

COLOPHONS

Huang I (early 19th century), 5 lines in small running script, dated 1802. Huang states that Wen wrote this when he was 52; and the strength of the calligraphy is extremely similar to Mi Fu's—a style that was rare in Wen's work. Huang also notes that he owns some calligraphy by Wen written in the style of Su Shih. [Signed] Recorded by Huang I of Chien-t'ang." [Seal] *Hsiao-sung* (horizontal rectangle, relief).

Shen Yin-mo (1882–1971), 19 lines in running script, dated 1946. Shen mentions that this scroll by Wen was written in the style of Mi Fu, whereas his running-cursive script usually reflects the influence of Huang T'ing-chien. As he concludes: "On opening this scroll, it is hardly recognizable as Wen's work. None of his extant works which I have seen are like this . . . He is the most diligent of all Ming calligraphers. . . . This handscroll is in [Chang] Ch'ung-ho's collection."[4] Shen inscribed the colophon at Chang Ch'ung-ho's request. [Signed] "Yin-mo." [Seal] *Shen Yin-mo* (square, intaglio).

Hu Shih (1891–1962), 11 lines in running script, dated 1957, punctuated and written in colloquial Chinese. Part of Hu Shih's colophon concerns a date mentioned by Wen Cheng-ming. Hu corrects Wen's error in recording the year: it should be the 8th year of Hung-chih, not the 9th year, as Wen wrote. [Signed] "Inscribed by Hu Shih for [Chang] Ch'ung-ho . . ." [Seal] *Hu Shih* (square, intaglio).

COLLECTOR

Unidentified, 1 seal.

COMPARATIVE MATERIAL

Ninety Years of Wu School Painting, pp. 147–48.

NOTES

1. This poem by the artist is recorded in *Wen-shih wu-chia chi* (Preface dated 1770, *SKCS* edn. *ch'u-chi, tsung-chi lei*), 4/2a, b; also recorded in Wen's *Fu-t'ien chi*, 1/78.

2. In the collected works of the Wen family, *Wen-shih wu-chia chi*, Wen Cheng-ming notes that he executed a painting entitled "Sunset over the Chin and Chiao Mountains" for Mr. Wu Te-cheng (unid.), an official in the Ministry of Works (?) (*Shui-pu*), and Wu responded with two poems, which are recorded, following Wen's, in the *Fu-t'ien chi* 1/79.

3. As Hu Shih states in his colophon, 1495 was the eighth year of the Hung-chih reign.

4. Chang Ch'ung-ho is Mrs. H. Frankel, the present owner of the scroll. She kindly called to our attention the reference in *Wen-shih wu-chia chi*.

52. Wen Cheng-ming (1470–1559)

"First Frost," poem in five-character meter.
Large running-cursive script (*hsing-ts'ao*).
Undated.
Hanging scroll, ink on paper.
$56\frac{1}{4}''$ × $12\frac{3}{4}''$ (142.8 cm. × 32.5 cm.).
Anonymous loan.

TRANSLATION

The leaves fall, the air is crisp and clear,
And yet the house retains the feeling of spring.
Flies strike against the paper of the empty window;
The garden is tranquil, birds spy on the inhabitants.
A bright sun passes over the eaves of the roof;
The common folk complete the year in poverty.
The first frost fills the city;
I wish to go out but fear the wind and dust.

SIGNATURE AND SEALS OF ARTIST

[Signed] "Cheng-ming." [Seals] *Yü-lan-t'ang* (square, relief), *Wen Cheng-ming yin* (square, intaglio), *Wei keng-yin wu i-chiang* (rectangle, relief).

No colophons.

COLLECTOR

Wang Chi-ch'ien (contemporary), 1 seal.

COMPARATIVE MATERIAL

Ninety Years of Wu School Painting, pp. 166, 283.

53a. Lu Shen (1477–1544)

"Streams and Rocks" (*Hsi-shih*), two-character frontispiece to a painting by Lu Chih (1496–1576).
Seal script (*chuan-shu*).
Undated.
Handscroll, frontispiece only: ink on pink gold-flecked paper.
$12\frac{3}{16}''$ × $27\frac{7}{8}''$ (30.9 cm. × 70.8 cm.).
Nelson Gallery–Atkins Museum, 40th Anniversary Memorial Acquisition Fund. Acc. no. F 75–44.

SIGNATURE AND SEAL OF ARTIST

[Signed] "Yen-weng." [Seal] *Yü-t'ang hsüeh-shih* (square, intaglio).

BIOGRAPHY OF ARTIST

Lu Shen (*tzu* Tzu-yuan, *hao* Yen-shan, posth. Wen-yü), a scholar-official, writer, calligrapher, and collector, was a native of Shanghai (Sungchiang). Lu received his *chin-shih* degree in 1505 and was appointed to the Hanlin Academy as a compiler in 1507. He served briefly as an attendant at the Emperor's lessons in 1512, was director of studies at the National University in Nanking from 1518 to 1521, then became chancellor in 1528. Because of political pressure he was demoted, and for short periods he held various other positions until the end of his official career. Lu Shen left behind a collection of comments on calligraphy and a series of biographies of calligraphers in his work entitled the *Shu-chi* (Preface dated 1508). (*DMB*, Hok-lam Chan.) During the period preceding Tung Ch'i-ch'ang, Lu was one of the most prominent calligraphers in the Sungchiang area.

COLLECTORS

Hsiang Yuan-pien (1525–90), 5 seals.
Yin Shu-po (1769–1847), 2 seals.
Yang Chi-chen (active ca. 1861–65), 5 seals.
Huang Ch'ü-ch'en (early to mid-19th century), 1 seal.
Unidentified, 3 seals.

53b. Wen Cheng-ming (1470–1559)

"Essay on Streams and Rocks" (*Hsi-shih chi*), also known as "Essay on Wu Yun-sheng,"[1] following the painting by Lu Chih (1496–1576).
Clerical script (*li-shu*), 40 lines.
Undated.
Handscroll, ink on paper.
$12\frac{3}{4}''$ × $50\frac{3}{4}''$ (32.4 cm. × 128.9 cm.).
Nelson Gallery–Atkins Museum; 40th Anniversary Memorial Acquisition Fund. Acc. no. F 75–44.

PARAPHRASE OF ILLUSTRATED SECTION (opening 6 lines)

The area of Hsin-an [S. Anhui] has many mountains and streams. . . . Most of the people from this district are extraordinary. Although some are more famous than others, all are admired for their will and integrity, which confirms the [historical] records. Mr. Wu Yun-sheng is such a person. His nature is lofty but simple. He disregards profits and personal desire.

SIGNATURE AND SEALS OF ARTIST

[Signed] "Written by the former *Tai-chao* of the Hanlin Academy, *Chiang-shih tso-lang*, and National Historiographer Wen Cheng-ming of Ch'ang-chou, in the Magnolia Hall (*Mu-lan-t'ang*)." [Seals] *Cheng-chung* (square, relief), *Yü-ch'ing shan-fang* (rectangle, intaglio).

COLOPHONS (in chronological order)

Hsiang Yuan-pien (1525–90), 2 lines in running script,

dated 1578. "Remounted in the 6th year of the Wan-li reign in the Ch'ih-sung Study. Numbered *shou*.[2] [Signed] Hsiang Yuan-pien." [Seals] *Hsiang Yuan-pien yin* (square, relief), *Tzu-ching-fu yin* (square, relief).

Pao Kuei-sheng (active late 19th century), 4 lines in running script. [Seals] *Hsiao-shan* (square, relief), *Pao Hsiao-tzu tz'u-sun* (rectangle, relief).

COLLECTORS

Hsiang Yuan-pien (1525–90), 20 seals.
Yang Chi-chen (active ca. 1861–65), 11 seals, 1 dated *hsin-mao*.
Huang Ch'ü-ch'en (active early to mid-19th century), 1 seal.

PUBLISHED

Chinesische Malerei (Hamburg, 1949–50), no. 16, p. 37.

COMPARATIVE MATERIAL

Ninety Years of Wu School Painting, pp. 59, 116, 127, 153, 183, 236, 242–43, 247, 254–59, 282–83.

NOTES

1. Hsi-shih is the *hao* of Wu Yun-sheng (active mid-16th century).
2. See *no. 18*, n. 2.

54. Ch'en Shun (1483–1544)

"Lotus under the Autumn Moon," poem in seven-character meter.
Cursive script (*ts'ao-shu*).
Undated.
Hanging scroll, ink on paper.
$51\frac{13}{16}'' \times 11\frac{15}{16}''$ (131.6 cm. × 30.3 cm.).
The Jeannette Shambaugh Elliott Collection at Princeton.

TRANSLATION

A bright autumn moon shines on the green waters,
On the Southern Lake [they] pick white duckweed.
The lovely lotus flowers seem to speak;
Melancholy overcomes the boatman.

SIGNATURE AND SEAL OF ARTIST

[Signed] "Written by Tao-fu." [Seal] *Pai-yang shan-jen* (square, intaglio).

BIOGRAPHY OF ARTIST

Ch'en Shun (or Tao-fu, *tzu* Fu-fu, *hao* Pai-yang shan-jen), a well-known painter and calligrapher of Suchou and a student of Wen Cheng-ming's, came from a well-to-do family and frequently entertained artistic and literary friends at his Five Lakes country residence. Ch'en was not only one of the most important and influential flower painters of the Ming period, but, influenced by Wen Cheng-ming, he also developed his own particular style of calligraphy, writing free-flowing running and cursive scripts. (*DMB*, Liu Lin-sheng.)

No colophons.

COLLECTORS

Mr. Cheng (unid.), 1 seal.
Wang Chi-ch'ien (contemporary), 1 seal.

COMPARATIVE MATERIAL

SNT 1/96–107. *SBT* 7/138; 8/15; 10/11–12. *SMS* 138. *Ming Ch'ing SHHC* 43. *SZ* 17/100–01.

55. Ch'en Shun (1483–1544)

"Thoughts on an Ancient Site" (*Yung-huai ku-chi*), three poems by Tu Fu (712–770).[1]
Large cursive script (*ts'ao-shu*).
Undated; probably ca. 1540.
Handscroll, ink on paper.
$10\frac{1}{2}'' \times 303\frac{1}{16}''$ (26.7 cm. × 769.7 cm.).
Anonymous loan.

TRANSLATION OF ILLUSTRATED SECTIONS

First poem:
By many a mountain and many a thousand valley I
come to the Gate of Ch'u.
The village where Ming-fei was born and bred is to be
found there still.[2]

Third poem (from the second line of characters illustrated):
But the cycle has passed on and the fortunes of the
House of Han were not to be restored;
And so, hopes blighted, he [Chu-ko Liang] perished and
his strategy was all in vain.[3]

[Trans. Hawkes, in *Primer*, no. 27,
pp. 174–77; no. 28, pp. 178–80.]

INSCRIPTION, SIGNATURE, AND SEALS OF ARTIST

"Written in a secluded place of the Pi-yun Studio at the Five Lakes Country Residence (*Wu-hu t'ien-she*). [Signed] Ch'en Tao-fu-fu." [Seals] *Fu-fu shih* (square, intaglio), *Pai-yang shan-jen* (square, intaglio).

No colophons.

COLLECTORS

Tung Hung-ch'i (unid.), 4 seals.
Yun Hsing-yun (unid.), 2 seals.
Chou Mo-nan (contemporary), 2 seals.
Wang Chi-ch'ien (contemporary), 1 seal.
Unidentified, 2 seals.

COMPARATIVE MATERIAL

Ecke, *Chinese Calligraphy*, no. 52. Ch'en Shun, "Studies from Life," handscroll, dated 1538 (National Palace Museum, Taipei). *SMS* 138.

NOTES

1. Ch'en transcribed 3 out of a set of 5 poems composed by Tu Fu after his visits to famous historical places.
2. This poem alludes to the birthplace of Wang Ch'iang, who was married to the King of the Huns in 33 B.C. (Hawkes,

A Little Primer of Tu Fu (Oxford, 1967), no. 27).

3. Written by Tu Fu after a visit to Chu-ko Liang's temple in K'uei-chou (Hawkes, *Primer*, no. 28).

56. Ch'en Shun (1483–1544)

"The Western Promontory" (*Hsi-ting*), two-character frontispiece to painting by the artist.
Seal script (*chuan-shu*).
Undated.
Handscroll, ink on paper.
Frontispiece only: 10⅓" × 31⅝" (26.2 cm. × 81 cm.).
Ching Yuan Chai.

SIGNATURE AND SEALS OF ARTIST

[Signed] "Tao-fu." [Seals] *Ch'en Tao-fu shih* (square, intaglio), *Ta-yao* (round, relief).

COLOPHONS

Ch'en Huan (*chin-shih* degree, 1511), 32 lines, dated 1533. [Signed] "Ch'in-hsi, Ch'en Huan." [Seals] *Yuan-ta* (square, relief), *Ch'in-hsi* (square, intaglio).

Wen Cheng-ming (1470–1559), 7 lines, undated. [Signed] "Cheng-ming." [Seals] *Wen Cheng-ming yin* (square, intaglio), *Cheng-chung* (square, relief).

Wang Ku-hsiang (1501–68), 5 lines, undated. [Signed] "Wang Ku-hsiang." [Seal] *Yu-shih* (square, intaglio).

Wang Wen (1497–1576), 6 lines, undated. [Signed] "Chung-shan, Wang Wen." [Seals] *K'o-yin-t'ing* (oval, relief), *Tzu-yü* (rectangle, intaglio), *T'ai-hsien chih chang* (rectangle, intaglio).

Hua Tzu-hsuan(?) (unid.), 7 lines, undated. [Signed] "Sung-feng, Chin." [Seal] *Hua Tzu-hsuan shih* (square, intaglio).

COLLECTORS

Sheng Hsuan-huai (late Ch'ing), 2 seals (on painting).
Unidentified, 1 seal (after Ch'en Huan's colophon).

NOTE

We are indebted to Professor James Cahill and Mr. Richard Vinograd of the University of California at Berkeley for providing all of the above information on this scroll.

57. Wang Ch'ung (1494–1533)

"Six Poems on the Lotus Marshes" (*Ho-hua-tang liu chueh-chü*).[1]
Running-cursive script (*hsing-ts'ao*), 80 lines.
Undated.
Handscroll, ink on paper, 6 numbered sheets mounted continuously. First and second sheets of gold-flecked cream-colored paper; remaining 4 sheets of gold-flecked blue paper.
10³⁄₁₆" × 276⁹⁄₁₆" (25.9 cm. × 702.5 cm.).
Collection of Mr. and Mrs. Wan-go H. C. Weng.

TRANSLATIONS OF ILLUSTRATED SECTIONS

First section (last line, first poem): "The fragrance of flowers and perfumes drift above the waves."

Second section (last two lines, fifth poem): "[The hermit] . . . herding a flock of geese, enjoys the flowers."

INSCRIPTION, SIGNATURE, AND SEALS OF ARTIST
(last section, 11 lines)

"Yesterday I talked with my friend Yü-chih about the marvelous scenery of the Lotus Marshes.[2] Yü-chih said that he didn't know [about the beauty of this place] so I composed six poems of four lines each to present to him. Perhaps [these poems] will take him traveling [even] while he rests. [Signed] Wang Ch'ung." [Seals] *Ta-ya-t'ang* (rectangle, relief), *Wang Lü-chi yin* (square, intaglio), *Ya-i shan-jen* (square, relief).

BIOGRAPHY OF ARTIST

Wang Ch'ung (*tzu* Lü-jen, Lü-chi; *hao* Ya-i shan-jen), a poet and calligrapher, was a native of Suchou and studied with Wen Cheng-ming's friend Ts'ai Yü. He failed the provincial examinations 8 times between 1510 and 1531, and yet was highly regarded by Wen Cheng-ming and his circle. His calligraphic ability is sometimes compared to that of Wen Cheng-ming and Chu Yun-ming. (*DMB*, Liu Lin-sheng.)

COLOPHONS

Weng Fang-kang (1733–1818), 4 lines in clerical script, dated 1798. Weng records that he saw this scroll at the Wei-ch'ing Studio with Hsiao-ch'ih, Lien-fu, and Chih-hsuan.[3] [Signed] "Recorded by Fang-kang." [Seal] *T'an-hsi shen-ting* (square, relief).

Hsiang Yuan-pien (1525–90), 2 lines in small running script. Hsiang states that these 6 poems in 7-character meter of 4 lines each (*chueh-chü*) were written in cursive script by Wang Ya-i. He gives it an inventory number, the character *yuan*,[4] and notes the price. [Seals] *Hsiang Yuan-pien yin* (square, relief), *Mo-lin mi-wan* (square, relief).

T'ieh-pao (1752–1824), 9 lines in running script, dated 1798. T'ieh-pao records that he purchased the scroll in 1798. [Signed] "T'ieh Ch'ing." [Seal] *T'ieh-pao ssu-yin* (square, relief).

Label, later mounted inside scroll: "Poetry writing of Ya-i shan-jen. [Signed] in the collection of Mei-an [T'ieh-pao's *hao*]."

COLLECTORS

Hsiang Yuan-pien (1525–90), 35 seals, 6 half-seals.
Ch'u T'ing-kuan (*chü-jen* degree, 1633), 2 seals.
Weng T'ung-ho (1830–1904), 3 seals.

PUBLISHED

Wang Ch'ung, *Ya-i shan-jen chi* (Preface dated 1538; Taipei reprint, 1968), pp. 357–59.

COMPARATIVE MATERIAL

Wang Ch'ung, "Nine Songs," handscroll, anonymous

collection, Princeton. *SZ* (old) 20/8, 40; (new) 17/102–05. *Shoen* 3/5/26. *Shanghai FSHC* 19. *SBT* 4/338–40; 7/140; 8/12–14; 10/13–15; 11/234–39. *Shohin* 194, 227. *Ming Ch'ing SHHC* 174–77. *SMS* 117. *Pai-chueh-chai MJFS* 2. *KKFS* 21–2/8–10. Wilson and Wong, *Friends*, no. 18, pp. 98–99.

NOTES

1. These 6 poems by the artist are recorded in his collected works, *Ya-i shan-jen chi* (Preface dated 1538; Taipei reprint, 1968), pp. 357–59. The title of the scroll is derived from the poems and is given in the first 2 lines of the scroll.

2. Yü-chih is the *tzu* of Yüan Pao (16th cent.), a member, during the Ming period, of the prominent Yüan family in Suchou.

3. Lien-fu is unidentified; Hsiao-ch'ih is possibly the *hao* of the Ch'ing painter and seal-carver Tung Hsun (1740–after 1808); and Chih-hsüan is the *hao* of P'an Shih-en (1769–1854).

4. See *no. 18*, n. 2, for an explanation of his inventory numbering system.

58. Wang Wen (1497–1576)

"Mountain Hermitage in Summer," poem in seven-character meter.
Cursive script (*ts'ao-shu*).
Undated.
Hanging scroll, ink on paper.
73″ × 22⅞″ (185.4 cm. × 58.1 cm.).
Anonymous loan.

TRANSLATION

Long summer in the mountain hermitage, the wind and
* sun so clear;*
Behind the house, azure clouds arise in the blue-green
* mountains.*
In the cool of evening, carrying a staff, I return alone.
Only cicadas sing deep in the dewy forest.

SIGNATURE AND SEALS OF ARTIST

[Signed] "Chung-shan." [Seals] *Yü-ssu-ma* (rectangle, relief), *Wang shih Tzu-yü* (square, relief), *T'ai-hsien chih chang* (rectangle, relief).

BIOGRAPHY OF ARTIST

Wang Wen (*tzu* Tzu-yü, *hao* Chung-shan, posth. Wen-ching), a native of Wu-hsi, Nan-Chihli, was a poet, painter, and calligrapher. He received the *chin-shih* degree in 1538, served in the Ministry of Revenue, and in 1544, in the Ministry of War in Nanking. After 1544, having declined several official posts, Wang went to live at Mt. Pao-chieh, on the shores of Lake T'ai, where he spent more than 20 years, associating mainly with Taoist priests and local scholars. The scenery around his house in Wu-hsi inspired his landscape paintings, which are known for their descriptive quality. (*DMB*, Lee Hwa-chou.)

No colophons.
No collectors' seals.

COMPARATIVE MATERIAL

Ecke, *Chinese Calligraphy*, fig. 14 (painting). For Wang

Wen's colophon to Ch'en Shun's "Western Promontory," see *no. 56*.

59. Wang Wen (1497–1576)

"Dragon Boat Song" (*Lung-chou hsing*), poem in seven-character meter.
Large cursive script (*ts'ao-shu*), 51 lines.
Dated 1571.
Handscroll, ink on paper.
22⅛″ × 370⅜″ (56.2 cm. × 940.7 cm.).
The Jeannette Shambaugh Elliott Collection at Princeton.

TRANSLATION OF ILLUSTRATED SECTION (10 opening lines)

Flags flying, drums rolling like clouds and thunder,
Myriad dragon boats glide across the water;
Along the banks, peach blossoms are seen as the
* morning mist disperses.*

INSCRIPTION, SIGNATURE, AND SEALS OF ARTIST

"On the 15th day of the 4th lunar month of summer, in the year *hsin-wei* of the Lung-ch'ing reign [1571], in the morning I sit in the Chen-i Pavilion. The shade of the *wu-t'ung* trees fills the yard, and two cranes dance face to face. I write out my old poem 'Inspired by Dragon Boats' (*Lung-chou chi-hsing*). In the past, when I went in an official capacity to supervise transport at the storehouse, it just happened that the Emperor came to Ch'eng-t'ien [Temple], then returned by boat across the river. [I] arrived at Ch'ing-yüan; while waiting for the Emperor I composed this poem. [Signed] Recorded by the old man of 75, Chung-shan, Wang Wen." [Seals] *Yü-ssu-ma* (rectangle, relief), *Wang shih Tzu-yü* (square, relief), *T'ai-hsien chih chang* (rectangle, relief).

COLOPHON

Kao Feng-han (1683–1748), complete transcription of the "Dragon Boat Song," 8 lines in small standard script, dated 1727. [Signed] "Transcribed by Wang Wen's later follower Kao Feng-han." [Seals] *Feng-han* (double seals, square, intaglio), *Nan-ts'un shu-hua* (square, relief), *Jan* (rectangle, relief), *Nan-kuo t'ien-chuang* (rectangle, intaglio).

COLLECTOR

Chou Mo-nan (contemporary), 2 seals.

60. Hsu Wei (1521–1593)

"Watching the Tides," poem in seven-character meter.
Cursive script (*ts'ao-shu*).
Undated.
Hanging scroll, ink on paper.
51⅝″ × 12⅜″ (131.1 cm. × 31.6 cm.).
Anonymous loan.

SIGNATURE AND SEALS OF ARTIST

[Signed] "T'ien-ch'ih tao-jen." [Seals] *Kung-sun ta-*

niang (rectangle, intaglio), *Wen-ch'ang shih* (square, intaglio), *Hsiang-kuan-chai* (square, relief).

BIOGRAPHY OF ARTIST

Hsu Wei (*tzu* Wen-ch'ang, *hao* T'ien-ch'ih, T'ien-shui-yueh, Ch'ing-t'eng, Shan-yin pu-i), painter, calligrapher, writer, poet, and dramatist, was from Shan-yin, Chekiang, and the son of his father's concubine. Although Hsu became a first degree candidate (*hsiu-ts'ai*) in 1540, he failed the higher provincial examinations 8 times. In 1547 he settled in Shao-hsing, in a studio called "Twig Hall" (*I-chih-t'ang*), where he wrote plays, poems, and essays with social and political overtones. During that time, from 1557 to 1562, he served a military commander who was later disgraced, and in fear of his own safety, Hsu attempted suicide. In 1566 he was sentenced to 7 years in prison for brutally beating his third wife to death. And he turned to painting as an outlet when he was freed in 1573. Hsu's progressive and uninhibited style of ink-flower painting, even more than Ch'en Shun's, inspired spontaneity in the works of the Ch'ing flower painters. As a calligrapher, Hsu judged himself so talented that he ranked his calligraphy above his painting. (*DMB*, I-cheng Liang and L. C. Goodrich; Ecke, "Study.")

No colophons.

COLLECTORS

Wang Shih-p'ing (Ch'ing dynasty, unid.), 1 seal.
Chou Mo-nan (contemporary), 1 seal.
Wang Chi-ch'ien (contemporary), 1 seal.

COMPARATIVE MATERIAL

Ecke, *Chinese Calligraphy*, fig. 12, no. 57. *SNT* 1/111–13. *SBT* 5/16–19. *Shohin* 176. *Shanghai FSHC* 20. *Ch'en-yuan, 100 Couplets* 3. *KKFS* 21–2/19–29. *Ming Ch'ing SHHC* 179. *CKMHCTS* 1009–38. *Masterpieces of Asian Art*, no. 44.

61. Hsu Wei (1521–1593)

"Twelve Plants and Twelve Calligraphies," painting and inscriptions by the artist.
Running script (*hsing-shu*).
Undated.
Handscroll, ink on paper.
12½" × 17' 1⅝" (31.8 cm. × 518.5 cm.).
Honolulu Academy of Arts, Martha Cooke Steadman Fund purchase, 1960. Acc. no. 2710.1.

No signature of artist.

SEALS OF ARTIST

Kung-sun ta-niang (rectangle, intaglio), *Hsu Wei yin* (square, intaglio), *Fo-shou,* (square, intaglio), *Wen-ch'ang shih* (square, intaglio), *Hsu Wei* (square, intaglio), *T'ien-ch'ih sou-hsien* (square, intaglio), *Hsu Wei chih yin* (square, intaglio), *Wen-ch'ang* (square, intaglio), *Ku-ch'in T'ien-shui-yueh* (rectangle, intaglio), *Hsiu-li ch'ing-she* (square, intaglio), *P'eng ?-fei ch'u-jen* (square, intaglio), *Shan-yin pu-i* (square, intaglio), *Wen-ch'ang* (rectangle, relief), *Wen-ch'ang* (rectangle, relief), *Sou-hsien* (rectangle, intaglio).

No colophons.

COLLECTORS

Liu Shih-heng (unid.), 1 seal.
Liu Chih-ssu (Liu Shih-heng's son; otherwise unid.), 1 seal.
Wang Ch'i-lei (unid.), 1 seal.
Ch'u Te-i (late 19th-early 20th centuries).
Hsueh-an (unid.), 1 seal.
Mr. Wu (unid.), 1 seal.

COMPARATIVE MATERIAL

For a similar work by Hsu Wei, see his handscroll published in *The Freer Gallery of Art I: China*, pl. 69 and p. 171. Neither scroll was signed or dated by the artist, but Tseng Yu-ho (see "A Study on Hsu Wei") has suggested that both paintings were probably done when he was in his sixties—that is, after 1573, when he was freed from prison.
Tseng Yu-ho, "A Study on Hsu Wei," *Ars Orientalis* 5 (1963): 243.

PUBLISHED

Le rouleau de Ma Fen et quelques peintures chinoises . . . du Musée d'Honolulu (Paris, 1960), no. 6. Tseng Yu-ho, "A Study on Hsu Wei," *Ars Orientalis* 5 (1963): 243. Ecke, *Chinese Painting in Hawaii*, pl. LVI, figs. 4, 5, 31, 68.

62. Chang Jui-t'u (1570–1641 ?)

"Out Wandering I Visit Ch'ang Shao-hsien" (*Yeh-wang yin kuo Ch'ang Shao-hsien*), poem in five-character meter by Tu Fu (712–770).
Running-cursive script (*hsing-ts'ao*).
Undated.
Hanging scroll, ink on silk.
68" × 17¹¹⁄₁₆" (172.7 cm. × 44.9 cm.).
Collection of Robert H. Ellsworth.

TRANSLATION

Together we ride across the country bridge,
Autumn scenery becomes peaceful.
Bamboo envelops [Mt.] Ch'ing-ch'eng;
A river descends from [Mt.] Kuan-k'ou.
Following the woodcutter's path we enter the village,
In orchards opened for us we taste the chestnuts.
[Once] high in the heavens, the sun has now set
[But] the recluse does not let us go home.

SIGNATURE AND SEALS OF ARTIST

[Signed] "Pai-hao-an tao-che, Jui-t'u." [Seals] *Pai-hao-an chu* (square, intaglio), *Jui-t'u chih yin* (square, relief).

BIOGRAPHY OF ARTIST

Chang Jui-t'u (*tzu* Ch'ang-kung, Kuo-ting, *hao* Erh-shui, Pai-hao-an chu, posth. Wen-yin), a native of Chin-chiang, Fukien, was a painter, calligrapher, and one-time Grand Secretary. He received the *chü-jen* degree in 1603, then in 1607 placed third in the palace examinations and became a compiler in the Hanlin Academy. Chang even-

tually became Vice-Minister of Rites and briefly served in the Grand Secretariat from 1626 to 1628. After 1629 he retired to his home to paint and to write.

Even in his own day Chang was considered—along with Hsing T'ung (1551–1612), Mi Wan-chung (*chin-shih* degree, 1595), and Tung Ch'i-ch'ang (1555–1636)—a talented painter and calligrapher. (*DMB*, L. Carrington Goodrich.)

No colophons.

COLLECTOR

R. H. Ellsworth (contemporary), 1 seal.

COMPARATIVE MATERIAL

See work by his son Chang Ch'ien-fu, *no. 63*. Ecke, *Chinese Calligraphy*, nos. 64–66. Wang Chuang-wei, "Erh-shui yü ch'i shu," in *Shu-fa ts'ung t'an*, p. 147–51. *SBT* 8/29–30; 11/240–51. *Shohin* 29. *SMS* 67, 185, 186. *SNT zoku* 144. *SZ* 21/44–49, pp. 18–27. Nakata Yūjirō, ed., *Chūgoku shojin den*, pp. 217–36.

63. Chang Ch'ien-fu (*chin-shih* degree, 1640)

"Visiting, Deep in the Mountains," poem in seven-character meter.
Cursive script (*ts'ao-shu*).
Undated.
Hanging scroll, ink on silk.
$65\frac{1}{4}''$ × $18\frac{1}{16}''$ (65.7 cm. × 45.9 cm.).
Chien-lu Collection.

TRANSLATION

A thousand mountains encircle a descending stream;
Obscured by mists, the waters meet the azure sky.
Looking into the distance, I imagine magnificent places,
And arriving there, I find the residents are only mortals.
Taoists build dwellings into the blue-green mountains,
Farmers plow furrows in the purple mists.
At dusk I linger, reluctant to depart,
So alluring are the plants and flowers.

SIGNATURE AND SEALS OF ARTIST

[Signed] "Chang Ch'ien-fu." [Seals] *Fei-lung* (round, intaglio), *Chang Ch'ien-fu yin* (square, relief), *Chung-lung-hsuan* (rectangle, relief).

BIOGRAPHY OF ARTIST

Little is known about Chang Ch'ien-fu. He was the only son of Chang Jui-t'u (1570–1641 ?), earned the *chin-shih* degree in 1640, and became a corrector in the Hanlin Academy.[1] His calligraphy clearly reflects the influence of his father Chang Jui-t'u.

No colophons.
No collectors' seals.

COMPARATIVE MATERIAL

On Chang Jui-t'u, see *no. 62*.

NOTE

1. For further biographical information, see *DMB* (Chang Jui-t'u entry). In *Chūgoku shojin den*, Nakata Yūjirō refers to Tanomura Chikuden's *Sanchūjin jozetsu* in identifying Ch'ien-fu as Chang Jui-t'u's younger brother. However, the fact that Ch'ien-fu received the *chin-shih* degree in 1640, just before Jui-t'u's death, would imply that he was his son.

64. Wang To (1592–1652)

"Transcription of letters by Wang Min" (A.D. 351–388).[1]
Running script (*hsing-shu*), 53 lines.
Dated 1641.
Handscroll, ink on silk.
$9\frac{13}{16}''$ × $95\frac{13}{16}''$ (24.9 cm. × 243.3 cm.).
Anonymous loan.

SIGNATURE AND SEALS OF ARTIST

"In the winter of the year *hsin-ssu* [1641] at Huai-chou [Honan].[2] [Signed] Wang To." [Seals] *Wang To chih yin* (square, intaglio), *T'ai-shih shih* (square, intaglio).

BIOGRAPHY OF ARTIST

Wang To (*tzu* Chueh-ssu, Chueh-chih; *hao* Sung-ch'iao, Tung-kao-chang, Ch'ih-hsien tao-jen; posthumous Wen-an), a painter and calligrapher, was a native of Meng-ching, Honan. He passed the *chin-shih* degree with distinction in 1622, was made Vice-Minister of Rites to supervise instruction in the Hanlin Academy in 1638, and was appointed the Minister of Rites in 1640. Wang retired, but resumed the post in 1644. Because he was among the prominent officials who surrendered Nanking to the Manchus, he lost the respect of many Chinese. (*DMB*, based on Mingshui Hung).

While Wang's influence was not as great as that of Tung Ch'i-ch'ang's (1555–1636) during the early Ch'ing, he is considered one of the best calligraphers of the late Ming period. He is particularly admired and influential in Japan, where many of his works are preserved.

No colophons.

COLLECTOR

Unidentified, 2 seals.

COMPARATIVE MATERIAL

SBT 4/351–360; 7/159–64; 8/35–37. *SMS* 41. *Shohin* 5, 39. *Shinchō shogafu* 2. *SG* 9/1–100. *SZ* 21/32–39, p. 26. *CKMHCTS* 1047–50.

NOTES

1. Wang To transcribed several personal letters originally written by Wang Min, the younger brother of Wang Hsun (350–401) and a nephew of the Tsin master-calligrapher Wang Hsi-chih (303 ?–361 ?). Considered by his contemporaries as having surpassed his older brother in calligraphy, Min was famous for his running script (*hsing-shu*). Because he held the same official position of *Chung-shu ling* as did his cousin Wang Hsien-chih (344–386), their contemporaries called him the

"Small Ling" (*Hsiao-ling*) and Wang Hsien-chih the "Great Ling" (*Ta-ling*).

Wang Min's brother, Wang Hsun, wrote the still-extant *Po-yuan t'ieh*, which, together with Wang Hsi-chih's *K'uai-hsueh shih-ch'ing* and Wang Hsien-chih's *Chung-ch'iu t'ieh*, comprised the so-called Three Rare Treasures (*San-hsi*) in Emperor Ch'ien-lung's collection, after which the Emperor named his famous hall *San-hsi-t'ang*.

2. While Wang To resided at Huai-chou from 1639 to 1642, he produced many works mentioning Huai-chou in their inscriptions.

65. Wang To (1592–1652)

"Poems Written while Drunk,"[1] four poems in five-character meter.
 Cursive script (*ts'ao-shu*), 62 lines.
 Undated.
 Handscroll, ink on satin.
 $10\frac{5}{16}'' \times 132\frac{3}{16}''$ (26.2 cm. × 335.6 cm.).
 Anonymous loan.

INSCRIPTION AND SIGNATURE OF ARTIST

"Presented to Yeh-ho. [Signed] Wang To." No seals.

No colophons.

COLLECTOR

Wang Chi-ch'ien (contemporary), 1 seal.

NOTE

1. These poems were probably written for Ting Yao-k'ang (1607–78) (*tzu* Hsi-sheng, *hao* Yeh-ho). A poet and writer, Ting moved to Chiangnan from his native Shantung and joined Tung Ch'i-ch'ang's literary circle. In 1649 he went to live in the capital and spent his time with other literary figures such as Wang To.

66. Wang Shih-min (1592–1680)

"In Pursuit of Antiquity" (*Ch'ü-ku*), two-character title to "Album of Landscapes after Sung and Yuan Masters," paintings by Wang Hui (1632–1717).
 Clerical script (*li-shu*).
 Undated; probably 1673–80.[1]
 Album leaf, ink on paper.
 $18\frac{7}{8}'' \times 11\frac{3}{16}''$ (47.9 cm. × 28.4 cm.).
 The Art Museum, Princeton University.

SIGNATURE AND SEALS OF ARTIST

[Signed] "Shih-min." [Seals] *Wang Shih-min yin* (square, intaglio), *Hsi-lu lao-jen* (square, relief).

BIOGRAPHY OF ARTIST

Wang Shih-min (*tzu* Hsun-chih, *hao* Yen-k'o, Hsi-lu lao-jen, Hsi-t'ien chü-jen), a native of the T'ai-ts'ang district of Kiangsu, was the senior and leading artist of the Four Wangs of early Ch'ing painting. Like his father

and grandfather, he became an eminent statesman, attaining the rank of Vice-Minister of Rites. After the fall of the Ming dynasty, he retired. Although Wang is known primarily as a landscape painter of the Orthodox School, he also achieved distinction as a skilled calligrapher of clerical script.

No colophons.

COLLECTORS

Pi Lung (active ca. 1736–96), 1 seal.
 Shen Ping-ch'eng (1823–95), 1 seal.

PUBLISHED

Whitfield, *In Pursuit of Antiquity*, no. 16 and frontispiece.

COMPARATIVE MATERIAL

SNT 1/207–08. *SBT* 6/114; 8/38, 39. Ch'en-yuan, *100 Couplets* 7. *Ming Ch'ing SHHC* 189.

NOTE

1. Since the album is dated 1673 in the artist's inscription, Wang Shih-min probably wrote the title soon thereafter.

67. Fu Shan (1607–1684)

"Clearing at Dusk," poem in five-character meter by Tu Fu (712–770).
 Running-cursive script (*hsing-ts'ao*).
 Undated.
 Hanging scroll, ink on paper.
 $89'' \times 29\frac{13}{16}''$ (226 cm. × 75.7 cm.).
 The Jeannette Shambaugh Elliott Collection at Princeton.

TRANSLATION

By evening a fearful wind passed through the village,
The secluded courtyard is wet after rain.
Rays of the setting sun bathe the fine grass;
Colors of the river shine through the bamboo curtain.
Books in disarray, who will straighten them?
My wine cup dry, I will replenish it.
I often hear useless gossip,
So don't take offense if this old man hides himself
 away.

SIGNATURE AND SEAL OF ARTIST

[Signed] "Fu Chen-shan." [Seal] *Fu Shan yin* (square, intaglio).

BIOGRAPHY OF ARTIST

Fu Shan (*ming* Ting-ch'en, *tzu* Ch'ing-chu, Jen-chung, *hao* Chu-i tao-jen) was an eminent scholar and teacher from Shansi. When he was 38, the Manchus conquered China and established the Ch'ing dynasty (1644–1911). Fu, who refused to serve the alien rulers, wore Taoist attire, and lamented the fall of the country in his poems. His literary works are collected in the *Shuang-hung-k'an*

chi. As a youth, he practiced the standard script of the Tsin and T'ang dynasties, then studied the calligraphy of Yen Chen-ch'ing (709–785). Not content merely to study former traditions, he created his own bold and somewhat eccentric style of writing, which is often compared to that of his contemporary Wang To.

No colophons.
No collectors' seals.

COMPARATIVE MATERIAL

SZ 21/50, 51. Ecke, *Chinese Calligraphy*, no. 77. *SBT* 6/245–252; 8/41. *Shohin* 39. *Shinchō shogafu* 1. *SMS* 112, 190. *Fu Shan shu-hua hsuan* (Peking, 1962).

68. Kung Hsien (ca. 1620–1689)

"The Solitary Willow Dwelling" (*Tu-liu-chü*), poem in seven-character meter, on painting by the artist.
Running script (*hsing-shu*), 10 lines.
Undated.
Hanging scroll, ink on paper.
$47\frac{1}{2}'' \times 23\frac{1}{8}''$ (120.6 cm. × 58.7 cm.).
Ching Yuan Chai.

SIGNATURE AND SEALS OF ARTIST

"Mr. Chung-yü [unid.] has sent me two poems on the Solitary Willow Dwelling, and so I respond to the poems and paint this painting. [Signed] Kung Hsien." [Seals] *Kung Hsien* (square, relief), *Chung-shan yeh-lao* (square, intaglio).

BIOGRAPHY OF ARTIST

Kung Hsien (early *ming* Ch'i-hsien, *tzu* Pan-ch'ien, Yeh-i, *hao* Ch'ai-chang) was born at K'un-shan, Kiangsu, around 1620. At an early age he moved to Nanking, where he spent most of his life. When the Manchus conquered China, he remained loyal to the Ming cause, retired to the mountains, and expressed his sentiments in poetry and painting. In 1655 Kung returned to Nanking, where he associated with a small coterie of kindred spirits. In the 1660's, on the outskirts of the city, he built his home, the Half-Acre Garden. Two decades later, in 1689, he died in poverty.

Kung Hsien was regarded primarily as a painter. Compared to his later calligraphy, the brushstrokes in this example are squarer and flatter, so that the scroll can be dated ca. 1674 (see Comparative Material, below).

No colophons.
No collectors' seals.

PUBLISHED

Marc F. Wilson, *Kung Hsien: Theorist and Technician in Painting* (Kansas City, 1969), nos. 16, 34.

COMPARATIVE MATERIAL

Calligraphy on 1674 "Cloudy Peaks," handscroll (Nelson Gallery–Atkins Museum), in Wilson, *Kung Hsien*, no. 9. Ecke, *Chinese Calligraphy*, no. 80. *SNT* 1/230–33. *CKMHCTS* 1095–1146.

69. Chu Ta (1626–1705)

"Thoughts on Wang Wei," transcription of a poem in five-character meter by Keng Wei (8th century).[1]
Cursive script (*ts'ao-shu*).
Undated.
Hanging scroll, ink on paper.
$60\frac{15}{16}'' \times 29\frac{5}{8}''$ (154.8 cm. × 75.3 cm.).
Collection of Mr. and Mrs. Fred Fang-yu Wang.

TRANSLATION

Your thoughts blend Confucianism, Moism, Taoism,
Your dwellings are built amid clouds and springs.
In your garden, the Meng-ch'eng hollow is quiet now;
The Wang River meanders naturally.
Buddhism has dissolved your many anxieties,
[The ancient royal] Hsi-yuan Garden inspires you to
* change your residence.*
Deep in the garden, spring bamboo grows old.
On a night of drizzling rain one can hear the slow
* tolling of the bell.*
Your worldly traces remain in temples.
Your literary works are kept in libraries like the
* ancient [library] Shih-ch'ü.*
I do not know who among your invited guests will
* inherit your books [as Wang Ts'an received his] from*
* Ts'ai Yung.*

[Based on trans. by Fred Fang-yu Wang.]

SIGNATURE AND SEALS OF ARTIST

[Signed] "Pa-ta shan-jen." [Seals] *K'o-te shen-hsien* (square, intaglio), *Pa-ta shan-jen* (rectangle, intaglio), *Yao-shu* (rectangle, relief).

BIOGRAPHY OF ARTIST

Chu Ta (*tzu* Jen-wu, *hao* Pa-ta shan-jen, Ko-shan) was a native of Nan-ch'ang, Kiangsi. Like Tao-chi, he was born into the Ming imperial family and became a Buddhist monk when the Manchus invaded China. Later, about 1660, Chu Ta changed from Buddhist to Taoist garb and founded a Taoist temple near Nan-ch'ang, where he lived. He is said to have feigned insanity and drunkenness in order to protect himself from political entanglements. His poetry is elusive and difficult to comprehend; and his painting and calligraphy truly reflect his creative genius.[2] (*DMB*, Chiu Ling-Yeong and Chaoying Fang.)

No colophons.

COLLECTOR

Chang Ta-ch'ien (contemporary), 4 seals.

PUBLISHED

SBT 8/53.

COMPARATIVE MATERIAL

Shohin 82, 220. *CKMHCTS* 1219–56. *SMS* 101. *Ta-feng-t'ang* III. *Masterpieces of Asian Art*, no. 46. Wang Shih-chieh et al., eds., *A Garland of Chinese Paintings* (Hong Kong, 1967). *SBT* 6/126–42; 8/49–53. *SNT* 1/237, 238, 240–48, 250. Vito Giacalone, *Chu Ta, A Selection of Paintings and Calligraphy* (New York, 1972).

NOTES

1. Originally entitled by Keng Wei (active ca. 766–779) "On Ch'ing-yuan Temple," which was located at Wang Wei's villa in Wang-ch'uan.

2. On Chu Ta's painting and calligraphy, see Fred Fang-yu Wang, "The Album of Flower Studies Signed 'Ch'uan-ch'i' in the National Palace Museum and the Early Work of Chu Ta," *Proceedings of the International Symposium on Chinese Painting*, pp. 529–94; Fred Fang-yu Wang, "The Calligraphy of Pa-ta shan-jen," an unpublished paper presented at the Symposium on Painting and Calligraphy by Ming *I-min* (Hong Kong, 1975); and Chou Shih-hsin, *Pa-ta shan-jen chi ch'i i-shu* (Taipei, 1974).

70. Chu Ta (1626–1705)

"Preface to 'Gathering along the River'" (*Lin-ho-chi hsu*), transcription of text by Wang Hsi-chih dated 353.[1]
Running script (*hsing-shu*).
Undated.
Album leaf, ink on paper.
$10\frac{5}{16}''$ × $7\frac{1}{2}''$ (26.2 cm. × 19.1 cm.).
Collection of Mr. and Mrs. Fred Fang-yu Wang.

TRANSLATION OF TEXT

In the ninth year of the Yung-ho reign [353] in late spring we met at the Orchid Pavilion in Shanyin of K'uai-chi for the Water Festival, to wash away the evil spirits.

Here are gathered all the illustrious persons, and both the old and the young assembled. Here are tall mountains and majestic peaks, trees with thick foliage and tall bamboos. Here are also clear streams and gurgling rapids, catching one's eye from the right and left. Drinking in succession from a cup floating down the curving stream, we group ourselves in order, sitting by the waterside. Today the sky is clear, the air is fresh, and the kind breeze is mild. How enjoyable it is to let our eyes travel over the entire landscape! Although there is no music from string and woodwind instruments, yet with alternate singing and drinking, we are well disposed to thoroughly enjoy a quiet, intimate conversation. So I have put down a sketch of these contemporaries and their sayings at this feast. [Entitled] The Preface to the Gathering along the River. [Based on trans. by Lin Yutang, in *The Importance of Living*, pp. 156–58.]

SIGNATURE AND SEALS OF ARTIST

[Signed] "Pa-ta shan-jen." [Seals] *Pa-ta shan-jen*(?) (horizontal rectangle, relief),[2] *K'o-te shen-hsien* (square, intaglio).

No colophons.

COLLECTOR

Chang Ta-ch'ien (contemporary), 1 seal.

COMPARATIVE MATERIAL

Ta-feng-t'ang III/28–30. *SMS* 118. Yang Yang, *Pa-ta shan-jen shu-hua chi* (Taipei, 1974), no. 16.

NOTES

1. Recorded in Liu I-ch'ing (403–444), *Shih-shuo hsin-yü*, 16. Some scholars consider the Lin-ho Preface, because of its literary style and content, to be the original version of the "Preface to the Orchid Pavilion Gathering" (*Lan-t'ing-chi hsu*).

2. For discussion on the reading of this seal, see Chou Shih-hsin, *Pa-ta shan-jen chi ch'i i-shu*, pp. 170–71.

71. Chu Ta (1626–1705)

Inscription to "Falling Flower," painting by the artist.
Cursive script (*ts'ao-shu*).
Album dated 1692.[1]
Album leaf, ink on paper.
$8\frac{7}{8}''$ × $11\frac{1}{4}''$ (22.5 cm. × 28.6 cm.).
Collection of Mr. and Mrs. Fred Fang-yu Wang.

INSCRIPTION, SIGNATURE, AND SEAL OF ARTIST

"Involved in Social Affairs" (*she-shih*),[2] two large characters. [Signed] "Pa-ta shan-jen." [Seal] *Pa-ta shan-jen*(?) (horizontal rectangle, relief).

No colophons.

COLLECTOR

Chang Ta-ch'ien (contemporary), 2 seals.

PUBLISHED

Yang Yang, *Pa-ta shan-jen shu-hua chi*, (Taipei, 1974), pl. 88. *Ta-feng-t'ang* III/10. Chang Wan-li and Hu Jen-mou, eds., *The Selected Painting and Calligraphy of Pa-ta shan-jen* (Hong Kong, 1969).

COMPARATIVE MATERIAL

Yang Yang, *Pa-ta shan-jen*, pl. 5.

NOTES

1. The other leaves that belong to this album are illustrated in Yang Yang, *Pa-ta shan-jen*, pls. 89–95.

2. We are indebted to Mr. Fred Fang-yu Wang for his interpretation of the term *she-shih*. An early use of the term is found in a series of letters on calligraphy written by T'ao Hung-ching to the Liang Emperor Wu (r. 502–549). (*FSYL* 2/21.) Chu Ta frequently signed other works with this phrase, perhaps indicating that by painting for someone else he was involving himself in society.

72. Tao-chi (1641–ca. 1710)

"Farewell Poem to Jen-an" [Huang Yü-chien, active 1650–90], poem in five-character meter mounted after "Rocky Bank of a River," painting by the artist.[1]
Large running script (*hsing-shu*), 23 lines.
Probably ca. 1684–90.[2]
Handscroll, ink on paper.
$11\frac{1}{16}''$ × $89\frac{15}{16}''$ (28.1 cm. × 228.4 cm.).
Keith McLeod Fund, Museum of Fine Arts, Boston; Acc. no. 55.387.

You and I are truly devoted friends. How many like us are there in this world?

As you fly away, let us write to each other. Short messages will keep our friendship close.

When we are together it is difficult to hide our clumsiness; when we are parted we feel sadness.

Our hearts will communicate. Washed by rain, the mountain Chu looks new.

I present this short poem to my elder Jen-an [Huang Yü-chien], who is about to return to his post at Jung-ch'eng, and ask for his kind correction and a poem in response. [Signed] Shih-t'ao, Chi, monk of the mountains.

[Based on trans. by Tomita and Tseng, in *Portfolio*, p. 23.]

SEALS OF ARTIST

The following 3 seals were added at a later date to replace the 3 original seals, which had been removed: *Ta-ti-t'ang*[3] (square, intaglio), *Ching-chiang-hou-jen* (square, intaglio), *Tsan-chih shih-shih-sun, A-chang* (rectangle, relief).

BIOGRAPHY OF ARTIST

Tao-chi (*tzu* Shih-t'ao, *hao* K'u-kua ho-shang, Ch'ing hsiang ch'en-jen; after 1696, Ta-ti-tzu) was born in Kuei-lin, Kwangsi. His original family name was Chu and he was a descendant of the Ming imperial family. After the Manchus established the Ch'ing dynasty in 1644, he was raised as a monk to avoid persecution. When Tao-chi was in his forties, he gained the reputation of being a great painter. The date of his death is not known, but there is no reliable record of his activity after 1707. A versatile artist, Tao-chi explored the entire range of script types and styles. His calligraphy, like his painting, is diverse, of high quality, and has a strong personal flavor.[4]

COLOPHONS

Chang Ch'i-t'u (early 19th century), 2 lines in running script, dated 1828. [Signed] "Chang Ch'i-t'u of Tan-t'u [Kiangsu]." [Seal] *Kuei-shan* (square, relief).

Wu Hu-fan (20th century), 12 lines in running script, written for Chang Ta-ch'ien and dated 1933. [Signed] "Recorded by Wu Hu-fan." [Seals] *Mei-ying shu-wu* (square, relief), *Wu Hu-fan* (square, half-relief, half-intaglio). Another 2-line colophon, written in small standard script by Wu Hu-fan, precedes the painting.

Hsu Ch'eng-yao (20th century), 4 lines in standard script, dated 1933. [Signed] "Hsu Ch'eng-yao." [Seal]————an (square, relief).

COLLECTORS

(seals on this section of calligraphy only)

Chang Tse (Shan-tzu, 1883–1940, Chang Ta-ch'ien's older brother), 3 seals.
Chang Ta-ch'ien (contemporary), 4 seals.

PUBLISHED

Tomita and Tseng, *Portfolio*, pls. 126–28, p. 23.

COMPARATIVE MATERIAL

CKMHCTS 1355–1472. Edwards, *The Painting of Tao-chi*. Fu, *Studies in Connoisseurship*. Chang Wan-li and Hu Jen-mou, eds., *The Selected Painting and Calligraphy of Shih-t'ao* (Hong Kong, 1967). Wang Shih-chieh et. al., eds., *A Garland of Chinese Paintings* 4 (Hong Kong, 1967). *Shohin* 82.

NOTES

1. The painting, dated 1691, and this poem are unrelated: apparently a later owner mounted them together in the same scroll. One poem, in 7-character meter inscribed in running script by Tao-chi on the painting paper, was meant to go with the painting.

2. Tao-chi's inscription, dated 1684, on a "Portrait of Huang Yü-chien [Jen-an]" shows that they were friends around that time. See Edwards, *The Painting of Tao-chi*, fig. 14.

3. Although Ta-ti-t'ang is a studio name which Tao-chi adopted after 1696–97, he executed the calligraphy before 1696. The seal was added at a later date.

4. For a detailed study of Tao-chi's life and art, see Edwards, *The Painting of Tao-chi* and Fu, *Studies in Connoisseurship*.

73. Tao-chi (1641–ca. 1710)

"Album of Twelve Landscape Paintings," inscription by the artist on each leaf.
Dated 1703 (last leaf).
Album of 12 leaves; ink and color on paper.
Each leaf: $18\frac{3}{4}$" × $12\frac{7}{16}$" (47.6 cm. × 31.6 cm.).
William Francis Warden Fund, Museum of Fine Arts, Boston; Acc. no. 48.11a–l.

INSCRIPTION, SIGNATURE, AND SEALS OF ARTIST
(on fourth leaf)

Quatrain in 6-character meter, written in clerical script, entitled "House by a Creek":
Even this cold and winding path is fit for the eye and mind to dwell upon;
How could vulgar mountains and foul waters be of no interest to Hu-t'ou [Ku K'ai-chih, 341–402] and Ta-ch'ih [Huang Kung-wang, 1269–1354]?"

[Trans. Tomita and Tseng, *Portfolio*, pp. 23–24].

[Signed] "Hsiao-ch'eng-k'o, A-chang, under the trees." [Seals] *Ch'ing-hsiang, Shih-t'ao* (rectangle, intaglio), *Kao-mang-tzu, Chi* (square, intaglio), *Ch'ih-chueh* (rectangle, relief).

INSCRIPTION, SIGNATURE, AND SEALS OF ARTIST
(on twelfth leaf)

Written in running script, entitled "Mountain Path": "The way [of painting] requires penetration. By means of free brushwork in sweeping manner the thousand peaks and the ten thousand valleys may be seen at a glance. As one looks at [the painting] fearsome lightning and driving clouds seem to come from it. With which [of these great names]—Ching [Hao, 10th century] or Kuan [T'ung, 10th century], Tung [Yüan, 10th century] or Chü [-jan, ca. 975], Ni [Tsan, 1301–74] or Huang [Kung-wang, 1269–1354], Shen [Chou, 1427–1509] or

Chao [Meng-fu, 1254–1322]—could such a picture be associated? I have seen works of very famous masters, but they all follow certain models or certain schools. How can I explain that in both writing and painting, nature endows each individual with peculiarity and each generation with its own responsibility?" (Trans. Tomita and Tseng, in *Portfolio*, p. 24.) [Signed] "Ta-ti-tzu presents this to [Wang?] Hsiao-weng that he may laugh at my work. In the second month of the year of *kuei-wei* [1703] at the Ch'ing-lien Thatched Pavilion." [Seals] *Ling-ting-lao-jen* (square, relief), *Ch'ien-yu Lung-mien*, *Chi* (rectangle, intaglio), *Hsia-tsun-che* (rectangle, relief).

No colophons.

COLLECTORS

Wang(?) Hsiao-shan (early 18th century), 2 seals.
Ma Yueh-kuan (1688–1755), 1 seal.
Chang Ta-ch'ien (contemporary), 1 seal.
Ch'en Ting-shan (contemporary), 1 seal.
Wang Chi-ch'ien (contemporary), 1 seal.

PUBLISHED

For publication references, see Edwards, *The Painting of Tao-chi*, no. 33, pp. 88–91, 162–67.

74. Kao Feng-han (1683–1748)

"Flowers and Calligraphy"
Running and cursive scripts (*hsing-shu, ts'ao-shu*).
Dated 1738.
Album of 14 leaves, ink on paper.
Each leaf: 9½″ × 17¼″ (24.2 cm. × 43.8 cm.).
The Jeannette Shambaugh Elliott Collection at Princeton.

LABEL BY ARTIST

"Album of Calligraphy and Painting by Fu-lao-jen [using] the left hand." (*Fu-lao-jen tso-shou shu-hua ts'e*). One line, dated 1738. [Signed] "Recorded on the 17th day of the 1st month, the day before Hsieh travels north." 3 seals.

FRONTISPIECE BY ARTIST (first two leaves)

"Ink Villa" (*mo-chuang*), 2 characters in cursive script, followed by inscription: "I have been unable to attain a high position, and recently my arm has become disabled, so I have nothing I can leave to you. Here, I just give you some of my work. Nephew Hsieh, keep it; in the future, when your empty stomach growls, take out this album and look at it. I wonder whether this can fill you. Ha! ha! [Signed] Fu-lao-jen, recorded with my left hand."

COLOPHON BY ARTIST (final two leaves)

"Although [Kao Ju-] hsieh is actually my nephew, he's just like a son. He was orphaned when he was young, so I raised him and he has become independent. It is as if he had two sets of parents, since he doesn't consider us as his aunt and uncle. He stayed at our house and shared our

poverty. Later, when I had a minor position in Chiangnan, he accompanied me there. Now I'm old and sick and have retired. My own son and daughter are not with me; only you, [Hsieh], share these difficult moments. After I fell sick and lost the use of my arm, I switched hands to write my calligraphy and to paint. I'm quite proud of myself; sometimes my right hand couldn't even achieve the same quality of naturalness [as my left hand now does]. The clumsiness [of my left hand] is at one with the Tao, something which the shallow-minded cannot understand. So I did these 10 leaves of painting and calligraphy, expending all my energy, and also recorded these comments for [my nephew, Hsieh] to leave to his descendants in order that they might understand the circumstances. [Signed] the 23rd day of the 12th month in the year *ting-ssu*, the 2nd year of the Ch'ien-lung reign [1738], at the Wu-men [Suchou] guest house on the Lane of Picking Lotuses." [Seals] *Kao* (square, intaglio), *Ming, Han* (square, intaglio).

BIOGRAPHY OF ARTIST

Kao Feng-han (*tzu* Hsi-yuan, *hao* Nan-ts'un, Nan-fu lao-jen), a native of Chiao-chou, Shantung, moved to Yangchou in 1736. He is often mentioned as one of the Yangchou Eccentrics. In 1737, when his right elbow became paralyzed, he was obliged, from then on, to use his left hand to write and to paint.

No colophons.

COLLECTOR

Hsu Po-chiao (contemporary), 6 seals.

COMPARATIVE MATERIAL

SNT 2/134–44. *SBT* 8/84–86.

75. Kao Feng-han (1683–1748)

"The Tang-ch'ü Stele," transcription of a Han dynasty stele by General Chang Fei.
Clerical script (*li-shu*).
Dated 1740.
Hanging scroll, ink on paper.
41 11/16″ × 15″ (105.9 cm. × 38 cm.).
Chien-lu Collection.

TRANSLATION

The Han General Chang Fei completely defeated the enemy General Chang Hsia at Tang-ch'ü. [Chang Fei] carved a stele [on the spot] while his horse waited.[1]

INSCRIPTIONS, SIGNATURE, AND SEALS OF ARTIST

First inscription, 3 lines in running-cursive script: "In the past I saw this Tang-ch'ü stele written by Chang Huan-hou [Fei]. His style of writing is comparable to that in the western [Han] capital; why do people consider him only brave and martial? Using my left hand to copy, [Signed] Kuei-yun ho-shang."
In the second inscription, 1 line in running-cursive

script (above the last line of the first inscription, above the character *chih*), Kao notes that in the *San-kuo chih* another character, also pronounced *tang*, has been substituted in the name of the battle site. [Signed] "Recorded the following day." [Seals] *Tso-hua* (gourd, relief), *Kao-tzu ming Han chih yin* (square, intaglio), *K'u-shu-sheng* (square, intaglio), *Keng-shen chih nien* (i.e. the year 1740), (rectangle, intaglio).

No colophons.
No collectors' seals.

COMPARATIVE MATERIAL

For another version of this same scroll, see *Shen-chou kuo-kuang chi*, vol. 4, no. 33.

NOTE

1. The General Chang Fei wrote this inscription, to be carved in stone, immediately after victory.

76. Li Shan (1686–ca. 1762)

"Orchids and Bamboo," poems inscribed on paintings by the artist.
Running script (*hsing-shu*).
Undated.
Album of 6 leaves, ink on paper.
Each leaf: 12$\frac{13}{16}$" × 18$\frac{1}{8}$" (32.5 cm. × 46 cm.).
The Jeannette Shambaugh Elliott Collection at Princeton.

TRANSLATION

(first leaf, poem in seven-character meter)

I face the pure shadows of a few ink traces
Who can recapture the spirit of the [Li] Sao by Ch'ü
[Yuan]?[1]
If I could spend this life in the mountains
I would always plant orchids at my gate.

SIGNATURE AND SEAL OF ARTIST

[Signed] "Ao-tao-jen." [Seal] *Shan yin* (square, intaglio).

TRANSLATION

(second leaf, poem in five-character meter)

I also madly paint bamboo,
My brush loaded with ink turns at the ends of branches.
I cannot use mineral green to paint meticulously the
* feathers of a parrot.*

SIGNATURE AND SEAL OF ARTIST

[Signed] "Fu-t'ang." [Seal] *Shan yin* (square, intaglio).

BIOGRAPHY OF ARTIST

Li Shan (*tzu* Tsung-yang, *hao* Fu-t'ang), a native of Yangchou, Kiangsu, and one of the painters known as the Eight Yangchou Eccentrics, received the *chü-jen* degree in 1711. He was later appointed subprefect of Shantung, but because he argued with his superior, he was

subsequently relieved of his post. In his residence south of Yangchou, Li led a dissipated life, spending much of his time drinking, as well as writing poetry and painting. His calligraphy, like his painting, is free and relaxed; and his inscriptions often play a prominent role in the composition of his paintings.

No colophons.

COLLECTORS (seals on first and second leaves only)

Mr. Feng (unid.), 1 seal (on mounting).
Sheng Hsing-sun (Ch'ing), 1 seal.
Unidentified, 1 seal (on mounting).

COMPARATIVE MATERIAL

Chang and Hu, eds., *Eight Eccentrics of Yangchow*, 1/3–12, 2/51–57, 3/96–98, 4/120, 5/130, 6/138, 7/149–52, 8/163. *CKMHCTS* 1527–32.

NOTE

1. In the poem "Encountering Sorrow" (*Li Sao*) frequent allusions are made to the orchid. In this poem Li Shan refers to the difficulty of capturing its spirit.

77. Chin Nung (1687–1764)

"Plum Blossoms and Calligraphy"
Archaic standard script (*k'ai-shu*).
Dated 1761.
Hanging scroll, ink on *lo-wen* paper.
45$\frac{5}{8}$" × 16$\frac{3}{8}$" (115.9 cm. × 41.6 cm.).
Yale University Art Gallery, The Leonard C. Hanna (B.A. 1913) Fund; Acc. no. 1976.26.2.

TRANSLATION OF INSCRIPTION

In the first year of the Ch'ien-lung reign [1736], while I was in the capital for the Imperial examinations, I went together with Hsu Liang-chih[1] of the Hanlin Academy to Minister Chang's home. The Minister took out and showed us a small hanging scroll of plum blossoms in ink by an imperial descendant of the Chao family [ref. to Chao Meng-chien]. Looking at it, one had a sensuous feeling of chilly fragrance and pure beauty undefiled, liked a dusted garment after washing. Now these two gentlemen have become immortals [i.e. died] and I myself am also aged. As I try to write out and paint these flowers from memory, I naturally feel sad and desolate. I can only regret that the two old gentlemen could not have seen my outspread branches filling this page; otherwise they might have licked their brushes and composed a poem in Chien-chai's [Ch'en Yü-i, 1090–1138][2] style and inscribed it on this painting. [Based on trans. in *Paintings by Ming and Ch'ing Masters from the Lok Tsai Hsien Collection*, no. 39.]

SIGNATURE AND SEALS OF ARTIST

[Signed] "Painted and recorded by old Nung, 75 years old." [Seals] *Chin Nung yin-hsin* (square, relief), *Ku-ch'uan* (round "cash," relief).

Chin Nung (*tzu* Shou-men, Hsi-chin; *hao* Tung-hsin, Ssu-nung), poet, painter, calligrapher, collector, and bibliophile, was from Ch'ien-t'ang, Chekiang, but lived many years in Yangchou and became known as one of the so-called Eight Yangchou Eccentrics. As a calligrapher, Chin was influenced by many rubbings of early tomb and bronze inscriptions in his private collection, so that his style of clerical script has a clearly archaic flavor. Two of Chin Nung's students, Lo P'ing (1733–99) and Hsiang Chün (ca. 1740–80), occasionally painted plum blossoms for the busy Chin Nung which Chin would then sign; his plum paintings should therefore be reevaluated.

No colophons.
No collectors' seals.

PUBLISHED

Sullivan, *The Arts of China*, pl. 210; *The Three Perfections: Chinese Painting, Poetry and Calligraphy*, p. 10. *Paintings by Ming and Ch'ing Masters from the Lok Tsai Hsien Collection*, no. 39. Chang and Hu, eds., *Eight Eccentrics of Yangchow* 2/66.

COMPARATIVE MATERIAL

SBT 5/98, 113; 7/183–87; 8/87–90; 9/11; 10/182. *Shohin* 50, 180, 183, 225. *SMS* 140. *Ming Ch'ing SHHC* 193. Chang and Hu, eds., *Eight Eccentrics of Yangchow*, 1/21–31, 2/65–72, 3/102, 4/123, 5/132, 6/140–43, 7/154, 8/169–75. *SG* 9/101–26. *SZ* 21/98, 99. *CKMHCTS* 1501–20. Chu-tsing Li, "The Bamboo Painting of Chin Nung," *Archives of Asian Art* 4 (1973): 57–75. Ecke, *Chinese Calligraphy*, no. 88. *The Freer Gallery of Art: China*, pl. 72.

NOTES

1. Liang-chih is the *tzu* of Hsu Pao-kuang (d. 1723), who served as Vice-Envoy to the tributary Liu-ch'iu (Ryukyu) Islands in 1719.

2. Chien-chai is the *hao* of the Sung poet Ch'en Yü-i (1090–1138), who was admired greatly by the Sung Emperor Hui-tsung for his poetry on plum paintings.

78a. Cheng Hsieh (1693–1765)

"Orchids and Bamboo," poem in seven-character meter inscribed on painting by the artist.
Running script (*hsing-shu*), 6 lines.
Dated 1742.
Handscroll, ink on paper.
13¾" × 147 3/16" (34.9 cm. × 373.8 cm.).
Anonymous loan, The Art Museum, Princeton University.

INSCRIPTION, SIGNATURE, AND SEALS OF ARTIST

"*I know that you are a person of pure heart*[1]
So I have painted this portrait of secluded orchids [for you].
In the future when you are old and retire in Chiangnan,
By the bamboo fence and thatched hut you will have a fragrant companion.

"In the spring, the 7th year of the Ch'ien-lung reign

[1742] I painted and inscribed [this scroll] for Mr. Chen-fan [Ch'eng To]. I ask him to correct both for me.

"[Signed] your junior, Pan-ch'iao, Cheng Hsieh bows [respectfully]." [Seals] *Cheng Hsieh chih yin* (square, intaglio), *Pan-ch'iao tao-jen* (rectangle, intaglio), *Kan-lan-hsuan* (rectangle, relief).

BIOGRAPHY OF ARTIST

Cheng Hsieh (*tzu* K'o-jou, *hao* Pan-ch'iao), from Hsing-hua, Kiangsu, a talented poet, painter, calligrapher, and seal carver, was known to be one of the so-called Eight Eccentrics of Yangchou. He received the *chin-shih* degree in 1736, served as Mayor of Wei prefecture in Shantung from 1736 to 1740, and then retired to paint and write. Cheng's calligraphy is distinctive because of the way he incorporated certain characteristics of clerical script into his running script.

COLOPHONS (on painting)

Ku Yuan-k'uei (*chü-jen* degree, 1744), poem in 5-character meter, 16 lines in small standard script, written for Ch'eng To (see his colophon, below), and dated 1759. [Seals] *Ku Yuan-k'uei yin* (square, intaglio), *Tuan-ch'ing* (square, relief), *Mei-p'o* (oval, relief).

Chu Wen-chen (1718–ca. 1777/8), poem in 5-character meter, 5 lines in clerical script; followed by inscription of 5 lines in running script in the style of Cheng Hsieh; written for Ch'eng To, undated. [Seals] *Ch'en Chen ssu-yin* (square, intaglio), *P'ing-ling wai-shih* (square, intaglio), *Wu-lin* (rectangle, intaglio), *Sheng-yü wu-hsü* (square, relief),[2] *I-p'ien Chiang-nan Shih-shih-lou* (square, intaglio).

Yun Hsi (d. 1758), 12 lines in running script, written for Ch'eng To and dated 1757. [Signed] "Recorded by Tzu-ch'iung tao-jen." [Seal] *Shen Wang hsiao-yin* (square, relief).

Ch'eng To (active ca. 1800–25), 12 lines in running script, undated. Ch'eng records that Cheng Hsieh visited the Kuang-ming Studio just when the orchids were in full bloom. Cheng painted this scroll, wrote a poem, and dedicated them both to Ch'eng To. In response, Ch'eng wrote a poem following the same rhyme pattern. [Signed] "Drafted by O-sheng, Ch'eng To." [Seals] *Ch'en To* (square, half-relief, half-intaglio), *Chen-fan* (square, relief), *Ssu-wu-chai* (rectangle, relief).

Lu Hui (1851–1920), preface and poem in 7-character meter, 16 lines in running script, following painting on separate piece of paper, dated 1901. Lu Hui composed this poem when Ho Ju-mu (*tzu* Hsi-po, d. 1921) showed him the scroll. [Signed] "Lien-fu, Hui." [Seals] *Wu-chiang Lu Hui chang* (square, intaglio), *Lien-fu* (square, relief).

COLLECTOR

Unidentified (probably 20th century), 1 seal.

COMPARATIVE MATERIAL

Ecke, *Chinese Calligraphy*, no. 90. *SBT* 8/101–03; 10/183. *SNT* 2/129. *Shohin* 151. *Ming Ch'ing SHHC* 179. *SMS* 151. Chang and Hu, eds., *Eight Eccentrics of Yangchow* 1/34–38; 2/75–81; 3/104–09; 4/125; 5/134; 6/145; 7/156, 157; 8/178.

1. A pun on the Chinese name of the cymbidium orchid, *su-hsin lan.*

2. The seal may be translated as "born in *wu-hsu* [the year 1718]."

78b. Wu Ch'ang-shih (1844–1927)

"Ink Play" (*Mo-hsi*), two-character frontispiece to "Orchids and Bamboo," a painting by Cheng Hsieh (1693–1765).
Seal script (*chuan-shu*).
Undated.
Handscroll, ink on gold-flecked cream-colored paper.
$13\frac{9}{16}$" × $22\frac{11}{16}$" (34.4 cm. × 57.6 cm.).
Anonymous loan, The Art Museum, Princeton University.

INSCRIPTION, SIGNATURE, AND SEALS OF ARTIST

Poem in 7-character meter, 5 lines in running-cursive script. Wu wrote the frontispiece and poem for his friend Hsi-po (20th century). [Signed] "The old Wu Chün-ch'ing." [Seals] *Wu Chün chih yin* (square, intaglio), *Ts'ang-shih* (square, relief).

BIOGRAPHY OF ARTIST

Wu Ch'ang-shih (*ming* Chün-ch'ing, *tzu* Ts'ang-shih, *hao* Fou-lu, K'u-t'ieh), from a scholarly family of An-chi, Chekiang, served briefly in several official positions. Ever since his early youth, Wu had practised seal carving based on Ch'in and Han styles. In seal script he specialized in the style of the Stone Drum inscriptions, which, together with his seal carving, has had considerable influence on modern artists. He also wrote strong and distinctive running script. As a flower painter, Wu is considered to be one of the best since the Yangchou Eccentrics.

COMPARATIVE MATERIAL

Shohin 101. *SNT* 1/58–60, 112, 150, 244, 252–54. *SBT* 8/239–46; 9/195–207, 249–58; 10/163, 164, 212–14, 242–43; 11/232; 12/455–62. *SMS* 131. *SZ* 24/91–93; fig. 16. Ch'enyuan, *100 Couplets* 171.

79. I Ping-shou (1754–1815)

"The Fragrance of Antiquity" (*Ku-hsiang*), two characters followed by artist's inscription.
Archaic clerical script (*ku-li*).
Dated 1811.
Horizontal hanging scroll, ink on paper.
$15\frac{1}{2}$" × $48\frac{3}{4}$" (39.4 cm. × 123.9 cm.).
The Jeannette Shambaugh Elliott Collection at Princeton.

INSCRIPTION, SIGNATURE, AND SEALS OF ARTIST

(8 lines in running script)

"The 'Grass Hall of the Flower Ravine' [*Hua-hsi ts'ao-t'ang*] is the place where Mr. Hua-hsi [unid.] lived.

I had already written those four characters [for him] at the capital seven years ago. The older the plum grows, the purer its fragrance. Now younger brother [Hua-hsi's son] Shu-yü follows his father's interests. He just happened to come again to this hall, so I now inscribe these two characters in order to encourage [the son Shu-yü] to think about [its meaning]. In the year *hsin-wei* of the Chia-ch'ing reign [1811], [Signed] I Ping-shou." [Seals] *I Ping-shou yin* (square, relief), *Mo-ch'ing* (square, relief), *Mo-an* (square, relief).

BIOGRAPHY OF ARTIST

I Ping-shou (*tzu* Tsu-szu, *hao* Mo-ch'ing), a native of Ning-hua, Fukien, was a prominent scholar who earned the *chin-shih* degree in 1789 and later twice held the position of prefect of Yangchou. In calligraphy he is best known for his clerical script, which is considered highly innovative. Although few continued his style, his son I Nien-tseng (1790–1861) was the most prominent among those who did.

No colophons.

COLLECTOR

Unidentified, 1 seal.

COMPARATIVE MATERIAL

Ecke, *Chinese Calligraphy*, no. 95. *SZ* 24/16–21. *SBT* 6/186–201; 7/207–14; 8/163–81; 9/45–61; 10/75–79, 186–96, 219–27; 12/389–97. *Shohin* 67. *Shinchō shogafu* 31.

80. Ta-shou (1791–1858)

"Title of a Han Dynasty Portrait," transcription of a Han dynasty stone carving.
Large Han-style seal script (*Han-chuan*).
Dated 1847.
Hanging scroll, ink on paper.
$50\frac{9}{16}$" × $19\frac{5}{16}$" (128.4 cm. × 49 cm.).
Anonymous loan.

TRANSLATION

Portrait of Chang Yuan-nien [unid.] of the Han dynasty, from Fei-hsien [Shantung]. (*Han Fei-hsien Chang Yuan-nien hua-hsiang.*)

INSCRIPTION, SIGNATURE, AND SEALS OF ARTIST

"In the autumn of the 27th year of the Tao-kuang reign [1847], I resided in the capital at the Hsing-ch'eng Temple. Mr. Wang also came, and he presented this rubbing to me, which is not recorded in the [collection of rubbings] *P'ing-chin tu-pei chi.*[1] Now I occasionally open and look at it, so I wrote the above. [Signed] Recorded by Liu-chou of Nan-p'ing." [Seals] *Ta-shou ssu-yin* (square, intaglio), *Liu-chou tu hua* (square, relief).

BIOGRAPHY OF ARTIST

Ta-shou (*tzu* Liu-chou), from Hai-ning, Chekiang, was a well-known monk, scholar, calligrapher, and seal carver.[2] He lived primarily in Suchou and Hangchou, but

traveled widely and developed a reputation as an important member of the Ch'ing *chin-shih hsueh* movement. Ta-shou also collected and studied many rubbings from early stele inscriptions, and his friend, the prominent Ch'ing scholar and calligrapher-historian Juan Yuan, saluted Ta-shou's interest in early inscriptions by calling him the "Monk of Bronze and Stone Studies" (*chin-shih seng*).

No colophons.
No collectors' seals.

COMPARATIVE MATERIAL

SNT 1/65. *SBT* 4/322, 9/113–14. *SZ* 25/fig. 31.

NOTES

1. *P'ing-chin tu-pei chi* was a collection of rubbings from steles compiled by the scholar-collector Sun Hsing-yen (1753–1818).
2. For dates and biographical information, see Kuan T'ing-fen, "Nan-p'ing t'ui-sou chuan," *Pei-chuan-chi pu* 58/23a.

81. Ho Shao-chi (1799–1873)

Couplet collated from the "Preface to the Orchid Pavilion Gathering," poem in seven-character meter.[1]
Running script (*hsing-shu*).
Undated.
Pair of hanging scrolls, ink on painted paper.[2]
$52\frac{5}{8}'' \times 12\frac{13}{16}''$ (133.6 cm. × 32.5 cm.).
Anonymous loan.

TRANSLATION

Into the mountains build a house; sitting, wander among them.
Rushing waters create torrents; from above listen to them.

SIGNATURE AND SEALS OF ARTIST

[Signed] "Tzu-chen, Ho Shao-chi." [Seals] *Ho Shao-chi yin* (square, relief), *Tzu-chen* (rectangle, intaglio).

BIOGRAPHY OF ARTIST

Ho Shao-chi (*tzu* Tzu-chen, *hao* Tung-chou, Yuan-sou), a native of Tao-chou, Hunan, was a poet and calligrapher. He passed the *chin-shih* examination in 1836 and became a compiler in the Hanlin Academy in 1839. Between then and 1852 he held various posts at court, traveled widely, and finally settled in Suchou.

As a calligrapher, Ho is said to have taken Yen Chen-ch'ing (709–785) as his model for standard and running scripts. Indeed, he was best known for his cursive, running, and clerical scripts. (*ECCP*, Li Man-kuei.)

No colophons.

COLLECTOR

Unidentified, 1 seal.

COMPARATIVE MATERIAL

SNT 1/194–97; 2/36–43, 57, 58. *SBT* 6/225–28; 7/235–37;

8/216–21; 9/125–27, 219–23; 10/204–06, 229. *SMS* 110. *Shinchō shogafu* 35. Ch'en-yuan, *100 Couplets* 139. *SZ* 24/46–55. *SG* 10/95–122.

NOTES

1. This couplet is composed of characters taken from the "Preface to the Orchid Pavilion Gathering" (*Lan-t'ing-chi hsu*), an essay written by the Tsin dynasty calligrapher Wang Hsi-chih (303?–361?). The characters are reorganized to form new sentences, a practice popular among Ch'ing dynasty calligraphers, who drew their material from early steles and other famous inscriptions.
2. The paper was specially treated with powder, after which a design of plum blossoms, bamboo leaves, and net weave was painted on in silvery gray ink.

82. Tso Tsung-t'ang (1812–1885)

"Early Summer Dwelling," couplet in seven-character meter.
Running script (*hsing-shu*).
Undated.
Pair of hanging scrolls, ink on paper.
$66\frac{1}{16}'' \times 12\frac{13}{16}''$ (167.8 cm. × 34 cm.).
Anonymous loan.

TRANSLATION

The day is long; swallows in the the rafters chatter idly.
The air is still; flowers in a vase naturally emit their fragrance.

SIGNATURE AND SEALS OF ARTIST

"Presented to Seventh Elder Brother Shao-lin,[1] [Signed] Tso Tsung-t'ang." [Seals] *Tung-ko ta-hsueh-shih chang* (square, intaglio), *T'ai-tzu t'ai-pao i-teng k'o-ching-po chia-i-teng ch'ing-ch'e-tu-wei* (square, relief).

BIOGRAPHY OF ARTIST

Tso Tsung-t'ang (*tzu* Chi-kao, P'u-ts'un, *hao* Lao-liang, Chung-chieh hsien-sheng, posth. Wen-hsiang), who was born into a scholarly family from Hsiang-yin, Hunan, passed the examination for the *chü-jen* degree in 1832, but failed to attain a higher degree after repeated attempts. He held various official posts, but is best known for his military campaigns against the Taiping rebels in the Kiangsi-Anhui area. (*ECCP*, Tu Lien-che.)

No colophons.
No collectors' seals.

COMPARATIVE MATERIAL

CTML 100: 20, 21. *Ch'ün-pi-lou shu-hua shih-ts'ui* (Oriental Society, 1974), no. 7. *Lok Tsai Hsien Couplets* 69.

NOTE

1. Otherwise unidentified. The phrase "seventh elder brother" (*ch'i-hsiung*) is a polite form of address, indicating that Shao-lin was the seventh son of his family.

83. Yang I-sun (1813–1881)

"Eulogy for Famous Officials" (*Ming-ch'en-hsu tsan*), inscription following Preface, both by Pan Ku (32–92).[1]
Seal script (*chuan-shu*).
Dated 1873.
Set of 8 hanging scrolls, ink on paper with red-lined grid.
Each panel: 92″ × 22$\frac{15}{16}$″ (233.7 cm. × 58.2 cm.).
Anonymous loan.

INSCRIPTION, SIGNATURE, AND SEALS OF ARTIST

"This is the early Han [text] 'Eulogy for Famous Officials' [*Ming-ch'en-hsu tsan*], which I wrote in the middle of winter of the 12th year of the T'ung-chih reign [1873] at my residence in Wan-ch'eng [Anhui], to present to my respected senior Hsi-yü [unid.] for his refined judgment. [Signed] Hao-sou, Yang I-sun of Hai-yü [Ch'ang-shu, Kiangsu] [wrote in] seal [script]." [Seals] *Tzu-yü* (square, intaglio), *Chi-hsiang-chih-chih shih* (square, relief), *Li-chi pu-mo* (rectangle, relief, on each panel), *Yang* (round, relief, on first panel).

BIOGRAPHY OF ARTIST

Yang I-sun (*tzu* Tzu-yü, *hao* Yung-ch'un, Hao-sou, Kuan-hao chü-shih), a native of Ch'ang-shou, Kiangsu, received the *chü-jen* degree in 1843 and became the prefect of Feng-yang, Anhui. He was well-known for his seal script and his study of Chinese etymology. One of his seals reads: "Capable of withstanding any worldshaking event" (*li-chieh pu-mo*), a statement of total self-confidence. In his late years Yang studied the inscriptions from the Stone Drums and those cast on bronze vessels. In the history of calligraphy he is often mentioned together with his contemporary Wu Ta-ch'eng (1835–1902).

No colophons.
No collectors' seals.

COMPARATIVE MATERIAL

CTML 100, pl. 26. *SBT* 8/227; 9/143, 144, 246–48. *Shohin* 179. *SMS* 159. *Shinchō shogafu* 37. *Lok Tsai Hsien Couplets* 70.

NOTE

1. The Han historian Pan Ku composed a preface in prose praising famous early officials. This eulogy, written in the form of a poem, concludes the essay.

84. Yü Yueh (1821–1906)

Excerpts from "The Literary Mind and the Carving of Dragons" (*Wen-hsin tiao-lung*), composed by Liu Hsieh (ca. 465–522).[1]
Clerical script (*li-shu*).
Undated.
Pair of hanging scrolls, ink on paper.
57$\frac{1}{2}$″ × 13$\frac{11}{16}$″ (146 cm. × 34.7 cm.).
Anonymous loan.

TRANSLATION

The world is filled with ten thousand things
Which harmonize in spirit and principle.
Great were the earlier scholars;
Their moods and literary expressions blend in perfect harmony.

[Adapted from a translation by Vincent Shih, in *The Literary Mind and the Carving of Dragons* by Liu Hsieh (1959).]

SIGNATURE AND SEALS OF ARTIST

[Signed] "Ch'ü-yuan, Yü Yueh." [Seals] *Yü Yueh ch'ang-shou* (square, intaglio), *Ch'ü-yuan chü-shih* (square, relief), *Hsien-huang t'ien-yü, hsieh-tso chü chia* (rectangle, relief)—that is, "In the former Emperor's words, [Yü Yueh's] calligraphy and composition both are excellent."

BIOGRAPHY OF ARTIST

Yü Yueh (*tzu* Yin-fu, *hao* Ch'ü-yuan), a native of Te-ch'ing, Chekiang, passed the examination for the *chü-jen* degree in 1844, then received the *chin-shih* degree in 1850 and joined the Hanlin Academy. In 1855 he was appointed Commissioner of Education in Honan, but was dismissed two years later. Yü Yueh then retired to Suchou and taught in the area for 30 years. In 1878 his students built a villa for him, *Yü-lou*, at the foot of Mt. Ku (Hangchou). He was esteemed as a teacher, outstanding scholar, and prolific writer. (*ECCP*, Tu Lien-che.)

No colophons.
No collectors' seals.

COMPARATIVE MATERIAL

CTML 100, pl. 30. *SBT* 6/242; 9/192. *Lok Tsai Hsien Couplets* 74.

NOTE

1. Yü Yueh borrowed the 4 phrases of 4 characters each that comprise this couplet from various passages in Liu Hsieh's essay of literary criticism, *The Literary Mind and the Carving of Dragons* (*Wen-hsin tiao-lung*). Yü Yueh did not alter the original order of the 4 characters within each phrase, but did rearrange the phrases to form a new couplet. See the eulogy (*tsan*) sections of chapters 6, 14, 30, and 42.

85. Weng T'ung-ho (1830–1904)

"Couplet on Confucian and Taoist Virtues," poem in seven-character meter.
Large standard script (*k'ai-shu*).
Undated.
Pair of hanging scrolls, ink on paper.
66″ × 16$\frac{7}{16}$″ (167.7 cm. × 41.7 cm.).
Mr. and Mrs. Shen C. Y. Fu.

TRANSLATION

Supervising farming and sericulture truly has its Way [Tao];
Imagining myself a fish or a bird, I almost forget what I am.

[Signed] "Weng T'ung-ho." [Seals] *Weng T'ung-ho yin* (square, intaglio), *Shu-p'ing* (square, relief).

BIOGRAPHY OF ARTIST

Weng T'ung-ho (*tzu* Sheng-chieh, Jen-fu, Sheng-pu, *hao* Shu-p'ing, Sung-ch'an, P'ing-cheng, Yun-chai, posth. Wen-an), a prominent official, writer, and calligrapher, was a native of Ch'ang-shu, Kiangsu, and the youngest son of the Grand Secretary Weng Hsin-ts'un (1791–1862). In 1856 he placed first in the examination for the *chin-shih* degree and began his career as a compiler of the first class in the Hanlin Academy. His official posts included those of Vice-President of the Board of Revenue (1876–78), President of the Censorate (1878–79), President of the Board of Punishments (1879), President of the Board of Works (1879–86), and President of the Board of Revenue (1886–98). He also served as tutor to the Emperor Mu-tsung (1865–75), then to the child-Emperor Te-tsung (1875–96). (*ECCP*, Fang Chao-ying.)

COLOPHON

Weng Pin-sun (*chin-shih* degree, 1877), grandnephew of Weng T'ung-ho and direct grandfather of the present owner, Wan-go H. C. Weng. Three lines in running-standard script, dated 1904. Pin-sun records that he presented this couplet written by his great-uncle to a friend Tzu-tsai (unid.) upon his request, just before Tzu-tsai left the capital for Kueichou. [Signed] "Weng Pin-sun." [Seals] *Pin-sun ch'ang-shou* (square, intaglio), *Hsiao-wei* (square, relief), *Weng Pin-sun yin* (square, intaglio), *Liu kuei hou-i* (square, relief).

No collectors' seals.

COMPARATIVE MATERIAL

See *no. 86. CTML 100*, pls. 9–11. *SNT* 1/72–73; 2/109, 239–43. *SZ* 24/76–77. *SBT* 5/236–39; 7/245–47; 10/117, 161; 11/230–31. *Shinchō shogafu* 39. Ch'en-yuan, *100 Couplets*, 163. *Lok Tsai Hsien Couplets* 80.

86. Weng T'ung-ho (1830–1904)

"Couplet on Confucian and Taoist Virtues," poem in seven-character meter.[1]
Large standard script (*k'ai-shu*).
Undated.
Pair of hanging scrolls, ink on paper.
66″ × 16$\frac{7}{16}$″ (167.7 cm. × 41.7 cm.).
Mr. and Mrs. Shen C. Y. Fu.

NOTE

1. This couplet is identical to the previous couplet: the placement of each character and the shape of each brushstroke match perfectly, and the faint oil marks correspond to the seals. However, only spotty traces of Weng Pin-sun's colophon are visible.
 In the process of mounting, the 2 layers of paper on which the couplet had been written were separated. This pair is the under-layer remounted as a separate couplet.

87. Weng T'ung-ho (1830–1904)

"Tiger" (*hu*).[1]
Large cursive script (*ts'ao-shu*).[2]
Dated 1890.
Hanging scroll, ink on mottled orange paper.
52$\frac{1}{16}$″ × 24$\frac{1}{2}$″ (132.2 cm. × 61.2 cm.).
Collection of Mr. and Mrs. Wan-go H. C. Weng.[3]

SIGNATURE AND SEALS OF ARTIST

[Signed] "T'ung-ho." [Seals] *Keng-yin wu-yin jen-yin jen-yin* (square, relief), *Weng T'ung-ho yin* (square, intaglio), *Shu-p'ing* (square, relief).

No colophons.
No collectors' seals.

NOTES

1. Weng T'ung-ho wrote this character in the cyclical year of the tiger, exactly 60 years after his birth. The repeated use of *yin* in the artist's seal *Keng-yin wu-yin jen-yin jen-yin* would indicate that the year, month, day, and hour of his birth all correspond to the sign of the tiger.
2. This character is written in a type of cursive script which in some ways relates to the Taoist style of writing (or "drawing") magical characters intended to ward off evil spirits.
3. Wan-go H. C. Weng, the present owner of the scroll, is a great-great-grandson of Weng T'ung-ho by adoption within the family and a direct grandson of Weng Pin-sun.

88. Wu Ta-ch'eng (1835–1902)

"Images of Evening in a Garden," couplet in seven-character meter.
Seal script (*chuan-shu*).
Undated.
Pair of hanging scrolls, ink on paper.
50″ × 11$\frac{1}{2}$″ (127 cm. × 29.2 cm.).
Collection of Lothar Ledderose.

TRANSLATION

Flowers border the jade railing in the bright moonlit evening;
Trees shade the golden rim of the well in the early setting sun.

SIGNATURE AND SEALS OF ARTIST

[Signed] "Wu Ta-ch'eng." [Seals] *K'o-chai* (square, intaglio), *Wu Ta-ch'eng yin* (square, intaglio).

BIOGRAPHY OF ARTIST

Wu Ta-ch'eng (original *ming* Ta-shun, *tzu* Chih-ching, Ch'ing-ch'ing, *hao* Heng-hsuan, K'o-chai, Pai-yun shan-ch'iao, Pai-yun ping-sou), a native of Suchou, was a government official, an archaeologist, and a calligrapher. In 1864 he received the *chü-jen* degree, and after having been tutored by Yü Yueh, in 1868 he passed the examination for the *chin-shih* degree. Wu subsequently served in various governmental and military capacities in northern China, then died of paralysis in 1902. Deeply interested in the study of archaeology, he collected ancient bronzes,

seals, and jades, and compiled annotated catalogues of his large collection. During the late Ch'ing, Wu was well known as a talented writer of seal script. (*ECCP*, Hiromu Momose.)

No colophons.
No collectors' seals.

PUBLISHED

Ledderose, *Die Siegelschrift (Chuan-shu) in der Ch'ing-zeit*, no. 135.

COMPARATIVE MATERIAL

SZ 24/82, 83. *SBT* 6/243, 244; 7/250, 252; 8/237; 9/191; 10/116. *SNT* 2/219, 220, 237. *Shohin* 234, 245. *SMS* 189.

89. Yang Shou-ching (1839–1915)

"Setting Sun over the Forest," couplet in seven-character meter.
Running script (*hsing-shu*).
Dated 1909.
Pair of hanging scrolls, ink on paper.
54⅝″ × 13¼″ (138.7 cm. × 33.7 cm.).
Anonymous loan.

TRANSLATION

*The slanting sun, shining over half the forest, like a
 gleaming emerald,
White clouds against the blue sky a thousand feet high,
 like a jade pagoda.*

SIGNATURE AND SEALS OF ARTIST

[Signed] "Yang Shou-ching." [Seals] *Yang Shou-ching* (square, intaglio), *Hsing-wu ch'i-shih i-hou shu* (square, intaglio).

BIOGRAPHY OF ARTIST

Yang Shou-ching (*tzu* Hsing-wu, *hao* Lin-su lao-jen), a native of I-tu, Hupei, never passed the examination for the *chin-shih* degree, despite repeated attempts, yet became a famous scholar of bibliography, geography, and the *chin-shih hsueh*. He was also a major book collector of the period. In 1880 Yang accompanied the Chinese ambassador Ho Ju-chang to Japan, where he had considerable influence on Japanese calligraphers, introducing them to Six Dynasties period rubbings as well as to his own style.

No colophons.
No collectors' seals.

COMPARATIVE MATERIAL

SNT 1/146. *SBT* 1/38; 11/126. *SZ* 24/86–89. *Shinchō shogafu*, pl. 41. *CTML 100*, pl. 62. Nishikawa Nei, *Showa rantei kinenten zuroku* (Tokyo, 1973), pl. 178.

90. K'ang Yu-wei (1858–1927)

"Your Writing will Last a Thousand Autumns," couplet in five-character meter.
Large running script (*hsing-shu*).
Undated.
Pair of hanging scrolls, ink on paper.
49″ × 11¾″ (124.5 cm. × 30 cm.).
Yale University Art Gallery.

TRANSLATION

*Your writing will last a thousand autumns;
Your poetry dominates the realm of verse.*

SIGNATURE AND SEALS OF ARTIST

[Signed] "K'ang Yu-wei." [Seals] *K'ang Yu-wei yin* (square, intaglio), *Wei-hsin pai-jih chih-tso shih-ssu-nien san-chou ta-ti yu-pien ssu-chou ching san-shih-kuo hsing ssu-shih-wan-li* (square, relief).

BIOGRAPHY OF ARTIST

K'ang Yu-wei (original *ming* Tsu-chih, *tzu* Kuang-hsia, *hao* Chang-su), a native of Nanhai, Kwangtung, was an eminent statesman, Confucian scholar, and writer.[1] In his book *Kuang I-chou shuang-chi* (completed 1889) K'ang expanded on the theories of calligraphy presented by the scholar Pao Shih-ch'en (1775–1855). In chapter 23 K'ang records that he first studied calligraphy with Chu Tz'u-ch'i (1807–81), who derived his brush method from Li Chien (1747–99) and Hsieh Lan-sheng (1760–1831). Afterward, he studied the style of Chang Yü-tsao (1823–94); K'ang's late calligraphic style was particularly influenced by the cliff inscription *Shih-men ming* (dated 509) and the *Ten Character Couplet (Shih-tzu lien)* by Ch'en T'uan (before 906–989) of the Sung.

No colophons.
No collectors' seals.

COMPARATIVE MATERIAL

SBT 5/240–261. *SZ* 24/94–97. Ch'en-yuan, *100 Couplets*, 177. *Lok Tsai Hsien Couplets* 82. See also K'ang Yu-wei, hanging scroll, Museum of Fine Arts, Boston.

NOTES

1. For further biographical material, see Richard C. Howard, "K'ang Yu-wei (1858–1927): His Intellectual Background and Early Thought," in Arthur Wright and Denis Twitchett, eds., *Confucian Personalities* (Stanford, 1962), pp. 294–316.

NOTES TO THE ESSAYS

ESSAY I

1. It should be added, almost categorically, that the earlier the time period, the fewer the extant works. Furthermore, the earlier a work's purported date, the more likely it is to be some form of reproduction or forgery. If a calligrapher enjoyed great fame, whatever his period, it is probable that forgeries and reproductions of his work were being made during his lifetime. Inevitably, the problem of authenticity is posed.

2. For a pioneering recent study of copies from which the four methods cited here are derived, see Wen Fong, "The Problem of Forgeries in Chinese Painting," *Artibus Asiae* 25 (1962): 95–119. No effort will be made in the discussion to quote extensively from the early materials except as they are relevant to the examples at hand. The reader is also referred to the following articles in English, which introduce the major Chinese sources on the history and methods of copying: E. Zürcher, "Imitation and Forgery in Ancient Chinese Painting and Calligraphy," *Oriental Art* n.s. 1, no. 4 (1955): 141–46; R. H. van Gulik, *Chinese Pictorial Art, as Viewed by the Connoisseur* (Rome, 1958); a review of the latter by James Cahill, in *Journal of the American Oriental Society* 81.4 (1961): 448–51; and Nakata Yūjirō, *Chūgoku shoronshū* (Tokyo, 1970), pp. 251–65 (in Japanese).

3. A finished copy on this paper is also called a *ying-huang* version.

4. Chang Shih-nan, *Yu-huan chi-wen* (Preface dated 1228; CPTC edn.), 5/2a–b.

5. The Southern Sung connoisseur Chao Hsi-ku had a different explanation for *ying-huang*: "*Ying-huang* papers were used by T'ang writers to copy sutras; the paper was dyed with a solution made from the *huang-po* tree. This solution prevented bookworms from attacking the paper." *Tung-t'ien ch'ing-lu-chi* (ISTP edn.), p. 258. Paper answering Chao's description is usually called *hsieh-ching-chih* ("paper for sutra writing"), and is generally fine, tight, and dense in texture, not transparent and therefore unsuitable for tracing. The physical characteristics and manufacture of these papers were dissimilar; the same term was probably used for both because of their color.

6. Chang Shih-nan, as cited above, n. 4.

7. Cf. also van Gulik, *Pictorial Art*, pp. 100, 110–11.

8. The style of the ancient master becomes the point of departure for a later free variation. This has been termed "art-historical art" by Professor Max Loehr, and appears primarily in the Ming and Ch'ing. See Loehr's "Art-historical Art: One Aspect of Ch'ing Painting," *Oriental Art* 16, no. 1 (1970): 35–37. For its appearance in Ming calligraphy, see the discussion on the revival of Sung styles in the Ming in essay IV.

9. The term "ink squeeze" is preferred by some to the term "rubbing." The actual process of applying the ink-soaked wad of silk to the paper surface is actually a process of "patting" or "tamping." "Rubbing" is used here because it has become the conventional term.

10. The earliest extant rubbings of calligraphy appear to date from the T'ang period. Rubbings discovered at the northwest Chinese oasis of Buddhism, Tun-huang, are now preserved in London and Paris: e.g. the *Hua-tu-ssu Yung-ch'an-shih t'a ming*, dated 631, by Ou-yang Hsun, now preserved in the British Museum (*SZ* 7/44–45, pp. 9–15; fig. 20, p. 163); the *Wen-ch'uan-ming* by the T'ang Emperor T'ai-tsung, dated 648, now in the Bibliothèque Nationale (ibid., 7/90–95, p. 175); the "Diamond Sutra," by Liu Kung-ch'uan, dated 824, also in the Bibliothèque Nationale (ibid., 9/82–83, p. 171).

11. The idea of taking an ink rubbing from a carved surface had, of course, originated earlier, before the need arose to reproduce calligraphy as an artistic form. Rubbings in *k'o-t'ieh* form should be distinguished from ordinary rubbings taken from objects such as inscribed stone steles or cast bronze vessels and bells, whose original purpose was the preservation of a text or commemoration of an event. Only later were rubbings taken from these objects to reproduce the text of the inscriptions. *K'o-t'ieh* should also be differentiated from processes designed merely to reproduce the content of a text, which was the basis of carved blocks for printing and eventually led to movable type. On the process of taking rubbings and the transition from block printing to printing, see T. F. Carter, *The Invention of Printing in China and Its Spread Westward* (New York, 1955), pp. 19–25, 37–45. Cf. also, van Gulik, *Pictorial Art*, pp. 86–90; and Tsien Tsuen-hsiun, *Written on Bamboo and Silk* (Chicago, 1962), pp. 4, 86–89.

12. The T'ang poet Han Yü (768–824) implies in his well-known "Song of the Stone Drums" (*Shih-ku-ko*) that rubbings had already been made of the text of the drums. The opening line reads: "Mr. Chang holds a version of the *shih-ku-wen*," and later on the poet asks, "Where, sir, did you obtain this paper version?" See Han Yü, *Ch'ang-li hsien-sheng chi* (SPTK edn.), 5/52.

13. Sun K'uang (1542–1613), *Shu-hua pa-pa*, as quoted in *I-lin ts'ung-lu*, 2/132. Cf. also van Gulik, *Pictorial Art*, pp. 91–92.

14. Chang Yen-yuan's *Fa-shu yao-lu* (ISTP edn.) contains two entries which suggest that tracing methods and the use of thin paper had existed by the 6th century. See the exchange between T'ao Hung-ching and Liang Wu-ti (ibid., 2/21) and Yü Ho, *Lun-shu-piao*, a memorial submitted to Sung Ming-ti in A.D. 470 (ibid., 2/14–15). Tsien cites two passages from the *Sui Shu* (A.D. 629–632) which indicate that stone inscriptions had been preserved in the Imperial library in the form of "rolls" (*chuan*) of ink squeezes, and that "those squeezes made during previous dynasties are still preserved in the Imperial collection" (Tsien, *Bamboo and Silk*, pp. 87–88).

15. Wu P'ing-i, *Hsu-shih fa-shu-chi*, in *Fa-shu yao-lu*, 3/50. Ho Yen-chih, in *Lan-t'ing-chi*, mentions *kung-feng t'a-shu-jen* (3/57). The "Pai-kuan-chih" chapter of the *T'ang Shu* (49) mentions *t'a-shu-shou* employed in the Ch'un-wen-kuan. See also Tsien, *Bamboo and Silk* (p. 88), in which other citations from the T'ang official histories are noted, recording the established practice.

16. *Li-tai ming-hua-chi* (ISTP edn.), 2/76. See also Zürcher, "Imitation and Forgery," pp. 144–45.

17. Lu Chi-shan appended his own colophon, dated 1338. In it, he says he learned the method from his teachers Yao Shih (active 1320?) and Chao Meng-fu (1254–1322). Colophons by K'o Chiu-ssu (1290–1343), Chieh Ch'i-ssu (1274–1344), and Ch'en Fang (active 1320–40?) follow. Little is known about Lu; his poems appear in the *Yuan Shih hsuan kuei-chi* (1798), *keng-hsia*.

18. See *San-hsi-t'ang fa-t'ieh* 25 (1754 ed.; Tainan reprint, 1971).

19. *Ch'ing-ho shu-hua-fang* (1616), (*ch'ou*), p. 26a, and *Mo-yuan hui-kuan* (1742, ISTP edn.), 1/5–6, respectively. Chang Ch'ou notes that "the copy" (*lin-pen*) was made on *ying-huang* paper by a T'ang artist, and An Ch'i's entry records it as an exceedingly fine "tracing copy" (*mo-pen*) from the T'ang period

The two connoisseurs agree that the work dates from the T'ang, but An Ch'i is more correct in saying that it is a "tracing copy," for *ying-huang* paper would not have been used if it were merely a "copy."

20. See *Shan-hu-wang*, as quoted in *SKT* 6/304; and Nishikawa Nei, "Shinjutsu no Gyojō-jō," *Shohin* 142 (1963): 2–10. The same type of paper was used for three other Wang Hsi-chih reproductions now in the Palace Museum, Taipei: *P'ing-an t'ieh*, *Ho-ju t'ieh*, and *Feng-chü t'ieh*. See *KKFS* 1, "Tsin Wang Hsi-chih mo-chi."

21. In the collection of the Imperial Household; see *SZ* 4/28–31.

22. See Nishikawa (as cited above n. 20). The *I-mu t'ieh* is reproduced in *T'ang-mo Wang Yu-chün* (see n. 23); *SMS* 48; and *Shohin* 142.

23. See *T'ang-mo Wang Yu-chün-chia shu-chi* (Liaoning, 1959).

24. The double *Cheng-ho* seals of Sung Hui-tsung have been moved to the first seam and placed between 2 other Hui-tsung seals. The small writing at the upper right, which identifies the scroll in the *Yü-ch'ing-chai* version, does not match any writing that now appears in the original. For the date of Wu's anthology, see *no. 2a*, n. 2.

25. The *San-hsi-t'ang* contains an identification in small characters which was written by Tung Ch'i-ch'ang and appears to the right of the original scroll.

26. *KKSHL* 8/1.

27. Because of the high quality of Ch'u's prose, the composition has been included in anthologies of T'ang writing; see, e.g., *no. 3*, n. 2.

28. It carried his Shao-hsing reign seals and a colophon by his chief connoisseur Mi Yu-jen (1072–1151), dated 1136 (*SKT* 7/337–38).

29. During the early Ming the scholar Sung Lien (1310–81) saw it and described it as being "gentle, with a moist feeling," like the writing of Yü Shih-nan (558–638), and with the structure of Wang Hsi-chih (*SLTC* 8/124). By the middle Ming, Hsu Yu-chen (1407–72), the maternal grandfather of Chu Yun-ming, had made a copy of the essay (Sun K'uang, *Shu-hua pa-pa*, 1/12a.). While it was in the collection of Shih Chien (1434–96), the connoisseur Wu K'uan (1436–1504, see *no. 31*) wrote a colophon to it in 1478. (On Shih Chien, see *Ming-jen*, p. 106; on Wu K'uan's colophon, see *P'ao-weng-chia-ts'ang-chi* [*SPTK* edn.], 49/305.) Then the historian and critic Wang Shih-chen (1526–1590) owned it and inscribed 2 colophons. (See Sun K'uang, *Shu-hua pa-pa*, 1/2b–3a.) By the time it had entered Wang's collection, 2 carved versions or reproductions of the "Elegy" had already been made. (See *SZ* 8/24–5, pp. 158–59, which reproduces the *Hsiu-ts'an-hsuan* version; and *SMS* 141, which reproduces the *Hsi-hung-t'ang* version.) Afterward, it was included in several Ming and Ch'ing compilations of *k'o-t'ieh*: Tung Ch'i-ch'ang, *Hsi-hung-t'ang t'ieh* (1603); Wang K'en-t'ang, *Yü-kang-chai t'ieh* (1611); Ch'en Yuan-jui, *Hsiu-ts'an-hsuan t'ieh* (ca. 1619); and Yang Shou-ching, *Lin-su-yuan t'ieh* (ca. 1891–92).

30. Little information is available about Yen Ch'eng (see *no. 3*), but much more is known about his father, Yen Na (1511–84), who held high ministerial positions. Wang Shih-chen mentioned him several times in his collected works and wrote Yen's tomb inscription and the text to his stele. See Wang Shih-chen, *Yen-chou shan-jen ssu-pu-hsu-kao* 38/8. 129/1. 153/15.

The whole Yen family were serious students of calligraphy: Yen Ch'eng had two brothers, Chi and Shu, whose calligraphy was praised by contemporaries. Yen Ch'eng himself appears to have been a man of many talents. Presumably, he was able to borrow the original "Elegy" when it was in Wang's hands. Yen Na was also known as a sometime painter and his prominence indicates he might have had a personal collection of art which would have formed his son's taste. On Yen Ch'eng,

see *Ming-jen*, 947; on Yen Na, ibid., 946; *Ming Shih*, 193; *SLTC*, 11/318; the latter reference also includes further material on Yen's family.

31. The *Ni K'uan tsan*, which is substantially different from the style found in his famous steles—e.g., his [*Yen-t'a*] *Sheng-chiao-hsu*, dated 653. For the major works and attributions, see *SZ* 8/1–25, pp. 10–18, figs. 18–26, pp. 153–60. Among the extant carved attributions, there is one in small running script, similar to the "Elegy," called *K'u-shu fu*, dated 630. In the late Ming the *K'u-shu fu* entered the collection of the Hua family of Wu-hsi; Wang Shih-chen is known to have borrowed a tracing copy of the *K'u-shu fu* made by a certain Hsu Yuan-fu to be reproduced by carving into an anthology (*SKT* 7/340). Thus this work and the "Elegy" were well known in the Ming.

32. In fact, 2 earlier connoisseurs, Ch'en Chi-ju (1558–1639) and Wang Shu (1668–1743), suspected that the original "Elegy" may have come from Mi Fu's hand. Actually, Wang was confused, since he even thought that Yü Huai (800–840), whose signature appears along with Hsueh Shao-p'eng's (ca. 1050–1100) at the end of the album, may have been the author. These 2 signatures were found on the original album and actually are a form of colophon indicating that Yü and Hsueh had seen the work.

33. *SZ* 15/107–08, pp. 174–75. This work by Mi Fu was also a memorial on the death of an imperial personage, the Empress.

34. See *Pao-chin ying-kuang chi* 8/67.

35. The Palace Museum version: *KKFS* 10–2/18–25 and *KKSL* 1/54–55. The Crawford version: published by Achilles Fang, in Sickman, ed., *Chinese Calligraphy and Painting*, no. 11, pp. 67–69.

36. This same seal is also impressed on a similar position in other famous Sung works, such as the album of "Four Letters" in cursive style in the Abe collection, Osaka (*SZ* 15/97–104). The above-mentioned scrolls also bear Sung Kao-tsung's *Shao-hsing* reign seal in several different cuttings. The *Shao-hsing* seal found on the Palace Museum *Han-shan* scroll is identical with that found on the "Scroll for Chang Ta-t'ung" *(no. 6)*. For a study of the development of Huang T'ing-chien's calligraphy, and a complete listing of the above-mentioned Sung seals on the early scrolls of calligraphy, see Shen Fu, "Huang T'ing-chien's Calligraphy and His Scroll for Chang Ta-t'ung: A Masterpiece Written in Exile" (Ph.D. dissertation, Princeton University, 1976), esp. chap. 3, pp. 77–104.

In addition, the Palace Museum scroll bears 2 authentic seal impressions belonging to the Southern Sung minister Chia Ssu-tao (1213–75). These seals tell us that the Palace Museum scroll entered Chia Ssu-tao's private collection after having been in the Imperial collection. Before the fall of the Sung, the Chia family property was confiscated, and the scroll re-entered the Sung Imperial collection. On Chia Ssu-tao, see H. Franke, "Chia Ssu-tao: A Bad Last Minister?" in A. Wright and D. Twitchett, eds., *Confucian Personalities* (Stanford, 1962), pp. 217–34; on his collection, see *SZ* 16, pp. 25–27.

37. The Ch'ien-lung Emperor's first reaction to the scroll as being "top grade" was actually correct. His second opinion was probably influenced by the different textual variants in the poems. (See *SCPC* III/1429.)

38. In 1968, and again in 1972, the author examined the *Han-shan P'ang Yun* scroll in the Palace Museum, Taipei.

39. For further discussion on the date of this scroll, see Shen Fu, "Huang T'ing-chien's Calligraphy," chap. 2, pp. 53–54. For a chronology dealing with 5 periods of Huang T'ing-chien's extant works, based on the internal data of the scrolls, see Shen Fu, ibid., chap. 2, pp. 32–67. The 5 periods may be summarized as follows: (1) Yuan-yu period (1086–93): Residence in the capital; (2) Shao-sheng period (1094–97): First exile at Ch'ien-chou, Szechuan; (3) Yuan-fu period (1098–1100): first exile (second residence) at Jung-chou,

Szechuan; (4) Yangtze River period (1101–03); Wandering and Waiting after the Pardon; (5) Ch'ung-ning period (1103–05): second exile, and death, at I-chou, Kwangsi.

40. According to the colophon by Chang Hung (dated 1957), and Prof. Achilles Fang, who first published the scroll, the seal belongs to Han T'o-chou (d. 1207). (See Sickman, ed., *Chinese Calligraphy and Painting*, p. 68.) For a discussion of Chin Chang-tsung's collection, see Toyama Gunji, *Kinchōshi kenkyū*, pp. 660–69.

41. Professor Achilles Fang also had reservations about the scroll's authenticity. His catalogue entry reads "Attributed to Huang T'ing-chien." Fang was influenced by the variants which appear in the text and which were noticed by the Ch'ien-lung Emperor. He notes: "The fact that these three poems as transcribed in the present scroll are truncated and read differently from the now available text may well lead to questioning whether they were actually written by Huang T'ing-chien." (Sickman, ed., *Chinese Calligraphy and Painting*, p. 68.) However, it has been shown that the Palace Museum version of the same scroll, which has the same text, is genuine on firm stylistic and documentary grounds. As Fang himself says, Huang T'ing-chien may have had a different Sung edition or version of the poems, and, indeed, rather than doubt the scroll, one may find the text of the poems valuable in comparison with the other extant editions.

42. For a discussion of the processes and psychology of copying, see Fu, *Studies in Connoisseurship*, esp. pp. 22–25 and 59–67.

43. Information supplied by Mr. Nan Ping Wong of Hong Kong, and Goleta, Cal.

44. For example, 8 of the "sets" have been identified by Wen Fong; see his "Forgeries," *Artibus Asiae* 25: 110, n. 63, in which he discusses the Chao Yuan set, "Farewell by a Stream," the original of which is now in the Metropolitan Museum of Art (see Fong and Fu, *Sung and Yuan Paintings*, no. 23).

45. For a recent comparative study of the 2 scrolls, see Mary Jane Clark, "Twin Pines and Level Distance: A Landscape Painting by Chao Meng-fu" (Master's thesis, Yale University, 1976).

46. As quoted by Nakata, *Chūgoku*, p. 258.

47. The same problem is posed with regard to the Yang Wei-chen colophon to Hsieh Po-ch'eng's "Gazing at a Waterfall" (Crawford collection; see *no. 23*, and discussion below.) The authenticity of the Chao Meng-fu original itself, in the Metropolitan Museum, demands a separate and meticulous presentation. The relationship between it and the Cincinnati version is quite clear, however; the Metropolitan "Twin Pines" is the original on which the Cincinnati version was based.

48. For further discussion, see essay IV and *no. 16*, n. 3.

49. *SCPC* I/934–35.

50. Reproduced in Edwards, et al., *The Painting of Tao-chi* (Michigan, 1967), fig. 14, pp. 38–39; on p. 67, the seal *Shan-kuo* is mistakenly read with an extra character. For the painting, see also Tomita and Tseng, *Portfolio of Chinese Paintings in the Museum: Yuan to Ch'ing Periods* (Boston, 1961), p. 23.

51. For a comparative study of Tao-chi's calligraphy, see Fu, *Studies in Connoisseurship*, pp. 59–67 and 212–17.

52. *Shen-chou kuo-kuang-chi* (Shanghai, 1908), 4/33; and later, the same version, in *SBT* (Tokyo, 1937), 8/86.

53. Cf. van Gulik, *Pictorial Art*, pp. 72–74, 108–09. The well-known "Seven Junipers" handscroll in the Honolulu Academy of Arts has been referred to as a second-layer painting in an attempt to explain certain problems found in its execution.

An example of a second-layer work is the handscroll attributed to Mu-ch'i, "Plants, Flowers and Birds," in ink on paper, in the Palace Museum, Taipei. (See *Three Hundred Masterpieces in the Palace Museum*, 3/120–23.) The painting has been retouched, false seals and signature have been added,

and the ink spots of the upper layer have soaked through the paper to the second layer.

54. When the connoisseur-painter Mi Fu (1051–1107) discussed mounting problems, he said one should never remove a second layer because it would destroy the spirit of the painting. If the painting is on silk and has a layer of backing paper mounted onto the silk before painting, it is even more essential to preserve this bottom layer. (Cf. van Gulik, *Pictorial Art*, pp. 189, 212.)

ESSAY II

1. For Hsu Shen and the importance of his dictionary, see Tsien, *Bamboo and Silk*, pp. 15, 22, 24. For Li Yang-ping, see *SZ* 10/1–3, figs. 9, 10, pp. 6–7, 182; and *SMS* 136, his *Li-shih San-fen-chi*, dated 767 (see also below, n. 4).

2. The T'ang poet Tu Fu (712–770) describes the destruction of the stele by fire and its perpetuation only by recarved versions. See "Li Ch'ao pa-fen hsiao-chuan ko," in *Fen-lei chi-chu Tu kung-pu-shih* (*SPTK* edn.) 16/284. The copy was made by Hsu Hsuan (see below, n. 7; and *SZ* I, figs, 82–83, p. 47; and cf. Tsien, *Bamboo and Silk*, pp. 12–13, 68–69).

3. *SMS* 14; *SZ* 1/135–6, and Tsien, ibid.

4. *SZ* fig. 10, p. 7; *SMS* 136. Three other dated works are: (a) dated 772, *P'an-jo-t'ai t'i-chi* (*SZ* 10/1–3); (b) dated 780, stele title to *Yen-chia miao-pei* (*SZ* [old series] 10/212); (c) dated 772, stele title to *Mao-shan Li Hsuan-ching pei* (P'an Po-ying, *Chung-kuo shu-fa chien-lun* [Shanghai, 1962], fig. 69).

5. The following is a partial listing of *pei-e* in seal script from the T'ang: (a) dated 632, anonymous, title for Ou-yang Hsun's *Chiu-ch'eng-kung Li-ch'uan-ming* (*SMS* 19); (b) dated 641, anonymous, title for Ch'u Sui-liang's *I-ch'ueh fo-k'an pei* (*SMS* 95); (c) dated 677, anonymous, title for T'ang Kao-tsung's *Li Chi pei* (*SMS* 139); (d) dated 823, Ch'en Tseng, title for Shen Ch'uan-shih's *Luo-ch'ih miao-pei* (*SZ* 10, p. 178; old *SZ* 11/262–3); (e) dated 841, title for Liu Kung-ch'uan's *Hsuan-mi-t'a pei* (*SMS* 134); (f) dated 855, title by Liu Kung-ch'uan for P'ei Hsiu's *Kuei-feng ch'an-shih pei* (*SZ* 10, p. 180). The writer of the title for *Hsuan-mi-t'a* was not identified, but it is quite possibly by Liu Kung-ch'uan himself, since he was known for his seal script; the writer of the title for P'ei Hsiu's stele was identified on the stele itself.

6. Extant examples indicate that there were other calligraphers writing in seal script who deviated from Li's more restricted type. Their calligraphy had variety and was often closer in style to the Han stele titles, but these artists are relatively few in number. For example: (a) ca. 720–730, anonymous, title to Li Yung's *Yun-hui chiang-chun pei* (old *SZ* 10/42); (b) dated 768, Ch'ü Ling-wen's *Wu-hsi ming* (old *SZ* 10/139–45). Ch'ü wrote the entire inscription and title in seal script.

7. This version was carved by his student Cheng Wen-pao. Hsu served as a high official in the Southern T'ang principality in the South (937–975), and later followed the last ruler north to serve the Sung (see *Sung-jen* 3/2002 and *Sung Shih* 441). Hsu was one of a number of scholars active in the collation and writing of commentaries on the *Shuo-wen* (see *SZ* 15, pp. 7–8).

Two other examples of Hsu's work are: (a) dated 990, title to the *Ta-sung ku T'ai-yuan Wen-chun mu-chih* (*SZ* 15, fig. 10, p. 7); (b) title to *Mao-shan Hsu Chen-jen ching-ming*, rubbing in the Shanghai Library (P'an Po-ying, *Shu-fa chien-lun*, fig. 78).

8. *Hsuan-ho shu-p'u* 2/55.

9. For example, some of whose works are extant are: (a) the monk Meng-ying's *Thousand Character Classic*, dated 965, which strongly resembles Li Yang-ping's *San-fen-chi* (*SZ* 15, fig. 11, p. 8); (b) Kuo Chung-shu (active 951–977; also known

as a painter), title to *Chang Chung-hsun ch'ao Kao-seng-chuan hsu* (rubbing in Freer Gallery of Art, Washington, D.C.); (c) an anonymous stele title, dated 1093, to Tao-ch'ien's *Ching-te-ssu chuan-lun-tsang chi* (*SZ* 15/111; *Genshoku nihon no bijutsu* [Tokyo, 1972], 29, fig. 66, p. 198); (d) dated 1142, anonymous, title to Cheng-chueh's *Ming-chou T'ieh-t'ung-shan Ching-te-ssu hsin-seng-t'ang chi* (*Genshoku* 29, fig. 68, p. 198).

10. For example, a work preserved in *k'o-t'ieh* form is *Mi-t'ieh shih-chuan*, dated 1141, extant only in fragments. The Shanghai Museum has *chuan* 9, which contains Mi Fu's seal and clerical script. See *Mi Fu chuan-li* (Peking, 1973).

11. From the Sung period, one work in seal script exists, a brush-written colophon by Chang Yu-chih to Yen Li-pen, *Pu-lien t'u*, in *Ku-kung po-wu-yuan ts'ang-hua* 2 (Peking, 1964): 5–8; and *Wen Wu* (1959), 7/3.
Works in seal script from the Southern Sung are relatively rare; 2 survive as rubbings: (a) dated 1141, Chai Shih-nien, title to Mi Yu-jen's *Wu-chun ch'ung-hsiu Ta-ch'eng-tien chi* (*SZ* 16, pp. 144–45); (b) dated 1179, Chang Shih (1133–80), title to Chu Hsi's *Liu Tzu-yü shen-tao-pei* (*SZ* 16, p. 155).
From the Chin, the name of one famous master survives—Tang Huai-yin—but no works (see *SLTC* 9/251).

12. For a brief history of the major literati calligrapher-painter-seal carvers, see *SZ* supplement, pp. 7–12; K'ung Yun-pai, *Chuan-k'o ju-men* (Ch'ang-an, 1935[?]), pp. 47ff.; and Yen I-p'ing, *Chuan-k'o ju-men* (Taipei, 1962), pp. 341ff. This is a major topic which deserves separate treatment.

13. Examples of titles in seal script by Chao Meng-fu: (a) ca. 1287–90, title to *Hsien-yü Fu-chun mu-chih-ming* (rubbing; see *San-hsi-t'ang hsu fa-t'ieh*, vol. 5); (b) ca. after 1302, *Hsuan-miao-kuan ch'ung-hsiu San-men-chi* (*SZ* 17/1; *Genshoku*, 29, p. 118; *SG* 7/54–55); (c) ca. 1308–09, *Ku tsung-kuan Chang-kung mu-chih-ming* (rubbing; see *Sung-hsueh-chai fa-shu mo-k'o*, extant in Freer Gallery of Art); (d) datable 1309–10, *Hu-chou Miao-yen-ssu chi* (handscroll in The Art Museum, Princeton University); and see *no. 15a*; (e) datable 1310, *Huai-yun-yuan chi* (mainland publication); (f) datable 1316, *Tan-pa-pei* (*SBT* 11/96–126); (g) datable 1319, *Ch'iu E mu-pei* (*SMS* 82); (h) datable 1320, *Hang-chou Fu-shen-kuan-chi* (Peking, 1959).

14. Cf. also Chiang I-han, "Record of Miao-yen Temple," *NPMB* 10, no. 3 (1975).

15. Neither work lapses into the looseness of his 1302 *San-men-chi*, nor the squat clumsiness of the 1316 *Tan-pa-pei* or 1319 *Chiu E pei*. Nor do they have the overly decorative and mechanical quality of his 1320 *Fu-shen-kuan pei* title-piece.

16. *Liao-ning sheng po-wu-kuan ts'ang-hua-chi* (Peking, 1962), 1/85; and Wang Shih-chieh et al., eds., *A Garland of Chinese Paintings* (Hong Kong, 1967), 2/18–1, respectively. We are indebted to Chiang I-han for Chao Yung's death date.

17. For an illustration, see *KK hsuan-ts'ui*, pl. 29.

18. *Yuan Chao Su shu Mu-wei i-jen mu-chih* (Taipei, 1961).

19. *SLTC* 10/268; see his biography in *Hsin Yuan Shih* 237. Wu's poetry is collected in *Yuan Shih-hsuan* (*erh-chi, chia*) and as *Chu-su shan-fang shih-chi*. Wu also wrote a treatise on the practice of seal script, "Hsueh-ku-pien: lun chuan-shu san-shih-wu chü," in *Shu-lun hsuan-ts'ui* (Taipei, 1962), pp. 194–98. T'ao Tsung-i (ca. 1316–ca. 1402) specifies that Wu specialized in seal script after Li Yang-ping (*Shu-shih hui-yao* [1376], 7/56).

20. Tu Mu (803–853), *Chang Hao-hao shih*, in *SBT* 2/111–14 and *SMS* 191/22.

21. See *KKSHL* 4/293; for his biography, see *Yuan Shih* 187.

22. *Shanghai po-wu-kuan ts'ang li-tai fa-shu hsuan-chi* 14 (Peking, 1964). For Wu Jui's biography, see Liu Chi (1311–75), "Wu Meng-ssu mu-chih-ming," in *Shih-i Po-wen-chi* (*SPTK* edn.): 8/198–99.

23. For *Tsu-ch'u-wen*, see *SZ* 1, fig. 85–86; for *Wei San-t'i shih-ching*, see *SZ* 3/65–67.

24. *SLTC* 11/283–85.

25. The biographies of Ming calligraphers provide considerable evidence that a sizeable number of scholars were known to have practiced clerical or seal scripts.

26. For Chin's biography, see *Ming-jen*, p. 306; *Ming Shih* 147; also *DMB*, pp. 340, 531, 567. For the epitaph, see *Pai-chueh-chai MJFS*, 1/68; and Shen Tu, "Hua-t'ing Chang-kung mu-chih-ming."

27. Ch'eng served in the Court of Imperial Sacrifices and in the Ministry of Personnel, and was asked to help in the compilation of the *Yung-lo ta-tien*. He was a painter of bamboo and plum, and became known for his seal and clerical styles. See *Ming-jen*, p. 684; *SLTC* 11/300; *T'u-hui pao-chien* 6/98.

28. Examples of frontispieces by Ch'eng Nan-yun: (a) *Fang-hu chen-chi*, to Fang Ts'ung-i's "Cloudy Mountains," in the Metropolitan Museum of Art, New York; (b) *Ch'ung-chiang tieh-chang*, to Chao Meng-fu's "Rivers and Mountains," in the Palace Museum, Taipei; (c) *Yeh-yen-t'u*, to "The Night Revels of Han Hsi-tsai" (see *Ta-feng-t'ang ming-chi* [Kyoto, 1955], 1/5); (d) *Fang-weng i-mo*, to Lu Yu's *Fang-weng i-mo*, Liaoning Museum.

29. Ch'eng was said to have derived his script style from a certain Ch'en Teng (1362–1428). Ch'en served in the Hanlin Academy, and at the time was considered a prominent calligrapher in his native Fukien and at the capital. He was learned in etymology, and many of the large plaques at court were executed by him. See *Ming-jen*, p. 591; *Ming Shih* 286; see also Yang Shih-ch'i's biography from *Kuo-ch'ao hsien-cheng-lu*, quoted in *SLTC* 11/300. No works by Ch'en are known to be extant; he did have a number of followers, however, besides Ch'eng Nan-yun, who were known for their seal script, 2 of whom were Shen Hung (see *SLTC* 11/299) and Tso Tsan (ibid., 11/302).

30. See *Ming-jen*, p. 308; also *T'u-hui pao-chien* 6/94; *SLTC* 11/300.

31. See *KKSHL* 4/113; also his *Shan-chü-t'u*, frontispiece to Ch'ien Hsuan's "Floating Jade Mountain" (Palace Museum, Peking); and his *Chia-ho pa-ching* to Wu Chen's painting (see Wang Shih-chieh et al., eds., *Garland of Chinese Painting*, 2/17–1).

32. See *SLTC* 11/306–07; for Li's biography, see *Ming-jen*, p. 201; *Ming Shih* 181; *DMB*, pp. 877–81 (Fang Chao-ying).
The following are a number of important frontispieces written by Li Tung-yang: (a) *Li Lung-mien shan-chuang-t'u*, to Li Kung-lin's "Dwelling in the Mountains," Palace Museum, Taipei (*KKSHL* 4/21); (b) *Ts'ang-chen tzu-hsu*, to Huai-su's "Autobiography," dated 1498, Palace Museum, Taipei (*KKFS* 7); (c) *Yü-shu chen-chi*, to Yü Shih-nan's *Ju-nan-kung-chu mu-chih-ming*, dated 1516 (*SBT* 1/31); (d) *Mi Nan-kung shih-han* to Mi Fu's *Shao-hsi-shih* (*SMS* 74; *KKFS* 11); (e) *Erh Lu wen-han* to Lu Chien-chih's *Lu Chi wen-fu* (*SMS* 195; *KKFS* 11; *SBT* 1/52); (f) *Ts'ao-t'ing shih-i* to Wu Chen's "Poetic Thoughts in a Thatched Cottage," Cleveland Museum of Art *(no. 24a)*; (g) *Chü fang-t'ing* to Cheng Hsi's landscape handscroll, Palace Museum, Taipei (*KKSHL* 4/125); (h) *Sung-hsueh-weng chen-chi*, frontispiece and colophon dated 1510, both in seal script, to Chao Meng-fu's transcription of *Ch'ung-chiang tieh-chang-shih*, Liaoning Museum.

33. For Hsu Lin's biography, see *DMB*, pp. 591–93 (Fang Chao-ying); *Ming-jen*, p. 470.

34. Another example of Hsu's work in a slightly different style is his frontispiece to the T'ang master Li Huai-lin, *Chueh-chiao-shu* (*SMS* 142); this work was included in Wen Cheng-ming's compilation of rubbings, *T'ing-yun-kuan t'ieh*.

35. From Chou Hui, *Chin-ling so-chih* (1610), as quoted in *SLTC* 11/315.

36. For Ch'iao Yü, see *Ming-jen*, p. 675; *Ming Shih* 194; and *DMB*, p. 662. The esteem was mutual. Hsu Lin regarded Ch'iao Yü as the finest master of seal script of the dynasty (*SLTC* 11/309).

37. *SLTC* 11/307. For Li's biography, see *Ming-jen*, p. 227; *Ming Shih* 49; also *DMB*, pp. 392, 1471.

38. *SBT* 2/129.

39. This style shows him to have been independent of the Li Yang-ping and Hsu Hsuan tradition, and shows some influence of the highly stylized *T'ien-fa shen-ch'an* stele, dated 276, and the *San-t'i shih-ching*, dated 240–248 (fig. 26), from the Wei period. Cf. *SMS* 12 and *SZ* 3/65–67, respectively.

40. A third work, a frontispiece to T'ang Yin's "Journey to Nanking," is in the Freer Gallery of Art, Washington, D.C. Wu I's calligraphy has been well presented recently by Marc Wilson and K. S. Wong in their study of the Crawford collection. See *Friends of Wen Cheng-ming*, nos. 12 and 17, pp. 80, 95–97. For the Freer work, see also Thomas Lawton, "Notes on Five Paintings," p. 207, n. 90, pl. 5.

41. For Lu's biography, see *DMB*, pp. 999–1003 (H. L. Chan); *Ming-jen*, p. 568; *Ming Shih* 286; and *SLTC* 11/319.

42. The diversity of ancient sources of Wen Cheng-ming's styles in painting has been the subject of several recent studies, including *Ninety Years of Wu School Painting*, National Palace Museum (Taipei, 1975); Anne de Coursey Clapp, *Wen Cheng-ming: The Ming Artist and Antiquity* (Ascona, 1975); Richard Edwards, *The Art of Wen Cheng-ming* (Ann Arbor, 1976); and Wilson and Wong, *Friends of Wen Cheng-ming*. For Chao Meng-fu, see the several studies by C. T. Li, especially *Autumn Colors on the Ch'iao and Hua Mountains* (Ascona, 1965).

For Wen's biography, see *DMB*, pp. 1471–74 (Richard Edwards); *Ming-jen*, p. 18; *Ming Shih* 287; and *SLTC* 11/311–14. See also, Chiang Chao-shen, "Wen Cheng-ming nien-p'u," *NPMQ* 5, no. 4 (1971): 39–88; 6, no. 1 (1972): 31–80; no. 2: 45–75; no. 3: 49–80; no. 4: 67–109. Chiang's work is the most comprehensive study on the entire Suchon circle to date.

43. *Ninety Years of Wu School Painting*, pp. 153, 183. See also, Wen Cheng-ming's transcription, dated 1558, of the *Huang-t'ing-ching*, in the Wango Weng collection (Ecke, *Chinese Calligraphy*, no. 50).

44. *Cho-cheng-yuan shih-hua-ts'e* (Chung-hua album, n.p., 1929), esp. leaves 12, 39, and 41. The Garden was established by the Censor Wang Hsien-ch'en, and Wen Cheng-ming was given a studio there. Another version of the album, dated 1551, is in the Earl Morse collection, New York, but contains writing in running script only; see Roderick Whitfield, *In Pursuit of Antiquity* (Princeton, 1969), no. 3, pp. 30, 66–75; and Edwards, *Wen Cheng-ming*, no. 51, pp. 175–81.

45. A frontispiece in 4 large characters, *Pin-feng chiu-kuan*, precedes "Illustrations of the Odes of Pin," an anonymous Sung dynasty handscroll in the Freer Gallery of Art; for the scroll, see Thomas Lawton, *Chinese Figure Painting* (Washington, 1973), no. 6, pp. 48–53.

46. See *Wen Wu* (1973), no. 5, p. 62. For Wen P'eng's biography, see *Ming-jen*, p. 17; *SZ* supplement, p. 61; for his place in the history of seal carving, ibid., p. 8; K'ung Yun-pai, *Chuan-k'o ju-men*, p. 48; and Yen I-p'ing, *Chuan-k'o ju-men*, pp. 342–43; the latter 3 sources all place Wen P'eng at the head of the list of later masters of seal carving. For works in other scripts by Wen, see Wilson and Wong, *Friends*, nos. 21, 22, pp. 106–10; and *SZ* 17/108–9. Wen P'eng, incidentally, was considered by Wang Shih-chen as the best master of tracing copies by the outline method in his day (*SLTC* 11/313).

47. *SLTC* 11/314; *SZ* 17, p. 193.

48. For a summary of these trends, see Ma Tsung-ho, *SLTC* 12/340–44; and *SZ* 21, pp. 1–11.

49. For Chao, see *SLTC* 11/333; for his biography, see *Ming-jen*, p. 760; *Ming Shih* 287 (appended to Wen Cheng-ming); and *DMB*, p. 344 (under Chu Lu). On the stele, see *SMS* 12, and *SZ* 3/77–82, pp. 172–73. See also above, n. 39.

50. Four titles of his work are included in the *Mei-shu ts'ung-shu* and *I-shu ts'ung-pien* series; in the latter, see vol. 3. A hanging scroll with calligraphy very close in style to the colophon in the exhibition is reproduced in *SZ* (old) 20/212.

51. See *SLTC* 11/336. No other information is available about Chang.

52. For illustrations, see e.g. *SG* (supplement) 162–63; for Fu Shan's biography, see *no. 67* and *ECCP*, pp. 260–62 (Ts'ui and Yang).

53. For further information regarding this important movement, see Li Yü-sun, *Chin-shih-hsueh lu* (Preface, 1822; Taipei, 1956); Chu Chien-hsin, *Chin-shih-hsueh* (Preface, 1938; Taipei, 1965); *SLTC* 12/340–44; *SZ* 24, pp. 14–23, 24–32; also, Lothar Ledderose, *Die Siegelschrift (Chuan-shu) in der Ch'ing-zeit* (Wiesbaden, 1970), pp. 57–64.

54. One version, dated 1728, is in the Hua Shu-ho collection, Taipei; for an analysis of this work, see Lothar Ledderose, "An Approach to Chinese Calligraphy," *NPMB* 7, no. 1 (1972): 3–6. For Wang Shu, see *SLTC* 12/372; *SZ* 21, p. 184.

The date of the Stone Drums has been a controversial issue among scholars; for a recent definitive study, see Chang Kuang-yuan, *Shih-ku-shih chih wen-shih lun-cheng* (Taipei, 1968).

55. See Hua Sung's frontispiece to Wu Jui's "Yuan Wu Meng-ssu chuan-li chen-chi," in *Shanghai FSHC*, vol. 14. Hua also specialized in seal carving, but is otherwise unknown.

56. On Ch'ien, see *SLTC* 12/398; *SZ* 24, p. 169; on Hung, *SLTC* 12/407; on Sun, *ECCP*, 675–77 (Tu Lien-che); *SLTC* 12/403.

57. On Teng, see *ECCP*, 715–16 (Hiromu Momose); also, Pao Shih-ch'en, *I-chou shuang-chi* (1851), 2/53–4; "Wan-pai shan-jen chuang," *SZ* 24/169; *SLTC* 12/398; and Ecke, *Chinese Calligraphy*, no. 94. One example of Teng's early work, dated 1781, is a hanging scroll in imitation of Li Yang-ping; see *SMS* 136/42 (1781).

58. On Teng's seal writing, see *Shohin* 81 (1927), no. 7, and *Han-pei-e* (Shanghai, 1937). For examples of Teng's later work, see *SZ* 24/2–4 (1792); *SMS* 118/1–18 (1796); *SMS* 165 (1804); and see Ledderose, *Siegelschrift*, pp. 70–83, figs. 33–50, for a discussion of Teng's stylistic development.

59. The calligraphers after Teng fall into two stylistic mainstreams: the first group, Wu Hsi-tsai (1799–1870), Hsu San-keng (1826–90), and Chao Chih-ch'ien (1829–84), tended to exaggerate certain of Teng's formal elements, such as his feeling for movement and fluctuations in brushwork. The second group is discussed in the text. On Wu, see *SLTC* 12/436; *SZ* 24/42–5, 173; and Ledderose, *Siegelschrift*, pp. 84–91. On Hsu, see *SZ* 24/90, 176; and Ledderose, pp. 96–100. On Chao, see *ECCP* 70 (Tu Lien-che); *SLTC* 12/439; and *SZ* 24/70–75, 176.

60. On Ta-shou's dates and activities, see Min Erh-ch'ang, *Pei-chuan-chi pu* (1931), 6/58/23; *Nan-p'ing t'ui-sou chuan* by Kuan T'ing-fen, a contemporary of Ta-shou; and Chen Yun, *Kuo-ch'ao shu-jen chi-lueh* (1908), 29/11/16. On Juan Yuan, see *ECCP* 399–402 (Fang Chao-ying).

61. According to his contemporary Yang Shou-ching (1839–1915). See *SLTC* 12/437; see also *SZ* 24/59, 175; *SMS* 159; *Shohin* 179; *ECCP* 716; and Ledderose, *Siegelschrift*, pp. 122–26. On Yang Shou-ching, see *SLTC* 12/444; *SZ* 24/86–9, 179; *ECCP* 484.

62. On Wu, see *ECCP* 880–82 (Hiromu Momose); Ku T'ing-lung, *Wu K'o-chai hsien-sheng nien-p'u* (Peking, 1935); also, *SLTC* 12/442; *SZ* 24/82–3, 178.

63. Wu's visit to Yang is recounted in the colophon to his *Tsai hsi p'ien*. See *SMS* 159/37–77.

64. *SLTC* 12/445; *SZ* 24/179–80; *Shohin* 101; and *Bokubi* 15. On the "Stone Drums," see above, n. 54.

65. *Hsuan-ho shu-p'u* 2/71.

66. Some dated examples that have survived are: (a) dated 736, Shih Wei-tse's *Ta-chih ch'an-shih-pei* (*SZ* 8/110–111); (b) dated 744, Hsu Hao's *Sung-yang-kuan Sheng-te kan-ying-sung* (*SZ* 10/6–7); (c) dated 745, T'ang Hsuan-tsung's (685–762) *Shih-t'ai Hsiao-ching* (*SZ* 8/91); (d) dated 752, Hsu Hao's

title-piece to Yen Chen-ch'ing's *To-pao-t'a pei* (*SMS* 52/4–6). The 752 title-piece by Hsu Hao is one of the largest extant works in clerical from the T'ang, but the writing is not as natural as his 744 stele.

67. See *Hsuan-ho shu-p'u* 2/72.

68. See Wang Shu, *Ch'un-hua mi-ko fa-t'ieh k'ao* (Preface 1730; Taipei, 1971); and *SZ* 15, pp. 5–7.

69. There is one example extant in the form of a colophon by the Chancellery Executive Wang Ch'in-jo (962–1025). It is dated 1010 and accompanies Yang Ning-shih's *Hsia-jih t'ieh*. Wang used primarily T'ang methods, exaggerating the contrast between the wide, flat, flaring diagonals and horizontals and the remainder of the strokes (*Ku-kung FSHC*, vol. 5). On Wang, see *Sung-jen* 1/350.

70. Mi is known to have followed the *Liu K'uan-pei* by Shih I-kuan. See *Ch'un-yü-t'ang t'ieh* (*SMS* 43/51–2), and also *Mi Fu chuan-li*.

71. See *Ku-kung FSHC*, vol. 2. On Huang, see *SZ* 15, p. 42; *Sung-jen* 4/2898; and *Sung Shih* 443. Huang was Librarian of the Imperial Collection.

During the Southern Sung period, Ch'ü Hung-liao wrote a colophon in clerical script to the calligraphy of Huang T'ing-chien's *Ti-chu-ming* (Fujii-Yurinkan collection). Ch'ü's colophon consists of 8 lines of clerical, which bears some resemblance to Mi Fu's, but has more stability. Again, a rare work from the Sung period.

72. See T'ao, *SSHY* 7/6 and *SLTC* 9/246. Kung K'ai's dates are based on the research of K. S. Wong of the Nelson Gallery.

73. *SLTC* 10/258; and *Yuan Shih* 172.

74. *KK hsuan-ts'ui*, pl. 29.

75. Mo Ch'ang (active ca. 1310–after 1352), a neighbor from Wu-hsing, Chekiang, was a second master whose style was probably similar to Chao's. Mo wrote a long colophon in clerical script dated 1352 to Hsien-yü Shu's "Admonitions to the Imperial Censors" *(no. 16)*, wherein he describes showing it to Chao and hearing him sigh in admiration at Hsien-yü Shu's writing. Kuo Ta-chung (active ca. 1320?), an unknown master working in Hangchou, also wrote a colophon on the same scroll in clerical script. For more information about the Hangchou circle, see Marilyn Fu, "The impact of the Re-unification."

76. See *Chinese Art Treasures*, cat. no. 79; and *Shu-shih hui-yao* 7/3.

77. The extant works of other masters of clerical script are: (a) dated 1343, colophons by Wu Jui and Tu Pen, to Chang Yen-fu's "Thorns and Bamboo," Nelson Gallery, Kansas City (Lee and Ho, *Chinese Art under the Mongols*, cat. no. 243); (b) dated 1334, Wu Jui's *Li-sao-ching*, Shanghai Museum (*Shanghai FSHC*, vol. 14); (c) dated 1361, Ch'u Huan's transcription of "Nine Songs" accompanying a painting by Chang Wu, Cleveland Museum (Lee and Ho, *Chinese Art*, cat. no. 8; Ch'u was a follower of Wu Jui); (d) undated, Fang Ts'ung-i's self-inscription to "Kao-kao-t'ing," Palace Museum, Taipei. Fang is mentioned as a master of clerical in T'ao, *SSHY* 7/21. Other masters were Lu Yu and Wang Chen-p'eng.

78. See Wenley, "A Breath of Spring," figs. 1 and 5. Yang served in the K'uei-chang-ko under the Emperor Wen-tsung; his informal history, *Shan-chü hsin-hua*, has been translated and annotated by Herbert Franke as "Beiträge zur Kulturgeschichte Chinas unter der Mongolenherrschaft: Das Shan-kü sin-hua des Yang Yü," *DMG: Abhandlungen für die Kunde des Morgenlandes* 32, no. 2 (Wiesbaden, 1956).

79. Even central Asians in China showed an interest in clerical script. One of the high-ranking *se-mu* (foreigners from the regions west of China) in the Mongol government was T'ai Pu-hua (1304–52), a highly accomplished calligrapher known also for his clerical script. See T'ao, *SSHY* 7/18; Ch'en Yüan, *Yuan Hsi-yü-jen hua-hua k'ao* (Preface, 1935; Taipei, 1960),

pp. 83–84; and text as translated and annotated by L. C. Goodrich and Ch'ien Hsing-hai, in *Western and Central Asians in China under the Mongols* (Los Angeles, 1966), pp. 197–201.

T'ai Pu-hua, who is identified as a Mongol in some sources, was also known for his seal, running, and standard scripts; a colophon in the latter is attached to Hsien-yü Shu's "Admonitions to the Imperial Censors" *(no. 16)*.

T'ao Tsung-i lists 10 books on etymology alone in his *Shu-shih hui-yao*.

80. Palace Museum, Taipei; see *KKFS*, vol. 4. The scroll has a double frontispiece, with the first written by Li Tung-yang in seal script.

81. *SLTC* 11/300. For another example of his work written at age 81, see the second frontispiece to Chao Meng-fu's "Jar-rim Window," handscroll in the Palace Museum, Taipei.

82. The following is a brief list of Wen's works in clerical script: (a) dated 1504, inscription to Fan An's poem "Lake T'ai," an album in the Palace Museum, Taipei (*Ninety Years of Wu School Painting*, no. 55, pp. 59, 242–43); (b) before 1510, frontispiece to an anonymous painting, *Tiao-yueh-t'ing*, handscroll, in the Palace Museum, Taipei (*KKSHL* 4/245); (c) undated, frontispiece to Shen Chou's "Pure and Remote Views," handscroll dated 1493 (*Ninety Years*, no. 43, p. 236), plus colophon in small clerical (ibid., p. 239); (d) dated 1530, frontispiece to Wen Po-jen's "Miniature Portrait of Yang Chi-ching," handscroll in the Palace Museum, Taipei (*Ninety Years*, no. 114, p. 247); (e) dated 1536 and 1545, two examples of "Thousand Character Classic," Palace Museum, Taipei (*Ninety Years*, no. 137, p. 153, and no. 163, p. 183).

83. Yao wrote a frontispiece to Sung K'o's transcription of the *Chi-chiu chang* (Palace Museum, Peking). See *Ku-kung FSHC*, vol. 17. Another extant work by Yao (Palace Museum, Taipei) is a frontispiece to Yü Ho's transcription of the *Chi-chiu-chang* (*KKSHL* 3/66–67).

84. Wen's eldest son, Wen P'eng (1498–1533), also practiced clerical script—in particular, a frontispiece in 4 large characters to a scroll of calligraphy by the elder statesman Wu K'uan (1436–1504), in the Shanghai Museum. The size is large and impressive, with thick brushwork; but the thickness has a bloated quality. It unfortunately does not measure up to his father's stern vigor. (*Shanghai FSHC*, vol. 16.)

85. Wang was praised as one of the best calligraphers of the time by Tung Ch'i-ch'ang, and his clerical script was singled out by Ch'in Tsu-yung. (See *SLTC* 12/348.)

86. For a study of Tao-chi's calligraphy, see Fu, *Studies in Connoisseurship*, esp. pp. 40–45, 59–67, and 210–18.

87. Cheng Fu's dates were given by his student Chang Mao, in his *Li-fa suo-yen*, where he claimed that he had met his teacher at age 70 in 1691 (as quoted in *Kuo-ch'ao shu-jen chi-lueh* 1/22–23). See also *SLTC* 12/352. For Cheng's work, see *SBT* 8/56–57. For the stele, see *SZ* 2/118–19.

88. See *ECCP* 182–85 (Fang Chao-ying).

89. Ibid., 800 (Tu Lien-che). Wan was the nephew of Wan Ssu-t'ung and the pupil of Huang Tsung-hsi. For his work, see *SBT* 8/75.

90. As recorded in Yü's *Ch'un-tsai-t'ang sui-pi* 1/1; see also *ECCP* 944–45 (Tu Lien-che).

91. "Ch'ü-yuan chi," in *Ch'un-tsai-t'ang tsa-wen hsu-pien* 1/11.

ESSAY III

1. The origin of cursive script in the late Ch'in period is advocated by Chao I (Later Han), in "Fei ts'ao-shu," *FSYL* 1/1; see also Liu Yen-t'ao, *Ts'ao-shu t'ung-lun* 7, who cites Ts'ai Yung as quoted by the Liang Emperor Wu. Its origin in the early Han period is advocated by Chang Huai-kuan (T'ang),

"Shu-tuan," *FSYL* 7/109, who cites its invention by Shih Yü upon imperial order; and Hsü Shen, in his Preface (ca. A.D. 100) to *Shuo-wen chieh-tzu*.

2. Currently, there are several theories about the origin of the term *chang-ts'ao*: (1) that this form of writing was used in memorials (*chang-tsou*) presented to the Emperor; (2) that it was created by the Emperor Chang of the Han; (3) that the Emperor Chang favored this script; (4) that Shih Yü used this script to transcribe the "Chi-chiu-chang"; and (5) that the standard script (*k'ai-shu*) during Chung Yu's (151–230) time was called *chang-k'ai*, and therefore the *ts'ao-shu* form was called *chang-ts'ao*.

The modern scholar of cursive script, Liu Yen-t'ao (see above, n. 1), objected to the first 4 reasons and proposed the last (see his *Ts'ao-shu t'ung-lun* 2/13–14). Theory 1 is supported by the scholar Tu Hsueh-chih, who believes that *chang-ts'ao* was the equivalent of *hsing-shu* during the developmental period of *li-shu*, and that it was the transitional script between *li-shu* and *li-ts'ao* (see his "Wen-tzu-hsueh kai-yao," in *Shu-lun hsuan-ts'ai* [Taichung]).

The modern historian Ch'i Kung favors the first and fifth theories, and supplements it with a sixth; he explains the meaning of *chang* as having certain "rules and regulations" which must be followed in writing the shortened forms, hence the term.

The second and fourth theories have no factual basis (although they are often cited), and each of the others have their own merits. As there is no contemporary evidence, the real origin of the term, which developed out of general usage, is lost to us. For an account in English on the rise of *chang-ts'ao*, see Ch'en Chih-mai, *Chinese Calligraphers and Their Art*, pp. 35–51.

3. For Chang Chih, see Chang Huai-kuan, "Shu-tuan," *FSYL* 7/110. This interpretation was reinforced by the editors of the *Hsuan-ho shu-p'u* in their preface to cursive script (13/291–92).

For a concise summary of the theories regarding Wang's dates and biographical information on the Wang family, see Toyama Gunji, *Chūgoku no sho to hito*, pp. 9–34; and Nakata Yūjirō, ed., *Chūgoku shojin den*, pp. 9–32, 291–92. For an account in English, see Ch'en Chih-mai, *Chinese Calligraphers*, pp. 52–76.

4. For Chang Hsu, see *SZ* 8, pp. 28–32, 190; and Toyama Gunji, *Chūgoku*, pp. 77–92. For Huai-su, see Nakata Yūjirō, ed., *Chūgoku shojin den*, pp. 312–13, and 126–32. His most famous work is "Self-statement," in the Palace Museum, Taipei; see *KKFS* 7 and *SMS* 27.

5. Lu was the author of the *Wen-fu*, the earliest treatise on poetics in verse form (see text in Hsiao T'ung [501–531], ed., *Wen-hsuan*, ch. 17; and the annotated translation by A. Fang, in *Harvard Journal of Asiatic Studies* 14 [1951]: 527–62).

For a study of the *P'ing-fu t'ieh*, see Nishikawa Nei, *Shohin* 92 (1958); also *Ku-kung FSHC* 1; *SZ* 3/118.

6. The period-style features are quite evident in these archaeological examples and help to establish a range by which to assess masterworks attributed to this period. The fragments are therefore exceedingly important in the study of all styles of early calligraphy, and the range of styles should be kept in mind in any discussion of attributions to the Han, Wei, and Tsin masters. See Edouard Chavannes, *Les Documents chinois découverts par Aurel Stein dans les Sables du Turkestan Oriental* (Oxford, 1913); August Conrady, *Die chinesischen Handschriften und Kleinfunde Sven Hedins in Lou-lan* (Stockholm, 1920); Lao Kan, *Documents of the Han Dynasty on Wooden Slips from Edsin Gol* (Taipei, 1957 and 1960); Lo Chen-yü and Wang Kuo-wei, *Liu-sha chui-chien k'ao-shih* (n.p., 1914); Henri Maspéro, *Les Documents chinois de la troisième expédition de Sir Aurel Stein en Asie Centrale* (London, 1953); Aurel Stein, *Serindia* (Oxford, 1921), vols. 1 and 2. For a concise review, see *SZ* 3/8–27, pp. 12–18; and *SMS* 108, 109.

7. The range and mixture of script types can be seen in the surviving copies and attributions. For example, in cursive forms there are the *Shih-ch'i t'ieh* (mainly *chang-ts'ao*), *Sang-luan t'ieh (fig. 2)* and *Feng-chü t'ieh* (mainly *hsing* with some *ts'ao*). For a complete study of Wang's works surviving as rubbings, see Nakata, *Ō Gishi o chūshin to suru hōjō no kenkyū*.

8. For examples of his attributions, see *SMS* 44, with notes by Fushimi Chūkei; and Ledderose, "Wang Hsien-chih and Mi Fu."

9. For Chih-yung's work in the Ogawa collection, Japan, see *SZ* 5/60–83, pp. 155–56; also *SMS* 72, with notes by Nakata Yūjirō. For Sun's work in the Palace Museum, Taipei, see *KKSHL* 1/15–16; *KKFS* 2; *SZ* 8/58–63, pp. 19–27, 168–70; and Goepper, *Shu-p'u: Der Traktat zur Schriftkunst des Sun Kuo-t'ing*.

10. On Kao-hsien, see *SZ* 8, p. 185; for his "Thousand Character Classic" in the Shanghai Museum, see *Shanghai FSHC* 3. For Yang's work, see *Ku-kung FSHC* 5; *SZ* 10/110–11 and p. 189. Chou Yueh's works are rare and extant mainly in rubbing form; for Su's work, see the excellent album leaf in the Takashima collection, Tokyo (*Kaiankyo-rakuji* 110).

11. For a study of his life and art, see Shen C. Y. Fu, "Huang T'ing-chien's Calligraphy." It should be noted that Huang's art theories constitute a major basis for the literati movement in painting and calligraphy, and that his influence on Ch'an monks in calligraphy was substantial.

12. The other is a transcription of a poem by Li Po (699–762) in the Fujii-Yurinkan, Kyoto (see *SMS* 32, with notes by Nakata). Neither this scroll nor the Crawford work are signed, but Huang T'ing-chien's seal, *Shan-ku chih-yin*, appears 8 times on the Li Po scroll—at the beginning and end, and on each join. A modification, then, needs to be made to the statement that the scroll "has no seal or signature" (Ecke, *Chinese Calligraphy*, no. 21). Huang's scroll in the Fujii-Yurinkan is an important example which can be dated internally by biographical data and style to a year or so before his death, 1104–05. The Crawford scroll is not signed, and no seals of Huang T'ing-chien appear, even on the joins. The absence of a signature or seal need not be the negative criterion for authorship, because a number of Huang T'ing-chien's genuine works do not bear any signature or seal. The following works, for example, also have no signature or seal: *Hua-ch'i hsun-jen* and the famous *Sung-feng-ko* (both in the Palace Museum, Taipei), as well as the *Chi ho-lan kua* (Palace Museum, Peking).

There is no doubt that both the Crawford and Fujii scrolls are authentic works by Huang T'ing-chien, and while the former exemplifies Huang's mature style, the Fujii scroll represents his old-age style, its sense of dignified struggle communicated by the angular patterns and discontinuous rhythms of the brush. It, too, is an extraordinary achievement for this great master.

13. This date is based on a study of Huang's stylistic development in running and cursive scripts, his theories of brushwork and composition, and the subject matter of the work. For a summary of Huang T'ing-chien's five periods, see above, essay I, n. 39.

14. *Shan-ku t'i-pa* (*ISTP* edn.) 5/48.

15. Stylistically, it is also close to another example of cursive dated 1096, *Ch'iu-p'u-ko*, which survives in rubbing form.

16. Mi's other major work in large writing, *Hung-hsien-shih* (Abe collection, Osaka), represents his old-age style, and is datable to ca. 1106 (see *SMS* 125, with notes by Nishikawa Nei; and *Shohin* 153).

17. This comment is found on Mi's *P'ing-ts'ao-shu t'ieh* (Palace Museum, Taipei; see *KKFS* 11–2/25; *SG* 6/124–25); it is recorded in *SKT* 11/531 and was included by Wen Cheng-ming in volume 5 of his *T'ing-yun-kuan t'ieh*, followed by a colophon by Chu Yun-ming.

18. See Chao's *Lin Huang Hsiang "Chi-chiu-chang"* (Peking, 1961), dated 1309, in the Liaoning Museum; his undated

transcription of the *Chi-chiu-chang* in Shanghai (*Chung-kuo li-tai shu-fa chan-lan* [Shanghai, 1973] 22–23); and his 1320 "Thousand Character Classic in Six Scripts" (coll. unknown).

19. On Sun, see above, n. 9. On Ho, see *SZ* 8/94–97, p. 189.

20. Exceptions were such late Yuan–early Ming painters as Ma Wan (ca. 1310–after 1378), Fang Ts'ung-i (1301?–after 1378), and Chuang Lin (14th century), who frequently inscribed their paintings with a relatively pure form of *chang-ts'ao*.

21. See Chao's colophon to an example of Hsien-yü Shu's cursive writing, in Chu Ts'un-li, *T'ieh-wang shan-hu* (1600), 5/23b. For a study of their mutual interest and complementary relationship, see Marilyn W. Fu, "The Impact of the Re-Unification."

22. The same observations may be made about a second genuine but undated version of the "Song of the Stone Drums," published in *SBT* 3/260–67 (present collection unknown). Hsien-yü Shu is known to have transcribed more than one version of a text he particularly liked.

23. Among the works in Hsien-yü Shu's collection were Yen Chen-ch'ing's "Draft Memorial for his Nephew Chi-ming," acquired in 1284, and Hsu Hao's *Chu Chü-ch'uan chuan*, acquired in 1286 (both in the Palace Museum, Taipei; see *KKSHL* 1/18–24 and *KKFS* 5; and *KKSHL* 1/24–27 respectively), as well as a "Ting-wu" version of the *Lan-t'ing-hsu* (with colophons attached, formerly in the Lin Po-shou collection, now Palace Museum, Taipei), and Wang Hsien-chih, *Pao-mu chih*, acquired in 1286. For details, see Marilyn W. Fu, "The Impact of the Re-Unification."

24. The fourth in a group of letters exchanged between Hsien-yü Shu and Chao Meng-fu on calligraphy and painting; see *KKSHL* 3/227–28.

25. As told by Yang Yü, *Shan-chü hsin-hua* (1360; *CPTC* edn.), 46a; and T'ao Tsung-i, *Cho-keng-lu* (1366; Taipei, 1971 repr.), 15/223–24.

26. Wu's derivation was noted by T'ao Tsung-i (see *SLTC* 10/278); on Ch'un-kuang, see ibid., 8/178.

27. Ibid., 10/278. This was Li Jih-hua's (1565–1635) observation. On Li, see *DMB*, pp. 826–30 (Fang Chao-ying).

28. Cf. *SZ* 9/78–79, dated 799. This work differs from his "wild" cursive style as seen in his "Self-statement" (*cf. fig. 44*).

29. Two other examples of his work in the Freer Gallery of Art demonstrate this fine integration: "Bamboo in Wind," dated 1350, and his "Joys of the Fisherman," dated 1352; also his superb "Stalks of Bamboo beside a Rock," dated 1347, in the Palace Museum, Taipei (see James Cahill, *Hills beyond a River: Chinese Painting of the Yuan Dynasty* [Tokyo, 1976], pls. 81, 82). Of these, the inscription to the "Fisherman" scroll contains the most draft-cursive elements. For further discussion of the integration of inscription and painting, see below, essay V.

30. In this sense, one can differ with Wu Jung-kuang in his colophon to K'ang-li Nao-nao's "Biography of a Carpenter" (*no. 21*), in which he says that Wu Chen was superior to K'ang-li. However, Wu Jung-kuang is one of the few critics to have noticed Wu Chen's calligraphy.

31. See *DMB*, pp. 435–38 (C. T. Li); Fong and Fu, *Sung and Yuan Paintings*, no. 22, pp. 120–21; and Cahill, *Hills beyond a River*, pls. 59, 61, pp. 127–28.

32. For a recent study including Yang's inscriptions, see Shen Fu, "A Landscape Painting by Yang Wei-chen," *NPMB* 8, no. 4 (1973); see also *DMB*, pp. 1547–53 (E. Worthy). Several paintings in American collections bear colophons by Yang Wei-chen: Ma Yuan's "Four Sages of Mt. Shang" (Cincinnati Art Museum); a poetic inscription on the "Spring Landscape," dated 1343 (Sackler collection); a colophon to Wang Yuan's "Quails and Sparrows in an Autumn Scene" (Perry collection, Cleveland); Yao T'ing-mei's "Leisure Enough to Spare" (Cleveland Museum; see Lee and Ho, *Chinese Art under the Mongols*, nos. 240, 260); and Hsieh

Po-ch'eng's "Gazing at a Waterfall" (*no. 23*; Crawford collection, New York). For further discussion, see also below, essay V.

33. A. G. Wenley, "A Breath of Spring," *Ars Orientalis* 2 (1957): 459–69.

34. Jao Chieh was a friend and patron of Kao Ch'i (1336–74), the poet. As a resident of Suchou, Jao joined Chang Shih-ch'eng's regime in 1362 as his "chief official for literary affairs," but was subsequently executed when the Ming was founded. For an excellent study and citation of poems and essays by Kao to Jao, see F. W. Mote, *The Poet Kao Ch'i* (Princeton, 1962). Jao is also known to have served the Yuan; T'ao Tsung-i listed and praised Jao's cursive writing in *Shu-shih hui-yao* (7/12b).

35. For another example of his work in the Palace Museum, Taipei, see *KKFS hsuan-ts'ui*, supplement, pl. 30; also *Kaiankyo-rakuji*, pl. 137.

36. *SLTC* 11/283–84. The "Three Sung" are also mentioned by T'ao Tsung-i in his *Shu-shih hui-yao*. This lineage was traced by Hsieh Chin (1369–1415), in his *Ku-chin ch'uan-shou p'u* (*SKT* 3/127); and Yang Shih-ch'i (1365–1444) in *SLTC* 10/208. Hsieh, a former Hanlin Chancellor and Grand Secretary, showed an interest in genealogical studies (see *DMB*, pp. 554–58 [H. L. Chan]).

37. *DMB*, pp. 1225–31 (F. W. Mote); *Ming-jen* p. 184; and *SLTC* 11/284, 11/287–88. Sung Sui was highly praised by contemporaries and appears to have excelled in seal and clerical as well. His sources are named by a later contemporary, Hsieh Chin (see above n. 36).

38. One of the Ten Friends of the North Wall, centered around the poet Kao Ch'i, Hsu Pen, and others, Sung K'o is said to have been nonconformist in behavior, fond of the martial arts, and a well-known poet. He undertook a brief military career, but retired to Suchou around 1356. Declining Chang Shih-ch'eng's offer to serve in his regime, Sung eventually was summoned by the Hung-wu Emperor to serve as Calligrapher-in-Waiting in the Hanlin Academy. See *DMB*, p. 595 (T. W. Weng), pp. 1223–24 (James J. Y. Liu); H. Vanderstappen, "Painters at the Early Ming Court," *Monumenta Serica* 15, no. 2 (1956): 299–300; and Mote, *Kao Ch'i*, p. 102.

39. His accomplishment in this vein is noted by both Kao Ch'i and Wang Shih-chen (1526–90) in *SLTC* 11/288–89. Among Sung K'o's works are his transcription of the *Chi-chiu-chang* (Palace Museum, Peking) in pure *chang-ts'ao* (see *Ku-kung FSHC* 17); his transcription of the 13 colophons of Chao Meng-fu to the "Tu-ku Lan-t'ing," in varying script styles (Li Ch'i-yen collection, Hong Kong; see *Lan-t'ing ta-kuan*, no. 163); his *Kung-yen-shih*, a hanging scroll (Palace Museum, Taipei; see *KKFS hsuan-ts'ui*, pl. 31; see also *KKFS* 21–1/5 and *SZ* 17/52–3); and his "Poem by Tu Fu" (*SBT* 4/268–78).

40. For studies of Suchou, the city and its culture, see F. W. Mote, "A Millenium of Chinese Urban History: Form, Time and Space Concepts in Soochow," *Rice University Studies* 59, no. 4 (1973); C. T. Li, "The Development of Painting in Soochow in the Yuan dynasty," *Proceedings of the International Symposium on Chinese Painting* (Taipei, 1972); Edwards, *Wen Cheng-ming*; and Wilson and Wong, *Friends*, especially, pp. 8–36.

41. See *SLTC* 11/289–90. For a rare example of Ch'en's work, see *KKFS hsuan-ts'ui* supplement, pl. 31. Ch'en Pi of Hua-t'ing should not be confused with two other northerners of the same name who were active later in the Ming (as cited in *Ming-jen* p. 605).

42. Lu Shen, *Yen-shan-chi* (*SKCP* edn.), 86/6b.

43. *SLTC* 11/296; also *DMB*, pp. 1191–92 (L. S. Liu).

44. As recorded in Chu's "Comments on Calligraphy," in Wen Cheng-ming, *T'ing-yun-kuan t'ieh*, vol. 11; and Ch'en Chi-ju (1542–1605), *Ni-ku-lu* (*ISTP* edn.), 4/307.

45. *Yen-shan-chi* 86/6b.

46. As recorded in T'u Lung (1542–1605), *Kao-p'an yü-shih* (*ISTP* edn.), 1/22. The *Lan-t'ing* transcription (Li Ch'i-yen collection) is cited above, n. 39. For the original "Tu-ku *Lan-t'ing*" and Chao's colophons, dated 1310 (Takashima collection), see *SMS* 56.

47. *SLTC* 11/297.

48. Also known as a poet and official, Chang received his *chin-shih* degree at age 41 and served as prefect of Nan-an, Kiangsi. (See *DMB*, pp. 98–99 [L. S. Liu], and *Ming-jen* p. 539.) For examples of his work, see *KKFS hsuan-ts'ui* supplement, pl. 36; Wang Shih-chieh et al., eds., *Garland of Chinese Calligraphy* 2/7; Ecke, *Chinese Calligraphy*, no. 39; and *SZ* 17/56–7.

49. Hsu served as a high official connected with water control, and eventually became Minister of War. See *DMB*, pp. 612–15 (W. Franke); *Ming-jen* 458. One example of his calligraphy was included by Wen Cheng-ming in his *T'ing-yun-kuan t'ieh*, vol. 10 (1556); see also *SLTC* 11/301, and below, essay V.

50. As reported by T'u Lung, *Kao-p'an yü-shih* 1/2b.

51. See *DMB*, pp. 1173–77 (R. Edwards); and Richard Edwards, *Field of Stones* (Washington, D.C., 1962).

The hanging scroll from the Detroit Institute is undated, but datable to 1507–09 on internal evidence. Wang Ao signs his official title as "Grand Secretary of the Wu-ying Tien," a position to which he was appointed in 1507. Since Shen Chou died in 1509, the interval between 1507 and 1509 is reasonable as the date of execution.

52. For the *Chi Wang Sheng-chiao-hsu*, see *SZ* 8/50–57; also cf. the fine commentary on Wen's calligraphy in the Crawford collection by Wilson and Wong, *Friends*, esp. pp. 92–94.

53. *DMB*, pp. 1368–69 (L. S. Liu); *Ming-jen* p. 79.

54. *T'ing-yun-kuan t'ieh*, vol. 11; see also discussion in essay VI, below.

55. On Ts'ai, see *Ming-jen* pp. 810–11; Edwards, *Wen Cheng-ming*, nos. 18, 86, 88, 90. Ts'ai's birthdate has been estimated from that of his father, Ts'ai P'ang's (1445–82). According to Chiang Chao-shen, Ts'ai knew Wen and Chu in 1503, and in 1504 the aged Shen Chou painted a handscroll for Ts'ai. In 1523 he accompanied Wen on his journey to the capital. See Chiang Chao-shen, "The Life of Wen Cheng-ming," *NPMQ* 6, no. 1 (1971): 39–42; no. 2 (1971): 54–55, 58; and Edwards, *Wen Cheng-ming*, pp. 86–93, no. 18, in which the nine important letters (Weng collection) on Wen's trip are published.

56. *Ya-i shan-jen-chi* 381, as quoted in Chiang, "Life of Wen Cheng-ming," *NPMQ* 6, no. 1: 62, 65–66; 6, no. 2: 47, 48, 50. In 1523 Wang's son married T'ang Yin's daughter (ibid., p. 57).

57. Cf. esp. *Ming Ch'ing SHHC* 170–73, an example of Ts'ai's writing, with Wang Ch'ung's, 174–77. Eleven leaves of Ts'ai's calligraphy accompany an album painting by Lu Chih (*KKSHL* 6/174; *DMB*, p. 990). Two of Ts'ai's inscriptions and one by Wang Ch'ung have been found on paintings by Wen Cheng-ming in the Palace Museum, Taipei (*Ninety Years*, pp. 7, 95, 128).

58. For a fine example in smaller cursive, see Ch'en's "Thousand Character Classic," dated 1535, in the Tokyo National Museum (*SMS* 138, with notes by Kakui Hiroshi). For an example of his cursive script writing as a frontispiece, see *Ninety Years* no. 132, p. 255.

59. For an example of his painting, see Ecke, *Chinese Calligraphy*, fig. 14 (a handscroll dated 1538 in The Art Museum, Princeton University).

60. *SLTC* 11/319.

61. *SKT* 2/137.

62. It should be noted that works signed "Yen-shan" ("Precipitous Mountains") such as *no. 53a* in the exhibition, date to after 1521, when, upon the death of his father, Lu Shen erected four picturesque rock formations near his residence (*DMB*, pp. 999–1003 [H. L. Chan]; also *Ming-jen*, p. 568 and *Ming Shih* 286).

63. See *SLTC* 11/320–21; *Ming-jen* p. 615; and *DMB*, p. 1073 (L. C. Goodrich). Mo Ju-chung's work is extant mostly in smaller formats, fans, and letters (e.g. see *SBT* 10/20).

64. See *SLTC* 11/321; also *Ming-jen* p. 616 and *DMB*, p. 1073 (L. C. Goodrich). The latter 2 sources erroneously attribute the *Hua-shuo* to Mo Shih-lung. For more information on Mo and a recent study verifying Tung Ch'i-ch'ang as author, see Shen Fu, "A Study of the Authorship of the 'Hua-shuo': A Summary," *Proceedings of the International Symposium on Chinese Painting*, and original Chinese text.

Mo has a number of smaller-sized works in running script; 2 of the most important are a hanging scroll and a handscroll from the Takashima collection, now in the Tokyo National Museum (*Kaiankyo-rakuji* 166 and 168; *SG* supplement 1, 134–39; and *SMS* 145, with commentary by H. Kakui). Other works may be found in *SZ* 21/5; *SBT* 1/35, 6/77–80, 7/153–54, 8/17, 10/26.

65. *Hua-ch'an-shih sui-pi* (Preface, 1720; *ISTP* edn.), p. 8.

66. Ma Tsung-ho gives a good account of the Ch'ing trend (*SLTC* 12/340). Chang Chao (1691–1745) was one of the more versatile of the court calligraphers who followed Tung's style (see Ecke, *Chinese Calligraphy*, no. 89); and Wang Wen-chih (1730–1802) is a good example from the late Ch'ing (ibid., no. 92).

67. See esp. his copy of Huai-su, "Self-statement," *SMS* 78. For further discussion of Tung's style see below, essay IV.

68. *Shu-lin chi-shih* 2/68; for an account of Che'n's philosophy, see also *Ming-jen*, p. 606; and *DMB*, pp. 153–56 (J. Ching and Huang P'ei).

69. The dry, dense ink tonality and blunt brushwork are comparable to Yao Shou's *(no. 28)*, but Yao's style includes the refinements and discipline of traditional methods, plus structural allusions to Huang T'ing-chien.

70. Ch'en Hsien-chang, *Pai-sha-tzu ch'uan-chi* (1505; 1771 edn.), 2/26ab.

71. See the definitive account by Tseng Yu-ho, "A Study of Hsu Wei," *Ars Orientalis* 5 (1963): 243–54. For his painting *(no.61)*, see also the brief discussion below, essay V.

72. As cited by his contemporary T'ao Wang-ling (1562–95?), in *SLTC* 11/325.

73. Ibid.; see also Yuan's preface to Hsu's collected works, as cited in Tseng, "A Study," p. 254. Not surprisingly, Yuan ranked Hsu above Wen Cheng-ming and Wang Ch'ung.

Stylistically, Hsu was not without some influence. The later calligrapher Hsu Yu (active 1630–63), a native of Fukien, used similar pictorial devices: exaggeration of character size, shifting of lines, and strong tonal contrasts of ink (see e.g. *SZ* 21/52).

74. See also the study by Nakata Yūjirō in *SZ* 21, pp. 18–27.

75. *Shu-lin chi-shih* 2/76.

76. Fu Shan, *Shuang-hung k'an-chi* (1911), 25/14ab.

77. *SLTC* 12/346.

78. *Shuang-hung k'an-chi* 25/16b.

79. Ibid., 25/6a.

80. *SLTC* 12/347.

81. On the cursive-seal movement and its impact, see above, essay II.

82. The signature on this work is a relatively late one. For an excellent study of Chu Ta, his sources, calligraphic development, and an hypothesis on the dating of works by signature style, see Fred Fang-yu Wang, "The Calligraphy of Pa-ta shan-jen," paper presented at the Symposium on Paintings and Calligraphy by Ming *I-min*, Chinese University of Hong Kong, 1975 (forthcoming in *Proceedings of the Symposium*, 1977).

According to Professor Wang's study, among a total of 69 *dated* works, 25 are inscriptions on paintings and 44 are individual works of calligraphy. The earliest is dated 1659, with the majority dating from 1685 to 1705. This hanging scroll was executed around 1699.

83. Generally speaking, there were two main trends of calligraphy in the Ch'ing period, that affiliated with the court and that outside the court. Court calligraphers practiced a neat and homogeneous style, later referred to as "examination-hall style" (*kuan-ko t'i*). For a succinct summary, see *SLTC* 12/340–44.

84. On this subject see Liu Yen-t'ao, *Ts'ao-shu t'ung-lun*, 6/139–47. Liu was the editor of a Shanghai journal, *Ts'ao-shu yüeh-k'an*, devoted to cursive script and published intermittently between 1941 and 1948.

85. For further details, see Liu, *Ts'ao-shu t'ung-lun*, 5/91–117; for an English summary of the contents of the book, see Ch'en Chih-mai, *Chinese Calligraphers and Their Art*, pp. 170–73.

ESSAY IV

1. Cf. the discussion in *SZ* 2, pp. 8–11 (Kanda Kiichiro).

2. Chang Huai-kuan, "Shu-tuan" in *FSYL* 7/110.

3. For biographical background related to his achievement, see Shen C. Y. Fu, "Huang T'ing-chien's Calligraphy."

4. On this subject, see ibid., pp. 204, 224–233 and n. 107. See also *SZ* 5, pp. 19–23 (Toyama Gunji) and *SMS* 54.

5. *Shan-ku t'i-pa* (ISTP edn.): 4/39–40.

6. On his official positions and change of signature, see Weng Fang-kang (1733–1818), *Mi Hai-yüeh nien-p'u* (*Yüeh-ya-t'ang* edn.; Taipei 1965 rpt). In Ecke, *Chinese Calligraphy*, no. 22, the order of the two graphs in Mi's name has been reversed. Mi also signed his works "Yüan-chang"; e.g. the scroll in the exhibition, *no. 8*, and another work in running-cursive script, the *Shu-shih-yü* (*Hsiang-shih t'ieh*) in the Palace Museum, Taipei (*KKFS* 11–2/27).

7. It should be noted, however, that the calligrapher Wu Yüeh (active ca. 1115–after 1156), who lived during Kao-tsung's reign, became known for a special type of cursive called "gossamer thread writing" (*yu-ssu-shu*). The style was striking but could not express the full potential of the Chinese brush. See Nakata Yūjirō's study of the work in *Chūgoku shoron-shu*, pp. 277–83; and *SZ* 16/33–34.

8. Chiang K'uei, *Hsu Shu-p'u* (ISTP edn.), p. 3. See also below, n. 63.

9. The prevailing disdain for the weakness of Southern Sung modes of calligraphy is given by T'ao Tsung-i's sharp criticism of Ch'ien Hsüan's style as having "not yet succeeded in sloughing off the decadent and debilitated spirit of the end of the Sung." (*Shu-shih hui-yao* 7/65; trans. J. Cahill.)

10. Chao was particularly fond of the *Tu-ku Lan-t'ing*, which he inscribed with thirteen colophons in 1310. (Tokyo National Museum; *SMS* 56.) Still, that was relatively late in his career; earlier he had become acquainted with other examples of the Two Wangs' calligraphy through his friendship with Chou Mi and Hsien-yü Shu (see *nos. 12* and *16*). On their association with the Tsin-T'ang works circulating in Hangchou, see Marilyn W. Fu, "The Impact of the Re-Unification."

11. On the background to this important work, see *SZ* 8/50–56, pp. 33–40, and *SMS* 18.

12. Wang Shu, *Hsu-chou t'i-pa* 11/21a.

13. For example, works known to have been in her collection which bear Feng's colophon are: Huang T'ing-chien's *Sung-feng-ko* (Palace Museum, Taipei; *KKFS* 10–2/1–5); and two recently excavated paintings from the royal tomb of the Ming Prince Chu T'an, Ch'ien Hsüan's "White Lotuses," and the anonymous handscroll, "Hibiscus and Butterfly," (see *Wen-hua ta-ko-ming ch'i-chien ch'u-t'u wen-wu* [Peking, 1972], pls. 133–35).

14. Several works have gained the distinction of being registered as National Treasures and Important Cultural Properties by the Japanese government. See the study on Feng's calligraphy by Kakui Hiroshi (*SMS* 178, pp. 42–46); also Fontein and Hickman, *Zen Painting and Calligraphy*, pp. xlii–xlv, and no. 16.

15. See *SMS* 23. Other works by Huang T'ing-chien in Shen Chou's collection were: (a) *Fa-yuan-wen*; (b) a transcription of a poem by Tu Fu (see Wu K'uan, *P'ao-weng chia-ts'ang-chi* [SPTK edn.], 48/298 and 49/305, respectively); (c) the cursive-script transcription of Li Po's poem, belonging to the Suchou collector Hua Ch'eng (*SMS* 32). See also Shen C. Y. Fu, "Huang T'ing-chien's Calligraphy," pp. 244–45.

16. For another example of Shen's frontispiece in a "plumper" style, see *Ninety Years*, no. 67, p. 243.

17. Chu's colophon is no longer attached to the scroll, but the text of his colophon is recorded in his collected works (*CSCL* 25/1595).

18. Ibid., 26/1638.

19. See *SMS* 23. Wen also wrote an inscription to Huang's transcription of *Yin Ch'ang-sheng shih san-p'ien* (extant in rubbing form; recorded in *Wen Tai-chao t'i-pa* [MSTK edn.] 3/272).

20. This scroll appears to be the earliest extant work of a group of scrolls in large-sized running script in Huang T'ing-chien style: (a) dated 1533–35 (*Ninety Years*, no. 132, pp. 147 and 154–55); (b) dated 1536 (ibid., no. 133, pp. 148, 258–59); (c) dated 1538 (*SZ* 17/78–81); (d) dated 1545 (*SZ* 17/82–83); (e) datable 1549 (*Ninety Years*, no. 167, pp. 188, 280–81); (f) dated 1550 (ibid., no. 169, pp. 190–91, 282–83); (g) dated 1559 (ibid., no. 200, pp. 224–25); (h) undated, hanging scroll in the Metropolitan Museum of Art (Edwards, *Wen Cheng-ming*, no. 19, p. 94); this same poem appears in the handscroll datable 1549; (i) undated hanging scroll (ibid., no. 20, pp. 95–96); and (j) undated hanging scroll (*SBT* 8/9). The handscroll, dated 1550, in the Palace Museum, is of particular interest because it contains no signature or seal of Wen, and had been attributed to Huang T'ing-chien by a previous collector. The works dated 1533–35 and datable 1549 otherwise share the thin, coarse, and dry brushwork which is closest to the Crawford scroll.

21. Such features may also be a function of the paper and brush used. The two large hanging scrolls cited above (h, i), for example, are written on softer, absorbent paper less resistant to the brush, so the coarseness seen, for example, in the 1533, 1549, and 1559 works in Taipei, are absent. Of the preceding list, the 1538 and 1550 works appear to be his finest.

22. *KKFS* 9–3/8–15. Wen's addition was written a year before his death at age 89. Another example of his Su Shih style is a facing leaf to his *Cho-cheng-yuan* album of paintings, dated 1533.

23. This critique represents Huang's reply to Su's criticism of his style (see above discussion). The famous exchange was recorded by Chou Hui (Sung dynasty), in *Tu-hsing tsa-chih*, as cited in Ting Ch'üan-ching, *Sung-jen i-shih hui-pien* (Shanghai, 1936): 12/597.

24. Wu K'uan collected Su Shih's *Ch'u-sung t'ieh* and *Tsui-weng ts'ao*. Wu also wrote colophons to several of Su's works. The *Ch'u-sung t'ieh* was probably the most influential, as he was asked to copy it by a friend, and not satisfied with one version, he re-copied it. Wu also mentioned that he was requested to make two copies of Su's calligraphy when genuine examples of Su's work could not be found. See Wu's *P'ao-weng chia-ts'ang-chi*, 49/304–305; 50/309; 50/311; 51/313; 51/318; 52/319.

25. See also Wu's *Chung-chu-shih*; it is in medium-sized running script, but does not compare in length or monumentality to the present scroll (*Shanghai FSHC* v. 16).

26. It should be noted that Su Shih exerted a strong influence during the late Northern Sung and in the north during the Chin (Jurched) dynasty. Subsequently, only a few isolated individuals carried on his style.

27. See *KKFS* 11–2/12 and *CSCL* 25/1593, his colophon to

Mi's *T'ien-ma fu*. Wang Shu has observed that Chu made a copy of the latter work (*Hsu-chou t'i-pa*, 11/14).

28. See Chu's *Tzu-shu shih-chuan* in Wang Wang-lin, ed., *T'ien-hsiang-lou ts'ang t'ieh* (1830–40 edn.), ch. 3.

29. Wen's interest in Mi is supported by his inclusion of Mi Fu's *Chih K'o-chun Te-ch'en ch'ih-tu* (Palace Museum, Taipei; *KKFS* 11-1/1–2) in volume 5 of his *T'ing-yun-kuan t'ieh*. It was possibly a key source of his knowledge of Mi's style; another smaller-scale example of Wen's "Mi-style" appears in his album, *Cho-cheng-yuan*, dated 1533.

30. For a more complete account, see Liu Ta-chieh, *Chung-kuo wen-hsueh fa-ta-shih* (Taipei, 1967 rpt), pp. 849–56.

31. The Sung revival also took place in painting. Ming masters, for example, not only imitated the styles, but also took Sung themes as subjects. For example, Su Shih's "Red Cliff" was among the most popular. The *Sung-wen* movement was succeeded by the Kung-an "school" in which a master like Yuan Hung-tao (1558–1610, *DMB*, pp. 1635–38) praised Su Shih and followed him faithfully as a model. See Liu, *Chung-kuo wen-hsueh fa-ta-shih*, pp. 857–68.

32. Indeed, one of Wang To's major accomplishments was his standard script in Yen's style. For a brief study of Wang's calligraphy in this style, see Shen C. Y. Fu, "The Calligraphy of Huang T'ing-chien," pp. 85–89.

33. The *Lin-ho* Preface appears to be a shorter account of the famous poetic gathering and purification ceremony held in A.D. 353. Chu Ta was fond of this version; in a colophon to another transcription, he notes that while the *Lan-t'ing* has 325 characters, the *Lin-ho* has only 125, and moreover, that he based his version on a rubbing. In 1889 the scholar Li Wen-t'ien (1834–95) called attention to the existence of the *Lin-ho chi-hsu*, which appears as part of the commentary (by Liu Hsiao-piao) to Lui I-ch'ing's (403–44) *Shih-shuo hsin-yü*. Li Wen-t'ien sought to disprove the contents and calligraphy style of the *Lan-t'ing* in favor of the *Lin-ho* as by Wang Hsi-chih. Most recently Kuo Mo-jo and other scholars have continued Li's attempts. (See *Wen Wu* nos. 6–12 [1965].)

34. In transcribing this text, it should be noted that not only did Chu Ta reject the traditional *Lan-t'ing*, but also the custom of employing Wang Hsi-chih's style to transcribe it. While others would slavishly copy the text and imitate Wang's style, Chu Ta underlines his independence here from such tradition-bound thinking.

35. For a more complete account of Chu Ta's calligraphy and stylistic development, see the study by Fred Fang-yu Wang, as cited above, essay III, n. 82.

36. For a summary of Tao-chi's periods and a study of his calligraphy styles, see Fu, *Studies in Connoisseurship*, pp. 36–45, 59–67, 210–31.

37. The best-known example of Tao-chi's large-sized calligraphy is "Wan-li's Porcelain Handle Brush," dated 1705, a hanging scroll in the University of Michigan Museum of Art. Its largest characters measure only 4½ inches (10.6 cm) in height, however. See Edwards, *The Painting of Tao-chi*, no. 34, pp. 91, 168.

38. Stylistically, "Farewell Poem" is a more mature work than the 1684 "Portrait." The strokes are more carefully formed and the structures not as clumsy, revealing of Tao-chi's greater study and practice. On the basis of style, a later date is proposed for "Farewell Poem," ca. 1684–90.

39. *SLTC* 12/431.

40. Ibid., 12/433. Ho's extant works are mainly in clerical and running-cursive scripts.

41. Cf. the hanging scroll dated 1855 in the Tokyo National Museum (*SZ* 24/54 and *SG* 10/117); and a rare album in standard script, datable to 1839–44, in the Tokyo National Museum (*SG* 10/110–13), which has the plump, smoother brushwork related to the couplet under discussion.

42. *SLTC* 12/433.

43. Ho's father, Ling-han (1772–1840), was President of the Censorate, Board of Works and Revenue; Ho Shao-yeh (1799–1839) was Shao-chi's twin brother; his other brothers were Shao-ch'i (born 1801, *chü-jen* 1834) and Shao-ching (*chü-jen* 1839). See ibid., 12/433–34 and *ECCP*, pp. 287–88 (Li Man-kuei).

44. Biographical details may be found in the chronology compiled by Yang's student, Hsiung Hui-chen, *Lin-su lao-jen nien-p'u* (Shanghai, 1933); see also *SLTC* 12/444.

45. Another important Japanese calligrapher who was influenced by Yang was Iwaya Ichiroku (1834–1905). Yang's contribution to the history of Japanese calligraphy is termed "the new wave" by Nakata Yūjirō (see his *The Art of Japanese Calligraphy*, A. Woodhull and A. Nikovskis, trans. [Tokyo: Heibonsha, 1973], pp. 50, 65–67). On his return to China, Yang maintained contact with Japanese intellectuals, for in 1911 he was visited by a Japanese scholar for whom he wrote the book, *Shu-hsueh erh-yen*. Yang's calligraphy continued to be in demand among Japanese who came to Shanghai to purchase it.

46. For references on Tuan-fang and his catalogues, see *ECCP*, pp. 780–82 (Hiromu Momose).

47. *ISTP* edn. v. 5, in 27 chapters. The title and contents pay homage to Pao Shih-ch'en (1775–1855).

48. *SZ* 24/97. For recent studies of K'ang, see Lo Jung-pang, ed., *K'ang Yu-wei: A Biography and a Symposium* (Tucson, 1967) and Kung-chuan Hsiao, *A Modern China and a New World: K'ang Yu-wei, Reformer and Utopian* (Seattle, 1975).

49. The word *k'ai* (also translated "regular," "block," or "formal" script) needs some explanation. In the pre-T'ang period it meant "model" or "standard," and referred to a type of clerical script, *pa-fen*, in use at the time. In modern usage "standard" (*k'ai*) refers to the script type which was most widely practiced during the T'ang. In the T'ang this script type was also called *chen-shu* or *cheng-shu*. (See Chang Huai-kuan, "Shu-tuan," in *FSYL* 7/108.)

50. The *Ku-lang pei* dated 272 is traditionally considered the earliest surviving work to exhibit the characteristics later to be known as "standard" script. E.g., see K'ang Yu-wei, *Kuang-i-chou shuang-chi*, p. 59; and *SZ* 3/75–6.

51. Yen Chen-ch'ing's *Tzu-shu kao-shen*, dated 780 (Shodō hakubutsukan, Tokyo), and Hsu Hao's *Chu Chü-ch'uan kao-shen*, dated 768 (Palace Museum, Taipei), are among the most convincing of the extant attributions. See *SZ* 10/60–65 and *KKFS* 6/16–21.

52. Dated 1054; another important example in smaller script is Ts'ai's *Hsieh tz'u yü-shu-shih*, dated 1052 (Shodō hakubutsukan). See *SZ* 15/8–15. For his biography see *Sung Shih* 320; and *SZ* 15, p. 181.

53. For a brief study of his calligraphy, see below, essay V, n. 29; and *SZ* 15, pp. 37–44 (Toyama Gunji).

54. See below, essay V, and n. 31.

55. For his biography, see *Sung-jen* 3/2398; *Sung Shih* 445; and *SZ* 16, p. 172.

56. For a study of these dated transcriptions, see Shen C. Y. Fu, "Chang Chi-chih and His Medium Regular Script," forthcoming in *NPMQ*. For an additional analysis, see also Ledderose, "An Approach to Chinese Calligraphy."

57. See especially the title-heads attributed to him in the Tōfukuji, Kyoto (*SG* 7/38–42).

58. For biographical information, see *Sung-jen* 4/3518–19; and *SZ* 16, p. 172.

59. *Tzu-shu-shih*, in Shanghai *FSHC* v. 10. For another fine example of his work, see "Three Poems on Plum Blossoms and Bamboo" in the Crawford collection (Ecke, *Chinese Calligraphy*, no. 28, and Sickman, ed., *Chinese Painting and Calligraphy*, no. 39, pp. 96–97). Two early colophons to this scroll confirm the fact that Chao died before 1268 (ibid., p. 97).

60. "Chao Tzu-ku shu-fa lun," *SKT* 3/166. A famous Tsin work in Chao's collection was a Ting-wu version of the *Lan-t'ing* Preface. (See Chou Mi, *Yun-yen kuo-yen lu* [ISTP edn.], p. 35.) This important scroll circulated among several genera-

tions of Yuan literati. (For an illustration, see Nishikawa Nei, *Showa rantei kinenten zuroku* [Tokyo, 1973], pls. 140–41.)

61. On the painting, see C. T. Li, *Autumn Colors on the Ch'iao and Hua Mountains* (Ascona, 1965); on the artistic activities in Hangchou, see ibid., and Marilyn W. Fu, "The Impact of the Re-Unification," and above, n. 10.

62. Other examples of Chou's calligraphy are his brief colophon to Yen Chen-ch'ing's *Chi chih Chi-ming wen-kao*, when the scroll was in Hsien-yü Shu's collection (see *KKFS* 5/7); and to the *Pao-mu-chih* (see *Shoen* 4). For biographical information, see *Sung-jen* 2/1446–47; *SZ* 16, pp. 172–73, and Hsia Ch'eng-t'ao, "Chou Ts'ao-ch'uang nien-p'u" in *T'ang-Sung Tz'u-jen nien-p'u* (Shanghai, 1961): 315–70.

63. Chou Mi's writing may also be compared to that of Chiang K'uei (1155?–1231?), the major lyric poet and author of *Hsu Shu-p'u*, who wrote in a reserved small-standard style apparently influenced by carved models of *fa-t'ieh*. (For biographical information, see Hsia, ibid., pp. 425–54; *SZ* 16, p. 161, and fig. 19, p. 12, for an illustration of a colophon.)

64. Kanda Kiichiro postulates three major stylistic phases, the first in which Chao studied Kao-tsung's style, the second, the methods of Wang Hsi-chih, and the third, in his late years, the brushwork of Li Yung and Liu Kung-ch'uan. See *SZ* 17, p. 3; also ibid., pp. 11–15 (Toyama Gunji). It is also possible that Chao was influenced by the revival of standard script as advocated by Chang Chi-chih.

65. E.g. see Li's "Stele of Li Ssu-hsun," *SMS* 17. Chao's immersion in the Tsin masters is seen in his thirteen colophons, dated 1310, which he wrote to the *Tu-ku Lan-t'ing*, a Ting-wu version belonging to the monk Tu-ku. (See *SMS* 56 and above, n. 11). The importance of the work for later calligraphers is revealed in Sung K'o's copy of the colophons (cf. below, *fig. 64*).

66. For Chao's other transcriptions, see above essay II, n. 13. Worthy of comparison with this work is (e) *Huai-yun-yuan chi*, dated 1310. This work has a greater fluency and breadth of scale, as there are 6 characters per column, as compared to 9 in the present scroll.

67. The sequence of Chao's official career is given in the following: Yang Tsai, "Chao-kung hsing-chuang," in *Sung-hsueh-chai wen-chi* (*SPTK* edn.): (*wai-chi*) 122–28; and Ou-yang Hsuan, "Chao Wen-min kung shen-tao-pei," in *Kuei-chai wen-chi* (*SPTK* edn.): 9/62–67; see also *SZ* 17, pp. 16–18 (Toyama Gunji).

68. The other is a transcription of the "Song of the Diaphanous Bronze Mirror" by the Chin poet Ma Chiu-ch'ou (1174–1232), an undated album (Palace Museum, Taipei; *KKFS* 17/20–34). Hsien-yü Shu's consciousness of his northern heritage and debt to the Chin poet-calligraphers is evidenced in his choice of content and script-size in these two works. See Marilyn W. Fu, "The Impact of the Re-Unification."

69. Teng Wen-yuan (1259–1329), Ch'iu Yuan (1247–after 1327), and T'ai Pu-hua (1304–52) (colophons 2, 6, and 13) mentioned the *I-ho-ming*; the *Li-tui-chi* was a cliff inscription in large script, dated 762. For a discussion of these sources, see ibid.

70. *SLTC* 10/258. The most famous example of Chao's small-standard writing is his *Han Hsieh-an chuan* dated 1320 (*SZ* 17/22–25), a work which epitomizes the "will-to-perfection" which characterized Chao Meng-fu's artistic personality.

71. For example, the colophons attached to Chao Meng-fu's "Bamboo, Rocks and Lonely Orchids," and to Yao T'ing-mei's "Leisure enough to Spare" (both Cleveland Museum of Art).

72. See *Yuan Shih* 88; F. W. Cleaves, "The 'Fifteen Palace Poems' by K'o Chiu-ssu," *HJAS* 20 (1957): 396 n. 20, 564 n. 136; and Shen C. Y. Fu, "The K'uei-chang-ko and the Imperial Patronage of Art," lecture delivered at the ACLS Yuan Workshop, Princeton University, July, 1975.

73. For his biography, see *Yuan Shih* 181; *Hsin Yuan Shih* 237; and Huang Chin, *Chin-hua Huang hsien-sheng wen-chi* (*SPTK* edn.): 30/306.

74. For his biography, see *Yuan Shih* 181; *Hsin Yuan Shih* 206; and Ou-yang Hsuan, *Kuei-chai wen-chi* (*SPTK* edn.): 9/69–74. His literary works may be found in *Tao-yuan hsueh-ku-lu* (*SPTK* edn., vols. 300–301).

75. For an excellent example in large script, see his colophon to Chao Meng-fu's handscroll, "Mountains and Rivers" (Palace Museum, Taipei; *KKFS* 18/15–16); and in small script, to Tung Yuan's "Waiting for the Ferry in Autumn" (Liaoning Museum; *Liaoning po-wu-kuan ts'ang-hua-chi* 1/21).

76. As noted in the colophons to "Palace Poems" (*no. 20*) by Weng Fang-kang (1733–1818) and Wang Wen-chih (1730–1802).

77. The second version of this work cited in the "Comparative Material" (*no. 20*), appears to be a close copy; it bears none of the subtleties evident here.

78. Another scholar serving in the K'uei-chang-ko who should be mentioned for his fine calligraphy was Chieh Hsi-ssu (1274–1344). His colophon, dated 1338, to Lu Chien-chih's *Wen-fu* (Palace Museum, Taipei; *KKFS* 18/19) is one of the finest examples of standard script in the Yuan.

79. The earliest dated example of Ni's writing appears on his "Enjoying the Wilderness" (Crawford collection; see Sickman, ed., *Chinese Painting and Calligraphy* no. 48, pp. 111–13) with inscriptions dated 1339 and 1354. This letter compares favorably with an inscription dated 1363 to his "Mountains Seen from a River Bank" (Palace Museum, Taipei).

80. Li Ch'i-yen collection, Hong Kong. See *Lan-t'ing ta-kuan* (Hong Kong, 1973, exhibition held at the Chinese University, Hong Kong) cat. no. 163. On Sung K'o, see also essay III, n. 38 and 39.

81. On Sung Lien, see above, essay III, n. 37. The Ming connoisseur Li Jih-hua (1565–1635) considered Sung Lien's small-standard the finest in the Ming (see *SLTC* 11/287); one of his best examples is his colophon to Chang Sheng-wen's "Scroll of Buddhist Images" (Palace Museum, Taipei; *KKFS* 21–1/2).

82. See his two versions, one in the Freer Gallery of Art, the other in the Palace Museum, Taipei.

83. His best example is dated 1551, a transcription of Ou-yang Hsiu's *Tsui-weng t'ing-chi* (Palace Museum, Taipei; *Ninety Years* no. 176, p. 200); cf. also, two other examples dated 1552 and 1544 (*SZ* 17/84–87).

84. In addition, Huang Tao-chou (1585–1646) and Tao-chi (1641–ca. 1710) revived Chung Yu's style in the south (see essay III and nos. 72, 73.)

85. For example, the "Epitaph of Wang Tan-hu," dated 359, and others excavated near Nanking (*SZ* 26/35–40; and *Shohin* 50).

86. In particular, Ch'ien Feng (1740–95) was admired for his monumental style after Yen.

87. See Tou Cheng (Ch'ing dynasty), *Shu-hua-chia pi-lu*: 4/15. Weng's father Weng Hsin-ts'un (1791–1862) was also a calligrapher and may have influenced his son's choice of Ou-yang as a model. For an example of the father's writing, see *CTML* 100, pl. 9; for his biography, see *ECCP*, pp. 858–59.

ESSAY V

1. For a general discussion of the relationship of poetry, painting, and calligraphy, see Aoki Masaru, *Shina bungaku geijutsu kō*, pp. 269–94; Shimada Shūjirō, "Shishoga Sanzetsu," *SZ* 17, pp. 28–36; Susan Bush, *The Chinese Literati on Painting*; Michael Sullivan, *The Three Perfections*; and Hans H. Frankel, "Poetry and Painting: Chinese and Western Views of their Convertibility."

2. The date of execution of the scroll is subject to debate, but it is generally believed that the painting has preserved the main characteristics of subject matter, composition, and figure-type of the Six Dynasties period.

3. For example: (a) Lu Hung (8th century), "Ten Views from a Thatched Cottage," Palace Museum, Taipei (see *Three Hundred Masterpieces* 1/5–14). (b) Li Kung-lin, "Illustrations of the Classic of Filial Piety," The Art Museum, Princeton University (see Richard Barnhart, "Li Kung-lin's Hsiao-ching-t'u," Ph.D. dissertation, Princeton University, 1967). (c) Anonymous, "T'ao Yuan-ming Returning to Seclusion," calligraphy by Li P'eng, Freer Gallery of Art (see Thomas Lawton, *Chinese Figure Painting*, no. 4, pp. 38–41). (d) Li T'ang, "Marquis Wen-kung of Chin Recovering his State," the Metropolitan Museum of Art (see Fong and Fu, *Sung and Yuan Paintings*, no. 2). (e) Ma Ho-chih, "Illustrations to the *Book of Odes*," with commentary by Mao; versions in the Museum of Fine Arts, Boston; the Metropolitan Museum; the British Museum, London; and the Fujii-Yurinkan, Kyoto (ibid., no. 4, and p. 43). (f) Anonymous, "Eighteen Songs of a Nomad Flute," the Metropolitan Museum of Art (ibid., no. 3). (g) Wu Yuan-chih, "Red Cliff," with calligraphy by Chao Ping-wen, Palace Museum, Taipei (see *Three Hundred Masterpieces* 3/132). (h) Chang Wu, "Nine Songs," Cleveland Museum of Art (see Lee and Ho, *Chinese Art under the Mongols*, no. 187).

4. On its early origins, varying denotations, and the implications of the term, see Aoki Masaru, *Aoki Masaru zenshū* (Tokyo, 1969): 6/112–16; Shimada Shūjirō, *SZ* 17, pp. 28–36.

5. See Lee and Ho, *Chinese Art under the Mongols*, no. 183.

6. See *SMS* 121, on sutra writings from the Six Dynasties period.

7. E.g. see *no. 3*, a copy after Ch'u Sui-liang, where 2 signatures of Sung personages are found at the end of the work. Chang Yen-yuan includes a listing of pre-T'ang colophon-signatures of this type; see *Li-tai ming-hua-chi* (Preface 847) 3/91–93.

8. Cf. Aoki, *Shina bungaku*, pp. 269–94.

9. Noted by Shen Te-ch'ien (1673–1769) in his *Shuo-shih ts'ui-yü* as quoted by Aoki, in *Aoki Masaru zenshū* 6/114. In the *SPTK* edition of Tu Fu's works, which is arranged by subject, *chuan* 16 is devoted exclusively to poems on paintings (see *Fen-lei chi-chu Tu kung-pu shih*).

10. Chu Ching-hsuan (ca. 840) records self-inscriptions by Chang Tsao and Wang Wei; see *T'ang-ch'ao ming-hua-lu* (*ISTP* edn.): pp. 22, 25; cf. A. C. Soper, trans., "T'ang-ch'ao ming-hua-lu," *Artibus Asiae* 31, no. 3/4 (1958): 216, 219. For Wu Tao-tzu, see Chang Yen-yuan, *Li-tai ming-hua-chi* 3/111; cf. W. B. Acker, trans., *Some T'ang and Pre-T'ang Texts on Chinese Painting* (Leiden, 1954), p. 259.

11. For the term, see Chang Yen-yuan, *Fa-shu yao-lu* 10/146. The ninth century colophons are recorded by Yeh Meng-te (1077–1148) in his *Pi-shu lu-hua*, which states that colophons dated 887 and 889 were once attached to Lu Hung's "Ten Views from a Thatched Cottage," *Pi-shu lu-hua*, *SKT* 9/362.

12. See Lu Hung, "Ten Views," *Three Hundred Master-pieces* 1/5–15.

13. For e.g., Su Shih, *Tung-p'o t'i-pa*, 6 *chuan*; Huang T'ing-chien, *Shan-ku t'i-pa*, 9 *chuan*; Mi Fu, *Hai-yueh t'i-pa*, 1 *chuan* (*ISTP* edns). In addition, their writings were the object of prohibition during a certain period when the opposing party was in power.

14. For the "Cold Food Festival" scroll in the Wang Shih-chieh collection, Taipei, see *SZ* 15/69–71; for "Five Horses," collection unknown, see *Pageant of Chinese Painting* (Tokyo, 1936): pls. 83–87.

15. On this subject, see essay IV and Shen Fu, "Huang T'ing-chien's Calligraphy."

16. For example: (a) Anonymous, "Streams and Mountains without End," Cleveland Museum of Art (see Sherman Lee and Wen Fong, *Streams and Mountains without End* [Ascona, 1967]). (b) Mr. Li, "Dream Journey over the Hsiao and Hsiang Rivers," Tokyo National Museum (see *Genshoku nihon no bijutsu*, 29/1–3). (c) Wu Yuan-chih, "Red Cliff," Palace Museum, Taipei (see *Three Hundred Masterpieces* 3/132). (d) Wang T'ing-yun, "Secluded Bamboo and Withered Tree," Fujii-Yurinkan, Kyoto (see *Shohin* 30 [1952]). (e) Li Shan, "Wind and Snow in the Fir-Pines," Freer Gallery of Art (see Thomas Lawton, "Notes on Five Paintings from a Ch'ing dynasty Collection," figs. 3, 5, 6). (f) Chou Wen-chü, "Palace Ladies," with colophon by Chang Ch'eng dated 1140, Cleveland Museum of Art. (g) Fan-lung, "Sixteen Lohans," with colophons by Chung-feng Ming-pen and two other Yuan monks (see Thomas Lawton, *Chinese Figure Painting*, no. 20, pp. 98–101).

17. According to Wang K'o-yü, the scroll originally bore the artist's own inscription and colophons by Hsien-yü Shu (dated 1296), Chao Meng-fu, Chou Mi, Ni Tsan, and Ch'en Ju-yen (dated 1352), Ch'iu Yuan, Teng Wen-yuan, Chang Ying, Liu Fu, Chang Shu-yeh, Lin Chung, Li Chih-kang, and Chang Po-ch'un (1242–1302). All but Ni and Ch'en (whose colophons were probably mounted out of order) were active in the early Yuan and were members of Chou Mi's Hangchou circle. See *Shan-hu-wang* (1643), 6/10; Fong and Fu, *Sung and Yuan Paintings*, pp. 143–44.

18. Fong and Fu, p. 71, in which the poem by Ch'iu Yuan is also translated.

19. See *KKSHL* 4/99–101; and Susan Bush, "Literati Culture under the Chin," *Oriental Art* 15 (1969): 104–05.

20. For further discussion of this work and its colophons, see Marilyn W. Fu, "The Impact of the Re-Unification."

21. See also his colophon, dated 1290, to Mi Yu-jen's "Cloudy Mountains," in the Metropolitan Museum of Art (see Fong and Fu, *Sung and Yuan Paintings*, no. 6; translation, p. 63), and his transcription of T'ao Ch'ien's "Home Again," appended to a painting by Ch'ien Hsuan, also in the Metropolitan (Ecke, *Chinese Calligraphy*, no. 32).

22. Lee and Ho, *Chinese Art under the Mongols*, no. 242; the fine colophons have not yet been published. Another colophon in smaller script by Yuan is also found on the scroll by Wang T'ing-yun; for Yuan's biography, see *Yuan Shih* 181 and *Hsin Yuan Shih* 206.

23. Wenley, "A Breath of Spring," pls. 2–3. For other colophons in western collections see above, essay III, n. 32.

24. See Wen Fong's discussion of the relationship of painting and calligraphy style in Fong and Fu, *Sung and Yuan Paintings*, pp. 88–91.

25. On these two paintings, see Chu-tsing Li, *Autumn Colors on the Ch'iao and Hua Mountains* (Ascona, 1965), and his "The Freer *Sheep and Goat* and Chao Meng-fu's Horse Paintings," *Artibus Asiae* 30 (1968): 279–326.

26. They thus differ from those by the Sung Emperor Hui-tsung, for example, whose poetic inscriptions on the painted handscroll proper often carried equal weight or dominated the painting. (Cf. discussion of hanging scrolls, below). See the Emperor's "Five-colored Parakeet" in the Museum of Fine Arts, Boston (*SZ* 15, fig. 57).

27. See above, n. 10.

28. See Su Shih, "T'i Wen Yü-k'o mo-chu ping-hsu," *Su Tung-p'o ch'uan-chi* [*ch'ien-chi*]; Taipei, 1964, 16/223.

29. For a brief study of his calligraphy, see Chuang Shang-yen, "The 'Slender Gold' calligraphy of Emperor Sung Hui-tsung," *NPMB* 2, no. 4 (1967).

30. *KKSHL* 5/65.

31. There are several fine examples in the Crawford collection (see Sickman, ed., *Chinese Calligraphy and Painting*, nos. 16–27, pp. 78–83); an example in the Museum of Fine Arts, Boston (see Tomita and Tseng, *Portfolio*, pl. 86); and in the Palace Museum, Taipei (see Chiang Chao-shen, "The Identity of Yang Mei-tzu and the Paintings of Ma Yuan," *NPMB* 2,

no. 2 (1967) and no. 3 (1967)); and several important examples in Japan, including a pair in the Tenryūji, Kyoto, with calligraphy by the Empress Yang (see Fontein and Hickman, *Zen Painting and Calligraphy*, no. 4, pp. 12–15, where the inscriber is erroneously identified as the sister-in-law of the Emperor Ning-tsung).

32. See Fu, *Studies in Connoisseurship*, p. 74.

33. Several early examples of inscriptions by littérateurs acquainted with Chao Meng-fu are in the Palace Museum, Taipei; for example, Li K'an (1245–1320) and Teng Wen-yuan (1257–1328) on a work by Kao K'o-kung (1245–1310) dated 1309; and Chao Meng-fu, Ch'iu Yuan, and K'o Chiu-ssu on a work by Ch'en Lin, dated 1301. These works and Chao's scroll cited in note 32, have been discussed recently by James Cahill in *Hills Beyond a River: Chinese Painting of the Yuan Dynasty* (Tokyo, 1976), pp. 38–46, 48–9, 157; pls. 17, 19, 77.

34. For a representative selection of works by the Four Great Yuan masters, see Cahill, *Hills beyond a River*.

35. For a study of Yang Wei-chen's inscriptions and the re-attribution of a previously anonymous painting to Yang, see Shen Fu, "A Landscape Painting by Yang Wei-chen," *NPMB* 7, no. 4 (1973).

36. *KKSHL* 5/274.

37. See *KKSHL* 5/232 and *Select Chinese Painting in the National Palace Museum* [Taipei, 1966], 6/4.

38. During the Muromachi period (1333–1573) the custom of inscribing paintings at literary gatherings was exported to Japan and became an important form of expression (*shigajiku*) for Zen monk-painters and poets. Having elaborated on the Chinese custom, as much as three-quarters of the picture area might be reserved for encomiums. See Shimada Shūjiro, "Shigajiku no Shosaizu ni tsuite," *Nihon Shogaku kenkyū Hōkoku*, no. 21 (Tokyo, 1943); and Y. Shimizu and C. Wheelwright, *Japanese Ink Paintings from American Collections: The Muromachi Period, An Exhibition in Honor of Shūjiro Shimada* (Princeton, 1976), pp. 17–39.

39. Shen Chou liked this format. A hanging scroll of peonies, composed in the same way, is in the Nanking Museum. Shen Chou inscribed the upper half himself, dating it 1506, but left enough space below his own inscription for responding poems by his friend Hsueh Chang-hsien. (See *Nan-ching po-wu-yuan ts'ang-hua-chi* [Peking, 1966], 1/19.)

40. For a larger work that includes the same term, see "Fish, Duck and Rock," dated 1694 (Drenowatz collection), in Chu-tsing Li, *A Thousand Peaks and Myriad Ravines* (Ascona, 1974), pp. 211–13, pl. 74.

41. The original album contained at least eighteen leaves. Four leaves belong to J. S. Lee, Hong Kong; two are in Stockholm. See Shen Fu, *Sekitō* (Bunjinga suihen vol. 8, Tokyo: Chuokoronsha, 1976), figs. 7–23.

Two albums comparable to the Boston album are "Landscapes, Vegetables and Flowers," datable ca. 1697–99 (see Fu, *Studies in Connoisseurship*, pp. 204–09; Marilyn Fu and Wen Fong, *The Wilderness Colors of Tao-chi* [New York, 1973]); and the album for Liu Shih-t'ou, dated 1703 (*Sekitō meigafu* [Tokyo, 1937], no. 11).

42. Cf. the translation by Tomita and Tseng, *Portfolio*, p. 24, which differs slightly and is quoted in *no. 73*.

43. For a fine example dated 1736 (Drenowatz collection), see Li, *A Thousand Peaks*, pls. 76–81.

44. Chin Nung may have been inspired by the precedent of the Yuan plum painter, Wang Mien. On his painting dated 1355, Wang first wrote a lengthy inscription in the upper right, then painted a huge branch of downward-hanging plum which circumvented the writing, so that the inscription appears superimposed on the image (in Sirén, *Chinese Painting*, 6/118). Wang Mien's calligraphy, which is rather small and contained in a block, was also consistent with Yuan style.

ESSAY VI

1. Wang Shu (1668–1743) noted that, "After Chao Meng-fu, there was a gap of two hundred years; then came Chu Yun-ming, who brought about a great change." See his *Hsu-chou t'i-pa* 11/14–15.

2. *SKT* 25/423, "Pa Chu shu Tung-p'o chi-yu chuan."

3. *KKSHL* 3/76, "Colophon to Ch'ien-wen ts'e."

4. *SLTC* 11/311.

5. An Shih-feng (ca. 1625), *Mo-lin k'uai-shih* (n.p., n.d.): 11/704.

6. *Ku Kung FSHC*, v. 19.

7. *Shu-lin chi-shih* 2/70.

8. *T'ing-yun-kuan t'ieh* (12 vols.), covering works from the Tsin and T'ang through the Ming, was carved between 1537 and 1560. Wen Cheng-ming gave his approval to an important group of writings by Chu Yun-ming which are included in this compilation. The outline tracing was done by his two sons, Wen P'eng and Chia, and three carvers were employed. See *SZ* 17, p. 10 (Nakata Yūjiro).

9. For Yang's biography, see *DMB*, pp. 1513–16 (Tu Lien-che), and *Ming-jen*, p. 711.

10. *KKSHL* 3/231–40. The text of the colophon is also recorded in Chu's collected works, see *CSCL* 26/1609–10.

11. For a full explication of the scroll's background, see Wilson and Wong, *Friends*, pp. 61–71, no. 9.

12. See Thomas Lawton, "Notes on Five Paintings from a Ch'ing Dynasty Collection," *Ars Orientalis* 8 (1970): 212, fig. 14. For a study of this scroll and a related one in the Palace Museum, Taipei, see Chiang Chao-shen, "Yang Chi-ching and the Wu School of Painters," *NPMB* 7, no. 3 (1973).

13. For other genuine examples of Ch'ien's and Hsing's calligraphy, see Fu, *Studies in Connoisseurship*, no. 3, pp. 86–95. The work discussed is a similar case in which several contemporaries of greater and lesser fame, including Chu Yun-ming, inscribed comments on a single sheet of paper.

14. *CSCL* 5/653.

15. *Ninety Years of Wu School Painting* (Taipei, 1975), no. 114, p. 248; Chiang Chao-shen, "Yang Chi-ching and the Wu School of Painters," *NPMB* 7, no. 3 (1973): 8; and *NPMQ* 8, no. 1 (1973): pl. 4.

16. According to the recent study of Yang and a reconstruction of three related scrolls by Chiang Chao-shen in the Palace Museum, Taipei, these two colophons and a third by T'ang Yin (1470–1523) should actually accompany another scroll by T'ang Yin, "The Lutanist," but were placed together with the "Portrait" in an early remounting. Since Chiang's argument is convincing, we go along with his tentative dating for the T'ang Yin scroll as ca. 1521, with the colophon by Chu Yun-ming also datable to that time. Even though the colophons have undergone some shifts in the remounting process, the original work they accompany was a contemporary one, so that the shifts do not diminish the significance of the colophon.

17. *Ninety Years*, no. 23, p. 24.

18. Ibid., no. 84, p. 90.

19. *SMS* 74/53–5 and *KKFS* 11–2.

20. *KKSHL* 1/101–4; *Ninety Years*, no. 96, p. 106 (partial reproduction).

21. *SMS* 160; for Huang, see *DMB*, pp. 661–65 (H. L. Chan). Huang Hsing-tseng's son Chi-shui (1509–74) studied calligraphy with Chu Yun-ming.

22. *SNT zoku* 5/68–69.

23. *CSCL* 26/1633, "Hsieh ko-t'i-shu yü Ku Ssu-hsun hou-hsu."

24. For Li, see *Ming-jen* 227, and *DMB*, pp. 392, 1471. An example of his running hand is published in *SZ* (old), 20/152. For Hsu, see *DMB*, pp. 612–15 (W. Franke) and *Ming-jen* 458. Hsu served as Grand Secretary and also as Minister of War.

25. See *DMB*, p. 392. Chu Hsien married the daughter of Hsu Yu-chen.

26. *SLTC* 11/310.

27. *CSCL* 11/937–38, "Nu-shu ting."

28. E.g., using a classic metaphor from Six Dynasties criticism, Wang Shu noted that Chu's *feng* and *ku* (lit. "wind and bone," or "style and structure") are not pure and suffer from a rather common tone (*su-yun*). See *Hsu-chou t'i-pa*, 11/14. Chu's contemporary, Wang Ch'ung, commented more sympathetically on Chu Yun-ming's personality: "He followed his own nature and did whatever he felt like doing [*jen-hsing tzu-pien*]." See *Ya-i-shan-jen-chi* 10/1–4.

29. The influence of Chu's grandfather, Hsu Yu-chen, who practiced Ou-yang's style, is visible here. See *SLTC* 11/301; for an example of Hsu's writing, see *T'ing-yun-kuan t'ieh*, v. 10.

30. *CSCL* 11/922, 26/1608–09.

31. Ibid., 26/1641.

32. *SLTC* 11/310.

33. Wang K'o-yü, in *Shan-hu-wang* (1643), as quoted in *SKT* 25/419.

34. *SKT* 25/412, colophon to a work in small writing.

35. *SLTC* 11/311.

36. Ibid. See his *Shu-fa ya-yen* (1559) (*ISTP* edn.). On the Hsiang family, see *DMB*, pp. 541–44 (Ch'en Chih-mai).

37. *Mo-lin k'uai-shih* 11/705.

38. *SMS* 11/22, colophon to Chu's transcription of the *Ch'u-shih-piao*.

39. *KKSHL* 1/105, and Wang Wang-lin, ed., *T'ien-hsiang-lou ts'ang-t'ieh* (1830–40), v. 3.

40. Two other works which should be compared are his *Ch'ien-tzu-wen*, dated 1523, in the Palace Museum, Taipei (*KKSHL* 1/106), and "Twenty Poems to T'ao Ch'ien's Rhymes I," dated 1525 (*SZ* 17/72–3).

41. Cf. also *SBT* 10/3.

42. *Mo-lin k'uai-shih* 11/707.

43. *SKT* 3/172.

44. Ecke, *Chinese Calligraphy*, no. 47.

45. *Toan-zō shogafu* (Osaka, 1928): 3/5.

46. Cf. trans. by J. Chaves, in Ecke, *Chinese Calligraphy*, no. 45.

47. This work should be compared with a scroll dated 1520, "Twenty Poems to T'ao Ch'ien's Rhymes II," in which a worn-out brush is also used, producing a similar feeling of weight (*SZ* 17/74–5).

CHINESE DYNASTIES

		B.C.
		1500
		1400
1766–1122	Shang Dynasty	1300
		1200
		1100
		1000
		900
		800
		700
1122–221	Chou Dynasty	600
		500
		400
		300
221–207	Ch'in Dynasty	200
		100
206 B.C. until 220 A.D.	Han Dynasty (Western and Eastern)	**0**
		100
220–265	Three Kingdoms (Wu, Wei, Shu)	200
		300
265–581	Six Dynasties (Tsin, 317–420)	400
		500
581–618	Sui Dynasty	600
		700
618–906	T'ang Dynasty	800
907–960	Five Dynasties	900
937–975	Southern T'ang	
960–1279	Sung Dynasty (Northern, 960–1126; Southern, 1127–1279)	**1000**
		1100
1115–1234	Chin Dynasty	1200
1279–1368	Yüan Dynasty	1300
		1400
1368–1644	Ming Dynasty	**1500**
		1600
		1700
1644–1912	Ch'ing Dynasty	1800
		1900
since 1912	Republic	

A.D.

ABBREVIATIONS

Archives	*Archives of Asian Art* (formerly *Archives of the Chinese Art Society of America*).
CSCL	Chu Yun-ming. *Chu shih chi-lueh.* In *Chu shih shih-wen-chi.*
CSWC	Chu Yun-ming. *Chu shih wen-chi.* In *Chu shih shih-wen-chi.*
Ch'en-yuan, 100 Couplets	*Ch'en-yuan chen-ts'ang Ming Ch'ing ying-t'ieh pai-lien.*
CTML 100	*Chin-tai ming-lien i-pai chung.*
CKMHCTS	*Chung-kuo ming-hua-chia ts'ung-shu.*
DMB	Goodrich and Fang. *Dictionary of Ming Biography 1368–1644.*
ECCP	Hummel, Arthur W. *Eminent Chinese of the Ch'ing Period.*
FSYL	Chang Yen-yuan. *Fa-shu yao-lu.*
HHSP	*Hsuan-ho shu-p'u.*
HJAS	*Harvard Journal of Asiatic Studies.*
ISTP	*I-shu ts'ung-pien.*
KKFS	*Ku-kung fa-shu.*
Ku-kung FSHC	*Ku-kung po-wu-yuan ts'ang li-tai fa-shu hsuan-chi.*
KKFS hsuan-ts'ui	*Ku-kung fa-shu hsuan-ts'ui.*
KKSHL	*Ku-kung shu-hua lu.*
Ming Ch'ing SHHC	*Ming Ch'ing shu-hua hsuan-chi.*
Ming-jen	*Ming-jen chuan-chi tzu-liao suo-yin.*
NPMB	*National Palace Museum Bulletin.*
NPMQ	*National Palace Museum Quarterly.*
Shanghai FSHC	*Shang-hai po-wu-kuan ts'ang li-tai fa-shu hsuan-chi.*
SBT	*Shina bokuseki taisei.*
SNT	*Shina nanga taisei.*
SCPC I, II, III	*Shih-ch'ü pao-chi ch'u-pien, hsu-pien, san-pien.*
SKT	Pien Yung-yü. *Shih-ku-t'ang shu-hua hui-k'ao.*
SG	*Shodō geijutsu.*
SZ	*Shodō zenshū.*
SMS	*Shoseki meihin sōkan.*
SLTC	Ma Tsung-ho. *Shu-lin tsao-chien.*
Sung-jen	*Sung-jen chuan-chi tzu-liao suo-yin.*
SPTK	*Ssu-pu ts'ung-k'an ch'u-pien suo-pen.*

SELECTED BIBLIOGRAPHY

Traditional painting catalogues cited in the essays and Catalogue have been omitted from the bibliography and may be found in Hin-cheung Lovell, *An Annotated Bibliography of Chinese Painting Catalogues and Related Texts.*

An Shih-feng. *Mo-lin k'uai-shih.* Reprint. 2 vols. Taipei, 1970.

Aoki Masaru. *Shina bungaku geijutsu kō.* Tokyo, 1949.

Barnhart, Richard M. "Chinese Calligraphy: The Inner World of the Brush," *Metropolitan Museum of Art Bulletin* 30, no. 5 (1972): 230–41.

———. "Exhibition of Chinese Calligraphy." Review of Tseng Yu-ho Ecke, *Chinese Calligraphy*, in *Oriental Art* 18 (1972): 91–93.

———. "Wei Fu-jen's *Pi Chen T'u* and the Early Texts on Calligraphy," *Archives of the Chinese Art Society of America* 18 (1964): 13–25.

Bush, Susan. *The Chinese Literati on Painting: Su Shih (1037–1101) to Tung Ch'i-ch'ang (1555–1636).* Cambridge, Mass., 1971.

Calligraphy of China and Japan: The Grand Tradition. Ann Arbor: University of Michigan Museum of Art, 1975.

Chang, Léon L. Y. *La Calligraphie chinoise.* Paris, 1971.

Chang Wan-li, and Hu Jen-mou, eds. *Selected Painting and Calligraphy of the Eight Eccentrics of Yangchow.* 8 vols. Hong Kong, 1970.

Chang Yen-yuan. *Fa-shu yao-lu. ISTP* edn. (*FSYL*).

Ch'en Chih-mai. *Chinese Calligraphers and Their Art.* London and New York, 1966.

Chen Chün [T'ang Yen]. *Kuo-ch'ao shu-jen chi-lüeh.* 2 vols. 1908. Reprint: Taipei, 1971.

Ch'en Hsien-chang. *Pai-sha hsien-sheng i-chi.* Ed. Ch'en Ying-yao. Hong Kong, 1959.

Ch'en Jen-t'ao [J. D. Ch'en]. *Ku-kung i-i shu-hua mu chiao-chu.* Hong Kong, 1956.

Ch'en-yuan chen-ts'ang Ming Ch'ing ying-t'ieh pai-lien. Ed. Ts'ai Ch'en-nan. Taipei, 1975. (*Ch'en-yuan, 100 Couplets*).

Ch'i-kung [pseud.]. *Ku-tai tzu-t'i lun-kao.* Peking, 1964.

Chiang Chao-shen. "Wen Cheng-ming nien-p'u," *National Palace Museum Quarterly* 5, no. 4 (1971): 39–88; 6, no. 1 (1971): 31–80; no. 2 (1971): 45–75; no. 3 (1972): 49–80; no. 4 (1972): 67–109; 7, no. 1 (1972): 75–109.

Chiang I-han. "Record of the Miao-yen Temple: A Calligraphic Handscroll by Chao Meng-fu (1254–1322)," *National Palace Museum Bulletin* 10, no. 3 (1975): 1–10.

Chiang Yee. *Chinese Calligraphy: An Introduction to Its Aesthetic and Technique.* 3rd rev. edn. Cambridge, Mass., 1973.

Chin-tai ming-lien i-pai chung. Ed. Wang Wang-sun. Taipei, 1962. (*CTML 100*).

Chu Yün-ming. *Chu shih shih-wen-chi: Chu shih wen-chi* (Preface, 1544) and *Chu shih chi-lüeh* (Preface, 1557).

Huai-hsing-t'ang chi edn., 1609. Reprint (in 3 vols.): Taipei, 1971. (*CSCL, CSWC*).

Chuang Shang-yen [Chuang Yen]. "Ku-kung po-wu-yuan chen-ts'ang ch'ien-jen fa-shu kai-kuan" [The preservation of calligraphy in the National Palace Museum]. *National Palace Museum Quarterly* 3, no. 4 (1969): 5–15.

———. "The 'Slender Gold' Calligraphy of Emperor Sung Hui-tsung," *National Palace Museum Bulletin* 2, no. 4 (1967).

Chung-kuo ku-tai shu-fa chan-lan chan-p'in hsuan-chi. Shanghai: Shanghai Museum, 1973.

Chung-kuo ming-hua-chia ts'ung-shu. 2 vols. Shanghai, 1959. Reprint (2 vols. in 1): Hong Kong, 1970. (*CKMHCTS*).

Driscoll, Lucy, and Toda Kenji. *Chinese Calligraphy.* 2nd edn. New York, 1964.

Ecke, Gustav. *Chinese Painting in Hawaii.* 3 vols. Honolulu, 1965.

Ecke, Tseng Yu-ho. *Chinese Calligraphy.* Philadelphia: Philadelphia Museum of Art, 1971.

Edwards, Richard. *The Art of Wen Cheng-ming.* Ann Arbor: University of Michigan Museum of Art, 1976.

——— et al. *The Painting of Tao-chi.* Ann Arbor: University of Michigan Museum of Art, 1967.

Ellsworth, Robert H. *Chinese Furniture.* New York, 1971.

Fong, Wen, "The Problem of Forgeries in Chinese Painting," *Artibus Asiae* 25 (1962): 95–119.

———, and Marilyn Fu. *Sung and Yuan Paintings.* New York: Metropolitan Museum of Art, 1973.

Fontein, Jan, and Money Hickman. *Zen Painting and Calligraphy.* Boston: Museum of Fine Arts, 1970.

———, and Wu Tung. *Unearthing China's Past.* Boston: Museum of Fine Arts, 1973.

Frankel, Hans H. "Poetry and Painting: Chinese and Western Views of Their Convertibility," *Comparative Literature* 9 (1957): 289–307.

Fu, Marilyn, and Shen Fu. *Studies in Connoisseurship: Chinese Paintings from the Arthur M. Sackler Collection.* 2nd rev. edn. Princeton: The Art Museum, Princeton University, 1976.

Fu, Marilyn W. "The Impact of the Re-Unification: Northern Elements in the Life and Art of Hsien-yü Shu (1257?–1302) and Their Relationship to Early Yuan Literati Culture." Paper presented at the ACLS Conference on the Mongol Conquest, July 1976.

Fu, Shen, C. Y. "Chang Chi-chih te chung-k'ai" [Chang Chi-chih and his medium-regular script], *National Palace Museum Quarterly.* Forthcoming.

———. "Huang T'ing-chien's Calligraphy and His Scroll for Chang Ta-t'ung: A Masterpiece Written in Exile." Ph.D. dissertation, Princeton University, 1976.

———. "A Landscape Painting by Yang Wei-chen," *National Palace Museum Bulletin* 8, no. 4 (1973): 1–13.

Fujiwara Sōsui. *Chūgoku shodō shi.* 4th edn. Tokyo, 1973.

Genshoku nihon no bijutsu, vol. 29. Tokyo, 1971.

Goepper, Roger. *SHO: Pinselschrift und Malerei in Japan vom 7.–19. Jahrhundert*. Köln: Museen der Stadt, 1975.

——. *Shu-p'u: der Traktat zur Schriftkunst des Sun Kuo-t'ing*. Wiesbaden, 1974.

Goodrich, L. Carrington, and Fang Chaoying, eds. *Dictionary of Ming Biography 1368–1644*. 2 vols. New York and London, 1976. (*DMB*).

van Gulik, R. H. *Chinese Pictorial Art as Viewed by the Connoisseur*. Rome, 1958.

Hsuan-ho shu-p'u. (Preface, 1120.) ISTP edn. (*HHSP*).

Hummel, Arthur W., ed. *Eminent Chinese of the Ch'ing Period*. 2 vols. Washington, D.C., 1943. Reprint (2 vols. in 1): Taipei, 1967. (*ECCP*).

I-shu ts'ung-pien. Ed. Yang Chia-lo. 36 vols. Taipei, 1962. (*ISTP*).

Iijima Syunkei. *Shodō jiten*. Tokyo, 1975.

Kaiankyo-rakuji. Ed. Kikujirō Takashima. Tokyo, 1964.

Ku-kung fa-shu. 21 vols. Taipei: National Palace Museum, 1962– . (*KKFS*).

Ku-kung fa-shu hsuan-ts'ui [Masterpieces of Chinese calligraphy in the National Palace Museum]. 2 vols. Taipei, 1970. (*KKFS hsuan-ts'ui*).

Ku-kung ming-hua san-pai chung [Three Hundred Masterpieces of Chinese Painting in the Palace Museum]. 6 vols. Taipei: National Palace and National Central Museums, 1959. (*Ku-kung 300*).

Ku-kung po-wu-yuan ts'ang li-tai fa-shu hsuan-chi. 26 vols. Peking: Palace Museum, 1963. (*Ku-kung FSHC*).

Ku-kung shu-hua chi. 5 vols. Peking: Palace Museum, 1931–34.

Ku-kung shu-hua lu. 4 vols. Taipei: National Palace Museum, 1965. (*KKSHL*).

Kuang-tung ming-chia shu-hua hsuan-chi. Hong Kong, 1960.

Lawton, Thomas. "Notes on Five Paintings from a Ch'ing Dynasty Collection," *Ars Orientalis* 8 (1970): 191–215.

Ledderose, Lothar. "An Approach to Chinese Calligraphy," *National Palace Museum Bulletin* 7, no. 1 (1972): 1–14.

——. "Mi Fu yü Wang Hsien-chih," *National Palace Museum Quarterly* 7, no. 2 (1972): 71–84.

——. *Die Siegelschrift (Chuan-shu) in der Ch'ing-Zeit: Ein Beitrag zur Geschichte der Chinesischen Schriftkunst*. Wiesbaden, 1970.

Lee, Sherman, and Ho Wai-kam. *Chinese Art under the Mongols: The Yuan Dynasty (1279–1368)*. Cleveland: Cleveland Museum of Art, 1968.

Liao-ning sheng po-wu-kuan fa-shu hsuan-chi. 16 vols. Peking, 1961– .

Liu Yen-t'ao. *Ts'ao-shu t'ung-lun*. Taipei, 1956.

Lok Tsai Hsien Collection of Calligraphy in Couplets. Hong Kong: Art Gallery of the Institute of Chinese Studies, Chinese University, 1972.

Lovell, Hin-cheung. *An Annotated Bibliography of Chinese Painting Catalogues and Related Texts*. Michigan Papers in Chinese Studies, no. 16. Ann Arbor: Center for Chinese Studies, University of Michigan, 1973.

Ma Tsung-ho. *Shu-lin tsao-chien*. (Preface, 1934.) ISTP edn. (*SLTC*).

Masterpieces of Asian Art in American Collections II. New York: The Asia Society, 1970.

Ming Ch'ing shu-hua hsuan-chi. Ed. Wong Nan-p'ing. Hong Kong, 1974. (*Ming Ch'ing SHHC*).

Ming-hsien mo-chi. Ed. Hsu An-ch'ao. 2 vols. Shanghai, 1933.

Ming-jen chuan-chi tzu-liao suo-yin. 2 vols. Taipei: National Central Library, 1964. (*Ming-jen*).

Nakata Yūjirō. *The Art of Japanese Calligraphy*. Trans. Alan Woodhull and A. Nikovskis. New York and Tokyo, 1973.

——. *Chūgoku shojin den*. Tokyo, 1973.

——. *Chūgoku shoron shū*. Tokyo, 1970.

——. *Ō Gishi o chūshin to suru hōjō no kenkyū*. Tokyo, 1960.

Ninety Years of Wu School Painting. Taipei: National Palace Museum, 1975.

Nishikawa Nei. "Shinjutsu no Gyojō-jō," *Shohin* 142 (1963): 2–10.

——. *Showa rantei kinenten zuroku*. Tokyo, 1973.

Pai-chueh-chai ming-jen fa-shu. Ed. Lo Chen-yü. N.p., n.d. (*Pai-chueh-chai MJFS*).

Paintings by Ming and Ch'ing Masters from the Lok Tsai Hsien Collection. New York: Sotheby Parke Bernet, 1976.

P'an Po-ying. *Chung-kuo shu-fa chien-lun*. Shanghai, 1962.

Pien Yung-yü. *Shih-ku-t'ang shu-hua hui-k'ao*. (Preface, 1682.) Reprint (in 4 vols.). Taipei, 1921. (*SKT*).

Proceedings of the International Symposium on Chinese Painting. Taipei: National Palace Museum, 1972.

Rosenfield, John M., and Fumiko E. and Edwin A. Cranston. *The Courtly Tradition in Japanese Art and Literature: Selections from the Hofer and Hyde Collections*. Cambridge, Mass.: Fogg Art Museum, Harvard University, 1973.

San-hsi-t'ang fa-t'ieh, hsu fa-t'ieh. 1747 and 1754. Reprint (in 3 vols.): Tainan, Taiwan, 1971.

Shang-hai po-wu-kuan ts'ang li-tai fa-shu hsuan-chi. 20 vols. Peking, 1964. (*Shanghai FSHC*).

Shih-ch'ü pao-chi ch'u-pien, hsu-pien, san-pien, 1744–45, 1791–93, 1793–1817. Reprint: Taipei, 1969. (*SCPC* I, II, III).

Shimada Shūjirō. "Shishoga Sanzetsu," *Shodō zenshū* 17 (1956): 28–36.

Shina bokuseki taisei. 10 vols. Tokyo, 1937. (*SBT*).

Shina nanga taisei, zoku-hen. 22 vols. Tokyo, 1935–37. (*SNT, SNT zoku*).

Shinchō shogafu. Ed. Naitō Torajirō. Osaka, 1916.

Shodō geijutsu. 24 vols. Tokyo, 1970–73. (*SG*).

Shodō zenshū. Old series, 25 vols. Tokyo, 1930–32. New series, 25 vols. Tokyo, 1954–68. (*SZ, SZ old*).

Shoen. Series 1 and 2. Tokyo, 1911–20, 1937–43.

Shohin. Tokyo, 1949– .

Shoseki meihin sōkan. 200 vols. Tokyo, 1964– . (*SMS*).

Sickman, Laurence, ed. *Chinese Calligraphy and Painting in the Collection of John M. Crawford, Jr.*, New York, 1962.

Ssu-pu ts'ung-k'an ch'u-pien suo-pen. Reprint. 440 vols. Taipei, 1965. (*SPTK*).

Sullivan, Michael. *The Three Perfections: Chinese Painting, Poetry, and Calligraphy.* London, 1974.

Sung-jen chuan-chi tzu-liao suo-yin. 7 vols. Ed. Ch'ang Pi-te et al. Taipei, 1974– . (*Sung-jen*).

Ta-feng-t'ang ming-chi. Ed. Chang Ta-ch'ien. 4 vols. Kyoto, 1955–56.

T'ao Tsung-i. *Shu-shih hui-yao.* (Preface, 1376.) Reprint. N.p., 1929.

Tōan-zō shogafu. Ed. Saitō Etsuzō. 4 vols. Osaka, 1928.

Tomita Kojirō, and Tseng Hsien-ch'i. *Portfolio of Chinese Paintings in the Museum: Yuan to Ch'ing Periods.* Boston: Museum of Fine Arts, 1961.

Tou Chen. *Kuo-ch'ao shu-hua-chia pi lu.* 1911. Reprint: Taipei, 1971.

Toyama Gunji. *Chūgoku no sho to hito.* Osaka, 1971.

Ts'ao-shu yueh-k'an. Shanghai, 1941–48.

Tsien Tsuen-hsuin. *Written on Bamboo and Silk: The Beginnings of Chinese Books and Inscriptions.* Chicago, 1962.

Wang Chuang-wei. *Shu-fa ts'ung-t'an.* Taipei, 1965.

Wang Shu. *Hsu-chou t'i-pa.* N.d. Reprint. Taipei, 1970.

Wen Cheng-ming. *Fu-t'ien-chi.* Ca. 1574. Reprint: 2 vols. Taipei, 1968.

———. *T'ing-yun-kuan t'ieh.* 12 vols. N.p. 1537–60.

Wen-wu ching-hua. Peking, 1959– .

Whitfield, Roderick. *In Pursuit of Antiquity: Chinese Paintings of the Ming and Ch'ing Dynasties from the Collection of Mr. and Mrs. Earl Morse.* Princeton: The Art Museum, Princeton University, 1969.

Wilson, Marc, and Kwan S. Wong. *Friends of Wen Cheng-ming: A View from the Crawford Collection.* New York: China Institute, 1974.

Yang Lien-sheng. "Chinese Calligraphy." In Laurence Sickman, ed., *Chinese Calligraphy and Painting in the Collection of John M. Crawford, Jr.* New York, 1962.

Yang Yü-hsun. *La Calligraphie chinoise depuis les Han.* Paris, 1937.

Yü Yu-jen. *Piao-chun ts'ao-shu.* Shanghai, 1936.

Zürcher, E. "Imitation and Forgery in Ancient Chinese Painting and Calligraphy," *Oriental Art* (n.s.) 1, no. 4 (1955): 141–46.

INDEX

Only calligraphers, colophon writers, and painters whose works appear in the exhibition are included. No. refers to entry number; numbers in italic refer to entry pages; numbers in bold face refer to illustration pages; numbers followed by n. refer to notes.

(Index prepared by Hongnam Kim)